THE PHILOSOPHY OF
PAUL WEISS

THE LIBRARY OF LIVING PHILOSOPHERS

PAUL ARTHUR SCHILPP, FOUNDER AND EDITOR 1939–1981
LEWIS EDWIN, HAHN, EDITOR, 1981–

Paul Arthur Schilpp, Editor
THE PHILOSOPHY OF JOHN DEWEY (1939, 1971, 1989)
THE PHILOSOPHY OF GEORGE SANTAYANA (1940, 1951)
THE PHILOSOPHY OF ALFRED NORTH WHITEHEAD (1941, 1951)
THE PHILOSOPHY OF G.E. MOORE (1942, 1971)
THE PHILOSOPHY OF BERTRAND RUSSELL (1944, 1971)
THE PHILOSOPHY OF ERNST CASSIRER (1949)
ALBERT EINSTEIN: PHILOSOPHER-SCIENTIST (1949, 1970)
THE PHILOSOPHY OF SARVEPALLI RADHAKRISHNAN (1952)
THE PHILOSOPHY OF KARL JASPERS (1957; aug. ed., 1981)
THE PHILOSOPHY OF C.D. BROAD (1959)
THE PHILOSOPHY OF RUDOLF CARNAP (1963)
THE PHILOSOPHY OF C. I. LEWIS (1968)
THE PHILOSOPHY OF KARL POPPER (1974)
THE PHILOSOPHY OF BRAND BLANSHARD (1980)
THE PHILOSOPHY OF JEAN-PAUL SARTRE (1981)

Paul Arthur Schilpp and Maurice Friedman, Editors
THE PHILOSOPHY OF MARTIN BUBER (1967)

Paul Arthur Schilpp and Lewis Edwin Hahn, Editors
THE PHILOSOPHY OF GABRIEL MARCEL (1984)
THE PHILOSOPHY OF W.V. QUINE (1986)
THE PHILOSOPHY OF GEORG HENRIK von WRIGHT (1989)

Lewis Edwin Hahn, Editor
THE PHILOSOPHY OF CHARLES HARTSHORNE (1991)
THE PHILOSOPHY OF A.J. AYER (1992)
THE PHILOSOPHY OF PAUL RICOEUR (1995)
THE PHILOSOPHY OF PAUL WEISS (1995)

In Preparation:
Lewis Edwin Hahn, Editor
THE PHILOSOPHY OF HANS-GEORG GADAMER
THE PHILOSOPHY OF RODERICK M. CHISHOLM
THE PHILOSOPHY OF DONALD DAVIDSON
THE PHILOSOPHY OF SIR PETER F. STRAWSON
THE PHILOSOPHY OF THOMAS S. KUHN
THE PHILOSOPHY OF JÜRGEN HABERMAS
THE PHILOSOPHY OF SEYYED HOSSEIN NASR

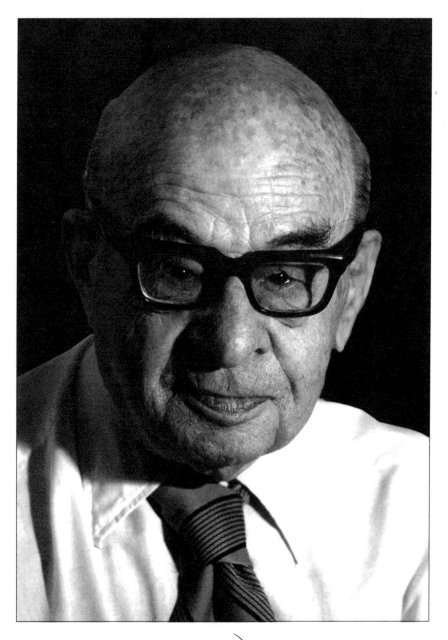

Paul Weiss

THE LIBRARY OF LIVING PHILOSOPHERS
VOLUME XXIII

THE PHILOSOPHY OF
PAUL WEISS

EDITED BY

LEWIS EDWIN HAHN

SOUTHERN ILLINOIS UNIVERSITY AT CARBONDALE

CHICAGO AND LA SALLE, ILLINOIS • OPEN COURT • ESTABLISHED 1887

 THE PHILOSOPHY OF PAUL WEISS

OPEN COURT and the above logo are registered in the U.S. Patent and Trademark Office.

Copyright © 1995 by The Library of Living Philosophers

First printing 1995

Printed and bound in the United States of America.

Library of Congress Cataloging-in-Publication Data

(The Cataloging-in-Publication Data has been applied for. It was unavailable at the time of going to press.)

The Library of Living Philosophers is published under the sponsorship of Southern Illinois University at Carbondale.

GENERAL INTRODUCTION
TO
THE LIBRARY OF LIVING PHILOSOPHERS

Founded in 1938 by Professor Paul Arthur Schilpp and edited by him until July 1981, when the present writer became editor, the Library of Living Philosophers is devoted to critical analysis and discussion of some of the world's greatest living philosophers. The format for the series provides for setting up in each volume a dialogue between the critics and the great philosopher. The aim is not refutation or confrontation but rather fruitful joining of issues and improved understanding of the positions and issues involved. That is, the goal is not overcoming those who differ from us philosophically but interacting creatively with them.

The basic idea for the series, according to Professor Schilpp's general introduction to each of the earlier volumes, came from the late F.C.S. Schiller, who declared in his essay on "Must Philosophers Disagree?" (in *Must Philosophers Disagree?* London: Macmillan, 1934) that the greatest obstacle to fruitful discussion in philosophy is "the curious etiquette which apparently taboos the asking of questions about a philosopher's meaning while he is alive." The "interminable controversies which fill the histories of philosophy," in Schiller's opinion, "could have been ended at once by asking the living philosophers a few searching questions." And while he may have been overly optimistic about ending "interminable controversies" in this way, it seems clear that directing searching questions to great philosophers about what they really mean or how they think certain difficulties in their philosophy can be resolved while they are still alive can produce far greater clarity of understanding and more fruitful philosophizing than might otherwise be had.

And to Paul Arthur Schilpp's undying credit, he acted on this basic thought in launching in 1938 the Library of Living Philosophers. It is planned that each volume in the Library of Living Philosophers include preferably an intellectual autobiography by the principal philosopher or an authorized biography of that thinker's publications, a series of expository and critical essays written by leading exponents and opponents of the philosopher's thought, and the philosopher's replies to the interpretations and queries in these articles. The intellectual autobiogra-

phies usually shed a great deal of light on both how the philosophies of the great thinkers developed and the major philosophical movements and issues of their time; and many of our great philosophers seek to orient their outlook not merely to their contemporaries but also to what they find most important in earlier philosophers. The bibliography will help provide ready access to the featured scholar's writings and thought.

With this format in mind, the Library expects to publish at more or less regular intervals a volume on one of the world's greater living philosophers.

In accordance with past practice, the editor has deemed it desirable to secure the services of an Advisory Board of philosophers to aid him in the selection of subjects of future volumes. The names of seven prominent American philosophers who have agreed to serve appear on the page following the Founder's General Introduction. To each of them the editor is most grateful.

Future volumes in this series will appear in as rapid succession as is feasible in view of the scholarly nature of this Library. The next volume in the series will be devoted to the philosophy of Hans-Georg Gadamer.

Volumes are also projected on Donald Davidson, Roderick M. Chisholm, Sir Peter F. Strawson, Thomas S. Kuhn, Jürgen Habermas, and Seyyed Hossein Nasr.

Throughout its career, since its founding in 1938, the Library of Living Philosophers, because of its scholarly nature, has never been self-supporting. We acknowledge gratefully that the generosity of the Edward C. Hegeler Foundation has made possible the publication of many volumes, but for support of future volumes additional funds are needed. On 20 February 1979 the Board of Trustees of Southern Illinois University contractually assumed sponsorship of the library, which is therefore no longer separately incorporated. Gifts specifically designated for the Library, however, may be made through the Southern Illinois University Foundation, and inasmuch as the latter is a tax-exempt institution, such gifts are tax-deductible.

LEWIS E. HAHN
EDITOR

DEPARTMENT OF PHILOSOPHY
SOUTHERN ILLINOIS UNIVERSITY AT CARBONDALE

FOUNDER'S GENERAL INTRODUCTION*
TO
THE LIBRARY OF LIVING PHILOSOPHERS

According to the late F.C.S. Schiller, the greatest obstacle to fruitful discussion in philosophy is "the curious etiquette which apparently taboos the asking of questions about a philosopher's meaning while he is alive." The "interminable controversies which fill the histories of philosophy", he goes on to say, "could have been ended at once by asking the living philosophers a few searching questions."

The confident optimism of this last remark undoubtedly goes too far. Living thinkers have often been asked "a few searching questions", but their answers have not stopped "interminable controversies" about their real meaning. It is nonetheless true that there would be far greater clarity of understanding than is now often the case if more such searching questions had been directed to great thinkers while they were still alive.

This, at any rate, is the basic thought behind the present undertaking. The volumes of the Library of Living Philosophers can in no sense take the place of the major writings of great and original thinkers. Students who would know the philosophies of such men as John Dewey, George Santayana, Alfred North Whitehead, G.E. Moore, Bertrand Russell, Ernst Cassirer, Karl Jaspers, Rudolf Carnap, Martin Buber, et al., will still need to read the writings of these men. There is no substitute for first-hand contact with the original thought of the philosopher himself. Least of all does this Library pretend to be such a substitute. The Library in fact will spare neither effort nor expense in offering to the student the best possible guide to the published writings of a given thinker. We shall attempt to meet this aim by providing at the end of each volume in our series as nearly complete a bibliography of the published work of the philosopher in question as possible. Nor should one overlook the fact that essays in each volume cannot but finally lead to this same goal. The interpretative and critical discussions of the various phases of a great

*This General Introduction sets forth in the founder's words the underlying conception of the Library. L.E.H.

thinker's work and, most of all, the reply of the thinker himself, are bound to lead the reader to the works of the philosopher himself.

At the same time, there is no denying that different experts find different ideas in the writings of the same philosopher. This is as true of the appreciative interpreter and grateful disciple as it is of the critical opponent. Nor can it be denied that such differences of reading and of interpretation on the part of other experts often leave the neophyte aghast before the whole maze of widely varying and even opposing interpretations. Who is right and whose interpretation shall he accept? When the doctors disagree among themselves, what is the poor student to do? If, in desperation, he decides that all of the interpreters are probably wrong and that the only thing for him to do is to go back to the original writings of the philosopher himself and then make his own decision— uninfluenced (as if this were possible) by the interpretation of anyone else—the result is not that he has actually come to the meaning of the original philosopher himself, but rather that he has set up one more interpretation, which may differ to a greater or lesser degree from the interpretations already existing. It is clear that in this direction lies chaos, just the kind of chaos which Schiller has so graphically and inimitably described.[1]

It is curious that until now no way of escaping this difficulty has been seriously considered. It has not occurred to students of philosophy that one effective way of meeting the problem at least partially is to put these varying interpretations and critiques before the philosopher while he is still alive and to ask him to act at one and the same time as both defendant and judge. If the world's greatest living philosophers can be induced to cooperate in an enterprise whereby their own work can, at least to some extent, be saved from becoming merely "desiccated lecture-fodder," which on the one hand "provides innocuous sustenance for ruminant professors," and on the other hand gives an opportunity to such ruminants and their understudies to "speculate safely, endlessly, and fruitlessly, about what a philosopher must have meant" (Schiller), they will have taken a long step toward making their intentions more clearly comprehensible.

With this in mind, the Library of Living Philosophers expects to publish at more or less regular intervals a volume on each of the greater among the world's living philosophers. In each case it will be the purpose of the editor of the Library to bring together in the volume the interpretations and criticisms of a wide range of that particular thinker's

1. In his essay "Must Philosophers Disagree?" in the volume of the same title (London: Macmillan, 1934), from which the above quotations were taken.

scholarly contemporaries, each of whom will be given a free hand to discuss the specific phase of the thinker's work that has been assigned to him. All contributed essays will finally be submitted to the philosopher with whose work and thought they are concerned, for his careful perusal and reply. And, although it would be expecting too much to imagine that the philosopher's reply will be able to stop all differences of interpretation and of critique, this should at least serve the purpose of stopping certain of the grosser and more general kinds of misinterpretations. If no further gain than this were to come from the present and projected volumes of this Library, it would seem to be fully justified.

In carrying out this principal purpose of the Library, the editor announces that (as far as is humanly possible) each volume will contain the following elements:

First, an intellectual autobiography of the thinker whenever this can be secured; in any case an authoritative and authorized biography;

Second, a series of expository and critical articles written by the leading exponents and opponents of the philosopher's thought;

Third, the reply to the critics and commentators by the philosopher himself; and

Fourth, a bibliography of writings of the philosopher to provide a ready instrument to give access to his writings and thought.

<div align="right">

PAUL ARTHUR SCHILPP
FOUNDER AND EDITOR, 1939–1981

</div>

DEPARTMENT OF PHILOSOPHY
SOUTHERN ILLINOIS UNIVERSITY AT CARBONDALE

ADVISORY BOARD

ACKNOWLEDGMENTS

The editor hereby gratefully acknowledges his obligation and sincere gratitude to all the publishers of Paul Weiss's books and publications for their kind and uniform courtesy in permitting us to quote—sometimes at some length—from Professor Weiss.

Editor's Note: I sadly report that we just learned of the death in October 1993 of one of our most distinguished contributors, Nathan Rotenstreich.

For the philosophers of the world and his many friends, the death of Nathan Rotenstreich is an irreplaceable loss.

LEWIS E. HAHN
17 NOVEMBER 1995

*Deceased.

TABLE OF CONTENTS

FRONTISPIECE iv
GENERAL INTRODUCTION TO THE LIBRARY OF LIVING
 PHILOSOPHERS vii
FOUNDER'S GENERAL INTRODUCTION TO THE LIBRARY OF LIVING
 PHILOSOPHERS xi
ACKNOWLEDGMENTS xii
PREFACE xvii

PART ONE: INTELLECTUAL AUTOBIOGRAPHY OF PAUL WEISS 1
 FACSIMILE OF WEISS'S HANDWRITING 2
 LOST IN THOUGHT: ALONE WITH OTHERS 3
 EXAMPLES OF WEISS'S ARTWORK 46

PART TWO: DESCRIPTIVE AND CRITICAL ESSAYS ON THE
 PHILOSOPHY OF PAUL WEISS, WITH REPLIES 53

A. METAPHYSICS

 1. Hans Lenk: Metaphysics, Interpretation, and the
 Subject 55
 REPLY TO HANS LENK 64

 2. John Lachs: Metaphysics and the Social
 Construction of Human Nature 73
 REPLY TO JOHN LACHS 84

 3. Daniel O. Dahlstrom: The Dunamis of Explanation 93
 REPLY TO DANIEL O. DAHLSTROM 110

4. Paul G. Kuntz: Cosmos and Chaos: Weiss's
 Systematic Categorization of the Universe 113
 REPLY TO PAUL G. KUNTZ 117

5. Andrew J. Reck: The Five Ontologies of Paul Weiss 139
 REPLY TO ANDREW J. RECK 153

6. George R. Lucas, Jr.: Philosophical Inquiry and
 Reflective Historical Engagement—Some Right
 and Wrong Uses of History in Philosophy 159
 REPLY TO GEORGE R. LUCAS 177

7. Thomas R. Flynn: History and Histories: Weiss
 and the Problematization of the Historical 183
 REPLY TO THOMAS R. FLYNN 201

B. EXPERIENCE, PRAGMATISM, AND METHOD

8. Nathan Rotenstreich: Experience and Possibilities 211
 REPLY TO NATHAN ROTENSTREICH 224

9. Sandra Rosenthal: Paul Weiss and Pragmatism: A
 Dialogue 229
 REPLY TO SANDRA ROSENTHAL 244

10. Kevin Kennedy: Adumbration and Metaphysics
 after Pragmatism 253
 REPLY TO KEVIN KENNEDY 269

11. Jay Schulkin: Paul Weiss's Vision of Philosophy
 and Nature 275
 REPLY TO JAY SCHULKIN 289

12. Eric Walther: The Self Revisited 295
 REPLY TO ERIC WALTHER 307

13. David Weissman: Method 313
 REPLY TO DAVID WEISSMAN 324

14. Abner Shimony: The Transient Now 331
 REPLY TO ABNER SHIMONY 349

C. RELIGION AND THEOLOGY

15. Jacquelyn Ann K. Kegley: Is Adventurous
 Humility Possible?: The One for the Many 355
 REPLY TO JACQUELYN ANN K. KEGLEY 368

16. Eugene Thomas Long: Philosophy and Religious
 Pluralism 373
 REPLY TO EUGENE THOMAS LONG 384

17. Robert Cummings Neville: Paul Weiss's Theology 389
 REPLY TO ROBERT CUMMINGS NEVILLE 415

D. LOGIC

18. Robert L. Castiglione: Weiss's Early Substitutional
 Logic 427
 REPLY TO ROBERT L. CASTIGLIONE 453

19. Eugenio Benitez: Paul Weiss, Metaphysics, and the
 Problem of Induction 459
 REPLY TO EUGENIO BENITEZ 472

E. ETHICS, MORALITY, AND POLITICS

20. Richard L. Barber: Real Possibility and Moral
 Obligation 479
 REPLY TO RICHARD L. BARBER 489

21. Antonio S. Cua: Reasonable Persons and the
 Good: Reflections on an Aspect of Weiss's Ethical
 Thought 495
 REPLY TO ANTONIO S. CUA 515

22. Thomas Krettek, S.J.: Paul Weiss and the
 Foundations of Political Philosophy 523
 REPLY TO THOMAS KRETTEK 538

F. CREATIVITY AND ART

23. William Desmond: Creativity and the Dunamis 543
 REPLY TO WILLIAM DESMOND 558

24. George Kimball Plochmann: System, Method, and
 Style in a Philosophy of Art 565
 REPLY TO GEORGE KIMBALL PLOCHMANN 585

25. Carl R. Hausman: Paul Weiss's Account of the
 Dynamic Structure of Creative Acts 591
 REPLY TO CARL R. HAUSMAN 608

26. Robert E. Wood: Paul Weiss: Metaphysics and
 Aesthetics 615
 REPLY TO ROBERT E. WOOD 630

G. SPORT

 27. Daniel A. Dombrowski: Weiss, Sport, and the
 Greek Ideal 637
 REPLY TO DANIEL A. DOMBROWSKI 655

 28. S. K. Wertz: The Metaphysics of Sport: The Play
 as Process 661
 REPLY TO S. K. WERTZ 675

PART THREE: BIBLIOGRAPHY OF THE WRITINGS OF
 PAUL WEISS 681

INDEX: BY S. S. RAMA RAO PAPPU 695

PREFACE

Broad, original, dynamic, prolific, and creative, Paul Weiss has made major contributions to several branches of philosophy and because of him philosophy in this country is different for the better, more diverse, more vital, and more important. Such of his works as *Modes of Being, Nine Basic Arts, Sport: A Philosophical Inquiry, First Considerations, Privacy, You, I and the Others,* some entries in *Philosophy in Process,* some chapters in his *Creative Ventures,* and his latest and perhaps best book, *Being and Other Realities,* open up new areas and deal both freshly and well with pivotal neglected questions.

As a speculative thinker he has tackled the great questions in philosophy and urged both the general public and other philosophers to do likewise in their own way. Much of his impact on behalf of philosophy has come through his example, discussions, and such activities as founding and editing the *Review of Metaphysics,* helping found the Conference on Science, Philosophy, and Religion, and the C.S. Peirce Society, and founding and leading the Metaphysical Society of America. He is also famous for his teaching. Of him Alfred North Whitehead said: "The danger of philosophical teaching is that it may become dead-alive" and added, "but in Paul Weiss's presence that is impossible."

Born 19 May 1901 on the lower East Side of New York City in an area populated almost exclusively by immigrant Jewish families, he developed into one of the greatest philosophers of our time, and for many decades he has been at the forefront of philosophy doing his own thing. As a student he was fortunate to have a wide range of highly diverse scholar-teachers. Early on he studied with Morris R. Cohen at the College of the City of New York, and at Harvard he did his dissertation with Whitehead and studied with W.E. Hocking, C.I. Lewis, R.B. Perry, Sheffer, Wolfson, and visiting professor Gilson. A post-doctoral Sears

Travelling Fellowship enabled him to visit the University of Berlin, the University of Freiburg, and the Sorbonne. At Freiburg he met both Husserl and Heidegger and in Paris once more he sat in on some of Gilson's lectures. As he tells us in his Intellectual Autobiography, he rounded out the trip by presenting a paper on "Entailment and the Future of Logic" at the Seventh World Congress of Philosophy at Oxford, England, 1–6 September 1930, and, of course, met many other philosophers.

But to cite one further item concerning his pioneering work, while a graduate student at Harvard, in collaboration with Charles Hartshorne, who accepted him as a co-editor, he edited the first six volumes of the first major edition of Peirce's Collected Papers (1931–1935) and thus helped make the man whom many regard as the most original philosopher this country has produced more widely studied and appreciated.

His intellectual autobiography tells us more about this editorial venture and also helps us better understand how Paul Weiss the master of abstraction dealt with the concrete. For example, we learn how he came to write about art and how he prepared for this by learning to draw and paint and engage in various other art forms. Although he regards himself as a highly expendable artist, I am happy that we have managed to include a small sampling of his art work, mainly drawings, in this volume.

I am grateful to Professor Weiss and his twenty-eight critics for making this volume possible. And special thanks are due Robert Castiglione for sharing with me the first volume of his biography in process of Weiss; also to G.K. and Carolyn Plochmann for counsel concerning Weiss's art work; and to Xiao Yang Yu for helping make available material important for the volume.

As ever, I am grateful for the support, encouragement, and cooperation of our publisher, Open Court Publishing Company, particularly M. Blouke Carus, David R. Steele, Kerri Mommer, and Edward Roberts. It is a pleasure to work with them. And I am most grateful for continued support, understanding, and encouragement from the administration of Southern Illinois University.

And once more it is a pleasure to express my gratitude to the staff of the Morris Library for their unfailing help in a number of ways. My warm thanks also go to Claudia Roseberry, Vernis Shownes, and the Philosophy Department secretariat for help in ever so many ways, and to Sharon R. Langrand I extend special thanks for help with manuscripts and proofs and all she does to keep our office functioning efficiently.

Finally, for warm support and counsel I am deeply grateful to my colleagues, especially Elizabeth R. Eames, John Howie, and Pat A. Manfredi.

LEWIS EDWIN HAHN
EDITOR

DEPARTMENT OF PHILOSOPHY
SOUTHERN ILLINOIS UNIVERSITY AT CARBONDALE
JUNE 1995

PART ONE

INTELLECTUAL AUTOBIOGRAPHY OF PAUL WEISS

Dear Lewis:

It is not often that I write longhand. Instead I type. When I do write longhand I soon switch to shorthand sometimes without noticing.

The foregoing in shorthand:

[shorthand symbols]

My shorthand was learned in 1914-15 and is perhaps un-intelligible to anyone but me. Sometimes I have difficulty in deciphering it.

[shorthand symbols] 1914-15 *[shorthand symbols]*

Paul

Weiss

Paul Weiss

LOST IN THOUGHT:
ALONE WITH OTHERS

I. MORE OR LESS CHRONOLOGICAL

*F*oreshadowings. When I was in the first grade, my teacher said that all the words in the English language were composed of the twenty-six letters we had so painfully learned. I was dumbfounded. I spent a good deal of the day going over my vocabulary, searching for a word not made up of some combination of those letters. I then exhibited some of the marks of the philosopher: a refusal to accept the word of authority, a struggle with a problem beyond my powers to resolve, and the use of an unsatisfactory method, followed by a belated discovery that the problem had been misconstrued, and the solution improperly sought. An English word, after all, is one that contains some combination of those letters. (I have heard from others that they have had a somewhat similar experience.)

As I looked about, it seemed to me that others exhibited a confidence indicating that they had an answer for every basic question. I then exhibited other characteristics of a philosopher—a failure to penetrate deeply enough beyond appearances, a readiness to believe that there were areas I had not probed, an ignorance of what the final answer might be, and a confidence that it was obtainable.

When my first-year Sunday school teacher said that Adam and Eve were the forebears of all humans, and then went on to say that God put a mark on Cain so that no one would kill him, I asked who these were. She did not know. I never returned to Sunday school again. My question was innocently put, but the inability of one, who supposedly knew the answer, to provide it, prefigured a life-long unwillingness to accept answers that left questions that could not be answered.

My Early Life. My father, Samuel, was a Hungarian. He left Hungary to avoid army service, travelled through Europe as a tinkerer, and

emigrated to the United States in the early 1890s. He had steady jobs as a tinsmith, coppersmith, boilermaker, and finally, as a foreman of a small group of immigrant boilermakers. He was a quasi-Orthodox Jew, observing the holidays, going to synagogue on many Saturdays, and more or less observant of traditional dietary laws. He did not grow a beard and was lax in demanding observances of traditional practices by his offspring—four boys, of whom I was the second. Two others died in infancy. I saw him rarely. He left for work before I woke, had dinner with the family shortly after he returned (usually, some kind of vegetable soup, soup-meat, and bread), and then retired to read a German newspaper. He spoke little English. On Saturdays, I saw little of him, for I then played in the street. On Sundays, we fooled around with him for a while; after lunch he went off to a coffeehouse where he spent the day playing cards with Hungarian cronies. I admired him for his strength and integrity, and was impressed with the fact that others came to him for advice.

My mother, Emma Rothschild Weiss, was born in Eisenach, Germany, the daughter of a butcher and sausage-stuffer. I don't know when she emigrated or why. She worked as a servant girl until she married. Red-haired, interested in the arts, she slipped away many a Wednesday afternoon to the second gallery of the opera house or theater. She knew English well enough to correct my spelling and grammar when I was in the eighth grade. I did not like her much, thinking she was too noisy and sloppy. I know now that I was gravely mistaken.

I was born on May 19, 1901, on the lower East Side in New York City, in an area densely populated, almost exclusively by immigrant Jewish families. My first recollection is living in a flat with a toilet in the hall, shared by other families. The hall was permeated with the smell of cooked cabbage. I was about five. We moved the next year to a subsection of Yorkville, a German enclave. Ours was a so-called 'railroad' flat. It had a kitchen that was the only source of heat, and in which our family life took place, a bedroom shared by my elder brother and myself, another shared by my two younger brothers, and a third shared by my mother and father. The front room contained our best furniture; it was reserved for visitors who hardly came, and for my father's Sunday mornings when he read his newspaper. We lived there until he died at sixty-five. My mother, as the result of a self-induced abortion, died some five years earlier.

The Working Class. New York City, at that time, was a cluster of villages, where one lived together mainly with those of a similar background, religion, or ethnicity. We had accounts, with the grocer and others, that were paid off each Saturday, when my father received his

wages. Only one person in my neighborhood, to my knowledge, had gone to college. Almost everyone else stopped short of graduating from elementary or high school. There was no evident envy of the rich, nor any particular interest shown in other ethnic or religious groups, or in those we saw or read about who lived in other ways. We were astonished when a young American couple and son rented the cheapest flat on the top floor. They made no attempt to make contact with us, or we with them. Our next-door neighbor was an Italian shoemaker with a large family, with whom we were not much involved. The greatest handicap we suffered, though hardly aware of the fact, was that we knew no one who had some connection, even with minor political figures. I do, though, remember receiving some small sum from a 'ward heeler'—as did a number of other boys—to inform those who had not voted by late afternoon, that they ought to go to the polls. For Thanksgiving, we brought food to school from home to fill baskets for the poor, and helped distribute them.

My father earned $28 a week in the last decade of his life. We paid a weekly small sum for insurance. On my father's death, I received my share of the inheritance, an unexpected $100.

Our first selection of merchandise, awarded for filling up books with stamps received for buying designated products, was an American flag. On the Fourth of July, our flag joined many others. All of us were staunch Americans, even the gangster who lived at the end of the street.

The Jews had their synagogues and lodges. The Italians had their societies, extended families, and church. The Irish remained apart from both, perhaps centered at their local church. The few I knew at school did not seem to be in a better or worse condition than we were. We knew no blacks, and did not often see one. We were provincials in a large, variegated metropolis. There was no serious unemployment problem at the time nor evident discontent. One was with one's own. That sufficed for both parent and offspring.

A Few Memories. I misbehaved in the first grade, showing off before the girls. As a consequence, my father had to take off a half-day from work. He spanked me before the entire class. I was then transferred to another school where there were only boys, all of them larger than I. There I began to take an interest in my studies. The teachers were exacting, and I enjoyed learning. I was allowed to skip two classes. Many dropped out by the sixth grade, at fourteen, with 'working papers'.

When we occasionally had chicken for supper, my father and eldest brother were given the legs. How I longed to be given one, or even to taste one. To this day, I eat chicken legs with a special relish, and with a faint memory of my painful deprivation.

I once planted an onion in a flowerpot. In a moment of anger, my

elder brother took the flowerpot and threw it into the street. I was so shocked, so hurt, that I then violated my brother's trust in me and told my mother that he was keeping back some of his pay from her. I still feel the shock, and am again and again irritated with myself for having betrayed his confidence. I was about twelve.

I wanted to buy a pair of roller skates. Taking orders for a fish store and delivering the fish on Fridays (those were the days before Vatican II, and there were Catholics in my neighborhood for whom Friday was a day on which one ate fish), I saved my pay and the small tips and, at the end of a month, was able to buy a pair of skates. That was a high point. I skated all over the city. Later I bought ice skates and spent many an evening going around and around the ice rink, rather mindlessly.

When I was in elementary school and high school, I would go to a library and read *The Book of Knowledge* day after day, never remembering for long what I had read. There was a periodical, *St. Nicholas* I think it was called, which offered prizes for answers to puzzles and for essays. I was frustrated because the library never seemed to get the magazine in time for me to send in an entry within the scheduled period.

I was run over twice, once by a horse-driven wagon, and the other I do not remember by what, though it must also have been a horse-driven wagon, for it was not often that an automobile went down our street. We sued the owners of the wagon but lost the case, a neighbor reporting that I could be seen hobbling around the house.

I was severely scalded on my leg from tumbling into the tub when my mother was pouring out the boiling water from a wash-boiler and I slipped from my perch. I spent a few weeks in the hospital. I was in the third grade and remember resenting the fact that they gave me kindergarten material to work on.

I was treated in a clinic, and we were greatly thrilled on receiving a post card from the physician who had treated me.

My Hebrew name is 'Peretz'. 'Paul' was my registered name, part of my mother's attempt to move upward in the American world. (My brothers were named Irving, Milford, and Arthur, the Anglicized versions of Isaac, Moses, and Abraham.) As part of a continuing but vain attempt at upward movement, I was sent to an upper class synagogue to prepare for my Bar Mitzvah. It did not work. I was never invited to any party by any of the other students.

It was not an unhappy childhood, but rather a not well-focussed one. At thirteen, I went for two weeks to the Henry Street Settlement House Summer Camp. It was a very happy time, my first away from the city, living with some half dozen others under the supervision of a college

student. I learned to swim, was taught elementary hygiene, some sports, and was beatifically happy.

I never had many close friends, nor did I feel the lack of them. I have always enjoyed having visitors, but to this day, I can spend day after day seeing no one, happily concentrating on some problem.

I write these comments without a sense of their having any relevance to my lifework. Although on various occasions I have remarked on different occurrences in my life that I thought would be of interest, I do not have a good idea of myself then, as a separate person or as together with others.

Ten Wasted Years. On graduating from public school, I asked my elder brother for advice. Having gone to a commercial high school for a year, he urged me to enroll there. It was poor advice. Although I did learn shorthand and typing, I did not benefit much from the courses in commercial Spanish, bookkeeping, or commercial arithmetic. My grades fell and, with my mother's encouragement, I dropped out in the third year. I then began to work in a series of minor jobs, as a stenographer, assistant bookkeeper, assistant to some division head, and the like. For a while I worked as a stenographer at MacLevey's gymnasium at Madison Square Garden. I saw such prize (we said 'price') fighters as Champion Jack Johnson, and the sycophantic, sleazy people who surrounded him. I remember being sent with some magazines to his secluded white wife, listening to Mac (originally 'Max') Levey's warnings against smoking, and learning about a world into which I never fully entered. I also exchanged lessons in shorthand for lessons in boxing. Neither student profited much but I, at least, learned one truth: my boxer-teacher told me to defend myself in any way I liked and said that he would be able to hit me with impunity (not his word); he was right. My last participation in the world of commerce was as a junior partner in my brother's forwarding business, a minor service performed at doctored, high prices. I also attended night high school, but never finished. All the while, I read widely but unsystematically, remembering little and benefitting less.

When I was about twenty-one, I attended City College in the evening, taking three successive classes in philosophy, three times a week. I had heard from a Japanese salesman that it was philosophy in which I seemed to be interested. There I won an essay contest. Acting on what I now think was a casual suggestion, I gave up my not too glorious career in commerce and, at twenty-two, entered City College of New York, supporting myself by teaching English to foreigners and by tutoring children of parents who wanted them to be in the company of a college student, and who perhaps might help them to better their grades and to see something of the city.

The student body at City College was entirely male, almost entirely Jewish, and made up of children of immigrants. Many had jobs at which they spent the afternoon and sometimes the evening or night. Professor Morris R. Cohen was the outstanding figure. He had a wide knowledge, an exceptionally quick mind, a fine memory, and a devastating wit. He was insistently dominant, even tyrannical in class, humiliating many. His insensitivity did not disturb me. What I wanted from him were answers to my questions, instruction on what to read and why, and help in understanding some difficult texts that I had begun to read on my own. This he did willingly and well, if spoken to outside class. I was surprised to learn, when I began to study logic in graduate school, that he was not the logician he thought he was—or perhaps the logician he wanted us to believe he was. I made out quite well at City College: I edited a literary magazine, graduated *Cum Laude,* and was elected to Phi Beta Kappa.

Whitehead. In my senior year, Whitehead's *Science and the Modern Word* appeared. I could not understand what he meant by 'extensive abstraction'. When I asked my friends at City College, who were majoring in physics and in mathematics, to explain it to me, they said that I would not be able to understand it. I therefore resolved to go to Harvard to find out. Cohen thought it was not a good idea. His best students, among whom were Sidney Hook and Ernest Nagel, usually went to Columbia University to study with Dewey. Although I fancied myself to be adept at arguing, I decided that I did not want to spend my life defending positions I had not understood. I think, perhaps, that I may not have felt that I would be able to compete successfully. I also had a bent toward logic, and knew that Whitehead was one of the authors of *Principia Mathematica.*

I arrived at Harvard in the spring of 1927. The undergraduates were primarily white, all male, most apparently rich. For many, the college carried them a little further than their preparatory schools, but with less supervision. Few seemed to be interested in learning. Students and faculty spoke and acted as though they were confident that they were at the greatest institution in the land. I tutored some and, after I had my doctorate and had returned from abroad, taught at both Harvard and Radcliffe for a year. I thought I was a poor teacher, though decades later I heard from one of my students who said that I was the best teacher he ever had.

The graduate students at Harvard had come from all over the country. Some of the logicians, among whom was Quine, were outstanding. Gilson (a visiting professor) did not think the Harvard graduate students compared well with his French students, lacking, as most did, knowledge of Latin or Greek, and a good understanding of the history of

thought. I admired C.I. Lewis as a person, but found that neither he nor his colleagues were much interested in teaching, nor did they have much to say beyond what they had published. Whitehead was unlike any of them, or any of the teachers at City College. Indeed, in the over sixty years that have passed since then, I have not encountered anyone more stimulating, more interested in ideas, more independent-minded. He was unfailingly genial and friendly, but with a self he never let many, perhaps any, reach. As a teacher, he was mainly concerned with stating his latest ideas, usually in a rather nonsystematic, unargued form but, to me, always arresting, original, challenging, and surprising. In every class and conversation, he led me to think about a multiplicity of things, not all of which were pertinent to what he had initially begun to say, to the questions I asked, or to the issues that apparently were being discussed. Although he rarely answered any questions, he sometimes silenced me by making me rethink my questions, and often enough by taking me up new avenues—or left me behind, vaguely dissatisfied.

An anecdote: Dissatisfied, as I still am, with his idea of process, I asked him if he thought that there ever would be a time when 1 + 1 would not equal 2. With a twinkle in his eye and a friendly smile, he said: "Not for a long time." I smile at the memory, but to this day I do not know the status that mathematical truths have in his system. His comments about Hegel were quite elementary, his knowledge of Kant quite thin. Criticisms of his spoken or written views were rarely met. I do not know if he had any close friends. I think, as time went on, I was the only philosopher he said was a friend, but I cannot say that we ever were close, intimate friends. He was not cold or detached, but reserved, living behind a barrier he maintained, even while being most genial, friendly, and responsive.

I learned more from him at his Sunday evenings 'at home' than I did from his lectures or his books, and then mainly not about some doctrine, but how important it was to have a disciplined mind that refused to be confined by any dogma, or even by positions once held. No criticisms disturbed him, though, as the anecdote makes evident, he also allowed himself to avoid direct confrontations with difficulties, that others might have with some of his ideas. His reply to me should have been followed by a clarification of the idea of process that I apparently had not well understood. The experience of being with him, hearing him talk about politics, poetry, culture, and history, to sense his disinterest in winning an argument, and to become aware of his indifference to being thought right or important, made me feel that I was at last in contact with someone I had vaguely sought over the years—a philosopher.

Harvard's philosophy department at that time was dominated by

logicians, dealing with issues rarely touched upon by Whitehead, even when he taught what he called 'a course in logic'. (My guess is that his colleagues asked him to give such a course, and that, in his amiable way, he assented, and then contented himself with calling what he did, 'logic', and making some odd references to 'propositions'.) Since he had long ago abandoned the interest he had shown in writing the *Principia Mathematica* with Bertrand Russell, I think he met the request of his colleagues with the announcement—and, I suppose, also with the belief that whatever he said exhibited logic in some guise.

Most of the best graduate students at the time studied with the logicians and were interested in little else. While I shared their desire to say, as clearly as I could, whatever I sought to maintain, I began to drift away from them, both because I was interested in the ideas that Whitehead was pointing toward, because they ignored my questions and probings, and because of the insights that Gilson provided about classical thinkers, most of whom I had not known, even by name.

The logicians, both students and teachers, seemed to have a contempt for the history of thought. They viewed themselves as being like axiomatizing mathematicians, or like scientists who began where their predecessors left off, and thought that this was what a philosopher should do. Gilson made me see how wrong they and I were. The turn Whitehead took did not interest them. They did not object to it, but just ignored it. I do not think that they had a good grasp of either mathematics or science. What they said of these fitted quite well with what textbooks reported about results achieved, or with what was published in technical journals. Creativity did not interest them. They were closer in spirit and practice to the late scholastics than they suspected. Gilson enabled me to see what a limited understanding of philosophy they—and I—had.

We heard nothing from our teachers about Husserl or Heidegger, Bergson or Collingwood. We were offered a poor course in Kant and none in Hegel. No time was spent discussing Dewey; Peirce was never mentioned. I learned about some of these, and still others, when I began teaching elsewhere, discovering to my surprise that there were many modern thinkers who dealt with issues I had not heard discussed or even mentioned in Cambridge.

My thoughts were in a perpetual whirl, due mainly to what Whitehead said, sometimes in class, but more often at his home. I do not think it was until I had begun to teach elsewhere that I really began my life-long, resolute, systematic effort to try to understand the nature of reality in its full range and complexity. Still, in the essay I wrote in honor of Whitehead, I did open up some basic issues that were near the center of my thought for at least a decade.

All the while I was at Harvard, Evelyn Whitehead kept an eye on me, quietly and kindly offering suggestions about my ways of speaking, dressing, and social functioning. She also saw to it that I was helped financially in many subtle and unsuspected ways, enabling me to continue studying and learning. I am immeasurably indebted to her. There are a number of entries in *Philosophy in Process* that make evident the extent and quality of her kindness. She had the look, the bearing, and the spirit of the *grande dame*. The Whiteheads were at home on Sunday evenings. Some days my wife and I were the only visitors; whether alone or together with others, the conversation was always interesting, eminently civilized and, for the two of us, an education itself.

Victoria. After my first semester at Harvard, Victoria (Brodkin) and I were married. Five years younger than I, she graduated, also in 1927, from Hunter College, a feebler, female counterpart of City College. She was one of four children living with a widowed mother who, though unable to write her name, was fiercely determined that her children be educated. She had to place Victoria and a brother in an orphan asylum for a year or two, an experience that was recalled by Victoria with horror throughout her life.

Victoria did not do well at Hunter. During my first year at Harvard she taught in a public school. The next year she came to Cambridge to work for a doctorate in English. She immediately began to grow remarkably, receiving the highest marks in her graduate classes. She more than carried her own in discussions with the Whiteheads, Felix Frankfurter, and others who occasionally visited the Whiteheads on Sunday evenings. She soon became Evelyn's good friend and confidante. I never did anything of importance without consulting her. Her doubts were stated frankly and clearly. She read every word of *Reality,* and understood it better than Whitehead or my contemporaries did. Today, there are some who are beginning to see what she had seen over five decades ago.

My Life in Crime. When I was in the first grade, I heard that apple trees grew from apple seeds. One day, when the afternoon was coming to an end, I ran down to the local park, looked to see if I were being noticed, saw that I was not, threw an apple seed on to the grass and fled home. I felt I was doing something that was forbidden, but still what should be done, though I hadn't a clear idea just what this was. When I began to work after having left high school, I participated in the petty chicanery that was carried out in most of the firms, and did so without protest. When I was at Harvard, in my first year, I ate at a cheap restaurant, but soon began to feel ill. The little money I had was not enough to allow me to eat at a better place. I heard that Harvard had a dining club that did

not bill you until the end of the semester. I enrolled at once, without having any expectation that I would be able to pay my bill. Fortunately, I was soon asked to tutor students who were taking an undergraduate class in logic and was able to meet the charges for meals when they became due. Since that time I have led a more or less honorable life.

Charles S. Peirce. I had heard of Peirce from Professor Cohen. He had published a collection of some of Peirce's papers when I was an undergraduate. When I heard that Hartshorne was editing the papers, I asked him if I could be of help. What a fortunate question that was. I was soon studying the writings of the greatest of American philosophers, more original and daring, more wide-ranging and dogged than any of my teachers, hardly known to anyone, and never mentioned in any course. I cannot think of him now, over sixty years later, without sadness charged with joy, still feeling the injustice of his having been neglected and the splendor of his fresh, free, radical thought.

The philosophy department had bought the Peirce manuscripts from his widow in an act of kindness. Hartshorne had been working on them for a number of years. He had been told to prepare a two-volume selection, but received no further instructions. No one visited him; no one checked to see how he was functioning. Early on, someone else had worked on them but had been dismissed. When I arrived at Hartshorne's office, I found him in the midst of a considerable disarray of thousands upon thousands of manuscript pages. He had planned to publish the requested two volumes under some such heading as "The Wit and Wisdom of Peirce." In the space allotted, it seemed to be the only way to make evident the greatness, richness, originality, and range of Peirce's thought. Backed by large funds, employing a permanent staff, there are some today who dismiss what, for the first time, was being done to make some of Peirce's brilliant, unpublished papers available.

Hartshorne said he knew nothing about logic. After I had worked on the unpublished papers on logic for a while, he turned all the logic and mathematical papers, published and unpublished, over to me. Later, he generously requested the department to appoint me as his co-editor. I received no instruction on how to proceed. Not until the papers were ready for publication did any member of the department look in to see what we had done. Some came for an hour, some for an hour or two. Some did not come at all.

I had persuaded the department to allow us to publish six volumes. When the papers were ready for publication, the department decided to publish the six volumes as having been produced under its auspices, with acknowledgments to Hartshorne and me for helping in the work. I was outraged. I finally persuaded the department to change its policy, partly

because, at that time, Hartshorne was on his way to Chicago, and I was about to accept an appointment at Bryn Mawr. I continued to work at Bryn Mawr on the editing of volumes 3 and 4, and to help with volumes 5 and 6. I confess that I continue to be angry with a department that planned such a usurpation. Most of all, I am glad that we had the opportunity to enable Peirce to be widely studied and appreciated for decades, before funds were raised to make possible a chronological edition of his works in some thirty volumes.

It is becoming more and more evident to more and more philosophers and those interested in major contributions to thought, both here and abroad, that Peirce is—to state it cautiously—the greatest American thinker, with a wider range and a greater originality in multiple fields than anyone has exhibited in modern times, here or abroad. He is perhaps—as he himself thought—to be compared with Leibniz, though he had a surer sense of what makes sense than Leibniz had. It is a matter of deep satisfaction to know that funds are now being provided so that all his writings, published and unpublished, will be made available.

A Free Year. I wrote my thesis on the nature of systems under Whitehead. He gave me little advice. The thesis was turned down when I submitted it with, I thought, Whitehead's approval. By that time, I had published a number of reviews and a technical paper or two on logic. Whitehead suggested my rearranging some chapters, making a few modifications here and there, and I was let pass. After a number of other newly minted doctors of philosophy turned down the invitation, I was offered a second-class fellowship for study abroad. Victoria and I went to Germany and France in 1929–30, when the Nazi danger began to take shape.

In Berlin we met Jacob Klein and Leo Strauss. Klein recommended that we go to Freiburg. We spent a semester there. I attended lectures by Heidegger, and seminars by Becker and Ebbinghaus. Heidegger raised suspicions in me of an undefined nature—but not apparently in the members of his large audience. He did not seem to me to be searching for truth, but mainly for approval. I learned more from our visits to cathedrals, museums, by going on trips to the Black Forest with students, reading German novels, poetry, and philosophy, and from conversations with others our age. The next term we went to Paris. I attended classes given by various philosophers, of which I remember only those by Gilson. On the way back, I read a paper on logic at the International Congress of Philosophy, met and discussed questions in the foundations of mathematics with Abraham Fraenkel and then, after a year's teaching at Harvard and Radcliffe, began the life of a teaching philosopher, lasting over sixty years.

Beginning a Career. Whitehead's recommendation resulted in my receiving an appointment at Bryn Mawr. At that time, Bryn Mawr was the self-chosen destination of the most intellectual, intelligent, determined, and well-prepared young women in America. They were hard-working, earnest, and confident. It is from them that I learned to put questions to my students, to elicit questions from them, and to discuss the answers on as close to an equal footing as I could manage.

Rarely are young teachers helped by older colleagues. If fortunate, they learn how to teach by arousing and satisfying students' more or less latent desires to understand, learn, and know. At Bryn Mawr, the desires were more explicit, the responses exceptionally honest, penetrating, and provocative. Some of those who were my students there have become life-long friends.

Told that my work on the Peirce papers, the articles I had written on logic, and the reviews published in national and professional journals would not merit my being appointed to a full professorship, I began the writing of the first of my books, *Reality*. Although it has been reprinted, and is today occasionally referred to—mainly because of its account of adumbration—it was not well-received.

The title, *Reality,* was deliberately chosen to point up the presuppositional, unexamined problems tacit in the title of Bradley's *Appearance and Reality* and Whitehead's *Process and Reality*. A dense book, it tried to show that ontology and epistemology presuppose one another. Along the way, it struggled to understand the nature of time, perception, and science, and to probe a host of other topics.

I rarely read any of my previous writings. Occasionally, I may look at one or two of them to prompt questions about what I am tentatively affirming, to make evident the need to change my vocabulary, to broaden my scope, or to take better account of what seemed not to be well-understood or adequately justified. I have refused to become a disciple of some other thinker, or of myself as expressed at some previous time. It is the position that the disciple accepts that needs examination, as later thinkers make evident. Nor have I tried to make what was subsequently learned fit in with what I had previously maintained. Instead, I have made each work a distinct venture. Again and again, I have subjected what I thought I had settled to fresh criticisms; again and again I have been aroused by overlooked issues and newly discovered difficulties.

A disciple fixates his master's thought, treating it as a fortress to be defended at all costs. Often enough, what the master said or intended is slighted, exaggerated, or qualified in the attempt to make a neat whole. A system should be coherent; it should be able to withstand criticism; its

strengths should be made manifest in the face of misconceptions, distortions, and poor alternatives; but one does it most justice, not by defending it against misconceptions, or rigidifying it in the form of a plurality of dogmas, but by using it as a means for letting in more light on what was vaguely known or implied. Whether one is one's own disciple or the disciple of another, one will block the way to genuine philosophizing. To avoid that, one must subject what had been arrived at, to remorseless criticism, and to be on the lookout for what had been overlooked, misconstrued, or not well understood. A disciple, of oneself or another, is one who, refusing to budge, concludes that nothing moves in fact or in thought.

What is primarily needed is not self-criticism, for this tends to overemphasize what has been done, but new probings and new perspectives, using criticisms as agents and for promptings. Philosophy is a search for a final, all-comprehensive account, a human's attempt to grasp what only omniscience could fully comprehend. A never-ending pursuit, it is hoped that later thinkers might use what is now done as a starting point and a corrective. One who does this will exhibit the spirit that animates scientists and other dedicated inquirers to a degree and in a manner nothing else could.

I usually prefer the book on which I am working to those that, after many rewritings, I finally published. I do not disown what I had done; sometimes I find that I had made a point in a better way than I do later in a somewhat different context. In any case, I usually find that some of the things previously maintained to be not wrong but incomplete, needing subtilization, supplementation, changes in emphasis, and a wider context. Could I deal with what I have written in the same way that Hartshorne and I dealt with the manuscripts of Peirce, it is possible that I could produce a work which would place a plurality of achievements over the decades within a context where they would enhance one another. Like every other inquirer, I am always moving on. Only after this lifetime venture is over will it be possible for someone to find a way of seeing how it all fits together.

I know that I am not particularly modest or self-effacing. Yet I do not enjoy writing autobiographical comments, evaluating what I have done, or scaling my philosophical endeavors relative to one another or to the works of others. I find serious faults in my predecessors but also in what I have done, preventing me from reaching that defiant yet somnolent state where I no longer live a living philosophy. I would like my past to serve as a goad, a warning, a suggestion, a test, and a promise.

Some of my major claims have been sustained by me for considerable periods, but approached from different angles. The kind of attitude that

is apparently behind the writings of the Platonic dialogues or of Peirce's explorations is what I have found most congenial. Unlike Plato and Peirce, though, I have tried to provide systematic accounts, more in the spirit of Kant and Hegel, but with each begun and carried out freed from an attempt to see how well the new explorations fit in with the old.

The past is a springboard, not a shackle or weight. What themes I have maintained over the years have often been dealt with from new positions. I think there is a thread running through all my writings, but I am not confident that it is worth isolating, unless it be to see how it is to be continued, snipped off, or modified preparatory to finding and using a better thread. I have one object in mind, to understand a pluralistic scheme of things, the singular this presupposes, and the unity of the two that permits them to be apart and pertinent to one another.

The Holocaust. The Holocaust affected me deeply, as it did so many. I found myself unable to read or speak German. (I had never been good at languages). I rarely speak of it, nor do my friends in Israel. I do not identify with the victims as mainly Jewish, but with them as innocents who, with others, were subject to an incredible, dehumanizing violence.

I read the writings of Heidegger and other Nazis with an alertness to the fact that they, no less than the rest of us, are not aggregates of ideas or attitudes. I think that, if one looks sharply enough, one will find the acceptance, defense, and a possible practice of brutality, distortion, and lies introduced into what is supposedly offered as the achievement of an honest, self-critical, persistent concern for what holds everywhere. That will not preclude some detached achievements by them. There have been other bigots—T.S. Eliot, Wagner, Dostoevsky. These did not, though, condone the slaughter of innocents. In any case, one would think that a philosopher would be so concerned with truth and value that, no matter how prejudiced he may be against any group, he would distance himself from those who carry out the horrendous acts.

Yale. I regretted that there were only a few graduate students in philosophy at Bryn Mawr. That was one of the reasons why I was pleased to receive an invitation from Yale to be a substitute for Brand Blanshard for a term in 1946. I was there faced with men—no women were enrolled in the undergraduate school until more than two decades later—many of whom had just returned from military service. They were older, some having gone through searing experiences, no longer enjoying the cozy atmosphere of their preparatory schools. I seemed to be just the teacher they needed and wanted. Their influence was considerable, and I was seriously considered for a permanent post. The fact that I was not a WASP, however, seemed to many to present an obstacle to my being

appointed as a professor of philosophy who would also teach undergraduates. Graduate students were more expendable and could be allowed to be taught by those who did not have the required stigmata. After considerable struggle, it was finally decided that the decisive step could be taken, and that one with the wrong ethnic background could be appointed as a full professor to teach both undergraduate and graduate students. I taught at Yale for over twenty years, more or less in the manner I had developed at Bryn Mawr. I offered a wide variety of courses on both the undergraduate and graduate level, with considerable success. I raised questions, tried to elicit questions, and replied in such a way that they would be challenged. After I retired from Yale, I taught as a visiting professor at the University of Denver and the Catholic University of America. My most recent contract with CUA terminated in 1994.

In those days the history of philosophy was taught in two semesters, one of which dealt with the pre-Socratics, Plato, and Aristotle, and the other of which began with Descartes and ended with Kant. Having been taught by Gilson, I was in a position to introduce the students to such figures as Augustine, Bonaventure, and Aquinas. My assistants were less appreciative than the students, in part because I used those figures, and referred to orthodox Judaic and Roman Catholic views, mainly to stimulate and open minds. I have always prepared for classes with great care but have also allowed the discussion to develop as it might. History and texts were treated as occasions, not as authorities to be accepted, or as exhausting the subject matter.

Pragmatism and positivism were the dominant views in America at that time. Objective idealism was reeling from the criticisms by British analytic philosophers and logicians. It was not easy for those who entertained other views to get a hearing. When I was asked by a graduate student to start and edit a journal devoted to my views, I agreed—provided that the finances could be underwritten, and that the journal would be devoted to publication of the writings of current, neglected thinkers. The name *The Review of Metaphysics* was deliberately chosen as a challenge. I also founded the Philosophy of Education Society, Inc. to promote the project in other ways, and then the Metaphysical Society of America as an independent institution, concerned with promoting the pursuit of basic issues. All three ventures, so far, have successfully resisted being taken over by factions, an always present danger. Should these become dominant, I hope new opportunities will be provided for those who are thinking independently about basic issues. Progress in understanding often depends on sudden turns, sharp punctuations, and probings in new directions.

Editing. An editor suspends his judgment of the truth of what he publishes so that justice can be done to the intent and achievement of the person in whose cause he has presumably enlisted. I did not, as a consequence, learn much from Peirce at the time I helped publish some of his major studies. Subsequently, when I reread passages here and there, I learned far more than I had when I concentrated on trying to make his salient positions better known.

I do not think that the work I did on the Peirce papers helped me much in determining the ways in which *The Review of Metaphysics* was to be edited. Both, though, demanded a different way of thinking and reading from that required when I was primarily concerned with knowing what is true or false, with the underpinnings of what is daily known, and with the ways all realities fit together. What now remains, almost thirty years after I gave up editing *The Review of Metaphysics,* is the memory of my having been in contact with many honest thinkers.

Although the editing of the works of a distinguished thinker differs from the editing of a periodical, mainly in that one enables the thinker to be made available in the best possible way, and that the other provides an opportunity for fresh forages into neglected or blurred areas to be carried out, they are similar in requiring the editor to perform a mediating role and therefore to vanish in the process. One thing is evident: those who edit have an obligation to advance knowledge. This requires those who edit periodicals to ignore their own predilections, to read manuscripts soon and with care, and to help those whose work is not found to be suitable, to improve it. If possible, authors should receive recommendations about the ways their submissions could be improved, and where their manuscripts, if rejected, might find acceptance. A full schedule of teaching, and an occupation with my own writings, did not get in the way either of providing judgments without delay or reading the page proofs of the published articles.

A Sharp Break. Our children, Judith and Jonathan, who had the run of the campus at Bryn Mawr, were just old enough to benefit from the move to New Haven. Victoria flourished. So did our children. So did I. Our home became a focal point for students. It did, though, take a while before I was able once again to think and write systematically.

Victoria died of lung cancer in 1953. The tenor and course of my life changed abruptly. I sold our house and went to India on the trip we had planned together. When I returned, I took up residence at one of the colleges and began to work on what I hoped would be a basic, comprehensive philosophic system. The result, *Modes of Being,* was well received in some quarters, but neglected by most contemporaries. When

such key terms as 'Actuality', 'Existence', and 'God', as used there, are replaced with others making more evident the nature of transcendent realities and how they function, much that would otherwise seem to be quite alien to what is later maintained will, I think, still stand. The work, in any case, provided a turning point in my thinking.

I decided to test what I had been maintaining by seeing if it cohered with and illuminated what was known in other areas. The first test of my speculations was to see if and how they might enable me to understand art, with which I had hardly more than an average acquaintance. Instead of reading many books on the subject or trying to deal with issues that most philosophers had taken to be pivotal, I decided to spend a sabbatical term by speaking to musicians, painters, dancers, architects, actors, poets, and other artists, going to acting classes, trying to paint and draw, and later, to produce a sculpture, and to write a play and a poem. I watched films being made, attended meetings of artists, and listened to the discussions that they carried out among themselves.

One outcome of these experiences was *The World of Art* and *Nine Basic Arts*. Later I took lessons in dancing and took a summer course at a culinary institute. One thing became more and more evident: most philosophers pay little attention to fields not previously ploughed or to views which stray far from received opinions. Those interested in art usually concentrate on just one or two arts and then primarily as finished products. Few seem to have watched a work in process. Few seem to care about the criticisms to which creators subject themselves. Too often the outcomes of the work of creators were dissected in accord with ideas, categories, and principles taken over, with little change, from other disciplines.

Later, when I wanted to learn about the nature of sport and to see how it tested what I had concluded about disciplined efforts, I became acquainted with ways of proceeding that seemed quite remote from and did not fit in well with what was commonly said about action, techniques, and achievements. I am confident that I would have learned much that I never surmised had I attended as well to the work of politicians, explorers, soldiers, hunters, and fishermen. I continued my examination of other enterprises of which I was ignorant. *History, Written and Lived, Cinematics, The God We Seek, The Making of Men, Toward a Perfected State,* and the chapters on mathematics, science, the understanding of what is involved in the achievement of a good character, and the nature of leadership and statesmanship in *Creative Ventures,* were some of the results.

Creativity. There is a remarkable confidence characteristic of but

more or less inarticulately expressed by those who give themselves to a creative life. Many, of course, have limited abilities, too many try to fit in with prevailing fashions, and very few attend to what philosophers say about their endeavors and outcomes. The creators, and many others, though, usually know what is genuine and what is not, what is relevant and what is not, what is and is not important. The sincerity, devotion, standards, commitments, even of those who are mediocre or followers, challenge almost every academic account.

Some creators find it hard to believe that the rest of the world does not know what they do. Composers, in particular, seem unable to believe that others do not understand the concerns, the values, and the discipline that pervade their work and outlook. One thing seems certain: no one can have a good understanding of art if he does not understand it to be the product of radically self-critical, persistent, and honest efforts to get something exactly right. To know artists at work is to know humans in one of their most admirable forms. In one of my most recent published works, *Creative Ventures,* I have returned to a consideration of art, as standing in contrast with creative work in mathematics, theoretical science, the achievement of a noble character, a glorious society, and a just state.

Spontaneity, effort, a willingness to learn, though praiseworthy, still leave a great gap between what is done and what ought to be achieved if one is to merit the designation of 'creator'. I never mastered the techniques needed for the production of splendid work in any of the arts.

One avoids the risk of romanticizing or exaggerating what artists do by making sure that one is thinking of the creator as involved in her work, and not of her as she would like to appear to others or even to herself. She does not live the kind of selfless, full life that hagiographers imagine their subjects to enjoy.

I gave myself to painting and drawing, but only for short periods, and then mainly as part of a learning experience, never believing that I was making a contribution, or that I had a future as an artist. At all times, I knew that I wanted, not to make but to understand, to know what was true always and everywhere, and what its main instantiations were.

I don't think I learned much from engaging in creative work unless it was that it was harder to carry through than I had imagined it to be, and quite unlike what is maintained by most who have interested themselves in discussions of it. One learns much if sincerely appreciative, but not what creativity in process is.

When an artist has finished her work, she is usually finished with it, and may as readily give it away as sell it. I can do that, too, because I have

done all I could to make it as good as I could. Alas, what I achieved was never first rate.

New Ideas. From 1955 until a few years ago, I kept an intellectual diary, interspersed with random observations and autobiographical remarks. I then tried out new ideas, followed out interesting leads for days at a time, raised difficulties with what I had previously maintained, and considered distinctions and issues that deserved acknowledgment and development, peppered with asides, witticisms, and insights. Some of the present remarks have partial counterparts in its volumes. On the whole what is written in *Philosophy in Process* is a direct report of daily reflection, published without significant change. Twelve volumes are now in print; two more have been completed. I think of the entries as punctuating my more systematic writings, leavening them, and pointing up topics worth exploring at length. My systematic works, in contrast, are the result of many rewritings, sometimes over a dozen, followed by revisions of the galleys and then of the page proofs. Although I was more or less content with each work before it was printed, I have usually been disturbed by what I later saw had been omitted, distorted, or bungled. By and large, I think that *Modes of Being, Nine Basic Arts, Sport: A Philosophical Inquiry, First Considerations, Privacy, You, I, and the Others,* some of the entries in *Philosophy in Process,* and some of the chapters in *Creative Ventures* open up new areas, and deal well with pivotal, neglected questions. I completed something like eight drafts of *Being and Other Realities.* I think it may prove to be my best work, since it deals in a fresh, systematic pluralistic way with what I think are the perennial basic issues.

Being and Other Realities takes all actualities to exist in one of four distinct domains—the humanistic, the personal, nature, and the cosmos. The first, so well explored by pragmatism, conventionalism, and empiricism, in not altogether disparate ways, is governed primarily by a transcendent power of affiliation, and makes primary use of a method of induction. The members of different domains are shown to be constituted by a joining of the same components but in different orders, with each component qualified by the others. Individual humans who contribute to the constitution of humanized realities are (in considerable accord with what was first noted in *Privacy*) understood to be realities distinct from all others, with characters, privacies, and possessed, used bodies. The dominant factor in individual persons is assessive, and the method most appropriate to understanding them as in a domain of their own is evaluative. Nature is a third domain with its own distinctive space, time, and causality, to be known mainly through a mastery of distinctive spans.

The fourth domain, the cosmos, is the locus of unit actualities that it is one of the aims of science to understand. Preceding the others, able to be even if these had not been or might cease to be, it is primarily subject to a coordinating condition, and is best mastered through the concerted activities of speculation and experiment. Like the others, it can also be understood as having members constituted by all the ultimates, but with the coordinator in a dominant position.

There are two ultimates that do not play a dominant role in any actuality—the dunamis and the rational, the one more or less related to the driving ongoing that is signalized in Bergson's *Elan Vital* and to which romantics, Taoists, and anti-rationalists refer, the other more or less answering to the Ideas of Plato, the forms of Aristotle, and the categories, formulas, and logics of their successors.

The dunamis and the rational become prominent when we are involved in the process of reaching the ultimates, and the Being these presuppose, as well as when we are occupied with passing from what is known or accepted to what is able to be known or to what is presupposed —and conversely. The neglect of either of these ultimates, or of them as intertwined, has prevented rationalists and vitalists, thinkers and makers, epistemologists and ontologists from realizing how dependent they are on one another.

From the time of *Modes of Being,* I have become more and more aware of the nature and reality of the ultimates. Their existence was recognized by some of the medievals, and characterized as 'the True', 'the Good,' and 'the Beautiful'. Some added 'the One' and 'Being' and thereupon committed two mistakes. Not only are 'the One' and 'Being' two names for the same reality, but they refer not to what is alongside the other three, but to what every actuality presupposes. No less serious is the fact that 'the True', 'the Good', and 'the Beautiful' are ideals, not ultimates.

The ultimates are realities, able to join together and be instantiated; ideals are indeterminates to which one might commit oneself and thereupon act to make them determinate and localized through creative acts. Alongside the good, the true, and the beautiful are 'glory' and 'justice', the one an ideal to be realized in a society, the other an ideal to be realized in a state. By themselves, all ideals are impotent, just beacons or lures. The ultimates, instead, are powerful and forever. They constitute ideals by converging as singulars at a common point, constitute actualities by having their joined nuances instantiated, and produce the fields in which those actualities are.

The outcome of the recognition that there are different kinds of

actualities and fields is a speculative or metaphysical pluralism. The ultimates are all subtended by a necessary Being. This necessarily produces the ultimates as sustainers of its possibility. Without them, there would be no possibility for Being. The independence of the ultimates from the Being that produces them as its agent is exhibited in their functioning on behalf of Being. They cannot avoid acting as Being's agents, but then, no matter how much they are compelled to act as Being requires, they must exist apart from it and, therefore, be able to act on their own. Made to function on behalf of Being, they are made to be in contradistinction to it. They can then act on their own, in ways Being does not dictate, but never without also acting on behalf of Being.

The existence of the ultimates is at least tacitly acknowledged when we refer to passages from one entity to another. Produced by Being, when and as this is—i.e., always, and inescapably sustaining the possibility of Being, they might do nothing else but necessarily refer the possibility to Being. Whatever else they do would be what need not have been done. Since whatever the ultimates do is on behalf of Being, when and as they constitute actualities they necessarily enable Being to be present within confines that they jointly produce.

As sustainers of Being's possibility, the ultimates are necessitated realities that can act in contingent ways. There is no determining whether as distinct from Being the ultimates will or will not act. Whatever they do besides sustaining Being's possibility will be due to them. One need not credit them with a free will, or suppose that they were once in an inactive state and subsequently became active. Because they are agents of Being they will do what Being requires them to do, but will still, like every agent, be able to act in other ways, and thereupon serve Being in ways Being does not specify. Conceivably the ultimates could produce actualities always; conceivably they might cease to produce any. If the former, they will always act on Being's behalf; if the latter, they will necessarily sustain Being's possibility and do nothing else. If this is right, the age-long problem of the origin of contingently existing beings has been solved.

One can imagine the ultimates being engaged in a process of coming together and adventitiously achieving lucky combinations that end in the constituting of actualities. The result would have to be cosmic unit bodies, for without them there would be no complex bodies.

We do not know whether the ultimates were always joined, perhaps in feeble ways, and just happened to come together in such a way that they constituted actualities, or whether they were joined when and as Being

produced them, and thereupon constituted an everlasting cosmos of unit bodies. All we can be sure of is that they are necessarily produced realities that necessarily act on behalf of Being to enable this to be possible and that, if they act in other ways, they do so on their own but still on behalf of Being. They will then serve it by conveying Being within the limits of, but beyond what they jointly constitute.

When humans are creative, they make use of the ultimates in the course of work making determinate the indeterminate ideals they committed themselves to realize. Those ideals, by themselves, continue to be indeterminate and prospective, thereby making it possible for other creators to carry out creative work on their own. Created works in art embody a realized ideal beauty, those in mathematics and science, an ideal truth; a well-led society is the outcome of the realization of an ideal glory; an excellent state is the outcome of the realization of an ideal justice, a noble human is the outcome of a successful act of realizing a good character. The realization of a distinctive ideal in each type of created work depends on the successful embodiment of limited forms of the ultimates in qualifying material.

Four of the ultimates—an assessor, affiliator, voluminosity, and coordinator—are instantiated in the constituting of every actuality. In these, the rational and the dunamis are always recessive. To pass from one of the actualities to some other in another domain, only the rational and the dunamis could therefore make it possible to leave one domain behind and to enter into any other. Knowing what ultimates are and how they can join one another, be utilized, and have their joint instantiations sustained, prepares the way, not for deductions or the manipulation of empty categories but, instead, for understanding of what is constituted by all the ultimates, and thereupon for the limited beings that can possess and use what these ultimates constitute.

The ultimates, since they are many, evidently presuppose a One, or Being. Since the ultimates and Being always are, there never is a primal one without a primal many, or conversely. That one is not identifiable with the God that concerns the pious, for it does not love, threaten, reward, or punish. Knowing nothing and desiring nothing, Being produces the ultimates when and as it is, compelling them to act in one way while still requiring them to act on its behalf when they act in another. They might not do more than sustain the possibility of Being. If they do more they will still act as agents of Being. In the one way they will be agents who must act as Being prescribes, in the other, they will act on their own, but always at the service of Being.

I see no reason why one should suppose that Being creates, loves,

threatens, rewards, forgives, or punishes. If one knows that there is a reality that does this, one will have made use of some intermediary other than the ultimates—a prophet perhaps, a sacred work, someone who has been anointed, or some other means by which one can bypass or go beyond Being.

A critical intelligence, clinging to what can be demonstrated, cannot get beyond what can be shown to be and shown to account for whatever else there is. Some claim that they have been picked out from a multitude or have been provided with the means to make contact with and perhaps even to know what is beyond Being. Since I object to arbitrary discriminations against any one, I suspect that what only some are able to reach does not in fact exist, or that it acts selectively in ways that do not elicit admiration or respect. I have no quarrel with those who find themselves blessed, but they should be troubled by the fact that others have been denied the blessing that has been so mysteriously bestowed on them who, I must confess, do not seem to be more worthy than I. The issue is touched upon again and again by some of my critics and in the answers I have offered, though I think without any advance being made in convincing the other side.

Not a skeptic, not an agonistic, not a pagan, not a believer, I find none of the claims about reality that theologians defend to be convincing, and am content to rest with the claim that I am a philosopher who does not accept anything whose only justification is a faith or a hope. Since I try to live my philosophy, I am unable to box it off and then try to act in accord with claims I cannot understand nor find good reasons for accepting.

The ultimates are not to be identified with transmogrified logical Kantian categories, nor with a point at which an Hegelian Absolute stops and reverses its course. 'Likely stories' are of little interest for one who wants to make sense of reality, and who is not content just to imagine what might have been had one become a novelist writing about a supposed reality existing beyond the reach of thought. Nor do I see a need to allow myself to be antecedently cabined in order to be in accord with the ideas or practices of those who occupy themselves with learning about what is characteristic of the members of some one domain. There is no more humbling a work than that of trying to learn what necessarily is and what this directly or indirectly produces. The acceptance of what one does not understand may satisfy, but it also reveals a failure of philosophic nerve.

If by 'proof' one means the provision of a premiss from which a reality necessarily follows, there surely cannot be a proof of Being. Being depends on nothing it does not provide. The only 'proof' of Being that

could be valid is one for which Being provides the premiss as that which Being makes exist in contrast with Being. Being does not create anything; it faces no ideal that it tries to realize; it does not work on recalcitrant material nor commit itself to do anything. It has no will, makes no decisions, does not arouse itself after a period of inactivity to produce agents. The ultimates that it produces when and as it is, could be personalized as angels with wills of their own, but one will then overly restrict the ultimates to the status of mediators between their source and human beings. We 'prove' Being by showing that it is presupposed by the ultimates, themselves operative well before there were human beings.

Some of these overly condensed affirmations are clarified in the course of my replies to some of the comments made by various contributors to this volume. My replies add little new to what I have published, except perhaps another formulation of some crucial points and another occasion to deal with theological claims. These have always interested me, mainly because they focus, though in blurred and dogmatic ways, on issues that are raised by all inquiries and realities. My main objection to what they maintain is that their points seem to come too easily, too quickly, and still leave the initial basic questions unresolved.

Once Being is acknowledged and understood, it is possible to understand how it and actualities interplay, and how the interinvolvements of the latter make a difference to their involvements with Being—and conversely. The ground will thereby be laid for an understanding of actualities and Being as intrinsically free, insistent on themselves, and accommodative of one another.

The acknowledgment of a plurality of domains, each with its own kind of actualities and as primarily subject to a distinctive ultimate, grounds an account in which pragmatic concerns, individual persons, nature, and the cosmos, stand in the way of reductions of any one to any other, or to something else.

Occam's law is otiose. No responsible thinker multiplies realities beyond necessity. Rather, almost everyone ignores some and, too often precludes the understanding of those that are irreducible, persistent, and presupposed in an intelligible, systematic account of what is and could be real.

The multifaceted richness of reality, of which both Aristotle and Hegel were so aware, escapes their categories. At the very least, provision must be made for the singularities, contingencies, and evidencing nature of actualities, functioning in different ways. Aristotle was not inclined to move beyond natural beings; Hegel was reluctant to grant a genuine existence to anything less than a final reality. The one, consequently

ended with an account that was too compressed, while the other ended with one too neatly ordered. What exists should be recognized to dictate to one's formulations, as surely as these are to be used to order and clarify that to which they refer.

II. MORE OR LESS ANALYTICAL

The Death of Philosophy. The nay-sayers are right: philosophy is dead. Indeed, it dies every day, everywhere, passing with the fading light. But the next day it is as alive as ever, sustained by a desire to get as close as one can to knowing what is true always, both about what is fixed and what passes away. Despair in philosophy is the underside of a disappointed, naive belief that some view or other was completely satisfactory, self-justified, without a flaw. The despair betrays the same innocence that sustained what is being rejected.

All philosophers fail. So do all scientists, historians, and artists. Because perfections had not been achieved, because no view is without defect, it does not follow, though, that some one may not be better than others. The fact that some account may not exhibit an advance on what had already been achieved in some area, or had missed a needed or desirable turn in the way in which an account might clarify what there is, should make evident that one must try again, perhaps beginning somewhere else and proceeding in another way. Everyone occasionally distorts or misconstrues what should have been acknowledged, clarified, and better understood. Those who are willing to accept the views of others as privileged serve as needed custodians, making one aware of what had been achieved, and where serious dangers lurk. They are not to be confused with their masters, for these are alert to the great obstacles that had to be overcome before the grand outcome could be reached.

Philosophers are not mathematicians building on what their predecessors had produced. They are not scientists working together in a community, all discarding what had once been accepted but now deemed unacceptable, or testing the strength and reach of some new affirmation or approach. They are explorers, not city planners. One does not have to benefit from their self-critical attitude before one sees the amusing self-entanglements that the 'postmoderns' get into as they try to subject everything to criticism except their own criticisms and what these presuppose.

No one is asked to be a philosopher. There is no community awaiting

her leadership, no great awards or honors that she is likely to receive, nor many supporters she is likely to have when she makes her most daring moves.

The Beginning. One unavoidably begins from where one is, in the daily world, using a common language, with a body having its own needs. Each is confronted with the flickering and the obdurate, the emotionally toned and the coldly clean, the transient and the persistent, the promising and the trivial. Those who start instead with the latest deliverances of the sciences take it for granted that the distance, from where they, the scientists, and everyone else actually began, was properly traversed, and that no signal scientific advances or reversals will occur in the future. Yet they agree that Aristotle's reliance on Ptolemaic astronomy and Kant's unquestioned acceptance of Newton's view and Euclidean geometry seriously hobbled them. Scientific theories and experiments enable one to know what nothing else could. So can history, so can a disciplined study of poetry or sport.

Wherever a philosopher begins, his official account is at a distance from where he in fact began. Hume made a great leap, from what he daily knew to his supposed initial impressions, using powers and agencies his account did not permit him to acknowledge. The quest, if it had acknowledged where it had in fact begun, would have got in the way of the subjectivism at which he ended. Sooner or later, a philosopher will keep in mind what he had initially accepted, and have this test and be tested by what is more intelligible and acceptable, pointing him toward what is being presupposed. Sooner or later, he must return to where he had in fact begun, clarifying it and justifying the step he had taken to reach his official beginning, always alert to the possibility that he may have moved in the wrong direction, blundered here or there, or stopped too soon.

Hegel remarked that if one says 'this' one has already moved away from what one confronted. This does not mean, as he apparently thought it did, that one had lost contact with all particular realities. A reference to any actuality will, of course, not be absorbed in the referent, but it also need not be alien to this. One does not—and a philosophy should acknowledge this—lose all contact with what is real just by speaking or thinking. The acknowledgment of that obvious truth requires one to know that wherever speculations lead, one remains an individual person both apart from and able to be related to others. Pre-philosophic beginnings are deepened when they are being departed from, thereby giving what is reached an import it would not otherwise have. Officially beginning with attenuated versions of what is daily accepted, a philoso-

pher may—indeed, should—move far from the familiar, without losing all hold on it.

From *Reality* on, and particularly in *Privacy, You, I, and the Others, Creative Ventures,* and *Being and Other Realities,* I have tried to show that one can pass beyond the surface of actualities by carrying out intensive, adumbrative acts. If this is done, it is possible to take account of individuals, persons, characters, consciousness, emotions, responsibility, and judgments. These, with other dimensions of individual persons, escape the reach of studies that concentrate on interplaying or encountered transient realities. One's body is not an addendum or a distinctive obstacle to oneself as having a reality outside the humanized world. An individual possesses a body, feels pain in, and acts on and through it. Aesthetic appreciations, perceptions, accepted accountabilities, preparations, and directed acts make evident not only that the body affects one's person as surely as this affects the body, but that both are possessed and used by individuals who are more unified and constant than either.

The claim that language is a purely communal matter stops short of what every playwright, poet, and novelist knows: language provides one way to achieve what sympathy, friendship, and love do more insistently, without reflection, and often quite well. Each of us moves beyond appearances when attending to what is present. When anyone refers to herself as an I, an I is used by her, as an individual, to pass from her public me toward the I as sustaining this. When acknowledging someone else, the move is carried out in another direction. The first makes use of an intermediating me; the second treats the appearance of another as a way station at which one might stop. The second is carried with some difficulty and never with complete success. We all penetrate beyond surfaces, though often in hardly noticed ways and not very deeply.

I know from personal experience that there is a difference in the result that one obtains from painting a clothed woman and that obtained from painting clothes on a painted nude. A nude is read in depth. Did one try to carry out such a reading on her as clothed, one would glimpse something of the nature of cloth; the painting of clothes on a painted nude is affected by the discernment that had accompanied the initial perception of the nude.

No reality hides behind its appearances. It is these in a denser, more unified guise, and able to be exhibited in other ways. No one exists completely cut off from all else. If the reality is a human, it will be an individual possessing and using a person, a living body, and an organism, each exhibiting something of what the individual is, and enabling others to know something about it as existing under the aegis of a society and/or a state.

The inalienateable rights possessed by an individual person are different from those that are publicly credited by a society or state, even those termed 'inalienable'. Inalienateable rights are intrinsic; inalienable rights depend on the decisions of the society or state to limit what it claims is within its province. Ideally, the two kinds of rights will be in accord. A society and a state deserve to be criticized if these different rights do not mesh, for it is their task to acknowledge as inalienable rights only those that are in accord with and perhaps provide a public backing for the exercise of those that are inalienateable. The right to life that Hobbes excluded from the rights that are to be sacrificed to a sovereign was an inalienateable right. Its acknowledgment, as he apparently did not realize, justifies a defiance of a multitude of sovereign decrees and its determinations of inalienable rights.

Without much effort, contact is often made with the inwardness of actualities other than humans. A more highly, somewhat differently charged effort must be made if one is to discern a person or an individual. Sympathy, love, fear are conspicuous, distinctively toned ways in which this is usually done. Sometimes it seems as if philosophers learned about other humans by imaginatively assuming the position of tyrants, detached and cold, knowing only surfaces. Each of us, in any case, knows much more than a common language, categorical expressions, formalizations, inherited traditions, or conventional wisdom allow.

Comprehensiveness. Dialecticians offer a method that supposedly moves irresistibly toward what is more and more comprehensive, self-maintaining, and explanatory. Their concern proceeds in a direction opposite to that daily followed, where appearances are intensively passed beyond toward what appears. For some, the outcome of the dialectic is more real and richer than anything else, leading them to dismiss as relatively unreal that with which they began or encountered on the way. The warrant for a dialectic is a clarification and a possible better grounding of that with which one began. It cannot destroy or absorb this, without losing the dialectician himself and those he would persuade.

There is no one predetermined way to move from the finite and incomplete to what is perfect and forever—or conversely. A comprehensive account is the outcome of a series of advances and retreats, acceptances countered by rejections, examinations followed by leaps, and the outcomes of these prompting new probings. What philosophy seeks to know is what already is, but not yet clarified or articulated.

What is finally to be arrived at is what makes it possible to understand why there are different kinds of realities, what these are, and how they are interrelated. One must take note of what had to be, but recognize that it is only a part of a totality of various kinds of realities, among which are

ourselves as well as what we need, use, interplay with, and presuppose. Our coming to be and passing away does not jeopardize what always is, but it does show that a comprehensive account of reality must have a place for the transient as well as for the permanent, for those who know as well as for what they know.

The finite, the contingent, the transient, and the feeble are not dangling appendages from what is necessary, forever, and all-powerful. When they are, they obstinately are, as real as what is grand or forever. Each is by itself and also related. The noble and base, the transient and the permanent, the tightly and the weakly joined are all to be acknowledged. A view that finds no place for all of them is at best incomplete, needing unsuspected supplements that conceivably might radically change the import of major claims.

A philosophic study leaves nothing in principle inexplicable. It cannot be achieved by adding up all the truths there are, or by taking note of every particular or difference. It seeks to understand what is essential, both as it is by itself, and as what others require. Its focus will mainly be on kinds, pivotal items, wide-ranging explanations, seemingly persistent incoherencies, apparent conflicts among the deliverances of experience, the claims of different kinds of investigations, and the distinctive kinds of members in the different domains. It seeks to know how, without ceasing to be apart, realities are nevertheless together. Persistent, often in the face of rejections and denials by other equally sincere and perhaps even more able minds, the most that one can honestly hope to achieve is a better understanding than had been previously achieved by oneself, and perhaps by others, backed by a hope that whatever avenues had been opened up will be traversed by others in better ways. Baffled, stopped again and again by difficulties that seem unsurmountable, a philosopher dedicates himself to the task of knowing why, how, and what there is. Thrown back again and again, ignored, rejected, and perhaps deprived, he is never defeated. Ideally, all criticisms will be treated as invitations to question, modify, or abandon what had been affirmed, and perhaps even cherished. In spirit he is closer to the scientists than are those who accept what these maintain and uncritically recapitulate or build on it.

No one lives up to all these demands. I doubt that there is anyone so pure that no sly idea ever intrudes, that no easy escape from difficulties does not look tempting, and no evasion ever crosses the mind. The understanding of actualities and what they presuppose depends on the carrying out of a series of adventures and explorations, each building on what had already been achieved, but with many moves carried out in new ways so as to reach what was faintly noted, and apparently would clarify and explain what had already been acknowledged. Respect for the

diversity of reality does not require a denial that there are essential as well as adventitious features, or that the realities are both apart and together with one another.

Different types of reality need to be explored by following different methods. Common essential factors in all need to be identified. To achieve a satisfactory, comprehensive account, a number of distinctive adventures and explorations must be carried out into what was initially glimpsed only faintly, and might explain what so far had been obscure or inexplicable. Wherever one arrives, whatever explanations serve to clarify what had before been obscure, are to be faced with such questions as: Are there exceptions? Is there something not explained? What is being presupposed by the inquirer and/or the reality? Is there something unjustified or incoherent in what is being maintained? Is what has been remarked in one place compatible with what is remarked in another? Questions such as these have driven me, again and again, to revise and revise what I had surmised, and to try to deal with new issues without regard for the ways they mesh with what had been previously maintained, or had, presumably, warranted. Only when it seems that hard questions had been fairly faced and well answered, does it seem right to move on to discover what must be acknowledged if both the old and the new are to be accommodated. Sometimes what had been accepted has to be modified, sometimes discarded, and often subtilized. Sometimes the new is found to play only variations on the old. I am not always confident that what I later affirmed is better than what it was supposed to replace, except in the sense of fitting better within a systematically understood whole. There is something learned by keeping oneself focussed on some limited area before passing on to consider what else there is. Still, one must move on, for no matter how well some isolated item be understood it depends on something else. Even Being, it has been noted, depends on the ultimates to have its possibility sustained and referred to.

Philosophy is not a creative enterprise. I have found that nothing I have ever maintained has been met with such disbelief by other philosophers. Apparently, 'creativity' is being used by me and them in different ways. Like the creators in the arts, mathematics, science, and in other areas, philosophers are committed, produce what has some elegance, is perhaps new, and may be deeply satisfying. But where creators face ideals that are to be made determinate, a philosopher tries to re-present what already is. Primarily occupied with explorations, trying to express what essentially is separate and together, he tries to produce a coherent, comprehensive system, in part as a way of making sure that nothing crucial has been overlooked. Self-critical, he is always on the alert to avoid oversights and unwarranted claims. One could, to justify the sup-

position that he was creative, take him to be faced with a prospective perfect system and to try to realize this by manipulating concepts. The idea of a perfect system, though, at least for me, is not a prospect but a goad and a check, not an ideal whose realization ends in the production of a truth that otherwise would not exist.

I have tried to produce comprehensive accounts a number of times: in *Reality, Modes of Being, First Considerations,* and am trying to do this again in 'Being and Other Realities'. They are not so many detached systems, nor parts of one grand project. They are works freshly undertaken, forming a series of interrelated emphases in a single endeavor. Even though the works had been subjected to criticisms by me at almost every turn, I continue to raise questions, many of them due to a reflection on other topics or because of a belated awareness that some things had been unduly slighted, overlooked, or misconstrued. One conspicuous result has been the need to refer to individuals as existing apart from all else. Another has been a better understanding of the natures and roles of the ultimates. A third has been a greater alertness to an ongoing vitality affecting everything. A fourth is the acknowledgment of different domains, each with its distinctive kinds of members. A fifth has been a better understanding of the nature of Being, and of its relation to other realities.

I have not paid sufficient attention to the philosophic issues raised by technology, economics, current affairs, poverty, racism, or war. A strong attempt to understand these and other neglected topics, without trying to fit them within the compass of what had already been maintained, would perhaps reveal an incompleteness in what had been maintained. Conceivably, they might require a revision or transformative additions to what had been held by me for decades. Whether or not what I had maintained is sustained, modified, or discarded by what such inquiries make evident, other explorations of these and other areas would undoubtedly promote the understanding of what is, as well as of what can be known about reality.

The challenges that scientists offer one another, the supports that the members of philosophical schools provide, and the satisfactions that a complete creation yields are denied to one who is carrying out a philosophic inquiry that is not limited by what others have maintained. A philosopher subjects what is pivotal and important in the daily or scholarly world to pressing probings into their adequacy, justification, constituents, and presuppositions, mainly when they happen to intersect his own distinctive method and goal. All the while, he seeks out what is amiss in his own work, so as to be better able to move on toward the achievement, or at least the promotion of the achievement of a view

that is more comprehensive and defensible. To say that this could not or should not be done is to presuppose truths needing a better defense than the observation that complete success has never been achieved.

Systematization. A miscellany of observations sometimes betrays a single outlook. The choices and the ordering of the results often evidence an attitude and sometimes expose basic truths. In the absence of an understanding of all reality, there is no sure way of knowing that what had been focussed on does or does not reveal arbitrary selections, or a failure to see the bearings of apparently very different parts on one another. Detached observations do not provide a good way to discover omissions or irrelevancies, or to distinguish the more from the less relevant. If one is to avoid preconceptions, or a failure to attend to them, it is necessary to be alert to the multifarious character of reality as existing and functioning independently of man, his interests, language, traditions, and procrustean tendencies. One way to do this is to be systematic, for one is then forced to attend to what might otherwise not be noted.

A philosophic system is primarily concerned with noting the relevance of types of occurrences to one another. Often enough, it will bring to the fore what might otherwise have been overlooked, and may enable one to note the relative unimportance of what was conspicuous, and to look for what otherwise would have remained unnoticed but tacitly acknowledged. It risks minimizing differences and multiplicity, denying the transience and vagueness that many items display, and may perhaps make unwarranted suppositions in the attempt to fill in what would otherwise be strange gaps. At its best, it will offer opportunities for the discovery of what it has omitted or distorted. Its rejection usually reveals a use of an unnoted, partly inchoate system, guiding the criticisms and perhaps distortive of what is being maintained. Not only do traditions and convention, language, custom, and practice, tradition, and preconceptions introduce unexamined assumptions, but they are usually rigidly applied. A self-critically achieved view replaces partly arbitrary, incoherent, and dogmatic claims with a deliberate, reasoned account. Ideally, what is achieved at any place will be seen to involve a commitment to attend to something else, usually contrastive, but occasionally oppositional and clarifying.

Occupied with discovery, never allowed to escape criticism and questioning, a philosophic system runs the risk of denying reality to what it cannot accommodate. Though it will use general terms, it must attend to individuals, creativity, the particular, the contingent, the immediate, what lies beyond the surface, the changing, and the idiosyncratic as well as their opposites. Even when sealed off, it continues to be defied by

what occurs. Inert, a system's processes and references must still underscore the fact that it cannot pull reality into itself. It must be constantly enlivened by those who interest themselves, not in it, but in the realities it purports to understand, as apart from and together with one another. Ideally, a philosophy enables one to look for what might otherwise have been neglected, to see connections between what otherwise would be treated as irrelevant, and to become alert to what is presupposed but had not been noted. This is best done by approaching the same issues from different positions, attending to their constituents, and understanding what these are, both as instantiated together and as apart from what they utilize, qualify, and presuppose.

From *Reality* on, I have tried to avoid pre-commitments to any outcome. I did, and still do, take daily life to provide an unavoidable beginning, and look for explanations in the operation of what plays a role everywhere. I was convinced that I and other individuals are more than imaginaries and that we have an effect on one another, that humans have persons, living bodies, and organisms, that they know contemporaries, that they exist for limited but still extended periods of time, and that each is unique. As the inquiry progressed, these preconceptions were dealt with from new perspectives. Although none were ever rejected, all were refined. Aspects not previously recognized were made evident, and articulations of what was originally accepted as evident were faced with the severest doubts and questions I could raise. The more the inquiry progressed, the more evident it became how claims grounded in what was known about one kind of reality were related to what was known about other kinds. Each stage provided a guide as well as a corrective, an invitation as well as a test. No attempt was made to yank what was newly discovered into a frame that had been previously provided. I tried to begin afresh again and again, and to subject both the parts and the whole to new doubts and new probings. Unfortunately, over the decades, changes in nomenclature seemed to have hidden from others what was constantly maintained.

A system aims at completeness, and makes evident omissions and relevancies otherwise overlooked. One part in it may suggest and sometimes may demand some other, requiring moves over unexplored regions, and thereupon facing one with new problems. What followed was seen to refer back to what preceded as surely as it referred to what had not yet been mastered. A philosophic system tests and gives different weights to its different parts, taking each claim to challenge the others and, at the very least, to reveal their limits.

Like mathematics, philosophy is committed to the mastery of basic permanent truths. Like an art, it takes each achieved position to commit

one to do something else, and to allow for a plurality of works that, as a totality, reveal what had been achieved. A plurality of distinct ventures, each occupied with producing a final work, exhibit a philosophy that cannot be completely understood by attending to just a few signal achievements. Despite such splendid examples as Plato's dialogues and Kant's three Critiques, there is a persistent tendency in critics to suppose that the work of a thinker breaks up into a series of unrelated efforts, or exhibits a single point of view maintained from beginning to the end of a philosophic career. There are separate productions, as well as a single outlook, with the two occurring together, each clarifying the other. It does not face a pale ideal or try to vitalize a union of instantiated ultimates. Demanding dedication, goaded by a desire to produce what is at once comprehensive, justified, and clarifying, it exhibits the result of a plurality of sustained efforts to reach a more and more inclusive, clarifying account of types of realities, as separate and together.

The great systems of philosophy attract some and repulse others, often enough because they seem tọ deny the distinctiveness and integrity of particular truths, seem to allow for no radical alterations or additions, and appear to overlook the inchoate, the lived with, the blurred, the unwanted, and the changing course of events. They often seem not to be able to make room for the suppositions or achievement of current science, or to deny any role for faith or foolishness. Too often, they seem to require a denial that there is a vital ongoing at the root of things, and appear to have no place for the existence of novelties, ugliness, evil, and individuals.

A philosophic system is not a tissue of noble truths. If it tries to take the untoward and regrettable to be variants of what is right and desirable, it will surely misconstrue their reality and import. The regrettable is no less in need of explanation, no less deserving to be located in a comprehensive account, as what it so effectively opposes and sometimes overthrows. Just as a symphony is not a congeries of pleasant sounds, an excellent systematic account is not a collection of agreeable opinions or references to what is pure or worthwhile. Truths about the undesirable are as clean and clear as are those about what is excellent. Defect and failure are not far down the scale of reality; they are not less real than what is desirable. What is real may be so joined that the result obscures or distorts what is desirable or essential, successfully opposing these despite their vaunted positivity.

Whatever there be, good or bad, strong or weak, instantiates the same irreducible factors. These, by joining in different orders and degrees, constitute persons, humanized objects, natural beings, and cosmic units.

None of these is a variant of the others. Existentialism is paralyzed before the fact that humans possess, use, and are affected by their organisms and living bodies as well as by other realities with which these are involved.

Ideals, as well as natural and cosmic beings, exist before there are humans. So do the ultimates, and Being. No matter what contortions are credited to what is not human or at its service, these exist before they are known. They surely do not lose all distinction, relation, and power if no humans take note of them. What constitutes them is not hypothesized, though there are times when our hypotheses are enabled to terminate at what provided the factors that together constitute them.

An hypothesis is what one entertains. If we are to reach anything other than what is entertained we must be subject to a power enabling us to pass from ourselves to what is apart from us, and there accommodates what is being presented to it. Neglect of the ultimates and their ability to bring what is at one end to bear on what is at another has left epistemology unable to answer the central questions it wants to provide: how does the knower know what is other than what he has in mind?

Ideals, as well as natural and cosmic beings, exist before there were humans. So do the ultimates, and Being as well. No hypothesis, intention, thought, or desire can reach them unless one or more ultimates transforms what is entertained into what is sustained apart from the hypothesis, intention, thought, or desire.

Pragmatism, Peirce held, offered a method. Dewey stretched its application to its limits. That still did not enable him to do justice to the nature of creative work in the arts, mathematics, or science. Wanting to attend to the problems of mankind, he did not see that one of those problems was to understand how to make something distinct from oneself become something known. Habits, like hypotheses, fail to take one from what is entertained to what sustains, modifies, and perhaps rejects this. The neglect of the ultimates has made modern philosophy and its presumed replacements, deconstructionism and its kin, a tissue of unrealizable claims to undress what confessedly is not reachable.

Nothing should be sacrificed to satisfy the demands of a system. The task is to organize, test, and make evident what there is and could be. It must submit to the very ultimates it claims to know, and the Being they presuppose. A pragmatism that is true to its cause demands that other ventures be carried out, if only to do justice to its aims. That, though, will require a submission to the real that is to be known. The experience on which pragmatism depends is a vitalizing connection between what is

separately entertained and what occurs. The connection could not be known unless one so submitted to this that one was able to benefit from its transformative power. We know much that is not of much use, but nothing at all would be of any use were what we entertained not enabled to be connected to what is apart from us by a power that transforms what is provided by us into what is apart from but acceptable by what is distinct from us.

Must one—should one—not accept current accounts of space-time, quanta, artificial intelligence, or to a Messiah, a divine creation, a day of last judgment, a perfect or self-perfecting God, or a divine forgiveness? Each enables us to understand or to bring together a vast number of occurrences—but only if it in fact occurs, and enables us to benefit from it. For us to know, there must be means provided by which we can reach others, or they can reach us. We too benefit from something that is both apart from us and is connected to them by agencies connecting us. There is a metaphysical truth hidden in the overly personalized references to the angels by the medievals.

If we know what natural or cosmic realities essentially are, we can take the views of current science to state what is justifiably maintained in any empirically oriented inquiry. If we keep alert to the essential difference between reason and faith, we can distinguish between what can be philosophically justified from what is claimed by those who do not allow themselves to be limited by this. Positivists and theologians are one in spirit, though pointed in different directions.

These remarks cannot be freed from a taint of arrogance. Scientists are members of a community dedicated to learning what is sustained by experiment and observation, and the production of devices that would not have been possible without them. Most theologians are religious, unshakably confident that they live under the aegis of a God who is not subject to any of the limitations characteristic of finite realities or even of an impersonal, final Being. A philosopher is not opposed to either; all he does is to make evident that there are problems and difficulties they have not faced and which they cannot overcome without knowing how to relate what is supposedly real apart from them, to themselves as having realities of their own.

Not willful fallibilists, philosophers are concerned with knowing what cannot be gainsaid. Neither endorsing nor rejecting what scientists or theologians claim, they try to understand how gaps between different kinds of entities can be traversed. No philosophers can begin with a God or with unit cosmic entities without somehow having managed to get beyond themselves as apart from all else. None could be reached by what is other than themselves unless use was made of what could reach them.

Usually, it is supposed that God or something in the cosmos not only exists apart from but provides the means for reaching them.

A philosophic system must find a place for quite different kinds of realities, each to be dealt with in a distinctive way. Some come to be and pass away. Some are products. Some encompass and some presuppose others. If they are actualities, they are constituted by ultimates joined to one another. If they are what actualities presuppose, they are to be dealt with in another way. The Being that is beyond all is to be understood in still another. Although what is forever will not pass away as humans and all other actualities sooner or later do, that does not mean that it alone is real, free, or intelligible.

Finite, confused, living for only a short while, it is individuals, not Being, that are able to know what Being is, and then only because the ultimates enabled them to be apart from Being itself. After one has arrived at Being one should return to where one had begun, without making an appeal to powers no one can show exist. Although an individual is a being and therefore can directly interplay with Being, he still is the result of actions by the ultimates. These are definitory of its finitude. When individuals act independently of what the ultimates constitute, they still act as beings limited by them.

Mediating Being and actualities in one way, the ultimates mediate actualities and Being in another. As the first, they convey Being beyond, but within the limits that they jointly constitute; as the second, they provide actualities with beings that are limited. In different ways, the ultimates enable Being and the actualities to be connected in ways neither controls. Each makes use of the ultimates and thereupon reaches the other through a distinctive mediation.

A guide, not a club, a re-presentation, not a representation, a philosophic system is at the service of an attempt to determine how different kinds of realities are constituted, and how they are related to one another. The divisions and distinctions will not be antecedently prescribed; they are produced along the way. Not a frame into which whatever is is to be squeezed or, failing that, to be rejected, the philosophy is produced together with an insistence on the nature and activities of what in fact occurs. If successful, it makes evident, as nothing else can, connections and holes otherwise overlooked. More a tool than an object, it is constantly restructured, enabling one to see what realities are, how they are alike and different, and what has still to be examined and justified. The desire to know requires no excuse. It does, though, sometimes compete with the desire to live responsibly, virtuously, or well. A speculative philosopher cannot escape ethical evaluations any more than anyone else can.

Evaluations. A philosophic system provides a splendid way to make evident the interrelations, supports, oppositions, similarities, and differences among what would otherwise be an inexplicable heterogeneity. Inevitably, some realities will be identified as more important than others. The system will try to see if, and to what extent, they control or account for other items. Inevitably, it will exhibit an assessment of the times and degrees to which human need, the intelligible, the observable, or the scientifically certifiable, are to be accorded pride of place.

Each evaluation is one of a number. Inevitably, it will itself be subject to an evaluation. One would be driven over an infinite regress could one not provide a warranted closure for all judgments. The bite of things, the vague, the transient, the dependent, the traditionalized, as well as the tacit presuppositions of the day must be noted and their legitimacy and weight determined. Although it is human evaluations that are inevitably operative, they do allow for the recognition of other kinds of determinants, having a more direct bearing on what is not human. Because of effective roles played by the ultimates, humans can come to know what is distinct from them in reality and functioning, and can take account of the factors that are most germane to other kinds of reality.

Modern accounts of nature and the cosmos have alerted many to the fact that humans are not the only or even the primary actualities. It is, of course, a human who says this, thereby making evident that assessments have only subordinate roles in other domains. Nevertheless, humans usually insist on their evaluations, carrying them over into the views that they have of whatever there is. A pluralism makes evident that such assessments are but a few of a number of primary ways in which items can be ordered. When that pluralism is acknowledged one will be in a position to take account of the major stresses and needs, the kinds of perfectings and orderings that in fact occur. Only then will it be unmistakably evident that the pluralism involves the acknowledgment of a primary, single, eternal Being.

A One and a Many need one another. The fact becomes evident when a beginning is made with actualities, their presupposed ultimates are evidenced, and one moves from these to Being.

Systematization does not require all items to be fitted into a hierarchy. It can acknowledge a plurality of different kinds of actualities, and recognize that all are constituted of the same ultimate factors, as having different degrees of efficacy. Only what all actualities presuppose should be credited with a superior status, and then because and so far as the actualities depend on them. The dependence is not eliminated when

the ultimates are acknowledged. If it were, the occasions for reaching what was presupposed would be cancelled.

Whatever mode of ordering that is followed in the course of a discovery, construction, and final organization of a single view is still subject to qualifications by that to which it refers. Whatever the account, it will end with items acknowledged one after the other. One such order might reflect a concern with a sequence in time. Another might stress a hierarchy of dependence. What is put later need not be more complex or better than what had preceded it. In the end, no matter what the order of presentation, the account will be grounded in and rectified by what exists in contradistinction to it. Both guiding and inviting, neither luring nor controlling, a philosophical system will be enriched by that to which it refers. Not a measure of what had been accomplished, nor determinative of what is to be considered, it attends to what clarifies what is already known, and brings forward what is hidden and effective. It makes evident the order that in fact prevails by taking account of the ways in which different kinds of beings are constituted, what they depend on, and how they interplay. One of its major tasks is to distinguish the greater from the lesser, and to determine the different weights they have when together. It is itself to be evaluated as well, with its focal points and interrelations confronted by what is otherwise encountered and known.

One must, again and again, ignore a philosophical account to see what is apart from it. At the end of any particular confrontation, one must ask some such questions as: Is something now known about stones, words, games, the nature of inquiry, truth, what ought to be done, oneself, logic, or love, that was not and perhaps could not have been well known before? The answers will allow one to assess what had been affirmed and to determine what must next be considered. One would have blundered, or at best be at risk, if the inchoate, the dense, the felt, the evanescent, or the trivial could not be acknowledged, except by ignoring or rejecting what one had affirmed.

A philosophy is a quest and a summary, a process and an achievement, presenting in communicable terms what occurs apart from it. Trying to make evident what every reality illustrates, it ends with the evaluation of its own adequacy, accuracy, and relevance.

Vitalized Intelligibility. A philosophy makes use of daily language to fixate some of its major claims; it also converts some familiar terms into technical ones, having specialized meanings. Try as one may, the traditions permeating the world in which its author lives, the biases implicit in the practices, the language, and interests of the time, the awareness of what is tacitly accepted in the desire to communicate, the

knowledge that everyone is fallible, has preconceptions, and limitations, should make one alert to the likelihood that he is making use of preconceptions that deserve justification. What is true of him is true of those who accept, as well as those who reject what he maintains. A philosophy readily misleads those who attend to it without suspicion.

The attempt to provide an integrated, intelligible account inevitably runs the risk of prompting the supposition that reality is as thin, as abstract, and as empty as a diagram. Enriching it with metaphor will make some alert to what is beyond the surface and of connections otherwise missed. Neither a poem nor a logic, neither science restated in an unusable form nor surmises linked together, it has not yet learned how it is best expressed.

A coherent, intelligible, interlocked set of pivotal affirmations is the fixated outcome of intermediations between the knower and known. What is said and done is subject to a dynamism, affecting even the most rigid of its formulations, challenging everything that is steady, and both qualifying and qualified by what is rational. What was merely rational, despite but also because of its clarity, would keep one from making contact with what it purports to reveal. It would, nevertheless, be foolish to disdain or to disown it for, like the laws of a state, it makes evident the major relations and the limits of what is acceptable and what is not. Without the Dunamis, it would not be able to do what it should do—have knower and known directly confront one another with minimal distortion. Never entirely neglected over the course of Western thought, and not allowed to deny a place for what is stable and common in the East, the study of the kind and degree of the interinvolvement of the Dunamis and the Rational in every area remains a still incompleted task.

Whatever language one uses, even when it is quickened by effective terms, is too inert to provide a good match for what occurs. It is also too diversified to do justice to what is singular, too time-bound to be appropriate to what is unchanging, and too impersonal to be able to match what humans are and intend. The omnipresent, irreducible joint presence of the Rational and the Dunamis yields an endlessly malleable, direct connection between knower and object, making possible the confrontation of this as what is known.

The evidenced does not extinguish what evidences it. Nor does what is finally settled annihilate the way it was reached, or preclude the need to return to one's beginning. The return will enrich that beginning to the degree that this is identified as having been or continuing to be the beginning of a move to that end. The way up and the way down meet midway in a perpetual making and unmaking of their interrelationship.

Philosophy and the Philosopher. A philosophy should be alive, vitalizing the thinker while remaining in consonance with a pulsating interinvolvement of basic realities. No one is sufficiently wise, serene, at home in the world, to do this as well as it should be done. These are stages that a philosopher must reach as a consequence of having lived an understanding of reality in its diversity and interconnections. Were one able to understand the entire scheme of things and one's place within it, one would be able to re-present the essentials of whatever there is, and of the kinds of connections they have to one another, within a well-integrated, defensible account. Occupied with trying to understand what is apart from oneself, success in knowing it will re-present it in a communicable shape. Stages in a philosophical autobiography will mesh with one becoming an enriched center for an indifferent, complex universe, marking out the primary directions all should follow, if what is real is to be maximally understood.

Every thinker has weaknesses. Each has the same polymorphous inclination toward vice and virtue, ego-centricity and objectivity, concern and detachment that others have. Each must try to reduce his faults, sometimes radically. What quiets his wonder should be used to turn what is daily known into a compressed version of what he has come to understand. No microcosm, all reality miniaturized, he is still self-diversified. Unduplicable, he uses his person, living body, and organism to find his place in relation to all else. Unless willing to learn as well as unlearn, to adventure and backtrack, he will not be able to produce the outcome he has committed himself to provide. The task allows no predilections, no political or other authority to provide more than an occasion for a fresh examination of what had been rejected or endorsed. Nothing will be disdained, help will be sought in every quarter, all the while that the philosopher continues at the self-accepted, lonely task of trying to understand the interlocked totality of diverse realities, and to provide sufficient warrants for his claims.

Hardly anything else sounds so perverse and arrogant as a philosophic work, perhaps because nothing else provides a greater challenge to, and a test for all affirmations and denials. Finite, transient, confused, trapped in a particular time, place, and culture, using ideas and words laden with unexamined qualifications, a philosopher nevertheless seeks to achieve the most inclusive of views. These need fillings, obtained in other ways.

Aristotle held that all men seek happiness, but thought that this had to be filled out by satisfying a number of essential needs or proper desires. 'Happiness', though, as not filled out, is so indeterminate and yet so personal that it is readily identified with satisfaction, contentment, complacency, or lasting pleasure. What is needed is a self-completion, a

fulfillment obtained with the help of a knowledge of what realities are, separately and together. That knowledge will help one to correct one's aims, and to understand what it is to which one should commit oneself.

If there is to be a concentration on the task of possessing all there is, though only in the abstract and in the form of knowledge, it is desirable to provide oneself and others with an outline both of what exists necessarily and the kinds of realities that exist contingently. It is the self-accepted task of philosophy to make evident and to justify claims about these in ways that are strong enough to withstand both casual doubts and vigorous objections. Those who accept it must make it their own, filling it out in their own ways. At the very least, each must learn to grasp what it is that other philosophers try to do and achieve in other ways and places, and to appreciate their endeavors by knowing their strengths and limitations. The major benefits a philosophic inquiry provides are obtained because they are not sought, rewarding those who are primarily concerned with doing all they can, so as to know what must be, and what other kinds of reality there are. The best philosophy makes evident what is still to be determined, and always presupposed.

For well over fifty years, I have clung to the same idea of what a philosophy should be. It was not, and still is not, as clear as I would like it to be. In any case, I have subtilized and filled it out more or less unreflectingly in the course of a resolute attempt to answer hard questions I have put to myself. My reflections about the course of my life, and what I did with it, have made evident that, like Being itself, I remain self-same while grounding what could not have been deduced from a knowledge of myself or anything else.

I have now completed my responses to the essays that follow. Although I have found it necessary to correct and qualify and sometimes to reject various claims, some of them maintained by a number, I am left with the vague feeling that some of my reflections and reactions may perhaps be untenable, and that I have been faced with truths of which I have not taken adequate account. I am grateful for this opportunity to become aware that there are issues I have to re-examine, and that some pivotal ideas may have to be refined, and perhaps abandoned.

After I read some of the discussions in previous volumes of this series as well as those in this, I was forced to conclude that neither the subject of the examination nor the critics learned much from one another. That does not make them worthless. Those who know little or nothing about the authors will still be able to attend to the discussions with a detachment that will allow them to make a sound judgment about the merits of the claims and counter-claims, and, perhaps, end with a better

grasp of the issues than any of us have been able to achieve. To promote that result I have reaffirmed some of the present remarks, usually in a modified form, to make them pertinent to the issues that were focussed on. Again and again references were made in the different essays to 'categories', 'God', 'process' philosophy, the use of hypotheses, and what was said in my earlier works. At the risk of repeating myself, I have tried to deal with these and some other recurring issues each time they were raised by the different writers. Those who read all the essays and my replies will most likely find that many of the overlaps underscore points that might otherwise not have been seen to be focal for many.

INTRODUCTION TO PAUL WEISS'S ART

Although Paul Weiss regards himself as a highly expendable artist, it is noteworthy that a master of speculation should be doing anything at all on the score of creating art and helping sensitize us to the concrete qualities of things. In addition, of course, he has devoted more time than most philosophers to trying to learn more about doing art. As he tells us in his reply to one of his critics in the present volume (p. 655), he "made an effort to learn about the production, constitution, achievements, and the presuppositions of various artistic ventures, speaking to artists of all kinds, and trying [his] hand at painting, drawing, poetry, playwriting, sculpture, and talking with composers, choreographers, actors, painters."

So here we are pleased to present reproductions of several of his drawings along with a photograph of one of his pieces of sculpture. Doing his drawings quite probably led him to see more in the concrete realm than he might have observed otherwise; and some of them bring to us a touch of freshness and novelty. In some cases he seems to have been having fun. I especially like certain of his sketches made with six lines or less. And it is good to share with you this sampling of his drawings and sculpture.

<div align="right">

Lewis Edwin Hahn
Editor

</div>

Department of Philosophy
Southern Illinois University at Carbondale
November 1995

Small Bird Sees His Shadow

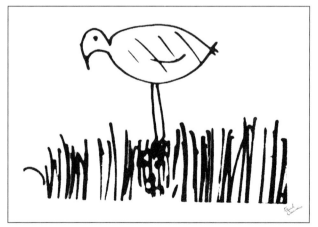

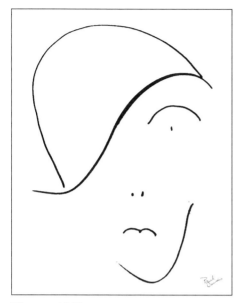

Woman with Hat

Self-Portrait 1975

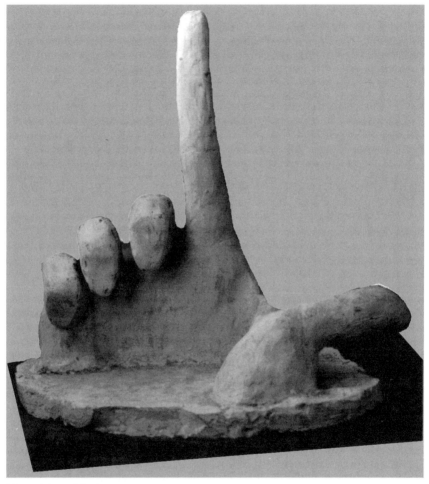

Finger Piece of Sculpture

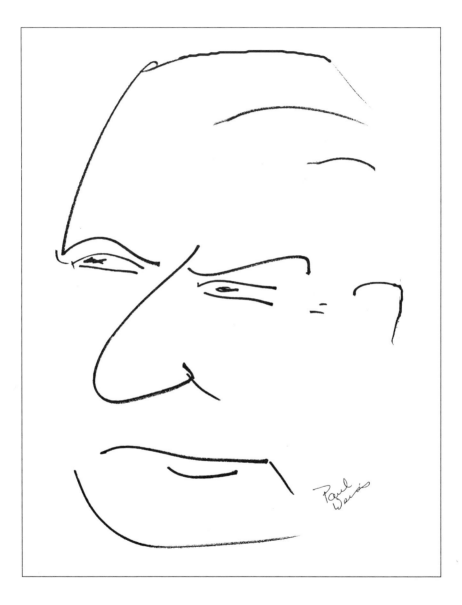

PART TWO

DESCRIPTIVE AND CRITICAL ESSAYS WITH REPLIES

1

Hans Lenk

METAPHYSICS, INTERPRETATION, AND THE SUBJECT

Paul Weiss is a bold metaphysician, maybe one of the last members of a dying species, at least of a species in danger. Sometimes (e.g. in Neville 1981, 211, 216) he is addressed as "our leading metaphysician in the grand style" or "our most creative and original metaphysician." I would agree if this evaluation refers to the American philosophical scene. Without any doubt, Weiss's systematic thoughts about a metaphysical theory of actualities and finalities grounding all, yet not only "subjective appearances" but also "objective appearances" (1974; 1977, 16) certainly provide a comprehensive framework for a metaphysical theory of a "grand" traditional style which, however, seems to be more of continental prominence than of genuine American descendence. All of this might, incidentally, be another reason why Weiss's philosophy does not admit of a widespread metaphysical or philosophical school and of any disciples in the narrow sense, beside his provocative ever-asking, even instigating, thoroughgoing criticism (cf. 1977, 192ff., 234). The philosopher is "always to ask the tough questions," Paul Weiss said on the occasion of a seminar I had the privilege to attend one day. And this is the job and challenge my friend, the metaphysician, tried to live up to throughout his admirably active, intellectually provoking, and deep-rooted long life, engendering a philosophical work of impressively systematic, self-contained entirely original books. Being a prolific writer he nevertheless has a certain all-pervading thread of impressive continuity regarding his metaphysical basic categories referring to actualities and the five funda-

mental "finalities," namely Being, Substance, Possibility, Existence, and Unity (1974, 232ff., 1977, passim).

With personal and subjective experiences concretizing in subjective appearances, Weiss usually tries to use an indirect argument for inferring the existence of deeper realities and objective factors and "objective appearances." The object I confront is but a "subjectified appearance" (1977, 11). Without objects to be known or perceived there would however be no perceiving subject. Without "locus and support" in some general or objective or re-identifiable factors there would be no "subjective appearances" which could be identified, understood, perceived, or acknowledged as such. Whereas the initial objects are "subjectified appearances" the abstraction from the subjective factors would lead to the notion of "an objective appearance, the product of the interplay of actualities and finalities" (1977, 11 et passim). The objective appearances are "the result of the interplay of exhibitions by distinct realities" (ibid., 15), (realities are sources or factors), be they textually present or be they active actualities which we can attend to if we go beyond the appearances by experientially moving "from a texture or condition toward an actuality or finality by a symbolizing act" (ibid., 17). Searching and ploughing "beyond all appearances" (1974) certainly does not occur as a "chaotic" process, but under the leading idea of the systematic and successive, if not gradual, unearthing of an underlying basic reality factor, or of underlying real factors. This certainly is born out of the human need for orientation and the philosophical craving for unity and systematicity. Weiss himself stresses the unifying function of his basic categories, namely the interpretation in terms of his five finalities. However, it is not clear, whether and why there are only five basic and ultimate finalities of this sort. Be this as it may, Weiss's approach is certainly a kind of ontological pluralism amounting to a metaphysics of actualities aiming at an all-comprehensive coherence of a quasi-Platonist, but not static, yet dynamic character. Besides the interrelation, interaction, and coordination within the systematic network, so to speak, the actualities remind us of Leibniz's monads (*Monaden*) with a kind of active tinge instead of bare passive reflection only.

In what follows I would like to take seriously one idea Weiss stresses in his *First Considerations* (1977, 37): "The imposition of an idea of a contextualizing unity on an appearance yields an interpretation of it." This statement might be generalized to cover the whole approach of Weiss's metaphysical analysis and to make it compatible with or re-interpret it in terms of a constructive methodological or transcendental interpretationism which I have tried to elaborate for two decades. My

thesis therefore is that Weiss's approach is an interpretive one with respect to ontology and epistemology and (relating to a discussion we had on repeated, though unfortunately rather scarce, occasions) particularly to the role of the subject in epistemology.

First of all, many of Weiss's statements in his basic metaphysical books dealing with the most general methodological apparatus of concepts, notions, methods, and reflections of experiences and the role and influence of realities, actualities, finalities, mainly stress the interpretational character of "moving experientially" or inferentially from appearances (both subjective and objective) to underlying actualities, finalities, and realities. All of these underlying factors are really interpretive constructs highlighting the transcendence beyond the appearances. The transcending activities or their results are epistemologically speaking methodological constructs using language, insights about dependencies, indirect concretizations, or even incorporations of the alleged underlying factors. This is valid also for the relational character and embeddedness of all the actualities within the contextual web of the finalities. This is again true for the pairing or severing between the process of evidencing and the hypostatized underlying factor called "the evidenced" (1977, 80ff.): "To understand what objectively, apart from any user, makes evidence be involved with actualities, detaches it, relates it to the evidenced, and passes from it to the evidenced, one must assume a position from which one can express himself in consonance with a way an impersonal, more distinctions, (qualifies) persistent source does" (1977, 83). Inasmuch as such pairings (ibid., 85), distinctions, and also contexts contribute to the constitution of a world of evidenced appearances and "evidence finalities outside the domain of actualities and appearances" (ibid., 39, 103), it is certainly a matter of an interpretation or an interpretive approach. Distinguishing involves, means, or *is* interpreting of sorts.

Second, any "unity of an objectified appearance" "restored" in a judgment "on the side of man" (ibid., 35) is certainly an interpretive enterprise. To conceive of underlying ultimate contexts called finalities as necessary realities is also a constructive projection which makes use of schemata, schematization, and special hypothetical or indispensable deep-rooted patterns of re-identification, realization, etc. that can be termed interpretational procedures. I define "schema interpretation" as establishing, constituting, and particularly utilizing schemata for ordering, structuring, perceiving any perceived, conceived, or conceptualized entity whatsoever. Schema interpretation is the more general variant of interpretation. Traditionally speaking, hermeneutics only dealt with a special case, namely text interpretation which is but a sub-type of the

general constructive and active schema interpretation. (See my 1991, 1992.)

Epistemologically speaking, therefore, Weiss's approach is an interpretive one. However, the question arises: may the "moving" beyond all appearances into the depths of real factors or hypostatized actualities or finalities be distinguished from any interpretive activity whatsoever and consist of a special methodological or methodical approach devoid of any interpretive character or even only impregnation? I think not. Inasmuch as symbols and symbolization or symbolizing acts are necessary to get into contact with the mentioned realities and actualities by way of reflecting them in appearances or parts of appearances (1977, 17, 1974, 83ff.), Weiss certainly and explicitly uses interpretative means and acts to "move" to "actualities" and "finalities." "Were there no symbols there would be no acquaintance with realities. We would know only appearances, but not know that they were appearances" (1974, 83, see also 91ff.). Weiss makes reference to Cassirer's philosophy of symbolic forms and maybe also to his philosophical anthropology of man as the "symbolic being" living in an artificial symbolic world (within a "net of symbols") interstitial between the world of nature outside of us and our internal world of consciousness. Whereas animals have also the capacity of using signs, at times even symbols whether they be genetically inherited or, in part at least, learned, man is characterized by the fact, that he may transcend beyond genetically fixed factors and dispositions and abstract from this rather restricted kind of necessity to use symbols. We can transcend this stage by making the symbols and the process of symbolization the object of an epistemological analysis on a higher level. We may not only flexibly use and change symbols, but also design, devise new systems of symbols, and analyze as well as question and problematize them. This means that the human being is not only the symbolic creature or *animal symbolicum* (Cassirer) but is the being capable of again and in turn interpreting his or her own symbolizing acts and systems. Humans are not only the interpreting beings, but the *meta-interpreting* beings, who are capable of distancing their symbolizing activity from themselves and again transcending that in another (meta-) interpreting project. This is true not only for epistemology, but for any research, knowledge, and insight regarding man or woman as an acting and living being in general.

When Weiss stresses the role of adumbratives and lucidatives, (e.g. 1974, 83ff., 96ff.) mediating dynamically between the different appearances and the underlying factors as well as the transcendence towards finalities and their impact on actualities, he is certainly referring to the constructive and projecting as well as structuring activity of applying

schemata onto at first rather floating vicissitudes of phenomena, conscious and other self-referring experiences. All that certainly amounts to interpretive processes.

This certainly does not mean that reality is just dissolving in interpretations. There is only a fundamental principle of the interpretive impregnatedness of any knowledge, insight, conception, action, motivation, valuation, and so on. We can only grasp any reality whatsoever by means of our forms and schemata of interpretation. There is no interpretation-free access to whatever object of knowledge and experience or objective of acting. This is what I call the fundamental principle of interpretativity or the interpretation-impregnatedness of any knowledge, perception, and action as well as our guiding lines, models, and frameworks of these. Therefore, any conception and experience of any reality or real factor, event, or object whatsoever is per se impregnated, pervaded, and intimately structured by interpretational schemata. Interpretation is the fundamental epistemological activity. I think, however, that a kind of pragmatic realism is not only compatible with but necessarily involved in such an approach of methodological sorts. If we act, we act on something or somebody. If we get an experiential insight or perception we have to hypostatize that there is something underlying which makes for the differentiation (by the way of interpretation of activities) between different objects and between objects and backgrounds as well as between the process of knowing and evidencing and the sources of these processes, namely the "evidenced" or known. We cannot really (in real life) dispense with a kind of pragmatic realism.

The interpretation-impregnatedness will certainly reveal itself as more outstanding with respect to any generalizations, abstractions, symbolizations, etc. "By symbolization one penetrates into realities" (Weiss 1977, 18; see also 1974, 83ff.). Symbolizing and symbolization processes are a fortiori interpretive processes or activities. In his *First Considerations* (1977, 9ff.) Weiss tries to describe the development of the distinction between subject and object, and between object and background. This is certainly a schematizing or interpretive activity. However, the question is, who is the I or self to be identified with the subject or the bearer or performer, respectively, of the distinguishing activity itself.

"Where remains and resides the subject?" asked Paul Weiss several times, when I tried to expound my internalistic interpretationist epistemological approach to him.

I think indeed that epistemologically speaking or from a methodological point of view, the interpretationist constructivism prevails and would lead to the answer that also the subject is but an interpretational construct, a construct of the self as an agency of perception, knowledge,

and action as well as interpretation and self-interpretation. Whereas it is always an actor, an interpreting subject, which may only be capable of interpreting, the hypostasis of an interpreting self or subject is interpretive itself. Some might think we are caught in an infinite regress if we superpose interpretational levels above one another. But this is, I think, not a kind of vicious circularity, but a necessary pragmatic differential stance we have to assume if we analyze our experience and gaining knowledge as activities. We might certainly question this kind of activity again, but then on a higher level of interpretational strata. These strata might in turn be questioned and analyzed in another epistemological approach of a still higher level. Is the process of interpretation just a kind of metaphysical event or process or happening (as for instance Günter Abel (1984) would interpret Nietzsche's approach of interpreting "Will-to-Power" centers)? Could we replace the quasi-Cartesian "I interpret therefore I am" by "interpreting takes place" ("Es interpretiert"), like Lichtenberg and Nietzsche commented on Descartes' cogito: "It thinks" or "a thought process occurs"? The usual conception of interpretation is that it is always an author or an agent who interprets: there is a center of interpretation as the bearer of the respective activity or process (even if it is only preconscious activation of schemata). If I am only as an interpreting being (in perceiving, conceiving, and acting) it is true yet that the interpreting self is only inferred, has a secondary status, can be conceptualized only on an analytic meta-level.

The subject itself is interpretation-impregnated and as such perceived and constituted by interpretational activities. But the subject itself is necessarily an interpretational construct, although we have to conceive of any activity of interpreting as the activity of a "real" subject. However, the reality of the subject is itself but a philosophical, ontological, or anthropological hypostatizing projection. We can only experience, even conceive of, the interpreting subject in terms of interpretational procedures, means, and constructs. This does not mean that reality does not exist independently from our interpretations, but that any process of coming into contact with reality or grasping it in notional forms can only be interpretive. This also pertains to the reality of the subject. Hypostatizing a reality is certainly also an epistemological step or activity connected with a specific perspective and an epistemological stance. This is also true for the reality of the subject. Thus we may argue for this by invoking what I have called a *petitio tollendi* (as I worked out two decades ago [1973] with respect to the foundation of logics: one cannot reject or criticize the principle of noncontradiction without using it on a higher meta-level or in a functionally equivalent variant). We cannot reject or deny a subject via an interpretational argument or by the instantiation of

a conviction which does not rely itself on an activity of a subject, namely the bearer of the conviction or the agent of the argumentation. (We may however think of interpreting subjects as agents like a sort of Leibnizian interpreting monads, though not necessarily subjugated by the "Will to Power" in Nietzschean terms: sympathetic resonating within the "dance" and the rhythms of life, within the big "Game of Life" and cosmical processes may also be an ideal of actively participating in the walk of life and nature [see my 1991a].)

"Where now remains the subject and its reality?" Weiss's question he repeatedly and insistently uttered may be answered in a differentiated manner: From the perspective of epistemology and methodology the subject is also but an interpretational construct; like any other hypostatized substratum it can only be interpretatively grasped or conceived. This insight does not preclude objectivity or reality of the interpreted designatum or referent, but may pragmatically and realistically be implied. The practice of life and action is indeed real, but itself also interpretation-impregnated. This however is an insight which we also can only gain by interpretation or from a specific interpretational perspective which we cannot dispense with. *Interpretatio inevitabilis!* Beyond that we can certainly differentiate and distinguish different levels of interpretational activities, be they from a methodological meta–point of view, from an interpreting active perspective of involvement and social and interhuman life or from the perspective of projecting entities (objects) or rather their conceptions into the external world which otherwise is conceived of (by and via interpretational activities) as the "real" world. An ontological interpretation, like the one forwarded by Weiss, is certainly possible which however would require (the as well interpretive conception of) real factors, reality, actualities, and finalities as his metaphysical approach does. This does not imply, however, that there is an absolute Archimedean base or takeoff point which can be exploited from a rationalistic deductivist point of view to derive a metaphysical theory beyond any doubt and criticism. The time of any justificational foundationalism and fundamentalism in metaphysics is over. Metaphysics is, and has always been, an interpretative discipline, a projecting, constructing, interpreting enterprise. Instead of searching in vain for absolute metaphysical certainty we should appreciate bold interpretive approaches like Weiss's metaphysical system as one which is mediating between the ontological attitudes of common-sense life on the one hand and scientific as well as highly systematized philosophical unifying structures on the other.

Still another interesting question is how interpretive constructs of that kind and particularly metaphysical words and conceptions originate

from language, culture, semiotics, and the whole world of symbols Cassirer had in mind. Indeed, a rather functionalist and socio-cultural model seems to be a viable approach dispensing with an absolute fundamentalist or foundationalist rigor but paying attention enough to the conceptual and symbol-mediated or even symbol-constituted character of any human conceptualization and orientation within the world. We have to hypostatize certain reidentifiability or constancy conditions of the presentation and perception of patterns, signs, and object and event structures. For this, it is necessary to distinguish between the interpretive and interpreted object, the subject of interpretation, and the respective activity or process of interpreting. It is a kind of pragmatic or functional transcendentalism which might be combined with a functionalistic semiotic in the Peircean tradition based on the Kantian one. Again, we can and should add Wittgenstein's late philosophical insight of a socio-constituted secondary reality which is an important part and parcel of the real social world as it is constituted, structured by institutions, habits, social rules, and above all, languages and culture. Man as the interpreting being is the cultural being. The meta-interpreting being is certainly dependent on culturally and socially evolved traditions, structures, rules of (interpretation-impregnated) actions, conceptions, habits, attitudes, and institutions. Epistemology and metaphysics with all their traditions and new probing projects, including methodological and transcendental interpretive constructivism itself combined with a pragmatic realism, is but one of these traditions.

HANS LENK

DEPARTMENT OF PHILOSOPHY
KARLSRUHE UNIVERSITY
JULY 1992

REFERENCES

Abel, G. *Nietzsche. Die Dynamik der Willen zur Macht und die ewige Wiederkehr.* Berlin–New York: de Gruyter 1984.
Cassirer, E. *Philosophie der symbolischen Formen.* 3 vols. Darmstadt: wissenschaftliche Buchgesellschaft, 1956, 1964.
Lenk H. *Prometheisches Philosophieren zwischen Praxis und Paradox.* Stuttgart: Radius, 1991(a).
Lenk, H. "Zu einem methodologischen und transzendentalen Interpretationismus," in: *Zeitschrift für Allgemeine Wissenschaftstheorie (Journal for General Philosophy of Science)* (1991).
Lenk, H. *Metalogik und Sprachanalyse.* Freiburg: Rombach, 1973.

Lenk, H. *Philosophie und Interpretation.* Frankfurt: Suhrkamp, 1993.

Lenk, H. *Interpretationskonstrukte. Zur Kritik der interpretatorischen Vernunft.* Frankfurt a. M.: Suhrkamp, 1993.

Lenk, H. *Interpretation und Realität.* Frankfurt a. M.: Suhrkamp, 1995.

Lenk, H. *Schemaspiele. Über Schemainterpretationen und Interpretationskonstrukte.* Frankfurt a. M.: Suhrkamp, 1995.

Neville, V. *"You, I and the Others* by Paul Weiss," in: *International Philosophical Quarterly* 21 (1981): 211–16.

Weiss, P. *Beyond All Appearances.* Carbondale–Edwardsville: Southern Illinois University Press, 1974.

Weiss, P. *First Considerations: An Examination of Philosophical Evidence.* Carbondale–Edwardsville, Southern Illinois University Press, 1977.

Weiss, P. *Philosophy in Process.* Vol. VIII Albany, N.Y.: The State University of New York Press, 1983.

REPLY TO HANS LENK

Hans Lenk is, I believe, the only philosopher who is also an Olympic gold medalist. He was among the very first to see the merits of my study of sport; there were no more than a few others. It has taken the philosophic community quite a while to catch up with them, and almost with him. A prolific writer, at home in many cultures, and at ease with many languages, he has spent his energies mainly in clarifying what he called "the philosophical study of technology." That does not, though, do justice to his wide range, multiple interests, and a willingness to deal with difficult problems.

He thinks that metaphysics is a "dying or an endangered species," and that the kind of metaphysics in which I am interested is apparently more continental than American in spirit. I think he is profoundly mistaken about the nature of nineteenth- and twentieth-century American thought, and the meaning that 'metaphysics' has for me and many others. He has overlooked the 'transcendentalists', the Metaphysical Club of which Peirce and James were members. He is also evidently unaware of the kinds of discussions that are carried out in the Metaphysical Society of America, the fact that it has hundreds of members with a wide variety of affiliations, is growing every year, and is attracting some of the most promising thinkers of the younger generation. American philosophic thought has always, like its population, had its elite and European-oriented thinkers, but it has also been affected by the empirical temper of the English, the robust common sense of the Scots, and a confidence that there is much to be gained by going on in its own way. Peirce is more representative of it, I think, than James or Dewey is, being more independent-minded, wider ranging, less willing to be confined within any pre-set limits.

I use the term 'metaphysics', not to refer to some speciality, but rather

to refer to an inquiry that pursues questions to their limits, and is attentive to the variety of realities of which account must be taken if we are to have a good understanding of any. I used the term in naming the periodical and the society I founded, in order to provide homes for an open-ended concern with serious thought, unafraid to examine presuppositions or to question what was taken for granted and necessarily presupposed, and to re-examine what had been tacitly assumed by ancient and modern thinkers, as well as by self-defined modern metaphysicians. It was initially directed at the reigning positivistic refusal to consider anything but the latest deliverances of physical science and the implications of an established symbolic logic, at the pragmatic refusal to examine its own presuppositions and its failure to do justice to the nature of mathematics, creativity, piety, private lives, and the depths of things.

I am not sure just what Lenk has in mind when he refers to a grand traditional style that "seems to be more of continental prominence than of genuine American descendence," but I think the variety, openness, interchange, and mixing of young and old, and those of various predilections, is closer to the spirit of American thinking than he realizes. If it were not, it would still be desirable to have thinkers occupy themselves with root questions and deal with them in fresh ways to get to the nub of things. 'Frontier thinking' has continued long after the physical frontier was mastered. Metaphysics, as I understand it, is one of its major exemplifications. American metaphysicians agree mainly in their determination to face hard questions, some old and some new, particularly if the answers help clarify what had often been misconstrued or uncritically accepted.

It is a mistake to think that Whitehead led the way. He did free a number of American thinkers—but few of his compatriots—from an obsessive occupation with language, formal logic, epistemology, and a temptation to content oneself with cleverly phrased rejections of other views. Those who today adhere most closely to his views go counter to his own intent and spirit. He was an honest and bold thinker who never was his own disciple. He never sought adherents.

Peirce expresses, far better than Whitehead does, the toughness and questioning, the daring originality and independence of mind that characterizes the most promising trends in American thought. He was neither a foundationalist nor an anti-foundationalist, but an inquirer, not tied to the past either through affirmation or rejection. His independence did not prevent him from learning from scholastic as well as Greek thinkers, from Kant as well as from Hegel, from anyone in fact who could enable him to get a better grip on things. Not a traditionalist nor a disciple, he was neither a slave to history nor one who neglected it. He

cuts closer to the grain of the venture that is 'metaphysics' than what Europeans take this to mean and have rightly begun to abandon. He also had a better acquaintance with and a better understanding of science and logic than Whitehead had. Today the Whiteheadeans form a cult whose members skirt embarrassing questions. Peirce forces those who follow him to rethink what he maintained, and then perhaps move on, as he did, into areas not previously noted or well-explored. He made evident that there is an excitement in honest, persistent thinking, and that nothing should be taken for granted, or any line of inquiry foreclosed. The apparent boldness of the negations that now occupy so many on the Continent hide a belief in the finality of Kantian or Hegelian views. For Dewey, as well as for Peirce, these and other great thinkers are springboards not shackles. So are other thinkers, whether they are pre-Socratics, Platos, Aristotles, a Scotus, a Descartes, or a Leibniz.

Whitehead was more systematic than Peirce, but he also had a narrower range and was content to make many claims without backing them with argument. Peirce never stopped probing. He made evident that there is an excitement in honest thinking, and that nothing should be taken for granted or any line of inquiry foreclosed. Negations, deconstructions, are at best ways to get rid of obscuring irrelevancies, preliminary to an attempt to move on. Every thinker worth the name gets rid of encrustations, in the course of a movement into what is essential and forever. I share Whitehead's attempt to provide a single coherent account, but do not respect the limits within which he operated.

The finalities—or better 'ultimates'—are not categories. Lenk is right to ask why there are just the number I focussed on. I never faced that question as fully or as well as I do in my most recent work, *Being and Other Realities*. A summary of that answer, all too brief, has already been provided in my autobiographical remarks. I will now make another attempt.

That there are so many ultimates and of such and such kinds is a contingent fact. There could have been more, and there could have been fewer but, whatever the number, they are when and as Being is. The explanation for their existence is provided by referring to Being; their number and natures are functions of the degree of independence they have to act on their own, but still in the service of Being. Being depends on nothing but that which it itself produces; did it not produce the ultimates, there would be nothing that would sustain Being's possibility. Only if Being were neither impossible nor possible, could it avoid having the ultimates be agents for it. Those agents like all others, remain distinct from their principal. Otherwise they would not be able to act on its behalf.

The ultimates are necessarily produced by Being so that it can be possible, but in that act Being enables the ultimates to be apart from it and, so far, also be able to act in ways it does not prescribe. As distinct from Being, the ultimates are also able to act as more than sustainers of Being's possibility, but never without continuing to be Being's agents. In the absence of Being, the ultimates would not be. When Being is, i.e., always, the ultimates are.

Compelled to sustain Being's possibility, the ultimates may do nothing more, but did the ultimates do no more than sustain Being's possibility, there would be no actualities. These might never have been constituted by the ultimates. If the ultimates produce them it will be because they act contingently and end at what contingently exists.

Why do the ultimates act when and as they do to produce actualities? When, in the course of establishing their independence from Being, they attain the stage where their separateness from one another is followed by a move to produce combinations of themselves. Since the ultimates are produced by Being to be Being's agents, they will, when joining at their nuances or as singulars, continue to act on Being's behalf, conveying Being as well as they can, beyond what they jointly constitute. As a consequence, Being will be brought within the outcome of conjunctions of the ultimates, able to own and use them.

There had to be ultimates, but these need not have subdivided nor to have joined both to constitute actualities and to convey Being beyond what was then produced. Their number and modes of action reflect the degree of independence that they have from Being. Had they less, there would be less than six of them; if they had more, there would be more than six. The degree of independence they have to act in ways in addition to those that Being necessitates cannot be determined by Being. Its agent, even when compelled to act on the principal's behalf, is always able to act in its own way, though never without benefitting Being.

The supposition that the ultimates are "methodological constructs," and not realities evidenced by every actuality and relation, leads Lenk to hold that what I have been maintaining is "certainly (!) a matter of interpretation." If 'interpretation' is used in a loose, broad, or flexible enough way, one might be willing to agree, but it would then be hard to know what it was on what one had agreed.

Lenk seems to take interpretation to be a subjective, mind-enclosed supposition or process. If it were, it would not be able to reach what supposedly was being interpreted. An interpretation links an interpreter to what is being interpreted. Is it, too, the product of an interpretation? Who provides this?

The supposition that there are only interpretations starts us off on an infinite regress. Lenk avoids that by quietly acknowledging himself to be real, and that he is somehow able to relate to what is being interpreted. What else could enable him to bridge the gap but ultimates in some guise? Only the ultimates are distinct from whatever is to be connected, and powerful enough to be able to connect them. Were the ultimates "constrictive projections," they would be no more than pointings or imagined escapes from a supposed black hole of a radical privacy. Lenk seems to say that there are realities but has no way of getting to them. A schema will not help unless, like Kant's, it is distinct from what is at both ends and, in fact, mediates the two.

I do not accept Cassirer's philosophy of symbolic forms for the same reason that I do not accept Lenk's 'projections'. Those forms, too, are unable to arrive at anything. Tough realist as Lenk in fact is, his theory defines him as one who is alone, vainly projecting some idea into . . . ? Humans, to be sure, interpret and even 'meta-interpret', and are able to "distance their symbolizing activity from themselves." What Lenk fails to show is that the distance could be traversed, or even that there is a distance to be traversed. A hardier realist would show how it is possible for anyone to be in touch with what is other than himself, or even to know that there was something toward which he should project what he has in mind. Is one projection as good as another? Why project? How does a projection differ from a wish, a want, a hope, an expectation, an intention, a belief, or a vain imagining? Despite himself, Lenk is a radical subjectivist, locked inside himself with nothing that will enable him to know or to make contact with anything else.

Lenk says, "There is no interpretation-free access to whatever knowledge and experience [there be]." Yes, there always is an element of interpretation but, while distinct from an interpreter and what is interpreted, it enables the one to become available to the other. We interpret, i.e., add suppositions and characterizations to everything to which we attend, but we could do this only in ourselves if we did not also, then and there, have the interpretation accommodated or rejected by what was being interpreted.

Perhaps an interpretation is a reality, and we and what we seek to understand are just idle terminal points? Were that the case, could it be known? By whom? How? It is one thing to claim that there are interpretations involved in all acknowledgments, and another to recognize that they mediate interpreters and interpreted. How quickly the supposedly tough-minded, hard-headed, empirically oriented Lenks turn themselves and all else into imaginaries afloat in the nowhere.

Lenk says that he hypothesizes and that he constructs the self. Who is that 'he'? Can what is hypothesized hypothesize, or is there not a nonhypothesized reality that does this? Did one not adumbrate when one came to the end of a 'projection', and thereupon make contact with what had a reality of its own, or at the very least was enabled to be so by what is distinct from both knower and known, and could one not bring the former to bear on the latter, no one would be able to know that the 'me' at which one arrived, when approaching oneself from the public world was the 'me' for an I.

There never could be connecting constructs unless these, their constructors, and the outcome had realities of their own. Constructs do not construct. Lenk admits that this kind of difficulty might be set before him. He thinks that he overcomes it by saying that this is what has to be assumed or that it is pragmatically justified. Does that make it a tenable view? Surely not. Assuming something does not mean that it is; what is pragmatically justified may not be otherwise justified. I assume and am pragmatically justified in standing on a ladder just bought from a reliable store. That will not prevent a rung from breaking. Pragmatic justifications may be enough to allow me to carry out my daily tasks. Philosophy, science, mathematics, and logic, all need something more.

Once again: If a subject is a necessary interpretational construct, who knows this, who produces what is needed, who offers this to others, themselves presumably also unreal constructs? Lenk says that "we may pragmatically and realistically (!)" imply a subject. Is it enough to imply one? To imply, in any case, is not yet to carry out a valid inference.

Lenk is willing to allow that there are realities to be impregnated with 'interpretations', he also allows for many levels of interpretation. This is not enough to enable him to answer such obvious questions as: Who does this? Where and with what does he start? Where does he end? He says that there is no need to suppose that there is an absolute Archimedean base or takeoff point "to be exploited from a rationalistic, deductivist point of view." I agree. He thinks that one need not suppose that one has a "metaphysical theory beyond any doubt and criticism." Again, I agree. A metaphysically tempered thinker seeks to know what is inescapable and/or able to clarify what otherwise would be arbitrary, unexplained, and possibly mistaken. No one else is so self-critical, so concerned with exposing what is being assumed, so occupied with knowing what is and must be, and with presenting the result in a manner that its faults can be focussed on and a better view achieved.

Lenk says, "The time of any justification for a foundationalism and

fundamentalism in metaphysics is over." Again, I agree. What is needed is a more vigorous, bolder, sustained effort than that made by both foundationalists and their critics. I make no claim to "metaphysical certainty." At most, I would like to achieve it. He may be right when he says that metaphysics is dying in Germany. Perhaps it took a wrong turn? Perhaps it became overly dogmatic? I cannot say, not knowing the patient.

Scientists, mathematicians, painters, leaders, and statesmen, all fail to achieve what they seek. That is one reason why they continue. It is also why I do.

A metaphysician tries to produce a final, all-comprehensive account and is, therefore, more self-critical, more self-aware, and also more daring and adventurous than other thinkers are. The very questions that Lenk raises and the kinds of solutions that he provides make evident that he is a metaphysician who has been frightened by excesses committed in its name.

Give the pursuit whatever name one likes, every philosopher is either a covert, half-hearted, or a genuinely dedicated metaphysician. To be a better one, he must not rest until he has faced up to every criticism and every doubt he can raise against what he has maintained. Only rarely, is he caught by surprise by the questions others raise. All the while, he knows that he can never do much more than inch a little further than where others stopped. He objects to such positions like those where Lenk remains, because the most obvious difficulties are not faced and surely not overcome. Were the attempt made, Lenk would be a better metaphysician, no matter what title he would have preferred be given to him. One thing is sure: he cannot remain where he now is, since he evidently presupposes what he is unable to acknowledge under the conditions he has set up. He says that he must "assume" what enables us to "analyze our experience." Would it be all right to assume that a griffin, a great-grandmother, a devil, or a God provided the needed means?

Again and again we are forced to assume this or that, but no philosopher can rest until he is able to understand and justify what is assumed. If we are told to assume the simplest or the most attractive or pleasant view, that demand will need to be examined and justified. Lenk does not mind climbing up that hill. As great an athlete as he is, he nevertheless cannot keep on climbing forever. On his view the top always recedes before him, yet all the while he exists at a particular place worth exploring, and from which he might be able to reach a top that is always there, and find a way to move down from it as well.

Lenk grants that there is a reality existing "independently of our interpretations." All I ask of him now is why he holds that view, and how

he would justify it. Surely 'implying' it is not where a philosopher can bring his inquiry to an end. It may, though, be a good place from where another beginning might be made, while justifying and clarifying what had been accepted.

P.W.

2

John Lachs

METAPHYSICS AND THE SOCIAL CONSTRUCTION OF HUMAN NATURE

The historian looking over philosophical developments in the last fifty years will not be impressed by their novelty or boldness. Judged by the number of those whose academic title includes the word "philosophy" or by the tidal wave of books and articles published each year, our field enjoys unprecedented prosperity. Yet we suffer from a loss of spirit that calls itself caution. We satisfy ourselves with small points of clarification or retreat to the study of the great thinkers of the past. We skirmish over how best to do our job, a job that in these skirmishes we never get to do. We hear more and more from thinkers who announce the end of philosophy, though they are unwilling to end their own. Those who don't philosophize keep telling us that we can't.

Lost in the love of texts and subtexts, lost in the controversies about language and thought is the great traditional task of philosophy. In the last fifty years, few have had the daring of Paul Weiss to attempt to see things and to see them whole, to settle for nothing less than an integrated vision of life and the cosmos. To be sure, such an ambitious enterprise is fraught with danger. But it is the danger of high adventure, of a grand challenge embraced, of doing what our calling demands. Even if, in the ultimate sense of learning the truth, such efforts are almost certain to fail, we must respect them as expressions of our insatiable drive to know. They probe the limits of understanding and show the power of creative mind. They grapple with the deepest questions of life, with the problems we can neither answer nor forget.

I do not share the qualms of positivists, sceptics and postmodern souls about the sort of enterprise Weiss undertakes and have nothing but admiration for his boldness. "The problem of the nature of man is one of our most neglected problems,"[1] he says, and proceeds to develop a full account of that nature. Targeting human life as the ultimate object of investigation and thinking, as he does, that moral concern is at the center

of that life seem to me clearly on the right track. I am not bothered in the least by the generality of Weiss's statements about our frame. My objection is only that he makes the wrong ones. In particular, he underestimates the extent to which human nature is a social product and, as a result, he falls prey to the age-old error of supposing that it is universal and uniform.

Both in his written work[2] and in his classes, Weiss showed a fascination with the Thomist view that there is something metaphysically unique about human beings. Aquinas thought that, at some point after conception, God substitutes a human soul for the animal form of the embryo. Although each such soul is a singular individual, all of them belong to the same species. They distinguish humans from perishable beasts and establish our everlasting moral self-identity.

Weiss raises a variety of objections to this view, but in the end adopts one not very different from it. To be sure, he rejects both the need for divine intervention in human reproduction and the idea that the embryo becomes human only after a while. He maintains, however, that we have selves or "fixed cores,"[3] which differentiate us from animals. Each human has such a self from conception; without it, we could not affirm the "undeniable truth" that "it is the same man who is adult and who was embryo or child."[4]

The self makes it possible for us to be identical through time and thus to be responsible for our acts. By means of it, we can evaluate ourselves and, when needed, exert self-control, criticize and even discipline ourselves. This nonbodily power, which is "essential and constant," serves as the source of our uniquely human abilities.[5] Regardless of their achievements, all humans have such a self or power and all animals lack it.[6]

Each self is connected to a body, though only to the sort of body we usually identify as human. Its presence is, therefore, in the end a matter of biology: as soon as sperm and egg unite, an unduplicable self attaches itself to the resultant organism. The breakthrough to full humanity cannot occur "through mere growth," he writes, "but requires a radical change in the composition of an entity, and . . . this is achieved at conception."[7] Although he says that the appearance of a self is not due to the physiological character of the sperm and egg, Weiss does not discuss what other features of such blobs of matter may be responsible for attracting selves and why selves do not inhabit the bodies of apes and porpoises.

Weiss struggles with how his view of a fundamental difference between humans and animals comports with the theory of evolution. He avers that the self emerges as a result of developments in the animal

psyche. Such psyches are presumably self-centered; when they become concerned with the good of others or the good everywhere, they turn into selves.[8] Weiss gives no hint of why, when, and how this change occurs or once occurred. The current absolute distinction between animals and humans suggests that it must have taken place long in the past and cannot be replicated now. We can easily teach chimpanzees to care about what happens not only to them and other apes, but also to all manner of beings that surround them. I doubt, however, that Weiss would think this gives them selves and thereby makes them human.

From time to time, Weiss speaks of selves as concerned not so much with the good of others as with the universal good.[9] This turns our attention away from moral concern as definitive of humans and toward abstract conceptual skills, making his position less satisfactory. A concrete moral being may be interested in the welfare of this or that or any number of needy individuals. Such devotion is quite different, however, from commitment to the universal good, which requires the ability to think in extremely general terms. We have little knowledge of how far animals are capable of totalizing thought, but it is clear that, even among humans, it is a late and difficult achievement.

The Indian tribes that lived by the shores of the Gulf of Mexico, for example, had names for the water adjoining their homes but none for the Gulf as a whole. It fell to mapmaking Europeans to make an abstract totality of all the bays and of the vast stretches of open water that connect the three Americas. If some humans have trouble thinking of the totality of a body of water part of which is before their eyes, we have little reason to suppose that they can be devoted to the sum of good in the world. Such sophisticated abstract conceptions must not be imputed to the embryo and can, therefore, not serve as the distinguishing feature of the human self.

This issue aside, the central problem Weiss faces is how humans can reproduce themselves. In our sexually liberated culture, this might seem unproblematic to anyone out of kindergarten. Nevertheless, Weiss's premises make the phenomenon difficult to explain. The union of sperm and egg is adequate to reproduce our physical nature. Our bodies, however, are not fully human without the presence in them of a self. How can such nonphysical, uniquely human selves be produced?

The problem arises because Weiss wants to maintain both that humans emerge as a result of evolutionary advance and that they are different not only in degree but in kind from animals. Our physical continuity with animals is undeniable; Weiss postulates the self to account for the discontinuity. Unfortunately, his tendency to ontologize makes him dismiss an obvious and well-explored explanation of the

generation of selves. Thinkers as diverse as Mill and Hegel maintain that human nature is a social product, that nothing but the forces of socialization can convert our biological potential into the complex actuality of a human life. Related to Weiss's view, this means that if what renders us human is indeed the presence in each of us of a self, then that self is developed over time through the processes of child-rearing and social interaction.

The argument Weiss presents against this view is less than convincing. "Man has a nature before he attains the status of a social being," he says, and thinks this implies that we "can be human and still exist apart from any society."[10] The context of these statements makes it clear that he has in mind fully developed human beings ("men," in his language): he speaks of retreating from society "many times during the day" and of remaining outside it indefinitely. This is perfectly possible for adults, though only in a superficial, primarily spatial way. Those in the early stages of development, however, cannot even do this; infants denied a nurturing social environment fail to survive. And though adults can leave society, society never leaves them. The skills, habits, value systems, thought patterns, and emotions that structure our lives are all products of socialization. They are the indelible marks the social world leaves on the soul, marks that define who we are and what will satisfy.

Instead of accepting the view that we are humanized in the process of social life, Weiss insists on an explanation that combines biological facts with metaphysical speculation. He realizes that the problem consists of two parts. One demands an answer to the question of how the first human emerged from nonhuman animal life. The other requires an account of the continued production of humans with selves through the physical means that is the only method open to human bodies.

There is an important difference between the two cases, according to Weiss. The second is easy, he thinks, because it requires only "a peculiar egg and sperm."[11] The initial emergence of humans is more difficult to explain and is likely to involve a multitude of circumstances. In a conjectural mood, Weiss asks if it occurred as a result of "the meeting of some animal sperm and egg" or after birth on account of "the acquisition of tools or speech." He replies uncertainly: "Perhaps both conditions are needed. Perhaps only in some unusual state of the world can the new kind of unity appear, be carried to term, and then live somewhat like a public man?"[12]

The language of the above quote reveals that Weiss thinks both of being human and, consequently, of the emergence of the human as all-or-none affairs. He sees evolution not as a gradual process of change in which something we may with hesitation call human appears over

many thousands of years. He supposes, instead, that there was a specific time in the past when the first human being was conceived and then "carried to term." No being prior to this had been human and this creature was human through and through. Such is precisely the view he must take if he is to remain consistent with his idea that we are rendered human by the self that attaches itself, in some mysterious way, to the zygote at fertilization. Weiss must have Adam in mind, though he situates the abrupt emergence of the fully human in a historical time and a biological matrix.

Once the first few humans are on the scene, explaining the rest of them presents little problem. An evolutionary achievement of this magnitude "cannot be undone." Accordingly, once "human beings are produced, only human beings are produced."[13] The "quantum leap" to humanity occurs at the radical event of conception. But such events are not unique to the human race and Weiss maintains that the physiological character of the sperm and egg are inadequate to assure the humanity of the offspring. What, then, accounts for it? Without a pause, he offers the following speculation: our humanity is due to the manner in which the sperm's and the egg's "lived-through beings as at once inward and acceptive of what is outwardly conditioned, are combined."[14]

I must admit to not being able to make much of this suggestion. I am bothered, of course, by the thought that there is no conceivable way for us to know about the inwardness of sperms. As to their acceptiveness, they strike me as pesky little things that are rather more aggressive than agreeable toward external conditions. But these epistemic qualms aside, how are inwardness and acceptiveness as necessary conditions of humanity themselves passed on from generation to generation? If as inheritable features of organic objects they are carried in the genes, then everything about the descent of humans can be explained by reference to physical facts alone. And why should we suppose that the proposed description is accurate about human sperms and eggs but somehow misses the mark concerning the genetic instruments of other species? Perhaps the sperms and eggs of whales are just as inward and acceptive as those of your neighbor down the street. And what if my wife's second cousin's eggs are not very acceptive? Does this mean that whales are more likely to produce human offspring than Ann?

What generates these problems is Weiss's notion that our humanity is an objective condition grounded in the possession of a self that accrues to us at conception. Each element of this notion is open to question and the idea as a whole is sufficiently improbable to justify doubt. The development of humans from apelike ancestors was too gradual to enable us to say that the creatures at any point in the continuum were simply either

human or not. Each group of forebears we have been able to identify were more or less human, or human in certain respects but not in others. Whether or not they were sufficiently like us to warrant being called human is a matter of judgment.

Such judgment seems never to drop out in issues as important as determining who is human and, therefore, who has obligations and rights. The history of civilization may, in fact, be viewed as the story of the development of an inclusive notion of humanity or, what comes to the same thing, the story of the gradual expansion of our sympathies. For many years, strangers, enemies, those of a different race or religion, people of divergent tastes or habits, cripples, idiots, and the mentally ill were not regarded as human. The fact that, by and large, now they are establishes neither that that is not a matter of judgment, nor that the inclusive opinion is right rather than just more satisfying or better.

Weiss might, of course, respond by saying that exclusivist judgments are simply wrong. To make this plausible, he must show either that we are in possession of a standard of humanity independent of what we can derive from observing ourselves and neighboring others or that our recognition of humans is intuitive. The first of these strikes me as completely hopeless. Our access to essences or abstract concepts is unavoidably mediated by sensory experience. Since our experience is severely circumscribed, one cannot avoid asking how good a sample my friends and I make as paradigms of the human frame. All standards we derive will be as partial, regional, and fallible as the experience that undergirds them.

The second alternative may seem to hold more promise and, accordingly, Weiss embraces it. He asks why we take autistic children, idiots, and the senile to be humans. After reviewing some rival opinions, he says, "Our acknowledgement of them as human is too immediate, too ungrounded in experience, reflection, or knowledge, to make it possible to account for their acceptance as humans in these suggested ways." Our feelings are evoked by these beings directly, we sympathize with them and respond to them in a way that appears to come without reflection or tutoring, from the depths of our soul.

Here again, Weiss forgets the formative experiences of children. Intuitions are deeply ingrained responses, flowers growing from the compost of habits. We learn to recognize humans in the crib: they are the loving shapes who minister to our needs. Thieving birds learn to identify humans no less breathlessly; the scarecrow does not even have to look much like a person for the flight to be unreflective and immediate. Without a history of interaction with many resembling and reliable people, we could not enjoy intuition of our kinship with humans. A child

growing up among wolves would learn to view itself as similar to them and them, instinctively, as family. Our intuitions are not native recognitions of essence but the residue of regional observations.

Weiss arrives at his account of human nature by ontologizing social processes. Humans acquire selves, that is, characteristic patterns of feeling and operation, through lengthy exposure to social attempts at handing on culture. Weiss attends only to the product of these efforts, a product which is itself always in process of change, converts it into a stable, enduring being and projects it to the moment of conception to serve as the element that renders us human from the start. The moves this involves appear suspect, if not transparently unacceptable, as soon as they are properly brought to critical attention. A philosopher as discerning as Weiss would have noticed them and would have had his suspicions aroused had he not thought that the postulation of such a self is necessary to account for self-evaluation, self-control, and self-identity.

Everyone who has dealt with children knows that teaching them the skills of evaluating, controlling, and disciplining themselves are central goals in raising them. We do not need to suppose that young people have a nonphysical self in order to explain how such education is possible. We see ample analogues to it in the way animals can be socialized. Extensive exposure to the way I affirm values in the yard has made my dogs act in ways that suggest a conscience: they try to control themselves and, when they cannot, they append bad feelings to self-indulgence. Sometimes they act in ways so human that I have to remind myself that they are only beasts. We have little reason to suppose that children learn in a different way or that they learn much better.

Self-identity is a different matter: instead of a skill taught, it is a condition determined by reference to socially developed standards. The demand for it is primarily moral and political, not metaphysical. We need to be sure, for example, that the people brought to justice are the same ones as those who committed the crimes. In other cases, we may have to find the rightful heirs to land and fortune, that is, let us say, the grown individuals identical with the children who drifted away from home. The problem may also be personal and psychological: victims of amnesia or those suffering from Alzheimer's disease may have to be identified and helped to recover their memories or their feelings that they know who they are. In all these situations, we operate with public standards of varying stringency, none of which refers and none of which needs to be supplemented with reference to an enduring, nonphysical self.

The postulation of a hypostatized self, therefore, is neither necessary nor useful. The social practices that involve questions of identity can

proceed happily without supposing that such things exist. And maintaining that they do adds nothing to our grasp of the world. They fail to offer criteria of identity independent of the ones we use and, because they are an odd sort of existents, their relations to the ordinary objects of our experience become vexed problems. Attending to the contexts of life in which questions of self-identity acquire function and significance makes it less tempting to invent a set of ontological structures that shadow social processes. This is particularly important because philosophy cannot focus its efforts on understanding and enriching life so long as it occupies itself with such coinage.

Weiss's tendency to ontologize social processes shows itself in another way, as well. He thinks that humans are different in kind from animals, that the human race is rigidly separated from all other species, and that human nature is invariant through time and space. All of us, therefore, manifest a single essence, which defines a fixed and uniform human nature objectively embodied in the world. Since who we are determines what we ought to do, this enables Weiss to hold all human beings to the same standard of behavior: all of us must pursue the universal good.

Why should we suppose that species are anything but collections of variously resembling individuals? The similarities must, of course, be adequate to justify lumping the creatures together, but what is adequate in any given case depends on the purposes we have and the decision we make on the basis of them. If we look only at ourselves and our friends, the similarities among humans may seem overwhelming. This, however, indicates not the uniformity of human nature, only a biased sample. The natural tendency on the part of those who establish absolute standards of humanity by such partial observations is to use the measure by which others fall short of it as a mark of their deficiency.

To see what is involved in classification, we must expand the sample to include all the individuals that constitute our apelike ancestors, the Neanderthals, China man, Java man, and the near-humans who resided in Africa, along with the full variety of people who lived in roughly the past 20,000 years. Among the last of these, we must take into account not only the shining exemplars of civilized intelligence, but also catatonic schizophrenics, congenital idiots, hydranencephalics, the borderline deranged, perverts, cannibals, those crippled or distorted in body, mind or will, mass murderers, necrophiliacs, and persons duller and less sensitive than sheep. Is there any essence we can detect that all these beings share? Many of them will seem far closer to animals of one sort or another than to humans, just as many domesticated animals will seem

like our sisters and brothers when compared to them. Nothing physical, mental, emotional or spiritual, no skills, desires or activities are common to them all. Even their genetic material differs: the average divergence among contemporary humans is 3,000 nucleotides.[15]

To order this vast continuum of individuals, we must pick out traits we think particularly important and decide how similar they must be to justify assigning those who display them to the same group. The choice of traits and the decision about adequate similarity constitute a double judgment, both of which involve our values and our purposes. Sorting by reference to the time at which the creatures lived may appear natural but expresses, in fact, an interest in tracing genetic heritage and developmental patterns. Viewed in this light, the last Neanderthal expired perhaps 25,000 years ago. If we group people by intellectual endowment and emotional propensities, however, a number who live today must be classed with the Neanderthals. To ask which is the correct way to classify is to miss the central role choice plays in the process. No way is *the* way, though some ways are clearly better for certain purposes. It all depends on what we want to do and what we are prepared to give up or overlook to accomplish it.

Simple ontological realists, such as Weiss, live in an austere world. Reality for them is like a heap of bones, each clearly articulated, sparingly endowed with properties, barely touching at the joints. A single thought captures what they are; their other properties can be derived from this their essence or else constitute an accumulation of irrelevance. I understand how one can think of the world in this fashion, but the image bears only the faintest resemblance to the rich reality that washes over us. The properties and relations surrounding us constitute a web indefinitely deep. Our minds can create neat, human order out of this luxuriance in any number of ways: the point is not to get to the ontological rock bottom or to uncover the intellectual structure that explains it all, but to organize it in a way that will make life more satisfactory. This, in the end, is the meaning of Weiss's correct insistence that our ultimate concern is always with the good. Lordly intellectuals may find it a sad lesson that knowledge is a subordinate instrument, but in their candid moments even they admit that none can live only the life of mind.

What, then, makes for the humanity of human beings? Different collections of features at different times. Picking properties that make the class exclusive may be unfortunate, unproductive, or lamentable, but it is not intellectually wrong. Within limits,[16] there are many ways of carving groups out of the continuum of individuals and, since each

stresses existing similarities, none is more accurate than the others. Morally, of course, some classifications are simply abominable. Excluding persons from the human race on account of their height, their gender, their religion, their income, their political persuasion, the color of their skin, or the length of their hair strikes us as unacceptable and perhaps even wicked. All of these (and more) have at one time or another been used to distinguish humans from those who do not count and we want to be ready to argue against them when people say they are markers adequate to strip others of rights. We cannot do so on purely epistemic grounds, but we can on the basis of our broader purposes.

An inclusive notion of human nature has, in fact, gained such dominance in the last hundred years that it may be time to insist on important differences between human natures. A single nature suggests a single perfection: if human nature is universal, the human good should, in broad outlines, be uniform. Intolerance used to live by excluding groups from right-bearing status; it can flourish now by forcing its standards on all admitted to the human race. Weiss appears to recognize this and, accordingly, raises the possibility that gender and color, perhaps even musculature, make for divergent human natures. He sees that there are important differences among us and thinks it "imperative that we do not minimize the bearing of gender, color, and age on individuals."[17]

Although this is a promising start, Weiss quickly reverts to his ontological schema and asks how such bodily features relate to the unchanging self that, after all, constitutes our nature. He replies that, in the end, the differences among us change only the efforts we must make. The fundamental task remains the same for all: to render ourselves "representative of mankind" and to make our exertions advance the universal "value intrinsic to the self."[18] Our differences are not, therefore, of the essence; as variations in our circumstances introduced by the body, they change only the details of how we pursue the good.

Such an approach acknowledges neither the role social life plays in creating the self nor the fact that who counts as human involves a social (and sometimes political) decision. Without such recognition, it is impossible to develop an adequate theory of human nature or even to understand the functions of such theories. Postulating a changeless self as the core of each human being misleadingly shifts emphasis from the realities of empirical life to the intangible characteristics of the hypothetical. Declaring that all selves share a concern for the universal good flies in the face of experience and throws the door open to the intolerant imposition of standards and to the widespread condemnation of those whose nature resists them.

It takes courage to do metaphysics in the old, time-honored way by setting sail for deep, uncharted waters. In matters of such profound impact on our lives as our conception of who we are, however, it may be better to steer close to the shoreline of facts.

JOHN LACHS

DEPARTMENT OF PHILOSOPHY
VANDERBILT UNIVERSITY
JUNE 1993

NOTES

1. Paul Weiss, *Nature and Man* (New York: Henry Holt, 1947), p. 134.
2. See, for example, *Nature and Man,* pp. 130–32.
3. Ibid., p. 267.
4. Ibid., p. 134.
5. Ibid., p. 127.
6. Ibid., p. 128.
7. Paul Weiss, *Philosophy in Process,* vol. 7 (Carbondale: Southern Illinois University Press, 1978), p. 498.
8. Ibid., p. 138.
9. *Man's Freedom,* p. 201; *Modes of Being,* p. 49.
10. *Man's Freedom,* pp. 37–38.
11. *Philosophy in Process,* vol. 7, p. 499.
12. Ibid.
13. Ibid., p. 498.
14. Ibid.
15. R. C. Lewontin, *Biology as Ideology* (New York: HarperPerennial, 1992), p. 68.
16. I discuss these limits in "Human Natures," *Proceedings and Addresses of the American Philosophical Association* 63 (1990): 29–39.
17. *Philosophy in Process,* vol. 7, p. 123.
18. Ibid., p. 124.

REPLY TO JOHN LACHS

To know John Lachs is to know that he will confront one with a lively, plausible, sensitive examination of a difficult issue. There is much in what he argues for that I would accept, were it offered as an addendum or qualification of what I have maintained, but not as a rejection or as an alternative. Since he bypasses a number of crucial issues, he also leaves me doubtful about the importance and pertinence of his major claims.

Lachs attends mainly to my early writings. I do not disown them, but I have added to, 'subtletized,' and modified many of the formulations on which he focusses. Most important, he pays no attention to my examinations of individuals, with their use of characters, persons, and living bodies, and their bearing on what occurs in the humanized world, that he calls 'society'. I have examined the nature of society at some length. Unlike him, I do not find that it precludes the understanding of humans as unique, self-identical sources of acts, only some of which society depends on and qualifies.

Lachs says that I underestimate "the extent to which human nature is a social product" and that I therefore fall "prey to the age-old error of supposing that it is universal and uniform." I have, though, examined morality, language, custom, laws, societies, and states, and have recognized them to be qualified by tradition and practice, and to change over time. The result does not compromise, but instead supplements what we know to be true of each of us, as apart from our public involvements.

Although I am in the same comprehensive society with an aborigine only in a loose, broad sense, I have no difficulty in acknowledging him to be another human. I can sympathize with him, and know that he has been treated shamefully. I think he thinks, feels, loves, and hates. If human nature is a social product, he and I must have been subject to the same social determinations. I think we are equals apart from these, but

qualify and are qualified by them in different ways. Each of us is unduplicable. Both of us possess and use our bodies in many similar ways, though often enough to do quite different things. Nor do I believe, as Lachs seems to, that "individual humans" are terms incompatibly or arbitrarily joined. Each of us is an unduplicable being with a private and a public side. The acknowledgment of one does not preclude the acknowledgment of the other. I do not know why Lachs disagrees.

I am astonished to hear that my view is akin to the Thomistic, with its supposed creation of souls by a God with a calendar (Hebrew, Roman, Julian, or Gregorian?) who inserts them in males a week after conception, and in females some weeks after. My views in fact are not altogether at odds with those expressed by some who lived well before Aquinas and in places where he has had no impact. Lachs does note that I do not accept the "need for divine intervention in human reproduction" but objects to my claiming that "we have selves or fixed cores which differentiate us from animals." He apparently believes that we are different from animals, only because we have been socialized. It is not clear whether or not he also thinks that, with proper socialization, animals would become humans while continuing to have different kinds of bodies or, conversely, if we were differently socialized, we might be just animals.

Lachs thinks I hold that as soon as a sperm and egg unite, an unduplicable self attaches itself to the resultant organism. Lachs has confused me with some current anti-abortionists. I must, to keep the record straight, reject the identification. I do not believe that there is anything in all my writings that would warrant his saying what he does about my view about individuals. I have never claimed that "blobs of matter may be responsible for attracting 'selves'."

No one knows just when a human comes to be. I have tried to show that the question comes down to the origin of an individual, i.e., a unique, confined being who owns, uses, and is limited by a character, person, and body. I have also tried to show what an individual is, how it is different from what it uses, and how it can be reached in intensive acts that go beyond what is publicly evident. Lachs shows no awareness of the fact. Nor is it clear whether or not he thinks that living beings differ in degree from the nonliving, that a difference in degree distinguishes different kinds of living beings, or that it applies only to those we usually take to be humans. Would an animal, if subject to the right socializations, be indistinguishable from those we now call 'human', except perhaps in what would then be termed irrelevant bodily shapes and abilities?

Lachs thinks that a concern with the "universal good" is not definitive of humans, since it "turns our attention away from moral concern as

definitive of humans and toward abstract conceptual skills." Are moral —or more accurately, ethical—concerns alone definitive of humans? Are not tradition, speculative thought, a knowledge of law, an interest in religion, an involvement in creative work, an acceptance of responsibility and the carrying out of commitments no less 'definitive'? If they are due to society, why do they often fail to comport with what society endorses? It does not take a long time for many to reach the point where society is criticized and deviations from its decrees forcefully expressed. Are those deviants, social products? Were it true that humans are devoted to adding to the sum of good in the world, there would be only a few who could rightly be called 'human'.

I do not "postulate the self." I discern it in those I love, and in whom I am interested, and occasionally in those who arouse my hopes and fears. I usually talk to others and not at them. I am, though, not sure exactly how humans are reproduced. Here I am one with Lachs and everyone else who has wrestled with the problem. That does not preclude us from knowing some of the major conditions that must be met before a human could exist. Although we cannot know the precise moment when he comes to be, we can know that when he does, he makes use of a body.

Sometimes I feel a pain in my leg. While I do not feel another's pain in his leg, I sometimes am aware of the fact that he is pained. I may need a grimace or a cry to alert me, but what I then do is my doing, passing beyond what is publicly evident toward him as individually and personally living through his pain. There are humans with weak or bad characters, due not to society, but to them as individuals existing apart from it.

Lachs says "nothing but the force of socialization can convert our biological potential into the complex actuality of a human life." Is that what occurs? Could what is an organism become an individual with responsibilities and emotions, and who might carry out scientific, philosophical, or creative work? Lachs does not say. How does he know what socialization achieves? Is that an idea that society made Lachs adopt—but not me and many others? He cannot have it both ways: take everything to be a product of socializations, and also suppose that what he is maintaining is more than the outcome of his socialization.

Lachs thinks that only adults retreat from society many times during the day. Is daydreaming not possible to the young? He says "the skills, habits, value systems, thought patterns, and emotions . . . are all products of socialization." He and I must have been differently socialized, for I don't think that is true. Is my socialization inferior to his? To know whether it is or not, must it not have to be measured against a truth about the nature of an ideal socialization? I was never taught to be afraid, to

wonder, or to want affection. My social life has had an effect on me, only because I provided it with what it could qualify. Yet Lachs seems to claim that what I am and do is amorphous, awaiting society to give it shape and form. Would not society produce the same definite product in and for all? Were there nothing more than what society provides, must there not be what is not socialized on which it acts? Lachs answers these troubling questions with a thundering silence.

Does society initially, and even now, work on what is more or less human? Is this what society had previously produced? Must one not sooner or later acknowledge something distinct from society on which society could be impressed? Initially, society could not have been a human society, but at best something else, more general, perhaps, and surely more amorphous than anything we know. How could it mold anything? How could what it works on become an individual who privately undergoes feelings and emotions, who thinks, and who might believe that society could be improved? No gain in understanding is achieved by supposing that there are beings who are 'more or less human' and that a society gradually turns some into full humans, with distinctive persons, private thoughts, emotions, purposes, and beliefs, able to criticize and oppose society.

Lachs says that there is no conceivable way for us to know about the inwardness of sperms [and eggs]. Since they are alive, they surely have a power that is not reducible to that through which it may be expressed in various ways over the course of a lifetime. When he goes on to ask how inwardness and acceptiveness are passed on from generation to generation, he begs a question, for when and as a living body of a distinctive kind is produced, the owner and user of that body is also produced. That owner and user does not exist in the public world. It is reached by carrying out intensive moves. These do not terminate in something cut off from all else, that somehow attaches itself to an alien body.

There is no conflict between the claim that the development of humans over the course of evolutionary history was gradual, and the claim that there was a time when humans first came to be. Gradual progressions sometimes come to crucial points when something new occurs. An acorn is not a miniature oak; a fertilized egg is not yet a chicken; drought is not a variant form of rain. It is not clear what Lachs means when he says that "being called human is a matter of judgment." Any judgment? Good judgment? On what will the judgment be based and judged? How will it be tested?

It surely is not true that the "inclusive notion of humanity is one with the story of the gradual expansion of our sympathies." Blacks were humans even when they were bought and sold like cotton and peas. Nor

is the acknowledgment of their equal humanity with their masters simply an acceptance of what is "just more satisfying or better," unless by that one means that the acceptance accords with the fact that they never were less human than their masters. Slaves might have had to accept their condition by force and law, but they still were humans just as surely as their masters were. The force and law that finally put an end to slavery in our country did not convert nonhumans or lesser humans to full humans; instead they backed their status as full humans.

Lachs says that our access to essences or abstract concepts is unavoidably mediated by sensory experience. This surely is not how complex numbers, non-Euclidean geometries, what is right and wrong, or what ought to be are known. He says, too, that a baby in a crib is a loving shape (!) who ministers (!) to our needs (!). I know that I never loved a shape in a crib; nor do I know of any of my needs to which it ministered. Immediate contact was made by me with a being whom I continued to know decades later, though the appearance had changed considerably. We do not know how to construct objects, having existences and natures of their own, just by combining our sense experiences. When Lachs allows for "an instinctive recognition" by a child that it is part of a family, he credits it with a knowledge of what a family is. Metaphysicians are more cautious in their attribution of abilities.

I am not sure what Lachs means when he says that "our intuitions are the residue of regional observations." Is that true also of an infant and a child? Is there any warrant for claiming that selves are "patterns of feeling" and that they are acquired "through lengthy exposure to social attempts at handing on culture?" I doubt that anyone in my family or circle ever had such a grand mission. Or is anything more intended than the claim that we sometimes act as social beings, and may enable our society to be continued in a more or less modified form? That would be a plausible thing to say, but it surely is not incompatible with, and in the end presupposes separately initiated acts that may or may not become subject to social determinations.

I can imagine one of Lachs's disciples in a courtroom pleading: "Don't hold me accountable. Society made me rob the bank. You should punish society, not me, and make it pay me for having so molded me that I shot the cashier." I also imagine the judge replying: "I am a better Lachsian than you. You have not been sufficiently socialized. I am sending you to prison for further socialization. When you get out you will be more human." "No, no," I hear the other Lachsians crying, "Send him back into society; that's the way to socialize him." I, and almost everyone else, recognize that society and state may hold someone accountable, though he may not have been responsible for initiating the

acts that society and state evaluate. Why ontologize society and suppose that it is all-inclusive and all-powerful?

What is it to be "more or less human?" Is the "history of civilization the study of the gradual expansion of our sympathies?" What are our sympathies? Do they express what we separately initiate? Lachs asks how an inwardness or acceptiveness is passed on from generation to generation. I never supposed it was. Each individual is unique. What it inherits it adopts in its own way, to end with it more or less modified. There is much that it cannot control but, as lived in and with, it is more than an idle accompaniment. An ailing body remains one's own even though one may be able to do little or nothing to overcome the limitations to which it subjects one. Our genes help determine the natures and functionings of our bodies; these in turn set limits to and qualify whatever differences individual possession and use introduce. Neither can be fully understood if taken to be no more than a variant of the other. Did Lachs read my writings as part of a sociological study? I do not read his as if they were. Indeed, he wants it to be known that I am wrong, not maladjusted, while I am trying to show that he has misconstrued what I have maintained, without ever doubting that he is a person.

Lachs seems to be a late subscriber to the now abandoned view that there is a steady progress being made toward some glorious omega point. Has he forgotten that we have had two world wars in this century? Has he forgotten both Hiroshima and the Holocaust? The socialization that he thinks is making us more and more human is a myth that dissipates when confronted with the very kind of brute facts Lachs asks us to remember. His supposition that there is socializing power that affects every one of us is not idle, but a reference to it is counterproductive if it makes one forget that each of us has responsibilities, and that we build strong good characters by initiating and carrying out individually initiated acts. Some of these have social consequences that are to be assessed on other than social grounds. An ought is not an is that a society has insisted on; its course, products, and role are themselves to be judged by individuals using their own judgment. Overlooking that fact, Lachs apparently finds no need to account for our obligations. Should society not serve us as surely as we should serve it? There are, Lachs rightly reminds us, patterns of feeling and operation that are acquired through lengthy exposure to social conditions, but he fails to note that these depend for their occurrence on acts privately directed by us beyond appearances toward what appears.

The self is not 'postulated' or hypothesized, or a simple essence. It is a source toward which we can move in intensive acts. Confusing schizophrenics, idiots, etc., with what they do, Lachs thinks that many of

them seem to be closer to animals than they are to humans. I doubt that he had ever known any. Still, there are some doctors in psychiatric wards who would agree with him. I have met them. Is there a good reason for supposing that they are right? If we accept Lachs's idea of the 'more or less human' would we not have to place those unfortunates not just close to but with or below some animals? I thought, when I watched those who had been said to be nonhumans, that the doctors who spoke in that way had blocked off what they had discerned, so that they could more effectively concentrate on using instruments that would presumably preclude further dysfunctional behavior.

Lachs says that we ought not to try "to get to the ontological rock bottom, or to uncover the intellectual structure that explains it all, but to organize it in a way that will make life more satisfactory. Could this be done if one did not know what is to be organized and what ought to be achieved? He does not explain why he says that prejudice is "unacceptable and perhaps even wicked" or how it can be eradicated "on the basis of our broader purposes." Isn't torture wrong, no matter what the purpose? Why does he think that some classifications are abominable? Suppose society endorsed them? Slaveholders have not had much difficulty in finding a justifying purpose. There are some who thought that the Nazis had one.

I have discussed the nature, needs, and limitations of society in a number of places, most particularly in *Toward a Perfected State*. A consideration of some of its major theses would have enabled Lachs to see that a knowledge of man contributes to a knowledge of society, and conversely. Does he think that social life creates the self? I wish I knew.

To say, as I do, that humans "share a concern for the universal good" is not yet to say that all humans are aware of the fact, but only that it is a prospect relevant to them as realities who exist outside as well as within the limits of society, facing a realizable future. Instead of showing us how to "steer close to the shoreline of facts" Lachs offers us an all-purpose society working on malleable material. Yet what society decrees and does is not necessarily final or right, beyond the reach of criticism.

The full, unduplicable reality of each of us has not been fully understood by anyone. Lachs points up considerations that every account must consider, but quickly hardens them into imperatives backed by denials that there are individuals who contribute to the result. The society that he takes to be primary is a special instance of what is presupposed by and conditions many occurrences. To know it, we must move beyond it, and identify what is able both to be expressed in and interplay with it. A good understanding of the nature of society should be matched with a good understanding of the nature of individuals. The fact

that no one fully knows what a human intrinsically is, instead of showing that there is no such reality, makes evident that there is still work for philosophers to carry out.

Lachs would have had a stronger position had he recognized that what he wants to affirm needs to be supplemented by an account of what individuals are, as apart from society and its influences. He would then be able to justify his welcome endorsement of an endeavor that refuses to stop with an examination of fragments torn from a more complete account.

P.W.

3

Daniel O. Dahlstrom

THE DUNAMIS OF EXPLANATION

We seek
Nothing beyond reality. Within it

Everything, the spirit's alchemicana
Included, the spirit that goes roundabout
And through included, not merely the visible,

The solid, but the movable, the moment,
The coming on of feasts and the habits of saints,
The pattern of the heavens and high, night air.
　　　　　　　　　　　　　　　—Wallace Stevens
　　　　Canto IX, *An Ordinary Evening in New Haven*

These lines from Stevens's difficult poem provide a splendid image of the sinuous energy and reach of Paul Weiss's mature metaphysics.[1] Weiss's philosophical speculations have always been marked by a tenacious attempt to determine what it concretely means to be *actual,* for everything from bare actualities ("the solid") to persons in both their privacies ("saints") and their various unions with one another ("feasts"). This very determination, however, as Weiss appreciated at an early stage of his speculations—probably on an ordinary evening in New Haven— entails the acknowledgment of *ultimate conditions* for those things ("the pattern of the heavens and high, night air"), sources of fixity in the form of what he now identifies as the voluminosity, rationality, stratification, affiliation, and coordination informing each actual thing and its relation to other things.[2] At the same time, actual things, relations, and processes are never in themselves simply instantiations of ultimate conditions nor do the ultimate conditions alone (any more than general laws of nature alone) explain why and how they obtain in a specific case. What needs explaining, in other words, is the significance of the 'and' in the claim that reality is made up of individual actual things *and* certain ultimate conditions. For Weiss, as for the reality-seekers in Stevens's poem, mere conjunction does not suffice. "We seek . . . the spirit that goes round-

about and through included . . . the movable . . . the coming on . . . and the habits. . . ." Neatly paralleling the spirit sought by Stevens's reality-seekers is what Weiss calls "a primary pulsating ground, or *Dunamis*" that is "at once potential, powerful, and dynamic."[3]

This essay is an attempt to explain what Weiss understands by this third reality, the Dunamis, and to do so by demonstrating the Dunamis of explanation itself. Though Weiss has comparatively little to say about explanation as such,[4] the nature of explanation has been a preoccupation of philosophers of science since the Second World War. Moreover, in recent years, even as the distinctive reality of the Dunamis was becoming clearer to Weiss, the discussion of explanation led to the acknowledgment of something, if not identical, then at least closely akin to what Weiss dubs 'the Dunamis'. One basic objective of this essay is to clarify and corroborate certain claims Weiss makes for the Dunamis by demonstrating the necessity of countenancing cognate claims in a context not restricted, indeed, not beholden to Weiss's metaphysical speculations. At the same time, while lending support to much of what Weiss has to say regarding the distinctive reality of the Dunamis, the pursuit of this essentially bridge-building objective raises fundamental questions, addressed in the conclusion of this essay, about the force of Weiss's metaphysical claims in the context of scientific explanation. In sum, this essay is conceived, on the one hand, as an endeavor to expand speculatively upon the explanatory possibilities afforded by the notion of the Dunamis and, on the other, as a request for greater clarification of its role in scientific explanation.

In line with these objectives, the essay is divided into four parts. The first part reviews Weiss's metaphilosophical introduction to the notion of the Dunamis as well as the evidence he gives of the Dunamis. The second part sorts out various uses of the term 'explanation' in order to specify the limited sense of explanation—nonintensional, causal explanation—probed in this study. How some influential, contemporary accounts of causal explanation argue for the necessity of countenancing something similar to the Dunamis is the focus of the third part of the following paper. In conclusion, the significance of the convergence between these contemporary accounts and Weiss's metaphysical account of explanation is explored.

I. METAPHILOSOPHY AND THE DUNAMIS

At the outset of his revealing and rhetorically effective essay, "The Dunamis," Weiss identifies three traditional philosophical strategies and

demonstrates how each fatally fixes on one of the realities identified in his mature metaphysics. Since Weiss, by his own account, only gradually came to realize the full import of countenancing the reality of the Dunamis, this metaphilosophical exercise also reveals something of the self-critical evolution in his own thinking. Above all, however, this metaphilosophical reflection successfully performs two tasks: it introduces the specific character of and evidence for the Dunamis, in contrast to other realities, and it draws attention to the particular difficulties of articulating the reality of the Dunamis.

The three philosophical strategies identified by Weiss are those of rationalists, nonrationalists, and neo-Hegelian thinkers who construe experience as some sort of middle ground, an original synthesis from which the intelligibility touted by the rationalist and the unintelligibility so dear to the nonrationalist are alike abstracted. Left to itself, each position is defective, Weiss argues. The rationalists fail, not in their endorsement of the distinctive reality and integrity of concepts, theories, and formal systems such as grammar and logic, but in their twin suppositions that the latter are detachable from a web of references (references that they make to other things and other things make to them) and that they lack the obduracy of the things involved in those references. It is precisely the ubiquitous obduracy of things, their resistance to conceptualization and theory, that impresses the irrationalist, and it is their contextuality that impresses the neo-Hegelian. At the same time, Weiss argues, irrationalists and neo-Hegelians can hardly reject the rationalist formalisms and conceptions *tout court* without surrendering the possibility of articulating their positions in any meaningful fashion.[5]

Each philosophical approach takes its start from the same "familiar world of daily life," but seizes upon a different reality in order to explain it. Rationalists are rightly taken by fixed structures, attenuated versions of what Weiss most recently identifies as "ultimate conditions." For rationalists, explanation amounts to the sheer instantiation of formal (logical, mathematical, natural) laws. Anti-rationalists, on the other hand, focus on the seemingly indeterminate reality of individual, actual events or things ("actualities," as Weiss once called them) or, in other words, their inexplicability as mere instances of formally articulated laws. There is, as the anti-rationalists note, a contingent integrity to these singular realities that, no less than the ultimate conditions of things, explains why things are what they are, precisely by always proving recalcitrant in some degree to those ultimate conditions.

In an attempt to do justice to both rationalist and anti-rationalist explanations of things, the neo-Hegelian contextualist attempts to elaborate something like a dynamic union of structure and unstructuredness.

Reflecting basic tensions in the Hegelian project itself, however, these contextualists all too often seem consigned to being either latter day "owls of Minerva" or closet eschatologists. They are forced either to embrace the counterintuitive and excessively timid claim that only the past can be explained (despite science's repeated successes in prediction) or to presume dogmatically a natural teleology to that dynamic union of structure and unstructuredness. Weiss's elaboration of the Dunamis is an attempt to do justice to the insight into this dynamic union without collapsing the latter into either an historicist contextualism or a dialectical absolutism. Just as Weiss's account of ultimate conditions and actualities is supposed to provide a more adequate explanation of what rationalists and anti-rationalists respectively and one-sidedly understand, so his account of the Dunamis is meant to appropriate critically the sort of explanation afforded by Hegel and his philosophical progeny.[6]

Weiss does not explicitly refer to "the Dunamis of explanation." However, some idea of how the Dunamis figures in explanation, especially in light of the foregoing metaphilosophical reflections, can be gathered from Weiss's elaboration of nine different "places" in which the Dunamis is actually encountered: *emotions* as the merger of privacy and body, *efficacious unions* (not mere relations) among limited numbers of actualities, the existence and acknowledgment of *contemporaries,* the sheer, fluid *passages* of things in contradistinction to stable structures and intelligible relations and to the things themselves, including their *genesis* from not being into being (or, in other words, from being inseparable from the Dunamis to being separate from it) and their *demise* from being into not being (from being distinguishable from the Dunamis to being an unseparated part of it), the *internal differentiation of ultimate conditions, creativity,* and *appreciation.*[7] While an outline of something like "the Dunamis of explanation" might be drawn from several of these topics in combination, the reference to the *passage* of things provides perhaps the most readily available indication of just how the Dunamis figures in explanation. The passage itself is something different from the things or states of affairs at the beginnings and ends of the passage as well as from any law of their passage. This dynamic process can be distinctly identified and that identification is, on the one hand, not merely retrospective (as for the historicizing contextualist) nor, on the other hand, does it ground an a priori inference about the specific course of realities in the future (as for the dialectical absolutist). In order, however, to show more precisely the evidence and the import of the Dunamis in explanation, qualifications are in order about the particular sense of 'explanation' in question here.

II. Detailed, Causal, and Meaningful Explanations

The Oxford English Dictionary identifies three obsolete meanings of the term 'explain': first (reflecting its Latin etymology of 'ex' + 'planus'), 'to smooth out,' second, 'to open out, to unfold,' and third, 'to make plainly visible, to display.' An overlapping or development among these obsolete meanings can be readily imagined. On a plain there is no hill behind which things might hide or in the shadows of which they might be obscured; things are out in the open, in full view. The intersection of these extinct uses of 'explain' is neatly captured by a line from Bulwer's *Chirologia, or the naturall language of the hand* (1644), cited by the authors of the OED: "The left hand explained into a Palme." Here smoothing out, unfolding, and displaying are all contained in a single act.[8]

Though there is certainly no reason to quarrel with this account of obsolete meanings of 'explain,' even a casual consideration of contemporary uses reveals how deeply words, like their human creators, can never escape their past. In regard to events we are unable ourselves to witness or to have witnessed, we typically seek an explanation of what is happening or has happened. We ask the survivors of an accident to "explain what happened," and in doing so we are not necessarily asking them to clarify why the accident occurred, but rather to "unfold" or "visualize" for us the details of the incident. Similarly, we may ask for an explanation of what happens or is happening or is supposed to happen in a specific process or operation; for example, "explain what happens in a viral mutation," "explain what happens in a primary election." In these cases, too, our query is not aimed at the cause but rather at the stages or steps of a process. This first, nonobsolete sense of 'explanation' may be dubbed 'detailed explanation.' Giving a detailed explanation is tantamount to providing an account or description.

In contrast to an accident's survivors, we expect experts to explain why the accident took place or, in other words, to "make clear" the cause of the accident. The task of science is traditionally identified with explaining in this sense of identifying causes; it is for physical scientists to explain why a gas expands at a certain temperature, for biomedical scientists to explain why the HIV virus mutates, for political scientists to explain why an election has a certain outcome. Explanations of this sort may accordingly be labelled 'causal explanations'.[9]

There are yet other instances when we seek an explanation and yet we are not asking for a report of the details of an event or a description of the stages or outcome of some process; nor are we interested so much in its

cause or causes. Sometimes we ask for an explanation of something that we are having trouble understanding. In these cases the explanation amounts to assigning a meaning to something that is more or less obscure to us. Explanations of this sort may be given of nature or natural phenomena, but more often such explanations are sought for matters in the world of human affairs, doings, and makings. Thus, we ask the rabbi to explain Passover, we implore a critic to give his explanation of a poem, or we request the legal scholar to explain a particularly difficult point of law. Since, in these cases we seek not so much the details or the causes as the meaning of something, this third sense of explanation may be aptly labelled 'meaningful explanation', an expression frequently synonymous with 'understanding' or 'interpretation'.[10]

In all these contemporary versions of explanation, links with the obsolete uses of the term 'explain' are unmistakable. This genealogy extends, moreover, to the reflexive form of the verb as well. When, for example, a plant manager shouts at a worker caught in the act of violating a safety regulation: "Explain yourself!," the manager may be invoking one or more of the discussed senses of 'explain'. He may be asking the worker to explain ("make plainly visible") what he did, why he did it, and/or what his perception is of the significance of his actions. Nor is such a reflexive use of the term 'explain' reserved only for human agents. Some machines, devices, directions, and the like are said to be 'self-explanatory'; computer programs are called 'user-friendly' because 'they explain themselves'.

Grammatical reflexivity is, of course, one thing, logical or ontological reflexivity quite another. While not determinable apart from a context that is grammatical and saturated with idiom, what counts as a logically significant expression cannot be simply read off the grammar and idiom of a language (or a comparison of grammars and idioms of various languages). The fact that the grammatical form of a verbal expression may be reflexive, that the subject and the object of the verb at times refer to the same thing (as in the sentences 'He explains himself thus' or 'That explains itself so') does not by itself indicate the logical structure of explanation, if there be such.

This difference between logical structure or function and grammatical form becomes patent if we consider some nonobsolete, reflexive uses of 'explain'. To say that a computer program or a set of instructions or even a poem 'explains itself' is a euphemism or metonym for an explanation —be it detailed, causal, and/or meaningful—so evident that any (further) elaboration would be trivial. 'The layout of the program is perspicuous' and 'the instructions are so clear as to render further comment superfluous'—each of these claims elucidates what it respec-

tively might mean to talk about something explaining itself and does so in a way not analyzable into '*x* explains *x* (in detailed, causal, and/or meaningful fashion)'.

Are all reflexive uses of the term 'explain' euphemistic? What about the worker who is asked to explain himself? Supposing that he does describe, identify the cause of, or interpret actions which are in some sense an extension of himself, the claim that 'he explains himself' is not a mere euphemism for the transparency of what he says. Indeed, the detailed, causal, or meaningful interpretation he gives of himself may be of questionable adequacy. Given such examples, it is clear that not all reflexive uses of 'explain' are euphemistic.

Nevertheless, there is something counterintuitive about analyzing 'he explains himself' into '*x* explains *x*'. Often, when we say that some thing ('thing' in the broad sense, including structures, events, and processes) explains another thing, the term 'explain' might be replaced *salva veritate* by 'cause' (or something like 'figure in the cause of' or 'contribute to the cause of'). In the case of these typically causal explanations, the use of the term 'explain' is both nonintensional and irreflexive. There are also intensional uses of the verb 'explain,' alerting us to the sense in which explanations are understood primarily as human activities. If 'cause' is substituted for 'explain' in those intensional uses, for example, in 'The political scientist explains the voters' antagonism thus', the meaning of the original assertion is obviously lost. For this reason, in an examination of explanation it is necessary to distinguish *nonintensional* from *intensional* uses of the verb 'explain' and its cognates.[11] Given the limitations of the present essay format, the discussion in the remainder of this essay is confined to causal explanation or, more exactly, the Dunamis of causal explanation.[12]

III. "THE CEMENT OF THE UNIVERSE"

Nonintensional, causal explanations are, as noted, typically irreflexive and this irreflexivity (together with transitivity) entails their asymmetry.[13] The *explanans* must be capable of being described *intrinsically* without involving or depending upon a description of what is being explained and the *explanandum* must not itself explain the *explanans*. What, for example, explains the playing conditions must be different from the playing conditions and must be such that it is not in turn explained by the playing conditions.

For a causal explanation, however, cause (*explanans*) and effect (*explanandum*) must not only be logically independent of one another;

they must also be *related* in some way. On the fatal, dogmatic assumption that knowledge of the power or necessity ("the cement of the universe") linking cause and effect must justify an a priori inference from cause to effect or effect to cause, Hume vainly looked for this relatedness solely in the mere succession or, more exactly, the constant conjunction of two successive events, each an instance of a particular "species of events."[14] His answer has been trenchantly criticized on several fronts. Mere succession does not allow for distinguishing between causal and noncausal sequences.[15] Moreover, causal claims such as 'smoking causes cancer' are typically and quite significantly made, not at all on the basis of constant conjunction, but on the basis of statistical relevance (and without being equivalent to an a priori inference from cause to effect).[16] Finally, not all causal explanations are matters of sequences and antecedent processes. In contemporary parlance, not all causal explanations are *etiological* explanations; there are also *constitutive* and, by some accounts, *teleological* explanations.[17]

These arguments against Hume's account of "the idea of necessary connexion" are, however, only negative. If a positive account of the relatedness of cause and effect cannot be given, then the possibility remains, very much in the spirit of some of Hume's remarks, that there is no essential difference between natural laws and accidental regularities.[18]

Reviewing these problems and building upon foundations provided by W.C. Kneale, J.L. Mackie argues that there must be some causal mechanism underlying succession and explaining it. Kneale approaches the question of natural necessity from that of logical necessity, arguing that the necessity of the relation between cause and effect must have something of the logical force of the "incompatibility of redness and greenness."[19] For Kneale the necessity involved in causal explanation resides in "transcendent hypotheses," for example, wave or particle theories in physics, the connections of which are intrinsically necessary and mathematically describable. Claiming that Kneale's transcendent hypotheses reveal only continuities and persistences ("an empirical counterpart of the rationalists' logical or near-logical necessity"), Mackie locates the necessity of causes in what he calls a "form of persistence" or a "qualitative or structural continuity," for example, "a certain wave-pattern changing into a certain other wave-pattern."[20] Conjecturing what these structures are and providing a mathematical description of them is the job of the scientist. The determination of these structures is a contingent matter, but they explain, Mackie argues, what Hume's appeal to regularity cannot: the difference between causal and noncausal sequences (and explanations).

Like Mackie, Wesley Salmon recognizes that, contrary to Hume's

analysis of causality, causal explanation is not provided by mere regularities, such as Kepler's 'laws' or the ideal gas law. Salmon takes specific issue with the deductive- and inductive-nomological views of explanation (originally formulated by Carnap, Hempel, and Braithwaite, among others) where explanation is regarded principally as an argument. The argument has a logically necessary form, having some general law(s) and particularly explanatory conditions as its premises (the *explanans*) and the fact-to-be-explained (the *explanandum*) as its conclusion. On this account, explanation and prediction are symmetrical and sufficient means for explanation are in hand when regularities and criteria for participation in those regularities have been identified. For obvious reasons, Salmon refers to this general view as "the inferential version" of the epistemic conception of explanation.[21]

Salmon raises several serious objections to this inferential version of explanation. First, the explanation of low probability events (for example, the poisoning that afflicts only a small percentage of people upon eating a particular sort of mushroom) presents a considerable problem to this view of explanation. Within a nondeterministic context, the certainty of the deductive-nomological argument passes over into high inductive probability. In the face of low probability events the defender of the nomological theory of explanation is then forced either to revert to determinism (with the dogmatic supposition that all low probability events are subsumable under some as yet unknown universal laws and thus at a later time amenable to deductive explanation) or to engage in the pretense that the determination of the high inductive probability of one sort of event provides an explanation of an instance of that event, while the determination of the low probability of another sort of event does not provide an explanation of an instance of the latter sort (as though the fact that a cancer patient comes from a population where seventy-five percent of the individuals contract cancer explains why he is afflicted by the disease while the fact that someone is from the other twenty-five percent of the population does not explain why that person did not contract the disease).[22]

The general difficulty with the nomological theory of explanation, according to Salmon, is that it confuses explanations of facts by general laws of nature with logical relations obtaining between statements or linguistic expressions of those facts and laws. The difference between arguments and explanations is underscored by the fact that irrelevancies, while harmless to arguments, are fatal to explanations. In an argument, whether deductive or inductive, an irrelevancy is a harmless premise of no import to the validity of the inference. For an explanation, on the other hand, if a statistically irrelevant fact is made part of the explana-

tion, the explanation is rendered nugatory and potentially dangerous. Consider the classic example of the cold remedy that is said to explain the disappearance of cold symptoms after two weeks where in the great majority of cases cold symptoms disappear two weeks after they first appear with or without medicinal treatment.

A further issue raised by Salmon is the temporal asymmetry in explanations and in inferences. While inferences can be retrodictive as well as predictive, it is at least counterintuitive to regard retrodictive inferences as explanations. The presence of a disease may be inferred from symptoms and symptoms may be inferred from the disease's presence, but the disease explains the symptoms and not vice versa. The amount of rainfall during the life of the tree can be inferred from the tree's rings, but the tree's rings do not explain the amount of rainfall. One key reason for this disparity between explanations and inferences is that the *explanandum* (for example, the symptoms) can never be antecedent to the *explanans* (for example, the disease), while inferences are in no way subject to this requirement. The temporal asymmetry in explanations and in inferences suggests, at the very least, that explanation is not, at bottom, an inference or, in other words, that even if some explanations can legitimately be given the form of an inference, inference is not an essential feature of explanations.

Beyond statistical relevance, Salmon argues, in most scientific contexts explanation must make appeal to *"causal processes."*[23] Unlike mere regularities, causal processes are able to propagate or transmit "their own uniformities of qualitative and structural features."[24] What allows the regularity in a causal process to be distinguished from other regularities is "the ability of the causal process to transmit a modification in its structure—a mark—resulting from an interaction."[25] To illustrate this point, consider the difference between the regularity of a moving object and the regularity of its shadow. The former regularity transmits a certain uniformity of its shape to its shadow but the reverse is not the case. That the moving object transmits a uniformity of its structural features to the shadow but the shadow does not transmit such a uniformity to the moving object can be empirically known from the fact that an alteration in the moving object is accompanied or followed by an alteration in the shadow but the reverse does not happen.

Despite some important differences, Mackie's study of causation and Salmon's study of explanation are in agreement in one crucial regard. In *The Cement of the Universe* Mackie concludes that "qualitative or structural continuity of process . . . over and above complex regularity" is a basic causal feature, empirically distinguishing causal from noncaus-

al sequences and ultimately answering the question: "What is the producing that Hume did not see?" In similar fashion Salmon claims that "causal processes constitute the physical connections between causes and effects that Hume sought—what he called 'the cement of the universe'."[26]

IV. The Metaphysics of Explanation

The "power or necessary connexion"[27] vainly sought by Hume but specified by Mackie and Salmon in their respective theories of explanation bears an unmistakable likeness to certain features attributed by Weiss to the Dunamis. In each case there is a recognition of the need to countenance transformational processes and interactions, irreducible to the particular termini (the onset and the outcome) of those processes and interactions, to a law (be it inductive, deductive, or statistically relevant) of those processes, or to the simple conjunction of the law and its instances.[28] Weiss has in fact continually argued (indeed, long before he introduced the Dunamis as such) for the necessity, not only of countenancing both the difference and the relatedness involved in explanations, but also of elaborating the dynamic unity of that difference and that relatedness (as it bears both upon a given explanans and explanandum and upon a given law and its instances). One of the great virtues of his philosophical vision, in my opinion, is the tenacity with which he holds onto this insight, or better, the tenacity of the hold of this insight on him.

While the arguments current in the philosophy of scientific explanation (reviewed in the preceding section) provide significant external support for upholding something like the reality of the Dunamis, this convergence of views also raises important questions about the differences between them and about the precise import of the Dunamis for scientific explanation. Some of these questions (the ones first addressed in what follows) are of a comparative nature, providing a particular focus for the general issue of the appropriate relationship of metaphysics to positive science and scientific methodology. These comparative questions point in turn to internal questions about Weiss's own understanding of the Dunamis within his metaphysical framework. In regard to both sorts of questions, the aim of these concluding remarks is merely to elicit clarification.

In regard to causal explanation, if the "processes" indicated by Mackie and Salmon do refer to the very reality that Weiss dubs "the Dunamis," are there sufficient reasons for preferring one account over

the other (in one respect or another)? In other words, again restricting the theme to causal explanation, are there reasons in specific contexts to favor the account given by the metaphysician over that given by the philosopher of science and vice versa? The answers to these questions depend upon understandings of the differences between these philosophical accounts, differences that can only be outlined here. For example, though it can be argued that each philosopher's account presumes no more than empirical evidence and fallible interpretations of it, Mackie's and Salmon's account of "causal processes" leaves to the sciences the specification of what those causal processes in each domain are; indeed, apart from the hierarchy of causal mechanisms, there may be no more than a family resemblance between the "causal processes" unearthed in different sciences. On the other hand, probably because it is not generated solely or even chiefly by considerations of causal explanation, Weiss's account of the Dunamis, while no less empirically based, accords to the Dunamis a unitary, speculative reality the basic content of which need not be left to theoretical and empirical sciences to determine. In fact, the Dunamis is said to underlie the realities examined by science; as Weiss puts it in 1983: "One ought to go part of the way with Bergson and hold that the ultimate units of interest to science are sustained by the *Dunamis.*"[29]

One possible advantage of the account given by the philosophers of science is, then, its minimalism that does not risk preempting and thereby possibly hindering creative research and experimentation. The problem with this claim, however, is its historically unwarranted presumption that metaphysical explanations inevitably lack heuristic value. Moreover, that comparatively "thin" characterization of "causal processes" promotes a strategy of explanation that may militate against the construction of an integral account of the causal processes underlying scientific explanations; the same cannot be said for Weiss's appeal to the Dunamis.[30] At the same time, however, as long as Weiss does not demonstrate how the Dunamis positively and distinctively functions in specific, causal explanations within one or more of the sciences, the Dunamis of explanation must appear to the scientific community as yet another commonsensical and mythical notion attributable to an "unsophisticated reasonableness," harmlessly vague and even eminently useful, as long as the specification of causal processes by the sciences has not begun to run its course. The mere fact that various sciences make appeal to "causal processes" and that philosophers of science such as Mackie and Salmon call attention to the necessary role those processes play in scientific explanation clearly does not establish that there is some one

universal reality to which those various appeals to "causal processes" refer.

These last remarks, it bears emphasizing, should be taken as a plea for clarification and specification and not a rejection of either the reality or the utility of what Weiss dubs "the Dunamis." In addition, they are made solely in connection with the evidence for the Dunamis of causal, scientific explanation. Yet, these are hardly idle pleas, not only because Weiss seems to be still very much a "philosopher in process," but also because they touch on an apparently unresolved problem regarding the place of the Dunamis (or at least aspects of the Dunamis presently under consideration) within Weiss's system.

Originally Weiss attributed a dynamic unity along with space and time to the finality that he entitled "Existence." In an entry dated April 19, 1983 Weiss acknowledges an ambiguity in this account of Existence. "But when I spoke of 'dynamics', or 'causality' [in terms of 'Existence'] I think I was making a dim reference to the *Dunamis.*" The precise relationship (similarity and difference) obtaining between the dynamism of the finality that Weiss once labelled "Existence" and the dynamism of the Dunamis was a subject to which Weiss returned in the following years. In an entry of August 3, 1984 he considers alternative ways to understand this relationship, for example, taking "Existence (a final Condition), to be spatial and temporal, but not dynamic, as I [Weiss] have previously held" or distinguishing the dynamism of the finality from that of the Dunamis. To do the latter, Weiss advises, "requires one to distinguish the causal dynamism of Existence which joins actualities in a single causal totality, from an ongoing in which there is no distinguishing of antecedent and consequent, and no reference to any particular things."[31] This atemporal understanding of the Dunamis resurfaces in Weiss's attempt to relate the latter to Aristotle's notion of material cause.[32]

This second alternative, however, does not square with Weiss's later account of the *passages,* the *genesis,* and the *demise* of things as evidence of the Dunamis. As Aristotle himself noted, there can be no talk of such changes without distinguishing what is antecedent and consequent not only *to,* but *in* the change. In fact, in later writings, Weiss continues to speak of the distensive causality of the finality of Existence or of voluminosity in contrast to the dynamism of the Dunamis.[33] What, then, is the specific difference between the causal dynamism attributed to the finality and the dynamism that the Dunamis is? The kinship of this internal question with the question regarding the import of the metaphysics of explanation for science is patent. Since Weiss construed the

natural laws uncovered by science to be subordinate to the finality of Existence, the question of whether there is a Dunamis of explanation beyond the "causal processes" demanded in contemporary philosophy of science and the question of the difference between the Dunamis and the dynamic processes specified by science are not identical from Weiss's metaphysical point of view, but they are equivalent.

DANIEL O. DAHLSTROM

SCHOOL OF PHILOSOPHY
THE CATHOLIC UNIVERSITY OF AMERICA
APRIL 1992

NOTES

1. Harold Bloom remarks that critics cannot agree about the poem "because the text is almost impossible to read, that is, the text keeps seeking 'reality' while continually putting into question its own apotheosis of 'reality'." A similar spirit animates *Philosophy in Process,* begun during Weiss's New Haven years. See Harold Bloom, *Wallace Stevens: The Poems of Our Climate* (Ithaca and London: Cornell University Press, 1976), 306.

2. Weiss originally articulated these ultimate conditions in the form of (four) "modes of being" and later as (five) "finalities"; see *Modes of Being* (1958), *Beyond All Appearances* (1974), *First Considerations* (1977), and *Being and Other Realities* (1995). For a precis of the latest published version of these "ultimate conditions," see *Creative Ventures* (1992), 4–6.

3. *Creative Ventures,* 4, 6, 311–25; for Weiss's own account of the genesis of this notion in his thinking, see *Philosophy in Process,* vol. 11, 5–6.

4. Weiss, however, in no way ignores the topic, as evidenced by several entries in volumes 9, 10, and 11 of *Philosophy in Process.* Also, though Weiss in *Creative Ventures,* 149–63 ("The Scientific Enterprise") and elsewhere does not *literally* make explanation the sort of theme that it is for contemporary philosophers of science, there are extensive reflections on abduction as a central part of the process of explanation in *Philosophy in Process,* vol. 10. In addition, many issues that contemporary philosophers associate with the problem of explanation are treated by Weiss under the heading of "causality" before the import of the Dunamis became relatively clear to him.

5. The verificationism of this sort of argument, common in Weiss's writings, is not one of the strengths of his mode of philosophical argumentation. It is no coincidence that sceptics do not figure in his canon of "great philosophers," that there is no acknowledgment in his writings either of differences among forms of scepticism or of any philosophical utility to scepticism, and that his dismissals of scepticism are largely verificationist refutations of straw men. In this connection see the typical remarks about scepticism and Weiss's telling response to Manley Thompson's request in *Philosophy in Process,* vol. 11, 253, 255, and 372. Further critical discussion of the verificationism of Weiss's

argumentation, it should be added, would have to contend with his account of the inseverability of three types of truth, underlying his elaboration of the three philosophical positions presently being discussed; see *Creative Ventures,* 312, n. 4.

6. Given this metaphilosophical precis, it is clear that Weiss, like Hegel, appreciates the necessarily synecdochal character of every attempt to explain things. The truth is a whole that is more than is conveyed by any particular explanation. While rationalists, irrationalists, and contextualists are all inebriated members of the bacchanalian revel that is the truth, Weiss has no intention of tipping the scales in favor of a merely contextualist explanation of things. In this connection it is no coincidence that Weiss gropes for an articulation of the Dunamis through a sustained attempt to show how Hegel's reasons for concluding to the absolute are critically accommodated by the notion of the Dunamis; see his repeated efforts to "get beyond Hegel" in *Philosophy in Process,* vol. 11, 3–4, 24–28, 41–58, 119–22, 156–57, 248–49.

7. *Creative Ventures,* 315–22; as for "the Dunamis of explanation," elaborated in the present essay, see *Creative Ventures,* 322: "There are surely more ways than these by which we can encounter and characterize the Dunamis."

8. This line from Bulwer, it should also be noted, is silently reflexive, thus exemplifying what is often explicit in the latter two obsolete uses of 'explain' (as in another phrase cited by the authors of OED: "a Seed . . . coming to explain itself into a Plant").

9. To my ear, the demand "Explain how it happened!" is ambiguous; context is required to determine whether the details or the cause of what happened are being requested.

10. The three uses of 'explain' elaborated here correspond to the three, nonobsolete definitions of 'explain' in OED, namely, 'unfold or give details of,' 'state the meaning or import of,' and 'make clear the cause, origin, or reason of something.' A fourth sense includes the rest, namely, where 'explain' is followed by a 'that'-clause.

11. Note, however, the difference between 'x explains y to (or for) z' and 'x causes y to (or for) z'. With more context, for example, where 'us' replaces 'z', the substitution would be incompatible with standard usage.

12. The distinction 'nonintensional/intensional' suggests a primacy to the use of 'explain' where a human being is signified by its grammatical subject, but this suggestion, which may betray a modern presumption, is misleading if we attach any significance to the obsolete meanings of the term. In one such former use of the term, as we have seen, a seed was said to 'explain itself into a Plant'. Nevertheless, in contemporary usage, the nonintensional uses of 'explain' seem typically to be invoked only in causal explanations (for example, 'the storm explains the playing conditions') whereas a person alone can be said to explain something, not in the sense of causing it, but in the sense of *giving* a detailed, causal, and/or meaningful explanation of it. Or, as Weiss aptly puts the matter (*Philosophy in Process,* vol. 11, 165), "An explanation is a 'because', which only in special cases is reducible to a 'cause'"; in this connection see also *Toward a Perfected State,* 109.

13. The conjunction of '$(x) - (xEx)$' and '$(x) (y) (z) (xEy . yEz \rightarrow xEz)$' implies '$(x) (y) (xEy \rightarrow - (yEx))$'; for a proof see W.V.O. Quine, *Methods of Logic,* 3rd ed. (New York: Holt, Rinehart and Winston, 1972), 265.

14. David Hume, *An Enquiry Concerning Human Understanding,* 1748[1],

1777² (Oxford: Clarendon Press, 1970), 74–75. My reference is confined to the first of Hume's two definitions of 'cause'. Mackie is to be credited with showing how Hume dogmatically assumes that identification of a causal sequence in contrast to a noncausal sequence ought to justify an a priori inference from the cause to the effect; see J.L. Mackie, *The Cement of the Universe: A Study of Causation* (Oxford: Clarendon, 1974), 12–13.

15. W.C. Kneale, *Probability and Induction* (Oxford: Clarendon, 1949), 70–103; Kneale makes the point that counterfactual conditionals can be derived from laws of nature, but not from contingent, actual universals; see Mackie's revision in "Counterfactuals and Causal Laws" in *Analytical Philosophy*, ed. R.J. Butler (Oxford: Clarendon, 1962), 66–80.

16. Wesley Salmon, *Scientific Explanation and the Causal Structure of the World* (Princeton: Princeton University Press, 1984), 185: "Whatever the basic *nature* of the causal relation itself, when we want to test for the presence of a cause-effect relation we seek *evidence*, not in the form of a constant conjunction, but, rather, in the form of a statistical relevance relationship."

17. For Weiss on constitutive causality, see *Philosophy in Process*, vol. 9, 144; see also Larry Wright, *Teleological Explanation* (Berkeley: University of California Press, 1976).

18. Mackie, 198–99.

19. Mackie, 214–15 (expositing Kneale's viewpoint): "The essential idea is that the things that enter into causal transactions, and hence also the events that are their doings, have insides which we do not and perhaps cannot perceive; the necessary connections hold between these internal features."

20. Mackie, 224: "Qualitative or structural continuity of process, then, may well be something in the objects, over and above complex regularity, which provides some backing for the conditional and especially counterfactual statements that emerge in the analysis of our ordinary causal concept." For Mackie's full argument see chapter 8: "The Necessity of Causes," 193–230.

21. Given the limited aims of the present paper, my discussion is confined to the contrast between what Salmon labels "the inferential version of the epistemic conception" of explanation and his own "ontic conception," a contrast summed up by his remark: "The time has come, it seems to me, to put the 'cause' back into 'because'" (Salmon, 96). His critical accounts of the "information-theoretic and the "erotetic" (van Fraassen's pragmatic) versions of the epistemic conception as well as the "modal conception" of explanation are not considered here. See chapter 1: "Scientific Explanation: Three General Conceptions" and chapter 4: "The Three Conceptions Revisited" in Salmon, 3–23 and 84–134.

22. Salmon, 52–53, 85–88.

23. Appeal must also be made to what Salmon calls *"causal interactions,"* and "conjunctive *common causes";* see Salmon, 178–83. However, in the context of this essay, it suffices to single out his argument for the explanatory necessity of acknowledging causal processes. Distinguishing three ontologies that respectively take physical things, events relatively localized in space and time, or processes having much greater temporal duration to be fundamental, Salmon himself takes the latter as basic entitities. Also, in this connection, though Salmon explicitly urges replacing Mackie's ontology of events with one of processes, I ignore this difference between them in order to underscore how their distinct accounts of causation point in a common direction that resembles the Dunamis; see Salmon, 138–47, but also 155–57. Finally to be noted is Salmon's acknowledgment that

his account of explanation does not apply to explanations in quantum mechanics; see Salmon, 278–79.

24. Salmon, 145.

25. Salmon, 153.

26. Compare Salmon, 155–57 and Mackie, 224–30.

27. David Hume, *A Treatise of Human Nature,* ed. Selby-Bigge (Oxford: Clarendon, 1888) I, Part III, Section XIV, 169: "But if we go any farther, and ascribe a power or necessary connexion to these objects, this is what we can never observe in them. . . ."

28. See Weiss's reference to a "transformative agency" in *Creative Ventures,* 158.

29. See *Philosophy in Process,* vol. 9, 311–12 and especially 424; also *Philosophy in Process,* vol. 10, 159: "The Dunamis makes possible both the coming to be and passing away of actualities, and the vitality of the finalities. With these two, it constitutes a universe, of which the cosmos is a subdivision. This could in principle be understood by science, in abstraction from the kind of intimacy and association that the Dunamis enables actualities to have"; see also *Philosophy in Process,* vol. 11, 277 for Weiss's remarks on seeing "a way of viewing the accepted world of science, and particularly physics, . . ."

30. Weiss's account is even more promising for a general theory of explanation when reflexive and intensional uses of explanation and thereby both the *Geisteswissenschaften* and the study of explanation as scientists' activity are considered. The present paper, however, is concerned solely with the import of Weiss's account of the Dunamis for causal explanation in the nonintensional, irreflexive sense. Worth mentioning in this regard is another possible, though highly speculative advantage to Weiss's elaboration of the Dunamis in connection with the logic of vagueness, namely, that it may provide a framework for unifying the noncausal, scientific explanation of quantum mechanics with the typically causal explanations in the rest of science.

31. *Philosophy in Process,* vol. 10, 43.

32. *Philosophy in Process,* vol. 10, 185–87.

33. *Creative Ventures,* 65: "Distinct actualities, despite their independent natures and activities, are all able to . . . affect one another because they are inseparable from a voluminosity. . . . In the absence of that voluminosity there would be only unit, unextended bodies, unable to be spatially, temporally, or causally connected."

REPLY TO DANIEL O. DAHLSTROM

Daniel O. Dahlstrom is a painstaking scholar, a fine expositor, the master of many different texts. He backs meticulous reading and sympathetic examinations with a sharp, critical mind, focussed on basic issues. He also knows how to read a difficult poem, not a minor accomplishment.

Dahlstrom asks for a "greater clarification of the role of the Dunamis in scientific explanations." I do not see why he limits the issue to scientific explanations, particularly as understood by a few philosophers. The Dunamis plays a part in every explanation, scientific or otherwise, for no less reason than that it is present in every occurrence, sometimes conspicuously, sometimes recessively, but always interinvolved with other ultimates.

Dahlstrom asks for an explanation of 'and' in the claim that reality is made up of actual things and ultimate conditions. I have discussed the nature of 'and' on a number of occasions. Some highlights: it is omnipresent, spelled out in every relation. Conversely, it condenses and abstracts from every one. It is abstractable from the Dunamis, and from any other ultimates. It is also abstractable from every actuality and relation, for these are constituted by all the ultimates, of which the Dunamis is one. Each ultimate grounds and enriches 'and' in a distinctive way.

The Dunamis, as he remarks, joins what otherwise might be separate. So do the other ultimates. What one ultimate does is qualified by and qualifies what the other ultimates do. The Dunamis joins what otherwise would be together only affiliatively, evaluatively, extensionally, coordinatively, or rationally; they join what, from their positions, the Dunamis keeps apart. Although the Dunamis is not 'a third reality', it does play a role in all explanations, as surely as the other ultimates do.

Dahlstrom provides an illuminating account of the nature of explana-

tion. He also says that his main concern is to discuss the Dunamis in causal explanations. A consideration of the other ultimates and other types of explanation might have made more evident to him the distinctive character of what he calls 'causal' explanation, supposed by him to be conspicuous in scientific accounts. Dahlstrom overlooks the large role that descriptions play, not only in geology and botany, but in physics as well, and the fact that the Dunamis must be acknowledged if one is to have a good grasp of ethics, sport, creative work, and philosophical discourse. After he enriched his understanding of causal and other kinds of explanation by recognizing the important role the Dunamis plays in explanations, and having specified what it is in which he is most interested, he then goes off on a tangent to examine a number of views that do not much promote the understanding of his chosen topic. Not having read all the authors he discusses, I accept his account of their views. At last, in section 4, he states his concern to "elicit clarifications" from me. I will try to provide them.

Dahlstrom asks how the Dunamis positively and distinctively functions in specific causal explanations within one or more of the sciences. He wants this to be shown in such a way that the scientific community will not treat the Dunamis as "another commensensical notion . . . harmlessly vague and even eminently useful." That is a poor reason for providing the explanations. What has been maintained should be clarified because it deserves clarification, not because the clarification is needed—is it really?—by the scientific community. Dahlstrom here conflates what philosophers of science maintain and what scientists seek, want, or need. Indeed, he refers only to the former.

A philosophy does not look for its warrant in its ability to help other enterprises. There is no necessity that it attend to the needs of those who occupy themselves with understanding some such central idea as explanation or causation as used in science—or religion, creativity, ethics, education, and so on. Each enterprise has its own distinctive concerns, its own methods, its own ways of proceeding, evidencing, and clarifying. It benefits most from other studies when these are well-carried out on their own terms. There is of course no reason why it may not attend to these others, indicate what is to be clarified, and show how it and they fit within a larger frame. For an account of the nature and activities of the Dunamis to be of most benefit to science or any other enterprise, it needs to be dealt with apart from these. Physicists benefit most from a mathematics carried out without concern for what will prove helpful to them. If a philosophy could help them, it will be one that did what it should, and did it well without regard for the uses to which it might be put.

The masters of particular fields are not always well aware of what they are presupposing, or how their work fits in with that of others. Those who have interrogated great poets and composers have found them not to be good expositors, or to have the best understanding of what they do so well. Their work, like the theoretical work of scientists, does not require them to be clear about what was presupposed, or what would promote a better understanding of what they had achieved within the limits they had set for themselves. Still, Dahlstrom's request is reasonable. A good answer to it might make a contribution to the philosophy of science. I will try to help provide it.

Dahlstrom asks: "What, then is the specific difference between the usual dynamism attributed to the finality [Existence or Voluminosity] and the dynamism that the Dunamis is?" The Dunamis is not only dynamic but potential and powerful as well. In any case, Dahlstrom is apparently asking about the difference between causation and the Dunamis. The Dunamis is an irreducible ultimate, able to be joined to all the others and, like them, is instantiated in whatever finite entities and fields there be. It is present in causation as surely as it is elsewhere, qualifying and qualified by the other ultimates. Some account of it is taken when one refers to 'efficient causes'; it is also present in rules. Formalists take some note of it when they understand a law to control and limit that to which it applies. Teleologists take account of it when they treat a final cause as a lure. It is tacitly acknowledged when mass is expressed in a formula that abstracts the figure associated with the speed of light and subjects this to a mathematical operation. Present everywhere and always, the Dunamis is effective in different degrees in different places and on different occasions just as the other ultimates are.

If one seeks an explanation that is beyond the 'causal process' that is of interest to contemporary philosophers of science, one must move to what they presuppose in their search for an 'explanation'. That will take one back to the factors that jointly yield what one seeks to understand in some domain. Usually, what is sought is an explanation that refers to antecedents rather than to presuppositions pertinent to all actualities and fields.

"Why did the chair break?" The answer, "A fat man sat on it," points to an antecedent cause. "It was poorly made, not really a chair," instead, points to the chair as made up of parts. These answers supplement one another. The Dunamis plays a role in both, since it is present in all causation, and is a constituent of every actuality. It plays less of a constitutive part in a poorly constructed chair than it does in one well-made, but it is never absent from either.

Dahlstrom would prefer, I think, that I deal with a familiar 'scientifi-

cally known' occurrence. Let me, therefore, ask for a scientific explanation of the conversion of hydrogen and oxygen into water. I will be referred to the ways unit bodies in the gases could, in certain specifiable circumstances, combine to produce more complex unit bodies in water. The 'in' here is an odd kind of 'in'. It does not refer to anything in the gases or the water but to units that are neither gaseous nor wet. Reference is made to those units to account for what is constant in the transformation of the gases into water. The gaseousness of the gases and the wetness of the water are ignored. The relation of the beginning and the end is best expressed, not by means of an equals sign, but by using a pair of opposite pointing arrows. Though these, too, are static and so far fail to reproduce a dunamically charged transformation, they alert us to the operative presence of the Dunamis. A formula can do no more than provide a desiccated summary between impotent end points. That will not eliminate the operation of the Dunamis. Although not noted in the formula it is present there, preventing the end points from being detached or from collapsing into one another.

The Dunamis is an integral part of every occurrence and every explanation. So are the other ultimates. What differs from case to case is the difference they make to one another and, thereupon, to the nature of what they jointly constitute. The role of the Dunamis in explanations, scientific or otherwise, is like its role everywhere else; it introduces a singular factor that separates what it joins.

Has the understanding of 'scientific explanation' now been advanced, enhanced, or clarified? Have I provided what Dahlstrom requests? I am not sure. When I reread what he says about the different views of leading philosophers of science, and suppose that he does not want me to attend to what scientists do, or to the formulae in which they express their results, I am left with the supposition that he wants me to attend to the process of causation, and to show whether and how the acknowledgment of the Dunamis adds anything to an account that recognizes causation is not to be reductively identified with a constant conjunction. The answer to the request: causation is a process in which the Dunamis plays a conspicuous part, vitalizing the necessity linking cause and effect, and qualifying these as well. Since it also vitalizes constant conjunctions, its acknowledgment will not, of itself, show that Hume is mistaken. Whether an antecedent and a consequent are adventitiously, steadily, or necessarily joined, the Dunamis is present and effective. It is more to the fore in the first than it is in the other two, and more prominent in the second than it is in the third. It does not add a new meaning, but it does make whatever there be more meaningful. In its absence there would be no causation, but there could conceivably be extensions, even a kind of

causality in the form of necessary connections between what exists at different times. This would be close to what Aristotle called a 'formal cause'. The Dunamis enables one not merely to relate an antecedent and a consequent as though they existed in a purely rational realm, but to enable one to pass from the one to the other.

The causal necessitation that concerned the philosophers whom Dahlstrom (and I) favor, focussed on a necessitation that already had the Dunamis operative in it. It was not a detached way of pointing to what was not yet actual, but an insistent, productive power, taking one from the beginning to the end of ordered ongoings that were confined within particular beginnings and endings. Were nothing more acknowledged than a necessity that connected an antecedent and a consequent, one would be occupied with what was just formal. The Dunamis enables a necessitation to be productive. The result is an entailment that is also a making, productive of what had to be.

A constant conjunction of A and B requires two passages, determined by what neither A nor B provides. Not only must A be conjoined with B, a plurality of such conjunctions must themselves be conjoined. Both require an actual passage from one position to another, made possible by the Dunamis. A is not conjoined with B except so far as there is some agency that operates on both A and B. The operation, coming as it does from a condition to an instantiation of it that in fact begins at A and ends at B, could be supplemented by another instantiation that begins at B and ends at A. The one is like a 'formal', the other like a 'final' effective cause. Different 'efficient' causes relating A and B instantiate the same 'formal' cause. The difference, then, between a 'constant conjunction' and an 'efficient cause' is the difference in outcome that the same 'formal' cause produces when it is just instantiated in passages from A to B, and when it qualifies and is qualified by the A with which it begins and the B at which it ends.

Hume not only abstracted from the fact that he used 'constant conjunction' to replace 'causation' and, therefore, made use of 'causality', but he thought that the 'constancy' of a conjunction warranted an elimination or replacement of a causal connection. To this charge, one might reply that Hume tried to do no more than to show that 'constant conjunction' made a reference to 'causality' unnecessarily or, at the very least, showed that this was all that was needed in order to account for the fact that if one begins with A, one ends at B. Since a formal relation does not show that either the antecedent or the consequent occurs, one would have to provide a premiss affirming that there were constant conjunctions, and thereupon infer that there could be no, there need be no, or

there were no causal connections between constantly conjoined A's and B's.

A valid inference is an act that does not just happen to arrive at a terminus, but is justified in doing so. That justification is not provided by joining a constant conjunction with a formal connection, but by having the conjunction conform to what is formally required. The claim "The constant conjunction of A and B entails that a necessary connection between A and B is suspect, denied, or replaced" needs to be justified apart from any experience, or from any inference it might justify.

If we begin with A and B as constantly conjoined, we cannot deduce that they are or are not related as cause and effect. Whatever we do conclude, though, will be the outcome of an act of inference. That act involves a passage from A to B. If justified the affirmation of B will have been the outcome of a passage to B from A, under the aegis of the necessary connection of A and B. A 'formal' cause connecting A and B is related to the 'efficient' inferential cause of B by A. No constant conjunction of the two kinds of cause will suffice to warrant the latter. Any B that is inferentially arrived at from A must be endorsed by a B that is entailed by an A. That endorsement is assessive, neither causal nor conjunctive. Hume could make his case only by appealing to an assessive power that accepts the B that is constantly conjoined to A to be what a formally justified B would endorse. Were there a B constantly conjoined to an A, it would need to be endorsed by a B that was necessitated by A. Could Hume show that any items were conjoined, were constantly conjoined, or were able to make one believe they were causally related?

There are constant conjunctions, but they depend on the operative presence of a conjoiner. There are legitimate warrants for holding that some conjunctions are justified instantiations of necessary connections, and some are not. If A and B are causally connected, they will be conjoined, but we cannot infer from the fact that they are conjoined that they are causally connected. Both causal and the conjunctive connections involve passages from A to B, the one requiring a primary use of the Rational, the other a primary use of the Dunamis. If no use is made of these ultimates, there would be no argument that Hume could provide, even one as weak as that which allowed for a replacement of a justifiable constant conjunction by a number that just happened to occur. Justifications presuppose ultimates. So do rejections of such justifications.

Hume never asked himself how a conjunction is possible, when it can be legitimately said to be 'constant', or why, or how it occurs. He did not see that there were just adventitious conjunctions, and others that were warranted by what is as rationally necessitated. He did not ask how the rationally necessitated and a presumably adventitious conjunction were

related, or how they could have the status of unities if there was nothing that had the power to connect them. The ultimates are operative in formal connections, experienced conjunctions, and in the relations between these. Nothing is gained by supposing that what is non-empirical needs nothing more than a filling.

Nothing is gained when, trying to explain how one gets from A to B, we ignore what connects them. The idea of a constant conjunction itself depends on suppositions with which it is, at best, only constantly conjoined. It cannot show that it does or must lead to the entertainment of the idea of a necessary connection. Both the idea of a constant conjunction and what is supposedly prompts one to suppose there is one, rest on the unexamined subordination, of them and their supposed effect, to controlling powers that connect them in necessary or contingent ways.

P.W.

4

Paul G. Kuntz

COSMOS AND CHAOS: WEISS'S SYSTEMATIC CATEGORIZATION OF THE UNIVERSE

P aul Weiss, in his first book *Reality,* asked what is "one immovable fulcral fact about which the whole can turn and to which one can resort for test and inspiration?"[1] From my reading of Weiss, I believe his answer is that order comes from disorder, or "cosmos" from "chaos." And, is this not the best possible answer?[2] Weiss may well demur from my use of terms from ancient myths of cosmogony for his metaphysical cosmology, but philosophers inherited from poets a language of deep significance.[3] An ordered whole, such as celebrated in Genesis as the work of a Creator, remains as eminent an inspiration as any poet or philosopher could require. That the universe is cosmos, an ordered and intelligible whole, combines many metaphors, and leads to the important belief that man continues the creativity of creation.[4]

Paul Weiss set out to bring into the language of common sense the basic contributions of both religion and science (R, 6–7) and his works subsequent to *Reality* have also dealt with the arts; education, history; moral, social, and political life; the world of sport. In all this diversity I find a center: that "one immovable fulcral fact about which the whole can turn and to which one can resort for test and inspiration" (R, 6). I believe that the answer to the root of all metaphysics is that order comes from disorder, creation, and in Weiss's dialectic there is also its opposite, disorder from order, destruction. Weiss is a dialectical philosopher who is constantly pointing out categoreal oppositions. Although some think of Hegel, I prefer to think of Pythagoras because Weiss also states ten oppositions of "a robust,

 (1) spatial and temporal world,
 (2) [one and] multiple,
 (3) animate and inanimate,

(4) organic and inorganic,
(5) isolated and related,
(6) persistent and changing,
(7) striving and quiescent,
(8) dominating and dominated,
(9) a world where men know and err, believe and feel,
(10) act and speculate" (R, 5–6).

Critics have chosen to interpret the technical details of Weiss's systems. These are admirable but they must not be divorced from Weiss's central rational faith, that we live in an interrelated whole that is intelligible.[5]

The reader may well reject my claim for the centrality of the belief in cosmos. The two chapters "cosmos" occur only in 1974 as chapter 14 of *Beyond All Appearances,* and in *First Considerations,* 1977 (173–82). Not always do absolute presuppositions come first in the order of composition. The rational faith in cosmos was always there, as in *Reality* (170–71). Then there are the dozen rich volumes of *Philosophy in Process* each of which deals with "cosmos" and altogether they add important modifications and applications of the "fulcral fact." It is from the whole development of Weiss's thought that the importance of cosmos emerges.[6]

But first to clear away a possible prejudice against faith in the intelligibility of the universe, we must consider "Some Paradoxes Relating to Order." This was a lecture in a series on order, at my invitation, and I was happy to publish it in *The Concept of Order* because, of all the essays, it took most seriously facts of disorder.[7] Richard Rorty in *Philosophy and the Mirror of Nature,* 1979, attacked the prejudice that there is a perfectly orderly cosmos and that our minds can mirror it perfectly. Were Weiss a naive rather than a very critical realist, there might have been some vulnerability.[8]

By choosing a title "Cosmos and Chaos" I have made Paul Weiss suspicious that I might suggest that he holds a basic faith expressed in *Genesis,* with the primordial initial stage of "tohu va bohu." Weiss explicitly rejects the biblical beliefs that it took God to "impose [order] on the world" and that the world, beginning with no order at all, could not have developed by chance. Weiss begins with the Peircian truth of statistical probability, that the more random the throws of heads and tails, the more equal the distribution. Disorder, in a paradoxical summary dear to Paul Weiss, is a form of order. Although no particular sequence is necessary, what is necessary is that any sequence must have some order; a very minimal kind, no doubt. Yet there is a beginning certainty that "An order of some kind seems to be inescapable . . . *though any*

given order seems to be contingent, some order is inescapable" (SPRTO, 14–15, italics added).

The next certainty, stated in various ways, is that "If there is . . . an order, there must be something which is ordered." This is important because when Weiss talks about the cosmos, he talks of "structure." This is "a genuine order, [which] requires something which it is to structure: otherwise it would collapse into a mere idea." I have elsewhere called this "order-realism." And this calls attention to the polar opposition of order to disorder, for in this polar opposition there must, if "order [is] meaningful . . . be some thing which, relative to the order in question, is disorderly" (SPRTO, 15). Since there are various types of order, there then can be no order that is not relatively disorderly, or as Weiss puts this certainty, "no order which excludes all disorder." (SPRTO, 15)

Although we need order in all thought and life, unlimited order is not good, and what is needed also is "spontaneity, rebellion, novelty, creativity" (SPRTO, 15). This pertains to the desired result of coherent philosophizing, a system in which the parts are encompassed and subordinated to the whole. Although it is desirable to control the parts, yet it is not absolutely desirable, for individual freedom is also good.

It is obvious also that not all orders are discovered, as we find the dimensions of our spatio-temporal-causal world. We impose order upon things but this is, according to Weiss, "to select one of the many orders that were there originally . . ." (SPRTO, 18). This is an interesting Weissian derivation from the ancient idea of the boundless, "the original conglomeration of orders" (SPRTO, 18). One of Weiss's best gems of philosophic wit is that "chaos is too many orders."

Among imposed orders are those that are "prescriptive orders," which leads him to the artist creating "new ways of looking at what already exists" (SPRTO, 18–19).

It is not only the arts that deal with ordering: the sciences search for "laws which dominate the spatio-temporal world, and which therefore dominate the spatio-temporal world. . . ." In this process of making sense of the world we use mathematical formulas. Although "alternative types of geometry" are invented, the application of these is not arbitrary, but "the best possible rational account of what is in fact occurring in the world" (SPRTO, 19).

In one kind of "prescriptive order," the theistic, we conceive of "all things in their ultimate meaning" as the world judged by "the omniscient absolute judge." "God" has the moral import of an "order of evaluation," according to "a final eternal standard of value" (SPRTO, 19–20).

Just as legitimate as this theistic ordering is the humanistic order of

existentialism. One perspective among others is that of a human anxious about his own death. That is no problem for the mathematical ordering, or even for the biological ordering of events.

This position defends as far as possible the real order of things, but allows for what Spinoza contrasted to the cosmos, our order of ideas. But there is no one absolute order, and therefore the position is an order-pluralism. The concluding statement gives the gist of what *Modes of Being* is about:[9]

> From different perspectives, different things stand out in prominence and other things fall away. One perspective need not be better than another. All are equally basic and are equally significant for different objectives. Each subordinates the others from its own position. Each is ultimate and has a value that the others do not have, and each gains by being subordinated to the others. They are all equal in ultimacy, but they do different things. Depending upon where one starts, one has a distinct way of ordering the entities comprising the world.
>
> But, if there is no best or right way of ordering, how are we going to have all of them at once, together? To get beyond all of them, or to speak of all of them, we must somehow stand away from them all. Does that mean that there is a higher order? I do not think so. To look at all basic ways of ordering things we must stand in one of these ways and talk in a very abstract way of it and the rest. (SPRTO, 20)

The bare statement of Weiss's philosophy of order may seem only too obvious, but axiomatic and definitional statements are logically stated before postulates of application to the world in which we find ourselves.

Paul Weiss was a logician, and in understanding what he means by cosmos, the basis of this systematic categorization, we must first recognize that his expertise was needed by Hartshorne in the editing of the manuscripts of Peirce.[10] The best way I have found to show what more there is in Metaphysics than relations considered logically is to construct the two essays on cosmos from *Beyond All Appearances,* 1974, and from *First Considerations,* 1977, as dealing with the *whats* that are related, the *hows* which relate these whats, and to specify the *whys* of the different modes of ordering. This is not to present any one of Weiss's categoreal systems, but a way of basing any set of categories on cosmos. I found the formula *what, how, why* necessary in simplifying the system of forty-five categories in *Process and Reality,* and since Weiss in *Reality* more than doubles that number, this simplification seems to me even more needed.[11] That Pythagoras hit on ten categories, which must have influenced Aristotle's, may tell us about our limited grasp: to keep ninety in mind is an extraordinary demand. Yet if the cosmos demands this for its comprehension, who are we to make excuses?

WHATS

What kinds of things are there? Among actualities Weiss mentions "an actual man is a unit" and another sort of actuality is a stone. Both are in "contexts provided by finalities, in the cosmos, units and relations are joined together in active interplay" (BAP, 293). This is the closest textual justification for my formula, What, How, Why.

The most important aspect of the context of men and stones and so forth is that there are possibilities and necessities. Another way of saying this about the cosmos is that the cosmos is "law-abiding." That is, there are some possible acts of actualities that are within the range of lawfulness or regularity, and other acts that are impossible. "Possibility lifts up those natures into the realm where necessity holds sway. Possibility turns the natures [of actualities] into terms for itself, and in turn enables possibility to be articulated" (BAP, 299–300).

> A cosmos is constituted of actualities, linked through the medium of their natures, is also a rational totality. . . . [When the actualities fit] the qualifications to which Possibility subjects them, they are intelligible units in an intelligible cosmos. (BAP, 300)

Since "laws of nature are logical and mathematical relations specialized and pertinent to the actualities that are being related" actualities can be regarded as "ontological intelligibles" which are "incarnations of logical and mathematical formulae" (FC, 176).

The most important aspect of existence is that there are dimensions of "time, space, and dynamics . . ." (FC, 177). Is this all there is in the cosmos: actualities, possibilities, necessities, laws based on mathematical and logical formulas, existence extended spatially, temporally, dynamically? These are all included under "Being" which undetermined, lacking the specifiable features of kinds of being, resembles nothing (BAP, 297).

> The idea of Being is the richest of all ideas, expressing what is present everywhere. It is also the emptiest of ideas, lacking as it does all internal differentiation. The identification of Being with nothing simply repeats the fact that Being lacks the determinate features which characterize other realities. But since Being abides, acts, is acted on, and has an individuality inseparable from its universality, it is forever what is not nothing. (BAP, 294)

One characteristic of man among the actualities is inwardness and the ability to make internal all qualifications of Being. Every kind of being internalizes something, and only man among actualities can internalize everything (BAP, 292).

But what then is Inwardness itself? This is God.

The final Inwardness can be called divine, for God . . . is a reality all internal, without surface, present everywhere, imposing qualifications on all actualities, and, with them, constituting appearances. But though they have common traits, God and the Inwardness are distinct finalities, God is a final Unity to which every unity belongs; the inwardness is a final Substance which maintains itself in opposition to every individual substance. (BAP, 296–97)

HOWS

How are things connected? Since the whats of the cosmos are all together, we could not encounter them, though we might talk about them unrelated to each other. Because the cosmos is units together, how different whats are related we have already had to include as many sorts of relations. Had we begun with relations, we would have had to deal with the kinds of things related, unless we had limited ourselves to relations as bare unspecified R, S, T, as do the purest of logician-mathematicians. Order can be so considered, but cosmos cannot. That is why we chose to discuss order before cosmos. Even when Weiss discussed randomness, which might be specified as a set of x's and y's, Weiss chose to talk of heads and tails of a coin, tossed to fall on one side or on the other.

The logic of relations gives us such sharply defined differences as between symmetrical, where ArB implies BrA, and asymmetrical, where ArB implies not BrA. By contrast "The Cosmos" begins with the least well defined relation, "actualities *make a difference* to finalities" (BAP, 292). Another first sentence with a similar vague relation is: "a collection is an area where the parts of one compound *may be together* with the parts of another" (FC, 173).

Weiss continues to be a logician in his cosmology: he has a sharp eye for symmetrical relations: among these are relations between actualities and between finalities: they "directly affect one another" (BAP, 293). But the opposite is also true of actualities: they "act independently" (BAP, 292, 249). Finalities "function together" (BAP, 293). Actualities limit one another and interact with one another (BAP, 297–98).

Asymmetries are no less important. One of the asymmetrical relations is that of actualities which are subject to laws. In support of the corresponding asymmetry in the human microcosm, no one person can dominate others, and therefore human society analogously must be subject to law. Otherwise no social order.

Existence, as the field of spatial, temporal, and causal relations, has symmetries such as present in the same space, or contemporaneous with

another in time, or cooperating together in the dynamic order. But the dimensions of space and time and dynamics are asymmetrical. Weiss is particularly interesting in analyzing the cosmos as the field of Dunamis:

> Every actuality is extended. It spreads out spatially, with a distinctive contour. It stretches out temporally, with a rhythm and a duration of its own. And it has effects as well as causes. Each of its extensions has a limited span; there are empty stretches beyond it as well as stretches which are ingredient in other actualities.
>
> The extension of an actuality is its own, giving it a distinctive place, geometry, and power. But it is also subject to Existence. As a consequence, the extensions of an actuality are distinguished from and made continuous with stretches connecting it with the stretches in other actualities.
>
> Cosmic extensions are universals in that they permit an endless number of delimitations. Each portion of space is spatial; each portion of time is temporal; each portion of a causal process is causal. But there is in fact no smaller subdivision than that constituted by some process or actuality. Apart from these, space, time, and causality, though endlessly divisible in thought, and imagined to have beginnings and endings, have neither unity nor limits. It is no less true that cosmic extensions are unique, having no duplicates. They remain undivided even when they are occupied and therefore subdivided by actualities. The whole of space is indivisible; the subdivisions of it are demarcated, not divided off from it into islands of their own. The whole of time abides; only filled moments of it pass away. The whole of causality stretches backward and forward without end; actualities and their activities merely have an occasional footing in it.
>
> By itself, Existence is uniform, monotonous, undifferentiated; the self-extended actualities that occupy it variegate and divide it. Actualities enable Existence to extend over and not merely be extended, to have distinguishable stretches and not to be simply indivisible. By itself an actuality's extensions are idiosyncratic, and do not necessarily cohere with the extensions characteristic of other actualities. Actualities need an encompassing extensionality, if they are to be extended together. They are independent, internally distended realities in their own right, which, by interplaying with Existence, attain the status of extended units in an extensional cosmos, whose occupants punctuate single extensions. Existence is benefitted by the actualities, since these provide it with diversitifications. Because the actualities give it so many different locations, Existence is multiply located. (BAP, 300–1)

In his first "cosmos" essay Weiss presents existence as spatially-temporally-causally together. In the second "cosmos" essay he considers how "time, space, and dynamics function independently of one another. It is conceivable . . . that one of them might be present and the others absent" (FC, 177). Although spatial relations and temporal relations can be analyzed separately, when it comes to causal relations "causality occurs in time and involves spatial objects . . ." (FC, 178–79).

In contrast to the asymmetries of existence (as well as its symmetries), Being is characterized by reciprocal relations: "since Being abides, *acts,*

is acted on, and has individuality inseparable from its universality, it is forever what is not nothing" (BAP, 297, emphasis added to stress the combination of Aristotle's ninth and tenth categories, in the commonly cited list, perhaps a tie between Aristotle's predicaments and Pythagorean opposites).

Among the most omnipresent of reciprocal relations is that between part and whole. As we shall see shortly, the cosmos itself is both one and many, and each opposite in a reciprocal relation requires the other. The basic category mistake is then to consider only one pole of an oppositional pair without the other, such as one without many or many without one.

The errors of opposite extremes to be avoided are those of monism and atomism. The monist so exaggerates the relations of identity, that all difference is denied. The atomist so exaggerates the difference between units that all similarity, especially sameness, is denied (FC, 174). Against monism there is the real independence of parts, against atomism is the real togetherness of the whole.

WHYS

To what end are things ordered? It is in considering the place of man the microcosm in the natural cosmos that Weiss brings into focus certain whys. Because man is purposive, he responds to ends. Man seeks finalities. Men cooperate together to seek the truth and to realize the good.

In a cosmos with certain ultimates, Being, Possibility, Existence, and Unity, "only man is able to internalize them all; physical things can internalize only the Inwardness; plants, internalize Possibility as well; the lower living beings also internalize Being, the higher living beings an internalization of Existence" (BAP, 292). What exactly is it to "internalize" a mode of being? What makes some things "lower"? It is being "physical" only? What makes some things "higher"? It is being "living" rather than nonliving? There is implicit in Weiss a kind of chain of beings, and this is a major assumption about the cosmos. A most important aspect is that man is unique and occupies, because of his ability to internalize all modes of being so high a place that we require some clarification of what there is above him.

The chapter "Cosmos" (*Beyond All Appearances,* chap. 14) can be read as a sketch of man's dignity. What is man that man is mindful of himself? Not that the Lord has placed him a little lower than the angels, but that man exceeds all the animals in having a mind, which Weiss

expresses as being a privacy. And although it is doubtful whether other animals come to a degree closer to the human, it is human to extend the idea of privacy to them (BAP, 295).

Among the characteristics stressed as essentially human is responsibility. Here is a contrasting summary: "Animals seem to have no power of reflection; they assume no responsibility; they do not criticize themselves; they do not discipline themselves; they do not have secrets (BAP, 295)." This is the clearest statement of a sharp step up from animal to human (or a sharp step down from human to animal), yet there is also "the continuity of the organized world. . . ." Weiss is to be counted among the hierarchical philosophers, even if, as he says, all actualities are on the same level.

With both degrees and continuity, the rungs and rails of the ladder, man's position at the top of the ladder of physical and animal existence, enables him to aspire to a higher state of being. Although Weiss says that all the modes are on the same level, it is man who aspires and can move upward. "Only men set out on a quest of finalities" (BAP, 303). In Platonic terms, the human can participate in finalities, and apparently all can "begin a movement into those finalities."

Weiss's expressions are sometimes Plotinian and Kabbalistic, and as with all mystics, we can only begin to comprehend in the metaphors what are the secrets of the sublime.

> A man becomes alert to the unity of an actuality by accepting it, thereby producing a single unity of himself and the object as lucidatively entrenching on the Unity that is beyond them both. This is not possible except so far as he has moved away from himself, as part of the world, into himself as also qualified by the Unity. By adding his own reverential attitude to the object's unity, he is able to move forward to Unity in a process of intensification controlled by the reality at which he is to arrive. Nothing that a man can do, of course, will increase or decrease the unity of an actuality; this is an affair solely between the actuality and the final Unity. The actuality accepts the Unity at the same time that this finality holds on to the actuality through a qualification of it. (BAP, 302)

Just as appropriate as choosing Unity or the One as a finality in which man can participate, is to contrast his philosophy to that of Kant. Is Weiss rebuking Kant for mocking Swedenborg? In a subtle dialectic, Weiss seems to say that Kant himself assumes transcendence, but only with regard to actualities, and misses the transcendence with regard to the finalities.

> Transcendence takes us in the direction either of actualities, or of one of the five finalities. It can be brought to a halt sooner than it need be, which is what

Kant does when he stops with a manifold and conditions. It then yields nothing more than factors for experience, to be tightened so as to constitute it, or a pair of contrastive, abstract, empty factors which can never be unified. Kant does not show that transcendence is impossible or futile or foolish, subjective, or avoidable. It would be one of these if its moves did not start with what occurs in fact, if it did not have degrees, if realities did not put in an appearance, and if there were no symbolic penetrations which begin at the finalities and evidence thicker versions of themselves. Because transcendence is possible, we are able to use appearances, and are able to see how there can be a cosmos. (BAP, 304)

The world of logic is a world of $x, y, z,$ unspecified, with relation R that is defined to be asymmetrical or symmetrical, intransitive or transitive, unconnected or connected. Clearly this is a very "thin" world, and Weiss was dissatisfied with it because of its unreality. Weiss was logician enough to know the limits of logic, and to turn to concrete terms with "thicker" relations, and it is worth noting that spatial and temporal relations do not satisfy that quest. A reduction of the causal relation to proximity and succession misses dynamism. Weiss's ontology must have in it all the sorts of real things there are and his systems aim to capture the full dynamism of processes. Weiss is metaphysician enough to know the limits of systems.

Weiss is a logician who knows the limits of logic, and a metaphysician who knows the limits of systems. This covers his studies of the hows of relations, and the whats of real entities. In his studies of whys, Weiss stresses the purposes of man, including the striving for perfection, completion, ultimate realization, and achievement of union. In this aspect he is a "mystic." Probably Weiss never so characterized himself in exactly this term, but how else can we describe the movement of man "in quest of finalities," and an ontology of degrees and continuity, with the attainment beyond appearances, of transcendent unity? Yet, once again, Weiss knows the limits of mysticism. Unity does not wipe out all distinctions, and the appeal then is to critical common sense.[12]

My study of hows, whats, and whys in his account of cosmos calls attention to the many-sidedness of Weiss's metaphysics. It is the product of the thinking of a logician, a metaphysician, and a mystic, albeit of a very intellectual sort. This is not an adequate characterization, for beyond this limit Weiss is an educator, an artist, a social prophet. When he discovers a realm of human activity ignored by philosophers, such as sport, Weiss plunges in to participate and to provide a systematic interpretation.[13]

The most unique philosophic contribution of Paul Weiss is *Philosophy in Process*.[14] It is most valuable in showing how a great metaphysician works. The dozen volumes come from more than thirty years of reflective struggle to grasp the cosmos, and as might be suspected, no system proves adequate. The "quest for finalities" which Weiss used, as we saw, in characterizing human nature, is as unended as the infinite itself. But why read the rough version of what is pruned and polished into essays and edited in books? Because, as I have found out in several cases, sometimes the more daring aspects are not carried over into safer more conventional forms. Just as in imaginative literature we can study the first-hand experience, such as the Diaries of Anais Nin, out of which the novelist refines her stories, so with the metaphysician Weiss.[15]

Even when we have finished the essays "Cosmos," from which the above account is drawn, there are many other problems and attempted solutions. These inner dialogues give authenticity and vividness to the rather dense compacted passages that spring from concentrated thought.

Among the interesting additional points about the cosmos, we learn from *Philosophy in Process* that cosmos is both the beginning point of philosophizing and its end. We could add the metaphor that cosmos is Alpha and Omega of philosophizing.

The question is put: "How do we begin a philosophic study" (PIP 6, 602)? The answer comes: "We must begin with an experience of the cosmos" (PIP 6, 603). What Weiss is rejecting is the attempt, because "there seem to be no rules [for] the movement," to require logic or analysis. The difficulty is that logic itself does not prescribe how to move beyond it. The solution is that we already "face . . . the entire truth as to the end to be reached. . . ." Because the cosmos may be studied in "some limited portion" there are also "many subordinate beginnings which have to do with special types of outcomes such as knowledge of finalities, or substances, or phenomena" (PIP 6, 602).

"To be in the cosmos" is the point of philosophic awakening. We then know from the beginning that what we want is "the whole truth of being."

With the aim of attaining "the whole truth of being" we can well understand why in addition to a succession of systems, Weiss has poured much of his reflection on methods and results into the yet unfinished *Philosophy in Process*. One result is "A comprehensive diagram [which] would be something like this:"

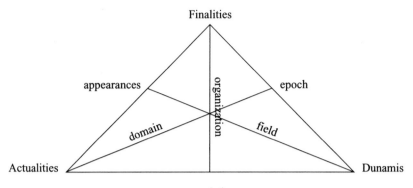

What is so very good about this suggestive diagram of what can't be mirrored, is that in *Actualities* it states the primary *whats* of the cosmos, in *Dunamis* it states the principles of the *hows,* and in *Finalities* it accounts for the *whys.* It then covers, as outlined above, the basic categoreal questions.

With these three points, the triangular pattern combines a broad horizontal base including Actualities and Dunamis, in which there is signified the equality of existence. But the triangle includes a vertical between "association" and Finalities that signifies degrees of value.

The pattern is not limited to two dimensions, vertical and horizontal, but has two diagonal sides, between Actualities and Finalities, and Dunamis and Finalities, and two more between Actualities and the midpoint of the opposing side, and Dunamis and the midpoint of its opposing side. The diagram is a bare minimum of relations, and nothing excludes other diagonals, including the interrelations between appearances, epoch, and association.

The lines are tensions between opposites, and the difference of angular inclination suggests to us that we need to distinguish different sorts of opposition. By including lines in a triangle we avoid thinking only of two poles, a limitation of such a polar model used by Emerson in "Compensation" as positive and negative of electricity or yea and nay in the language of answers.

What Weiss's cosmic interrelations allow him to express is that Actualities, "singular privacies and bodies in a world, are produced out of the Dunamis with the help of final Conditions" (PIP 6, 602). There are dynamic interrelations, as in his model "the cosmos is as a family" in which we must include three or more terms.[16]

These six points are my interpretation of Weiss's diagram, and may be mistaken reasons for using this as a kind of Omega of his reflection on the cosmos. His own exposition is full of apologies for the inadequacies of the terminology. An adequate account would require definitions of the nine abstract nouns and the six lines connecting them.

Weiss's own exposition is striking because of the interconnections that signify "interplay," "interaction," "conversion," "energizing," "intermixing," "converting," "constituting," much as we had been told of a family with "intertwined" relations (PIP 6, 162–63).

Does the triangular diagram also illustrate the recognition of opposites, the extremes horizontally and vertically, both of which are to be embraced in an adequate philosophy? Does the peak of finalities illustrate the finding of unity, on a higher level, of a midpoint between extremes of Actualities and Dunamis on the highest level? Is this a version of Hegel's reconciliation of opposites and sublimation?

We are told in the same volume in which Weiss devised his triangular diagram of the cosmos that it is characterized logically as a "conjoint disjunct." The Finalities of the cosmos are "conjoint disjuncts" (PIP 10, 132) and "all of these are in a conjoint disjunct" (PIP 10, 365–69). Are the end points of a line illustrative of disjunction while the line between them is the conjunction? In addition to recognizing the Finalities as "conjoint disjuncts," are the agencies of Dunamis and the "Actualities also conjoint disjuncts?" Perhaps then the three corners of the great cosmic triangle are themselves three triangles.

It is rash to draw conclusions about philosophy presented in a *Philosophy in Process*. If the earlier volumes present problems and methods, it is volume 10 that reaches exciting results. It is safer to raise questions about what is still to be concluded, especially since beyond the dozen volumes, volumes 12 and 13 are ready to be published. Yet even what is available has not been studied critically. I should have been happy to have found essays on Weiss's theory of the cosmos.

What can we now say about Weiss's systematic categorization of the cosmos? If the cosmos is an interrelated dynamic whole, the categories cannot be as Aristotle's a list of predicates of substance or as Kant's groups of intelligible forms of understanding. Weiss's succession of systems resembles the work of Peirce, but happily is not dominated by any *idée fixe* that all categories must be forced into the mould of firstness, secondness, and thirdness.[17] Weiss began his work on categories with a first book rather than leaving it, as did Whitehead, a sketch in *Process and Reality*, too late to refine in application and defend against alternative systems. Weiss's "comprehensive diagram" may come to be recognized

as a use of the relational concepts that succeeds where Peirce and Whitehead failed.

Cosmos was said to be both the beginning point of philosophizing and its end. But what was this beginning point? Was it like the confrontation with the mountains and rivers conveyed by Wordsworth that meant so much to Whitehead? Was it the intimation of a lawful creation which inspired Newton and Kant and filled them with awe? Was it something like Moses hearing a command from a burning bush or Isaiah awed by a vision in the temple? Weiss has told us that as a young man he was drawn to Spinoza. There must be other and earlier sources of inspiration to have motivated and sustained such a major career.

What of the case for a central belief in cosmos? The attack on such conviction by Rorty seems feeble compared with the strength of Weiss's elaboration and application. "Cosmos" is now the title of a most successful presentation of the world uncovered by science.[18] The name of "chaos" has been most prominent in the research of the past decade, and on Paul Weiss's shelves is the best selling volume of James Gleik, *Chaos.*[19] In all areas there are phenomena that do not conform to commonly accepted laws. Had a scientist followed Rorty, he would have abandoned physics. The best collateral evidence that Weiss has been right, and Rorty wrong, is that when there are exceptions to previously believed laws, this is the opportunity to reveal unsuspected forms of intelligibility. The ample evidence is a volume from the American Academy for the Advancement of Science.[20] *The Ubiquity of Chaos* could just as well or better be titled, *The Ubiquity of Order.*

PAUL G. KUNTZ

DEPARTMENT OF PHILOSOPHY
EMORY UNIVERSITY
OCTOBER 1992

NOTES

1. Paul Weiss, *Reality* (Princeton: Princeton University Press, 1938; reprinted, New York: Peter Smith, 1949). Abbreviated in text "R."

2. Paul G. Kuntz, "Voegelin's Experiences of Disorder Out of Order and Vision of Order Out of Disorder: A Philosophic Meditation on His Theory of Order-Disorder," in *Eric Voegelin's Significance for the Modern Mind,* ed. Ellis Sandoz (Baton Rouge, La.: Louisiana State University Press, 1991), pp. 111–73.

Paul G. Kuntz, "Charles Hartshorne's Theory of Order and Disorder," in *The Philosophy of Charles Hartshorne,* ed. Lewis Edwin Hahn, Library of Living Philosophers, vol. XX (La Salle, Ill.: Open Court, 1991), pp. 415–30.

3. Werner Jaeger, "Philosophical Speculation: The Discovery of the World Order," *Paideia: The Ideals of Greek Culture* (Oxford: Basil Blackwell, Book One, 1939), pp. 148–83. Gilbert Highet translated from *Paideia: Die Formung des griechischen Menschen*, I.B.D., 2te Aufl. (Berlin: W. de Gruyter & Co., 1936–1947).

On the changing meanings of *Kosmos* from the *eukosmia* of good behavior of Solon's citizen to the discipline of the good soul in Plato's *Gorgias*, see Jaeger, *Paideia*, vol. II (New York: Oxford University Press, 1943), p. 146. The recent literature includes Gregory Vlastos, "The Greeks Discover the Cosmos," *Plato's Universe* (Seattle: University of Washington Press), pp. 3–22; Norman J. Girardot, "Chaos," *The Encyclopedia of Religion*, vol. 3, ed. Mircea Eliade et al. (Chicago: University of Chicago Press, 1987), pp. 213–18. *Cosmogony and Ethical Order*, ed. Robin W. Lovin and Frank E. Reynolds (Chicago: University of Chicago Press, 1985); Stephen Toulmin, *The Return to Cosmology: Post Modern Science and the Theology of Nature* (Berkeley: University of California Press, 1982).

4. Stephen C. Pepper, *World Hypotheses: A Study in Evidence* (Berkeley: University of California Press, 1942).

Stephen C. Pepper, *The Basis of Criticism in the Arts* (Cambridge: Harvard University Press, 1946).

5. Paul Weiss, *Creative Ventures* (Carbondale, Ill.: Southern Illinois University Press, 1991).

6. Paul Weiss, *Beyond All Appearances* (Carbondale, Ill.: Southern Illinois University Press, 1974), abbreviated in text "BAP," *First Considerations* (Carbondale, Ill.: Southern Illinois University Press, 1977), abbreviated in text "FC."

7. Paul Weiss, "Some Paradoxes Relating to Order," *The Concept of Order* in Paul G. Kuntz, ed. (Seattle: University of Washington Press, 1968), 14–20 abbreviated in text, "SPRTO."

8. Paul Weiss, ever anxious for his work to be challenged, to test its validity, secured from Richard Rorty a brief letter, little more than one page, "Questions of Philosophical Style," in *First Considerations*, op. cit., 206–7. Weiss's reply is considerably longer, since his former student had turned to Heidegger, Quine, Wittgenstein, and Derrida, whose methods are called "dissolving." Weiss calls his own approach "constructive," 208–11. Richard Rorty's *Philosophy and the Mirror of Nature* (Princeton: Princeton University Press), appeared two years later, 1979.

9. Paul Weiss, *Modes of Being*, 2 vols. (Carbondale, Ill.: Southern Illinois University Press, 1958).

10. Paul Weiss's doctoral dissertation was "Logic and System," Harvard University, 1929, and was published in *The Monist* as "The Nature of Systems," 4, 73 (1930), also "The Metaphysics of Logic of Classes," January (1932), 112–54.

11. Paul G. Kuntz, *Alfred North Whitehead* (Boston: G.K. Hall, 1984), chap. 4, and Marion L. Kuntz and Paul G. Kuntz, "Naming the Categories: Back to Aristotle by Way of Whitehead," *Journal of Speculative Philosophy* 2 (1988): 30–47.

12. Paul Weiss, "The God of Religion, Theology, and Mysticism," *Logos*, vol. 1, 1980, pp. 65–77. In his first paragraph Weiss distinguishes the "mystic" from the metaphysician in that the latter has an "unemotionally metaphysically known final Unity." When I call Weiss a metaphysical mystic, I mean so only in the latter sense.

13. Paul Weiss, *Sport: A Philosophic Inquiry* (Carbondale, Ill.: Southern Illinois University Press, 1969).

14. Paul Weiss, *Philosophy in Process* (Carbondale, Ill.: Southern Illinois University Press), vol. 1–7, 1966–78; vol. 7, pt. 2–11 (Albany, N.Y.: State University of New York Press, 1985–1989), Abbreviated "PIP."

15. PIP 10, pp. 162 ff.

16. On the Cosmos as a family see PIP 2, p. 626; PIP 5, p. 762.

17. Paul G. Kuntz, "Doing Something for the Categories: Peirce's Cable of Methods and the Resulting Tree of Categories," in *From Time and Change to Consciousness: Studies in the Metaphysics of Charles Pierce,* ed. Edward C. Moore and Richard S. Robin (Oxford and Providence, R.I.: Berg Publishers, 1994), 177–98.

18. Carl Sagan, *Cosmos,* a TV program now available as a book. Sagan ties the development of science to the philosophic revolution of ancient Greece that

> made Cosmos out of Chaos. The early Greeks had believed that the first being was Chaos, corresponding to the phrase in Genesis in the same context, "without form." Chaos created and then mated with a goddess called Night, and their offspring eventually produced all the gods and men. A universe created from Chaos was in perfect keeping with the Greek belief in an unpredictable Nature run by capricious gods. But in the sixth century B.C., in Ionia, a new concept developed, one of the great ideas of the human species. The universe is knowable, the ancient Ionians argued, because it exhibits an internal order: there are regularities in Nature that permit its secrets to be uncovered. Nature is not entirely unpredictable; there are rules even she must obey. This ordered and admirable character of the universe was called Cosmos.

Carl Sagan, *Cosmos* (New York: Random House, 1980), p. 175. Scientists themselves commonly call the prior state of disorder "soup," as does Robert Jastrow: "In the course of 3 billion years, life on earth evolved from a soup of organic molecules to the carnival of animals that now plays across the face of the planet." Robert Jastrow, *Red Giants and White Dwarfs* (New York: W. W. Norton, New Edition), 1979, p. 248.

19. James Gleick, *Chaos: Making a New Science* (New York: Viking, 1987).

20. Saul Krasner, ed., *The Ubiquity of Chaos* (Washington, D.C.: American Association for the Advancement of Science, 1990).

REPLY TO PAUL G. KUNTZ

Paul G. Kuntz has the gift of being able to grasp the import of new ideas of the most diverse kinds, and to make evident their promise and import, as well as the problems they face. He was one of the first to see the merit and to grasp the implications of the study of sport and of *Philosophy in Process*. His questions point the way to new answers, and his answers prompt moves into unsuspected areas. Here he focusses on issues that are at the root of all philosophic inquiries.

The twelve published volumes of *Philosophy in Process,* and the two still waiting publication, span decades. They make possible the examination of many topics, making evident that the process of philosophic thinking is more a series of sudden openings, leaps, surmises, and suggestions than a single, straightforward move to some simple, already known outcome. New suggestions and explorations, sometimes expressed by making use of new terms, were often offered, sometimes maintained for a while, and then just as suddenly abandoned. Rarely rewritten, the entries were presented with no attempt made to make them consistent or even to be in some accord with what was developed in other more systematic studies. It would not be seriously amiss to view them as presenting the dunamic side of a philosophic quest, qualified by and qualifying what is presented in other works. Together with these, the entries in *Philosophy in Process* make evident that a philosophy is at once structured and vibrant, adventurous and self-critical, with asides and insights promoting the achievement of a comprehensive, self-critical account. It makes evident that an Aristotelian view needs a Platonic supplement, that Schopenhauer and Nietzsche add to Hegel, and that an interest in logic is not incompatible with an interest in knowing what is real.

I, today, use 'cosmos' to refer to the object of scientific inquiry as well

as to the object of a philosophic cosmology. 'Universe', 'Totality', or just 'Reality', instead, are used to refer to an all-encompassing complex of different kinds of irreducible beings, and the different ways in which they refer to and are related to one another. References to 'categories' are bound to mislead those who know their Aristotle, Kant, and Hegel. I take them to be primarily ways for encapsulating the outcome of summations, orderings, and differentiations of realities and activities. I have not been constant in the ways I have used the term. It took me a while to see that 'categories' were not helpful ways to refer to pivotal truths and basic realities. Were the fact kept in mind, it should be possible to bring Kuntz's account in closer accord with what I think I intended and, surely, with what I am trying to maintain today.

I am glad to be prompted to recall that I "was not alone in continuing on the highway of systematic metaphysics." Eli Karlin, Otis Lee, Charles Hartshorne, John E. Smith, Ellen Haring, Mortimer J. Adler, John Wild, and F.S.C. Northrop were quick to give an early needed support to the task of making the Metaphysical Society of America the great success it now is, and to make the *Review of Metaphysics* find a place in a world where positivism, analytic philosophy, objective idealism, and a polemical pragmatism dismissed one another—and all else. Kuntz's contributions to these enterprises have never been sufficiently acknowledged.

Kuntz thinks that 'order comes from disorder'. The view is in good accord with some recent conjectures by current scientists. It also is both allied to and departs from Peirce's idea that an unstructured 'mind' becomes more and more habituated until it becomes dead matter. Why must one come out of the other? Does it? Are not the stable and the unstable, the fixed and the changing always present, with now the one and now the other in a dominant position? Evolution and progress do not appear to have the promise today that they had in the heyday of Darwin.

Kuntz is one of the few who have recognized Stephen Pepper's contribution to a pluralistic account. Pepper's references to 'root metaphors', unfortunately, got in the way of the awareness that he was pointing to a number of different, legitimate, and compatible ways of grasping reality in its primal diversity.

Kuntz neatly encapsulates the "assumption of all philosophers" that we "live in an interrelated whole that is intelligible." Room, though, should have been made for the accounts of romantics, atomists, mystics. The result would be a wild miscellany if these different approaches were not dealt with inside of a single account in which they are unavoidably modified and enriched. I think we can understand them, and talk of them in more comprehensive ways if we speak from the position of Being, the

ultimates, and actualities, as both separate from and interinvolved with one another. His use of 'whats', 'hows', and 'whys' while needing supplementation by 'wheres', 'whens', 'ifs', and 'buts', does offer a good entrance into central topics.

I would today speak of Being as a primal reality, but immediately add that it has multiple differentiations. These are more like undulations than rays, emphasizing the fact that they contrast with Being only because this produces what sustains them in the form of its possibility. As I now see it, the God of the pious is beyond all categorizations and is to be reached, if real, only with its help. The faith of the religious is, at the very least, made possible by that which it is designed to reach.

Am I "to be counted among the hierarchical philosophers?" Perhaps, since I recognize the dependence of actualities on the ultimates, the dependence of the ultimates on Being, and take humans to have a greater value than societies, subhumans, or any bodies could have. Kuntz thinks that I am a mystic. Others have said so, too. I don't see why, unless it be that I think we arrive at ultimates and Being through a dunamically charged process of evidencing and presupposing. Mystics, I think, seek to lose themselves in the awesome grandeur that terminates their quest. I, in contrast, think we always remain obstinately here and now, no matter what we think and do. I cannot identify any Plotinian or Kabbalistic elements in my thought. Transcendentalizing moves, I think, take us to what can be understood. To be sure, they are not termini of a mere rationalism. Rationally determined moves qualify and are qualified by affiliative, evaluative, extensional, coordinative, and dunamic powers.

What is subordinated is not reduced to nothing; it makes a difference to what dominates and qualifies it. If dunamic moves were identified with mystical ones, we would have to hold that there is a mystical moment in every act and item, qualified by and qualifying them in different degrees in different places. My acknowledgment of that fact does not justify terming me a 'mystic'.

Kuntz asks: "How else can we describe the movement of man in quest of finalities, and an ontology of degrees and continuity with the attainment beyond appearances, of transcendent unity?" 'Intensive evidencing', 'rational-dunamic moves to presuppositions', 'abduction' are some of the expressions that I have used to name what occurs. They point up the fact that speculation is not idle, random, ungrounded, or undirected, and that as it progresses it becomes more and more subject to what necessarily is. They do not require that one lose oneself in the ultimates or the Being on which these depend for their reality. A mystic thinks he can lose himself in the reality where he believes he can finally arrive. I

think he, and I as well, continue to remain finite, transient, never wholly caught up in Being.

Kuntz rightly notes that some of the more daring suggestions and leads in *Philosophy in Process* are not carried over into safer, more conventional forms. It would be a little more exact to say I did not try to do so. When in the course of the writing of other works, I faced similar issues, I dealt with them in contexts that were not usually noted when they were stated in *Philosophy in Process*. Most of them are leakages not leads, effulgences not preparations, spontaneous expressions not preparations. They could as readily become parts of accounts other than those with which I dealt at length. Somewhat like mathematics, philosophy holds on to its past achievements; like science, it also discards what cannot find a place within it as it continues to carry out its never-ending effort to arrive at what is basic and unimpeachable.

Kuntz makes many excellent selections from *Philosophy in Process*. Space limits have forced him to elide some of them. Having forgotten the passages, I read both those in his original and shortened manuscripts as almost new observations, and liked what I read. Today, though, I would state many of them in new ways without, I think, seriously affecting their primary intent and implications. In the quotation under 'phenomenology', it is to be noted that I speak of phenomena as acting as though they had causal efficacy. They do not, I now think, have it but, at best, mediate and qualify causal acts. I have always understood phenomenology to be primarily descriptive and, therefore, to depend on other enterprises to account for the materials it uses.

In *Creative Ventures* it is maintained that not only artists, but some mathematicians and scientists, the noble, leaders, and statesmen-led rulers and ruled as well, are truly creative. The Dunamis is sometimes recognized to play a large role in the creative process, but its presence in the products is too often overlooked.

Kuntz makes evident that a satisfactory philosophy fills out and subtletizes what has elsewhere been warrantedly held, sharpening differences, remarking on similarities, bringing forward what is always present but hardly noticed, and that it is involved in the practices and achievements of all enterprises. It is, though, no more correct to say that the new considerations and qualifications that I introduced in any of my works produced a series of new views than it is to say that what was initially affirmed was maintained without additions, subtractions, modifications, and changes in perspective over the years. One can grow in stature while remaining self-same. This does not mean that nothing had to be discarded or that what is newly affirmed is necessarily better than what

had preceded it. In any case, it is a matter for others to evaluate, if they wish.

It is the same sea that is now calm and then turbulent. No sea is neither, and none that is both at the same time and place. Nor is it amorphous or unknowable. At the very least we know it as that which is able to be the one and the other, reachable through either. A philosopher is not as wide or deep as the sea, but if we attend to him intensively, whatever he expresses will provide a means for reaching him and perhaps discerning what he intends.

Kuntz raises important questions about the relation of the indeterminate to the determinate. To answer those questions properly it is necessary to distinguish different kinds of indeterminates and determinates. There are determinate features, determinate subdivisions of some of these, determinate relations, determinate constituents, determinate fields, determinate ultimates and a determinate Being. All but the last is dependent and limited. Few remain unchanged for long periods. The Dunamis plays a role in all, in their interplays and passages, leaving much hardly altered. Determinateness and indeterminateness are present everywhere with one or the other prominent at different places and times. The envisagement of my studies over the years (a topic focussed on by Reck) as a 'succession of systems' is misleading; it becomes harmless if 'succession' is understood to exhibit vitally interconnected stopping points.

Kuntz asks where the beginning point of philosophizing is. Could it be anywhere other than where one is, asking "What am I presupposing?" Such questions as "What is real?" "Who am I?" "What ought I do?" play variations on this. Schemata or maps may prove helpful in marking out the path traversed, making it possible to see how one emphasis or claim clicks with others. These are the 'problems of mankind' no less than peace and the living of a satisfying life together with others. Whatever the answers, they ground such other questions as, "How should I proceed?" and "How can I avoid error?" I think there can be no rest until one faces comprehensive answers with other questions, and comprehensive questions with answers, until one ends with answers to searching questions about the knowledge and nature of every kind of reality, and the ways they are related to one another.

Kuntz remarks that I make it a matter of principle "never to rule out any hypothesis." I accept the characterization, with the proviso that 'hypothesis' be treated as shorthand for 'opening', 'lead', or 'reasonable answer', and that one not stop until all fit together. Those who enroll themselves in some school, or who become their own disciples, clinging to what they cannot justify, have come to the end of their philosophic

lives. His characterization of my method, or perhaps better, multiple intertwined methods, is acute. As he remarks, nothing is to be sealed off as beyond the reach of doubt, criticism, examination, modification, and perhaps rejection. The most which anyone can hope to achieve is a better account than any now available, hoping that others will carry on the work of thinking about fundamentals, and will do this vigorously, fearlessly, and well. The best of completed accounts is one that stimulates others to obtain a better.

P.W.

5

Andrew J. Reck

THE FIVE ONTOLOGIES OF PAUL WEISS

I. Definitions

As philosophical teacher and the author of numerous original books and papers, as founder and long-time editor of the *Review of Metaphysics,* and as founder and first president of the Metaphysical Society of America, Paul Weiss is indisputably the most prominent American creative metaphysician of his time. For probing the philosophical depths and articulating his findings in a singular system of thought, he aspires to be ranked with the greatest of the great philosophers— Plato, Aristotle, Kant, and Hegel. In the effort to ascertain and to illuminate the conceptual contours of Weiss's philosophical thinking and writing in his preferred field of metaphysics, I will endeavor in this critical essay to concentrate on his ontology or, as I think the evidence reveals, on his ontologies.

Conventionally, metaphysics is defined as the study of being and knowing, embracing, then, both ontology and epistemology. Weiss began his career in metaphysics when Kant's influence was prevalent in American philosophical schools. Historically Kant had subordinated ontology to epistemology. Early, however, Weiss perceived that an adequate philosophy requires epistemology and ontology, that neither is inherently prior to the other. Ontology, which inquires into the nature of being, presupposes that there are valid ways of knowing, while epistemology, which investigates the processes, range, and validity of cognition, presupposes that knowing is a real activity occurring in a real world. As acknowledged, the mutual involvement of epistemology and ontology lead to circularity. Weiss emphasized this circularity when he wrote: "As ontology and epistemology necessarily find their justification in one another a comprehensive philosophic discourse necessarily commits a *petitio principii,* assuming in one branch what it dissects in the other. Ideally, all philosophic procedure is circular."[1] Despite the circularity,

however, it is feasible to examine Weiss's ontological investigations independently of his epistemology, on the assumption that, whatever the strengths or the weaknesses of his theory of knowledge, he offers sufficient ontological theory amenable to clarification, criticism, and evaluation.

Since my focus will be directed to Weiss's ontology, I will therefore forego questions about knowledge, logic, and method and concentrate on questions about his theories of being or reality. An ontology is, at least, a sketch or ground-map of being. To explore Weiss's voluminous writings is to discover not one but at least five sketches or ground-maps—in other words, at least five ontologies. There are two pre-modal ontologies, one modal ontology, and two post-modal ontologies. In proceeding in this way, I am motivated by serious critical questions. Are Weiss's ontologies consistent with each other? Does Weiss have a coherent metaphysics—in particular, a coherent conception of being? And if the ontologies perplex individually and collectively, is there some key to rendering the complexity intelligible and to moderating the perplexity? Would, indeed, such a key be desirable, or even possible?

II. The Pre-Modal Ontologies

Weiss's pre-modal ontology is spelled out in those works which antedate *Modes of Being*. The first is to be found in his early book, *Reality* (1939). Viewed in its historical context, this book confronts the philosophy of process advocated by Bergson and Weiss's mentor, Whitehead, with the great tradition of substance philosophy stemming from Aristotle. Just as Whitehead had sought, in *Process and Reality* (1929), to reconcile process with permanence by importing a Platonic doctrine of eternal objects into the flux, so Weiss undertook to reconcile process with permanency by reconstruing the entities subject to the flux in substantialist terms derived from Aristotle. If Whitehead's philosophical cosmology may be regarded as the first conservative reaction within process philosophy in behalf of the great speculative tradition of Western thought, Weiss's metaphysics may be esteemed as a second conservative reaction.

In his book, *Reality,* Weiss introduced an intricate descriptive, explanatory system of sixty-six categories and located the category of being within this framework. Being is placed after the categories of modality—impossibility and necessity. It is located, moreover, on the same level as the second category of modality—necessity; and there are two categories of being: multiplicity and singularity (or individuality). Hence being is not the first or ultimate category.

The first or ultimate category is a logical structure. It is distinct from its content, which is being. Indeed, Weiss defined the ultimate category as "a universal and inescapable conceptualization of every possible object of truth."[2] The basic form of this category is "the law of contradiction as a synthetic, discursive structure, so general that everything whatsoever can be an illustration of it, and so related to the real, about which it asks, as to enable it to be exemplified in everything."[3] As related to perception and experience, the law of contradiction is "the category of Unity."[4] As related to formal thought, it is a principle of the logical modalities of impossibility and necessity. Hence the ultimate category is the concept of a structure that expresses the modalities of impossibility and necessity on the one hand, and that relates to experienceable content as a principle of unity on the other. The category of being, then, is not first, as Hegel and perhaps the later Weiss regard it. Rather the category of being follows the modal category of necessity. In this sense the question: Why being instead of nothing? does not arise for Weiss. Being *is*—necessarily. And dialectically the category of being entails the subcategories of multiplicity and singularity. That being is signifies, therefore, that beings are.

Hence for Weiss in *Reality* logic furnishes the most general structure for which being as beings, investigated in ontology, is the content. Simply stated, in the first pre-modal ontology, being is a generic concept, which like Hegel's concept of being would be tantamount to nothing, except that it is necessarily instantiated in a plurality of realities. The question: What is being? is translated into the question: What is reality? And this question is, in its turn, pluralized into the central question of Weiss's early work: What are realities? Weiss's treatment of the question of being is, therefore, pluralistic to the core.

In critical opposition to the doctrine of the atomicity of actualities Whitehead upheld on the implicit fallacious assumption that to be is to be complete, Weiss presented what may be construed to be his formula for being within the first pre-modal ontology. He wrote: *"To be is to be incomplete.* . . . No reality is completely confined within the span of a moment and it cannot therefore perish with the passage of that moment. Realities persist while they change because, though they are wholly present as actual, as virtual they are still future, unaffected by the adventures of that moment of time which is then present."[5] Generically, this formula was to pervade all his later thinking; it is perhaps the dynamic principle of his pluralism and his creative ventures. In *Reality,* however, the beings Weiss acknowledged were all individual realities, or actualities, caught up in a spatio-temporal process. Hence his first

formula for being as depicted in *Reality* may be restated: To be is to be real—i.e., an incomplete actuality.

Hence Weiss himself found his first pre-modal ontology defective. Here cosmology and its relation to ontology are germane. Whereas ontology is the study of being—or rather, of the beings, cosmology treats the relatedness of beings, the interplay of beings with each other in such a way as to constitute a cosmos. Now the cosmos projected by the first pre-modal ontology is no real cosmos, since it is devoid of the requisite unity. Each actual entity is locked in its own time, since there is no guarantee that it shares a common future with any other. Each, in fact, is defined as incomplete yet driven to complete itself, although it can complete itself only by devouring all the others, which is existentially impossible. The moral consequences of this cosmology are dreadful, as Weiss himself soon apprehended.

When Weiss turned to the theory of man and of morality in his books, *Nature and Man* (1947) and *Man's Freedom* (1950), he recognized that moral experience presupposes a cosmos in which actualities may be united by reference to a common, possible good. Weiss's ontological investigations pressed forward because of moral considerations. The first pre-modal ontology, therefore, was replaced by a second pre-modal ontology. In addition to reality pulverized into a multiplicity of actualities, Weiss came to acknowledge another mode of being. Morality at least demanded the admission of one non-actual mode of being, termed the Good, or Ideality. Hence the second pre-modal ontology presents two sorts of beings—actualities and ideal possibility. This bifurcation of being, attended by intolerable pressures imposed upon moral, human actualities, impelled Weiss to formulate yet a third ontology—the modal ontology. But before proceeding to consider the modal ontology, it is useful to pause and reflect on the formula for being in the second pre-modal ontology. In the second pre-modal ontology the formula for being is: To be is to be actual or ideal.

III. The Modal Ontology

Weiss's quest for a theory of being that could both ground a coherent cosmology and also provide for morality led to the modal ontology. As in *Reality,* so in *Modes of Being,* Weiss sought to deduce the category of being from the primary category of logic. Whereas in the former work the deduction is to beings of the same type, in the latter work, however, it is to different types or conditions of being. According to Weiss in *Modes of Being,* a category expresses the essentials of any cognition; it is "an

ultimate unifying form."[6] The primary category, Weiss said, "is a category of being as well as of knowledge. Indeed, it is because it is a category of being that it can be a category not of belief or opinion but of truth, of a world apart from the fact of cognition."[7] Inescapable and necessary, the category "embodies the law of contradiction."[8] At this point Weiss amended the position taken in *Reality,* where he linked the category restrictively to the law of contradiction. In *Modes of Being* the law of identity, the law of excluded middle, and the law of inference also embody the one primary category. Thus the primary category reflects the division of being into four modes of being—Actuality, Ideality, Existence, and God. The law of identity indicates God in its unitary nature. The law of excluded middle points to Ideality as the domain of possibility available for alternative specifications. The law of inference represents Existence as process; and the law of contradiction is, as Weiss said, "most appropriate to Actualities and the rest of reality as determinate entities over against one another, interrelated by means of a symmetrical relation of otherness." He continued: "There are then in a sense four basic categories. If we abstract from all the content of any one of them we get a category neutral to the different modes of being. Such an abstract category is the common denominator of the four categories and can be characterized as the category of 'being' or togetherness."[9]

The pre-modal ontologies testified to Actuality and Ideality. The modal ontology added Existence and God.

In the modal ontology as in the pre-modal ontologies, Weiss presents Actuality as a plurality of actualities. Although each actuality is radically different from all others, actualities display common salient characteristics. Encountered in experience, they are spatial beings with bodies, and by virtue of their physical properties they relate to one another. There are two kinds of actualities: simple beings, and compound beings that consist of simple beings. Primary actualities are the actualities that are active. All simple actualities and some compound actualities are primary—i.e., active. The activities of primary actualities constitute causality. Activity as causality involves a temporal sequence of cause and effect. So actualities are temporal as well as spatial. Each actuality, moreover, has a private and a public nature. Human beings are a special subclass of actualities. Endowed with minds and a moral nature, they discern nonactual modes of being.

Ideality, first delineated in Weiss's ethical writings, *Nature and Man* and *Man's Freedom,* where it appears in the guise of the Good, is present in *Modes of Being* in two other guises as well: as the Future and as the Principle of Perfection. Formally considered, ideality is possibility. Weiss held with Plato that possibilities are exterior to and independent of

actualities, and with Aristotle that possibilities are relevant to actualities. At this point Weiss's linkage of morality to ontology is transparent. As he said: "The Good is a possibility which ought to be realized."[10] At the same time an ontology of merely two modes—Actuality and Ideality— proves inadequate if the cosmos is to be a moral whole. As Weiss recognized in *Man's Freedom:* "Man is the guilty creature, a being who can never entirely live up to his obligations, and knows it."[11]

Adumbrated in the pre-modal ontology, existence as a distinctive mode of being comes into its own in the modal ontology. As Weiss declared: "An irreducible mode of being, Existence is sheer vitality, forever passing from one portion or guise to another. By encapsulating a portion of Existence within the confines of its own nature, each entity is able to stand away from all others at the same time that it is caught inside a wider realm of Existence, where it is kept at a distance from others."[12] Thus Existence is both the field embracing all actualities and the internal vitality of each being. Space, Time, and Energy are the main features of Existence. As the field, Existence comprises "a cosmos of energy," "a whole of time," and "a cosmic contemporary world."[13] As the internal vitality of each being, Existence is "in perpetual inward tension": "Existence perpetually divides."[14] Nevertheless, Existence is intelligible; it has an essence, an intelligible unity expressible as a predicate. For, as Weiss argued, if Existence were not intelligible, "we would not know what it was for something to exist rather than not exist."[15] Whereas the modes of Actuality and Ideality accommodate the classical Western ontologies, the mode of Existence absorbs those currents in contemporary thought stirred by process philosophers and existentialists.

The fourth mode of being is God. Weiss elucidates:

> Distinct from Actualities, Ideality, and Existence, God lacks the essential features of these. Singular, he is, despite his individuality, no contingent, striving Actuality. Determinate and inward, he is, despite his perfection, no mere Ideal. Not spatiotemporal, he is, despite his Existence, simple.
>
> Undivided, the counterpart of our idea of him, God's being is distinct from his actual individuality, his ideal essence and his vital existence. His being is all of these together, one and undistinguished. Absolute in comprehensiveness, he is limited in excellence, since he is without the reality which the other modes possess. Finite, since there are others, he is yet internally infinite, able to encompass all.[16]

Critical reflection upon the moral condition of man and of the cosmos persuaded Weiss to acknowledge God as a mode of being. Convinced that in the presence of the Good, human beings cannot escape being guilty, Weiss identified their guilt as ontological. While the Good

prescribes that the values of all beings be maximized, human beings necessarily make choices which deny the goods of some beings. Although obligated, humans are unable to meet their obligations. In this sense, "ought" does not imply "can." However, for the cosmos, according to Weiss, "ought" does imply "can." Weiss wrote: " 'One can because one ought' is not true; but 'This can be because this ought to be' is necessarily true. What ought to be is that which can be, because what ought to be is the Good, and this is possible. Or, to put it another way, the Good is cosmic in import, its 'can be' has cosmic range."[17] The Good that neither Actuality nor Existence can realize constitutes "a residuum which no action in time could ever exhaust,"[18] it is left over for God to realize.

The four modes of being are "on a footing, independent, irreducible, final."[19] Yet each mode is incomplete. Because each lacks the being of the others, each is imperfect. Each has ontological needs for the other modes, illustrated by the moral predicament of human actualities, but represented generally throughout the modes. There results an interplay or "togetherness" of the modes.

Togetherness seems to suggest sometimes that the modes are abstractions from the interplay, so that the interplay is the most fundamental being; and at other times that one mode of being—say, God—is the most fundamental, embracing the other beings within its own organic wholeness. Weiss, however, stressed that this is not the case. In the modal ontology togetherness is not a fifth mode of being. "The togetherness of the four beings is the being of them together. . . . The being of the four modes together is the four of them together. Such a togetherness is not a new distinct entity; it is a fact constituted by the demands or thrusts of each to the others as met by their counter demands and counter thrusts."[20] Hence the modal ontology is basically pluralistic. The concept of being is, accordingly, shorthand for four concepts, one each for the beings Actuality, Ideality, Existence, and God.

As Weiss himself articulated the third or modal ontological formula for being: "To be is to be one of four distinct modes. . . ."[21] This third formula for being has as a corollary formula: 'To be is to be a mode together with other modes.'

IV. POST-MODAL ONTOLOGIES

Weiss's post-modal ontologies were first discerned in his work, *Philosophy in Process* (1966 to the present). While Weiss entertains a variety of topics in the earlier volumes of *Philosophy in Process,* he is preoccupied

with the four-fold universe of Actuality, Ideality, Existence, and God. These four modes, abbreviated as A, I, E, and G, are schematically juxtaposed and interrelated in page after page, seeming at times to obsess him. Nevertheless, Weiss's ongoing investigations led to revision of his modal system, confirming his own description of his journal as "an exhibition of an effort at 'open thinking.'"[22]

Weiss's ontological investigations in the years covered by the volumes of *Philosophy in Process* from the publication of *Modes of Being* (1958) to the publication of *First Considerations* (1977) reveal his attempts to probe yet more deeply into the metaphysical principles he strove to enunciate. He acknowledged that his theory in *Modes* had concentrated so intensely on Actuality that the other "modes of being are rarely attended to . . ." and that "an account of Actuality . . . [is presented] as having the other three modes incapsulated in it, and functioning relevantly with respect to actualities."[23] As Weiss's critical reflections on the modal ontology advanced, he distinguished more clearly beings from their subdivisions and roles and the nature of contexts from the entities that dwell within them. Paramount among his discoveries was the clarifying distinction between Actuality and actualities. Actualities act on actualities; the other modes of being act on actualities through Actuality. As Weiss declared: "Actuality does have a distinctive Being; so do actualities. They each have a status which allows them to be explained in terms of entities of the same type—Actuality by the other modes of Being, and actualities by one another. But this need not be thought to be incompatible with Actuality and actualities at the same time constituting a unity. . . ."[24] Weiss further sharpened his focus on Being, refusing to reify it in general and stressing that "Being is present in the beings that there are. That is why they are."[25] He kept distinct five different meanings of the term being: 1) objective nature—i.e., "Being as a One for a plurality;" 2) operative nature—i.e., "Being as a One modified so as to be the Being for a plurality of complex entities;" 3) entity—i.e., "the being of any particularities;" 4) entitative being—i.e., "the being which all actualities have in common;" and 5) true Being—i.e., "Being as adumbrated, the Being in which and from which all others must somehow be" or, in more exact language, "Actuality, Ideality, Existence, or God."[26]

Weiss's ongoing ontological investigations culminated in a radical revision of the modal ontology. In his 1970 paper, "On What There is Beyond the Things There Are," Weiss explicitly distinguished actualities from Actuality. This distinction marks the passage from the modal to the post-modal ontologies. As Weiss amplified: "The things in this world are real. But they do come to be and pass away. All are oriented in Actuality,

a permanent and final being, not to be dealt with in terms appropriate to those actualities and that by which they are compelled."[27] Whereas Weiss condemned traditional philosophy for allowing Actuality to swallow up actualities, he contended that other permanent finalities—in the terms of the modal ontology, Ideality, Existence, and God—checked this outcome, while simultaneously exerting compelling powers to which actualities are subject. These finalities or ultimate beings had to be addressed in their own right.

First Considerations (1980) presents Weiss's first formulation of a post-modal ontology—his fourth ontology. In this work Weiss distinguished two sorts of realities: actualities and necessary realities. The necessary realities, also called finalities, are five: Substance, Being, Possibility, Existence, and Unity. In distinguishing actualities from finalities Weiss has, of course, demonstrated a departure from his modal ontology which incapsulated actualities within Actuality. But other departures from the modal ontology are equally conspicuous. Whereas the modes of Ideality, Existence, and God are correlatable with the finalities of Possibility, Existence, and Unity, the mode of Actuality, having already been distinguished from actualities, is further altered; in the first post-modal ontology, it is transformed into two finalities— Substance and Being. This is not to deny that in other respects the first post-modal ontology duplicates the modal ontology. On the contrary, since in a system of philosophy the parts are internally related to one another, it follows that any change in any part will reverberate as changes in the other parts of the system. Additionally, Weiss persistently reconceptualizes, with differing degrees of variation, all parts of his system. Nonetheless, the most fundamental revisions of the modal ontology to be found in the first post-modal ontology pertain to Actuality as it divides into actualities and subsequently is replaced by the two finalities—Substance and Being.

While Weiss's first pre-modal ontology established the substantiality of actualities, then called realities, in opposition to process philosophy, it did so by affirming these actualities, despite their intrinsic incompleteness, to be substantial in themselves, although subject to limitations imposed upon them by each other. Still, unclearly perhaps, by retaining the conception of actualities as substantial in the modal ontology, Weiss's focus on Actuality had tended to reduce actualities to moments of a single mode. In the transition to the first post-modal ontology, the absorption of actualities by Actuality is avoided not only by their distinction from Actuality but by the recognition that the other modes intervene in a no less compelling manner in respect to actualities.

Ironically, the reconception of Actuality as two finalities, Substance and Being, and their roles in compelling actualities to be substantial and to be ontic, undermine their substantiality and their being. What actualities are becomes dependent on Substance and Being. Weiss's endeavor to save their substantiality and their being, initiated in his earliest ontological investigations, seems to have proved futile as a consequence of his thinking in the first pre-modal ontology.[28] Of Substance Weiss writes:

> Together with other finalities, Substance not only provides a context for the exhibitions of actualities, but governs and cosmically relates all actualities. It operates on disparate items, contrasting and fitting them to one another without regard to where they are or how they act.
> Substantiality is imposed on all actualities. It insistently provides them with determinations, controls the result, qualifies this, provides a context for their exhibitions, and conditions them all as cosmic units.[29]

Of Being he says: " 'Being' is a name initially applicable to a finality. It is derivately applicable to actualities precisely because a finality is operative there. . . . An actuality by itself has a being because a being has been given to it. Being enters into it in the form of an alien factor with which it is then intertwined."[30] Hence Weiss's first post-modal ontology, his fourth ontology, may be formulated as follows: 'To be is to be the finality—Being, or to be an actuality or a finality derivatively as Being is operative in it.'

Weiss's ontological investigations did not rest with the publication of *First Considerations*. As he labored on new works, he also reexamined his fundamental philosophical principles—his theory of actualities and finalities. These reflections may be traced in the subsequent volumes of *Philosophy in Process*. In these later volumes, as well as in his book, *Privacy* (1983), Weiss announced the discovery of a first principle distinct from actualities and from the five finalities—namely, the *Dunamis*. This ultimate principle plays a central role in Weiss's investigations into creativity; it is, in an early approach, defined as "the source of vital dynamics extending through an entire work, thereby enabling this to be vitalized."[31] The upshot of Weiss's continuing ontological investigations, therefore, is the advocacy of a second post-modal ontology—his fifth ontology.[32]

Weiss's fifth ontology is discernible in his book *Creative Ventures* (1992), although its presentation is constrained by his specific inquiry into creativity in its concrete expressions. Consequently, this book is not an autonomous metaphysical investigation, such as his works, *Reality, Modes of Being,* and *First Considerations* are. In *Creative Ventures* there are actualities, the five finalities, and a sixth ultimate—the Dunamis. As

Weiss says: "Ultimate factors are of two basic kinds—a number of *conditions* ('modes of being' I once termed them) and a primary pulsating ground, or *Dunamis.* These factors come together in uncontrolled ways to constitute limited, distinct, existent actualities as well as future, indeterminate prospects."[33]

Five ultimates, like the finalities in *First Considerations,* are the conditions that are compulsive for actualities, imposing specifications they must meet in order to be actual. These conditions are: 1) the voluminous, 2) the rational, 3) the stratifier, 4) the affiliator, and 5) the coordinator. Each of these conditions is briefly described. The voluminous is "spatial, temporal, or transformative." The rational is "sheer intelligibility or form." The stratifier is "an assessing, ordering power." The affiliator "enables items to be interinvolved with one another as more or less compatible and supportive." And the coordinator simply indicates that "emphasis be put on a coordinating condition" in order to create something.[34]

From the first post-modal ontology presented in *First Considerations* a radical change in ontological orientation has occurred. Semantic shifts make it perilous to attempt precise correlations between the categories of this new ontology and the earlier ontologies. Existence in *Modes of Being,* revised as the finality of Existence in *First Considerations,* is now further altered to be the voluminous—a kind of spatio-temporal, causal matrix. The Rational in *Creative Ventures* corresponds to Ideality in *Modes* and Possibility in *First Considerations.* Perplexities multiply as additional correlations are attempted. Actuality in *Modes,* subsequently distinguished from actualities, was replaced by two finalities in *First Considerations*—Substance and Being, while God in *Modes* yielded to the finality of Unity in *First Considerations.* It is tempting to suggest correspondences between Unity and the stratifier, Substance and the affiliator, and Being and the coordinator. But each of the ultimate conditions has been reconceptualized to render such correspondences vulnerable before probing critique.

The paramount novelty of Weiss's fifth ontology is the Dunamis. Although Weiss has published a paper on the Dunamis, which reappears in *Creative Ventures* as an appendix, this principle is an elusive ultimate. It is not a condition that actualities are required to meet, because a condition is a kind of fixity. Why and how actualities come into being and pass away, why and how they pulsate, why and how life, death, and becoming exist, instead of merely static being or nothing, are questions Weiss refers to the Dunamis. The only metaphysical guarantee that there are actualities is perhaps the Dunamis. Hence it is plausible to formulate

Weiss's fifth ontology thus: To be is to be an actuality conditioned by five ultimates and responding to or connected with the sixth ultimate—the Dunamis, or to be an ultimate.

V. Closing Reflection

The five ontologies of Paul Weiss may be concisely summed up in the set of formulas discovered in the course of my critical investigation.

Ontology I (the first pre-modal ontology): A. To be is to be incomplete. B. (Corollary). To be is to be real—i.e., an incomplete actuality.

Ontology II (the second pre-modal ontology): To be is to be actual or ideal.

Ontology III (the modal ontology): A. To be is to be one of four distinct modes. B. (Corollary). To be is to be a mode together with other modes.

Ontology IV (the first post-modal ontology): To be is to be the finality—Being, or to be an actuality or a finality derivatively as Being is operative in it.

Ontology V (the second post-modal ontology): To be is to be an actuality conditioned by five ultimates and responding to or connected with the sixth ultimate—the Dunamis, or to be an ultimate.

The five ontologies of Paul Weiss give pause to reflect. If the ontologies be considered abstractly, then they are many, and they are incompatible. A philosopher could favor one against the others, or dismiss them all as incoherent. The earlier ontologies stress the being of actualities. The modal ontology loses their being in Actuality. The post-modal ontologies seek to save their being, but primarily through the finalities which Weiss attends to as the ultimate beings. The Dunamis in particular threatens the ontological status enjoyed by actualities in the earlier ontologies, since it accounts for all creative activities. Hence it is plausible that the ultimates are the hypostases of actualities. On the other hand, the actualities are the starting point for ontological inquiry, the first claimants to reality or being, so that the ultimates would seem to be modes and powers only for their being. Thinking swims in being, sometimes fast, sometimes slow, sometimes swiftly dashing on the rocks of nothingness, sometimes drifting, sometimes still, but flowing and

flowing in being. Yet the troubling questions remain whether these five ontologies are consistent with one another, whether, in Weiss's case, Aristotelianism has been surrendered to a dynamic neo-Platonism. History joins what argument separates. If the historic career of a singular philosophical actuality engaged in a creative venture be the point of reference, then these five ontologies may be interpreted as phases in the development of a singular system of unfolding thought. Whether the fifth ontology is Weiss's final ontology remains to be seen.[35] As Weiss once confessed: "One way of summarizing what I have been doing over the years, is to take all thinking to be primarily occupied with reconstituting what is daily encountered so that its various components are understood as they are by themselves, and to see what results from their interplaying in different ways and degrees."[36]

ANDREW J. RECK

DEPARTMENT OF PHILOSOPHY
TULANE UNIVERSITY
MAY 1992

NOTES

1. Paul Weiss, *Reality* (Princeton: Princeton University Press, 1939; reprinted New York: Peter Smith, 1949), p. 10.
2. Ibid., p. 144.
3. Ibid., pp. 144–45.
4. Ibid., p. 155.
5. Ibid., p. 209.
6. Paul Weiss, *Modes of Being* (Carbondale, Ill.: Southern Illinois University Press, 1958), p. 86.
7. Loc. cit.
8. Ibid., p. 88.
9. Ibid., p. 89.
10. Ibid., p. 112.
11. Paul Weiss, *Man's Freedom* (New Haven: Yale University Press, 1950), p. 259.
12. Paul Weiss, *Modes of Being*, p. 185.
13. Ibid., pp. 186–87.
14. Ibid., p. 186.
15. Ibid., p. 198.
16. Ibid., p. 331.
17. Ibid., p. 104.
18. Ibid., p. 183.
19. Ibid., p. 277.
20. Ibid., p. 514.

21. Ibid., p. 518.
22. Paul Weiss, *Philosophy in Process* (Carbondale, Ill.: Southern Illinois University Press, 1966–1971), vol. 1, p. 186.
23. Paul Weiss, *Philosophy in Process,* 4, pp. 27, 46.
24. Ibid., 4, p. 128.
25. Ibid., 4, p. 545.
26. Ibid., 3, pp. 221–23.
27. Paul Weiss, "On What There Is Beyond the Things There Are," *Contemporary American Philosophy; Second Series,* edited by J. E. Smith (New York: Humanities Press, 1970), p. 89.
28. See my objections to the first post-modal ontology, "Objections to Some Supposed First Principles," in Paul Weiss, *First Considerations* (Carbondale: Southern Illinois University Press, 1977), pp. 238–43. See also Weiss's reply, ibid., pp. 244–51.
29. Paul Weiss, *First Considerations,* pp. 117–18.
30. Ibid., p. 124.
31. Paul Weiss, *Philosophy in Process,* vol. 10, April 15, 1984–January 18, 1986 (Albany: State University of New York Press, 1987), p. 373.
32. See my reviews of the following: Paul Weiss, *Philosophy in Process,* vol. 8, April 28, 1979–July 28, 1980), in International Studies in Philosophy, vol. 21 (1989), 154; Paul Weiss, *Philosophy in Process,* vol. 10, April 15, 1984–January 18, 1986, in ibid., vol. 24 (1992), 148–49; and *Philosophy in Process,* vol. 11, 19 January 1986–27 May 1987, in ibid., 24 (1992), 149–50. In these reviews I attend mainly to Weiss's changes from one ontology to another.
33. Paul Weiss, *Creative Ventures* (Carbondale and Edwardsville: Southern Illinois University Press, 1992), pp. 4–5.
34. Ibid., pp. 5–6.
35. It is reported that Weiss's latest work in progress is *Being and Other Realities,* in Paul Hendreckson, "The Philosopher's Battle of the Nineties," *The Washington Post* (Sunday, January 10, 1992), Section D, pp. 1, 8–9. [Editor's note: *Being and Other Realities* was published by Open Court in 1995.]
36. Paul Weiss, *Philosophy in Process,* vol. 10, p. 71.

REPLY TO ANDREW J. RECK

I know of no one who is more sensitive, more alert to nuances, more open to different views, so radically honest, careful, sound, and objective an historian of the foundations of American political philosophy and of recent American philosophic original thought. I accept his praise, though I do raise my eyebrows. I do try to benefit from his criticisms, but rarely succeed. One reason for this is perhaps that he takes what I have written to be settled fact and evidence, where I take it to be the outcome of an exploration, warranting and making possible another attempt, that I think will advance and enrich what had been maintained. The essays of a number of others in this volume make assumptions somewhat similar to but also deviating from his, enabling me to recur to the same issues from different angles and perhaps with different results.

Reck says that he has discovered "at least five ontologies" in my writings. I am troubled by his "at least." Does he glimpse others, or is he just allowing for the possibility that others might be uncovered? In any case, he provides needed categorizations of and plausible references to them. Often enough he finds separations where I thought I had introduced subtletizations, qualifications, and corrections, and made some advance. I have paid little attention to the question whether or not I expanded, contracted, or altered some previous view, in good part because I took off from where I had ended, again and again returned to the beginning, probing, questioning, and advancing. Often enough, I found myself facing issues that I had not before seen to be central or as complex as I had first surmised.

After he has neatly distinguished the 'five ontologies' Reck remarks that "these five ontologies may be interpreted as phases in the development. . . ." Had he begun with that idea, he would have produced a different study, more in consonance with the way I envisage what

was done. I would have liked to see the result. Although it would not deny the legitimacy of the approach he has taken, it would surely provide it with a needed supplement.

I find little to reject or to repudiate in what I had once maintained, though I do think much needs subtletizations, qualifications, and supplementation. When I tried to see what light I could throw on what I had dealt with speculatively and systematically, I would usually find that there were areas that defied mastery unless I modified what I had claimed, named, and distinguished. If there are five or more 'ontologies', they mark stages in what I hope are insights, clarifications, subtletizations, and gain in comprehensiveness. Sometimes I found it necessary to abandon what seemed quite evident—the primacy given to the law of contradiction, for example, in *Reality*. Sometimes it was necessary to mark out sharp differences among factors not well-distinguished before. It took quite a while before the dunamic factor was identified in what was called 'Existence' and then recognized to be present everywhere. Again and again, I found it necessary to alter, amalgamate, distinguish, add to, and subtract from what I had decided, usually after much rethinking and rewriting, in order to progress in the effort to obtain a more coherent, defensible, and adequate account of the primary kinds of reality and the ways they are interrelated. By speaking of five ontologies, Reck rigidifies pauses in a single venture. Instead of referring to five ontologies, it would have been better to refer to a sequence of stresses in an ongoing inquiry.

Although each of my works was written as a final account, some were belatedly discovered to have dealt with reality from too restricted an angle. That, of course, was not what I had intended to do. It was only when I became aware that some central issues had been overlooked or inadequately dealt with that I began another investigation. Although I did rewrite my manuscripts many times, I did not become aware of what was amiss or missing until I had finished another study. Plato did something like that when he dealt with politics, Aristotle with ethics, Kant with judgment, Peirce with logic, and Whitehead with perception.

Looking back, with Reck, but without reading the works again, I see strong accounts backed by unexamined assumptions. It is usually these that were later brought forward and, I think, a better, more complete, subtler view presented, usually clarifying what before had not been adequately understood. I do not see how, but I can well imagine that some of the earlier accounts might be taken to be better than the later ones. That would not compromise the later, for they may well be

justified, given what had been assumed. What was written later never claimed to reinstate what had been said earlier. New works were written under the stimulation of the old, not as supports, additions, or corrections, though they often did provide these.

Not all of my works are 'ontologies'. It is odd that Reck takes no notice of them, particularly since many were prompted by one of the supposed five ontologies and fed into what followed. Reck's five are too disjunct, even when taken to be phases, to do justice to what they are in the context of a single attempt to understand what always is and has to be, as well as to the different kinds of actualities there are and their relations to one another. Inquiries into such topics as sport, education, society, religion, art, film, and politics served as tests and occasions for moving into aspects of reality not previously well grasped. Observations and criticisms by friends and students were usually found to be closer to the mark than the comments of reviewers or critics but, for the most part, it was the non-ontological works that made evident that what had been previously maintained was inadequate.

Reality did not set out to nor did it attempt to "reconcile process with permanency . . . in substantialist terms derived from Aristotle." I have always thought that Aristotle's 'matter' was too passive, unintelligible and perhaps unlocalized to be able to add to what his 'forms' needed. The work began with what everyone acknowledges—robust actualities persisting over periods of time, striving to obtain what they need to have. It would be more correct to speak of an actuality having an 'inner and outer' when the inner is understood to be denser and more powerful than the outer. Aristotelian forms and matter are abstract aspects of what is prior to both. Aquinas was acutely aware of that fact, but never made evident what it was that was prior. It has taken me almost a lifetime to identify and understand it and, finally, to know what an individual is.

At the end of chapters in one part of *Reality,* I offered a series of linked categories as summations of what had been spelled out in the previous discussion, thinking that they made more conspicuous what had been learned. The fact that I intended this or that does not, of course, preclude any from seeing either more or less merit than I do in what had been achieved.

Reck is right in taking me to have been pluralistic in temper from the beginning of my inquiries. I was not that pluralistic when I was a logician, even when I saw that Aristotle and Leibniz had quite different logics, and had been alerted by Peirce to the fact that almost every great philosophy grounded a distinctive logic. Logic, today, is studied and taught mainly

by those who follow the lead of Leibniz, with modest modifications here and there. Even the supposed divergencies exhibited in modal and multivalued logics cling to the structures endorsed by the extensional Leibnizians. I did not develop an intensional logic though, with Everett Nelson, I did and still maintain that there is a need for one that moves dunamically (as I now would say), from the thin to the thick, from the ongoing to the formal, from actualities to ultimates, from the ultimates to Being—and back again. Adumbration, discernment, evidencing, perception all provide conspicuous forms of it, usually accompanied by the Rational playing a subordinate role.

Reck rightly notes that I began with a rejection of Whitehead's temporalized atomic view of actualities. My reasons given for the rejection have been known to but blithely ignored by his self-appointed defenders. It does not seem to disturb them that they are unable to account for responsibility, accountability, commitments, perception, identity, memory, a primal creativity, and a 'God' who functions as a pivot with two natures inexplicably connected. They also blithely ignore the fact that a 'self-cause' is a contradiction in terms. Whitehead properly and successfully opposed the dominant analytic views of the day, but I do not think that he provided a viable alternative to them or even laid the ground for one. I am very much in Whitehead's debt for his resolute rejection of all cleverness, easy answers, and his example in probing where his contemporaries did not, perhaps because they could not fit them into their accepted views or deal with them by using their unexamined methods. His *Process and Reality* is a culmination of a number of distinct endeavors he made to provide a cosmology; it surely is less than a comprehensive metaphysics. His knowledge of Plato was one-sided, his Aristotle was not well-grounded, his Kant was apparently mainly confined to a reading of the early part of the first *Critique,* and his understanding of Hegel comical, where it is not pitiful and regrettable. I admired him and still do. My way of expressing that fact has been to try to be as resolute as he was, but more self-questioning, more open to criticism, and more comprehensive. I am confident that were he alive today he would not be a 'process philosopher'. He did not care for my *Reality.* (The letter he wrote to me about it should be in Victor Lowe's *nachlass.*) It is never enough to take account of what contemporaries did not or could not consider, nor to provide a richly textured cosmology backed by little or no argument. He should have tried to do justice to reality in all its diversity and complexity, with places for the constant and the idiosyncratic, for individuals, traditionalized societies, and operative political organizations, for vice, guilt,

failure, sadness, and despair, as well as for virtue, innocence, success, joy, and hope.

Reck is right to take the early formulation "to be is to be incomplete" —to be incomplete. I do not think, though, that it is correct to say that I sought to "deduce the category of being from the primary category of logic," though he surely is right to remark that I continued to speak of a category of being for quite some time. He rightly remarks that I tried to attach the different laws of logic to different kinds of entities. That was a mistake, though on the right track.

I do not agree that the ultimates are "hypostasies of actualities." They are realities that jointly constitute actualities and the fields in which these interplay. They are contingent realities necessarily existing because required by Being when and as this is—always. The actualities are constituted by all of them combined in different orders and in different degrees.

Reck asks "whether these five ontologies are consistent with one another, whether in Weiss's case, Aristotelianism has been surrendered to a dynamic neo-Platonism." I do not think there was an Aristotelian-ism in the first place; if there were, it was not then surrendered, but instead was more sharply delineated, supplemented, and extended. I have maintained that view quite steadily over the decades. If so, is there not a thread among the supposed five ontologies that shows them to be variations on the same theme? It would have helped had Reck begun his account where he ended, and reversed his steps. Even if all his distinc-tions could be maintained, they would then have a different coloring and import.

Reck has treated my works as historic documents. Accepting that assumption, I have tried to add needed footnotes. I do not repudiate what I had previously published. Indeed, each work was worked over too many times to allow for a repudiation. Each was subject to too much questioning by me and sometimes by others to allow it to be understood as anything less than an attempt to master reality from a distinctive position and in the light of issues raised by attending to other enterprises, what they have made evident and how what was claimed could be justified. I hope that his account will enable others to see both the strengths and weaknesses involved in publishing a series of books in which what had been achieved, provided a base both for adding, subtracting, and making another effort to obtain a more adequate, better grounded account that was somewhat closer to the nub of abiding truth, than was possible before. It may well be that some of my earlier works are sounder than later ones. I do not think so, though they do contain

explorations and achieve results that could with some modifications be made part of a more comprehensive, sounder account. Reck's study should help one discover if that is worth doing and, perhaps, even what should next be done. If it does not, it will still serve to show what a fine historical account can—and cannot—do.

P.W.

6

George R. Lucas, Jr.

PHILOSOPHICAL INQUIRY AND REFLECTIVE HISTORICAL ENGAGEMENT—SOME RIGHT AND WRONG USES OF HISTORY IN PHILOSOPHY

Several years ago I served as program chairman for the Metaphysical Society of America, a society founded by Professor Paul Weiss. The topic of the annual meeting that particular year had to do with the metaphysics of time. Believing then, as I do now, that methodological and ideological differences ought not to separate philosophers from one another's work, I invited a distinguished philosopher of "analytic" persuasion to address the society—an individual who had devoted his career principally to the metaphysics of time.

The lecture, focussing on the different linguistic formulations used to address matters of space versus matters of time, was not well received. Afterwards, Professor Weiss, cane in hand, chased down and finally accosted the beleaguered guest, asking him brusquely, "Whom do you read?"

It quickly became clear that Professor Weiss was *not* inquiring about that philosopher's close friends, or even about the small contemporary community of like-minded inquirers with whom he might exchange research papers. Instead, Weiss's question was directed toward a perceived deficiency in the lecture just given: namely, that it failed to contextualize or to situate the issues under discussion within a familiar historical tradition of discourse on its topic. As a result, the lecture seemed to emanate from "nowhere," and was largely unintelligible to members of the group who might not have been intimately familiar with the lecturer's own work, or the work of a few of his close colleagues. That the general philosophic public might itself be unaware of this individual's

own recent contributions was, in turn, inconceivable to that individual himself. My experiment in ecumenism had foundered on the rocks of cultural incommensurability.

In his answer to Professor Weiss's post-lecture question, however, that lecturer revealed three interesting facts about himself, viz.: (1) that he had not read widely in the history of philosophy; (2) that he did not regard historical texts, figures, and traditions in philosophy as useful resources for his own work on the problem of time; and (3) that the lecture we had just heard constituted a dialogue between himself as lecturer and his own earlier work on this topic, which he was now repudiating, or at least questioning. As a result, those who were not privy to this ongoing "private discourse" were shut out of the necessary interpretive context for understanding it. Many listeners, in addition, had the strange feeling of *déjà vu:* hadn't they heard some of this man's views before and perhaps elsewhere (e.g., in Augustine), and if so, why then did this particular lecturer feel it necessary to "reinvent the wheel" on this topic?

Such lacunae and such attitudes toward history typify the practice of philosophy in Great Britain and America during most of the twentieth century. When it is not dismissed as a canon of sacred but irrelevant texts and a hagiography of famous but outmoded predecessors, the history of philosophy has often been taken as a record of previous intellectual deficiencies and outright errors which have only recently been discovered and rectified. The history of philosophy, for much of the century just ending, has had about as much relevance for the *current practice* of philosophy as has the history of science for the current practice of physics or chemistry. To be sure: upon occasion a Thomas Kuhn or an Alasdair MacIntyre has risen to object that the histories of the sciences, too, *are* essentially and vitally related to the current practice of these disciplines. Notwithstanding such objections, however, practitioners of the natural sciences have endeavored to behave as if their histories were merely antiquarian curiosities, and contemporary philosophers, eager to cloak themselves in the mantle of authority of the sciences, have followed close behind.

Paul Weiss, as his students and colleagues would attest, and as his own extensive writings reveal, has rejected this mainstream tendency among his colleagues in analytic philosophy. As his autobiographical comments for this volume indicate, he has been adamant throughout his own career that philosophy depends upon a knowledge of and an ongoing dialogue with its history. What he found absent in the lecture described above was neither intelligence nor significance, but philosophical depth and breadth of understanding, all of which would have been more in evidence, had

the lecturer's own reflections proceeded against the backdrop of a thorough grounding in past discussions of time by important predecessor philosophers.

I heartily agree with Weiss's basic position on the preeminent importance of the history of philosophy in the task of carrying out meaningful philosophical inquiry in the present. Such inquiry cannot start over from zero each time it is begun. Philosophical problems or puzzles of the sorts that Anglo-American analytic philosophers are wont to struggle over begin or arise out of somewhere. And that "somewhere" is an interpretive cultural context forged in the crucible of historical concerns.

The questions I wish to pursue in this paper thus are: How precisely ought we to approach that history? What *happens* when we study that history? And finally, in what sense is the study of history supposed to give rise to contemporary philosophical reflection, or participate in formulating contemporary philosophical problems?

There are several possible answers to these questions, and not all of them are entirely satisfactory. While the relationship of philosophy to its history may be essential, the relationship itself is nonetheless somewhat mysterious and imprecise. In particular, it seems to me that there are several possible relationships to history that are abusive and unproductive, and which ought to be avoided. It is possible that the desire to avoid at least some of these abuses may serve to explain why so many contemporary or recent philosophers have been prone to ignore or downgrade the importance of the history of philosophy generally. Yet that tendency simply to ignore or downgrade the significance of history serves more to threaten the enterprise of philosophy itself than to solve the problem of "bad historical consciousness" (to use Nietzsche's derogatory phrase).

Let us consider the problem as Weiss himself would: from the ground up, with no exclusionary rules or dogmatic presuppositions about what "counts" as acceptable discourse, in the mode of a thoughtful conversation, consisting in a series of dialectical observations and examinations of these possible positions.

I. Privacy: Why We Can't Ignore History

One of Professor Weiss's recurrent metaphysical preoccupations has to do with what makes an actuality what it is, and what distinguishes one actuality from another. "To be is to be incomplete," he writes in one of his earliest works.[1] A determinate entity is a complex mixture of

conditional features, which define a given thing in relational contrast to other things, and essential features, which uniquely define the particular entity in question from its own perspective, and which are shared with no one and nothing else. Essential features define privacy; conditional features are public.[2]

The problem with the analytic lecturer on time described above is that, cut off from the historical background discussion of the metaphysical question that concerns him, his own contribution to that question is entirely private and idiosyncratic. A dialogue with history provides, in Weiss's language, the "conditional" features of one's own view that define it in relation to, and as distinct from, other views. Absent the historical or relational (conditional) components, the philosopher is bound to produce a purely private view framed in a private language, and hence inaccessible and unintelligible to others. Incompleteness, as Weiss notes, is a feature of existents that makes each dependent upon others. But our analytic lecturer's ahistorical view of philosophic discourse attempts mistakenly to generate philosophical positions which are completely *independent* of public discourse. Contrary to intention and expectation, however, the result of this discourse is not a novel insight, but privacy and unintelligibility. Such philosophers speak only to themselves.

It is entirely appropriate for a poet or rhapsode to "spin out" or generate his or her own private world entirely as a product of imagination. The philosopher, however, who is ostensibly engaged in a public quest for the *logos,* is *not* similarly licensed to say whatever he or she pleases. Philosophers are obliged to give reasons—Plato spoke of the quest for the "causal *logismoi,"* the narrative threads, that bind opinions together into coherent knowledge.

To be sure, philosophical reasons are not merely references to historical events as some sort of irrational appeal to the presumed authority of "tradition" alone. As Aristotle's mode of investigation illustrates, the grounds or "reasons" for reaching some philosophical conclusion or holding a given philosophical view are always couched in historical summaries and evaluations, and result in historically-generated narratives. Aristotle does not begin from "nowhere" to conduct an investigation of the Good or of *ousia:* rather, he begins always *in media res,* with an analysis of common opinions, of cultural orientations, of the views of previous authorities, and the like, all of which are *then* subjected to rational cross-examination. Plato's *dramatis personae* in each of the dialogues fulfill a similar function. In plain language, the philosophers (unlike the novelists) don't just "make this stuff up." Rather, they begin in the midst of historical conversations about

historically generated questions or problems, and proceed to give accounts or "solutions" to these, the intelligibility and plausibility of which are grounded in that same history.

Philosophers, I have argued elsewhere,[3] are less like poets and *littérateurs* than like jurists and rabbis: their interpretive license is anchored in some tradition of public discussion and dialogue within which they participate, and in which their questions or philosophical problems are framed. Indeed, elaborating on this Aristotelian-historical model of appropriate philosophical method, Alasdair MacIntyre suggests that the most substantive definition of "truth" possible in science or in philosophy is an exhaustive narrative account of some issue that fully encompasses all prior and all rival positions on that issue, explaining in the process how reasonable persons could have held these rival views, what the views themselves explained, what they failed to explain, and why.[4] Jointly, these discussions of truth and of philosophical method suggest that history is not merely important, but paramount, in both philosophical and scientific explanation.

I do not dispute that there may be value in having some individual philosopher hammer out his or her own unique perspective on the world—some view that this individual is perhaps privileged to hold alone. There may be some comfort, and perhaps even some wisdom, for each individual who engages in such an enterprise. This activity, however, is not philosophy but poetry or mysticism: such activity, whatever it signifies and however "creative" it may be, is not inquiry directed toward a community and its common problems. If philosophy *were* the business of each individual forging his or her private and unique perspective on the world, then it is not clear what role discussion and criticism would play in this entirely aesthetic enterprise—nor, indeed, why one would bother to teach, promote, and publish one's views, since, by definition, there could be no conceivable audience for them. Again, as both Plato's and Aristotle's writings indicate, philosophical inquiry *begins* with this infinite multiplicity of private views; it would thus be quite odd to argue that such a multiplicity were its end or goal. One need not be committed to authoritarian or universalist notions of absolute truth to believe that philosophical inquiry is motivated by something more than the perpetuation of already-existing chaos, arbitrariness, and explanatory incoherence.

The history of philosophy provides the corrective for this creative excess toward infinite multiplicity. History is not simply memory and recollection; it is also the process of loss to oblivion and forgetting.[5] History winnows and selects, and preserves for us not *everything* that *could* be said, but only some of the most significant things that *have* been

said. This is not to argue that such a Darwinian-like process of winnowing and selection is just and equitable, let alone infallible. Its very limitedness reminds us that there are voices in the margins of history that deserve to be heard, and perhaps also contributions lost to oblivion that should have been heard. But this, in turn, reminds us that such claims are public claims to address, and to contribute to the *logos*. History does not celebrate privacy, but records the legacy of public debate and discussion.

II. Discipleship: An Error from Which History Might Spare Us

Discipleship is the surrender of one's self to the power of another. It is the antithesis of "privacy," which is isolation and self-absorption, a kind of philosophical solipsism.

The disciple is not a self-absorbed solipsist, but an uncritical advocate of another's views. Such an attitude is appropriate in religion, where surrender and devotion or submission are required, but the disciple does not make the best philosopher.

It is often true that good philosophers, like charismatic religious leaders, attract disciples in addition to attracting the attention of a public audience. If philosophy is a kind of vital public discourse, then an audience is potentially a good thing, indeed a prerequisite for "doing" philosophy itself. An audience to listen to, and to discuss one's views, however, is quite different from a disciple, who memorizes and imitates them. The imitation is never equal to the original. Here I am led to think in unflattering ways of Husserlian phenomenologists, who treasure each scribble on scrap paper in the archives of the master, no matter how trivial, as a potential source of divine insight; or of the entire French tradition of the *homme d'lettre,* as well as of that culture's fatal attraction to "celebrity" figures in philosophy. Indeed, in this instance I am obliged also to consider many of the self-styled students of Professor Weiss's own teacher, Alfred North Whitehead—disciples who pour over the texts of *Process and Reality* to the exclusion of every other source of philosophic insight, despite Whitehead's own frequent and urgent warnings that such scholasticism is not the avenue toward philosophical insight and truth.

Whitehead's aversion to discipleship as the antithesis of true philosophy is hardly original. It is, as he would have observed, merely a footnote to (or a gloss on) Plato, who on a number of occasions (e.g., in the *Phaedrus* and the *Meno*) has the person of Socrates gently but firmly contend with disciples and discount the substitution of memorization and imitation for true knowledge. Thus Meno, the disciple of the famous

Sophist, Gorgias, can do little else than recite what he was taught by his master; while Phaedrus, a young man infatuated with the celebrity Greek rhapsode, Lyceus, desires to commit Lyceus's latest speech to memory. Against both, however, Socrates argues patiently and consistently that true learning and wisdom cannot be derived in such a fashion, but can only come as the result of one's own independent inquiry.[6]

Dogmatic discipleship and the absorption with philosophical celebrities threatens to stifle true philosophical inquiry. The encounter with the history of philosophy, however, presents the would-be disciple with too many options to permit a surrender of his or her own critical independence. I have always found it significant that few of Alfred North Whitehead's own students became his uncritical disciples; certainly no one would dare label Paul Weiss an "uncritical disciple" of Whitehead. Interestingly, the same holds true of Professor Weiss's own best students, such as Robert Neville: few if any of these students could be accused of uncritical discipleship, despite their acknowledgment of their profound indebtedness to Weiss as their gifted teacher. It is the mark of a great teacher to produce, not clones or slaves, but creative individuals who are original thinkers in their own right. Both Whitehead and Weiss achieve this distinction.

In both instances, this independence of thought is nurtured in students and colleagues by forcing their continual encounter with the history of philosophy. Weiss's question to the ahistorical analytic thinker in the illustration above was not: "Have you read *my work* on time?" Rather, it was an admonition to the lecturer to immerse himself in philosophy's history. Both Whitehead and Weiss actively encouraged their students to undertake such an immersion, including careful study of past great philosophers whose views may have been contrary to their own. For both of these great teachers, the tradition itself promoted critical inquiry, originality, and independence, and nurtured, rather than suppressed, what Derrida terms "philosophy in the margins." Surely Weiss himself represents a powerful philosophical voice from the cultural and economic margins of our society—a voice enhanced, rather than diminished, by encounter with the history of philosophy.[7]

Here I can identify a kind of dialectical tension and danger stemming from these first two abuses of philosophy which a study of its history seeks to avoid. Discipleship is a community activity, and hence is an antidote to privacy. Likewise, privacy, though a form of existential "incompleteness" in Weiss's terms, is a celebration of individual creativity and independence, and hence might emerge as a response to, or as an attempt to avoid, discipleship. Of these two abuses, it is my distinct impression that Weiss himself would find "discipleship" and the aban-

donment of one's own individuality as far more loathsome than "meta-physical privacy."

Weiss's students, in my opinion, tend to err in the direction of creative independence: by being encouraged to strike out on their own, by each being charged to forge for himself a unique metaphysical vision, those students become prone to privacy and to metaphysical poetics in the name of individuality. While such creative expressions may be of value to each of the individuals who generates them, because they lack the conditional features of historicity and publicity, most of these idiosyncratic systems and world views lack value for the community.

III. Exegesis: An Abuse of History in Excess Devotion

One reason for the decided unpopularity of historical studies has been the characterization of intellectual history as merely antiquarianism, pursued through textual exegesis. The creative philosopher wants to wrestle with problems, with issues, and not get bogged down in discussing who said what, said it when, or said it first. Weiss himself has shown a great impatience with supposed philosophic inquiry which reduces to mere textual exegesis of the sort that forms, for example, the cornerstone of German philosophical scholarship. Such studies, while "learned and scholarly," are often lifeless and unenlightening, providing a bewildering welter of detail that masks the absence of an original and insightful interpretive framework. The problem with excessive reliance on exegesis, in short, is that the activity itself becomes the end in itself. The scholars pursuing such study are not motivated by substantive philosophical ideas. Accuracy, not wisdom, becomes the overarching goal.

Such scholarship, requiring a mastery of languages and of historical minutiae, certainly has its place in the service of philosophy, but ought never to be mistaken *for* philosophy. In a sense, the exegetical tendency, characteristic of a good deal of European philosophy, is the handmaiden or fellow-traveler to discipleship. The belief in the authority of a given text or author begets the willingness to attend to that text and its author with meticulous detail, abandoning, in the process, one's own creative distance and objectivity. Once again, this is an example of the "bad historical consciousness" of which Nietzsche spoke: each new philosopher's insight or contribution constitutes, at best, a footnote or annotation to the extant text or tradition, which thus becomes an intolerable burden on philosophical innovation.

The advocacy of the importance of history for philosophy should not be confused with this obvious abuse of history, nor with the scholasti-

cism and pedantry it tends to foster. American philosophers, whether under the tutelage of Weiss or under the influence of positivism, tend to avoid the twin perils of discipleship and exegetical scholasticism, as noted—but, in the process, become especially prone to philosophical privacy. European, and especially German philosophers, by contrast, labor under the burden of excessive discipleship and scholastic exegesis, both of which tend to suppress truly original scholarship even, paradoxically, while preserving intact a rich cultural heritage of philosophy. These mutual extremes and their shortcomings seem to constitute the twin ironies of possible cultural attitudes toward history among philosophers.

IV. HAGIOGRAPHY: AN ABUSE OF HISTORY ABOUT WHICH LITTLE NEED BE SAID

This likewise follows closely (2) and (3) above, and is the antithesis of (1). Richard Rorty refers to this tendency disparagingly as doxography,[8] the uncritical litany of "great dead white European males" and their philosophical accomplishments. This is the sort of narrative characteristic of philosophy textbooks with an historical bent, perhaps prompting the kind of urge for independence that results in the excess of privacy. It is not the reverence for historical figures and the "Western tradition" that is at fault, so much as the uncritical and uninspired celebration of these. The textbook doxology may have its place as the site of first acquaintence for many with the achievements of their ancestors. The truncated, excerpted, excised, caricatured "Cliff Notes" version of those achievements, however, is seldom the sort of recitative that inspires study and emulation of those accomplishments.

V. CARICATURE: THE SORT OF HISTORY ONE DOES WHEN ONE DOESN'T 'DO' HISTORY

Among those who are impatient with history, and who see in the Germanic "bad historical consciousness" an excess of discipleship, exegesis, and hagiography, there is a counter tendency to caricature the history of philosophy as a series of mistakes and deficiencies, and to take past philosophers in hand as though they were ignorant or recalcitrant schoolboys. Bertrand Russell's history of Western philosophy exemplified such a harsh, superficial attitude; Paul Weiss has not himself been immune from this cavalier treatment of history; his Harvard graduate-school colleague Charles Hartshorne has made a career of such rhetoric.[9]

The caricature of the history of philosophy as a series of problems and mistakes stems from seeing philosophy itself as inductive and empirical, but also deductive, rational, and logical, in analogy with the natural sciences. Philosophy, on this model, is primarily an argumentative and combative exercise. Accordingly, philosophy's history (on this same model) can be consistently portrayed as an ongoing competition between rival and mutually exclusive "theories," each of which can be cast in propositional form. Such philosophical positions or "theories" should be capable of falsification by appeal to evidence and to rational (i.e., deductive, syllogistic) argument—whence the history of philosophy can be portrayed as the refutation of rival positions, and ultimately, as the gradual triumph of truth over mistakes and deficiencies. The history of philosophy thus comes to occupy the position vacated by a similar (but now abandoned) view of the history of the natural sciences.

This background assumption about what philosophical activity is— viz., the discovery of truth through the successive refutation of false candidates for (or rival "theories" of) truth—encourages caricature precisely through the reduction of complicated and delicately nuanced views to their most superficial propositional form. The matter is made all the worse if the historian's attempt to render a philosopher's position in terms of propositions yields (as it often does) propositions that the philosopher in question never actually held![10]

But in truth, there is a kind of venerable tradition to this tendency to caricature: we find it first in Aristotle, who was often guilty of rendering what he took to be rival theories in false and even deliberately misleading propositional form, only to refute or "correct" them himself. Let us also note that Aristotle's concept is grounded in an explicit appeal to history and in perhaps the first clear-cut example we have of a history of philosophy.[11]

Lest what I am about to say end up providing merely another example of what I intend to condemn, let me hasten to qualify my remarks about Aristotle. We do not now know, for example, to what extent there may have been an ongoing collaboration or other sort of mutual influence of Plato and Aristotle upon one another in later years, a knowledge of which might serve to radically transform the general impression of mutual aversion, antagonism, and antipathy that has passed into history. Neither do we know what sort of once-complete texts, now lost to us, Aristotle himself may have possessed from the pre-Socratics, and upon which he may have based what would, in their light, turn out to be fairer evaluations than seem presently the case. Thus, what I am about to cite may itself be a vast misunderstanding and injustice, a case of a tradition of historical caricature in its own right.

What I refer to, then, may not be Aristotle's behavior, so much as the misimpression that historical transmission and loss have bequeathed to us. Nevertheless regrettably, and perhaps unintentionally, it is Aristotle (or, at least, it is the implicit object lesson that many contemporary philosophers derive from their limited reading of Aristotle) who gives rise to the notion that the literary and complex mythical views of pre-Socratic philosophers can be cast into propositional form, boiled down, summarized, analyzed, criticized, dismissed as inadequate, or "corrected" after the manner of a stern missionary instructing ignorant savages.[12] It is Aristotle who bequeaths to Western civilization the now-familiar and largely unquestioned proposition that Plato held a "theory" of Forms that can be encapsulated in a few short sentences, despite the fact that Plato not only denies ever holding such a theory, but also denies that such a theory could, in principle, ever be formulated.[13] It is Aristotle who seems, at least, to instruct by example, first how to caricature a predecessor or opponent by ignoring the historical or literary context of a philosophical discussion (such as the dialogic context of the discussion of the *eide* by Plato), and then how to demolish the resulting caricature under the guise of "rational analysis."

Thus through Aristotle, or else through an unfortunate, partial, and unflattering legacy from Aristotle, is born a now-venerable and long-standing tradition regarding the vocation of philosophy as a kind of warfare: a vicious debate between rival, and mutually exclusive positions with more or less "rational and evidential" warrant. Such an image of philosophy is utterly alien to the perspective of Plato, just cited above, in which one ascends to the realm of the true, not by logical technique, but by means of dialectic (which is never a source of certainty, but rather of warranted belief)—and thus not to *episteme,* nor even to *theoria,* but to *sophia.*[14]

We find echoes of this presumed Aristotelian legacy throughout the history of philosophy. For example, R.G. Collingwood, in his *Autobiography,* bemoans the ascendancy of the military style of philosophy as caricature and combat among the Oxford dons of his day.[15] It was apparently this view of philosophy as endless and pointless "rational disputation" prevalent among late medieval Aristotelians that wearied Gassendi, and may have impelled him (as Lynn Joy suggests) to seek alternative modes of philosophic investigation through his historical studies of the neglected works of Epicurus.[16] It was apparently also dissatisfaction with this argumentative and disputational style of philosophizing that led Italian Renaissance scholars like Nicholas Cusanus and Vico to the radical view that philosophy consisted, after all, in rhetoric, and that (in Vico's famous phrase) "the true is the made," in which case

the quest for irrefragable evidence or "knock-down" arguments is sophistry, and its pursuit doomed to produce only foolishness and what David Hume, for similar reasons, termed "false philosophy."[17]

It is this questionable Aristotelian legacy of rational combat that encourages Rorty (though perhaps there is a certain poetic justice in this) to offer frequently outrageous and historically naive speculations on "what an ideally reasonable and educable Aristotle could be brought to accept," or about the sort of "premises" onto which Plato might be "driven back" as adequate formulations of positions Plato himself never held, were he resurrected among us to participate in such thoroughly *un*edifying conversations about his philosophical views.[18] It bears further mention that this image of philosophy as "warfare" has been assailed by feminist critics in recent years as the *arche,* not of any presumed disinterested quest for wisdom or truth, but merely of male violence and aggressiveness. Finally, I would venture to claim on the basis of personal experience that it is this mode of philosophizing that has alienated philosophers from most of their academic colleagues in the modern university, and in the process transformed philosophy as a vocation into an object of popular ridicule.

My point in airing all this dirty professional laundry is that this, the most infamous and now widely criticized and deplored method of doing philosophy, has deep historical roots in the Western tradition stretching back to Aristotle—and that, even there, this bellicose conception of the vocation of the philosopher is thoroughly grounded in, and depends vitally for its plausibility upon, a peculiar and still prevalent *abuse* of historical traditions that results in a caricature of philosophy and of the best philosophers.

VI. Inquiry and Reflective Historical Engagement: The Right Way to Approach Philosophy and Its History

I have thus far focused on all of the wrong ways to approach history in the service of philosophy. I now wish to return to one of my other main opening questions in conclusion. That question was: in what sense is the study of history supposed to give rise to contemporary philosophical reflection, or participate in formulating contemporary philosophical problems? Are there prescriptions for adequate uses of history in philosophy?

I have repeatedly invoked the image of Professor Weiss's own teacher, Alfred North Whitehead, during the course of the foregoing discussion. I

make no secret of, or apology for the fact that I regard Whitehead as one of the twentieth century's most profound and original, and also misunderstood and underappreciated philosophers.[19] Whitehead, I have argued, deserves a place in the canon of Western philosophy alongside the likes of those major figures whom he himself read with such inspiration: Plato, Locke, Descartes, and Hume. In this century, only Wittgenstein rivals Whitehead's originality and accomplishment.

I find it thus especially instructive to turn to the contrasting examples of Whitehead and of his own student and colleague, Bertrand Russell, regarding the manner in which both of these philosophers came to terms with the history of philosophy. Russell, as we know, wrote a best-selling history of Western philosophy, and was renowned as an interpreter of Leibniz and Hume. Whitehead wrote no history, nor did he produce a book-length study of any of the major figures of Western thought. Yet when we examine the original work of each, it seems transparent to me that it was Whitehead, rather than Russell, who was actually reading, studying, and deriving inspiration through a kind of sustained dialogue with the history of Western thought.

Russell's "history," for example, consisted largely of caricature and castigation of the errors and mistakes of past philosophers. He evidences no real knowledge of, let alone empathetic appreciation for Kant, Hegel, or other more recent European philosophers. He was especially snide and dismissive of William James; yet, years later, Russell came to adopt as his own a metaphysical position quite akin to that he had earlier repudiated, even going so far as to describe his own position as a kind of "neutral monism," after James. Russell's distaste for Bergson and Bradley are, of course, legendary.[20]

Now contrast this with Whitehead: though he disagreed sharply with Bradley and cast himself as a critical realist in opposition to Bradley's monistic and mystical idealism, Whitehead studied Bradley carefully and incorporated a number of the latter's arguments and positions in the text of *Process and Reality,* acknowledging a deep indebtedness to this historical "conversation" with Bradley's work.[21] To each of the other figures cited—Bergson, Hume, Leibniz, and James—Whitehead reacted with moderation, care, and historical sensitivity, carrying out a critical dialogue that resulted in the derivation of some important new insight from each of these historical figures for Whitehead's own original philosophical position.

Indeed, when we survey Whitehead's *magnum opus, Process and Reality,* and his other great work, *Science and the Modern World,* we perceive that Whitehead did his best and most original work not in the

form of private and idiosyncratic reflections of limited scope, but in the form of a sustained, ongoing dialogue with the great figures of Western philosophical thought.

Science and the Modern World, for example, presents us with one of the first historical treatments of the rise of modern science in the demise of medieval and Renaissance thought. Indeed, almost half a century before Thomas Kuhn's great work, Whitehead argued on historical grounds that Newtonianism was an historical artifact whose nineteenth-century triumphs masked the inconsistencies and incoherence contained within its earlier synthesis of what had once been rival historical positions fraught with tension and debate. While demonstrating how historical consensus for a dominant scientific paradigm is gradually forged over time, Whitehead simultaneously exposed those hidden fractures and inconsistencies, suggesting precisely that new physical discoveries would threaten to blow apart this fragile consensus and bring about a revolutionary transformation in a culture's world view.

The original text of the 1927–28 Gifford Lectures, comprising the core of *Process and Reality,* continues this historical dialogue in broader compass. Whitehead's "essay in cosmology" proposes, in fact, to discuss his own metaphysical system against the backdrop of what the history of philosophy "discloses," according to Whitehead, as the "two cosmologies which at different periods have dominated European thought, Plato's *Timaeus,* and the cosmology of the seventeenth century, whose chief authors were Galileo, Descartes, Newton [and] Locke."[22] Part II of *Process and Reality,* the bulk of the Gifford's text, introduces and "derives" most of the main concepts of Whitehead's own event metaphysics as a product of his analysis of positions and arguments that he finds in Plato, Kant, Hume, Newton, Spinoza, and especially Locke.

The course of these arguments make it clear that Whitehead was neither trained nor skilled as a textual exegete or intellectual historian. His reading of Locke, though detailed, enthusiastic, and appreciative, is quite idiosyncratic and selective. His interpretation of Kant is limited and highly suspect; his dismissive account of Hegel smacks of the worst excesses of Russell, and certainly reflects the unlearned bias of the period. Whitehead's appreciative "footnotes to Plato" consist much more in a series of footnotes to Aristotle, whom, according to R.G. Collingwood, Whitehead had not read extensively. All these *desiderata* are treated in detail elsewhere.[23]

My point is thus certainly *not* to extoll Whitehead as a consummate "historian" of philosophy. He was not.[24] Rather, Whitehead saw *philosophy itself* as irreducibly historical, as a kind of vast, ongoing conversation in which one must immerse oneself, and to which one's own philosophic

stance is constructed as a response. That method or approach—a critical reverence for the historical traditions of philosophy that I would term "reflective historical engagement"—constitutes Whitehead's greatest contribution, far beyond the specifics of his own cosmology.

VII. CONCLUSION

Whitehead's major works illustrate an attitude or method toward the "doing" of philosophy which contrasts sharply with the prevailing attitudes that I cited at the outset as characteristic of anglo-American philosophy in the twentieth century. This approach to the originality of one's own work likewise stands in sharp contrast to the approach taken by my invited MSA lecturer on time, recounted in the opening of this paper.

Professor Weiss's perspicuous question to that lecturer—"Whom do you *read?*"—thus serves as summation for the entire thrust of the present argument. While one's reading cannot be arbitrary or incompetent, neither must it be the sort of scholastic pedantry and antiquarianism that has often passed for historical or textual scholarship. The reading is, rather, an inspiration or stimulus to one's own thought through the creative encounter with the living thoughts of those who have preceded.

It is precisely in this sense that I claim that philosophy is irreducibly historical; namely, it begins and ends in a continual dialectic with themes and issues bequeathed as the legacy of the past. New philosophic insights will emerge only from this "reflective historical engagement" with philosophy's history.

More recently, in Professor Weiss's living room study, the conversation turned from a lively debate about our relationship to and use of history and historical texts, to the question of death and immortality. "I have a private wish, a hope," Weiss remarked, "that this sort of thing doesn't end here, but that there will be a kind of place for philosophy and philosophers. Plato, Aristotle, and Descartes will be there, among others, and my fondest hope is that I shall be privileged to draw near and to listen to them." I have little doubt but that Weiss will be welcomed and included there, as he has been here, as a vigorous participant and contributor to that "conversation that we are."

GEORGE R. LUCAS, JR.
DIVISION OF RESEARCH PROGRAMS
NATIONAL ENDOWMENT FOR THE HUMANITIES
JUNE 1992

NOTES

1. *Reality* (New York: Peter Smith, 1939), p. 209.
2. Cf. Paul Weiss, *Privacy* (Carbondale, Ill.; Southern Illinois University Press, 1983); and also Robert C. Neville, commenting and elaborating upon this metaphysical definition of determinate being in *The Recovery of the Measure* (Albany, N.Y.; SUNY Press, 1990).
3. Cf. "Philosophy, Its History, and Hermeneutics" in *The Philosophy of Hans Georg Gadamer*, ed. Lewis E. Hahn (LaSalle, Ill.; Open Court; forthcoming, 1996). Library of Living Philosophers series.
4. E.g., in *Three Rival Versions of Moral Enquiry* (Notre Dame, Ind.: Notre Dame University Press, 1990); cf. his more recent essay, "Narrativity and Truth," and my own analysis, "Refutation, Narrative, and Engagement," both in *Philosophical Imagination and Cultural Memory: the Philosophical Uses of Historical Traditions*, ed. Patricia Cook (Durham, N.C.: Duke University Press, 1993).
5. I argue for this description of the history of philosophy in greater detail in "Refutation, Narrative, and Engagement: Three Conceptions of the History of Philosophy," in *Philosophic Imagination and Cultural Memory*, 104–21.
6. Cf. Patricia J. Cook, *Forgetting in the Dialogues of Plato* (Diss. Emory University, 1992).
7. In his own autobiographical remarks for this volume, Weiss himself provides ample illustrations of this point—none more charming than his experience as a young assistant professor and the first Jewish faculty member at Bryn Mawr College, to whom a female student remarked in wonder: "You speak to us of Plato and Aristotle, but you sound like my tailor!"
8. "Philosophy and History: 4 Genres", in *Philosophy and Its History*, ed. Jerome Schneewind, Richard Rorty, and Quentin Skinner (Cambridge: Cambridge University Press, 1984), pp. 61–67.
9. Cf. "Hartshorne and the Development of Process Philosophies," in *The Philosophy of Charles Hartshorne*, The Library of Living Philosophers, vol. XX, ed. Lewis E. Hahn (La Salle, Ill.: Open Court, 1991), pp. 509–10.
10. Alasdair MacIntyre offers an instructive example of this process of caricature at work, attacking the impoverished and confused interpretation by R.M. Hare of *akrasia* as alleged "moral backsliding" in Plato. On MacIntyre's account, Plato could not, with competence and plausibility, be made to hold the position that Hare attributes to him, and then proceeds to dismantle; cf. "The Relation of Philosophy to Its Past," in *Philosophy and its History*, p. 35ff.
11. E.g., in his account of the developmental history of metaphysics, in Book A of the *Metaphysics*, chs. 3–6; 983a24–988a32; and in the *Physics* at several junctures: e.g., 187a11–187b6, 191a22–192b5; 196a17–196b10. Though he disagrees sharply with my attribution of this "bad habit" to Aristotle, Alasdair MacIntyre also observes, against those who hold that Plato held positions and advanced arguments in the manner of a contemporary analytic philosopher: "To call [a] context dialectical is to say that we misunderstand Socrates if we take him in these passages to be making *assertions* in the course of moving towards *conclusions*. . . . Socrates' philosophical activity . . . was a very different kind of activity from that in which most subsequent philosophers have engaged when they have asserted promises [sic; premises] and inferred conclusions, *and the first*

subsequent philosopher to misunderstand him was Aristotle." Cf. "The Relation of Philosophy to its Past," p. 36; my emphases.

12. So in *Physics* I:8, for example, Aristotle discusses the "difficulty of the early thinkers" who were "misled in their search for truth and the nature of things by their inexperience" (191a22–25), offers a patronizing account of their "errors" (191b11), and how, if only they had had the vision of truth now accorded to the author of the *Physics,* "all their ignorance would have been dispelled." (191b43).

In the famous passages from the *Metaphysics* I:3, Aristotle acknowledges the mythical origins of early Ionian views like those of Thales (983b29–984a5), but does not perceive any philosophical or historical significance in this genetic account, other than to brand such views as early superstitious nonsense. Subsequently, he disparages the accounts of Hesiod and Empedocles concerning love and strife, suggesting that they grasped the significance of their own views "vaguely, and with no clarity, but as untrained men behave in fights" (985a14); that, in general, the Presocratics "do not seem to know what they say" or were guilty of either inconsistency or, in the case of the atomists, "lazy neglect" (985b19).

13. Aristotle discusses Plato's "theory of forms" in the *Metaphysics [Alpha,* ch. 6] referring to the propositional summaries on this topic which he attributes to Plato as a "theory [which is] not a reasonable one" (988a). The matter is complicated further, in that *theoria* does not carry the same connotations of "foundational, propositional claim in falsifiable form" associated with the modern English term "theory." In addition, W.D. Ross (whose translations I am citing) frequently translates *eide* interchangeably as "Ideas," "Forms", "universals," and "essences" (cf., e.g., Ross's translation of 987b, l. 3, 14, 19; 988a, l. 9–11, etc.). See also Alasdair MacIntyre's comment on Aristotle in n. 11 above.

Plato seems to deny the very possibility of a "theory" of Forms, as well as disavow his own formulation of such a theory, in his disputed "VIIth Letter." However, there is ample evidence for this position in canonical works. The Forms are certainly not to be described as logical or metaphysical essences or universals, as Aristotle (and many commentators since) sometimes seems to suggest. Rather, each *eidos* is, Socrates says, ὑπόθεσις [*Phaedo* 100b], a "supposing," a provisional hypothesis. Indeed, Socrates describes dialectic in Book VI of the *Republic* (511b–c) as the procedure by which one ascends a ladder from opinion to truth—*logoi* passing through a series of *eide,* each described as: "assumptions *not* as absolute beginnings but literally as hypotheses, underpinnings, footings, and springboards so to speak, to enable it [reason] to rise to *that which requires no assumption* and is the *archai* of all . . ." [Richard Shorey trans., p. 115; my emphases]

14. Indeed, Aristotle specifically rejects this Platonic conception of philosophy at *Metaphysics* 1004b25, describing dialectic as "merely critical, whereas philosophy claims to know [episteme]."

15. R.G. Collingwood, *Autobiography* (Oxford: Oxford University Press, 1939), ch. VI "The Decay of Realism."

16. Cf. Lynn Sumida Joy's conjectures on this point in *Gassendi the Atomist: Advocate of History in an Age of Science* (Cambridge: Cambridge University Press, 1988), pp. 37–38.

17. Cf. Donald Phillip Verene: "Canons for Speculative Philosophy," in

Journal of Speculative Philosophy 1, no. 1 [new series] (1987): 21–43; and *Vico's Science of Imagination* (Cornell University Press, 1983); cf. also Donald W. Livingston, *Hume's Philosophy of 'Common Life'* (Chicago: University of Chicago Press, 1984); Nicholas Capaldi, *David Hume* (New York: Peter Lang, 1990).

18. Rorty, "The Historiography of Philosophy," pp. 51, 53.

19. Cf. *The Rehabilitation of Whitehead: An Analytic and Historical Assessment of Process Philosophy* (Albany, N.Y.: State University of New York Press, 1989), passim.

20. I trace the evolution of Russell's thought in *The Rehabilitation of Whitehead,* ch. VII.

21. E.g., *Process and Reality* (New York: Macmillan, 1929), pp. vii–ix. Cf. also Leemon McHenry, *Whitehead and Bradley* (Albany, N.Y.: State University of New York Press, 1991).

22. *Process and Reality,* p. ix.

23. I have simply given a quick summary here of arguments offered in great detail in my *Rehabilitation of Whitehead.* For further discussion of Whitehead's relation to Kant and Hegel, cf. my essays "The Interpretation of Kant in Whitehead's Philosophy," and "Eine Whiteheadische Auslegung der Naturphilosophie Hegels" in *Whitehead und der deutsche Idealismus,* ed. George R. Lucas, Jr. and Antoon Braeckman (Frankfurt and Bern: Peter Lang, 1990), pp. 13–32; 83–92.

24. For example, in *Process and Reality,* Whitehead argues that apart from actual entities and their adventures, "all the rest is silence." These words, which his disciples often quote and attribute to him, in fact represent Hamlet's final, dying words in Act V. But here Whitehead misses a trick: if he were going to quote from Hamlet (*Process and Reality* is sprinkled with quotes from Shakespeare, including especially "Hamlet" and "A Midsummer Night's Dream") he should have quoted Hamlet to Horatio earlier in Act V, scene ii: "Some god there is who shapes our ends, rough-hew them how we may." The metaphysical doctrine of *Process and Reality* could be summed up by inverting the phrase: "Some god there is who *rough-hews* our ends, shape them finally how we may." History, its documents and traditions, needs to be carefully and thoroughly and thoughtfully used to make our case most effectively for us. Whitehead was, like most, something less than a master of this technique. But he was, unlike many, its conscious user and proponent!

REPLY TO GEORGE R. LUCAS

George R. Lucas and Andrew J. Reck are different types of philosophic historians who are also historians of philosophy. Where Reck is more inclined to trace the thoughts of individual thinkers, Lucas is more interested in the history of philosophy, the import of history, and the roles some of its major figures play in it. Each also is interested in doing what the other focusses on. I agree with almost every thing he says about the importance of the history of philosophy, though I would give much greater weight to the distinctive contributions the major thinkers made, sometimes in ignorance of what was said by others, and oblivious of contributions that would have helped clarify, subtletize, and advance what was being developed.

A history of philosophy is a history of great thinkers, not because they had once existed, but because they were great thinkers. Some, like Hegel, had a fine grasp of the history; others, like Descartes, paid little attention to it. Like the history of painting, the history of philosophy is dotted with a number of great figures who have struggled on their own, hardly aware that there had been others. Many a revolution has been begun in reaction to what was seen to be distortive and destructive, but with little knowledge of how it had become so. Granted that the successors to the medieval thinkers discarded much that deserved to be preserved, it does not seem likely that they would not have taken the sharp turns and made the great leaps that they did, had they known what they were ignoring or misconstruing. Sometimes it is desirable to continue along a straight road; sometimes it is better to get off it.

Philosophy is not encompassed within a single temporal span. Nor is it forever tied to the great philosophers of the past. The first philosophers, evidently, had no history of philosophy to fall back on, though they, too,

had their antecedents and must have learned something from their contemporaries and what was known by previous thinkers in allied fields. It would be wasteful, petulant, and finally self-defeating for anyone to suppose that later thinkers could do little more than provide footnotes to an idealized philosopher's thoughts. Such a move betrays an ignorance of the history of thought. Whitehead and Heidegger made the same mistake, the one out of ignorance, the other deliberately, the one too readily endorsing, the other dogmatically condemning a common heritage.

I agree with Lucas that philosophy is not hermetically sealed off from its history. Nor are its practitioners detached from their contemporaries. Philosophy is a subject so difficult, with a scope so great, instruments so poor, conclusions so novel and daring, and using methods so insufficiently tested, that one would be foolish not to look for help wherever it could be obtained—in the history of philosophy, in contemporary discussions, in other disciplines, from one's friends, and from one's colleagues and students. Lucas does not do justice to his own intent when he jumps from Plato and Aristotle to Whitehead and Weiss.

There was much missed by those who lived after Aristotle and before Descartes. Much was routinized, distorted, and too quickly tucked inside a questionable theology, but they also added to and subtletized what they understood to have been earlier views. They did understand the role and importance of commitment, transcendents, ethics, law, tradition, and religion, as well as the distinctiveness of humans. They did not recognize the horror of slavery, the nature and dignity of women, the need for explorations, the nature of human creativity, the democratic state, or even the purpose that Aristotle took logic to serve. It would help modern logicians if they went back to Aristotle to discover what he thought it should help one do. It would then be evident that he was right to deduce 'some' for 'all', and that he understood the middle term in a way they do not.

Lucas rightly stresses the importance of history and particularly of the history of philosophy, as well as the fact that philosophers belong to an historically tempered enterprise. He then rather quickly and with an overemphasis, obscures the fact that the history of philosophy is a history of *philosophy,* and that the community of philosophers has a future as well as a past. Projects like *The Library of Living Philosophers* make evident that it has a present as well, quite different from that in which scientists live.

A philosopher who listens to nobody should not be surprised to find that no one listens to him. Yet every philosopher must start afresh and

proceed on his own, over a largely unexplored territory. He unduly limits himself if he tries to fit in neatly with those who had preceded him, allows himself to be pulled into current trends, or to anticipate what the next turn will be in acceptable, current talk. Other philosophers, in the past and in the present, are there for him to use, learn from, be criticized by, even made to be more formidable than they in fact are. He would be most historical if, instead of trying to adapt his thoughts to what others past or present might claim, he began afresh and, in any case, did not necessarily confine himself to digging at the same places with the same instruments, or stopping where they had. I think Lucas would agree. My remarks then should serve mainly as reminders or cautionary notes.

There is no place that could be properly said to be unable to provide a stimulus, knowledge, challenge, suggestion, correction, or direction to one intent on finding final answers. Every fact and truth can test the reach and claim of a philosophic account. There are personalists and panpsychists who must be dumbfounded by discovering that there is something that they can eat; materialists who must be astonished to learn that what they say can be misunderstood, epistemologists who are left speechless when they discover that they can be perceived, and language philosophers who are perplexed by the fact that they want others to agree with them, not only verbally but in fact. All exhibit a slide from the path of inquiry into the roots of things that presumably interested them initially, and that continue to affect them as they carry out an inquiry that seems to face unresolvable difficulties about its place and referents. All the while, each labors alone, even while remaining alert to the danger of clinging too close to great predecessors or of ignoring them altogether. There is an ever present temptation to fudge, slide over difficulties, to be overconfident, to express the vices that one should always be on the alert to counter.

A philosopher is always alone—and always together with those who have contributed to the traditions he inherited and who continue to peer through both his innocent and his sophisticated suppositions, rejections, and affirmations. History opens our eyes, but sometimes it blinds. It should help and protect, but also prompt one to move on in ways and along paths that had not been previously traversed.

History and community are indispensable, but it is not to be forgotten that they are not to be accepted but used, perhaps even made to serve a purpose of which they have no inkling. The object is not to fit in with the past but to progress, and thereupon to belong to history in a way one otherwise could not. Much is gained by studying the history of architecture, provided only that one remembers that we are not Greeks

or medievals, nor their negatives. What is true of architecture is true of other enterprises, including the writing of the history of philosophy. As Lucas rightly remarks, "philosophy cannot start over from zero each time," but one must quickly add that it also cannot rightly suppose that all or most of the work has already been done. Better: philosophy always starts here and now, but then makes use of what it can and should in order to penetrate a little further into the tempting darkness that meets our first, earnest questions, and hovers over our most sophisticated answers.

Lucas rightly notes "philosophers are obligated to give reasons." He seems to assume that the obligation is to others. That surely is right. In addition, though, there is the obligation one has to oneself as dedicated to the task of grasping the totality of reality in principle, and as subdivided into its essential, and other major components.

I think Lucas is mistaken in thinking that novelists create out of nothing. Like other creators, they too begin with an awareness of what is below the surface of things. So do philosophers. These may, but they need not begin "in the midst of historical conversations about historically-generated questions or problems." It would take hard work, though I suppose it is possible, to see even a Descartes, a Hume, or a Kant having such conversations.

The modern philosophers whom Lucas admires and praises, I have already remarked, had a poor grasp of the history of philosophy. I do not claim to have much of a grasp, but it is much greater than theirs. Whitehead's early books show little interest in history, and whatever history he does acknowledge is quickly tailored to fit in with his interests in the course of science and cosmology.

Are philosophers more "like jurists and rabbis" than they are like poets or other artists? I think not. Jurists and rabbis yield more to tradition and dogma than philosophers should. They share artists' interest in the depths of things, and are willing to begin again and again to produce works that have their own integrity, and yet benefit from one another. There is no constitution, precedent, holy book that philosophers pledge themselves to uphold and re-present. Not anarchists, they also are not upholders of a tradition or a dogma. No one in the present or the past has the right to say how the quest is to be carried out, though questions and criticisms are needed to make sure that what is thought and said is viable, and that it points the way to what is next to be done. For a philosopher, history is important, but it is not of paramount importance. With other enterprises, it offers indispensable help. A philosopher is no cave dweller, but one who has managed to break enough of his chains to peer at what is drenched in light. He does not have to get used to being

in the light, but he must be helped by those who have attended to what he did not, and then, not just in order to see better, but to see further.

Lucas says that an individual philosopher might "hammer out his or her own unique perception of the world" but that would find her not philosophizing but engaged in poetry and mysticism. I think he misconstrues both poetry and mysticism. There is, moreover, a history of poetry of which many poets are acutely aware, and the fact that most mystics are members of particular religious communities. More important: lonely labor is but the other side of the use of what others had done. I think Lucas stops too short with his Plato and Aristotle, his Whitehead and his Weiss.

The first man to ask "Who am I?", "What ought I do?", "What is real?", "What is being presupposed?", "What can I know with certainty?" was a philosopher in embryo. Everyone after him had to ask the same questions in some form or other, quite near the beginning of his venture. A philosopher does not forge a "private and unique perspective on the world." What interest could that have for the rest of us? What he seeks is a carefully developed view of reality that he tests just by being who he is, doing what he does, and saying whatever he may. He leaves his singular mark on what he presents, though that is not what he sets out to do.

Everyone of us is with and apart both from some who have been and those who now are. Our differences are mainly a matter of degree, all the while that each of us is unique and exhibits that fact in what each does. Were our uniqueness too prominent the result would be idiosyncratic; if hidden, the result would be abstract, remote, dislocated. The perspective that any one might provide should be no more than an inescapable strand running through whatever is maintained. It is usually of not much interest except for those who seek to discover otherwise overlooked clues or biases. Usually, though, we look for it only after we have learned that someone has acted in disgraceful or very questionable ways. We tend to ignore Plato's employment by a tyrant; but we remember Heidegger's life as a Nazi. The achievements of the one and his assumed guise of a reporter of Socrates have allowed most to put aside the low esteem in which Plato was held by contemporaries. The achievements of the other become less and less of interest the more evident it becomes how snarled the thread is that runs through his works. Perhaps Lucas would agree. If so, let this serve as a means for shoring up a needed corrective to regrettable tendencies in some academics, and as a warning that vice corrodes the expression of the most original ideas.

I am somewhat surprised by what he says about Peirce. It is wrong to fit him wholly in the nineteenth century, for he did important work for a

decade after 1900. I am also surprised by what he says about the importance of Wittgenstein. I must have missed what had preceded his strange remarks.

I am so heartily in agreement with Lucas's criticism of the poor way some contemporaries have treated the history of their subject that I wish he had indicated why he incidentally included me among those he condemns. I do not have his mastery of the history of ideas. If I am subject to the kind of criticism he has levelled against Russell and Hartshorne (both of whose histories I have reviewed unfavorably) I wish he had made this evident, and that I have the ability to reform. I doubt that philosophy is irreducibly historical or that it begins and ends in a continuous dialectic with themes and issues received from the past. That doubt does not becloud my appreciation of Lucas's robust defense of the value of a good historical understanding of philosophy, but with the caveat that this is only part of a great, grand, unending task.

P.W.

7

Thomas R. Flynn

HISTORY AND HISTORIES: WEISS AND THE PROBLEMATIZATION OF THE HISTORICAL

Systematic philosophy, the kind fashioned by the founders of the discipline as well as its most honored practitioners, has been out of favor in the English-speaking world at least since Moore and Russell turned against the idealism of F.H. Bradley and his predecessors late in the last century.[1] On the European continent it barely withstood the attacks of Kierkegaard, Nietzsche, and the Vienna Circle, if one dare mention these three in the same phrase. True, idealism survived in aesthetics on both sides of the Channel, and the ghost of Hegel continued to haunt philosophical Marxists and existentialists.[2] But the speculative metaphysics that grounded philosophy in the grand style, enabling it to bring "the many into the one," or at least to endeavor to do so, was largely set aside in favor of more "modest" undertakings such as logic, epistemology, ethics, philosophical psychology, and, of course, the philosophy of language.

The career of the philosophy of history as a subdiscipline rather mirrors this transformation. The predominance of Hegel and Hegelianism, including its historical materialist avatar, entailed a growing respect for history with a capital "H." The evolutionary model came to dominate biological and social science in late modernity. As Foucault put it with characteristic acuity:

> What first comes to light in the nineteenth century is a simple form of human historicity—the fact that man as such is exposed to the event. Hence the concern whether to find laws for this pure form (which gives us philosophies such as that of Spengler) or to define it on the basis of the fact that man lives, works, speaks, and thinks: and this gives us interpretations of history from the standpoint of man envisaged as a living species, or from the standpoint of economic laws, or from that of cultural totalities.[3]

But in our century, such "speculative" philosophy of history, as it came to be called, found, for example, in the works of Spengler and Toynbee, tended to be dismissed by philosophers for at least two reasons. It was perceived as fatalistic and pessimistic or as anti-democratic and totalitarian, though the latter criticism would scarcely apply to Toynbee. But the chief reason for its decline was the corresponding demise of metaphysical (read "holistic") accounts of reality itself. After all, it seemed to be urged, if the whole is nonexistent or unintelligible, why attempt to connect the parts? In fact, for the more metaphysically inclined, it could be argued that, without a whole, there is no such thing as a part. History, then, appears reduced to the positivists' "one damn thing after another." Any attempt to make sense of it *all* seems redolent of the infamous "blind man in a dark room looking for a black cat that isn't there" . . . and finding it.

Enter the epistemologist and the philosopher of the social sciences. Just as epistemological questions seemed to take center stage in our philosophical reflections on the age of "British Empiricism and Continental Rationalism" (whose very designations are epistemic), so those philosophers who addressed questions of history at all, did so in terms of methodology (holism versus individualism) and epistemology (cause versus reason, lawlike explanation versus "understanding"). One could discuss the nature of historical reasoning in the context of scientific investigation generally, its homogeneity or heterogeneity, for example, without having to bother with such "metaphysical questions" as Does History have an existence apart from the agents who live it? Does it carry a meaning and/or goal of its own? Does it have its own distinctive time, space, power, and causation? The philosophy of history, especially in the English-speaking world, became a subspecies of the philosophy of the social sciences, its questions derived from the problems proper to that field.

Paul Weiss has always been a maverick. His originality is due in part to his unwillingness to "go with the flow," whether it be with the antiseptic dismantlings of analytic philosophy, the angstful musings of existentialism, or even the compromising spirit of pragmatism. As befits a profound thinker with a mind of his own, his reading of other philosophers is more in search of challenging questions than in pursuit of answers. His answers are his own.

And so it is when this systematic thinker turns to the inevitable question of our historical being, for it is always in terms of "being" that he philosophizes. A kind of metaphysical Midas, every topic he touches turns into a facet of being. This is both his strength and his weakness. For it locates him in the venerable tradition of classical Western philosophy

extending back at least to that "sober man in a band of drunkards," as Aristotle characterized Anaxagoras.[4] Indeed, one suspects that this is how Weiss sees his philosophical self in the contemporary intellectual community. But his metaphysical habit of mind likewise makes him vulnerable to every form of anti- and now post-metaphysical philosophizing that comes along. Intellectual street fighter that he is, he doubtless enjoys the scrapping. But it raises other problems that I shall mention toward the end of this essay.

Before turning to the elements of Weiss's theory of history and the general topics it addresses, I should mention another and increasingly popular alternative to the speculative approach in our day, namely, the narrativist. There is no doubt, or rather, there was none before the ascendancy of the *Annales* school of historiography, that history tells stories.[5] The peculiar "logic" of the story has come to be taken by many, analyst and Continental philosopher alike, as proper to historical explanation.[6] This has the twin advantages of avoiding metaphysical commitments while respecting the specificity of the "lived." Whether it exhausts historical "reality" is, of course, another matter, one reserved for the metaphysician, Weiss would insist.

I

History: Written and Lived,[7] the book on which I shall focus my attention, is dedicated to the distinguished historian of medieval philosophy, Etienne Gilson. It was Gilson who once quipped that metaphysics always buries its undertakers. This volume instantiates that claim. In fact, since its appearance, critics have remarked that it is more an essay in metaphysics than a philosophy of history in the current sense.[8] Although Weiss introduces it as one of an empirically ordered set of studies, including works on aesthetics, philosophical psychology, political and social philosophy, and natural theology, it presupposes the "speculative dimension" of his *Modes of Being* (1958), whose categories it works in and whose principles it applies.[9] Not that *History* is a simple variation on themes from *Modes,* as its critics have often claimed. On the contrary, Weiss is sensitive to the relative autonomy of these more "empirical" disciplines. He sees history as a domain with its distinctive being and rationale. He treats its categories and problems organically, as modifying and supplementing one another, which is not to say that he subscribes to an "organic" view of history or society in general, the discredited holism mentioned above.

Although Weiss sets as one of his objectives "to understand what

historians ideally do and accomplish" (4), his own work is suspiciously free of citations from, much less extended studies of, the works of actual historians. This has long been acknowledged as a flaw in his project. It was one of Collingwood's distinctions among philosophers of history in our century, that he was a practicing historian as well.[10] Of course, what William James would call the weasel word in the foregoing quotation is "ideally." This secures the metaphysical high ground for the philosopher, enabling him/her to direct empirical traffic down below: "You don't ask that question or employ this method? Well, you ought to." This penchant has made philosophers suspect in the eyes of working historians.

But what is seen by historians as immodesty is interpreted by philosophers as properly philosophical inquiry. Philosophy being the "science of presuppositions," it is natural to address the "takens for granted" of historical inquiry just as one asks about the unquestioned premises of natural science or ethical discourse.[11] The pinch is felt when these philosophical analyses cease being descriptive and become *normative:* "what historians *ideally* do and accomplish." What makes the term "ideal" slippery is its double function as denoting what historians "would like to accomplish" and what they "ought to accomplish." As Hume cautioned long ago, the descriptive imperceptibly becomes normative, the "is" funnels into an "ought." Weiss seems to trade on that ambiguity and thus runs the risk of failing to meet historians where they really are. This is less a criticism of Weiss himself, as we shall see, than of the approach he champions, the speculative discipline as such. But it states a *caveat* with which we must read any speculative philosopher of history.

Like Aristotle and so many of the rest of us, Weiss sees himself as a philosopher of the mean. This comes to the fore at the very start of his inquiry when he distinguishes his position from that of the followers of Croce and of Ranke, who in practice, he claims, fail to distinguish and separate "History" (written) from "history" (lived). With the "historians," he adopts the sane middle course: monuments and documents, ruins and inventions—each marks an ending for which there is a "relevant beginning from which an historical narrative could take its start" (9). But narrative must not be confused with the narrated, Hegel's *historia rerum gestarum* with the *res gestae.*

Weiss's sharp distinction between "objective history" or the "single sequential order, embracing all men," and its narrative, which he calls "history *tout court,*" enables him to incorporate the interests and selectivity of individual historians into his conceptual scheme. Again he appeals to the actual practice of "historians":

Historians also know that the present is the end of whatever past there is. This is true even when nothing of importance is happening in that present. The point is obvious, constantly misunderstood or overlooked—and of enormous importance. The historian quite clearly begins with something present. He could not avoid doing so. All his data are to be found there. He can perceive, observe, and think in no other time than the present. (9)

History, in other words, is understood "backwards," as Kierkegaard conceded to Hegel.

"But it is lived forwards," the protoexistentialist insisted,[12] and this too Weiss would accept, though in a very un-Kierkegaardian sense. It all turns on the notion of final cause (again, the sober Anaxagoras).

Like the historian's inquiry, the historic world . . . is governed by a final cause giving value, direction and meaning to what precedes it. . . . The historian thinks teleologically before he writes chronologically; the historic is governed teleologically when and as it becomes chronologically. (10)

But, of course, chronology is not teleology; not every sequence, not even every "ordered" sequence, is teleological. The names in the telephone directory are ordered, but the value of this ordering is purely instrumental. The name you are searching for is more important than all the rest "at the moment." And here the metaphysics of *Modes of Being* becomes ingredient in Weiss's argument. For at this juncture he introduces what I take to be the pivotal concept of his theory of history and the notion that most clearly separates him from most philosophers of history writing today: what he calls "the historic *ought-to-be.*"

II

Because Weiss sees the historic *ought-to-be* as "at best only a delimited form" of the absolute good which he discusses at length in *Modes,* one should review his position on that topic elsewhere. I shall not pursue it here. But because the concept is the distinguishing characteristic of his metaphysics of history, as we may now call it, I want to attend to its function in *History* in some detail.

This historic ideal must be distinguished from the empirical concept of what any historian might *de facto* take to be excellent, worthwhile, or right. (With this distinction, Weiss clarifies the ambiguity of "ideally" mentioned earlier.) It is a priori in the sense that it is both universal and unconditioned. As ideal, it creates a space in which to contrast what occurred with what might have been. Since the historian, Weiss insists, labors in the vineyard of the contrary-to-fact conditional, the contrastive and evaluative power of this ought-to-be is formidable and pervasive.

But its role is more than that of Weber's famous "objective possibili-
ty," which refers to the set of conditions that are jointly sufficient for the
occurrence of "something like" the historical event in question. Weber
used the concept of objective possibility to support the counterfactuals
that enabled him to distinguish "adequate" from merely "accidental"
causes of historical events. Thus the winning of the battle of Marathon
was an adequate cause of the subsequent rise of Greek culture whereas
the shots fired in Munich on a day in March 1848 were accidental to the
Bavarian revolution because we can conclude from an assessment of
objective possibility that, unlike the former, the latter "would have
happened anyway." "Objective possibility" is thus a nomological con-
cept for Weber. It presumes factual knowledge of conditions at the time
in question and knowledge of relevant empirical laws. What it yields is
not absolute necessity but various degrees of probability, high for the
adequate cause and low for the accidental. Unfortunately, "probability"
is a notion that Weber fails to clarify.[13]

Instead, the historical ought-to-be grounds the comparative judg-
ments between societies and epochs that Weiss insists are warranted by
reflective historians. If the historical ideal of human freedom requires the
bonum of the examined life, for example, we may well be justified in
condemning ancient Rome for not producing great philosophers. But as a
"historic" ideal, this ought-to-be must leave enough *spielraum* for the
contingency and ambiguity of human action, without which one might
register chronological sequence, but not history properly speaking.
Weber shares the intuition that history requires contingency and ambigu-
ity, but he grounds these features in the probability that obtains between
historical fact and empirical law. Since he denies that history is a totality,
he seems forced into this "epistemological" solution to the problem of
historical freedom. Weiss, on the contrary, while allowing that "historic
beings all act with some degree of unpredictable freedom (116), sees the
historical ought-to-be as unifying the dispersion of history into a
meaningful whole after the manner of Aristotle's final cause, the "cause
of causes." Weiss believes that at least some Marxists and religious
believers subscribe to a kind of predestination that sacrifices the reality
of human freedom to the actuality of the historic ideal.[14]

Weiss translates this problem into that of necessity and freedom.
Seeking the mean once more, he picks his way between Leibnizians, who
deny that the whole of history could be less good than it in fact has been,
and skeptics who assume that there is no way to distinguish between the
historically significant and insignificant. Against both extremes, he
insists that "all [that] men have produced in public through an interplay

with exterior forces is historic, that different items in the historic world have different values measurable by one ought-to-be, and that this ought-to-be can govern the past only by going through the gateway of the present" (17). If this sounds like Whitehead's ideal objects "concressing" into actual entities whereby the "many become one, and are increased by one," the resonance is not imagined.[15] Others will have dealt with the Whiteheadian dimension of Weiss's inspiration, so it may suffice simply to note it at this point.

The historic ideal has a content which Weiss elaborates throughout the book.

[It] encompasses all history. It demands that men be one, not be broken up into factions, not be opposed to one another's presence, being or promise. It obligates men to live in peace. . . . The historic ought-to-be asks of objective history that public men, severally and together, be there fulfilled, be at their best. Every outcome is defective to the degree it falls short of this historic ideal. Whatever is ineffective with respect to such a defective outcome is a desirable hindrance, slowing up the historic time by which that defective outcome was attained. (19)

In sum, the historic ought-to-be "endows all occurrences relevant to the peace and prosperity [of humankind] with historic status" (56).

As Weiss conceives it, this historic ideal of peace and prosperity is the bulwark against the erosion of relativism, both moral and epistemic. It enables us to assess the past in terms, not only of the present but of its *meaning* or significance for the future course of history. (This occurs always via the present on whose existence the reality of the past depends.) The ought-to-be enables the historian to recognize his/her perspective without falling into uncritical perspectivism. But the specific content of the peace and prosperity ingredient in this ideal is reciprocally dependent on a precise concept of human nature, to which we shall turn shortly.

How are we to gain access to this loadstone that gives direction to our seemingly dispersed and idiosyncratic behavior? What is the vehicle of its epiphany? The key lies in Weiss's reference to the necessary role of the "present" in dealing with the past. Meaning-direction, it seems, is a relation, which is discovered, not decided upon. And one term of this relation is our present: its actions and institutions, no doubt, but also our common sense, from which the scientist must distance himself but which the historian can never abandon. Again it is the "nuclear meaning common to different societal common-sensical worlds" that Weiss enlists to bring us out of our presentism and cultural relativism (31).

III

Historical Truth. Weiss insists that the historian never arrives at certainty; he or she "rarely ends with more than a not altogether sifted totality of plausible, hypothetical, guessed-at and imagined formulations of what had been." Indeed, if a choice has to be made, Weiss believes, the historian "will try to be comprehensive rather than precise or accurate. Were this not the case, he would rarely do more than date and catalogue" (45). In other words, the "filling in" of the blanks left between epistemic certainties, the connecting of the dots of historical fact into the flow of narrative is a case of conjecture and intelligent imagination.[16] Weiss is sensitive to the central role of hypothesis and informed "fictioning" in this process when he observes that "the historian seeks to provide a full account. He would like it to be true," Weiss concedes, but a "comprehensive account" is the defining feature of the historian's goal. Yet even here the metaphysical dimension is unavoidable. The historian too "wants in the end not merely a truth in history but a truth for history, or better, a shared knowledge in which the truths of history are but one part . . ." (47). Presumably, this epistemic commitment serves to distinguish the historian from the historical novelist, a point to which I shall return.[17]

Human Nature. Classical historian, Paul Veyne, cites Maritain approvingly to the effect that "any philosophy of history must be based on 'a sound philosophy of man.'"[18] Weiss is very much the classical metaphysician in this regard. He insists that the historian supposes "that there is a stable nature to man enabling one to provide a plausible link between his different manifestations" (53). Otherwise the sheer factual multiplicity would yield confusion, not intelligibility. Note that the root of whatever "plausibility" the historian produces is a function of a "constant unchanging human nature," for "it is only because there is a common core in all of us that we are able to identify ourselves with others and with what they have made their own" (54). The alternative, by implication, is brute historical facticity, empty chronicles, random linkages. The concept of chance is marginalized in Weiss's account. He subordinates it to a fundamental cosmology in which the normative dimension of human nature (the historical ought-to-be) is paramount. This is an object lesson in the sense-making role of human nature in total history. In other words, the battle over the meaning/meanings of history has already been waged on the metaphysical plane, Weiss implies, before contesting epistemologists or philosophers of social science even enter the field.

This normative function of human nature is operative in the telling

parallel that Weiss draws between biography and history. Both phenomena establish a unity amid the diversity of individual or collective lives respectively. He avoids the trap of reading history as national biography—a criticism leveled at traditional history by the *Annalistes*—because his metaphysics extends the horizon of narrative to all humankind. Here as elsewhere, Weiss gains a certain *acualité* by his trenchant critique of modernist categories and methods. But like the individual whose clothing is once more in style, Weiss's thinking does not quite fit the current mode. Not that he is a loose or shabby theorist; quite to the contrary. But there is more than one way to be unfashionable just as there is more than one way to get inebriated, though sobriety is of a piece. Indeed, his deepest convictions and claims are radically opposed to the relativist and anti-humanist tendencies and theses of so-called postmodern philosophy. Like those archetypical modernists, Hegel and Sartre, Weiss is a thinker of unities, though, unlike them, not precisely of totalities: "History takes account of common features and recognizes that there is a single mankind which is being diversely displayed over the course of time" (55–56).

Theory of Knowledge. Since the revival of skepticism and the rise of modernity, metaphysics has had to ride on the back of epistemology, a precarious vehicle, as a survey of modern philosophy attests. Again a philosopher of the mean, Weiss defends a broad empiricism in this domain, which claims that "we experience what we encounter, and we encounter powers, dispositions, habits, tendencies, inclinations, purposes, no one of which is sensed or observed" (86). It is in this sense that we "encounter" the past, which is both "inside" and outside the present. To the extent that it is "outside," it is reached by inference; insofar as it is "inside," it can be encountered (94).

Here as elsewhere, one could object that the absence of an operative concept of intentionality (such as we find in phenomenology, for example) lands Weiss in the implicit skepticism of an "inside/outside" epistemology regarding the past just as it does with regard to the present. The point of "historicity" as an ontological dimension of the human condition is precisely to evade such reliance on inference except to supplement a more primitive temporal "spread" of the individual across three dimensions. In other words, like Plato's Meno, if we were not already "in the past" to some degree, we could not reason our way out of the immediate. As Russell observed, it is not logically inconsistent that the entire universe along with our memories came into existence a moment ago (or, indeed, at this very moment).

IV

Historical Narrative. Indicative of changing philosophical interest and fashion is the fact that one of the shortest chapters of *History and Histories* is perhaps its most relevant to current discussion on the topic, namely, the one on historical narrative. As I mentioned earlier, the recent upsurge of narrativist approaches to historical understanding has been fostered by a general dissatisfaction with "covering law" and other models from the natural and social sciences to account for our experience of historical explanation. Weiss shares this uneasiness. But the narrativists part company with Weiss in their suspicion of the kind of metaphysical concepts and categories that he marshalls in almost Scholastic manner to explain "what historians actually do." An entire subdiscipline of narratology has arisen to bring insights taken from literary criticism to bear on historical intelligibility.[19]

In the remainder of this essay, I shall speak in a multiplicity of voices, none entirely my own. My purpose is to place Weiss's undertaking in a foreign landscape in order to see how it weathers the rhetorical storms that have been blowing our way in the past two decades. The effect may be as instructive for current "discourse" as it is illuminating for the metaphysics of history.

First of all, I believe that Weiss would object that narratologists confuse history lived with history written unless they respect the distinctions he introduces or their equivalent. The metaphysician will not be edged out of the conversation by merely changing the topic! After all, he/she has something to say about whatever there is, was or could be. It is only by being ignored, by being shut out of the dialogue, as it were, that metaphysics loses its force. It has not lost its voice, Weiss would insist, only its hearing in the present conversation.

In partial response but also as a gloss on Weiss's presumed objection (and an object lesson in the new discourse), let me cite an example from a working historian-philosopher, Michel de Certeau on the matter of historical "beginnings." Referring to the fact that any historical narrative deals with a limited portion of the time line extending from our present to the distant past (Weiss speaks of the historian's "desire to periodize" [96]), de Certeau points out:

> By allowing the present to be 'situated' in time and, finally, to be symbolized, narrative posits it within a necessary relation to a 'beginning' which is *nothing,* or which serves merely as a limit. The anchoring of the narrative conveys everywhere a tacit relation to something which cannot have a place in history—an originary non-place—without which, however, there would

be no historiography. Writing disperses through its chronological staging the reference of the entire narrative to something unspoken that is its postulate. This non-place marks the interstice between practice and writing. The qualitative gap between one and the other is doubtless manifested through the fact that writing de-natures and inverts the time of practice. But only a silent passage to the borderline effectively poses their difference. A zero-point in time connects one to the other. It is the threshold which leads from the fabrication of the object to the construction of the sign.[20]

De Certeau agrees with Weiss, in effect, that a qualitative gap between history and histories is a necessary postulate of historiography.

Weiss distinguishes sharply between the historic and the historical, between history (lived) and histories (written), as we have seen. He claims that the former in each of these pairs is "without gaps." Like Sartre's being-in-itself, Weiss argues that "the past is completely determinate, completely manifested, without potentialities, without any capacity to change or to become. It is what a present has left behind, no more, no less, *no other"* (105, emphasis mine). But it is precisely this "other," I would argue, that makes the past "history" and not merely "historical," as Weiss claims. It is the "other," as de Certeau points out, that constitutes the *difference* without which historiography cannot exist: "From this point of view [the non-place mentioned above], there is, within the Greek *episteme,* a link between the absence of zero in mathematics and the absence of history which thinks of the past as a difference" (WH, 111, n. 96). The gap is real and must be maintained. If we have a history and do not merely figure in an eternal return of the same, it is because as Augustine proclaims and Pascal repeated, "Something happened to man."[21] It is difference that accounts for the singularity and unrepeatability of the event.

But this harsh facticity of the historical event implies a tighter relation between history and histories than Weiss seems willing to allow. Our "historicity" is prior to the narratives we spin to give it voice. There are no facts "in themselves," free of context, waiting to be uncovered (one does not have to be an idealist to recognize this situation). Existential historicity is not an addition *ab extra* to a "history" that goes on without us. There is no history-in-itself; there is only history-for-us, even if that "us" is *Jedermann.* We are "in" the past the way we are "in-the-world," by virtue of our condition as "having already been." Whenever we try to reach a concrete perspective on our lives, we find ourselves *in medias res.* The "other" that establishes the "qualitative gap" is bilateral and reciprocal. Or so it could be argued.

Here we find ourselves in a perplexity. One of the hallmarks of idealist metaphysics is the claim that potentiality is intrinsically mind-

dependent, that wherever we discover or conclude to the existence of dispositions, powers, or what Aristotle called *dynamis* generally, we are in the presence of mind.[22] Without at least implicit reference to mind (however one may wish to conceive of it), one is left with that which is "completely determinate, completely manifested, without potentialities, without any capacity to change or become. . . . no more, no less, no other." This is not a confusion of History with history, as Weiss claims, but a characterization of being-sans-mind. One of the reasons why idealist metaphysics has been so at home with the philosophy of history is its championing (in Hegelian quarters and among relativists) of the position that *mind itself is historical,* not only that there is reason *in* history (like the *logos spermatikos* of the Stoics, a claim that Weiss could support), but that *reason itself has a history*—a basic thesis of Foucault's brilliant, if problematic, *The Order of Things.*[23]

As if to anticipate objections from poststructuralist thinkers, Weiss argues:

> There is, as a matter of fact, something absurd in the attempt to take the ultimately real to be events, process, flux. In such a universe there are no beings which can act, persist or be responsible. Artists, workers, ethical men, heroes, and villains would therefore not be part of it. A universe of flux provides no ground for a history in which men act. (118)

But Weiss is too harsh on these philosophers of history. Taking the part of *advocatus diaboli,* for a moment, I would point out that the radicality of the poststructuralist approach to history lies precisely in its denial that there has to be an "ultimately real," whether events, process, or flux. This is indeed, "something absurd" for a conceptual scheme that presumes such ultimacy as the ground of rationality. But this simply brings to the surface the fundamental fact that what we have between Weiss and the poststructuralists is a difference in philosophical *ethos,* not a metaphysical conflict or mere *lis de verbis.* Poststructuralist thinkers share a Wittgensteinian proclivity for the rule-governed but conventional. Yet their focus on the historical is a function of a Nietzschean rage for the contingent, the chance event. Taking Foucault as the model for this approach to history, it is the very "anthropologizing" claims of Weiss's metaphysics that he finds unacceptably constraining on thought. To think otherwise (*se déprendre de soi-même*), which Foucault takes for the "ethic of an intellectual" in our day,[24] is to bring this Other into play at every stage of thought. This means that one not exempt reason itself from the historical process.

Whether this leads to confusion or finally breaks a dogmatic rationalism is not to be settled a priori under pain of begging the question at

issue. The confrontation, if such even be possible at so primordial a level, between the poststructuralists and Weiss comes down to a "decision of principle" versus a set of fundamental insights. Foucault's "tool chests" are so many attempts to pursue to the utmost this ethos of thinking otherwise. What has resulted so far is a certain set of insights about specific regions of interest, especially in literary theory and the social sciences. These are the modest results of limited inquiries. But at their base is a hypothetical imperative, an ethos, not a *fundamentum inconcussum*. With the pragmatists and others, the poststructuralists are content to tread water in the middle of the pool rather than grasp frantically at sense data along the sides or stand firmly at the shallow end.

In sum, what distinguishes Weiss from contemporary poststructuralist philosophers is a profound *crisis of criteria*. Nowhere is this more evident than in their respective approaches to the nature and meaning of history. Again, Weiss, the philosopher of the mean, is facing what have been journalistically described as the "prophets of extremity."[25] But what must frustrate this metaphysical warrior profoundly is the *de jure* impossibility of engaging this new enemy in combat. The "disappearance of [the normative concept] of man," which Foucault hails as "the unfolding of a space in which it is once more possible to think" (OT 342), removes the very condition of the possibility of history as Weiss sees it. But there is no common ground, no shared *locus standi* from which to assess this space. Once more, it is not so much a question of the "end" of history as of the "end" of metaphysics. In an odd way, Weiss joins with the poststructuralists in insisting on the interrelation between these questions against the advocates of a nonmetaphysical philosophy of history. But the resemblance, as they say in the movies, is purely coincidental.

V

Weiss and the Utopian Urge. I noted the distinctive character and role of Weiss's "historical ought-to-be" in his theory of history. Remaining within the horizon of "what historians ideally do," he has set forth an image of universal peace and prosperity that has tantalized thinkers as diverse as Kant, Marx, and Sartre as they try to make sense out of human history as a whole. I wish to conclude with reference to a perhaps surprising similarity between Weiss and Jean-Paul Sartre in this regard. Of course there are profound differences as well, some of which will be noted in the process. But the striking similarity of historical values is indicative of something in the human condition—perhaps Maritain's

"sound philosophy of man"—that sustains the most disparate attempts to make sense of the vast configuration of actions, events, artifacts and institutions that we call the field of history. As if concluding an empirical generalization, Weiss observes: "It is the hope of mankind that these [individuals in communities and institutions] will never be entirely closed off from one another, and that eventually they will all merge into one civilized whole, without denying to the men their rights as individuals, or their roles as constituents of communities and institutions" (129). He adds: "History is mankind expressed over time, inching on in the production of a single civilization where men flourish in peace and justice, fulfilling themselves together as wills, bodies, minds, and persons." In other words, far from being an aimless sequence of events, "history, without qualification, is the process of the civilizing of mankind" (131).

What strikes me about Weiss's approach to history, in the final analysis, is its *evaluative* and *poietic* nature. History is going somewhere, it answers our basic need for excellence and hence for community, tranquility, and the other goods, instrumental for or ingredient in that full realization. But the histories we create are vehicles for *promoting* that goal. Weiss is less explicit on this matter and could learn from Sartre in that regard, but it seems to follow from the many parallels he draws between historian and novelist. As "poiesis," the craft of history has its own proper excellence. This includes faithfulness to the "facts," no doubt, but also fidelity to that drive for peace and well-being that urges us to forge ahead communally, despite individual sacrifices and collective set-backs. But this is precisely what Sartre called for on several occasions, especially in the posthumously published second volume to his *Critique of Dialectical Reason,* subtitled, "The Intelligibility of History."

Two years after Sartre had elaborated an original and far-reaching social philosophy in his *Critique of Dialectical Reason,* Weiss pronounced: "No man can . . . be a reflective existentialist, nominalist or personalist" (124). It is unfortunate that Weiss seems never to have read this work, much less its second volume, published in 1985, because there Sartre defends the historical ideal of "One World," an expression he will always cite in English. By "One World" he means both the *fact* of our modern technological interlinkages and resultant socioeconomic interdependencies, and the *value* of creating a "socialism of abundance" where freedoms would treat one another as free, a situation designated throughout his writings as "the reign of freedom," the "city of ends," the "reign of man" and the like. The point is that this functions as a Kantian *als ob,* fixing the meaning-direction (*sens*) that we may give to our past via our

present endeavors to construct a history (both written and lived, since writing history is a historical action as well) of peace and prosperity for all. The very writing of history, its selection of significant events and their incorporation into a plausible narrative contributes toward such a meaning-direction. In the end, the distinction between history (written) and the historical novel may be one of *degree,* not kind. As Raymond Aron and Sartre were fond of saying: History is a novel that is true.

VI

Teleology and the Paradox of Committed History. The foregoing comparison with Sartre is illuminating. It underscores the difference a metaphysics makes. Sartre was an ontologist but not a metaphysician, that is, he refrained from questioning our ultimate origins or ends, not because he did not respect such questions but because he found them ending in a "direct intuition of contingency."[26] Weiss would read this as a metaphysical black hole swallowing up history as well. He argues that the four modes of being are basic and irreducible. As the necessary conditions for human action, they are essential for anything like history to be real. "The historic world is one product resulting from an interrelating of the basic realities which make up the universe" (119). The edifying observations that Whitehead made here and there about "objective immortality" are echoed by Weiss in his discussion of the very real attempt by individuals to meet the challenges of "futility, guilt, and worthlessness" with which history inevitably plagues us. With one last bow toward the mean, he acknowledges the religious drive to meet these challenges, but betrays a certain Enlightenment prejudice by favoring "engaging in the arts or . . . participating in history" as the "direct" ways to meet the challenge to be effective, upright and worthy. In a manner that suggests Sartre's famous model of "exemplary choices,"[27] Weiss urges: "The values [ingredient in a complete life] can be acquired . . . if a man will make himself a representative of all mankind, firstly by separating himself from his own achievements and making them available to all, and secondly by accepting the achievements of others as his own" (138).

Both Weiss and Sartre imply what Aquinas and Maritain voice openly, that the philosophy of history belongs with *practical* philosophy, specifically as a subdivision of ethics, thereby giving primacy to the question of the good for the human agent as a social being.[28] If Weiss, with his insistence on the "speculative" nature of his enterprise, seems less convincing (or convinced) in this regard, his refusal to see his

approach to history as simply "applied metaphysics" supports my
contention. This is confirmed by the pivotal role he accords the "histori-
cal ought-to-be" in his theory.

Still, it is an intellectualist metaphysics that distinguishes Weiss from
the voluntarist Sartre in this domain. (It separates him from the
poststructuralists as well.) The ought-to-be is "discovered" in the cosmos
that Weiss's metaphysics sustains and explains. The historical "as if" is
decided upon in the Sartrean universe that has no ultimate why nor final
wherefore. To settle the matter by appeal to one or the other conceptual
schemes is to beg the question; to speak of ultimate undecidability or
reason-constituting "choice" is to do likewise. Again, we are faced with a
crisis of criteria: decision of principle or principled decision. Second-
level history has not so much carried us away from our roots and bases as
it has uncovered them for all to see and/or interpret.

<div align="right">THOMAS R. FLYNN</div>

DEPARTMENT OF PHILOSOPHY
EMORY UNIVERSITY
FEBRUARY 1993

NOTES

1. "It was towards the end of 1898 that Moore and I rebelled against both
Kant and Hegel. Moore led the way, but I followed closely in his footsteps"
(Bertrand A. W. Russell, *My Philosophical Development* [London: Allen and
Unwin, 1959], p. 54).

2. See George Kline's important essay, "The Existentialist Rediscovery of
Hegel and Marx," in Edward N. Lee and Maurice Mandelbaum, eds., *Phenome-
nology and Existentialism* (Baltimore: Johns Hopkins Press, 1967), pp. 113–138.

3. Michel Foucault, *The Order of Things* (New York: Random House,
1970), p. 370.

4. Actually, Aristotle's expression was: "He seemed like a sober man in
contrast with the random talk of his predecessors" (*Met.* A 3, 984b19). I thank
Steven Strange for this reference.

5. For a summary of the nature and rise of the *Annales* school of
philosophy, see Paul Ricoeur's Zaharoff Lecture, *The Contribution of French
Historiography to the Theory of History* (Oxford: Clarendon Press, 1989).
Because it was written in 1962, before the "Annalistes" became a household
word among nonspecialists, Weiss's book fails to mention either them or their
journal. Still, Fernand Braudel's path-breaking, *The Mediterranean and the
Mediterranean World in the Age of Philip II* had appeared in France over a decade
earlier (1949).

6. See Arthur Danto, *Analytical Philosophy of History* (Cambridge: Cam-
bridge University Press, 1965) and William Dray, *Laws and Explanation in*

History (Oxford: Oxford University Press, 1957), for the analysts, and Paul Ricoeur's formidable *Time and Narrative* (3 vols. [Chicago: University of Chicago Press, 1983–88), for the Continental side.

7. Paul Weiss, *History Written and Lived* (New Haven, Conn.: Yale University Press, 1962). Unless noted otherwise, all page references in the body of my essay are to this work.

8. See, for example, Charles Frankel's early review in *History and Theory* 4 (1964), 105–6.

9. In addition to the systematic account offered in *Modes of Being,* Weiss explains, "there should also be an empirically oriented set of studies revealing the experienceable significance of the realities which the systematic study isolated" (vii).

On the one hand, Weiss claims that *History* is not simply the application of the metaphysics of *Modes of Being* to the historical realm (see vii). Yet on the other, he explicitly appeals to the four basic realities exposited in the latter work, viz., Actuality, Ideality, Existence, and God, to explain "the world which the historian presupposes" (5; see 119 ff.).

10. The list of other prominent philosopher-historians or historian-philosophers would certainly include Max Weber, Henri-Irénée Marrou, and Raymond Aron, none of whom Weiss mentions in his study.

11. "But the past has a being which the historian takes for granted and which cannot be fully grasped by following his methods" (5).

12. "It is perfectly true, as philosophers say, that life must be understood backwards. But they forget the other proposition, that it must be lived forwards." Søren Kierkegaard, *Journals,* trans. and ed. Alexander Dru (New York: Harper Torchbooks, 1948), p. 89 (1843).

13. See my *Sartre and Marxist Existentialism. The Test Case of Collective Responsibility* (Chicago: University of Chicago Press, 1984), p. 73.

14. One of the aspects of Weiss's thought that has put him out of step with the philosophical parade as it marched through the '60s but which is beginning to regain attention in philosophical discourse both on the Continent and in the English-speaking world is his willingness to treat questions where speculative philosophy and theology overlap. In the philosophy of history, the issue of predestination, whether sacred or secular, is a prime example. The primary role of God in sustaining the reality of the past is another (see chapter 10). Not that these matters are once more common coin. But the virtual exclusion of theological questions from philosophical conversation seems to have abated as the positivist habit of mind takes the defensive.

15. See A.N. Whitehead, *Process and Reality* (New York: Harper Torchbooks, 1929), p. 32.

Weiss admits the similarity between his account of how we both infer and encounter the past and Whitehead's notion of the "objective immortality" that things achieve when they perish in time. But he wishes to detach that acceptable position from Whitehead's "odd though regrettable central thesis that actual occasions perish as soon as they have come to be" (93).

16. The historian "knows only a few of the relevant items and their bearing on those that follow. He must therefore content himself with tracing a line between the items about which he knows something, and then constructing a plausible account of the intermediaries he does not know and for which he may never have evidence" (69).

17. "To say with Langlois that 'there are no historical facts' and that the 'historical character is not in the facts but in the manner of knowing them,' is to suppose that the historian creates history. It is to confound the writing of history with what the writing is about. If there were no historic facts an historical account would be indistinguishable from an historical novel. One such account would then be no more true than another, but only more coherent, effective, or entertaining" (65).

18. Paul Veyne, *Writing History*, trans. Mina Moore-Rinvolucri (Middletown, Conn.: Wesleyan University Press, 1984), p. 156.

19. See, for example, Gerald Prince, *Narratology* (Berlin: Mouton, 1982), Gérard Genette *Figures*, 3 vols. (Paris: Seuil, 1969–72), Paul Ricoeur, *Time and Narrative*, 3 vols. (Chicago: University of Chicago Press, 1984–88), Paul Veyne, *Writing History*, and Mieke Bal, *Narratologie: Les Instances du récit* (Paris: Klincksieck, 1977).

20. Michel de Certeau, *The Writing of History*, trans. Tom Conley (New York: Columbia University Press, 1988), pp. 90–91; hereafter WH.

21. Sartre reaffirms this insight in secular guise: "If History has its *own consistency*, if, by itself, it refuses to evaporate into sociology, it is precisely because of its uniqueness. The first historical event is that *there be history*. And if there is a history, it contains the universal within itself as one of its abstract structures rather than being able to be universal. Pascal saw this clearly: the original fault that makes all universalization impossible. Free, a sinner, historical, man is a being to whom something has happened" (Jean-Paul Sartre, *Notebooks for an Ethics*, trans. David Pellauer (Chicago: University of Chicago Press, 1993), p. 58.

22. Nicholas Rescher argues this forcefully in his *Human Knowledge in Idealistic Perspective* (Princeton, N.J.: Princeton University Press, 1991).

23. See Michel Foucault, *The Order of Things*, p. 342 and *passim*.

24. Interview with François Ewald, "Le Souci de la vérité," *Magazine Littéraire*, 207 (May 1984), p. 22.

25. See Allan Megill, *The Prophets of Extremity: Nietzsche, Heidegger, Foucault, Derrida* (Berkeley: University of California Press, 1985).

26. *Being and Nothingness*, trans. Hazel E. Barnes (New York: Philosophical Library, 1956), p. 297; also see pp. 297–302 and 617 ff.

27. "I create a certain image of the man that I chose; choosing myself, I choose man," and "I am obliged at every instant to perform actions which are examples" ("Existentialism Is a Humanism," in Walter Kaufmann, ed., *Existential Philosophy from Dostoyevsky to Sartre* [Cleveland: Meridian Books, 1956], pp. 292 and 293).

28. See my "Time Redeemed: Maritain's Christian Philosophy of History," in Deal W. Hudson and Matthew J. Mancini, eds., *Understanding Maritain: Philosopher and Friend* (Macon, Ga.: Mercer University Press, 1987), p. 307.

REPLY TO THOMAS R. FLYNN

Thomas R. Flynn's thoughtful examination of the philosophy of history reveals a knowledge much wider and deeper than I and many other writers on the philosophy of history can claim. My study, no less than my examinations of the arts, politics, mathematics, religion, and other basic enterprises would surely have benefitted had I a greater mastery of major works in these fields. When I carried out my various specialized studies, it was one of my major desires to test what I had come to understand about the nature of reality, as well as to achieve a better grasp of the more limited fields.

The speculative and the empirical both challenge and support one another; a philosophy must attend to both if it is to be broad gauged, pertinent, coherent, and illuminating. I never supposed that other types of inquiry were to be replaced by a single view within which all others were to be tucked, usually by being clipped, and then dressed in a uniform. Over the decades I have found good reasons to modify and sometimes abandon what I had previously maintained, and to pursue more limited issues in such a way that their relations to one another could be better understood and their common conditions exposed. Special studies can benefit from a knowledge of broader, more basic, 'metaphysical' groundings; speculations need to take account of and make provision for the pursuit and achievements of other enterprises. The large and the small, the one and the many, provide goads and checks for one another.

I know that my studies of metaphysical issues have been enriched by what I had learned from the practitioners of more limited enterprises as well as from those who have reflected on what these did and had achieved. The converse is also true. I have become aware of issues,

usually overlooked or misconstrued, by what speculative inquiries have shown to be essential.

Much is gained by moving backwards and forwards from the comprehensive to the specialized. A better metaphysics would provide better clues and underpinnings for the understanding of more limited studies. A better mastery of what is done in special areas and a knowledge of how the practitioners function, as well as of what their interpreters and critics have said, offer strong checks on what is speculatively achieved. I know that what I have maintained in every area need supplementation, subtletization, modification, and rectification. Only skeptics think that they have shown that all inquiry should or has come to an end. Flynn is here making a contribution to the continuation of the study of history, though I think it will involve more contributions from the speculative side than he seems to allow.

I do not think that philosophy 'in the grand style' is primarily occupied with bringing 'the many into the one.' Other tasks and topics—the nature of Being, contingency, knowledge, the constituting of actualities and fields, the good life, creativity, and the problem of passing from one type of occurrence to another—need to be addressed again and again from many angles, just as the nature of the pursuit and achievements of other, more specialized studies must. The many and the one have distinctive natures; each is to be dealt with separately, and in the light of what is known about the other.

I am not confident that I have understood Flynn's claim that I philosophize in terms of 'being' and that "every topic . . . turns into a facet of being." Being is not a topic that is central in my studies of cinematics, sport, politics, logic—or history. Being, to be sure, is pertinent to all of them, but it is not central. Every inquiry can benefit from a comprehensive metaphysical inquiry. This helps clarify the nature, presuppositions, and limits of other studies. It in turn can benefit from a knowledge of their procedures, subject matters, achievements, and claims. Flynn's note 9 seems to acknowledge the fact to a degree that his text does not.

Is my study of history "suspiciously free of citations from . . . the works of actual historians?" Since it sought to understand the nature of history and what the writing of it involved, citations from their works or from philosophers writing about historians and history, though helpful and perhaps even desirable, are not necessary. One can understand the nature of religion without paying much attention to theologians or even to the reports of the pious. Knowledge of these is surely desirable, but a little goes a long way. One interested in understanding the nature of art need not consult the leading practitioners, the leading critics, or know

the history of the subject and the writings about it. Greek plays are quite different from modern ones, but Aristotle was still able to understand tragedies in a way that illuminates all of them.

A philosopher needs all the help he can get. The outcomes of other inquiries deserve to be taken seriously, but this does not mean that they are not also to be understood from a position which, while appreciative of their distinctiveness, sees them as fitting into one that is more comprehensive. I do not think that Flynn would object. What he seems to insist upon, instead, is the desirability of studying the writings of philosophers of history. Even those whose presuppositions are untenable?

Historians analyze, look for evidences, try to provide justified accounts, using the available evidences. I do not think they are necessarily better able to tell us what history is than philosophers of history are. But it does not follow that one should therefore turn from an examination of what history is and what historians do to a study of philosophers of history, particularly when these are granted the dispensation of not having to study other philosophers of history. What Flynn should have done was to confront my account with difficulties, facts, and omissions, no matter what their source, making evident how it should be corrected, and perhaps even discarded.

The tinge of arrogance that clings to these remarks is not much different from that which accompanies the resolute pursuit of inquiries in other fields. I wonder if Flynn thinks that Kant should have examined all other major views of space and time, psychology, mathematics, ethics, and religion before advancing his own. Is all intellectual advance the outcome of 'combats'? Is there no warrant for studies occupied with isolating the essential and the presupposed, checking what is claimed by reflections on what is unavoidable and crucial, as well as with what other inquiries have made evident? Why should one not attend to the subject matter itself and use whatever guides one can, all the while that one tries to mark out the essential parts of basic disciplines and take account their presuppositions?

Is philosophy an arena where different views are to be treated as opposing forces in a battle that never ends? Or is it not rather an enterprise in which the essential nature of reality and basic inquiries are made evident? Does not a true philosopher level sharper criticisms about what he has himself thought or concluded than anyone else does? No one has more than a limited vision. All commit errors. All are guilty for having failed to consider crucial questions as fully as they deserve. All need help. I have received most of it from students and friends who asked apparently innocent questions revealing perplexities in their understand-

ing what I had claimed, but I have also gained much from my readings of our great predecessors, though usually only after I had followed out issues on my own. There is no question but that what I have maintained has been influenced by many, but I have always tried to carry on my studies by concentrating on the issues rather than on what others had maintained. I do not think an advance would have been made had I, instead, attended more to what is presently to the fore. Instead of examining what various philosophers and commentators have said about history—a not unworthy endeavor—one can justifiably attend to it as instantiating principles that other enterprises also instantiate, each in a distinctive way, with its own distinctive problems and solutions.

Flynn's mention of me in the same sentence with Aristotle makes evident that he is trying to praise me. But I do not recognize his Aristotle as one who, outside his ethics, is a 'philosopher of the mean'. Nor do I think I am one. The presupposed is not a mean; nor is an individual, Being, evidence, commitments, fears, or hopes. I look for no mean between truth and falsehood, right and wrong, being and nonbeing, though there surely are midpoints that deserve to be noted and sometimes passed beyond. The mean deserves examination, but to suppose it is present everywhere or is to be preferred in every case is to treat it as an extreme. Had I always kept that fact clearly in mind, I think I would have avoided my somewhat loose use of the idea of a 'final cause'. What is to be is a contributor to what occurs and, though it is not a mean, it also is not a fixity. The indeterminate is made determinate when use is made of it. Mediators, agents, signs, instruments, though they make possible connections and passages from one extreme to another, are too insistent, efficacious, and demanding to be properly viewed as outcomes of conflicts between extremes. I think my best account of the 'ought-to-be' is to be found in *Creative Ventures,* a work much later than the one Flynn examines with such sympathy.

Ideals are indeterminate and have little efficacy. Their nature has become more and more evident to me over the decades, with the greatest advance in understanding being achieved in the course of the study of creativity. What I maintained about them, the future, and possibilities over the years has to be modified in the light of what was learned, particularly in the course of trying to understand the arts, mathematics, science, character, leadership, and politics. History faces prospects that are less than luring ideals and more than mere possibilities. Like ideals, those prospects are relevant to what is present; like possibilities, they become determinate only when realized.

I was a student of Whitehead's. He made me alert to the kind of ideal to which a true philosopher attends. He was undogmatic, flexible, honest,

and interested in a multitude of subjects, most of which he did not write about. Weak in his knowledge and understanding of the arts, with a poor grasp of such major philosophic figures as Aristotle, Augustine, Kant, and Hegel, he saw clearly how his contemporaries lost their way. Overly concerned with trying to be in good consonance with current, dominant physical views, he rarely bothered himself with the justification of his claims, I found him to be inspiring and exciting, but too often content to stop with a multiplicity of undefended claims and unexamined presuppositions. I think he would not be interested in the writings of his self-anointed disciples, for he was more intent on opening up rather than in closing the road by which one might reach basic and lasting truths. On that point he was one with Peirce. More or less content to follow insight with insight, which he punctuated with so-called 'categories', he was not very self-critical, unless perhaps in the quiet of his study. I doubt that there is much of a connection between Whitehead's account of how the many become one and what I take to occur in time. That does not reduce the incalculable debt I owe him in showing me what a splendid philosophical spirit is like.

Flynn speaks of 'an operative concept of intentionality'. I wish he had taken time to discuss this. Does an intentionality ever reach what exists apart from it? Is it, could it be anything more than a prolongation of what is and remains private? There are phenomenologists today who plaintively complain that the standard view is 'idealistic' or 'subjectivistic', and that the fact is not faced by those who hold that view. It is not evident, however, how any phenomenologist ever could reach what exists independently of himself. Nor is it evident how one could bracket anything without first getting beyond it.

Flynn notes that Russell's view that the present might have been created with all its 'remembered' or past content just a moment ago, but he fails to note that the idea of a divine creation makes a similar supposition. Did the trees in the Garden of Eden not have rings? Were there no young and old snakes or ripened apples there; had the sun not shown before there was anyone to see it? Was the innocence of Adam so complete that he could not distinguish between what had been and what is?

The 'now' should be distinguished from the 'present'. Were the universe created at any time together with evidences of a past, it would not be present but only now. What is now is static; what is present is always passing, inseparable from a past that is being used inside of whatever is present. The past inside the present forces what is future to become a past for a new present, i.e., for that future to be made determinate. A passing time is one in which a future is becoming present,

a present is becoming past, and what had been an effective past is replaced by what had been completed as a present.

There is no passing time in the cosmos, but only a sequence of distinct occurrences. When nature and other domains are produced, cosmic units are accommodated in a passing time. Freeze the passage and the past, present, and future will all disappear, to leave nothing but the now. If there is a present, there is what is becoming past, and a future that is becoming present. There is a present that is becoming past, a past that is becoming more and more recessive, and a future that is becoming present. A Russellian past is a static part of a static now. That past does not interest an historian. The evidences to which he attends are caught up in a passing time.

The past that had once been present is in a changing relation to an ever new present. An historian seeks to understand the past as it had been when it was present. To do that, he must fixate it, treat it as a now, and then provide a sequence of nows that will enable him to end with the evidences, with which he began as located at the end of that sequence. What he knows is a sequence of nows. To convey the nature of the passing time that in fact is never stopped by any now, he provides a vitalized report.

I did not spend sufficient time on the examination of the difference between history as lived (in a passing time) and a history presenting a sequence of nows. The difference is blurred when one speaks of history as a narrative. At best the reference could be only to a written history, accompanied perhaps by a statement of the difference between written histories and stories, dramatic works, and epics. Not only is a passing history outside the reach of the historian, but the history that he records and reports never attains the status of a true narrative. It could not, since it is never freed from limitations placed on it by particular matters of fact. A narration is not a narrative, if one means by the latter what storytellers provide. There is a sharp difference between a written history and the history that in fact had occurred, for the one attempts to make evident a passage that in fact occurred, while the other occurs whether or not any note is taken of it.

Flynn remarks that philosophy is a 'science of presuppositions'. The observation should have been kept in focus. It is also true that it is a study of what is presupposed. Were it only the first, it would focus on and end with a necessary, final Being. It is no less a study of what it is with which one begins an inquiry, how it functions, and how one is then able to end at what is necessary.

When Flynn says that I "fail to meet historians where they really are," I am not sure just how serious he thinks the criticism is. I was not, after

all, interested in reporting what historians thought about the nature of history, or in studying what other philosophers had said historians were doing. Instead, I wanted to understand the nature of living and written history with the help of what I had learned in other studies—and conversely. No knowledge is to be despised, but it is nevertheless possible to cut close to the bone of truth by attending to the essential features and differentiations of various disciplines, as well as to their common presuppositions, different aims, and practices, and the world with which they deal in specialized ways. As a matter of fact, I have discussed some of the crucial issues with knowledgeable masters in the various fields into which I attempted to enter, guided by what I had glimpsed of what was the ground of all, and the distinctive aims of each. It is not clear whether or not Flynn thinks my time would have been better spent had I turned away from the study of history to an examination of what others had said about it. To judge from his references, he seems to think that, instead of attending to the nature of history and how it is to be understood and conveyed, I should have tried to engage philosophers of history in a discussion. I have, though, been convinced that the aridity of much of what passes for philosophy today is due to the fact that philosophers, instead of attending to reality, attend to one another. A good deal can be gained from healthy discussion, but what we are offered are polemics in which attitudes are exhibited but few arguments advanced and defended, while ignoring the reality that was supposed to be clarified and the claims that should have been justified.

Flynn, to judge from his references, is inclined to look to philosophers of history rather than to history itself or great historical studies. I, for one, would have gained much, had he exposed weaknesses in the account I offered, and had he not spent so much time in presenting, without defense, views that did not coincide with mine. It would have benefitted all had some historic occurrence and some historic account been focussed on and an attempt made to show how different approaches did more or less justice to them. He succeeds, though, in making evident that there are a number of interesting questions that deserve examination.

Is there any reason to believe that "there is no history-in-itself; there is only history-for-us . . . We are 'in' the past in the way we are 'in the world'?" Are there no brute unalterable facts? Are there no ruins, records, traces to be accepted as guides and tests, whose neglect or misconstrual turns a written history into a story of what might have been? Is it true that in the absence of an at least implicit reference to 'mind . . . one is left with that which is completely determinate?' Are there no indeterminates in fact? Peirce remarked that twilight is vague, being both day and night. Is there no twilight when there are no living

beings? How could there be a 'history-for-us' if there were no history and no us to be related? In the absence of the first would there be any reason to prefer one history rather than another, except on the basis of congeniality, prejudice, or arbitrary determination? Is the 'us' fixed, or will it vary over time, so that there will be only a series of histories each appropriate to a different 'us'?

Reason, says Flynn, following Foucault, itself has a history. Yes, but that does not mean that it cannot remain constant throughout its existence. To exist in time does not preclude remaining self-same. Was it not the same world war that was begun at one time and ended years later? Did it not encompass a series of battles with distinctive natures of which a history must take account, whether it is agreeable or desirable to 'us'? Who is us? Mankind at this time, mankind over all time, the disinterested as well as the interested, the learned and the unlearned, the liars and forgers, the conscientious historians, the masters, and the incompetents as well? The reason that has a history is the reason that expresses its user. The reason that transcends history has a nature that remains constant, no matter who makes use of it or when. If reason is what Foucault takes it to be, it and what it deals with passed away together with his comments about it. One cannot have it both ways: historicize everything and one's own position is inexorably swept away, or say something that holds for all that is, and thereupon allow for what does not pass away.

Flynn apparently thinks that I should engage Foucault, and others having related views, in 'combat'. I do and I do not. The criticism I have just advanced about their position is serious but ignored by them. How can there be a combat if a serious criticism of a view is not met? I have found no defenses of relativistic, skeptical, or deconstructionistic positions that do not make a quiet dispensation for their defenders. Must their dismissals nevertheless have to be opposed? Yes, but there is no need to discuss them, when in the attempt to present them their defenders must dismiss themselves as well as others. Why should anyone spend time rejecting those whose suppositions preclude them from giving what they say any other status but that of a claim that destroys itself and the claimant, or requires them to have a status denied to all others? No, because I have in fact answered them by making evident what everyone and therefore they, like the rest of us, presuppose and which in fact precludes all radical relativisms and subjectivisms.

I am sorry to say that I have not read Sartre's *Critique of Dialectical Reason.* I began losing interest in his philosophical writings once it became evident that he was trapped within a radical subjectivism. Does

his *Critique* take a different position? Had Flynn shown that Sartre had successfully provided for an understanding of objective history, I would gladly read Sartre's writings on the subject.

Flynn makes the arresting suggestion that the difference between history written and history lived is a matter of degree. Is there a point where they merge or meet? Does narrative not follow its own course? One concerned with writing history attends to evidences, and then adjusts its claims to make them accord with realities over which they have no control. The fact that it is difficult to know what had occurred, does not extinguish the fact that there is a difference between a warranted claim that something occurred and an imagined story into which historic facts might be fitted. A historian does, like a narrator, focus on tensions, climaxes, sudden turns, but these are supposed to have their duplicates in fact. A narrative, in contrast, has its own logic; it need pay attention to no particular matter of fact, search for no evidences or documents, nor claim to report what had in fact occurred in some segment of a passing time.

I think Flynn settles too quickly with the claim that there is a crisis of criteria. Different criteria can be judged in terms of their coherence, their presuppositions, their consequences, and the manner in which they comport with what else there is and could be known in other ways. It is not enough to deny what others maintain. It surely is not enough to stop with sweeping, undefended claims. I wish these issues had been touched upon in this generous, flexibly, nuanced account. Had they been, what now seems to be problematic in the view I provided could then perhaps be shown to be justified or unjustified, and thereupon allow all of us to move on in one direction or another.

P.W.

8

Nathan Rotenstreich

EXPERIENCE AND POSSIBILITIES

I

The term experience is very commonly used in our everyday expressions. In spite of that integration, the term is loaded with several meanings, some of which became prominent in the philosophical systems. To refer to these meanings will be of some help for placing Paul Weiss's interpretation of experience in a philosophical context.

Aristotle and those who followed his exposition related experience to memory or remembrance. St. Thomas speaks about many memories, probably pointing to the accumulated character of the memories and not just to the sporadic occurrences which are recalled. In our everyday usage, we speak about an experienced person or an experienced physician, indicating the accumulated character of his memories.

When experience is understood as perception, it is interpreted as referring to that which is immediately given in the encounter with the surrounding environment or nature or world. This interpretation of experience is central in the empiricist philosophy, and it probably led Kant to distinguish between perception and experience proper. Kant points to the difference between perception and experience, interpreting experience as a synthetic connection of phenomena (perceptions) in consciousness, so far as this connection is necessary. "Hence the pure concepts of the understanding are those under which all perceptions must be subsumed. They can serve for judgements of experience in which the synthetical unity of the perception is represented as necessary and universally valid."[1]

We notice that in Kant's conception, experience is not a sporadic occurrence; it is a synthetic connection. Moreover the connection is necessary and thus is not an impression which comes and goes. Because of that, Kant refers to judgments of experience and not to receptions by way of perceptions. Eventually the synthesis implied in experience is considered to be necessary and universally valid. To be sure, in the footnote Kant speaks about experience teaching me something. In this sense, he stresses the perception that lies in experience, for example, that the heat always follows the shining of the sun on the stone. Kant adds that consequently the proposition of experience is always so far accidental. But the character of the judgment of experience is related to the concept of cause. Therefore, this heat necessarily follows the shining of the sun and here again the reference is to the judgment of the experience and not to experience as accidental. In a sense, we could say that there are two levels of experience—one of perception related to the accidental occurrence or interpretation and the other related to the judgment of experience, which is related to the category of causality. Summing up, we can say that for Kant there is already a synthesis in experience, when experience is understood in its broader sense as a synthesis.

The synthetic character of experience is emphasized in Hegel's interpretation of it; and we mention Hegel in this context because of the fact that he tried to overcome the difference between perception and experience as synthesis and because of the relevance of that interpretation of experience to John Dewey's system. Indeed, philosophy is a sublation from the point of view of experience to the point of view of proofs, that is to say, to that of the absolute necessity of things.[2] To be sure, experience is related to the consciousness of reality and it is the next consciousness of that content, i.e., of reality. Experience does not contain the necessity of the conjunction of that which exists; it teaches only that the objects are as they are, but this awareness or consciousness is not self-enclosed, but it leads to the philosophical interpretation.[3]

II

Let us move now to some interpretations of experience present in American philosophical systems, because of the impact of these interpretations on Paul Weiss's systematic reference to experience. William James refers to experience as having a meaning for our life. This leads him to the statement that the world of our present consciousness is only one out of many worlds of consciousness that exist; those other worlds

must contain experiences. What is significant in this statement[4] is the statement about the possibility of different worlds, and these are not just constructions, but contain experiences. James says that the experiences are only psychological phenomena.[5] This would imply that experiences as referring to other worlds would be psychological phenomena as well, that is to say that they are phenomena of the inner world of the experiencing person. This would be an interpretation of experience which comes back to impressions and does not refer to the synthesis of experience, let alone to the necessary connections characteristic of it.

To some extent, Whitehead stressed this aspect of experience in his statement that "consciousness presupposes experience, and not experience consciousness." The particularity of things experienced[6] is the correlate of consciousness as presupposing experience, and this position of experience and the particularity of the things are the basis of a realistic philosophy. Probably that realism becomes prominent in Whitehead's statement that in perception there is a discloser of *objectified* data[7] (and we may wonder why Whitehead refers to *objectified* data and not to *objective* ones). In any case, the position of experience does not imply its scattered character or the impressionistic essence of perception or experience.

Coming now to Dewey's different interpretations of experience, let us stress in the first place that Dewey speaks about cognitive experiences, but also about other modes of experience. In this context, he stresses the fact that connections exist in the most immediate cognitive experience,[8] that is to say, that already within experience, there are relations cognized or negatively said, experience is not identical with sporadic perception. And indeed, he speaks about the accumulated information about the past, and in this sense, he comes back to the Aristotelian interpretation of experience, though he does not relate experience to memory. We could say that in Dewey's interpretation there is a built-in synthesis within experience: hence experience is capable of incorporating rational control within itself.[9]

The conjunction of the accumulated character of experience and the possible integration of rational control[10] is formulated by Dewey in the very programmatic statement: "Just as we after considerable experience, understand meaning directly, when we hear conversation on a familiar subject or read a book, so because of experience, we come to recognize objects on sight." (*Logic*). Experience is not interpreted as just encountering reality, but as being in nature, continuous with it and part of it.[11] We can probably understand Dewey's position as looking at nature as an all-embracing realm. Thus there is no correlation between experience

and nature, but a continuity from nature to experience and concurrently from experience to nature. Dewey attempted to integrate experience into the system of pragmatism and therefore looked at experience as a projection towards the unknown. The prospective character of experience is more primary than the retrospective aspect of it. It is clear that this interpretation goes beyond the interpretation of experience as being related to memory, since memory is by definition a recognition of that which occurred in the past, either as coming back to it, or as being held within the reservoir of consciousness.

This brief survey of different interpretations of experience may lead us to a reference to Michael Oakeshott's book *Experience and Its Modes.* Oakeshott speaks about sensation as immediate experience, probably pointing to the empiricist interpretation and to Kant's distinction between perception and experience. In Oakeshott's own view, experience stands for the concrete whole, the analysis of which leads to the distinction or division between "experiencing" and "what is experienced."[12] Yet, eventually, Oakeshott's statement goes even beyond Kant's interpretation of experience when he says: "The general character of experience I have taken to be thought or judgement."[13] Hence he does not consider experience as synthesis but as thought as such, becoming manifest in judgement. Oakeshott goes even beyond Hegel when he says that what is achieved in experience is a coherent world of ideas.[14] Hence experience is conceived not as a step towards ideas, but as the world of ideas present in it.[15] Eventually "no separation is possible between reality and experience; reality is experience and is nothing but experience."[16] One could try to interpret that position as related to Berkeley and going beyond him, because there is no identity between reality and perception but between reality and the world of concepts.

We come now to Paul Weiss's conception of experience. We shall refer to his different books which deal in different systematic contexts with the essence of it.

III

It might be considered as indicative that Paul Weiss presents his philosophical exploration of the realm of religion by referring directly— as it is present in the title of the book—to God, i.e., to the ontological fundamental component of the religious attitude. At the same time, he speaks about the God we seek and not about the psychological aspect of the religious experience. We could suggest that what is emphasized in the

title of the book is the distance between man and God and concurrently the active attitude on the part of man reminding us that in German, experience is *Erfahrung,* that is to say *fahren*—going out, which is an active manifestation of the human attitude.

Indeed, Paul Weiss says that what we experience has grounds outside the experience. There is a correlation inherent in experience. Therefore experience involves not only an experiencer, an experiencing, and something experienced; it presupposes someone who *can* experience, and something which *can* be experienced.[17] The fact that *can* is underlined in this sentence points to the potentiality preceding the act of experience, both on the part of the subject experiencing and on the part of the object experienced. To put it differently, experience is not an instantaneous event, because it essentially points to its background which is beyond or before the act as such. In the context of the religious experience it is said that it helps us to identify the reality of God; reality in turn makes an experience be a religious experience.[18] We can conjecture that this statement is an implicit criticism of James's interpretation of religious experience, and indeed, William James's book is mentioned on the same page. The criticism amounts to the aspect of identifying the reality as God, that is to say, it points to the intentionality of experience directed to the reality. It is not self-enclosed as a psychological event.

The correlation pointed out before is stressed in the analysis of experience: "The mine is a part of a much larger experienced world."[19] The much larger experienced world can be interpreted as reality at large. Therefore: "Private experience is almost, not-yet public experience."[20] It points toward the potentiality of enlarging the scope of experience by going beyond the personal component of it. This statement shows that experience is not self-enclosed and, indeed, is probably related to the non-instantaneous aspect of experience. The interrelation between the aspects is described as pointing to the episodic and constant.[21] Moreover, experience is a product of interplay of different realities.[22] At this juncture, the constant aspect is not only the surrounding realm of experience, but is a clue to its nature and import.[23] Indeed, Paul Weiss uses the term "correlative"[24]; the correlation is not confined, as said before, to the surrounding reality in which the person lives—what could perhaps be expressed in Husserl's terminology as a world we live in (*Lebenswelt*). The reference is to other reality and thus to the multi-faceted structure of experience as being at once focal and peripheral, mine and not mine, private and public, episodic and constant.[25] What is probably more significant in this statement is that experience is mine and not mine, that is to say that within the boundaries of experience as a

personal occurrence there is at least a presupposition that experience is not confined to myself. That presupposition is probably related to the presence of the fellow person within the horizon of the experiencing person, but also to the awareness that reality or realities as experienced are not of a personal character. One could assume that the statement "We do not come to know what religious experience is like until we have exercised a faith, participated in community . . ."[26] is a positive statement about the aspect of mine and not-mine of experience. The metaphoric expression that my experience is at once a road and a barrier points to the different aspects of experience which in turn are related to the active character of it.

Probably there is a relation between the multifaceted structure of experience and the awareness or presupposition that there are many types of experience. In this context, there are only some types mentioned, like the ethical and political experiences, aesthetic, historical, and religious experiences.[27] The variety of the types of experience is related to different sides of our separated and interrelated selves.[28] Since the self is broader and perhaps deeper than the focal experience here and now, the presupposition that the self exists leads to the anticipation of different types of that person's experience. They are essentially manifestations of the broad context of the experiencing person. That breadth does not imply that here and now we attend to different experiences simultaneously. It is rare that we attend to more than one or two of these at a time.[29] Here again the potentiality of experiencing is the manifestation of the personality, and it is presupposed for the sake of identifying the experience in its focal aspect, even when the focus does not imply the intentionality in its actual exposition. When we refer to the content of experience, it is said that the experienced content is broken up into a locally and cosmically adumbrated.[30] One could say that the cosmically adumbrated dimension goes beyond the instantaneous focus of experience, but the very encounter with the largest realm as cosmos points to the possibility of enlarging the scope of the present experience and again points to that which is the world at large. The experienced content is not a tissue of sensations and impressions, since in every experience "one can distinguish a *focal* region and a *peripheral*, what is *mine*, and what is *not-mine*, the *private* and the *public*, the *episodic* and the constant.[31] This multiplicity presupposes the self in its breadth, or consciousness at large and therefore "the center of gravity of conscious beings is outside the focal regions where they mainly live." It is clear that consciousness is not limited to its intentionality to the world we live in, but directs itself potentially to different realms. We know that our daily world does not

exhaust reality. Thus the transcendence of the instantaneous component is an expression of consciousness, not only as the potentiality or as a potential agent, but of the awareness that the world is not confined to what we perceive here and now. There is a mobility from that which is experienced in the world we live in and our transcending attitude, and there is apparently a sort of continuity with leaps in it from a sound base in experience to our speculations.[32] Experience connects us to other realities,[33] and probably the other realities do not refer to that which is ultra-mundane but to the plurality of components and contents which are correlates of experience. The experienced is a consequence or product of something more real than it is. Experience has an objective pole which I do not constitute.[34]

One could say that the objective or ontological dimension of experience as formulated here, is the precondition of the possibility of speaking about God within the relation to experience. In this context, the difference between eternity and everlastingness is significant; religious experience is not an experience of eternity. It is an experience of everlastingness.[35] This statement is rather significant because it says explicitly that there is no experience of eternity or to put it differently, that eternity is beyond and above experience. What can be experienced and can be considered as the seed of religious experience is everlastingness, that is to say, that which is real, goes on and is not exhausted in the objective pole of our present experience. Eternity can be viewed as beyond and above time, while everlastingness refers directly or indirectly to the ongoing process within the framework of time. Everlastingness can be considered as an extrapolation of the human reference to time. Thus it remains within the human boundaries. Eternity transcends those boundaries and cannot be within the horizon of experience. Indeed, we notice the limits of experience.

From the systematic point of view, it is significant that Weiss deals with different aspects of experience in the context of man's seeking of God. The reference to reaching to God through the intellect and thus: "God must first be looked at in terms provided by experience, and then must be confronted in terms which transcend experience." Hence there is the assumption that experience is present in the realm of the attitude to God, but cannot be sufficient to provide for the full scope of that attitude. We could say by summing up this part of our exploration, that the emphasis lies on the correlation between man and God and not on reception on the one hand and on immersion on the other. The reference to God in that sphere cannot rely on the immediate aspect of experience, because of the ontological dimension to which by definition the position

of God is related. Hence we could say, to use the phenomenological term, that Weiss refers to the intentionality essential to experience. There is a built-in distance between experience and its content. Weiss speaks about the categorized content we experience and further "the unity which is our very self is answered by the unitary categorial centers of whatever other beings there are, actual possible existential or divine."[36] It is significant that the reference here is again to the correlation between the self on the one hand and the diversity of the contents the self refers to in his/her intentionality on the other.

IV

It might be plausible to look into some of the comments made on experience in the realm of aesthetics or arts. To be sure, Weiss says that aesthetic experience is immediate, direct. "Distance between experiencer and experienced object is broken down; in it, content is emotionally tinged, processed and enjoyed, its value heightened and its import changed."[37] Yet he says that not all immediate experience is aesthetic experience. Therefore passive acceptance of the stream of passing impressions does not yield the kind of immediacy he refers to. Summing up, it is said: "An aesthetic experience is most rewarding when ideas are not denied but are made subordinate to the act of making immediate contact with what is present."[38] Probably immediacy cannot exhaust the essence of the aesthetic experience because of the presence of ideas in it. The outcome can be considered as immediate. It is self-enclosed, as the work of art is. But the process and the structure grounded in it and eventually inherent in experience as such, contains different components including that of ideas. Indeed, on the end of the human beings, when art is dealt with, it is said that it requires an integrated use of mind, body, emotion, and will.[39] Hence, art and concurrently the aesthetic experience is an integration of different components, or it presupposes them. The experienced pluralities turned into harmonious totalities of the single unity which is ourselves[40] is a re-statement of the integration of different aspects within the human subject. Still it may have its bearing on the content towards which the experiencing intentionality refers. On the end of the content, we find again the contextual aspect. It is said that the perpetual content is always spread out, sometimes spatially and always temporally. The significance of the scope in which the content is placed, is systematically present because perpetual time is time in which we carry over our experience of

the past into the present. To put it differently we can say that there is no instantaneous experience, or positively, the contextual or spheric dimension is either the framework of the experience here and now, or inherent in it, even when in our momentary act we are not aware of that dimension.

Pointing to the component of the realm which accompanies the aesthetic experience even when it is presented as immediate, is rather significant, because we come to the conclusion that there might be a step by way of continuity from what is inherent in experience as an act and the systematic philosophical interpretation of it. Let us recall that for instance in Kant's presentation of the aesthetic delight, he points to different attitudes, referring to different components evoking the attitude, like for instance, the agreeable which gratifies a man, the beautiful which pleases him, or the good, which is esteemed. Hence, there is no way to detach the attitude from a particular content. Within the attitude we already disclose a sort of interpretation of the content on the one hand and the adequate response to it on the other, like for instance, inclinational favor or respect. It is the task of the philosophical approach to experience, if we may sum up this part of our exposition, that that approach articulates analytically or conceptually what is inherent in experience, and secondly, places the particular experience within a scope of variety or plurality of experiences. These two directions of the philosophical approach to experience are present in the various formulations of Weiss's conception. We shall add now one additional component before moving to a broader summing up.

V

"We experience when we perceive and also when we do not. If we perceive as well as experience, we live in two present moments."[41] Hence it is said that we have an orientation outside the experience. The distinction between perception and experience is indicated here. There is a description of a naively experienced world,[42] and we can assume that that description is meant to point to the limited aspect of experience and concurrently to something which is larger. From the point of view of history, it is significant because the past is no longer present. Still it is integrated in the present and it is said that it is encountered in the present.[43] It goes without saying that the encounter in this context cannot imply an immediate reception of the past. It points rather to an interpretation of the relation between past and present or to the

awareness of the person within the present of the relation between the dimension of the present and that of the past. A polemic comment is rather significant in this context:

> Daily experience and the various sciences pay no attention to positivistic theories, and clearly and vigorously affirm that things have a power to act in ways they do not exhibit. To predict is in effect to say that there is now something not yet manifest which will and therefore can be. Cut out all reference to potentialities and you deny yourself the right to speak of laws or of predictions, and consequently of dispositions, capacities, abilities, plans, habits and real existents.[44]

This polemic comment indicates that the aspect of experience related to human existence has to be considered as placed in the context of potentialities and their variations. That which is manifest does not exhaust the potentialities. Therefore, that which goes beyond the immediate present moment is within the horizon of human reality or to put it differently, since we always live in an unfinished present Weiss refers here to the unfinished historical present. Experience either refers cognitively to that which is beyond the present moment or the reality in which experience occurs and to which it refers, contains in itself the dimension of the unfinished. Hence we could say that Weiss's systematic exposition of experience is an attempt to show that experience, by going out towards the content, goes out towards the potentiality which would be recognized within the structure of the content and by way of the correlation to the potentialities of the self or of the subject. We shall now sum up our analysis.

It goes without saying that Weiss's exposition of the essence of experience cannot be isolated from his metaphysical or ontological conception. Referring to that background, we shall confine ourselves to two aspects and mainly to the relation between experience and the notion of possibility or potentiality.

Perception is present or even inherent in experience. Since perception is the other expression for the encounter with the surrounding world and that encounter is of the essence of experience, Weiss says, "Through perception, an external world can be truly known. Otherwise, we would never know we had made a perceptual error." Still, "Perception involves the use of non-sensuous content. Otherwise, it would not provide knowledge of an external world."[45] In this sense, perception is inherent in experience, but does not exhaust its essence. This is so because the potentiality or the possibility is presupposed even in the immediate acts of experience.

Weiss identifies the speculative method of philosophy with the

inference to presuppositions.[46] As he says: "there must be possibilities, otherwise an actuality would not be able to continue or pass away."[47] "An actuality seeks to adjust itself to possibilities. Otherwise, possibilities would not be generic meanings which set the conditions for future actualization."[48] In this sense, possibility or potentiality is presupposed not by way of a logical calculus but because of the dynamic character of that which is encountered as being actual. The validity of potentiality in terms of that which is actual is applied also to experience. The correlation of experience and that which is experienced is manifested also in the validity of the concept of potentiality vis-à-vis both the content and the act. The act cannot be detached from the broad field of potentiality as the content cannot be. Thus we could say, by applying traditional terms, that potentiality is both objective and subjective and the dynamic character of reality which embraces the two is the basic presupposition which finds its focus in potentiality. Experience as an actual occurrence is an activity and as such a manifestation of potentiality. If we conceive of potentiality as that which is not real as yet, that essence finds its manifestation in thinking and in knowledge, but also in experience.

This leads us to two additional comments. One is that there is no experience as a *tabula rasa*. A sort of interpretation is inherent in the act of experience. The shift from that interpretation to the philosophical articulation of it is not accidental or to put it differently, it is not a leap. The philosophical interpretation points to the meaning inherent in experience and concurrently to the partial character of any act of interpretation. It is partial because it does not exhaust that which is actual, let alone that which is potential.

The second comment on the position of experience leads us to consider experience not only within the boundaries of that which is actual but also within the intentionality to creations of human potentiality, i.e., to the created realms of human creativity, like art in its variations. Art once created is a realm, or in the various plural realms or modes and as such evokes experiences which are of an aesthetic character. Hence, the correlation present within reality or actuality is also present in the encounter with works of art. To put it negatively, no exposition of experience bound to one component can do justice to the essence of it. Since experience takes place in different realms including those of human creativity, we can sum up by saying that what is characteristic of experience is its structure, i.e., the relation between potentiality and actuality and not the identical components in terms of the particular acts which activate potentiality and actualize it. Precisely the placing of experience within the ontological status enables us to discern analogies

between different acts of experience and concurrently the difference between them.

NATHAN ROTENSTREICH

ACADEMY OF SCIENCES AND HUMANITIES
THE HEBREW UNIVERSITY OF JERUSALEM
JULY 1992

NOTES

1. *Prolegomena,* para 22.
2. *System d. Philosophie* III, Glockner's ed., vol. 10, p. 268.
3. *System d. Philosophie* I, Glockner's ed., vol. 8, p. 56.
4. *Varieties of Religious Experience* (New York: The Modern Library, 1962), p. 509.
5. Ibid., p. 499.
6. Alfred North Whitehead, *Process and Reality* (New York: Free Press, 1929), p. 68.
7. Ibid., p. 128.
8. John Dewey: "Experience, Knowledge and Value: A Rejoinder," incl. in: *The Philosophy of John Dewey,* the Library of Living Philosophers, ed. Paul Arthur Schilpp (Evanston and Chicago: Northwestern University Press, 1939), p. 532.
9. "The Empirical Survey of Empiricisms" incl. in: *John Dewey on Experience, Nature, and Freedom,* ed. by Richard Bernstein (New York: Liberal Arts Press, 1960), p. 77.
10. Ibid., p. 78.
11. Consult: Richard J. Bernstein, *John Dewey* (New York: Washington Square Press, 1960). The book analyzes various aspects of Dewey's theory of experience.
12. *Experience and its Modes* (Cambridge: Cambridge University Press, 1933), pp. 9, 13.
13. Ibid., p. 27.
14. Ibid., p. 34.
15. Ibid., p. 48.
16. Ibid., p. 54.
17. *The God We Seek* (Carbondale: Southern Illinois University Press, 1962), p. 73.
18. Ibid., p. 53.
19. Ibid., p. 38.
20. Ibid., p. 42.
21. Ibid., p. 45.
22. Ibid., p. 46.
23. Ibid., p. 47.
24. Ibid., p. 48.
25. Ibid., p. 49.

26. Ibid., p. 59.
27. Ibid., p. 31.
28. Ibid., p. 52.
29. Ibid., p. 53.
30. Ibid.
31. Ibid., p. 19.
32. Ibid., p. 21.
33. Ibid., p. 65.
34. Ibid., p. 94.
35. Ibid., pp. 20–24.
36. Ibid.?
37. *The World of Art* (Carbondale: Southern Illinois University Press, 1961), p. 20.
38 Ibid., p. 21.
39. *Nine Basic Arts* (Carbondale: Southern Illinois University Press, 1961), p. 9.
40. Ibid., p. 38.
41. *History: Written and Lived* (Carbondale: Southern Illinois University Press, 1962), p. 183.
42. Ibid., p. 32.
43. Ibid., p. 82.
44. Ibid., p. 123.
45. *Modes of Being* (Carbondale: Southern Illinois University Press, 1958), pp. 400–401.
46. Ibid., p. 82.
47. Ibid., p. 389.
48. Ibid., p. 391.

REPLY TO NATHAN ROTENSTREICH

Nathan Rotenstreich was one of the central figures in the youth aliyah, saving children from the Holocaust. He and Martin Buber translated Kant into Hebrew. He was a rector of the Hebrew University, and is the author of a large number of books and articles of many subjects in many languages. In the present study he brings together many of the accounts I have offered about the nature of experience. He knows what experience is in fact and in theory.

Rotenstreich notes that James takes experience to be only psychological. I am not sure that I understand him when he says that the view does not refer to a 'synthesis' of experience and the necessary connections characteristic of it. Is he perhaps taking Kant to express the correct view? We have experiences of the psychical, the contingent, the lived with and the lived in, independently of categorizations, whether these are grounded in a logic, or are produced to make easier study and comparisons possible. He then goes on to refer to Whitehead's view that perception discloses objectified data, following this with the wonder "why Whitehead does not refer to objective ones." It is not evident whether he is holding (as I do) that experiences of what is not private have a private and an objective grounding. It must have. Did it not have the one, there would be no one who perceived; did it not have the other, there would be nothing that was perceived. There is both a separating and a joining of knower and known in the course of an experience.

One risks an over-Kantianization by referring to 'syntheses'. I am not sure whether or not Rotenstreich also holds that there is a set of categories on one side with disparate items on the other awaiting to be captured in a judgmental act. He notes that for Dewey experience is not interpreted as just encountering reality, but as being in, continuous with, and part of nature, and a "projection towards the unknown." His is

as good a summary of Dewey's many-sided view of experience as could be provided in such a short space. It is hard to know, though, whether or not Dewey or Rotenstreich thinks there is a primal experiencing in which we participate in different ways and degrees, or if, instead, there are various experiencings. I suppose one would do most justice to what Dewey intends if it were said that there is a primal ongoing involvement of various items that become distinguished when humans add their interests and thereupon their stabilities and rigidifications to what is carrying them along. It is misleading, though, to speak of that ongoing involvement as 'experience', since it too quickly leads to a focussing on a presupposed experiencer. Nothing is gained by replacing 'experience' by 'process', except perhaps a freeing of what is intended from attachments to experiencers. Were this done, one would then be faced with the problem of connecting 'experience' with those who experience.

Rotenstreich takes experience to be a "projection towards the unknown." A projection, though, never arrives anywhere. If it terminated in something the projector would not become acquainted with this, unless she was somehow carried along, or what brought the projection to an end hurled the result back to her, the projector. To perceive, to know, to become acquainted with anything other there must be that at which one can begin, what can transmit what is then provided, and can end at what accommodates the result. If that result is known, what was begun with will still remain what it is, qualify and be qualified by what brings it to bear on the terminus, and have the result accommodated by what exists apart from it. The great pragmatists were not happy with their overhumanized approach to reality, but an ontologizing of 'experience' does little more than blur the question whether or not there is an experience apart from any experiencers, and if these contribute to what acts independently of and mediates them.

In section III, Rotenstreich examines my view of experience. It is not correct to say that my account of the relation of the sought Good and the seeker of it is solely 'ontological'. If it were, no activity would be carried out by individuals and groups that could end in something known. Either there is something external to those who know, or knowing is at best a private, closed off occurrence.

What is thought about can terminate in what is apart from thought only if some power began with the one, brought it to bear on the other, and the other accommodated it, all the while that what provided the beginning and what provided the end remained apart from one another. Dewey and Rotenstreich made no provision for the needed connection. A more cautious view—mine—recognizes that the ultimates are both

powerful and neutral enough to accept and be qualified by what is at one end and enable this to be accommodated at the other. They are more persistent and effective than that with which they begin and that at which they end.

It is not entirely correct to say that my account of the relation of the Good that is sought and its seeker is solely 'ontological'. If it were this, the Good would not be known and there would be no commitments to realize it. There is an ontological dimension, or at least an ontological claim expressed here, but it is one that is charged with interest, concern, and dedication.

Rotenstreich rightly emphasizes my claim that experience presupposes "someone who *can* experience, and something which *can* be experienced," and that "the can . . . points to the potentiality preceding the act of experience. . . ." Potentialities presuppose realities. Habits and abilities, as not yet exercised, are in realities even when no use is made of them. I do not think it is helpful to speak of the 'intentionality of experience' since an 'intentionality' does not arrive at a terminus grounded in what exists apart from it. Were that terminus already reached, 'intentionality' would serve only to fill in details in what apparently was devoid of them. Two meanings of 'know', evidently, need to be distinguished. One emphasizes the knower as arriving at a terminus, the other emphasizes a reality able to accommodate what is entertained. Never entirely separable, the one is in focus at the beginning and the other at the end of an act of knowing.

Rotenstreich says, "Since the self is broader and perhaps deeper than the focal experience here and now, the presupposition that the self exists leads to the anticipation of different types of that person's experience. They are essentially manifestations of the broad context of the experiencing person." There is an experiencing person only because there is a person able to experience, what exists in contradistinction to experience, and what this makes it possible to terminate at. The arrival at the known is continued in acts of discernment, i.e., in adumbrations carried out in single moves, charged with fellow-feeling, even when drenched with hatred, fear, disgust, and dread.

Experiencing presupposes an experiencer, and must terminate in what accommodates what this provides—or conversely, it begins with what an object makes available and enables this to be made available to an experiencer. To know, a mediating experience must be so empowered that it bridges the gap between subject and object.

Rotenstreich says that I hold there "is a built-in distance between experience and its content." He seems to be saying that I hold there is a contentless experience and an unexperienced content to be experienced.

I do hold that experience is not identifiable with an experiencer or with what terminates the experience, but not that the experience does not affect or is not affected by the experiencer or by that at which the experience terminates. A relation does not fall short of its terms; it terminates at and is accommodated by them. The relation that experience provides is qualified by both its beginning and its end. It is a dunamic rational power, charged with one's interest, desires, hopes, and the like, and qualified by what satisfies or disappoints these.

Rightly remarking that the relation between potentiality and actuality is characteristic of experience, Rotenstreich unnecessarily adds "in its structure." I am not sure just what he intends to hem in by that addition. I would agree with him, if what he meant to say is that they are always interrelated. He does remark that the relation does not have the same 'components' at all times, presumably meaning that it does not necessarily have the same content throughout. More important is his concluding sentence, where he indicates that the understanding of experience as having an ontological status allows one to understand differences and the ways they differ. The reference to 'analogies' will mislead. If it be put aside, we are left with a desirable outcome: experience is transformative, not just an underpinning, precondition, or test.

Every actuality is involved with others, affecting and being affected by it. Experience is one special way in which the interinvolvement occurs. Constituted by the experiencer and the experienced, it not only relates but involves them with one another. It is to be neither subjectified nor objectified but, instead, is to be understood to be a fluctuating union of the two, with one end sustained by a conscious being. There are other kinds of interinvolvements as well. Not every interplay, even of the most sensitive of humans, is experiential. We stretch our terms quite out of shape if we use 'experience' to relate us to whatever resists us. It is but one of many kinds of ways in which connections are made with what exists apart from us. Hunger, fear, and hope may terminate at objects existing apart from us. There are not just termini and then relations that connect them, or relations that might subsequently be provided with termini. Nor are there just experiencers, experienced objects, or an experiencing. All are interinvolved in various ways and degrees.

Experiencing adds no problems not already exhibited in other ways in which disparate items qualify and are qualified by the agencies that relate them, unless it be that it conventionally seems to place more emphasis on the beginning of an effective connection than on the end. In references to 'shock', 'suffering', and the like, the emphasis is evidently reversed. The best philosophic account of it would take it to be a transformative

connection in which sometimes the one and sometimes the other terminus is emphasized, in one of the many ways in which it is possible to pass from one position to another. Not all of these will involve conscious or sensitive beings. The passage from ice to fluid to steam needs no experiencer, though a poet might well credit an experience to the water that is going through these phases. Instead of concentrating exclusively on experience, its nature would, I think, be better understood did one first focus on the nature of the major types of transformation and ways in which beginnings might or might not, always, sometimes, or never keep certain termini apart while enabling them to make a difference to one another.

P.W.

9

Sandra B. Rosenthal

PAUL WEISS AND PRAGMATISM: A DIALOGUE

The goals of the following examination of Paul Weiss's philosophy are threefold; first, to show that in spite of his ongoing attack[1] on classical American pragmatism,[2] Weiss himself embraces some key pragmatic doctrines concerning both knowledge and method which he does not recognize to be so because of his own narrow interpretation of pragmatism; second, to indicate the path by which Weiss ultimately parts company with pragmatism concerning the nature of reality; third, to indicate some fundamental issues for coming to grips with and/or evaluating these divergent paths.[3]

In eliciting the common denominators between Weiss and pragmatism, the discussion will be focused on the limited but crucial issues of their shared understanding of our access to the reality of objects within nature and, interrelated with this, their shared understanding of the method of gaining knowledge in all areas, including philosophic knowledge. Before turning to this limited discussion, however, a general overview of Weiss's categorial schema and its progressive development should be sketched, for no area of his position can ultimately be sundered from this general schema, though it will become more relevant in the latter part of this essay.

In his early work, *Reality*,[4] Weiss developed a naturalism inclusive of only actualities. Later, in *Modes of Being*,[5] he presents four modes or categorial natures as reciprocally related, each one being necessary to the character of the whole, none being self sufficient. These modes are Actuality, Ideality or Possibility, Existence, and God. Being, which for actualities is expressed in the principle of noncontradiction, is here not a mode but the totality or coordination of the four modes. Still later, in *Beyond All Appearances*,[6] Weiss distinguishes between two independently functioning, irreducible types of realities, Actuality and Finalities, the latter being irreducible permanent realities incorporated by actualities.

Being, which is now a distinct finality, is a conditioning ultimate which coordinates the expressions of individual actualities and the other finalities, and the finality, Substance, is added. The five finalities are now named Substance, Being, Possibility, Existence, and Unity. Actualities are the individuals in which finalities are expressed. This schema remains unchanged in his more recent work, *First Considerations.*[7]

In his prolific writings, Weiss is concerned to greater or lesser extent with actualities, the relationship between actualities and Finalities, the relationship among Finalities, and the evidence for actualities and Finalities. And, while the finalities toward which actualities point, or which they evidence, have changed for Weiss over time, the epistemological themes introduced in *Reality* are, in his other works, operative without significant change. This includes his understanding of method and of our access to actualities and, ultimately, to finalities. What is involved for him here is the fundamental project of showing the manner by which one can move from the appearances of the everyday world of experience to actualities, and eventually to finalities. The ensuing discussion will turn toward specific features of this move.

Weiss recognizes, with pragmatism, that philosophers must begin where they are—immersed in the thick world of everyday experience—and from this draw out certain features and dimensions.[8] He recommends that philosophers begin with the phenomenological method, attending carefully "to the nuances and subtleties of what is present."[9] To stay there, however, is to acknowledge evidence but not utilize it.[10] And, in being true to the phenomenological rootedness of the move to a speculative cosmology, he stresses that the content of such a cosmology must be truly philosophic rather than scientific, and in this respect takes pragmatism to task.

That he is in agreement rather than at odds with pragmatism here is missed by Weiss because he does not make the distinction, crucial within pragmatic philosophy, between scientific content and scientific method. His continual objections to the scientific approach of pragmatism conflates these two distinct types of concern. The pragmatic emphasis is on the *method* of science, the method of experimental inquiry by which one provides a creative interpretation which directs the way one focuses on experience and which is tested by its adequacy in integrating its data in intelligible, workable fashion in the ongoing course of experience. Scientific method is a self-corrective method of inquiry by which creative hypotheses[11] are tested by their workability in the ongoing course of experience, while yet legislating for the analysis of experience. This is not a vicious circle but an ongoing cumulative process of development which requires both the phenomenological attention and speculative interpreta-

tion which Weiss demands. The very dynamics of this method of science, which characterize the dynamics of knowledge[12] at all levels according to pragmatic philosophy, including philosophic knowledge itself, are operative in Weiss's understanding of philosophic method. This can be seen clearly and concisely in his response to a critic's objection to his speculative move from a phenomenology of experience to the assertion of specific finalities. As he stresses, the philosopher "has no recourse but to struggle honestly, self-critically, imaginatively toward the outcome which the evidence demands, correcting himself in the light of the deviations he finds between what he is saying and what intelligibility, coherence, and explanation require, and experience reveals."[13] Indeed, Weiss himself explicitly recognizes the import of scientific method in his claim that "we inevitably move on to integrate and organize what we perceive. Habitual expectations are modes of using the past to illuminate the future, and thus contain the nucleus of the hypotheses of science."[14]

What differs for philosophy and science is not the method but the content, for unlike science, notes Weiss, "A philosophy, if successful, should arrive at outcomes which govern, interrelate, and are specialized by everything. To engage in it properly, one attends to a *distinctive kind of evidence—that which can be found anywhere.* . . . If it finds what has been intruded on every particular, it has evidence enough to warrant a bold yet cautious move toward that which produced the evidence."[15] Or, as Peirce stresses, the philosopher is concerned with "a kind of phenomena with which every man's experience is so saturated that he usually pays no particular attention to them."[16]

Weiss stresses that through the examination of finalities we come to see more clearly the nature of the actualities we encounter in our everyday experience. Lived experience leads toward conceptual comprehension and conceptual comprehension clarifies lived experience. The implication of this method is that no phenomenological examination of experience can be devoid of interpretive selectivity. And, indeed, though Weiss objects to Peirce's phenomenology because he "attended primarily to the possible classes into which encountered content could be placed. Nuanced phenomena in their full concreteness were ignored",[17] yet Weiss himself recognizes that a really "pure" phenomenology would be so void of distinctions that one could only "live through" it, not examine it.[18] The difference between Peirce and Weiss is not that Peirce ignores the full concreteness and nuances of phenomena, but rather that the categorial net which emerges from, yet delineates for, phenomenological attentiveness differs for each.[19]

For Weiss and the pragmatists alike, speculative metaphysics is an endeavor rooted in and verified by lived experience. It thus offers an

"explanation" of experience by providing a speculative examination and integration of the features of that independently real universe that presents itself, or intrudes within, the immediacy of our experience. This very understanding of metaphysical method presupposes an epistemic situation which undercuts the alternatives of foundationalism or anti-foundationalism, as well as phenomenalistic approaches of all types. Ontological presence intrudes itself within the field of awareness, and thus there is an ontological dimension within the very heart of experience with epistemic-phenomenological dimensions that can be studied from within, though our grasp of these dimensions is interpretive and fallible. And, for both Weiss and pragmatism, this interpretive contact with the real is founded in a pre-articulate, indefinitely rich level of experiencing through which we encounter that which resists us. For Weiss and pragmatism alike, we do not think to an ontological presence but rather live through it. To further develop this the ensuing discussion will first turn to a sketch of Weiss's theory of perception.

The perceived, according to Weiss, is a present, sensed, intelligible, but not completely understood object, the apprehension of which involves the coalescence of three distinct but interdependent types of apprehension. These three types are indication, contemplation, and adumbration, which mark out, respectively, a presence, a nature, and an unarticulated concreteness. He terms the objects of these types of apprehension the indicated, the contemplated, and the adumbrated, because "these designations suggest their corresponding activities, are intended to be functional rather than static in significance, and are somewhat freer from the associations which cluster about and distort more traditional terms."[20] Perception is the union of an interpreted contemplated with an objective indicated to form an articulate object of knowledge. For example, in the perceptual claim, "This is a book," the indicated "this" is related to the contemplated "book." This latter is a universal contemplated meaning of which the particular is an instance. This perceptual relation itself merges into an adumbrated, which is at once a more substantial yet unarticulated version of the articulate object of knowledge. This third element indicates the "thickness" of the encountered, beyond the indicated-contemplated surface jutting into our side. There is a pre-articulate level of experiencing through which we encounter that which resists us but which is irreducible to the contemplated-indicated surface, as well as to the verification that the contemplated fits the indicated. It allows for awareness of individual things in their independent reality, and eventually for the speculative comprehension of finalities.[21]

These three types of apprehension involved in perceptual awareness

must not be understood as bringing together distinct elements. Weiss stresses that while we understand a concrete object only insofar as we abstract and discriminate, yet the object is concrete and undiscriminated and is known to be such.[22] And again, these "could not have been used as naturally pertinent to one another unless they were originally unseparated components of something given."[23] Nor can the appearances which lead us toward the encounter with things be separated from the concreteness of things, for Weiss insists that appearances are realities appearing. Appearances are contextually dependent continuations of what actualities are in themselves.

Weiss pits his position here against pragmatism, objecting that pragmatism involves merely a workable manipulation of the contemplated-indicated surfaces, a "surface realism." Yet, the key feature of encounter with the concreteness of things for Weiss is the element of resistance. He stresses that objects stand over against us in defiance not only of our wrong judgments but also of our correct ones. And, this sense of resistance is precisely a key feature which, according to the pragmatists, throws us out onto an independent, dense, universe. We continually encounter that resistance which Mead calls the inside of objects, an inside which cannot be obtained by cutting the object in two, for then one gets only more surfaces. That resistance which Peirce captures through his category of secondness is emphasized throughout pragmatism, for the field of awareness is "thickened" by ontological presence. Weiss recognizes that " 'The given' within experience is infected, as the pragmatists have long insisted, with our attitudes and tendencies." Yet Weiss also stresses that "the absolute given," which is "there" independently of experience, and the interaction with which it gives rise to experience, "is innocent."[24] Both these dimensions, however, are operative in pragmatism and, indeed, the distinction between the absolute given and the given as embedded within our tendencies and purposes, made explicit by Lewis, is implicitly operative in all the pragmatists.[25] The absolute given, for both Weiss and pragmatism, represents what is there before knowledge, but which we come to know, and which is known "as apart from." Further, for both, the "agencies by which we know" may add to their data,[26] and thus reality does not "conform to"[27] but accommodates.[28]

For Weiss, the primordial contact with this thick, dense, resisting universe is rooted in an inarticulate level of experiencing within which perceptual knowledge and cognition in general emerges. Adumbration involves inarticulate anticipation, a sense of a more to be had which outruns our experience, a thickened but vague apprehension which is not conceptualization but rather that from which conceptualization emerges.

It is "felt" rather than known. While Weiss puts this in radical opposition to the pragmatic "surface" and the pragmatic focus on the objective methods of science,[29] this adumbrative access to the real[30] is remarkably similar to Dewey's primary experience and James's relatively pure experience. James's relatively pure experience and Dewey's primary experience get one closer not to "mental stuff" but to grasp of surrounding environment as it "feels."[31] It does not draw one within the subjective but throws one outward onto the universe. All experience, as Dewey states, "is *of* as well as *in* nature."[32] As James states of primary experience, it includes "a little past, a little future, a little awareness of our own body, of each other's persons, of these sublimities we are trying to talk about of the earth's geography, and the direction of history. . . . Feeling, however dimly and subconsciously all these things, your pulse of inner life is continuous with them, belongs to them, and they to it."[33] For James, as for all the pragmatists, feeling is an epistemic level not an ontological or psychological category. Ontological presence is first "felt" rather than known via concepts and categories. Concepts and categories are abstractions which always omit something of the thickened awareness at the felt level of a dense, resisting, intruding universe.

Thus, for Weiss and pragmatism alike, we are unified with an ontological presence but cannot grasp it in terms of any absolute grounding. It provides the touchstone for the workability of our perceptual claims as well as our second-level reflective claims, be they the claims of science or the claims of philosophy. For both Weiss and pragmatism, we encounter the independently real without a direct grasp of either primitive, indubitable data or absolute principles grasped by reason. Knowledge is always incomplete,[34] is an interaction between knower and known,[35] and is rooted in a pre-articulate level of experience which gives us access to the richness of a reality which "overflows" our demarcations and conceptualizations. And, for Weiss as for pragmatism, these demarcations and conceptualizations emerge through activity which is driven by our desires, values, and interests, and are judged by their workability.[36] Every selection is value laden, carries out some value scheme. Further, as Weiss so well states, even "the most abstract and fanciful concept" must incorporate sensuous perceptual aspects. It has meaning because of its relation to the perceptual through conceivable active transformations."[37]

The key themes of pragmatism which have been seen to be operative as key themes in Weiss's understanding of our access to the real and in his move toward a speculative characterization of nature are:

First, epistemology is not understood as an account of abstract conditions of our understanding, but rather as an endeavor which opens

meanings to the fullness and richness of their epistemic depth at the fundamental level of existence. To investigate the primordial epistemic level grounding any knowledge is to investigate also the structure and process of the being of the knower. It is a task both epistemic and ontological.

Second, traditional empiricism is not empirical enough, it is not radically empirical. Experience overflows our attempts to divide it up and grasp it discretely. Experience overflows the rigid boundaries of conceptual distinctions. This 'radical empiricism'[38] regains the rich textures lost by traditional empiricism.

Third, experience is not the coming together of a separate subject and object, of a subjective realm of the contents of experience and an objective realm of nature. The entire attempt to somehow relate subjective sense data to an objective world is rejected. Rather, experience is permeated by ontological presence.

Fourth, the view of knowledge and experience is radically nonspectator. In no way are humans merely spectators in the universe, just seeing what is there. Rather, what we experience is always a product of two factors, what is there and our interpretations or purposes or goal-oriented activity in terms of which we interact with what is there. Our purposes, what we are doing, affect the very character of what we experience.

Fifth, and as a result of the combination of the latter two points, both positions undercut the alternatives of foundationalism or nonfoundationalism and, along with this, the closely related dichotomies of objectivism or relativism, since each, in its own way, represents the alternatives of an absolute grounding of knowledge or skepticism.

Sixth, there is a reversal of the building block model of experience and knowledge in favor of an understanding of them as holistic. We do not begin with bits and pieces which we put together. All experience and knowledge involve contextually set selectivity which is guided by our intents, purposes, desires.

Seventh, philosophy must begin where we are, immersed in the world of thick experience and, from an examination of this experience, draw out certain features and dimensions. This "drawing out" or speculative extrapolation from experience involves a creative interpretation which directs the way we focus on experience and which is judged by the intelligibility it in turn introduces into the examination of experience. This allows for fallibilism, pluralism, and open-endedness, for the espousal of a method which is continuous with the method of science, and for the rejection of all attempts to absolutize the contents of physics, favoring instead a truly philosophic cosmology. Further, such a cosmolo-

gy must allow for the fact that the nature we experience evinces both the stable and the precarious, continuity and novelty, activity and structure, change and order.[39]

Yet, in spite of these similarities, while the evidencing through experience which Weiss develops leads squarely to a substance philosophy, pragmatic philosophy is through and through a temporalism in which a metaphysics of substance gives way to a philosophy of process. That pre-articulate experience which for Weiss demands substance, according to pragmatism throws us outward onto a processive universe. This is succinctly expressed in Mead's claim concerning the universe, that at the "boundary" of experience or the "outer edge" of primordial activity, "things pass."[40] For all the pragmatists, the lived through primordial experience of "felt" temporality opens us onto a processive universe. This central difference between Weiss and pragmatism, and key philosophic issues with which it is entangled, will be briefly explored.

Weiss lists five types of evidence for actualities as substances. First, appearances qua appearances are inert, yet they defy our epistemic imposition of boundaries by the pull on them "originating from beyond those appearances." Second, an appearance is subject to "coarsening," a density which, though continuous with the appearance, is distinct in nature and function. Third, certain appearances have a relationship of belonging together that they do not have with other appearances of the same type, leading to a common source upon which they converge. Fourth, though our actions are directed by appearances, they are "efficacious but incompletely so" because they reach insistent actualities which terminate and resist them. Finally, we are aware that we do not know all there is to be known; "beyond anything we know, there is always an adumbrative, promising more to know. We come to know an actuality by symbolizing along the route of an adumbration."[41]

Yet, none of these examples gives evidence of substance as opposed to process but rather of a "substantial" universe in the sense of a thick or dense universe, one which exhibits persistence, resistance, and efficacy. Indeed, Weiss himself, after stating that every actuality is a substance, goes on to speak in terms of substantiality,[42] and to continually stress characteristics which can also hold of process. And, the choice between understanding this substantiality in terms of process or of substance lies, for Weiss and pragmatism alike, in the conceptual clarity each can provide for understanding the pervasive features of experience. Thus, it is these competing conceptual clarifications of our everyday experience which must be compared.

Weiss continually opposes his substance view to the Whiteheadean

alternative of an event ontology.[43] Whitehead substituted for an ontology of substance an ontology of events. As Weiss continually characterizes his specific objections, these events or actual occasions do not occur through time but at a time. Events do not change, but perish; there is a succession of events. Thus Weiss stresses that "events just are," no event can "persist and react." As he states, "Some contemporaries have thought it desirable to replace substances with events. These, strung together, are supposed to yield a semblance of persistence, continuity, and distinctiveness—the supposed characteristics of substances. But such an account fails to yield anything that might act.[44] Events occur, but it is substances that perform, move, change."[45] Weiss does not accept traditional notions of substance, stressing that the alternative to traditional views of substance, need not be a theory of Whiteheadian events, but "another account of substance."[46] Substances, for Weiss, are persisting temporal objects. Similarly, however, the alternative to any view of substance need not be a Whiteheadean view of events but a different account of process, a pragmatic understanding of process.

Weiss, as has been noted, attacks process philosophy, which he equates with the Whiteheadean type, on the basis of the relation of novelty and continuity or endurance. He does not read pragmatism in terms of process philosophy, but does attack it on the basis of the relation between actuality and possibility housed within it.[47] Yet, pragmatic philosophy, precisely as a non-Whiteheadean type of process philosophy, and as incorporating the features of substantiality that Weiss claims require substance, resolves the problems of the interrelation of actuality and possibility and of novelty and continuity in a way which eludes Weiss's various objections. The ensuing discussion will briefly explore and evaluate the paths of Weiss and pragmatism in resolving these issues.

Weiss, like many others, objects to what he considers to be the over-futurism of pragmatic philosophy, holding that it supposes that what we grasp in the present are "solely future consequences." Thus, "were pragmatism correct, we could never verify anything, for an act of verification necessitates a grasp of the nature of what is now occurring and a reference back to the hypothesis, not necessarily a reference forward to something still in the future."[48] For similar reasons, Weiss objects that pragmatism "cannot handle the problem of the reality of the past."[49] Yet, there is a very great difference between "future actualizations," "future possibilities of actualizations," and "present possibilities for future actualizations," though these (and especially the latter two), are often used interchangeably. The pragmatic emphasis on possible consequences does not put undue emphasis on the future but rather

requires the acknowledgment of *present possibilities for* future actualizations. Past as well as future are drawn into the present for pragmatism, but in the form of present potentialities and possibilities which are real now.

Weiss's position denies that there is a direction to past time in and of itself, but only in terms of an external future.[50] Further, in relegating possibilities solely to the future, Weiss holds that while they are "directive of things in the present," yet "These possibilities are external to the things in the present." Possibilities provide an "external future" for persisting actualities.[51] Without determinations by this external future, there would be only a plurality of present ongoings indeterminately related to one another.[52] Because possibilities are external to actualities or temporal substances, there is no "logical space" for possibilities which fail to be realized. Rather, possibilities are indeterminate, (the possibility of "either A or B"), and are made determinate as incorporated in actualities. (Either A occurs or B occurs). An actuality makes concrete and determinate the more inclusive, less determinate "inevitably realized possibility."[53]

Within pragmatism, possibilities do not outrun what occurs in the present merely as future to present, but rather the nature of the present is partially constituted by possibilities and potentialities,[54] many of which will never be actualized, and some of which will cease to be. The emerging present is the arena of the dynamic, active, interacting, resisting, enduring ontologically dense universe which intrudes within experience, and this ontological density is rich with possibilities and potentialities which are real now as possibilities and potentialities. This can be the case because the present contains actualizations, potentialities, and possibilities all emerging from the past and projecting toward a novel future. The ontological density of the independently real, resisting, enduring, processive universe is "temporally thick," for novel emerging present actualizations are inclusive of present possibilities and potentialities which a dynamic past has embedded in the changing present. Process is, as James so well expresses, the "living, moving, active thickness of the real."[55] What is indicated by "process" is the thick ontological density of "the causal dynamic relatedness of activity and history."[56] Possibilities and potentialities are not ephemeral, abstract, ways of being, but are dynamic tendencies embedded in the concretely rich processive universe as ways or tendencies of behaving. Existence is the arena of natural resistance, what we encounter, what our knowledge must adequately incorporate. We encounter possibilities and potentialities as well as actualities, however, and these former, as well as the latter, have a brute "thereness" and natural resistance which are partially

constitutive of the present and which our knowledge must incorporate if it is to be successful.

It was seen above that Weiss claims that substantiality requires actualities or substances. Yet, within his philosophy, it seems to be not substance or actuality but rather the Finality termed existence which allows the characteristics he desires. He holds that "Each actuality exists apart from all the others. Each fills out a present of the same kind and duration, but in its own distinctive way, to make this its own present, having nothing to do with any other."[57] And, as he clarifies the role of existence,

> Existence is what makes the Actuality effective, dynamic, able to act and interact. . . . By virtue of the continuity of the Existence in the Actualities with the Existence which lies between them, the Actualities are related to one another across an extended space. As the whole of Existence moves on, it implicates those Actualities; these, so long as they maintain a hold on their Existence, will move into the future concordantly. Despite the fact that every Actuality exists in itself, it is, by virtue of the continuity of its Existence with the rest of Existence, not only a being which keeps abreast in time with independent contemporaries, but which interplays with them, interacts with them to constitute a single slab of present cosmic time.[58]

Thus, it is the Existence which an actuality encloses which is the source of its vitality, "grounds space and time, and exhibits cosmic laws,"[59] allows actualities to be open to experience,[60] and provides the continuity which relates separate, distinct actualities to one another.[61]

This last point involves what is ultimately at issue in the choice between understanding reality as substance—even substance as temporal in the sense of persisting through change, or understanding reality as pragmatic process. For this is ultimately the choice between what is more fundamental, discreteness or continuity, the "coming together" or the "emergence within." This can be brought home by briefly encapsulating the respective views of time in Weiss's position and in pragmatism, the latter being most explicitly represented in Mead's writings. Both Mead and Weiss are explicit in recognizing that the flow of time cannot be a simple continuum, but rather requires "breaks." What is at issue between them in understanding time is, which is more fundamental. As Weiss states of time, "The impression remains that time is one continuous flow, though in fact it is a sequence of fixities displacing one another without interval."[62] "Time is a sequence of distinct, indivisible, extended units. An extended time without these units would be a simple continuum.[63] In this way, there is a "continuum of atomic instants."[64]

Mead agrees that the flow of time cannot be understood as a simple continuity, but holds there must be some break, not of continuity, but

within continuity.[65] The continuity is the condition for the novelty, while the novelty reveals the continuity though the oncoming adjustment which accommodates the novel, rendering it continuous with what came before. The putting together of discrete units of any type can yield only a pseudo-continuum.

Although Weiss fought to avoid this, yet ultimately within his position discreteness is primary, be it the units of time or the "units" of substance, resulting in a quasi-continuum, in discrete elements which must come together, even though "in a sequence without interval."[66] For pragmatism, continuity is primary, and interacting portions yield the emergence of quasi-discretes, be it present, past, and future, or persisting "individuals." Both Weiss and pragmatism attempt to account for a resisting, thick, ontologically dense universe characterized by both persistence and change, continuity and discreteness, lawfulness and spontaneity. Weiss's epistemology, like that of pragmatism, fits the paradigm of "emerging elements within," rather than the "coming together of." Yet it is precisely the divergence here concerning the nature of reality that ultimately splits Weiss and pragmatism apart. One can only wonder what sort of dialogue may have ensued had Weiss read pragmatism as a unique process philosophy providing a universe of resistance, efficacy, and persistence within creative passage; in brief, as a philosophy of substantiality without substance.

SANDRA B. ROSENTHAL

DEPARTMENT OF PHILOSOPHY
LOYOLA UNIVERSITY
JULY 1992

NOTES

1. These span his entire writing career

2. "Pragmatism," as used in this essay, always refers to classical American pragmatism. And, by classical American pragmatism is intended that position incorporating the works of its five major contributors: Charles Peirce, William James, John Dewey, C.I. Lewis, and G.H. Mead.

That these five pragmatists provide a unified perspective is assumed in this essay, but this claim is defended elsewhere in some depth. Similarly, the basic tenets of this unified view of pragmatism are assumed and utilized here, but are defended at some length in that work. See my *Speculative Pragmatism* (Amherst, Mass.: University of Massachusetts Press, 1986). Paperback edition (Peru, Ill.: Open Court Publishing Co., 1990).

3. This type of analysis could be done in virtually all areas of Weiss's

philosophy, including the areas, important for Weiss and pragmatism alike, of value, selfhood, and community. This paper, however, can of course not do it all.

4. (Carbondale and Edwardsville: Southern Illinois University Press, 1938).

5. Two vols. (Carbondale: Southern Illinois University Press, 1958.)

6. (Carbondale and Edwardsville: Southern Illinois University Press, 1974).

7. Dunamis, in addition to actualities and finalities, constitutes the third type of reality. Having noted this third type, added only in his most recent works, it will be put aside, for it is not relevant for the present analysis.

8. Thus he insightfully observes that many works on epistemology would have been better had they been written backwards, revealing how "from the material of daily life (with which they usually end), they had obtained the suppositions with which they formally began.

9. *First Considerations* (Carbondale and Edwardsville: Southern Illinois University Press, 1977), p. 195.

10. Ibid.

11. Weiss recognizes Peirce's acute characterization of this step in his concept of abduction. *Reality,* p. 56. And, as Peirce points out, the creative hypotheses or abductions of science shade into the abductions of perceptual awareness without any line of demarcation between them. *Collected Papers,* vols. 1–6, ed. Charles Hartshorne and Paul Weiss (Cambridge: Belknap Press of Harvard University, 1931–35), 5.181.

12. The term 'knowledge' here is not limited to the reflective level but is taken in a broad sense inclusive of the dynamics operative in even the most primitive perceptual awareness.

13. *First Considerations,* p. 193.

14. *Reality* (Carbondale and Edwardsville: Southern Illinois University Press), p. 142. In *Toward a Perfected State* (Albany: State University of New York Press, 1986), Weiss argues forcefully against taking science as the model for knowledge, but it is clear from his discussion that what he is objecting to is a view which reduces away all human creativity—a reductionist view of scientific method which involves at least implicitly a reduction of human activities to the behavior of scientific contents. Pragmatism, in accepting scientific method as used in this essay, would agree with Weiss not only that one must be able to account for the creativity of artists, but also that "scientists and historians are creative as surely as artists are." p. 92.

15. *First Considerations,* p. 194. Italics added.

16. Peirce, *Collected Papers,* 6.2.

17. *Beyond All Appearances,* p. 21.

18. Ibid., p. 22.

19. This will be discussed in the latter part of this paper.

20. *Reality,* p. 31.

21. In *Beyond All Appearances,* Weiss distinguishes adumbration from lucidation. Adumbration is now reserved for our relation to actualities, while lucidation refers to our relation to finalities. This distinction need not be pursued here, however.

22. *Reality,* p. 32.

23. Ibid., p. 66.

24. Weiss also has a "variable given," which need not be discussed for present purposes. See *Reality,* p. 68.

25. Weiss explicitly objects to Lewis on other grounds which are not directly relevant here. *Reality,* p. 21.

26. *Beyond All Appearances,* p. 53.

27. Weiss distinguishes three types of truth: embedded, objective, and conformal, but the latter is not equivalent to a "conform" or "correspondence" theory of truth. These three types represent functional distinctions. Each may be considered primary, depending upon the context, and each shares features of the others, though in more limited forms. *Toward a Perfected State,* pp. 84ff.

28. *Toward A Perfected State* (Carbondale and Edwardsville: Southern Illinois University Press, 1980), p. 401, note 7.

29. *Beyond All Appearances,* p. 44. Weiss also claims that for pragmatism, what is known is the result of the use of the objective devices of an impersonal science, and that it provides too limited a view of human relevance and practical effects. Here he specifically criticizes Peirce and Dewey. Ibid., pp. 44–46. He also makes a distinction between "a philosophy of practice, in contrast with a pragmatism" and fails to recognize the richness of human existence and the breadth of conceivable consequences within pragmatism. Ibid. In *Modes of Being,* Weiss claims that Peirce's conceivable practical effects "spawned a whole family of doctrines." Peirce, James, and Dewey, according to Weiss, each had a reductionism because each had a limited, but different, set of items in terms of which to frame the evaluation of effects. p. 65.

30. I am grateful to Kevin Kennedy for corresponding with me about a paper in which he compared Weiss's theory of adumbration with the theory of anteceptive experience developed in my *Speculative Pragmatism,* and for his ongoing dialogue with me in this general area.

31. For Weiss, adumbration serves the added function of providing an intimation of the Whole, and has a kind of Platonic character to it. In this regard he can be seen as somewhat opposed to the pragmatists.

32. *Experience and Nature* (1981), *The Later Works,* ed. Jo Ann Boydston (Carbondale and Edwardsville: Southern Illinois University Press, 1981–), vol. 1, pp. 12–13. Italics in text.

33. *A Pluralistic Universe* (1977) in *The Works of William James,* ed. Frederick Burkhardt (Cambridge: Harvard University Press, 1975–), p. 129.

34. Weiss objects to "some pragmatists," namely Peirce, as holding to an identity theory of knowledge and reality when inquiry is complete. *Beyond All Appearances,* p. 33. Though Peirce is explicit in this claim, what this claim intends is far more complex.

35. Weiss objects to the pragmatic understanding of reciprocity because "one would then have no explanation of why the interplay occurs, unless it be to overcome a poorer form of the interplay, where the distinguishable items fail to mesh properly. In such a view, there is not only no accounting for the failure, but once there was a perfect fit all activity would stop. *Privacy* (Carbondale and Edwardsville: Southern Illinois University Press), p. 225. This is related to his view that pragmatism is a surface realism, with no access to or awareness of the thick depth of reality.

36. *Beyond All Appearances,* pp. 55–56.

37. *Reality,* p. 44

38. This term of course is taken from William James.

39. See, for example, *Religion and Art* (Milwaukee: Marquette University Press, 1963), pp. 31ff.

40. Mead, *Philosophy of the Act,* ed. Charles Morris (Chicago: University of Chicago Press, 1938), p. 345.

41. *Beyond All Appearances,* 228–29.

42. *First Considerations,* p. 107.

43. The following discussion is not concerned with Whitehead's position per se but with Weiss's interpretation of it. Whether or not his criticisms are valid is irrelevant for the present purpose.

44. Weiss sees the Humean and Whiteheadean views of causality "belonging together" as two sides of the same coin. *Cinematics* (Carbondale and Edwardsville: Southern Illinois University Press, 1975), p. 68.

45. *Beyond All Appearances,* p. 53.

46. Ibid.

47. The crucial problem of possibility for Weiss is what first led him toward finalities. For his own statement of this progression see *First Considerations,* p. 204.

48. *Reality,* pp. 45–46.

49. *Beyond All Appearances,* p. 44.

50. *Modes of Being,* vol. I, p. 229.

51. *Man's Freedom* (New Haven: Yale University Press, 1950), p.18.

52. *History: Written and Lived* (Carbondale: Southern Illinois University Press, 1962), p. 153.

53. *Modes of Being,* p.116.

54. Weiss does not seem to focus much on potentialities, and makes no clear distinction between potentialities and possibilities, a distinction which would be needed for a more adequate interrelation of his position with that of pragmatism.

55. James, *A Pluralistic Universe,* p. 116.

56. Ibid., p. 122.

57. *First Considerations,* p. 178.

58. *Modes of Being,* p. 223.

59. Ibid., p. 242.

60. Ibid., p. 232.

61. Ibid.

62. *Sport: A Philosophic Inquiry* (Carbondale and Edwardsville: Southern Illinois University Press, 1969), p. 115.

63. Ibid.

64. *Reality,* p. 233. An atomic unit for Weiss is not pointlike, but rather is itself an "indivisible extension." Ibid.

65. *The Philosophy of the Present,* ed. Arthur Murphy (La Salle, Ill.: Open Court, 1959), pp. 114–16; "The Nature of the Past," *Selected Writings,* ed. Andrew Reck (New York: Bobbs-Merrill Co., 1964), p. 350.

66. In *Privacy,* where Weiss introduces his notion of the Dunamis (see note 7), he speaks of it as an aboriginal, active continuum (p. 17). Yet, "The irreducible units which condense it are to be understood in both Democritean and Leibnizian terms, the one emphasizing the bodily side of them, the other the private." p. 21 The entire discussion then proceeds in terms of indivisible atomic units, either atoms or atomic monads. This attempt to discuss continuity in terms of indivisible atomic units runs into the same problems which permeate his analysis of time.

His entire discussion of the Dunamis has been dismissed by some critics as superfluous.

REPLY TO SANDRA B. ROSENTHAL

There are at least two different ways in which one can understand Sandra Rosenthal. One, which she prefers, tries to do maximum justice to the pragmatic movement by extracting pivotal contributions of its leading members and then trying to present them in a single account. This she does exceptionally well. The other, that I think does more justice to her insights, utilizes pragmatic ideas to produce an entirely new account, superior to those of her predecessors. I think she is an original pragmatist, going beyond the position others have reached, to provide a stronger, more flexible, promising version. I confess that in the light of this advance, my usual assessment of pragmatism is too narrow, though I also think that, despite the contributions she has made, the view still has a number of fatal limitations. Even in her view, creativity in the arts, mathematics, humans, society, and state seem to be out of reach, and religion, history, education, cosmology, and ethics are never sufficiently well grounded or well treated. She makes a strong effort to present my views accurately and well. I will try to match it.

I think Peirce was right to take pragmatism to be primarily a method, not a doctrine, refusing to squeeze everything within a pragmatic frame. He was right, too, in not trying to reduce all legitimate inquiry to what could fit within the compass of a 'scientific method'. Interested in determining the procedures and claims science presupposed, neither he nor others tried to understand its presuppositions in its relation to the presuppositions of other disciplines.

Despite my comparative ignorance and inexperience in science, I do think pragmatists misconstrue science. Its work is actually carried out in a looser way, its conclusions are more tentative, and the commitments, dedications, surmises, and doubts of its practitioners play larger roles than the pragmatists seem to realize. Rosenthal does say that pragmatism

is primarily concerned with "carrying out . . . experimental inquiry" involving "creative interpretation," but I am not confident that this was ever done. It would have helped had the characterization been spelled out and documented.

What is an interpretation? How does a creative interpretation differ from others? Is it similar to that which artists engage in? In what respects are they alike and different? Does Rosenthal mean by 'creative' anything more than being imaginative, original, and/or suggestive, and perhaps eventually useful?

Rosenthal says that "scientific method is a self-corrective method of inquiry by which creative hypotheses are tested in their workability in the ongoing course of experience. . . ." Would it be correct to say that this is a supposition all scientists accept? I think she is right in maintaining that there is something held in common by scientists, but there also are great differences in the way they work.

Scientists, as Peirce knew from experience but did not always know how to make it relevant to his own work, are members of a single community of inquirers who accept, as Kuhn remarks, a common paradigm for a while. They do not, though, march in step, nor are they always in agreement. If they tried to form a solid front, it would take a severe jolt to get them to renew the type of inquiry that interested their predecessors. Their willingness to raise difficulties about their own findings, or of those that have been long accepted, is worth duplicating, not the claims they now make about what happens to occur in some domain.

Is an hypothesis not something in mind? If so, how could it enable one to get to what is outside the mind? Could an hypothesis, 'creative' or not, take one from what is in mind to what is in fact? Peirce's abductive method is worthless if it does not bridge the gap between what one entertains and what occurs. No hypothesis can 'legislate', for at best, it expresses a hope that there might be something else. I understand how one might be able to formulate an hypothesis; I do not see how one is then enabled to arrive elsewhere. The issue has cropped up in the contributions of Lenk, Rotenstreich, Walther, Weissman, and others, but I don't see that it is defended by them with any more success than Rosenthal has been able to provide.

An hypothesis: The recourse to hypotheses is the last gasp of a seriously flawed view.

Rosenthal says that "the categorical net which emerges from yet delineates" is different for Peirce and for me. Yes—and no. I do not think a 'categorical net' enables one to achieve anything. Once again, what is needed is what can bridge the gap separating the affirmed or

acknowledged and what exists apart from this. Could the gap be bridged, were what one entertains not in fact related to what is not in one's mind? Must this not be what has a nature and power of its own able to qualify and be qualified by what is at each end?

"Ontological presence," Rosenthal says, "intrudes itself within the field of awareness." It would have helped had she made evident whether this is her view, or the view of others as well. She does say that our grasp "is interpretive and fallible." Yes, every claim one makes is interpretive and fallible. In some cases though, they seriously affect, while in others they do not compromise what we had initially thought. She claims that I and the pragmatists "do not think to an ontological presence but rather live through it." Once again, it would have helped had she given some references or, if the idea is her own, some justification, and an indication of how it fits in with the prevailing or even established pragmatic outlook. Nor is it correct to say that I hold that we "do not think to an ontological presence." Indeed, I have long insisted that we do indeed reach realities by having our acts controlled by mediating ultimates.

Is there nothing that is presupposed when we understand, or when we live in the humanized world? If there are, how are they known? What is their status? Are they always present? Do they have anything to do with what occurs in the cosmos and nature, particularly at a time before there were humans? Pragmatists, like the rest of us, seem to have goals, but these do not seem to have the status even effective of lures. How could they?

Where I speak of a resistance encountered, Rosenthal speaks of "a sense of resistance" that throws us out onto an independent, dense, universe. That surely cannot be right. There is a resistance, not just a 'sense' of one. It could affect us only if there were something able to impinge on us. She also refers to Peirce's secondness, but does not show how this could tell us what resists us, how we could be affected by it, or how it could be known. She speaks of what is "implicitly operative." What does 'implicitly' here mean? Is it another way of referring to what is supposed, presupposed, experienced, but not noticed or articulated?

Rosenthal says that "adumbration involves inarticulate anticipation." Yes it does, but only because it in fact takes one into what there is. We can anticipate, because we are already involved with what already satisfies us in part, leaving over a denser, more satisfying, adumbratively graspable, resistant, and accommodative reality. She apparently thinks it is enough to anticipate, to have "a sense of a more to be had." I, instead, stress the fact that we are acquainted with that which we seek to know better. She seems to suppose that we just hope and that we sometimes

find our hope satisfied; I maintain, instead, that we are already acquainted with realities in depth and therefore are at once satisfied and lured beyond where we seemed to have stopped. Adumbration has no antecedently determined limit. It continues beyond where it seems to have ended and where we, for the moment, may be content to rest. To know, to love, to hate is to be aware of what has not yet been brought within the confines of any such act. No pragmatist is pragmatic enough if a full stop is made with what is hoped for, intended, or hypothesized.

"Nature" for the pragmatists, and particularly for Dewey, seems to be a term with many duties. It apparently applies to raw, unfiltered experience, and to what encompasses us and other living beings, and perhaps also to humans in a sophisticated state that is assumed to have been misconstrued by all other philosophers and mastered by scientists. Nature should not be identified with the humanized world, within which pragmatism works so well. It existed before there were any humans, and it has its own distinctive members. We do not exist in it. Ours is a world in which only humanly qualified values, associations, extensions, aggregations, the rational, and the dunamic are operative. Nature existed before and even now exists apart from humans and humanizations.

Rosenthal takes feeling to have an epistemic, not an ontological role, but gives no reason for supposing that it is not both. While there is a "thickened awareness at the felt level of a dense resisting, intruding universe"—'universe' is surely too grandiose a designation to be used here—too sharp a line between the felt and known must not be drawn. I do not see why the ontologic may not occur before the epistemic, nor why that priority must always prevail. Sometimes our fears make us aware of what might not be noticed, sometimes what we know makes us fearful. Nor do I think it right to say that "concepts and categories are abstractions." I think it better to say with Chauncey Wright that they are factual finders.

Rosenthal thinks I agree with pragmatism in holding that "we are unified with an ontological presence but cannot grasp it in terms of any absolute grounding." No. It is at the very heart of my view to show that we ought to and can find such a "grounding." How could one know that we could not grasp it if we had not already known of it and had so far already 'grasped' it? Every actuality and interplay is qualified by all the ultimates. These are involved in every appreciation, as Dewey too seems to acknowledge despite his dreadful attempt to deal with art as that which provides a "consummatory experience."

Rosenthal lists three pragmatic themes that she thinks are operative in my view:

1. Rightly remarking that epistemology does not provide "an account

of abstract conditions of our understanding," she gratuitously adds that it is occupied with opening meanings, and with investigating "the structure and process of the being of the knower." Epistemology deals with more than meanings, attempting, at the very least, to show how one can know something that is real.

2. Rightly remarking that "experience overflows the rigid boundaries of conceptual distinctions" she neglects to remark that this is done in acts as well. We do this when we evidence the ultimates and pass on to what these in turn presuppose. We do it also when we commit ourselves, believe, carry out technical and creative work, and speculate.

3. Experience, Rosenthal illuminatingly remarks, is "permeated by ontological presence" but then fails to tell us what this is, whether or not we could know its source, or the difference it makes to what is experienced.

In all three admirable attempts to reveal agreements, she overlooks essential differences, leaving over the question how one knows, and whether or not experience presupposes anything.

Rosenthal denies that humans are ever just spectators. Once again an important point is blunted. We can quietly observe; we can be spectators while we participate. There are perhaps no periods 'in the language of reality' but there surely are commas and some semicolons. Sometimes we survey before we plunge, and sometimes we plunge and then survey. Pragmatism, even in Rosenthal's enriched version, is so anxious to free itself from the frozen views it liberally attributes to those who disagree with it, that it fails to benefit from what in fact led to the acceptance of those views. The half-measures and unexamined prejudgments of pragmatism are not to be defended by setting them in contrast to other half-measures and unexamined prejudices. Its truths are best defended by seeing them together with other equally well-grounded truths about realities that existed before there were any pragmatists.

Rosenthal thinks that what is needed is a "method which is continuous with the method of science." Why not a method continuous with those employed in technology, painting, the courts, architecture, history, or any number of other respectable enterprises as well? If science is to be given a preferential status, a reason should be provided. Is it its success in predictions? In promoting technical advances? Its use of experiments? Do these suffice? Why not also look to religions because of the solace they bring to many, to novelists for the insights they provide into the depths of humans and subhumans, to logic for its precision, to love and hate for their earnestness and absorptions? Why not look beyond all of them to what is real? Why not ask what is being presupposed? It is not sound procedure to accept, without question, the methods or achievements of

any other enterprise as setting limits beyond which no one can go. It is not wise to accept them as though they contained indubitables. Why suppose that any provides a model for every other?

I think pragmatism is more than a Peircean method for clarifying ideas or meanings, I do not think it should be kept within the limits of Dewey's view, or of all the major pragmatists, even when purified and interlocked so skillfully by Rosenthal. It has a distinctive area—the humanized world—where, without excluding the use of other methods, it is most useful and fruitful. Its success there does not justify its denying that there are other ways in which we should proceed if we are to know about ourselves, nature, and the cosmos, what they all presuppose, and the Being that subtends whatever there be. It violates the spirit of pragmatism to take it alone to be viable. One goes counter to the facts if one supposes that nothing can be known by doing what pragmatism cannot.

Rosenthal denies that the contents of physics are absolutized by pragmatism, claiming that it, instead, favors "a truly philosophic cosmology." Does it not absolutize what it takes to be the method of physics? Is it able to do justice to the creative work and achievements of mathematicians? Does it allow for a nature or cosmos that exists independently of all humans? She would like to ally pragmatism with a temporalism, "a philosophy of process." What she seems to have in mind is not the philosophy of Whitehead or his self-defined followers, but something else, whose nature is not quite clear. Does she, with them, think that there are no persistent realities, no humans with lives stretching over ninety years, no guilt for deeds carried out long ago, nothing self-identical over the years, no stable laws of logic, and only a God who could be for more than a moment?

My references to substances were not intended to preclude references to change, ongoings, coming to be, and passing away. These are more than idle aspects of Aristotelian beings. References to them served to check the tendency to hold that there were actualities that were 'self-caused' and existed for just a moment. She recognizes that I do not hold a traditional view of substance. I wish she had shown us how she has met, as she claims, to have overcome my difficulties with the process view. If I had to choose, I would prefer Rosenthal's idea of philosophy of process to the one now favored, for she does not have recourse to the idea of self-causes, or of an eternal triune God, with faces directed in opposite directions and related by that of which nothing is known.

Yes, there is a "primordial experience" of a felt temporality—but there is also one of spatiality, causality, affiliation, coordination, value, vibrancy, and rationality, in the little and in the large, qualified by and

qualifying one another. Rosenthal seems on the verge of saying this, since she claims that there is a kind of substantial or dense universe, but stops short of saying that there is anything in it that is substantial and thick, persistent over time, with an inwardness of its own. It would have helped had she made evident what she means when she says that "past as well as future are drawn into the present." They must have a status of their own if they are to be able to make a difference to what is now. One can utilize the past and take account of the future, without making them vanish.

Instead of the dichotomy, possibilities outrunning what occurs in the present or the present partially constituted by possibilities, I would, once again, say 'both', and think I would then be in better accord with the pragmatic vision that she is. I do not see how, on her view, it is possible to know that there is anything that does intrude, and what its nature is when not intruding. Is it first abstracted and then reified?

Rosenthal speaks of the present as containing "potentialities and possibilities, all emerging from the past and projecting toward a novel future." Is not what is projected still present? If there is a future, is it not what is not yet present? 'Process' thought would have helped her here, for processes have beginnings giving way to endings. Were those processes not supposed to occur inside disjunct occasions, 'process' could be identified with the Dunamis as not sealed off from the other ultimates. I can see that one might say that a potentiality is a 'dunamic tendency', but the tendency must be subjected to a dynamism if the potentiality is to be realized.

It is confusing to link possibilities and potentialities in the way Rosenthal does. Possibilities are prospects that await realization by powers distinct from themselves. These begin at the potentialities and end by turning possibilities into realities. Perhaps what is meant is that if there are no tendencies there will be no directing the passage to a sought end? If so, reference should be made to the ways those tendencies qualify and are qualified by the agencies that utilize them.

Rosenthal finds a difficulty with my view that actualities are realities that persist over time, and are sometimes termed 'substances' in the attempt to differentiate persistent beings from supposed societies of atomic events. She prefers to speak of "some break, not of continuity, but with continuity." If the continuity refers to the Dunamis, I am in closer agreement with her and Mead than she recognizes, provided only that the other ultimates are also recognized to be involved in transitions, not only over time, but over space and from domain to domain. She then says that I take 'discreteness' rather than continuity to be primary. I think they are inseparable, sometimes with the one and sometimes with the other

dominant. There will still be a difference between her improved version of pragmatism and what I think must be maintained, as long as she has not made it possible to understand what exists apart from, before, or after there are any humans.

Rosenthal has provided a strong, flexible pragmatic view. If it is developed along the lines she has mapped out, it will, unfortunately, continue to be a limited view, applicable to only a part of reality. Other accounts are needed if justice is to be done to individual persons, nature, the cosmos, the ultimates, and the Being they all presuppose. In the end, even her strengthened version cannot stand unless it acknowledges another philosophy, within which it will have a needed, honorable place.

P.W.

10

Kevin Kennedy

ADUMBRATION AND METAPHYSICS AFTER PRAGMATISM

What should characterize metaphysical speculation in the post-pragmatic period? I propose that an interpretation and integration of the basic insights in Paul Weiss's notion of adumbration will provide an answer to this question. It will also contribute a way of understanding his work and reveal its relation to the central tenets of pragmatism.

A post-pragmatic metaphysics must try to understand the way the world is by filling out a speculative account with experiential interactions. Ordinary experience in the daily commonsense world, which is inescapable but yet indefinable, must be the starting point. However, it cannot be an indubitable foundation. There is no point or set of truths which can serve as an anchor. Founding philosophy in clear, unmistakable intuitions from which all legitimate conclusions can be deduced consistently fails. It is time to abandon not philosophy, but deductivism.[1]

For post-pragmatic metaphysics, a pristinely defined starting point is either impossible or useless, "as useless a preliminary as going to the North Pole would be in order to get to Constantinople by coming down regularly upon a meridian."[2] We must not conclude from this, however, that all reasoning is equally legitimate (or illegitimate). Pragmatism avoids this conclusion by rendering all theories subject to the test of workings, satisfactions, or instrumentality.

We need to go beyond pragmatism, however, because it can seem self-contained and disconnected.[3] As a metaphysical system it fails its own test. If all we know is that our projections of meaning in an intrinsically unknowable process universe are presently working, then we will never have the confidence and faith needed to live nobly and well. We need to go further, albeit carefully. We must be able to say legitimately that we "know" something beyond our experience and not simply by hypothesis.

By making knowledge claims which are fallible and openended,

post-pragmatic metaphysics will provide an opportunity for discourse which is more than idle conversation. We cannot avoid making ambitious metaphysical claims. We should adopt the best and most irrefutable of them, and borne upon them, "sail through the dangers of life as upon a raft."[4] Post-pragmatic metaphysics ought to justify the confidence that we can discern the nature of things, sometimes perspicaciously, and govern ourselves in terms of those insights.

Adumbration allows us to do this. It is a kind of "ontologizing" response to reductionism. Reductionism in its many forms denies the reality of anything that might conceivably, even in the distant future, be understood in terms of less complex entities and interactions. Adumbration appreciates the reality of everything, if even the most attenuated derivative. It is a radical openness to being. It errs on the side of superfluity. Yet it can be more easily corrected by recourse to ordinary experience than can a deadening reductionism which paves the way for irrationalism as a reprieve.

After a brief introduction to Weiss's early formulation of adumbration, the fundamental insights emerging from it will be integrated and interpreted in connection with five basic tenets of the pragmatic movement. This in turn will shed light on the character of post-pragmatic metaphysics.

I

In *Reality* (1938), adumbration is understood to be an experience of the real beyond our articulations.[5] Even in this early work there are "perceptual" and "speculative" aspects to adumbration. The former consists of the perception of an object's substantiality beyond our articulations of it; the latter of our immediate awareness of a "domain of ignorance," that is, the rest of reality outside our articulate knowledge (*R,* 59). *Reality* presents a naturalism comprehending only actualities and the discussion of adumbration there begins with its delineation as an element of perception.

In the perceptual judgment, "This is a book," the 'this' is a bare "indicated" which locates; 'book' is the "contemplated" or generic meaning. Both are joined by the copula to match the original unity in the real, independent object.

> The adumbrated is the real as just beyond the grasp of articulate knowledge; a given unity of contemplated and indicated, less relativized and more substantial than their judged togetherness; the contemplated and indicated as the specific nature of the object. (*R,* 57)

The perceptual adumbrated is the objective counterpart of the copula as used affirmatively in a perceptual judgment. It brings to judgment the real, more substantial unity of the object.[6]

The "speculative" aspect of adumbration is our immediate awareness of the rest of reality which is left outside our articulate knowing.

> We are always aware of something of which we are ignorant, not because we contradictorily know the object we are still to know, but because what we know is had as part of a fuller real. . . .We cannot define knowing except as a 'knowing of' and thus as a correlate to ignorance. (*R*, 61)

Though Weiss considers adumbration here an aspect of perceptual knowledge, the doctrine is connected to the wider metaphysical problem of the paradox of ignorance. We need to resolve this paradox and reveal the relevance of the known to the unknown. Otherwise, we cannot explain how we progressively and systematically conquer the unknown, while recognizing it as what we wanted to know (*R*, 59–61).

The speculative aspect of adumbration becomes clearer when Weiss connects adumbration with the all inclusive "Category," the law of contradiction. The law of contradiction for Weiss, as for Aristotle, is a law of both thought and being. On Weiss's interpretation it contains within itself a formal reference to its material content, the real, in terms of the adumbrated.

> The law of contradiction is determinate in nature because inseparable from a completely universalizable variable 'any adumbrated'. . . . The law of contradiction is thus reality in general, variably referred to, and vaguely possessing the meaning of its external specific guises. (*R*, 147)

The speculative aspect of adumbration puts us in contact with the rest of the real. That real has a determinate character which we do not create but discover. Its most primary form is the law of contradiction. That law is not an abstraction, and it cannot be adequately understood simply in terms of its logical expression. A minimum of real content is said to be inseparable from the law of contradiction which "the law exhibits in its penumbral reference to the rest of the real that can fill and specify it" (*R*, 147). The relation between any category and what it categorizes is taken up again in *Modes of Being* (1958).[7] Weiss refers to St. Thomas Aquinas's discussion in *De Ente de Essentia* of the distinction between "concavity" and "snubnosedness." "Concavity" has a purely formal meaning which can be defined mathematically. "Snubnosedness" makes a formal reference to material content because it cannot be understood in abstraction from flesh of which it is the form. This reveals, Weiss argues, that a formal reference to what is not formal is possible (*MOB*, 1.100). If this is

the case, our knowledge of a category or categorial nature is also an adumbration of what it categorizes.

In *Reality,* the substantial unity of an actuality is adumbrated, as well as the rest of being as governed by the Category. In *Modes of Being,* this governance by the primary Category develops into four interlocked modes, including Actuality, which together exhaust being. The modes later become known as conditions governing the expressions of actualities, or "finalities," in the analysis of experience in *Beyond All Appearances.*[8] In each instance, the basic insights embodied in the theory of adumbration, advance metaphysical speculation.[9]

This rather grand metaphysical outlook at first sight must look entirely foreign to thinkers in the pragmatic tradition. However, an examination of some of the principal concerns of that perspective in fact shows the opposite.

II

Pragmatism can be credited with having made a number of basic insights operative in contemporary philosophical discourse. And although pragmatism appeared to be swept away in the middle of the century, it has contributed to and reemerged with the collapse of logical positivism. Generalizing across admittedly important differences among the pragmatists, which are not crucial here, some of the basic insights are:

1. Cartesian doubt is artificial and consequently of little or no use. Real doubts are raised by real situations in which agents find themselves unsure of what action to take and thought ensues as a result.[10]

2. The Archimedean point which Descartes's doubt hoped to reveal is nowhere to be found. There are no infallibly certain intuitions which can be employed as bedrock foundations whether rational a priori or empiricist sense impressions.[11]

3. Experience is not mentally constructed from atomic sensory data, it has directly within it transitional aspects; experience contains continuities as well as discontinuities. Experience cannot be conceived as a "veil of ideas" through which we penetrate to Reality which is non-empirical.[12]

4. The meaning of our concepts is what they predict regarding future experiences; outside of some conceivable experience they can have no meaning.[13]

5. The spectator theory of knowledge in which a passive knower

comes to know a fully formed antecedent reality which in no way is affected by his interests is rejected in favor of one in which knowledge is seen as just one of many relations which evolve in an ongoing organism-environment interaction where purposes are central.[14]

In comparison with the five characteristics of pragmatism enumerated here, Weiss stands both within and without the fold. In what follows, his incorporation and further development of pragmatic ideas is presented in terms of adumbration.

1. Rejection of Cartesian Doubt

Weiss certainly makes no use of Cartesian doubt. Reflection begins where we are with whatever preconceptions we have, in the daily commonsense world (*BAA*, 7–8). Philosophic doubt is not a beginning but a late stage of reflection depending on the tacit acceptance of a great deal (*R*, 24–26). Peirce's rejection of Cartesian doubt accepts that there are many things, particularly commonsensical ones, that we cannot really doubt. Similarly, Weiss seeks to ground and clarify our commonsense notions, not undermine them. This takes him beyond commonsense into metaphysics. In *Modes of Being,* a dialectical consideration of what is required if the commonsense notion of individuals is true, permits a move to the three other modes.[15] For example, speculative inferences to the reality of other modes are warranted by the fact that actualities can aim at a common good and be contemporaneous (*MOB,* 14–17).

However, Weiss does not confine thinking to the prompting of philosophic or pragmatic doubts. The wonder which Aristotle says is the beginning of philosophy, Weiss calls a "primary disequilibrium" which is rooted in the interdependence of realities. It is not a disagreeable state, nor one a successful inquiry would finally banish (*BAA*, 5–11). Weiss allows for a sense of the philosophical life as an end in itself. William James seems to have attempted to conceive a life of reflection pragmatically, but Dewey makes a clear distinction between what he calls "aesthetic revery" and knowing.[16]

2. Fallibilism and Foundationalism

According to Weiss there are no primitive, unmistakable data which serve as atomistic building blocks or a priori foundations (*BAA,* xviii). There is, however, an adumbrative, penetrative move into real individuals and the irreducible modes or unchanging conditions called finalities. This is a kind of fallibilistic foundationalism where the

foundations are neither purely formal, certain, nor clear since they are adumbrated.

In fact, Weiss explicitly links adumbration with fallibilism. Adumbration points to the metaphysical truth behind the epistemological doctrine of fallibilism. Adumbration provides direct knowledge, from within the perception itself, that a particular perception does not exhaust the being of the object perceived. Adumbration is opposed to the empiricist interpretation of fallibilism in which all knowledge is inductive and probable (*MOB,* 1.66). Paradoxically, on the empiricist interpretation one cannot be certain that in the future they will not be omniscient; it can only be judged unlikely on the basis of a fallible induction. This possibility contradicts the metaphysical implication of the empiricist conception of knowledge, that knowledge is a limited progressive systematization of a larger, perhaps unlimited domain. By contrast, adumbration makes us directly aware of our ignorance, of the reality beyond us which cannot ever be entirely comprehended. "We therefore know, no matter when and what we perceive, that there is always more to the perceived and to the real object than that which we isolate and then unify in a judgment" (*MOB,* 1.66). Knowledge is always knowledge *of* what is not yet caught in knowledge. Since empiricism tries to bring all of the content of the known within the circle of articulate knowing, there can be no assurance whether its object is known or not. Weiss, conversely, adumbrates what is left outside our articulate knowing, and knows it is there. While perceiving we adumbratively apprehend that there is something lying beyond our knowledge; adumbration is the ground of "contrite fallibilism" (*MOB,* 520–21).

The logical expression of this connection between adumbration and fallibilism can be seen in Weiss's early paper on Russell's theory of types.[17] That theory holds that it is impossible or meaningless to state propositions which are unrestricted or self-referential. The difficulty Weiss takes up concerns whether the theory itself is unrestricted: if so, it is self-contradictory, if not, one embarks on an infinite regress of propositions stating the theory's limitations. One possible solution to the problems involved is suggested by a consideration of the proposition, "All truths are but partially true." Weiss says this proposition could be an absolute truth about finite propositions, including itself, but not absolutely true as regards all truths. "By pointing out the limitations of a finite statement it indicates that there is an absolute truth in terms of which it is relatively true."[18] Weiss points out that a theory can be unlimited in regard to some limited set, provided it is thereby limited by some higher principle. Accordingly, Weiss can interpret the truth of fallibilism later as an unrestricted statement about perceptual (and

speculative) knowledge, which is restricted by a different type of knowledge, namely adumbration. Adumbration is a direct but inarticulate knowledge of the inexhaustible character of the object of knowledge which, abstractly considered, serves as a higher and limiting principle.

3. Reinterpretation of Experience

The interpretation of experience within the tradition of British Empiricism was exposed by the pragmatists to be insufficiently empirical because of its failure to note the givenness of process and transition. The isolated sense impressions which were taken as requiring association are interpreted by Peirce as already the result of inferences,[19] by James as merely a resting-place or substantive part of the stream of consciousness, if not a mythical element,[20] and by Dewey as "ulterior checking meanings" which cannot be transformed into primary data except by the fallacy of converting a functional office into an antecedent existence.[21] Weiss also rejects the atomistic interpretation of experience shared by classical British Empiricism and logical positivism on the grounds that isolated atomic data are inert and irrelevant to any others. They are had only by an act of extreme abstraction tearing them from the realities which ordinary experience deals with (BAA, 65).

Process and transition are taken to be real by the pragmatists not only as an aspect of experience but as a metaphysical category. Peirce advances the doctrine of objective continuity or synechism. According to James, the stream of consciousness comprehends feelings of transition which reveal real continuities in rerum natura.[22] Whitehead, of course, articulates a process philosophy which is partially indebted to James.[23] Weiss, on the other hand, reacts against Whitehead's process philosophy, interpreting it as a theoretical outgrowth of Humean epistemology.[24]

Therefore, in spite of its affinities with the pragmatic criticisms of British empiricism, Weiss's interpretation of experience comprises a further reaction against process philosophy. Weiss does not replace atomism with process but sees both as abstractions from the daily, commonsense world. The pragmatic emphasis on transition and process is incorporated in Weiss's metaphysics in two ways: experienced relations are read as evidence of ultimate contexts, modes, or "finalities"; the experience of continuity is primarily one of penetration from perceptual surfaces to ontological depths.

Weiss does not interpret transitional aspects of experience exclusively as evidence of a temporal unfolding but also as evidence of real contexts. These, in turn, are interpreted as attenuated versions of finalities, the governing conditions delineated in Weiss's later post-modal ontology.[25]

In the *Principles of Psychology*, James says we have feelings of "and," "if," and "by" as surely as we do of "blue." Then "so surely as relations between objects exist *in rerum natura*, so surely, do feelings exist to which these relations are known."[26] In Weiss's post-modal interpretation of experience in *Beyond All Appearances*, actualities appear within contexts with "variegated shifting features . . . an encountered kaleidoscope of colors, shapes, interchanges, slippages, montages and transactions" (*BAA*, 75–76). So for Weiss, as surely as experience contains transitions and contexts, so surely do there exist relations *in rerum natura*, namely, the finalities. Finalities are "irreducible permanent realities" (*BAA*, 233). A finality is final not transitory; however a finality is not abstract and incapable of interaction. Finalities are involved with all else and effective while maintaining their own status.

Weiss's recognition of continuity in experience is found in his account of the mode of Existence, and then later in the Dunamis.[27] However, for the purposes of this essay a central place in which continuity is found is in adumbration. The extensive transitions of experience are supplemented by an intensive penetration in adumbration. We are able to penetrate beyond appearances to the realities which are their sources. In his later writings, Weiss distinguishes "objective appearances" from both knowers and realities. Objective appearances are derivates of a multiplicity of interacting self-identical actualities and finalities. Realities are beings in themselves. Appearances are mediated versions of beings provided by their interactions. The realities are where the appearances are but are those appearances purified to more fully reveal what each being is outside of its interinvolvements. For Weiss, there is no being which cannot appear, but appearances cannot exhaust a being (*BAA*, 59, 80).

The reality disclosed by an adumbrative penetration of an appearance is not then accorded an exalted status or a different "metaphysical" location. It is where the appearance is as its source, a purified and intensified version of the appearance reached over a continuous route provided for an adumbration.

In spite of contrasting appearances and realities, Weiss insists that appearances do not constitute a barrier or veil (*BAA*, 80). Weiss's presentation can be misleading in this regard. Moreover it would be useless to deny the idealistic strain in Weiss's metaphysics. This is apparent in his association of appearances with surfaces and realities with the objects of emotions like love and sympathy, awe and wonder. On the other hand, there is no Absolute perspective achieved in Weiss's metaphysics.

To block this idealistic misinterpretation of Weiss's metaphysics we must note the progressive development of the doctrine of adumbration.[28] It evolves from a dual perceptual/speculative aspect in *Reality*, to a ten-fold expression in *Modes of Being*, and then informs the analysis of experience and knowledge in *Beyond All Appearances*.

In *Modes of Being*, adumbration is said to pertain properly only to our knowledge of actualities through perception (*MOB*, 521). This necessitates the articulation of several other ways in which one purportedly grasps what something is from a perspective we do not in fact occupy. Finally, a neutral position, "the I," is reached which encompasses the togetherness of the modes.

Weiss concludes that for any *x*-valued modal ontology, the conditions for non-distortive knowledge include "the absolute perspective, I" which is "pure" and "translucent" (*MOB*, 527). The I is not a *tertium quid*, however, but only the togetherness of the modes (*MOB*, 528). Even this highest level of abstraction cannot be understood as the achievement of an accurate mirroring of all reality. Rather, Weiss argues that there are two senses of knowledge. There is knowledge which is rooted in the primary perspective I. This consists of a capacity to abstractly assume the totality of positions of a system of virtually endless permutations of beings, data pertaining to them, and the external perspectives from which they are approached. There is also knowledge carried out under the limitation of approaching an external reality from a limited perspective with isolated data (*MOB*, 528–29). These two senses of knowledge are mutually dependent: if the I isolates data to approach a reality it automatically assumes the position of some other reality and becomes identical with it. Since the modes are interlocked the knowledge of one is incipiently the knowledge of the others.

We do not in speculation reach an Absolute or exalted Being as the final and perfect completion of knowledge. A speculative adumbration of the Category, the modes or a finality finds in these formal references to what completes them and requires a corresponding perceptual adumbration from a limited perspective within that governed content.

4. Pragmatic Theory of Meaning

Weiss incorporates into his systematic reflections the insight encapsulated in Peirce's pragmatic maxim, but as a methodological principle not as a metaphysical doctrine. That is, he recognizes the meaninglessness of positing some wholly transcendent being, which the pragmatic theory of meaning scouts. However, as Peirce remarked, "pragmatism is, in itself, no doctrine of metaphysics . . . it is merely a method of ascertaining the

meanings of hard words and of abstract concepts."[29] Accepting the caution or restraint embodied in the pragmatic maxim in a metaphysical inquiry is no reason to not seek ultimate answers. These conceptions must have "conceivable effects" whether in perception or in a more broadly conceived reflective experience.

The progressive development of the theory of adumbration permits a broader conception of reflective experience. It opens a path for post-pragmatic metaphysics by elucidating how realities become known in perception and speculation. The speculative aspect of adumbration embodies the pragmatic criticism of extreme abstraction because it does not confuse abstractions with the governing conditions they express. The perceptual aspect of adumbration breaks out of a phenomenalism which would deny metaphysics altogether.

Weiss clarifies the meaning of ideas regarding actualities and finalities through experiential analyses which are informed by adumbration. Pragmatists often couch the theory of meaning in terms borrowed from the methods of the empirical sciences and liable to positivistic interpretations. Weiss's conception of experiential meaning is somewhat wider. The meaning of an idea is given in any other as qualified by that conceivable transformation which would convert it into the former, according to Weiss (*MOB*, 1.71). Pragmatist theories of meaning concentrate on transforming intellectual concepts into empirical, pragmatic meanings. Weiss thinks this is only one kind of transformation which can enable us to clarify our ideas (*MOB*, 1.70). Theoretical distinctions shed light on practical matters as well as vice versa. For Weiss no one domain, whether it be the empirical, theoretical, practical, artistic, theological, social, etc., is so privileged that an accurate rendering of the meaning of some concept awaits its transformation into approved terms of that privileged domain. The meanings of the daily, commonsense world have an initial primacy but it is obvious that these are gradually if slightly affected by theoretical meanings. All ideas are clarified by their transformation into some others which are situated elsewhere. Which transformations are most appropriate will not depend on the purported epistemological ultimacy of some privileged domain but on success in clarification and explanation.

It is clear that Weiss believes this theory of meaning is justified by (if not based upon) Peirce's logical theories. For Peirce, inference is an act of replacement or substitution of one idea for another which occurs by virtue of a habit which can be expressed in the form of a leading principle. All this substitution requires is that an antecedent is made to give way to a consequent in a repeatable manner.[30] Therefore, where the pragmatists are critical of any ideas, especially scientific or metaphysical

ones, which cannot be transformed into empirically, pragmatically meaningful terms, Weiss widens the doctrine to include more than one sort of transformation and more than one direction. The relevance of Weiss's post-pragmatic theory of meaning to his metaphysical speculation is that it is to some extent holistic and nonfoundational. Meaning is a consequence of any conceivable transformation, and since no one set of transformations is privileged, no particular set of meanings is entirely foundational. The theory is foundational, though informally, in that it does say that some meanings are more ultimate than others in the context of ontological discourse.[31] Those meanings are adumbrative elements which are both continuous with realities and, for that reason, not perfectly clear, well-defined, and easily manipulable signs.[32]

5. Spectator Theory of Knowledge

In pragmatic theories, knowledge consists of the use of one experience to anticipate or successfully predict another, not a static relation in which an independent reality is copied or presented to a knower. By confining themselves to the more successful experimental methods of the empirical sciences, these theories banish unknowable, nonempirical transcendent egos and objects. The spectator or copy theory issues in hopeless dualisms like that of subject/object, realism/idealism rooted in the relativity of perception: if the perceived is the real, then we cannot account for illusion and error; if it is not, how is knowledge of the independently real possible?

Weiss significantly differs with the pragmatists in not attempting to eliminate the polar realities of subject and object by reducing them to functional offices (*FC,* 210–11). When these are conceived in extreme independence the natural result is a hopeless dichotomy. Denied their integrity and independence, however, they stand in contradiction to ordinary experience, custom, law, science, and religion. The conception of realities as functions rather than as antecedent existences is incompatible with the commonsensical notion of their capacity for obduracy (in the case of a thing), action (in the case of a person), or the conditioning of individuals (in the case of abiding contexts like the laws of nature). Reflection must begin in the daily, commonsense world, and return there often to measure the compatibility of its theoretical formulations. For this reason Weiss defends the integrity and independence of a private knower and a public object but in a way which will prevent the classic dualisms from arising.

The theory of adumbration contributes to the debate by rooting the

epistemological account in an ontological analysis, loosening and deep-
ening the foundations of the speculative account beyond the clearly
articulated and formalizable, and expanding the relation between the
knower and the object to permit the delineation of lesser dualities. These
strategies ground commonsense notions without making them irreduci-
ble. The commonsense notions, however, constrain metaphysical
speculations—even when, like process metaphysics, they are more or less
based on current scientific theory.

Weiss employs a strategy of constructing over a dualism rather than
dissolving it (*FC*, 208, 210). He overarchs the polar opposites of knower
and known by situating them within a larger scheme and working from
one to the other. *Beyond All Appearances* fashions a terminology of
knowings and knowns marking intermediate positions along a continu-
ous route from the object as it is caught up in our knowing of it, to the
object as in itself.[33] The series of relations is:

Knowing → Knowledge → Known → Object

"Knowing" is the act whose outcome is "knowledge"; the latter is
distinct from the "known" which knowledge is the knowledge of; the
"known" is distinct from the "object" which it knows (*BAA*, 38).
Adumbration means that there is a continuum extending across these
positions. That does not reduce them to functions, however. Weiss's
thinking displays the wisdom of knowing when a difference in degree
becomes a difference in kind. Driving down a curved stretch of road at
some point heads us in the opposite direction. Even when we go "around
the bend" we are on the same road, though it may not be recognizable
from that position.

The dichotomy of discontinuous and transcendent subjects and
objects is replaced by a continuum where differences in degree become
differences in kind. What is criticized by James and Dewey as the copy
theory of knowledge is criticized by Weiss as the "identity theory"
wherein the act of knowing and the object are identical (*BAA*, 38). For
Weiss, the known is inseparable from knowledge which denotes the
known as situated within relations which make it part of knowledge. On
the other hand, the known comprehends the independent object since it
is not knowledge but the known. Remove the known from its relation to
knowledge and it would dissipate, leaving only the possibility of being
known on the side of the object. Such terminologies are usually confusing
but they have at least the benefit of working through the various relations
involved in our knowledge of independent reality. Once it is seen where
the problems lie they can be put aside.

Knowledge adds boundaries and relations to the independent object making it known (*BAA,* 39). The act of knowing is an imposition of a limit and therefore, Weiss claims, neither an Aristotelian thinking on thinking nor a Hegelian Absolute self-consciousness is a case of knowing (*BAA,* 39). Even though the content of knowledge and known is identical, it functions differently at these two different positions along the continuum. Formal foundationalists claim that the known is identical to the object known in some special case.[34] Weiss denies all such instances, whether they are particular or universal. There are for Weiss no bedrock data (*BAA,* 40): there are no completely hard data, nor are there completely soft data awaiting our "sculpting."[35]

> (K)nowledge involves the imposition of a boundary, thereby at once constituting the known and making it possible to recognize that there is present something not yet known because not affected by our knowing. (*BAA,* 40)

We would have nothing to work on or sculpt were it not for the independent character of the real. Our very constitution of the known indicates this.

6. Conclusion: Implications for Post-Pragmatic Metaphysics

This paper has tried to show how an interpretation of the theory of adumbration which integrates it with the basic tenets of pragmatism discloses some of the contours of post-pragmatic metaphysics. Post-pragmatic metaphysics begins in ordinary experience and returns there often to correct and concretize its speculations. It is fallibilistic but foundational, making ambitious metaphysical claims rooted in and enriching the meaning of a broadly conceived reflective experience. Ordinary experience is conceived neither as atomistic nor as an undifferentiated flux. Its transitional aspects reveal depth as well as governing conditions. Post-pragmatic metaphysics understands knowledge as a movement from one position to another in a pluralistic cosmos. This never yields an absolute perspective nor is it ever disconnected from the togetherness of all there is.[36]

Paul Weiss's theory of adumbration should be of interest to philosophers who, while sympathetic to pragmatic criticisms of foundationalism, dualism, and absolute idealism, are still convinced of the importance and fruitfulness of metaphysical speculation. My interpretation has ranged widely over both Weiss's systematic reflections and the theories of the pragmatic thinkers. It marks out some general directions and possibilities. While both pragmatists and Paul Weiss might disagree

with what is said here, it is clear that the theory of adumbration is a rich mine of suggestions for speculation in the post-pragmatic period.[37]

KEVIN KENNEDY

DEPARTMENT OF PHILOSOPHY
ST. JOHN'S UNIVERSITY
JULY 1992

NOTES

1. See Frederick Will, *Beyond Deduction: Ampliative Aspects of Philosophical Reflection* (New York: Routledge, 1988), chap. I, "Deductivism."
2. Charles S. Peirce, *Collected Papers of Charles Sanders Peirce,* ed. Charles Hartshorne and Paul Weiss (Cambridge: Harvard University Press, 1931–35), vol. 5, para. 265. References will be made in the standard form to volume (prior to decimal point) and paragraph number (after).
3. This was a reaction to Sandra Rosenthal's *Speculative Pragmatism* (Amherst: University of Massachusetts Press, 1986). See the articles published under the heading "Metaphysics after Pragmatism" in *Journal of Speculative Philosophy,* vol. 2, no. 4 (1988). See also John Ryder's Review of *Speculative Pragmatism,* in the same journal, vol. 2, no. 3 (1988) and David Weissman's "Metaphysics after Pragmatism" in the *Review of Metaphysics,* 42 (Mar. 1989). The present paper grew out of one delivered at the Symposium on the Philosophy of Paul Weiss in May 1991, at the Catholic University of America. It proposed the relevance of adumbration to this debate and its similarities with Rosenthal's "anteceptive experience."
4. Plato, *Phaedo,* (85d) trans. G.M.A. Grube (Indianapolis: Hackett Publishing Co., 1977), 36.
5. Paul Weiss, *Reality* (Princeton: Princeton University Press, 1938). Henceforth, references to this work will be made in the text by an *"R"* followed by the page number.
6. My distinction between perceptual and speculative aspects of adumbration is not to be confused with Weiss's between the "perceptual" and "recessive" adumbrated. For Weiss, the perceptual adumbrated is the objective counterpart of the copula in the perceptual judgment. It is said to be part of a recessive adumbrated beyond the judgment serving as the correlate of the judged perceptual fact (*R,* 58). Both of the latter are included in what I call the perceptual aspect.
7. *Modes of Being* (Carbondale: Southern Illinois University Press, 1958). Henceforth, references to this work will be made in the text by an *"MOB"* followed by the page number or numbered proposition.
8. Paul Weiss, *Beyond All Appearances* (Carbondale: Southern Illinois University Press, 1977). Henceforth, references to this work will be made in the text by a *"BAA"* followed by the page number.
9. For the purposes of this paper I am using "adumbration" to stand for the plethora of insights Weiss has developed regarding our knowledge of realities beyond any explicit or exhaustive presentation. Among these are nine approaches

including adumbration in *Modes of Being*, "symbolization" in *Beyond All Appearances*, "evidencing" in *First Considerations*, "discernment" of persons in *Privacy*, etc. Although I cannot argue it here, I believe each of these has the general character of the original adumbration with its perceptual and speculative aspects.

10. *Collected Papers*, 5.265.

11. C.I. Lewis, *Mind and the World-Order* (New York: Scribner's Sons, 1929), 23.

12. William James, *The Principles of Psychology*, vol. I (New York: Dover Publications, Inc., 1950), 229–48. John E. Smith, *Purpose and Thought: The Meaning of Pragmatism* (New Haven: Yale University Press, 1978), 779.

13. *Collected Papers*, 5.388–410. There are, of course, important differences in whether the meaning is found in something conceptual or general, as it was for Peirce, an individual act, as for James, etc. The meaning, for all the pragmatists however, must have reference to experience broadly conceived, and not be wholly transcendent.

14. John Dewey, *Experience and Nature* (New York: Dover Publications, Inc., 1958), 68, 308–10.

15. The other modes are Ideality (a Possibility to be filled out, a Good to be realized), Existence (a perpetually self-dividing space-time-causal field), and God (a primal unity). Together, these four irreducible modes are said to exhaust being (*MOB*, Introduction, pp. 14–17).

16. William James, *Pragmatism and four essays from The Meaning of Truth* (New York: New American Library, 1974), 174. Dewey, *Experience and Nature*, 331.

17. Paul Weiss, "The Theory of Types," *Mind* 37, no. 147 (1928), 338–48.

18. "Theory of Types," 347.

19. *Collected Papers*, 5.213–263, "Questions Concerning Certain Faculties Claimed for Man."

20. *Principles of Psychology*, 229–43.

21. *Experience and Nature*, 327.

22. *Principles*, I, 245.

23. Alfred North Whitehead, *Process and Reality*, Corrected Edition, ed. David Ray Griffin and Donald W. Sherburne (New York: Free Press, 1978), xii, 50n.

24. See Weiss's reply to Robert Neville: "I am not aware, though, of any effort made by Whitehead to trace appearances back to their sources. Had he been interested in doing this, he would not have adopted Hume's view of sense data and Leibniz's view of contemporaries, and contented himself with a descriptive cosmology." Paul Weiss, *First Considerations: An Examination of Philosophical Evidence* (Carbondale: Southern Illinois University Press, 1977), 229. Henceforth, references to this work will be made in the text by an *"FC"* followed by the page number.

25. In the post-modal ontology of *Beyond All Appearances* and *First Considerations*, Actuality is divided into two governing conditions or finalities, Being and Substance and individual actualities. The Ideal and God become the finalities of Possibility and Unity, respectively. These systemic changes are largely irrelevant to the role of adumbration and analysis of experience. See *BAA*, 272.

26. *Principles*, I, 245.

27. The concept of the Dunamis appears in *Privacy* (Carbondale: Southern Illinois University Press, 1983), 20–21. The dunamis is "a primal, insistent continuum, primitive, unbounded, and indeterminate" with similarities to Plato's receptacle, Aristotle's prime matter, and Whitehead's Creativity.

28. The progressive unfolding of adumbration in a series of works is elucidated in a paper which brings out the Platonic and Heideggerian resonances of the doctrine by Robert E. Wood, "Weiss on Adumbration," in *Creativity and Common Sense: Essays in Honor of Paul Weiss*, ed. Thomas Krettek (Albany: State University of New York Press, 1987), 43–54. See also my "Weiss's Theory of the Proposition and its Relevance to the Development of his Systematic Metaphysics: A Reply to Krettek," *Ultimate Reality and Meaning*, 18 (1995).

29. *Collected Papers*, 5.464.

30. Paul Weiss, "The Logic of the Creative Process," *Studies in the Philosophy of Charles Sanders Peirce*, ed. Philip P. Wiener and Frederick H. Young (Cambridge: Harvard University Press, 1952), 166–7.

31. "Informal foundationalism" is defended by Thomas Russman in his *A Prospectus for the Triumph of Realism* (Macon, Ga.: Mercer University Press, 1987).

32. Weiss's conception of reasoning seems to have much in common with Will's notion of "ampliative philosophical governance." See *Beyond Deduction*, chap. III, "Ampliative Governance." See also my summary and comments in the *Review of Metaphysics* (March 1992), 643–45.

33. This hearkens back to the procedure of John Dewey and Arthur Bentley in their "A Terminology for Knowings and Knowns," in *Journal of Philosophy* 42, 9 (April 1945) reprinted in *Dewey and his Critics*, ed. Sydney Morgenbesser (New York: Journal of Philosophy, Inc., 1977), 285–307.

34. For instance, Alfred Jules Ayer, *Language, Truth and Logic* (New York: Dover Publications, Inc., 1936), 42. "It is true that in talking of 'its' appearances we appear to distinguish the thing from the appearances, but that is simply an accident of linguistic usage. Logical analysis shows that what makes these 'appearances' the 'appearances of' the same thing is not their relationship to an entity other than themselves, but their relationship to one another." Notice that in the controversy between Weiss and phenomenalism, metaphysical implications are attributed to phenomenalist epistemology.

35. The expression is from Feyerabend and is critically analyzed in Stephen Yates, "Feyerabend, Realism and Historicity," *American Catholic Philosophical Quarterly* 65 (Autumn, 1991), 429–43.

36. See my "Pluralism and the Thought of Paul Weiss," *Metaphysics as a Cultural Presence*, ed. Joseph Grange (State University of New York Press, forthcoming).

37. I am very grateful to my colleague Douglas Rasmussen for his critical comments on earlier versions of this paper.

REPLY TO KEVIN KENNEDY

Sandra Rosenthal and Kevin Kennedy's papers should be read together. In their different ways they point to a new turn in American pragmatism. Although Rosenthal speaks of a speculative pragmatism, and Kennedy of a post-pragmatic period open to metaphysical speculation, they seem to be moving in the same direction. I think that Kennedy's approach is more promising than Rosenthal's because it allows for a greater freedom to ventures that pay no attention to pragmatic commitments and constraints. I see no great difficulty in getting the two to converge or at least to supplement one another. With Peirce, I think that pragmatism has a more limited role and promise than either acknowledges.

Kennedy says that "we need to go beyond pragmatism because it can seem self-contained and disconnected." The suggestion contains two parts, one of which I think should be accepted and the other rejected. We should go beyond pragmatism, but we should also recognize that its self-containedness and disconnection is one of its major strengths, since they make it singularly appropriate to explorations in the humanized world. Other domains are outside the reach of humans unless they are helped by mediating ultimates acting independently of, while qualifying and being qualified by them. The nature of individual persons, privacies, creative work in mathematics and other areas, the religion of the pious, and the study of ultimates as well as the Being they presuppose, seem well beyond its powers and interests. It cannot deal with the depths of things, and thereupon make evident what sympathy, love, fear, and hate reach toward. Uniqueness, necessity, and presuppositions escape its net.

Kennedy remarks on a serious difficulty that points up the inadequacy of the pragmatic approach: it does not make evident how we are to live both nobly and well. To do that we must sometimes stand apart, pull away from the ongoing and successful, and what most others support

and cherish, to try to know if there are other and perhaps better objectives. Each of us should be completed, enhanced in a congenial world, but as the intellectual life of pragmatic thinkers makes evident, we also must stand away from that world to assess it, judge it, and perhaps leave it behind for a while to attend to what is outside its reach. Pragmatists spend too much time criticizing others and repeating themselves, thereby revealing a rather unpragmatic temper, making evident that they are like those they condemn. Everyone is both together. It is a philosophic task to attend to what their juncture enables one to understand.

Kennedy rightly takes adumbration to be a kind of "ontologizing" response to reductionism. He then says that "it errs on the side of superfluity." I wish he had given reasons for his saying that. Indeed, I do not understand what he means, unless he intends to claim that it is so evidently a part of experience that there is no sense in distinguishing it. Since it is not acknowledged by analysts, linguistic philosophers, phenomenologists, or pragmatists, and has its role exaggerated by romantics and psycho-analysts, it surely needs to be distinguished and examined, without supposing that it is thereby torn away from all other factors.

Kennedy is a fine expositor. Again and again, he notes dimensions of my view that have been ignored or misconstrued by others. I think it necessary, though, to correct his observation that "our knowledge of a category or categorial nature is also an adumbration of what it categorizes" by remarking that the knowledge of a category is inseparable from the adumbrative involvement with the source of the content. An adumbration that stopped at the categorized is an adumbration denied its continuation beyond that point, hardly noticeable though it be.

Kennedy provides a fine summary statement of the basic insights of pragmatism and of my divergences and objections to it. I will comment on all of them, with the understanding that some of my claims, though properly set in contrast with what pragmatists hold, could be accepted by them:

1. Pragmatism rejects the Cartesian doubt altogether. I think it should be rejected only when that doubt is understood to require the rejection of what it questions. It could, indeed it should, be used to provide a good check on what is claimed, no matter what the view, forcing one to look for satisfactory justifications and warrants. Descartes erred in supposing that there were warrants only for clear and distinct ideas, though at times he did seem to suppose that these were self-warranting. If they did need a God to warrant them, there would be nothing in the way of supposing

that God warranted the acceptance of what, though blurred, promoted our welfare, justified transitions, and fended off theoretical doubts. Why should one wait to be blocked by what is in the way of continued inquiry before raising questions about its correctness and presuppositions? One can, indeed should, anticipate such blockings, and therefore raise questions even when all goes well. Workmen can cooperate and build a fine wall, but surely it is not amiss to ask whether the wall should be built, whether or not there is another way to build it, and so on. Pragmatists want questions to be raised by or about what blocks one's way. It has none to ask of itself, and therefore does not know how to find out what its own limits are, and whether or not there is something that it could not encompass. If Descartes was too bold and arbitrary in his doubtings, pragmatists are too timid and self-conscious in theirs. Doubts should be raised even where one is not sure "of what action to take and what thought ensues as a result." There is no inconsistency in holding tight to something and yet searching for and questioning every supposition that had been unreflectingly made.

Cartesians and pragmatists are at one in supposing that questioning is a form of or a warrant for a rejecting. It need not be. At its best, it is a way of becoming aware of what might enlarge, enrich, and locate what had been accepted. There are not many who ask if it is possible to look back into the past, but once the question is raised, one becomes aware that the supposition that one could so look raises difficulties that had not been noted.

2. Kennedy acutely notes that a foundationalism need not be dogmatic, and that it could allow for a kind of fallibilism. I think he is not using 'foundationalism'—particularly if it is supposed to apply to views such as mine—in the way it is currently used. For most, it is a derogatory term. Fallibilism does not require one to hold that nothing is certain, but only that everything is open to questioning. Even the commonsense world where one begins all inquiries, and to which one must finally return, is questionable in detail. Still, it provides the only place from which one can begin to inquire, and to which one finally returns, clearer-headed, enriched, and perhaps chastened. Inescapable, there is nothing in it that does not require clarification, supplementation, and modification. The very habits and the scientific method that enchant the pragmatists offer ways in which the pragmatists can question the commonsense world in which they live with the rest of us.

Kennedy perceptively relates adumbration, falliblism, and a criticism of Russell's theory of types. I do not agree, though, that perceptual and speculative knowledge are "restricted by adumbration." Adumbration

takes us toward the reality that appears, abduction, in contrast, takes us to what has the power to enable our hypotheses to end at what may or may not sustain them.

3. Current pragmatists run the risk of trying to fit in with the trend to take 'process' to be a primary and perhaps even the only reality. There are, though, stabilities as well as change, the rational as well as the dunamic, the persistent as well as the vanishing. If everything is in flux, there would be no fixed obligations, commitments, no lasting guilt, no obdurate past, no steady, permanent ideals, no pragmatism that remains self-same over a period of time, unless it be in the shape of an inert 'society'. As Kennedy acutely notes, both 'atomism' (i.e., the view that there are persistent realities, not necessarily unit bodies, that have their own centers), and 'process' can be taken to be abstractions from the daily commonsense world. They are, of course, more than this. Both are constitutive of what occurs there and elsewhere.

Every actuality has some degree of value, is extended, is more or less in accord with others, and is disjoined from them. In all, both the rational and the dunamis play a role. I do not think Kennedy gives sufficient weight to all of these, perhaps because he is more inclined to consider epistemic issues. That leads him to focus on adumbration, while recognizing it to have an ontological import as well. Ontologists are interested in knowing what the actualities essentially are and what it is that they presuppose. Systematic philosophers deal with epistemology and ontology both separately and as impinging on one another. Adumbrations begin with the one and end at the other. A reverse ontological move is made when actualities possess and use what the ultimates jointly constitute.

Kennedy thinks there is an "idealistic strain" in my view. Since I think that the view I have been presenting has a place for every other type of view, qualified and limited by one another, one could also say that there was a 'materialistic', an 'analytic', a 'phenomenological', etc., strain in it as well, not because these were synthesized, but because they are so many specialized versions of it.

References to sympathy, awe, and wonder are not distinctively idealistic. Even a pragmatist could allow for them in limited and qualified forms. Idealists do no more than that. Nor is it correct to say that "if the I isolates data, to approach a reality it automatically assumes the position of some other reality and becomes identical with it." I never become identical with anything else, but what I am and what I entertain can, through the help of the ultimates, be made available for accommodation by others on their own terms, without myself or what I initially provide being destroyed or even appreciably changed.

I confess to being unable to understand what Kennedy intends in the last paragraph of this section. The difficulty is due perhaps to the fact that some of my earlier works were not clear about what all the ultimates presuppose.

Kennedy is surely right to remark that the pragmatic theory of meaning need not, indeed should not, preclude a resolute inquiry seeking final answers. The quest could take a lifetime. Conceivably, like a scientific inquiry, as well as mathematical and other types of creativity, it will never come to an end, as long as it is dealt with by humans like us, fallible, frustrated, and foolish, never satisfied with what are evidently not final answers. He recognizes that there is more than one way in which to clarify our ideas and that they may find embodiment in many different places. I think that view grounds a stronger pragmatism than has so far been achieved, and points the way beyond this.

5. Kennedy rightly notes that I do not think that subjects and objects can be adequately dealt with as functions. Subjects and objects are facets of realities, themselves always more than what they manifest. We get to those realities through adumbrations, and understand how they are constituted by seeing how abductively reached ultimates join one another. To his neat schema of knowing, knowledge, and known object, I would add relations that, operating apart from these realities, sustain what is known of them. Knowing is continuous with the knower and known, each providing a place for instantiations of the ultimates.

6. There is some warrant for supposing that what I have been expounding is a "post-pragmatic metaphysics." I have always taken common sense to be an unavoidable and inextinguishable beginning, and think that we must come to terms with it at the end. My explicit and implicit acknowledgments of the strength of pragmatism must not, though, be detached from the recognition that it is to be confined to the humanized world, requiring supplementation by other approaches pertinent to other domains, all encompassed within a systematic understanding of the ways they are related to one another and to the ultimates and Being.

Viewed in the light of the diversity of kinds of realities, 'pragmatism', 'speculative pragmatism', and 'post-pragmatism' need supplementation by what is independently known about individual persons, nature, the cosmos, and what they all presuppose. The result will be 'post-pragmatic' if one supposes not only that our necessary start within the humanized world qualifies what is subsequently maintained, but that there is no reaching an understanding of this from other positions. Once other domains besides the humanized are recognized, one can take a stand with any of them. Once it is recognized that what is in each domain is

constituted by the same ultimates, though in different orders and degrees of insistency, the limitations characteristic of each domain and of them together, can be passed beyond. Once that is done, and all the domains are viewed from that perspective, one would be justified in also speaking of a post-personalistic, post-naturalistic, or post-cosmological view.

Kennedy's is a fine, suggestive study, making it possible for pragmatists to hold on to what they had achieved, and yet be able to move on to a more comprehensive, satisfactory view in which theirs will have a necessary place.

Kennedy allows for the advances Rosenthal has made, and points the way in which hers, and other extensions of the pragmatic account, can be better grounded and well-supplemented. It is time now for them to attend to what is outside the reach of pragmatism, and thereupon find its indispensable place within a larger set of procedures and what these jointly clarify. Some of the others will have a place alongside it; each will have a primary role in a different part of a complex totality. This will itself be known only through a bolder, controlled inquiry into what provides a place for each of them, with its limited topic and role.

P.W.

11

Jay Schulkin

PAUL WEISS'S VISION OF PHILOSOPHY AND NATURE

INTRODUCTION: WEISS THE MAN

Paul Weiss goes right to the point. When Weiss described Peirce he compactly said "Peirce had size" ("C.S. Peirce, Philosopher," 120). Weiss also has size. His path led him from the lower East Side of New York, to City College as an undergraduate, from common sense to rational common sense. Then he was off to Harvard as a graduate student, and began to express a large philosophic vision. This was later expressed at Bryn Mawr College as a young professor and then at Yale, where he spent most of his career, eventually to become the Sterling Professor of Philosophy. After his retirement from Yale, Weiss assumed a post at Catholic University where he has been ever since. He did this while remaining an iconoclast, very much his own philosopher, outside other people's systems that dominated the day.

His brand of philosophy frames a metaphysics for everyday experience. His philosophy perhaps should be called "phenomenological metaphysics." It is the steadfast and tenacious hold onto the real which so appeals about Weiss's philosophy. Weiss's mode of argument is richly dialectical. His style of prose? He writes a bit like Hemingway; short, direct sentences. Opinions are clearly presented.

But unlike many of those that influenced him, Aristotle, Kant, Peirce, or Whitehead, Weiss is not a scientist. Weiss's sense of reality is not that of science but of brute "rational" common sense. He believes philosophy is closer to art than science: science he thinks is closer to practice. Science is more derivative than for his teachers and predecessors. His philosophy of nature, influenced by biology and other sciences, is independent of them—"over and against them" to use a Weissian idiom. This is important for Weiss.

In this commentary, I characterize several of Weiss's philosophical

positions, his sense of philosophy, the real, philosophical, and ethical categories and the implications for a philosophy of nature. For Weiss, "philosophy is the deliberate attempt to say what the ultimate nature of things really is" ("Adventurous Humility," 337). Weiss is rooted in the real sense of everyday survival. This view impacted his phenomenology and metaphysics and philosophy of nature. What comes across are substances trying to survive, maintaining their dignity, evolving as nature's expression of free individuals. This commentary is therefore about Weiss's philosophic approach and his philosophy of nature; the two are bound together, but not reducible to one another. I begin first by briefly discussing philosophers that are reflected in Weiss's philosophy of nature. After doing so I then characterize his early work, his sense of the real, ethics, and his philosophy of nature and man. Peirce figures throughout the text, and serves as the basis in which to think about Weiss's philosophy of nature.

INFLUENCES ON WEISS AND HIS PHILOSOPHY OF NATURE

Aristotle: Weiss is clearly and profoundly influenced by Aristotle. While Whitehead may have passed judgment that all western thought is a footnote to Plato, the commonsense approach to philosophy and the emphasis on substances derives directly from Aristotle. And while Weiss may have wanted to write Hegel's *Phenomenology of Mind,* his philosophic approach is closer to Aristotle than Hegel.

Aristotle, unlike Weiss, was also a biologist. Aristotle's vision of nature was about the development of substances. Nature was teleological; but the order was fixed. As Weiss put it, "Aristotle's view is that the species are fixed . . ." (*Modes of Being,* 47). Weiss is modern. Species are not fixed, but evolve. Weiss's philosophy of nature acknowledges the nonfixed order, and represents freedom into the natural order of things. Such freedom was within constraints, the constraints of nature.

Weiss, like Aristotle, believed teleology is the stuff of nature. Nature is replete with purpose. Weiss, like Aristotle, is a substance philosopher; the stuff of experience and of nature are substances. As he put it, "we live in a commonsense world whose substances are caught in a dynamic field" (*The World of Art,* 78).

Spinoza: Substances do something besides develop; they persevere and they self-regulate. Spinoza's vision of nature was that of persevering; so too for Weiss's. Self-preservation and perseverance are central terms in Weiss's account of nature. There is the sense of struggle in Weiss's

account of nature and everyday experience. In Weiss's words, "Spinoza identifies the effort to preserve itself with the very essence of a thing" (*Reality,* 213). For Weiss it would be every substance.

Peirce: Weiss states: "I have learned more from Peirce than anyone else" ("C.S. Peirce, Philosopher," 139). Indeed the scholarly care with which he and Charles Hartshorne assembled the *Collected Works of Charles S. Peirce* is testimonial of great intellectual devotion to the greatest of American philosophers, that "laboratory scientist," as Peirce liked to call himself. Peirce maintained a philosophy of nature and our place within it; minds were adapting to nature, coping with it, enjoying it, respecting it. Weiss would later capture much of the same sense of our tie to nature.

But Peirce was knotted to the practice of science; Weiss is not. Peirce had authority in science; his philosophy of nature reflected that. Weiss does not, and is suspicious of those in the sciences. Because Peirce was an experimentalist, he understood that some hypotheses get rejected. Testing ideas was at the heart of the inquiring modern mind. As Weiss notes, Peirce's concern was with method. Weiss's concern is never with method. Weiss thinks Peirce was never dialectical. The experimental method precluded or inhibited it.

But while Peirce was an experimentalist and never lost sight of the experimental method, and developed it, he was critical of narrow empiricism. His philosophy of nature was tied to human and scientific inquiry. Weiss is not an experimentalist, nor an empiricist. His tie to the real is common sense. His commonsense philosophy is that of a rationalist, with good sense to hold onto what is important.

For Peirce, ideas were tied to nature; nature constrained the range of ideas that one could entertain. Adaptation figured. Local problem-solving and environmental constraints were the stuff of which the mind was structured. The world figured in the kind of mind that evolved. Of course the mind is more than about problem-solving as Peirce understood and Weiss understands.

In problem-solving perhaps there is a relationship between what Peirce called "abduction" and Weiss called "adumbration." Abduction, or the genesis of ideas was distinguished from deduction and induction by Peirce. For Peirce abduction is tied to creativity and the acquisition of new knowledge. Abduction is also the mechanism of hitting on the right idea and one wonders whether the real impacts the range of acceptable hypotheses. But for abduction to be operative, the not quite graspable adumbrated is a shadowy present. As Weiss put it "the adumbrated is the real as just beyond the grasp of articulated knowledge" (*Reality,* 57). The

movement is from the adumbrated to the abducted in problem-solving, in the evolutionary selection of cognitive abilities.

The real laws of evolution are about adaptation and unexpected change. Such evolutionary changes are about necessity in addition to chance and choice. While Weiss is an avowed evolutionist, it is not readily detectable whether anything like "evolutionary love" that Peirce envisioned is endemic to nature. Weiss is more hard-nosed about biology than Peirce. Weiss's vision of nature, unlike Peirce's is not remotely Hegelian.

For Peirce and Weiss nature is replete with purpose, and ethics and freedom are a part of natural events. From Peirce, Weiss appreciates logic, the nature of systems and metaphysical categories. The categorical nature of things is to be discerned. But unlike Peirce, nature is not "frozen mind" for Weiss. Weiss is less influenced by Hegel than Peirce was. But Weiss is close to Hegel in being a "professional philosopher." They were also both rationalists.

The term Peirce used was "critical commonsensism" at times to characterize his philosophy. Common sense was simply not to be accepted, but is a starting point for philosophical reflections. Thus despite the emphasis on common sense in both philosophers, both would agree that "the observations of common sense are not to be accepted without reservation" (*The World of Art,* 50).

Weiss leads the way in systematic metaphysics. Both Peirce and Weiss recognized the pervasiveness of metaphysics. Peirce did metaphysics and generated a list of categories that influenced Weiss as did Kant's. But Peirce never wrote the systematic treatise; Weiss developed that art (*Modes of Being*). In this regard, Weiss is much closer to Hegel than to either Kant or Peirce, though Peirce's categories of Firstness, Secondness, and Thirdness are much closer to the growth of history found in Hegel's *Phenomenology of Mind,* than the metaphysical categories that Weiss himself generated. Again, perhaps the laboratory and piece-meal approach that Peirce exemplified precluded it.

Again, Weiss's approach is not empirical, while tied to common sense. As a rationalist he moves from the particular to the whole. His philosophic approach never seems to be hypothetical the way Peirce's categories were, though Weiss's metaphysical categories continue to change to this day.

Consider Weiss's two teachers in the context of the real, and the philosophy of nature, and the background of Peirce.

Weiss's Two Teachers: Cohen and Whitehead

"I owe an incalculable debt to the inspired teaching and warm friendship of Morris R. Cohen, and to civilizing contact and vitalizing conversations of Alfred North Whitehead teacher and friend" (preface from *Reality*).

Cohen: Weiss's interest in Peirce was no doubt spurred early on by his teacher at City College, Morris Cohen. Twenty years earlier, Cohen had assembled a collection of Peirce's essays. When Weiss offered to help Charles Hartshorne in assembling the larger body of Peirce's work no doubt some of Cohen's enthusiasm for Peirce had rubbed off on Weiss.

Peirce and Cohen understood the science of their day. As I indicated, Peirce was a practicing scientist; he made contributions in optics, psychophysics, measurement theory, logic. For Cohen science stood for reason and rationality. Cohen looked at science from outside, as Weiss has. The experimental spirit is not part of Weiss, as it was not of Cohen.

Both Peirce and Cohen had a strong sense of the real. For Cohen, Aristotelian rationality predominated. Like Weiss, Cohen remained steadfast to the commonplace and to reason. Cohen suggested that "sound metaphysics like science should begin—though it should not end with the commonplace" (*Reason and Nature*, 168). Weiss says the same.

Peirce and Cohen also thought reason was broader than science. In an age when science came to be seen as the identification of reason and knowledge, Weiss asserts that reason is larger than science, though to be sure responsive to science. Weiss's rationalism was much closer to Cohen's than it was to Peirce's experimentalism. Despite Weiss's rationalism he never reifies reason or science, something Cohen did (see Weiss's review of *Reason and Nature*). Moreover, Weiss did metaphysics; Cohen did not.

From Cohen, as from Peirce, Weiss took home the message of the predominance of the real. Neither thinker was bashful of this fact; neither would Weiss be.

Whitehead: Weiss was influenced by Whitehead's work in logic, systems, and metaphysics. Whitehead, with speculative flair, set the standard for systematic metaphysics in the twentieth century. This was best expressed in his *Process and Reality*. It was after all Whitehead who generated a profound and revolutionary philosophy of nature; it was a way from the bifurcation of mind and value from nature.

Matter was alive for Whitehead. Not so for Weiss. This conception of Whitehead's defied common sense. This view of Whitehead's is found early on in his *Concept of Nature* and continued in his last book *Modes of*

Thought. For Weiss, one is not sure whether nature is alive in any way that Whitehead envisioned it to be. His common sense rejects animism as an adequate philosophy. His mistrust of biology as playing too big a role in philosophy would discount this. Weiss's concern is to move beyond biology, and he is right, but perhaps one still needs to be grounded in it. Weiss is not. Peirce and Whitehead were.

Weiss rejects many of the categories from his esteemed and beloved teacher. Whitehead's categorical schemes, while interesting, appear to have no impact on the categories that Weiss himself generates. Weiss could never accept an account in which commonsense causation was called into question (see Weiss's "History and Objective Immortality"). The simple experience of kicking a chair Weiss would retort cannot be accounted for in Whiteheadian terms. Weiss rejects the Whiteheadian reinterpretation of "perpetual perishing" that can be traced to Locke, or the notion of "misplaced concreteness." Both concepts undermined traditional notions of causation and substance which Weiss defends and his philosophy of nature reflects.

Weiss rejects the nonsubstance philosophy of Whitehead. Substances persisted, and insisted on their survival and integrity. Moreover, for Weiss things were concrete, and we need to take hold of this fact. For Whitehead, this would be to make the mistake of "misplaced concreteness." Weiss's rejection of Whitehead is akin to Moore's rejection of Idealism; both relied on brute experience of the commonplace. Therefore, Weiss's reverence for Whitehead, and his appreciation of the man and the mind does not translate into the substance of Weiss's work; substances are the very thing Whitehead was trying to do without.

Weiss, like his two teachers Morris Cohen and Alfred North Whitehead, holds a strong conviction that a philosophical system captures what is real, basic to experience, informative about nature, and relevant to us. The real impact of phenomenological qualities, for Weiss, can also function to raise one's humanity, despite the omnipresent drive to survive.

Weiss's Early Work

Weiss's early work wrestles with logic and systems (see his *The Nature of Systems*). Weiss's early work shows him to be quite knowledgeable in the technical side of logic, exploring issues such as contradiction, relativity in logic, and the theory of types. Weiss's interest in logic perhaps has more to do with the analysis of systems, which like Peirce and Whitehead

eventually lead to the formulation of his metaphysics. Like his teachers his concerns were also larger than technical issues in logic. The study of symbolic logic was beginning to decline somewhat when Weiss was a student, and yet at the same time for professional philosophers it was increasingly the standard by which one measured the truth or meaning of an assertion. Logic framed in clarity the unmistakable meaning and worth of a proposition, what was real, was true, and what was science (Carnap). But a philosophy of nature needed to be wider and deeper than the formal representation of scientific facts in logic. Weiss despite his emphasis on representation in his philosophy of nature was not seduced by the scientism of his day and the use of logic towards this end.

For Weiss, the systematic representations of knowledge constitute a philosophy of nature. But Weiss wants more than an account of a philosophy of nature. Weiss always seemed to hold that "philosophy is the deliberate attempt to say what the ultimate nature of things really is" ("Adventurous Humility," 337).

WEISS'S RECURRENT SENSE OF THE REAL

"All inquirers are modes of answering the simple question: what is the real" (*Reality*, 141).

We in the modern age run the risk of losing the real; losing it to sophisticated discourse at a philosophical parlor (Rorty). There are other ways of losing the real, to instrumental reason and use divorced from the value that lay in things, losing the real to cultural constructivism, or losing the real to the scientism of molecular chauvinism in biology, or the particles uncovered in physics.

Weiss generates a philosophy of the real, a metaphysics of our sense of being in the world. From Weiss, one gathers the sense of entities trying to survive, forging out a place where they can cohabit with others. As I indicated, surviving is the very stuff of Weiss's philosophic vision of man and nature. His language reflects surviving and maintaining the integrity of oneself. This is the stuff of nature. But it is larger than that; it is the stuff of metaphysical entities. Thus, while his sense of the real reflects everyday survival, the scope of man and his nature is not narrow despite this tie to the bruteness of the everyday. His phenomenology and metaphysics, in addition to his philosophy of nature, is replete with wanting to resist, persist, and insist on the continuation of one's being.

Weiss's philosophy of nature, and our evolution, is perhaps found in the complex facts of humans trying to forge out a life, and yet pursue

ends that accomplish worth. His phenomenology is not lost in isolated experience, but everyday survival in working to maintain one's own dignity, be the locus of responsibility, be respectful of the privacies of others, and knowledgeable about oneself and others (see his *You, I and Others*). His phenomenology is rooted in commonplace concerns.

Weiss has undergone various stages in which his categories have evolved. I will not discuss their evolution. Given the above, it is easy to see how Weiss's sense of the real is basic except for what he called Finalities (see *First Considerations*). Metaphysically, for Weiss, reality is composed of either Actualities or Finalities. But it is the actualities that are substances, or what was called "substantiality." Importantly, all thinking originates or terminates "in something outside itself" (*Modes of Being*, 80). Weiss, though, is not talking about a philosophy of nature here.

One sometimes hears that biology is about the real; it keeps one tied to the ground. But as I have said, the real is a much larger category than nature. As, Weiss stated it, "to exist is to be related to whatever is real" (*Reality*, 172). Again, Weiss's sense of the real is that of substances trying to maintain their worth, acknowledging that of others and cohabiting together. This is at the heart of Weiss's philosophy of nature. But such substances are incomplete. Though natural systems, for instance, are self-regulatory they depend upon others. Substances are trying to maintain their integrity and uniqueness, while they need others.

On Weiss's view, a philosophy of nature and our position in it, captures that "to be is to be incomplete" (*Reality*, 202). Substances are not perfect, they are incomplete. There is a drive built into our nature to want to compete and complete ourselves: to perfect ourselves. There is creative tension, in Weiss's thought, because substances are at once complete and incomplete. The resolution of the tension, perhaps, requires some notion of natural freedom. Weiss wants man to fulfill his destiny, to become the ethical animal that marks us. We can achieve this because "man is a free being in nature" (Introduction, *Nature and Man*, xv). He wants to ground ethics "in the bed rock of nature" (Preface, *Nature and Man*).

ETHICS AND NATURE; MAN'S FREEDOM

The central issues that concern Weiss about nature are ethics and freedom (see his *Man's Freedom*). They sit at the heart of his philosophy of nature. For Weiss, man is an ethical species. He insists that we have an obligation to do good; it is an imperative. We have duties and responsibil-

ities that inform our action. It is part of our biology and nature. We should not be simply swayed by pleasures and pains in our ethical decisions. Weiss seems to naturalize ethics, without it being an affront to our sensibilities. He is clearly not reductionistic. Our sense of nature has to include the ethical, otherwise it will misconstrue us.

Weiss's ethics is naturalistic, and reminds us that even as ethicists we tend to be egocentric. He insists that we discern what we can do for others, and what we owe nature. Our ethical imperatives are tied to nature. Our evolution is from within nature as is our dependence upon it. We owe something to nature; it provides us with the resources for life; there is an appropriate ethics. The ethics is not simply egocentric. We have responsibility to do the right thing.

Ethics is linked to our evolution. We are linked as fellow human beings; natural rights bind us together as members of the same ethical species. Weiss insists that uniqueness is just as much in our nature as it is being part of the same ethical species and being bonded biologically by our nature. The philosophical task is to evaluate both the commonality and the differences.

Our nature is ethical, and evolving in nature is our freedom. Weiss tries to reconcile biology and evolution on the one hand and our sense of freedom on the other. For Weiss, part of evolution is the emergence of man's freedom. He says "freedom is behind evolution" (*Nature and Man,* 102). Freedom is not outside of nature, but constitutive of it with regard to our human nature. Freedom is part of the evolutionary process.

Weiss also wants to insure that nature's purposes were not eradicated by the philosophical sciences that stipulated that teleological explanations were less substantial and real than the mechanical. Such teleological events are tied to substances persisting and pursuing what they want, need, and ought to do. Nowhere is this as clear as when it comes to ethical animals: human beings. Weiss's philosophy of nature represents this message.

Weiss's vision of man paints an evolving animal in nature, which is the ethical man with freedom. Man's duty? It is to make the absolute good concrete. Not everybody would agree with what the absolute good is. But suppose it was the golden rule, which Weiss emphasizes, that provides one with a concrete context.

Thus underlying the ethics is one major rule, namely "the golden rule is the principle of justice" ("Adventurous Humility," 428). At one point Weiss asserts: "it is man's end to become deity incarnate" ("Towards A Cosmological Ethics," 651), to embody the golden rule. Perhaps he intended this to be expressed as an inherent right, a natural right.

But exacerbated *Angst* is not the stuff of Weiss's ethics. It is too

grounded in commonsense action. Like Aristotle whose Ethics is perhaps as close to Weiss's book *Man's Freedom,* his ethics is about balance and self regulation. The ethics is grounded in a biological conception of man, but again not reduced to biology. There is a creative tension in Weiss's philosophy of nature between his insistence on keeping philosophy separate from biology, and his grounding ethics as evolving in nature and very much part of biology.

WEISS'S PHILOSOPHY OF MAN AND NATURE

One understands the plight of struggle and resurgence from Weiss's philosophy of nature. His metaphysical phenomenology is rich with acts of struggle and triumph amidst the elevation of human worth. As each substance perseveres to survive, the metaphysics of Weiss asserts that "each being is concrete independent substantial individual" (*Nature and Man,* 33), and yet there is dependency amidst the mutual contribution in the regulatory process.

A philosophy of nature envisions man's nature as balancing the private and the public; this is an important theme for Weiss (Privacy). Man's perfected state, as he puts it, is existing in communities (*Toward A Perfected State*). Man's nature is again that "man is the ethical animal" ("Some Neglected Ethical Questions," 216), an ethical substance.

But in *Modes of Being* and other works of Weiss it is clear that man's nature is to be responsible. He is the creature in evolution that has achieved that status. Weiss's metaphysics perhaps justifies this moral responsibility, and an ethic that is no longer egocentric. Weiss's metaphysics transcends the "Cartesian turn" that has dominated philosophy.

Thus with regard to a philosophy of nature, it must take into account the categories that have evolved. A philosophy of nature must say something about the nature of representation and knowledge and about problem solving. This Weiss does.

The fulfillment of man's nature, for Weiss, is expressed in the creative act of art (see his *World of Art*). The biology of substances is better understood in the working of the artist bringing something new into life than that of the biologist on Weiss's view. Weiss's vision of nature is closer to the artist than the scientist. This is consistent with his view of the relationship between science and art to philosophy.

Weiss's concern is to capture the whole of things, nature is only one part. Weiss thinks that philosophy of nature would require knowledge of each Mode of Being, or Finalities (*Beyond All Appearances*), or Finalities or Actualities (*First Considerations;* see also *Creative Ventures* for a

further development in his thought). Metaphysics is never just about nature. It is about the good, the possible, unity, etc. But with regard to nature, we come back to the idea of substance and self-regulation and the idea of the ethical animal, and that "actualities insist on themselves" (*Beyond All Appearances,* 107). And Weiss always returns to the knowledge of the real.

Weiss did not always engage his contemporaries. He was not absorbed in their problems. His peers' vision of nature was largely what science narrowly construed and dictated (Quine, Goodman; though see Buchler and Northrop). The language of physics dominated the discourse; biology had not yet flourished in philosophy of science circles. Perhaps only figures like Northrop who engaged both the biological and physical sciences and who worked to bridge science and the humanities, held to a large vision of science.

Weiss's obsession is with representation, whether of nature or anything else (e.g. see Neville's, "Paul Weiss's Philosophy in Process"). What we want to capture are representations of the real in the context of practice embodied in a speculative framework that makes sense of commonality. This Weiss attempts to do in a number of places. Philosophy of nature will necessitate this.

A philosophy of nature, needs to recover nature as a measure of the real (e.g. Neville). But Weiss's vision of nature would have been better informed if he had known the sciences (see Weissman's commentary in "First Considerations"). Still science should not define what is true and real for a philosophy of nature or metaphysics. Moreover, metaphysics is not autonomous from science; science is part of the humanities.

I believe a philosophy of nature needs to capture the aliveness of nature, our coping with the precarious (Dewey) and enjoying the contrasts (Whitehead), as we persevere to survive. Weiss is concerned with representation and system, but also survival.

Nature is replete with action. Transactions are the stuff of everyday discourse (Dewey). Weiss perhaps did not provide a strong enough foundation in this domain, as other philosophers of nature such as Peirce, Dewey, or Whitehead had done.

But taking the lead from Weiss one wants to locate humans as evolving in nature, that man's burden and evolutionary legacy is his freedom, though it is a freedom that is not absolute. We need a vision, though not necessarily of substances, as self-regulating, adjusting entities (e.g. Weissman; Schulkin). We need a conception of an ethics of responsibility towards others and nature. Naturalistic ethics transcends the self, our narrow concerns.

Weiss is correct to assert that a philosophy of nature is larger than the

domain of science. But the contents of a philosophy of nature are themselves empirical in some large sense of the term. And most importantly philosophy of nature grounds man and his duties. Man is the bearer of responsibility. A philosophy of nature reveals the rights inherent in man, emphasizes the persisting plight of man's existence, and the common bonds amongst us.

As I was reminded recently in conversation with Paul Weiss, there is something important about a philosophy of nature that needs to capture our appreciation of nature and our participation in it. Participation once meant the loss of objectivity. With the onset of modern physics such non-interference is discarded. A philosophy of nature is about our mutual bonds with other points of life, and our participation in the natural world, as we discover facts about ourselves, and other living things.

Weiss's Legacy

I have only characterized but a small fraction of Paul Weiss's philosophy. My focus has been on his sense of nature, our evolution in it, the nature of substances, and his commonsense philosophy. I have also, to some extent, indicated what a philosophy of nature should take into account.

I studied with Paul Weiss one summer, over twenty years ago. I went to study both the works of William James and Charles S. Peirce with him. Weiss has strong views. He quickly, in a revealing tone, asked why I wanted to study James. He said "Peirce it was easy to understand." He continued, "Peirce is a great philosopher." But James he underrated. I never did read James with Weiss. But it was enough to study Peirce, America's complete philosopher, with Weiss.

As a practicing scientist Peirce is closer to me than Weiss. And I believe that Weiss would have been better informed if he had appreciated experimental science, the way Peirce had done. Philosophy is best served as it incorporates the hypothetical-experimental method, even when the hypotheses are vague. This is not the vision of narrow scientism as the legitimation of the true and the real and the important. The battle against scientism remains, and will. But to eschew the experimental method, as I think Weiss does, is to miss how our minds evolved in nature, trying to adapt to circumstances, and how our ideas are constrained by a background of an evolving nature. A philosophy of nature has to capture this fact about us.

But Weiss does something important in his philosophy of nature. First, he captures the commonsense fact about survival, about our

persisting. And he understands that "bodies are not only living but lived" (*Privacy,* 4). Second, he ties this to ethics, an ethics that accounts for our evolving in nature. Third, this nature of ours is about freedom; freedom is endemic to our biology. And fourth, Weiss never loses sight of the real. His phenomenology and metaphysics are permeated with the stuff of real existence. The dignity and privacy of the individual is pervasive to his substance philosophy. Fifth, his philosophy of nature is non-egocentric, an important fact about his ethics, while sixth, acknowledging that "a person is a locus of rights" (*Privacy,* 298). Weiss, as a great philosopher adumbrates, to use his term, abducing to use Peirce's, many of our important concerns.

JAY SCHULKIN

UNIVERSITY OF PENNSYLVANIA
GEORGETOWN UNIVERSITY
NATIONAL INSTITUTE OF MENTAL HEALTH
SEPTEMBER 1992

REFERENCES

Aristotle. 1968. *Metaphysics.* Trans. R. Hope. Ann Arbor: University of Michigan Press.
Aristotle. 1974. *Ethics.* Trans. J.A.K. Thompson. Baltimore: Penguin Press.
Buchler, J. 1966. *Metaphysics of Natural Complexes.* New York: Columbia University Press.
Carnap, R. 1929; 1967. *The Logical Structure of the World.* Trans. R.A. George. Berkeley: University of California Press.
Cohen, M. 1931; 1959. *Reason and Nature.* New York: Dover Press.
Dewey, J. 1925, 1989. *Experience and Nature.* La Salle: Open Court.
Goodman, N. 1972. *Problems and Projects.* New York: Bobbs-Merrill.
Hegel, G.W.F. 1807; 1967. *The Phenomenology of Mind.* Trans. J. B. Baillie. New York: Harper Torchbooks.
Krettek, T., ed. 1987. *Creativity and Common Sense: Essays in Honor of Paul Weiss.* Albany: SUNY Press.
Neville, R.C. 1970. "Paul Weiss's Philosophy in Process." *Review of Metaphysics* 24: 267–301.
Neville, R.C. 1989. *Recovery of the Measure.* Albany: SUNY Press.
Northrop, F.S.C. 1962, 1972. *Man, Nature and God.* New York: Simon and Schuster.
Peirce, C.S. *Collected Papers.* 1931–1934; 1974. Ed. C. Hartshorne and P. Weiss. Cambridge: Harvard University Press.
Peirce, C.S. *Chance, Love and Logic.* 1923. Ed. M.R. Cohen. New York: Harcourt, Brace and Company, Inc.

Quine, W.V.O. 1953, 1961. *From a Logical Point of View.* Cambridge: Harvard University Press.

Rorty, R. 1982. *Consequences of Pragmatism.* Minneapolis: University of Minnesota Press.

Schulkin, J. 1992. *The Pursuit of Inquiry.* Albany: SUNY Press.

Spinoza, B. 1688; 1955. *On the Improvement of the Understanding, The Ethics.* Trans. R.H.M. Elwes. New York: Dover Press.

Weiss, P. 1928. "Relativity in Logic," *Monist* 37: 536–48.

Weiss, P. 1929. *The Nature of Systems.* Chicago: Open Court.

Weiss, P. 1931. "Review of Reason and Nature" (Morris Cohen). *The City College Alumnus* 4: 61–63.

Weiss, P. 1938, 1966. *Reality.* Carbondale: Southern Illinois University Press.

Weiss, P. 1938. "Towards a Cosmological Ethics." *Journal of Philosophy* 35: 645–51.

Weiss, P. 1940. "The Essence of Peirce's System." *Journal of Philosophy* 37: 253–64.

Weiss, P. 1941. "Adventurous Humility." *Ethics.* 51: 337–48.

Weiss, P. 1947, 1967. *Nature and Man.* Carbondale: Southern Illinois University Press.

Weiss, P. 1950, 1967. *Man's Freedom.* Carbondale: Southern Illinois University Press.

Weiss, P. 1952. "Some Neglected Ethical Questions." In *Moral Principles of Action,* ed. R.N. Ansten. New York: Harper and Row.

Weiss, P. 1958, 1968. *Modes of Being.* Carbondale: Southern Illinois University Press.

Weiss, P. 1961. *The World of Art.* Carbondale: Southern Illinois University Press.

Weiss, P. 1961. "History and Objective Immortality." In *The Relevance of Whitehead,* ed. I. Leclerc. New York: Macmillan.

Weiss, P. 1965. "Charles S. Peirce, Philosopher." In *Perspectives on Peirce,* ed. R.J. Bernstein. New Haven: Yale University Press.

Weiss, P. 1974. *Beyond All Appearances.* Carbondale: Southern Illinois University Press.

Weiss, P. 1976. *First Considerations.* Carbondale: Southern Illinois University Press.

Weiss, P. 1980. *You, I and Others.* Carbondale: Southern Illinois University Press.

Weiss, P. 1983. *Privacy.* Carbondale: Southern Illinois University Press.

Weiss, P. 1986. *Toward A Perfected State.* Albany: SUNY Press.

Weiss, P. 1992. *Creative Ventures.* Carbondale: Southern Illinois University Press.

Weissman, D. 1987. "First Considerations." In *Creativity and Common Sense: Essays in Honor of Paul Weiss,* ed. T. Krettek. Albany: SUNY Press.

Weissman, D. 1989. *Hypothesis and the Spiral of Reflection.* Albany: SUNY Press.

Whitehead, A.N. 1920, 1964. *Concept of Nature.* Cambridge: Cambridge University Press.

Whitehead, A.N. 1925, 1978. *Process and Reality.* New York: Free Press.

Whitehead, A.N. 1938. *Modes of Thought.* New York: Macmillan.

REPLY TO JAY SCHULKIN

Jay Schulkin has managed, in a limited space, to reveal much of the spirit that has sustained my studies over the years. He has tethered his account to an interest in nature, and has dealt with it as a disciplined inquirer who is also a philosopher. Generous in his praise and perceptive in his understanding of how my views comport with those of some great thinkers, he makes evident that some of my claims need to be clarified and perhaps modified, if they are to be in good accord with what has been maintained by others.

With some others—Shimony for one, who is also a disciplined scientific as well as a philosophic thinker—Schulkin refers to me as a 'phenomenologist'. The term, since the time of Hegel, has been used in a number of not altogether compatible ways. Peirce's and Husserl's use of the term are not only different from one another, but from Hegel's as well. All apparently agree in supposing that phenomenology is occupied with describing what occurs, and in bracketing questions about what is a presupposed ground or precondition. I, too, have tried to describe, to attune to appearances, and report on what is observable. But I have never been content to stop there. Nor did Hegel or Peirce. The observable, the experienced, the obtrusive are qualified by and qualify what sustains them and what they themselves presuppose. What is distinct is also related; whatever is real makes a difference to what is other than itself. The fact has been insisted on by objective idealists, but with the accompaniment of the claim that the distinct is not really so, and that there is a single, never really mastered totality in which all distinctions are blurred or eliminated. I reject that claim, as I must, even if I were to try to accept it.

'Phenomenologist' is apparently being used by Schulkin and Shimony as a term of praise, perhaps to emphasize my desire to attend to what in fact occurs and my refusal to accept some method or outlook which

does not accommodate it. If this is what is intended, I accept the honor, but then only as relevant to only a part of what I think I am doing. The ultimates, Being, and individual persons are outside the reach of a phenomenology. After these are known and the knowledge made available, a good phenomenological description of what had been known in other ways, will be possible and well worth having. In their absence, a phenomenology has no evident beginning nor end.

Anything can be described in an apparently endless number of ways, depending on the different angles from which it is approached, the level of generality with which one is concerned, the kinds of neighbors that are noted, and the connections that are focused on. I have been interested in the outcomes of the ways in which the ultimates are jointly instantiated, in providing 'descriptions' of the items involved, and the outcome of their joint use, and what accounts for them. I have looked for reasons and attended to limits and boundaries. I have questioned and criticized, speculated and argued. Phenomenology, since it does not, in any of its major forms, concern itself with reasons and arguments, could never provide more than one of a number of possibly questionable ways in which realities can be viewed. If what is intended in referring to me as a phenomenologist, is a reference to my willingness to attend to what is, and a refusal to neglect or reject anything because some method or outlook cannot accommodate it, I accept the designation, but then only as referring to a part of what I do. I suppose one might speak of a phenomenological examination of the ultimates, Being, and individual persons, and perhaps even of their interrelations, but then 'phenomenology' would begin to turn into a number of descriptions of what is already known in other and better controlled ways.

Schulkin rightly remarks that I am not a scientist. Perhaps I should have spent some time trying to share in the lives and participate in the work of those who were dedicated to making contributions to some branch of scientific study. Many of those who profess to speak authoritatively of science have actually contributed little if anything to the subject, or have been content to recapitulate what scientists claim. Schulkin, unlike them, is an experienced investigator, though apparently in only one area.

It is not often that those, who are engaged in exploring some field, can give a good account of what they are doing. Usually they are not well-equipped to provide good reports about what is observed. It is a rare scientist or painter, poet, musician, novelist, architect, actor, or dancer, who knows how to articulate and communicate the nature of what had been done so well. There is a great gap between what the textbooks say and what is in fact done. We can do no better than listen to what such

scientifically disciplined philosophers as Peirce, Shimony, and Schulkin tell us about what they do, while checking their affirmations and objections against what else we know.

At all times, we must keep in mind the difference between a lived method, the aims, values, and conditions characteristic of an enterprise, and what is pertinent to other kinds of inquiry. Science is an ongoing, communal venture, making assumptions it never examines. Its results need and deserve to be understood from other positions, if the full import of its claims are to be understood. What it can tell us is only part of what we should and can learn. We need no science to tell us how to listen to a symphony, how to create, or how to speculate, though all, of course, can be subjected to scientific scrutiny and some things learned that would not otherwise be known.

Schulkin rightly allies me more with Aristotle than with Plato, particularly when I attend to actualities, though I have found the platonically-minded to be more open to new ideas than those who favor Aristotle. I think nature is but one of a number of distinct domains, each of which is to be understood by carrying out a distinctive method, pertinent to a distinctive kind of actuality. What occurs in nature occupies a distinctive extended span. Some spans are purposively ordered, i.e., are oriented toward prospective outcomes that help determine what is achieved. The purposive is not, as Kant made evident, to be identified with the purposed, lacking as it does a conceived outcome guiding acts designed to realize it.

Humans, outside nature, have purposes; what is inside nature does not. Did natural beings, or nature as a whole have purposes, as the usual teleological and some theological views suppose, there would be prospects that dictate what was done. Were they only purposive, they would have tendencies that might peter out and nothing ever terminated at. A purpose governs objectives; the purposive is that toward which occurrences are oriented. Since nature existed long before there were humans, and continues to exist apart from them, we must be on our guard not to attribute to its members characteristics that are distinctively human.

What we can observe and directly interplay with is in ourselves or in the humanized world. Were it not for the ultimates, both nature and the cosmos would be no more than imagined outcomes of projections that never escape the confines of the humanized world (as Wittgenstein seems to have seen), or of a privacy where most epistemologists are confined. That does not mean I am not concerned with methods. On the contrary. Indeed, in *Being and Other Realities* I try to show that there are distinctive methods appropriate to understanding what occurs in differ-

ent domains and, in addition, take account of distinctive adumbrative, intensive moves into actualities, and of evidencings that enable us to reach the ultimates. We must not, though, be so occupied with methodology that we forget that methods are to be used by persons to enable them to know realities existing apart from themselves. One interested in knowing what occurs in nature must know what is not qualified by humanizations, language, or attitudes, and that its members are primarily extensionalized. Although some naturalists speak as though they did nothing more than observe with care and speak with precision, they at best allow what is in nature to be maximally but not altogether freed from humanizing factors.

Schulkin is not the only essayist in this work to identify abduction and adumbration. I once tried to see if the former could be taken to be an instance of the latter, but soon concluded that it could not. Abduction moves from actualities to the ultimates as they are apart from these; adumbration penetrates beyond appearances into what appears. Evidently, they move in quite different directions, and end at quite different realities. This is now so evident to me that I do not understand how I ever thought that abduction might possibly be a kind of adumbration.

Schulkin asks if I accept anything like Peirce's "evolutionary love." I do not. Peirce never did show why anyone should suppose that it occurs. Having lived through the time of Darwin's tremendous impact on the intellectual community, and occasionally using the idea of evolution to prompt suppositions about what was at the root of everything, Peirce too quickly cosmologized the idea. I am not confident that evolutionary theory applies to individual persons, with their characters, privacies, and possessed bodies, able to speculate and to think about "evolutionary love." Few today are as sure as were those a century ago, that the members of the humanized world or that individual persons are subject to evolution. Nor does there seem to be evidence that there is anything like a cosmic 'love' or that the assumption that there is clarifies anything.

Schulkin remarks that while I am a "professional philosopher" in somewhat the sense in which Hegel was, I do not accept his view of nature, as one stage in the relentless progress toward an all-absorbing Absolute. Still, with Hegel, I think that, in the absence of a complete system, there is no knowing what crucial realities may have been overlooked or misconstrued, and might, therefore, jeopardize what had been taken to be sound. No one, though, can remain a Hegelian as long as he remembers that there are contingencies. Hegel had no place for them, though he does have a place for the category 'Contingency' as one moment in an irresistible progress to the Absolute.

No system is tenable if it allows no place for contingencies, or if it

cannot explain how there could be any. Unless one can show that what necessarily acts to produce what is contingent, contingent occurrences might be accounted for by referring to some prior contingent acts, and so on back and back without end. What will still not be accounted for would be the entire sequence of contingent occurrences. Is this necessary or is it contingent? To account for the existence of contingencies, one must, sooner or later, refer to a necessary reality, dependent on nothing else. One would then have to show why this must produce what must act on behalf of that necessary Being and therefore be able to act in contingent ways.

Schulkin rightly calls attention to M.R. Cohen's effect on me and, more important, to his early recognition of Peirce's greatness, his awareness of the importance of the commonplace, and his respect for science and logic. Schulkin remarks that Whitehead "generated a profound and revolutionary philosophy of nature"—or, more accurately, of the cosmos. I do not think it is correct to say that for Whitehead "matter was alive" or that he "defied common sense." He respected it, while avoiding indurated superstitions as well as unwarranted beliefs about luck, change, and providence.

While I agree that "the real is a much larger category (!) than nature" and that Schulkin is right to emphasize the claim that "substances are at once complete and incomplete," and that I once dealt with ethics as not entirely sunderable from nature, I would today say that no ethics is well-grounded if it does not take humans to be in a domain of their own. Ethics has been too often concentrated on what a person ought to become or on what persons ought to be and do. Both should be considered and then as nested in a more comprehensive totality in which there are other kinds of realities. "Ethics is linked to our evolution" is true in the sense that ethical beings came about in the course of an evolutionary process. But when our ancestors become individual persons they escaped the confines of nature, and were able to be together as members of a common humanized world.

I don't think it is entirely correct to suppose that I take the Golden Rule to be the major principle of ethics. I thought that the last chapter of *Man's Freedom* made that evident.

I am glad to see that Northrop's work is appreciated. He was one of the first to be aware of Whitehead's importance. He also sought to account for the differences distinguishing diverse cultures in a daring, original work, pointed up the underpinnings of law, and was alert to the epistemic and ontological implications of Einstein's views. His contributions have not yet been sufficiently appreciated.

I do not see why one should say that nature is "a measure of the real"

any more than individual persons, the members of the humanized world, or the unit bodies in the cosmos are. Each is subtended by the ultimates. Even humans, when they evolve from their predecessors in nature, are constituted by the same factors as their predecessors were, though in a different way.

Why should philosophy "incorporate the hypothetical, experimental method?" It is not a science. Indeed, that method is a distillate of what scientists in fact do. Did one wish to do justice to the method (perhaps better, methods) scientists in fact pursue, one would have to take account of their hesitations, wild surmises, sudden leaps, retreats, qualifications, and other features of their living enterprise. Yet, whatever its successes, science will always fall short of helping us understand poetry, history, teaching, creative work, philosophy, and ourselves.

Schulkin ends with a deft summary. It is too kind, neat, and generous for me to want to spoil it. Yet, without the qualifications that I have here indicated, it cannot stand.

P.W.

12

Eric Walther

THE SELF REVISITED

An interesting corollary that has been drawn recently from the computational model of mind is that the self—our sense of being a unitary subject who enjoys and suffers, desires, understands, speaks and acts—is an illusion. This follows from the fact that each of those conscious processes is rather widely distributed in the brain, both spatially and temporally, and there is no locus or threshold where "it all comes together." The self, it is suggested, is a "virtual machine" in the sense of computer science: an approximating projection into ideal linear sequence of what is actually implemented in many overlapping parallel subprocesses. Daniel Dennett has systematically explored these recent ideas in his important book, *Consciousness Explained.*[1]

Firmly opposing the dominant trend in contemporary philosophy, Paul Weiss has always rejected the view that the sciences have any special authority with regard to the nature of reality. Philosophers who defer to physics in determining the nature of space and time, to biology in elucidating the nature of life, or to the brain sciences in explaining mind and consciousness, "allow scientists to do their thinking for them." I totally disagree with this point of view. It seems to me that our deepest commonsense intuitions, e.g. about simultaneity, or vitality, or the conscious self, may rest on factual errors. Only science is equipped to uncover such errors, though philosophy has an important role to play in working out the interpretive consequences.

In May of 1959, the final exam for "Nature, Man and Society," a course taught by Mr. Weiss at Yale, featured this question: "What warrant is there for holding that there is a self? What are its main features? How is it related to mind and will?" Although this student's answer has not been preserved, the appearance of Dennett's book is a good occasion for revisiting the concept of the self. The textbook for that course, *Nature and Man,*[2] is the work where Mr. Weiss first developed an account of the self, and I shall base my discussion on that book. After

describing the features that Mr. Weiss attributes to the self, I shall ask whether such a self must really exist to explain those features, or whether they are better described as concomitants of the illusion of having such a self.

Mr. Weiss maintains that all men (viz. human individuals) have selves, whereas an animal has at most (i.e. if it is conscious) a psyche. The possession of a self marks man as a higher being than any animal. A self is created "well before birth" in the human embryo, in a metaphysical drama of self-creation. Confronted with grave obstacles to its continuing self-realization, the "human" embryo transforms its not-yet-human nature into something higher. Man is characterized by his concern for an all-encompassing ideal good, rather than the limited good of the individual itself or its species. Having such a concern, and having a self, are metaphysically equivalent. Though the self is the source of all a man's nonbodily powers (thought, emotion, desire, will, etc.), it is the source of his bodily manifestations as well, inseparable from the body and bearing no hint of immortality. (Not in *Nature and Man* anyway. *Modes of Being,* 1956, announces that the self is immortal, a conversion that I find regrettable and will not discuss here.)

There are at least six distinguishable features and factors in man to which Mr. Weiss pays particular attention in offering warrant for his claim that there is a self. First, the self is "a human constant," an unchanging factor at the source of every variable expression of an individual's nature that makes him self-identical throughout his life. Second, the self is active. One and the same agent exists at the source of all a man's actions and manifestations, including his bare continuing to exist. (Persistence, the continuing of a thing in existence, is always an act, the bringing-into-being of a future, in Mr. Weiss's view.) Third, the self is the private innermost first-personal core of a person. Fourth, the self is the locus of man's nonbodily powers. Fifth, the self unifies and integrates mind and body in a way that makes possible self-discipline and self-criticism. Finally, the self is the source of man's ultimate concern: the ground upon which he stands in orienting his future toward an all-embracing Good, the ontological source of obligations and values. These features will now be examined in order.

The first indicator of a man's self is his identity. A man is self-same from (before) birth until death, no matter what changes in mind and body he may undergo. Mr. Weiss takes this to indicate that what he is, i.e. his self, must be a constant, something absolutely unchanging and unchangeable. A sufficient refutation of the suggestion that a man is X, is that X varies or changes in some way. That which changes is an

expression of the self; the changing expression—be it the body, bodily life, reason, memory, personal character, will, etc.—has its source in something immune from change, the self.

The rationale for this account is obscure, since a dog remains the same dog (despite changes in its body, memories, character, etc.) *without* having any self. Even inanimate entities persist and have the ultimate inwardness of privacy, in Mr. Weiss's view. But neither the privacy of an actual entity nor the richer psyche of an animal carries with it that constancy and immunity from change that characterize a self.

Mr. Weiss asserts that there is a fundamental difference between the identity of selves and the identity of other beings. Subhuman beings persist by "failing to be different"; only the self persists by succeeding, by "fully realizing" the possibility of being itself in the coming moment. This distinctive way of moving into the future is correlated with the idea that man's concern is with the universally-relevant absolute Good, while the concern of other beings is with a restricted Good. But this imaginative speculation is pointless unless it starts from some directly recognizable distinctiveness about man's self-identity that needs explaining.

Fortunately, when seeking to illustrate the uniqueness of human self-identity Mr. Weiss does invariably refer to something more clearly distinctive of man: the possibility of guilt. A man in his fifties is still guilty of his childhood failings, because he is still the very same man who failed. (Mr. Weiss does not emphasize the subjective phenomena of guilt; the point is not that a man feels guilty or recognizes his guilt, but that he *is* guilty and therefore could appropriately have such feelings.) Only a being self-identical in the human sense can be guilty.

I think we can conclude that the identity that indicates the presence of a self is not well described as an existing sameness that must underlie differences. Such descriptions are misleading because they are not specific to beings with selves. There is no reason to deny that this old dog is *the same* dog as the one that bit the mailman ten years ago, even if the dog's earlier motives, habits, and memories have been utterly expunged. But one can sensibly think that the earlier acts of a much changed dog are not properly *attributable* to that dog, in the way the earlier acts of a much changed man *are* properly attributable to him.

Following this clue, one should center a man's self-identity in his special way of *attributing* everything that is his, past, present, and future, to a constant unchangeable self. Whatever he does, however he changes, both he and we should attribute these things to a "private responsible inside"—to a constant self. As Locke said, a man is self *to himself,* and "self" is primarily a forensic term. We do not think of subhuman beings

as having this type of absolute self-sameness because we do not attribute things to them in this distinctive way: holding them responsible for the things attributed to them.

Why couldn't a person make these attributions and take himself to be such a self, even though such a self does not actually exist? No doubt Mr. Weiss believes that if a person did not *exist* as such a self, it wouldn't occur to him to make such self-positing attributions—it *couldn't* come into his mind to do so, any more than it can come into a dog's mind. As an elaboration of the Weissean view this is unexceptionable, but as an argument it begs the question. There are any number of possible explanations for why it is possible for men to think about themselves in ways a dog cannot; that a man *actually is* what he takes himself to be is by no means a necessary implication of that possibility.

It might be felt that if these self-attributions are attributions to a thing that doesn't exist, then they would be arbitrary and revisable. But that doesn't follow if they are inseparable from what makes it possible for me to be a self to myself at all. Only by relating all my actions, judgments, and bodily manifestations to some single existent core can I take them really to be mine, to belong to "that identical one that is I" (a dictionary definition of "myself"). I disagree with those modern theorists of personal identity who think that our usual style of self-identification is likely to evolve into a wider social self-consciousness or a de-centered Buddhist consciousness under the impact of philosophical analysis. But the point here is that if this individualistic self-identification proves to be deeply rooted and ineradicable, that proves only that we *posit* a self, not that such a self exists.

But how *can* we posit ourselves, yet endorse the philosophical theory that no such self exists? Can an atheist still pray to God? Isn't it a contradiction to say "I do not exist"? No, this most paradoxical way of putting the question is to be welcomed. The ordinary self-positing of the "I" should not be replaced by some more cautious positing of a better candidate for real existence. I do take myself to be absolutely one and selfsame in all my acts and manifestations, even if there is no such thing. Descartes was right to claim that it is so evident in immediate consciousness that it is the *same* I that understands, perceives, desires, and acts that no explanation could make it clearer. There is nothing momentary or evanescent in the I that thinks and acts. Descartes's fallacy was to construe this self-positing as a proof that what is then posited must exist.

"But the positing really occurs; it's the I that posits, not the posited I, whose existence is undeniable." Yes, the positing really occurs: things occur in the brain, and the collective effects are appropriately called a positing. But when we refer to an I that does this positing, that is just

another instance of the posited I. We construe self-positing as an act like any other, an act performed by the self.

The self is active: this brings us to its second main feature in Mr. Weiss's account. The self is the ultimate source of a man's acts. Moreover, as the innermost core of a man, nothing external can direct or determine it; it is self-directed and self-determining. Otherwise I myself wouldn't truly be the source of my acts; they wouldn't originate in me. But activity as such is not an indicator of the self: all actual beings, in Mr. Weiss's view, are active. Activity indicates a self when the act has meaning within a personal history: informed by the agent's past, imbued with responsibilities, concerned with a meaningful future.

An act is distinguished from an event by the positing of an agent as its source. It is easy enough to think of the many facts and factors that influence a person's behavior, including his thoughts and feelings, leading causally to the initiation of an action, but the person himself might as well be *absent from* this picture. Most pointedly, if I think this way about my own behavior, then *I myself* didn't initiate the action: it flowed naturally, causally, from all those interacting factors. It's very different when a person's behavior is construed as he himself acting. An act is undertaken by a single self who envisages its outcome, persists through its performance, and has it as his own self-defining act when it is finished.

In addition, the one who acts also *has* acted and *will* act: an act is not the stepping-forth into the world of a newborn self. The one who acts has a history which is being carried forward in that act: the very one who is doing this, did that. In this way a person becomes concretely responsible for what he becomes. It makes no difference whether the essential self-defining occurred in the past and is habitually carried forward in the present act, or whether it has been forged in a present "moment of truth": the same self lies at the source of the action in either case.

We now wish to consider how this account fares if we take it as a description of how a (possibly non-existent) self is *posited* when human behavior is construed as action. The obvious advantage of this way of seeing things is that it co-exists comfortably with scientific explanations of behavior. We are not forced to think that somehow, somewhere, the self makes its own contribution to the natural causal processes, intervening in some scientifically incomprehensible way. The "selfy" construal is irrelevant and makes no contribution to elucidating the causal factors that determine behavior. It has a very different purpose.

The point of construing behavior as action is to bring it under control. When I (and others) take thoughts, feelings, and desires to be mine, we take them to be manifestations of the single unitary self which has acted

and will act again. But they can be more or less appropriate to, more or less well integrated within, that particular self. Saying that a feeling is mine amounts to making it mine, often changing it in the process and setting the stage for more profound changes. Psychotherapy teaches that the integrated self is an incomplete achievement, always in need of present reshaping. "If you're not working on your self, you're not working."

It seems to me that the effectiveness (in controlling behavior and realizing personal integration) of positing a self as an identical originating agent for a person's acts is not compromised by the view that this self does not actually exist. Some self-positings, no doubt, are more effective, realistic, or sincere than others, but there is no need to imagine this degree of realism as the extent of approximation to an actual underlying reality. Still, it might seem that there is some deep unavoidable insincerity about self-positing construals if the self doesn't exist. Surely there is a difference between acting in ways that reveal one's true self, and "acting" in the sense of playing a role, appearing in the guise of a character that doesn't really exist. Hamlet may be as realistic a character as you like, but the self of the actor who plays Hamlet must be real in a more robust sense.

This objection brings us to the third characteristic element in Mr. Weiss's account: the self is the innermost private first-personal core of a person. Mr. Weiss holds that all actual entities have a private nature. This privacy is the underivative and ultimate source of the individual's public knowable characteristics. The thing known has an inside that is never captured in knowledge; this reference to "the adumbrated" gives knowledge its rootedness in the real, keeping it from being a mere conceptual construct. The case of man is special because his ultimate privacy is first-personal and is the source of what is uniquely human. The self is the inside for which the physical body functions as an outside: a physical manifestation of an inner reality that is more than physical. The self quickens and sustains its body, giving that body its uniquely human nonbodily powers (a claim to be discussed below).

The first-personal character of the self is its capacity to act, to experience consciously, to desire and plan and comprehend. To know what a self is, we must trace its manifestations (actions, emotions, etc.) back to their source, reversing the direction in which the manifestation itself flows. There is no reason to think we can do this more accurately in our own case than in the case of others. The difference is that in the one case our understanding merges with our own open-ended readiness for further actions and reflections; in the other case it ends in our positing of the not-yet-expressed multiplicities of the other person's privacy.

Although the assertions made by this account are metaphysical, the payoff seems to me to be epistemological. The constant intention is to exhibit the thing known (the self in this case) as autonomous in relation to knowledge; its nature is determined in entire independence of the enterprise of knowing it. Our success in grasping it is inevitably partial, because what we grasp emerges from an absolutely private inner being. So we should never think that we have plumbed an individual soul to its very depths. Further manifestations, or more perceptive study of previous manifestations, may always reveal a person more intimately or more profoundly than anything previously discovered.

Is anything lost from this account if the truth of the matter is that it describes our construal or positing of an inner self, not the actual existence of an inner self? It seems not. In fact, the last remarks can be applied with literal exactness to the profundity of fictional characters. No assessment of either—real person or fictional character—is final; both have inexhaustible reserves of new interest for new approaches. It might be assumed that the imagined profundity of fictional characters is modelled on the really intuited profundity of actual men and women, but it has often been observed that the opposite is equally true. So let us take another look at the claim that the self of the actor who plays Hamlet must be real "in a more robust sense" than is Hamlet himself.

The difference is that the playing of Hamlet must (for everyone but the insane) be a deliberate undertaking. The many possible roles of that sort contrast with the one role, unique to each individual, that is played undeliberately. Being oneself *is* more like acting than like simply being. At its most honest, it is effortful, integrating sincere acceptance of what one has been with earnest projection of what one shall be. This is more naturally understood as an interpretive project from which and through which a self emerges, than as the self-expression of something simply existent. This self project is undertaken automatically and without deliberation by the human organism. As Daniel Dennett says: "I am my body's dream. . . . a fictional character in a sort of novel composed by my body in action."[3]

Dennett thinks that the production of these fictional characters (ourselves) is a consequence of the fundamentally narrative character of our consciousness. "Our fundamental tactic of self-protection, self-control, and self-definition is not spinning webs or building dams, but telling stories, and more particularly concocting and controlling the story we tell others—and ourselves—about who we are. And just as spiders don't have to think, consciously and deliberately, about how to spin their webs, and just as beavers, unlike professional human engineers, do not consciously and deliberately plan the structures they build, we (unlike

professional human storytellers) do not consciously and deliberately figure out what narratives to tell and how to tell them. Our tales are spun, but for the most part we don't spin them; they spin us. . . . These strings or streams of narrative issue forth *as if* from a single source—not just in the obvious physical sense of flowing from just one mouth, or one pencil or pen, but in a more subtle sense: their effect on any audience is to encourage them to (try to) posit a unified agent whose words they are, about whom they are: in short, to posit a *center of narrative gravity.*"[4]

The theory that the self is a fiction automatically generated by the human organism is a nonstarter unless the phenomena of mind and consciousness can be fully explained by the natural sciences. Mr. Weiss repeatedly asserts that there are nonbodily powers and features in man. He speaks often and confidently of mind and body as divergent factors that "go their own ways" though they cannot be completely sundered from one another (since they are both manifestations of a single deeper reality, the self). "There are times when occurrences in the mind merely reflect the occurrences in the body or conversely; there are other times when mind and body condition one another. A depressing thought may occasionally paralyze the body, a diseased gland may corrupt the mind. But it is also true that the thought of glory can force weary legs to keep on running, and weary legs can make sweet the thought of rest" (p. 219).

When needing to emphasize the distinction between mind and body, Mr. Weiss freely asserts that the mind and mental phenomena generally (conceiving, imagining, emotion, desire, will, etc.) are "nonbodily" and "nonmaterial." The act of contemplating "cannot be found by looking into a material brain" (p. 241). Yet one will look in vain for *arguments* intended to show that a materialist interpretation of mental phenomena is unfeasible. For Mr. Weiss, the suggestion that what we call "mind" is simply the functioning brain amounts to the absurd denial that men have minds at all: it is an "error of unwarranted subtraction." This is quite incorrect: the suggestion is made in the course of offering explanations of whatever abilities men are found to have, not in denying such abilities.

Upon what, then, is Mr. Weiss's confident distinction between mind and body based? Everything points to our unreconstructed common sense and ordinary language. People distinguish between their minds and their bodies all the time. It's part of our ordinary way of looking at ourselves. To say that contemplation is "nonbodily" seems to mean nothing more than that we take it to be "an act of the mind" as opposed to a bodily manifestation. I am inclined to think that this commonsense mind-body distinction is the opposite of helpful just when we most want to rely on it: e.g. "am I really sick, or is this just in my mind?" But perhaps it has a wide usefulness in many situations. In any case, Mr.

Weiss's elaborate discussion of the relations between mind and body is quite enlightening when read as an account of what we *take ourselves to be.* It is question-begging if read as an attempt to show that mental phenomena *are* nonbodily.

For someone who conceives of the mind as something distinct in nature from the body, the interinvolvement of the two is an embarrassment. Mr. Weiss proposes to dissolve this embarrassment by conceiving both mind and body as possessions of a single self which vitalizes and reshapes both of them, relating them to one another in a way that would not be possible if each were ultimately real in itself. It is to be noted that the benefits are all related to how mind and body are conceived. If the purposes of this conceiving are distinct and different from the purposes of scientific explanation of what exists, then there is no conflict between the fictions of the world of You, I, and The Others and the world of real existence.

An interesting example is provided by Mr. Weiss's discussion of the location of pains. Since they are consciously felt, Mr. Weiss cannot regard them as entirely bodily. But they aren't nonbodily either. "Pains and pleasures are no more in the brain than they are in any other part of the body. . . . Nor are they in the mind. They are in the body, though it is necessary to be conscious of them if they are to exist" (p. 111). Usually they are where we feel them as being. The fact that a physiological disturbance is transmitted through intermediate locations has nothing to do with where the pain is. In cases like the phantom limb, the pain is in the stump and we mistakenly locate it in the absent leg.—All of this is clearly an account of where we *take* pain to be, and of pain *as we (ordinarily) construe it.* It would undermine all the strengths of the account to take it as a description of actual reality.

Mind and body are discordant in many ways: this is what Mr. Weiss takes to be "the mind-body problem." Its solution is to construe both mind and body as "vitalized and possessed by the concerned self," which thereby alters them and "enables them to converge on a common objective." The feeling of that convergence is emotion; the specification of that objective is desire; the bringing of that convergence to actuality is will. Thus it appears to be the self that makes these things possible. On the other hand, emotion and desire (and maybe will too) surely exist in animals (which don't have selves); so the self makes these things possible *in man,* and these faculties have potentialities in man that are absent in animals. Indeed, the reference to a "concerned" self is a reminder of man's distinctive concern with an all-encompassing good. Thus man's emotion, desire, will, etc. are capable of taking on an ethical flavor, and show their distinctive nature only in doing so. Once again, it seems that

the essential contribution of the self is to permit us to *think about* our emotions, desires, etc. as essentially bound up with our ethical concerns. And they are indeed made different by being taken in this way—whether that self which is posited as their source really exists or not.

Mr. Weiss asserts that self-discipline and self-criticism are possible for man only because he has a self with powers and a nature of its own, acting on both mind and body and infecting them with its concern. The possibilities of self-discipline and self-criticism do indeed comprise important parts of what we take to be distinctive about man, and they are somewhat paradoxical. They seem to posit a distinction between what disciplines (or criticizes) and what gets disciplined (or criticized), and both must somehow be *oneself.* Yet it is hard to identify oneself wholeheartedly with both factors at once.

Mr. Weiss holds that self-criticism requires judgment, a nonbodily act. In addition, self-discipline requires that the self must have powers that the body doesn't have, and use them to act on the body. There is an echo here of an old Thomistic view (which Mr. Weiss cites approvingly) that the organ of knowledge cannot be material because if it were, its own material form or essence would distort whatever conceptions it might form of other essences. But the view that knowledge requires a literal "shaping" of an idea to the essence of the thing known is outdated for many reasons. Nor does the assumption that discipline of the body requires nonbodily powers seem compelling today. There is a very considerable gap between the abstract models of self-critical machines that have been discussed by computer scientists and the most sophisticated systems actually built, but there are no obvious contradictions in the models.

Suppose, however, that Mr. Weiss's account is not taken as a set of claims about what must exist or cannot exist, but as the characteristic (perhaps even essential) way in which we *think of ourselves* as criticizing and controlling ourselves. Disciplining oneself does enable one to overcome obstacles that defeat one without discipline. What better way to manage this disciplining of oneself than to take the discipliner as a self that stands over against the body, mastering and controlling it, while all the time inevitably yielding to it in some respects, since that body is also a manifestation of that same self. If I think of mind and body as my "possessions," I can use the one to bring the other into better accord with my intentions. If I take every goal, ideal, or principle that I might have as expressions of a concern rooted in something deeper (a self), then they are not unalterable criteria; they are visions of the good that are subject to criticism in comparison with whatever other ideas may emerge from that self. Lack of a fixed ultimate nature is an embarrassment for a self

that must actually exist; a self which is only a posit can be as ultimately indeterminate as one likes.

Mr. Weiss relates each of the distinctive features of the self to its "concern." The self is concerned with an all-inclusive, universally relevant Good. This concern gives man an ethical orientation that is impossible for animals because they lack selves. Mr. Weiss is concerned to show that all actual beings (nonliving things, plants, animals) are active and concerned; what distinguishes man is the impartiality of which he is capable. The limited and partial objectives of other beings are seen by man as needing to be harmonized within the perspective of a universal good. "Whether it knows it or not, for every self the world is one in which the objectives of particular things are approached from the vantage of a universal good, in terms of which those limited goods ought to be enhanced and made concordant" (p. 260).

The question we have been asking is doubled in this case: does the strength and usefulness of Mr. Weiss's account require the *existence* of this self and this Good, or is it enough that we *posit* these two factors in an automatic and perhaps inevitable self-construal (so that they are compelling fictions, not realities)? I will not explore how compelling this particular way of grounding the ethical in man actually is; it was superseded in Mr. Weiss's thought by the more complex *Modes of Being* system anyway. But to the extent that something like this were compelling, to the extent that we did ground the ethical by relating our selves on the deepest level to an absolute and indeterminate harmonizing Ideal, the foundation of ethics would thereby be established whether that self and that Ideal exist or not.

It might appear disastrous to place fictions at the foundation of ethics. But so far as the account was successful, it would not be an arbitrary fiction, but would be as compelling as the assumption that we exist. To act surely presupposes a sense of self; if the sense of ethical obligation were equally secure, and secured by the same fundamental self-construal, the foundation of ethics would be eminently satisfactory.

My conclusion admittedly could not be more contrary to the intentions that Mr. Weiss pursued in *Nature and Man.* He hoped to ground ethics "deep in the bedrock of nature," by showing that man's unique powers are enhancements or intensifications of what all real entities, even inanimate things, possess. Success in such an undertaking requires that the account given of those entities should be persuasive in itself. If the account merely projected back into the inanimate the sort of thing we want to say about man, it would defeat its own purpose. Mr. Weiss is perfectly clear in acknowledging this. He openly undertakes to persuade us that even a stone acts freely and spontaneously, attempting to bring

into existence, both in itself and in other beings, a good that it recognizes and is concerned with. We must be equally clear in declaring that he fails in that undertaking. We cannot be persuaded today by any account of reality that pays as little attention to the natural sciences as his does. So I think the incompatibility of my interpretation with Mr. Weiss's intentions does not count against it. His account must be saved from its own intentions anyway.

Mr. Weiss's concern has always been to describe the world we live in: a world with snails and stones, plants and men, "a heavy book, a crying child, a shooting star." Some inhabitants of that world are fictional, but the fictions are of differing importance. Most of what we are inclined to attribute to that shooting star is fictional, for example, and in most contexts it doesn't make much difference whether we posit the fictional star or the actual rock. When it comes to ourselves, the fiction is crucial because it is indispensable to our sense of the existence of ourselves and others. Thought and action, compassion and commitment, everything human positively requires the positing of selves. The world that Mr. Weiss describes is entirely consistent with the self-as-fiction hypothesis.

I point to a rainbow, showing my friend where to look: "there it is, over there!" But it is extravagant and unnecessary to make place for rainbows in reality. We locate, look at, and enjoy the rainbow; it doesn't matter that it doesn't exist. The same can be said of me and my friend: in reality, we too do not exist. That does not prevent us from speaking and acting and living earnestly within the one world we can live in: the familiar but partly fictional world in which we are the all-important main characters.

ERIC WALTHER

DEPARTMENT OF PHILOSOPHY
C W POST COLLEGE, LONG ISLAND UNIVERSITY
SEPTEMBER 1992

NOTES

1. Daniel C. Dennett, *Consciousness Explained* (Boston: Little, Brown and Company, 1991).
2. Paul Weiss, *Nature and Man* (New York: Henry Holt and Company, 1947). In the text of this article, citations by page number are to this book.
3. Daniel C. Dennett, "Reflections" (on Borges), in Douglas R. Hofstadter and D. C. Dennett, *The Mind's I* (New York: Basic Books, 1981), p. 351.
4. Daniel C. Dennett, op cit., 1991, p. 418.

REPLY TO ERIC WALTHER

Eric Walther is a resolute, courageous, bold thinker, at home in the world of computers. If he accepts a premiss, he bravely accepts the necessitated conclusion, no matter how odd or counterintuitive, and whether or not it conforms with what else is accepted and sometimes explicitly claimed. It does not seem to occur to him that his suppositions might be at fault. He reminds me of the story of a man who was reporting an experience he said he had in Africa: "There was a lion in front of me, another to my right, a third to my left, and still another in back of me." "What a terrible situation to be in," his friend remarked. "What did you do?" "What could I do? I was killed."

Here is what Walther says at the end of his paper: "We locate, look at, and enjoy the rainbow; it doesn't matter that it doesn't exist. The same can be said of me and my friend; in reality we too do not exist. That does not prevent us from speaking and acting and living earnestly within the one world we can live in: the familiar but partly fictional world in which we are the all-important characters." How did he get to that self-destructive conclusion? "The self," he says, "is an illusion." He does not say for whom it is an illusion. He does not tell us what is not a physiological occurrence, or how it could be the locus of such an occurrence, contenting himself with affirming that "conscious processes" are "widely distributed in the brain." He says that "our deepest commonsense intuitions may rest on factual errors. Only science is equipped to uncover such errors." He does not tell us how such errors are made, or where they occur. Who or what makes the corrections? He speaks of "the illusion of having . . . a self" but does not tell us who has the illusion. (I would not, today, say that "the self is immortal.") I agree with him that I had no right to say that.

He says that "a dog remains the same dog *without* having any self,"

conflating what is the same by continuity and the same by virtue of a persistent, possessed, and used body. I am sorry if I wrote so loosely somewhere to lead Walther to think that I hold that "inanimate entities persist and have the ultimate inwardness of privacy."

Walther says that I must start "from some directly recognizable distinctiveness about man's self-identity." Is something more needed than an I, intensively reached-toward from the position of the me that I publicly address, or from the you others do? Is not each of us unique? Do love and sympathy, hate, and fear stop abruptly at the surface of the appearance of another person? Who is it that wills, thinks, believes? Is Walther just making sounds, or is he expressing what he thinks is true? Did he vanish when he stated what he believes, or does he continue to be and to believe it?

He remarks that I hold that a self-identical human can be guilty for what was decided and done in the past. If he agrees, is it then possible for him to take the identity of a dog over time to be equatable with man's? There is also a latent confusion in his understanding of responsibility and accountability. The one refers to what characterizes an individual for what he had initiated, the other to what a society or state attributes to him. I can be responsible for that for which I am not accountable, and can be accountable for that for which I am not responsible. Animals are never responsible but they may be held accountable; humans can be both responsible and taken to be accountable.

I agree that one need not actually be what one takes oneself to be, but there surely is a great difference between what a human is and what someone might suppose her to be. References to humans must, like other references, be made by humans. That surely does not mean that one is then making a self-reference. References to humans—here Walther and I are in agreement—can be as impersonal as references to other realities. Both are made by humans. Those that are legitimate end in what exists apart from the individual who refers to them.

Walther says that if an "individualistic self-identification proves to be deeply rooted and ineradicable, that proves only that we *posit* a self, not that such a self exists." I find it hard to unravel this. What or who posits the self? Something that is posited? Does it not require a self to make the posit? Walther does try to answer these questions, saying that "things occur in the brain and the collective effects are appropriately called a positing." He never does show that they in fact occur in the brain. Nor does he tell us who knows about the positing, or how this is done. He says "We construe self-positing as an act like any other, an act performed by the self." What is it to construe? Who or what is the self that does the construing?

Sometimes it is difficult to know whether Walther thinks he is paraphrasing me, is expressing an interpretation of what I have maintained, or is expressing his own view. I wish he had used more quotation marks and given explicit references to crucial passages. I do not know whose view he is presenting when he says that "An act is undertaken by a single self who envisages the outcome." I suppose he is trying to recapitulate what I have maintained, or at least to express obvious implications from this. If so, I am not sure just what he thinks is amiss here.

He evidently wants to hold that "a (possible non-existent) self is *posited* when human behavior is construed as action." Uncritically accepting what he takes science to have conclusively proved, he objects to the idea that there is a self that intervenes in actions "in some scientifically incomprehensible way." Could not what is scientifically incomprehensible be comprehensible in other ways? Are ambition, hatred, or creative acts scientifically comprehensible? Are Being, beauty, philosophy, and science scientifically comprehensible? I have no idea how Walther would try to answer these rather obvious questions.

"Saying (!) that a feeling is mine amounts to making it mine." Does it? Walther apparently never met a liar or a hypocrite, and has been unusually fortunate in his encounters with politicians and deans. He thinks that there can be 'self-positings' even if the self does not actually exist. Is he here caught up in what is no more than a verbal contradiction? He speaks of a 'degree of' realism, but denies that it is an approximation to an actual underlying reality. Does he know that there is such a reality? Does he know how to measure the supposed degree?

I put aside Walther's account of what are not exact re-presentations of my views of a person, privacy, and individual, readily supposing that some of the things he says about my views of them are due in good part to the poor way in which I may have expressed myself. I doubt, though, that the fault is entirely mine, since others have understood them quite well. Walther, in any event, thinks that all we need do is to construe or posit an inner self, but does not ask himself what it is that could engage in such construing or positing.

"Being oneself *is* more like acting than like simply being . . . it is a sincere acceptance of what one has been, with an earnest projection of what one shall be." Putting aside the questions raised by such terms as 'acceptance', 'earnest', and 'projection', it should be noted that there is a vast difference between an actor and the individual he might want to portray. An actual Prince Hamlet sometimes speaks not as a prince but as a young man. An actor portraying Hamlet always speaks as a prince. If Hamlet always lived as a prince, he would be pompous, one who had

confused himself with his position or role. An actor portraying Hamlet never allows himself to be other than Prince Hamlet.

Walther apparently agrees with Dennett when quoting "I am my body's dream" and "a fictional character is a sort of novel composed by my body in action." He does not tell us how a body can dream or produce fictional characters. Accepting Dennett's idea that unified agents are posited as "centers of narrative gravity" he does not stop to tell us who does the positing or how, who knows it, how it is known, or how one knows about the positing.

Fichte tried to solve the problem of knowing what is other than oneself by taking an ego to posit a non-ego. Dennett and Walther solve the problem of knowing the self by taking a non-ego to posit an ego. No progress is made by converting the one failure into the other. Indeed, the difficulty is increased since the supposed positing presumably is produced by that which requires the posited to refer back to it.

He remarks that "The theory that the self is a fiction automatically generated by the organism is a nonstarter unless the phenomena of mind and consciousness can be fully explained by the natural sciences." He thinks he meets the difficulty by referring to "what we take ourselves to be." Does he not here presuppose a real 'we' carrying out the 'taking'?

He thinks it is embarrassing for me to hold that there is an interinvolvement of a distinct mind and a distinct body. He does not deny that the two are united when we are in pain, are emotional, or are engaged in purposive or creative acts. Still, he takes the "world of You, I, and the Others" to be one of fictions and the world that is scientifically known to be one of realities. Yet he apparently allows only for bodies and bodily movements. Are posits then possible? Is knowledge then possible?

Walther does take account of what I have said about pain, but thinks that this can tell us only of pain as we "ordinarily construe it," and that it cannot describe what is real. He then misinterprets my view by treating it as though it were a variant on Aristotle's and Thomas's. His alternative is a 'materialism'. Is this privately entertained? Is it offered as true? Or is it just a byproduct of the ways in which parts of his brain operate?

In the attempt to refer to what is a better, more comprehensive, satisfactory view, Walther offers us some supposed public effects of the activity of his brain. It is not clear whether or not he thinks the brain is a manifestation of the self, or thinks that this is what I think it to be. If the brain is just a body or complex of bodies, can it posit anything? When he asks if it is not enough to posit a self and the Good in a self-construal, he does not stop to tell us who or how such a construal could be produced. Is the positing done by some unknown power? Getting ready to get in his own way, he remarks that "it might appear disastrous to place fictions at

the foundation of ethics" and that "to act surely presupposes a sense of self." Who or what uses the fictions? Who or what has the sense of self? We are then faced with the editorial or dictatorial 'we'. "We cannot be persuaded today by any account of reality that pays as little attention to the natural sciences as his [Weiss's] does." How did I and others get to be excluded from that 'we'? Who is it who holds the "self-as-fiction" hypothesis? And, then, just before he draws the inevitable final conclusion to his account, he says "it is extravagant and unnecessary to make a place for rainbows in reality." If they have no place there, what does? How could this be known? By whom?

Had the story about the lions been told by Walther I would say, "Since you are positing what cannot be consistently maintained, why not just unposit or deposit it?"

P.W.

13

David Weissman

METHOD

How does a philosopher generate and justify his claims? Paul Weiss was sensitive to this question from the start of his career: chapter 1 of his first book, *Reality,* opens with a section titled, "On Method." Weiss describes there a practice that carries through all of his books and reflections, including an early draft of his current manuscript, *Being and Other Realities.* For if Weiss has sometimes changed his mind about many things, his views about method are stable. There is a steady commitment, though details have evolved, to the idea that *adumbration* is the route to philosophic truth. What follows is a characterization and appraisal of this, Weiss's method.

I

Weiss is lavish in his characterizations of experience, from the artistic and political to the athletic, from the private to the social. Curiously for the metaphysician Weiss would become, these descriptions are first supplied in the name of *common sense:*

> Common sense, taken as the common basic faith of mature, active men, is the unyielding confidence that the rejection of such a world, blurred and unarticulated though it be in large part, is monstrous and futile. It is to that world that one must turn to justify, if possible, and to clarify, if true, the tacit dogmas of unreflecting men regarding the nature of objects when not under surveillance, the common attitudes towards fate, spirits and the morrow, and the traditional faith in God, the soul and the life hereafter. Should any philosopher substitute for it another, no matter how glorious and noble, he must be deemed a failure.[1]

Does this imply that we should never want to exceed common sense? No: merely that the results of our philosophizing should be consonant with it. For if other thinkers, some scientists for example, look for empirical data normally absent from ordinary experience, the philosopher can make all

of his or her discoveries by examining the data available already to common sense. "The philosopher," says Weiss, "is not concerned with discovering more empirical facts than those he already naively knows;"[2] and from the manuscript for *Being and Other Realities,*

> Beginning anywhere and with anything in the world in which we daily live, (philosophy) will attend to the major ways in which the main types of occurrence are distinguished and interrelated, without compromising the understanding of them as realities, at once self-maintained and dependent on others.[3]

There is, however, a difference in the uses that are made of ordinary experience. Common sense is quick to pigeonhole the data in ways congenial to its prejudices. Philosophy does, or should, look deeper: "We reach the real by moving intensively from appearance to what appears, adumbrating it when and as we attend to it as surfaced, manifested, available."[4] It is *adumbration* that is focal for Weiss's method: we are to discern all the modes of being, all the finalities prefigured—adumbrated —in any fragment of experience.

Why does Weiss devote himself to chronicling the varieties of experience when any bit of it might be the sufficient basis for knowing all the categories of being? Partly because of his zest for so much of experience; more to the point, because of wanting to confirm that there is a one, i.e., the small set of categories, exhibited or intimated by this many.

II

Weiss must tell us how to move adumbratively from appearance to the realities exhibited or prefigured within them. Our contacts with other people are a favored example:

> At times faintly, at other times more evidently, we discern and thereupon speak to and interplay with others as distinct persons. Had we initially focused on their public acts or appearances we would still have passed intensively beyond these, into them as realities. We never completely obscure the fact, even when we make a great effort to keep to the surface. When we converse, and more evidently, when we sympathize, we move intensively and insistently toward what we discerned, occasionally noting this or that stress or feature along the way. Discernment is penetrative, acceptive of what is reached in a single, intensive act. Adumbration is a progressive discernment.[5]

Compare this passage written fifty-five years earlier: "It is by means of (adumbration that) we mark the dynamic, singular lilt of a thing as

unfolding itself in time. The adumbrated is the real as just beyond the grasp of articulate knowledge."[6]

Weiss must tell us about the relation of the appearances intimating some ulterior reality, and that thing itself. What, for example, are the kinds of realities known by adumbration? Are these, for example, perceptual objects and their effects, as the apple is cause of an impression in us while someone's behavior is evidence of his distress. From *Reality* through the writing of *Modes of Being,* Weiss supposed that adumbration should be construed in this narrow way, with causes adumbrated in our perceivings. Later, all of the categories, Weiss's "finalities" and "ultimates," are said to be available for knowledge by way of adumbration. Adumbration is the alleged source for all the claims made and, presumably, confirmed within such books as *Beyond All Appearances* and *First Considerations,* though now the question is more difficult, and more urgent than before. Then, "adumbration" might have seemed a mere neologism specifying the relation of a cause and its perceptual effect. Now, we need specify the character of that process which supplies our knowledge of the transcendent. How do we accomplish this "progressive discernment"?

III

Weiss writes of adumbration in many places; but what he says of it is often allusive, nearly metaphorical. He might respond that the activity defies precise formulation because it, like the objects adumbrated, exceeds our capacity for exact representation. Still, Weiss does try to characterize it. "Adumbration," he says, "is the act of acknowledging a transcending concrete, which enters into knowledge only as that which provides substance to the propositional unity of indicated and contemplated."[7] This is an early formulation, from *Reality.* A later one is reminiscent of Hegelian notions and Platonic ideas:

> An intensive logical move is an intensive thrust carried out in thought, arriving at a terminus. It depends for its justification on the logic or form of the intensive move. A direct move reaches the objective, with which it is concerned, at the point where the objective takes over. An intensive rational move, instead, identifies the terminus, and conceives the nature of what is beyond as a more intensive version of what is intellectually reached.[8]

We get some clarification when Weiss explains what he requires of adumbration by comparing it to the "direct" but inferential and hypothetical method of science:

The philosophic method is a 'philoanalysis,' and its outcome an account of the nature and functioning of a plurality of ultimates. The scientific is abductive, and its outcome a hypothetical explanation of the structure and activity of occurrences in the cosmos. Neither need attend to the results of the other, and would be foolish to adopt its method.[9]

Notice, however, that philosophic method as Weiss understands it is, sometimes at least, an instance of abductive method, as when Weiss summarizes a discussion of examples with the remark that, "Adumbration would then seem to be a kind of abduction used to penetrate into reality."[10] Which instinct is the surer one: scientific and philosophic methods are essentially different; or the one is sometimes appropriated for the purposes of the other? Characterizing each one separately helps to explain what I take to be the deeper tendency in Weiss's thinking: adumbration is not a kind of abduction.

Abduction (or *retroduction*), says Peirce, is "reasoning from consequent to antecedent."[11] Seeing smoke, we infer that there is a fire, thereby explaining the smoke. Abductions are hypotheses. They are speculative (but in Weiss's terms "direct" rather than progressive) identifications of causes, constituents, or conditions. These hypothesized referents may be particular or general. They may be perceivable in principle or not, as fire may not be perceived at the moment of seeing smoke though it is perceivable, while black holes and natural laws are neither one. Scientists who are denied their abductions cannot advance beyond the recitation of lab or field notes. And equally, ordinary practice is directed by hypotheses specifying conditions for the effects desired, as no one cooks dinner without a plan, however crude. These are, paradigmatically, cases where empirical data without concepts are blind.

Weiss is suspicious of science because of its alleged reductionism, [12] and unhappy with abduction, because abduction inferences are fallible: "What is surprising is to find philosophers trying to build comprehensive systems on what contemporary scientists *surmise* (my emphasis)."[13] Building comprehensive systems is not objectionable in itself: Weiss does that. It is rather that one should not build on sand. Scientific abductions are fallible, and endlessly revised, for we do typically misidentify to some degree the causes, constituents, or conditions cited by our abductions. Weiss supposes that his adumbrations may avert these errors:

> Where science remains with abductive hypotheses directed at what exists in the cosmos, getting to hypotheses by imaginative leaps from initial data, philosophy attempts to reach ultimates by intensively using evidence now present, and therefore what other accounts must at least tacitly acknowledge, if only in specialized forms.[14]

Weiss supposes, at least once, that he has himself achieved results which are, partly, exempt from error:

> In *Beyond All Appearances* I began what, for me at least, was a comparatively new range of philosophic inquiries, I there sought to isolate *unmistakable* (my emphasis) evidences of what was ultimately real, and to trace these back to their original sources. . . . It has been pleasant to find that a great deal of what it maintained requires no significant alterations.[15]

How does adumbration avoid the errors which mar abductions? The answer, I infer, is that adumbration must start from something correctly if obscurely perceived, before advancing "intensively" to its terminus or ground. There must be something given, something having enough articulation within itself to act as a lure for understanding. Thought seeking the ground of those articulations can then move through this content, penetrating it until that clarifying terminus is achieved.

Does Weiss acknowledge a given, then describe our intensive advance from the given to its terminus? Yes, he does, in that section of *Reality* which immediately succeeds the one that introduces his ideas about adumbration. Here is a sample passage: "The adumbrated . . . is the locus for bare indicateds and abstracted contemplateds. It is that factor which lies beyond them both, making possible their union so that they may constitute a single, intelligible, perceptual object."[16] Weiss supposed when writing *Reality,* and even through the writing of *Modes of Being,* that it is only physical objects which are adumbrated as they draw us to themselves by way of their effects upon us. That view is superseded, when Weiss supposes that "finalities," or "ultimates," not only actual particulars are adumbrated by our representations, as happens when we reflect upon such categorial notions as possibility, substance, unity, or God. This is reflection that may begin in perception, though it may also begin in that provisional commentary with which the philosopher embroiders perception:

> The data for ontological speculations are . . . perceptual facts, the understanding of whose presence and nature requires a study of being as private and public. Each begins by dissecting and generalizing data encountered in experience, using the result to frame partial, i.e., analytic characterizations embracing whatever there may be, and then speculatively, i.e., by creative reasoning, providing the supplement which is a necessary correlative to all formal results.[17]

What is the "supplement" here invoked? Perhaps Weiss was thinking of abductive inference—hypothesis—when writing this passage. Yet that cannot be his considered, final judgment, because hypothesis can produce only fallible, revisable results, though philosophy is different from

science because of being able to discern the universal and necessary
ground of all of being in any single drop of experience.

IV

What is left to us if abductive inference is not the method of intensive
discernment and advance, hence not the method of adumbration? Other
interpretations may be possible, though with none of them known to me,
I suggest that Weiss's adumbration is the near cousin of the rational
intuition claimed by Plato and Leibniz. As Weiss, himself, has written,
using the "analagous traditional terms," the objects of adumbration are
"the intuited."[18] Rational intuition, like adumbration is said to advance
upon and grasp the things conditioning our appearances. It does that by
moving intensively from obscure, indefinite appearances, i.e., our given,
to their clear, definitive ground.

There is more compelling evidence that "adumbration" is Weiss's
term for rational intuition in volume 4 of *Philosophy in Process:*

> There is no need to limit adumbration, as the text (*Modes of Being*) does to
> perception. And it is not clear how in adumbration one makes "immediate
> contact with the being over against us" unless adumbration is not a mere
> epistemological but also an ontological act. . . . If adumbration is to tell us
> something about the object from another side, it must have a transcendental
> aspect, and I am not sure that it does. Is it perhaps a dimension of the act of
> knowing which, as it penetrates more and more into the object, becomes
> more and more possessed by that object to become a way of making evident
> what that object is? . . . I think this is the most hopeful and also plausible
> way of speaking of adumbration. . . . This alternative . . . takes adumbra-
> tion to be an act that becomes more and more possessed by something,
> which is not known except as that which possesses it.[19]

And:

> There is an adumbration involved in all apprehending, not only the
> perceptual. And this adumbration can be seen in two ways. It can be seen to
> be an act of perceptual transcending, thick with content continuous with
> what is not perceived; and it can be seen to be an act of nonperceptual
> transcending which is thick with content continuous with what is not
> perceived. When we perceive we find ourselves thrusting out with the former
> type of adumbration, at the same time that we find ourselves being intruded
> on by the second type of adumbration. Because of the former, when we
> perceive we are aware of the fact that the object has other roles; because of
> the latter, we are aware that the object has a solidity, a concreteness not
> evident on the surface. Because we have both types together when and as we

perceive, we are aware of an adumbrated content beyond. This adumbrated content is effective in a perceptual content that is transcendent to the adumbrated content.[20]

We are closer now to the Platonic nerve in Weiss's method. Think of percepts, and even of most conceptual data, as images at the back of the cave. It is *nous* that will liberate us:

> Every perception is a kind of intellection, since it focuses on the nature of the thing. The judgment we make when we perceive dissects the nature into articulated components, and via adumbration refers it toward that which it should control. Adumbration is an epistemological version of the actual control that is exerted.[21]

Weiss is saying that things perceived are obscure until and unless they are apprehended as instances of the forms they instantiate:

> When we hold actuality and Actuality apart, the discursive side of the Actuality unites with the adumbrated side of the actuality. The result is an *actual object*. It is actual because it is an instance of Actuality; it possesses a nature as an actuality because it has discursive nature of Actuality (in a delimited form) within it. . . . The object stands over against the perceptual content to which I have private access, and is kept from being relativized with respect to such content, through its union with the nature which the actuality has, because of its possession of the discursive side of Actuality.[22]

There is, I suggest, nothing casual in Weiss's characterization of adumbration, in *Reality,* as "intuition." There is equally nothing careless in his saying that the philosopher, unlike the scientist, has no use for empirical data additional to the ones already available: all of the controlling finalities or ultimates are already intimated and progressively discernible in every datum. The difference between adumbration and abduction is, therefore, categorial and plain. The one discerns its object, moving as Leibniz said from obscure to clear ideas. The other is an imaginative surmise, a leap into the dark, where the cure for likely error is the (presumed) ease of contriving different hypotheses.

Weiss never supposes that adumbrations are exempt from error: Peircian falliblism is burned deeply into his thinking. It is most important, therefore, that rational intuition should couple these two things: the possibility for error, and the promise of grasping things as, or almost as, they are. Weiss, like Leibniz and Plato satisfies this first condition when error in our judgments is evidence that the obscurity of our ideas has misled us. Only a further penetration, a greater intensification can bring us to the source for whatever is articulate in those first perceptions.

V

There are two questions remaining: Does Weiss supply any evidence, independent of his claims about adumbration, that we have a power for rational intuition? What would be the consequences for his metaphysical views if there were no rational intuition?

Weiss has very little to say of intuition, despite what I take to be his reliance upon it. There are only sporadic references, each one phrased in words that vary in no systematic way:

> ... categorial insight is constitutive in that it does yield the very nature of the modes of Being in relation to one another, as having the very structure of the category.[23]

> Transcendental judgment is continuous with the constitutive, and this with the empirical; the penetrative, the adoptive, and the responsive attitudes are continuous with one another, and are expressed in the foregoing categorial and judgmental forms.[24]

The claim to having intuition is invoked in these several ways, but never justified. Hence the first of the two questions above: do we have a power for rational intuition, one that moves from feelings about an object obscurely apprehended through successive representations to a final, if incomplete grasp of its object? Is there evidence, independent of Weiss's resort to it, of a power within us for penetrative, insightful understanding? One way of answering the question is Weiss's own: we start our philosophizing in the middle of experience, taking that experience at face value, describing it in the terms of our shared, common sense. If common sense recommends that we endorse the claims to penetrative intuition, then we take that claim into our philosophy, even making it, as Weiss does, the essential route to philosophic understanding.

A different way of answering the question requires that we examine the creatures to whom rational intuition is ascribed. We look at the human animal, asking about its critical parts and their function. Thought and perception are, we remark, the activity of physical systems within us humans, especially the activity of the brain and peripheral sensors. Is there evidence that human brains may have a power for rational intuition? That is surely a very dubious assumption for anyone who supposes that our faculties are limited by our physiology. That we represent, calculate, and evaluate is not in doubt. That we do or could intuit is very suspect. Weiss assumes at the core of his method a faculty which, almost certainly, we do not have. Adumbration, this implies, cannot do for us what Weiss requires of it.

He would likely reply that I have begged the question. Why must we

assume that our human faculties are limited to the ones for which the human brain is qualified? Are not minds more and other than the behaviors of physical systems? Weiss supposes, as common sense also testifies, that they are. But common sense is often mistaken, and Weiss frequently concedes that his own views have been erroneous. What evidence does Weiss have, independent of his reliance upon it, that we humans do have a power for rational intuition? Nothing known to me in Weiss's work is evidence of that sort: nothing, independent of his views about adumbration, supports the claim that mental activities are other than or more than the activities of brain or body.

VI

Suppose that Weiss is denied his method by virtue of the fact that there is no power for rational intuition. Is this consequential for Weiss's views about matters other than adumbration? No and yes.

No, because Weiss himself has sometimes supposed that he could use Peirce's abductive method to infer beyond experience to its conditions. We do infer from smoke to fire; we can infer from actualities to conditioning but unobservable possibles. Indeed Weiss would be severely challenged to tell how his penetrative insight, i.e., adumbration, could ever displace abduction as the way of moving beyond our characterizations of things to several of their vital features. Let dispositions and natural laws be our examples. No one looking at a face, tongue, or larynx can tell what language it can speak, though we do speculate about this as we also hypothesize about the set of least constraints operating upon everything in space and time. Equally, we speculate about such metaphysical differences as the one between possibility and actuality. Abduction is, plausibly, the method for identifying that small set of categorial differences exhibited in everything that is.[25]

Weiss could not agree without compromising some of his other views. One is the claim that we advance some way into the essential privacies of things, people included, by way of penetrative discernment.[26] We would need to admit that empathy for someone or something is never more than the complex of a feeling and a hypothesis, however responsive the one to whom the feelings are addressed. Equally, we could not say that the very character of the "ultimates" is incompletely decided or achieved until they are known adumbratively. That formulation would be denied us, because hypotheses and the act of hypothesizing (by themselves) make no difference to either the character or the existence of the things represented.

Still more reluctantly, Weiss would need agree that philosophic method is not different from the one common to ordinary practice and natural science. Both of them progress by using abductions as leading principles for action or conception. The garage mechanic speculates about the cause of a noisy engine before using his hypothesis to direct the behaviors that may eliminate the noise. The physicist generalizing from group theory hypothesizes that there are particles additional to the ones already discovered. He then estimates what properties those particles should have, and looks for evidence testing the hypothesis. The metaphysician wanting an exhaustive specification of the world's categorial form can do no better. Hypothesis is all the method required for saying, as Weiss does in his more recent speculations, that Being is both a constrained nature naturing, and nature natured, i.e., it is Dunamis constrained by certain intrinsic categorial features, and the actualities generated within it.

There is only this point to distinguish the philosophy Weiss favors from natural science. It will be true, as Weiss has said, that any empirical evidence, not only the refined evidence required by particular sciences, may be evidence for all of the philosopher's speculations about the categorial form of Being. That Plato needed none of those empirical refinements is evidence that philosophy does sometimes have aims different from the ones of science. It does not follow that philosophy must have a method different from the abductive, experimental one of science and practice. It could not have a different method and still satisfy that account of our vocation which Paul Weiss has himself proposed: "That philosophy is best which makes sense of the widest range of facts by showing them in intelligible interrelationship, each supporting the others."[27]

DAVID WEISSMAN

DEPARTMENT OF PHILOSOPHY
THE CITY COLLEGE OF THE CITY UNIVERSITY OF NEW YORK
MAY 1992

NOTES

1. Paul Weiss, *Reality* (Carbondale: Southern Illinois University Press, 1966), p. 6
2. Ibid., p. 8
3. Paul Weiss, *Being and Other Realities,* privately distributed in June 1991, pp. 4–5

METHOD 323

4. Ibid., pp. 3–4

5. Ibid., p. 12

6. Weiss, *Reality,* p. 57

7. Ibid., p. 64

8. Paul Weiss, *Philosophy in Process,* volume 10 (Albany: State University of New York Press, 1987), p. 47

9. Ibid., p. 72

10. Ibid., p. 56

11. Charles S. Peirce, *Charles S. Peirce: Selected Writings,* edited by Philip P. Wiener (New York: Dover, 1966), p. 368.

12. Paul Weiss, *Privacy* (Carbondale: Southern Illinois University Press, 1983), pp. 1–6.

13. Weiss, *Being and Other Realities,* p. 35

14. Weiss, *Philosophy in Process,* volume 10, pp. 72–73; also see *Privacy,* p. 11: "A satisfactory account cannot rest with only hypothetical formulations. These have alternatives no less basic. What is needed is reliable evidence and the careful and precise use of it. The evidences enable one to move to and into the actualities and finalities beyond any pre-assignable point."

15. Weiss, *Privacy,* p. xi. It is only superficially paradoxical that one should have a method which promises to isolate unmistakable evidences while acknowledging, as Weiss usually does, that conclusions expressing his earlier penetrations of the evidence are faulty. See pp. 13–14 below.

16. Weiss, *Reality,* p. 64.

17. Ibid., p. 89.

18. Ibid., p. 32.

19. Paul Weiss, *Philosophy in Process,* volume 4 (Carbondale: Southern Illinois University Press, 1969), pp. 108–9.

20. Ibid., p. 230.

21. Ibid., p. 573.

22. Ibid., p. 385.

23. Ibid., p. 117.

24. Ibid., p. 117.

25. David Weissman, *Hypothesis and the Spiral of Reflection* (Albany: State University of New York Press, 1989), pp. 36–39 and 157–77.

26. Weiss, *Privacy,* p. 38.

27. Weiss, *Philosophy in Process,* volume 4, p. 180. For views about method very similar to Weiss's own, see Henri Bergson, *The Creative Mind,* translated by Mabel L. Andison (New York: Carol Publishing Group, 1992), p. 32: "Intuition . . . signifies first of all consciousness, but immediate consciousness, a vision which is scarcely distinguishable from the object seen, a knowledge which is contact and even coincidence." For a reading of Weiss's *adumbration* complementary to my own, see: Robert E. Wood, "Weiss on Adumbration," *Creativity and Common Sense,* edited by Thomas Krettek (Albany: State University of New York Press, 1987), pp. 43–54.

REPLY TO DAVID WEISSMAN

Suppose someone claimed that there were only one-eyed men. Suppose, on being shown a man who is two-eyed, it was maintained that the thesis was proved twice over. If somebody pointed to the fact that one eye winked, or that the two were differently located, the references would undoubtedly be dismissed as irrelevant. David Weissman, I think, would accept this as a good characterization of the ways analytic philosophers act. He does not see that he comes perilously close to being subject to the same criticism.

How could one convince them, and perhaps him? The issue does not come down to the acknowledgment of this or that fact, but to principles that can be justified, and can help one understand what otherwise would be mysterious or inexplicable. One account might be simpler than others, but nothing would be gained if central issues were ignored and difficulties not met and overcome.

One can today hold to a Ptolemaic astronomy, but there are so many post-hoc adjustments to be made that one will at last abandon it for what clarifies without facing one with more obscurities. A philosophic account could be dealt with in a similar manner. Some disciples of long-departed masters spend their lives in the exercise. What they do might be useful, particularly if their masters had isolated what every occurrence instantiates, leaving to their followers only the task of rejecting other accounts, or bringing the accepted principles into play in areas not previously considered. What must be altered or discarded is either what cannot be accommodated even in principle, or what precludes such truths as that each of us knows some things, has a privacy, character, and an individuality, makes use of a possessed body, is one among many other kinds of reality, and instantiates basic, common, and persistent conditions.

Although Weissman does agree with many, he is no disciple, nor a

member of any school. Yet, like so many, he seems unable to understand any criticism, even those that point up failures, inconsistencies, and unjustified claims. I am not sure that he has room for the acknowledgment of realities distinct from himself or his hypotheses, or whether or not he allows for inquiries into privacies, characters, individuals, possessed bodies, what these presuppose, and the ways they interplay.

Weissman thinks that adumbration for me is "the route to philosophic truth." He is mistaken. It refers to the process by which we pass from appearances to what sustains and expresses itself by and through them. I once tentatively suggested that adumbration might be a means for reaching what all actualities presuppose, but have come to see, and have said again and again, that one arrives at the ultimates, as not yet instantiated, by carrying out a distinctive evidencing act. Not only does adumbration not provide a "route to philosophic truth," but that 'route' ends at what is more basic and persistent than any appearance is. Again and again, a philosophic inquiry moves forward into unexplored territory and returns to what had supposedly been well known, testing each by the other and, often enough, modifying what had been initially acknowledged or surmised. Weissman has confused 'philosophic method' with the various methods that are pertinent to more limited inquiries. A philosophy enables one to identify and assess all of them, and to understand realities and powers that they had overlooked or misconstrued.

Weissman thinks it odd that one should begin reflection by attending to what one initially knows as a commonsense person. Where else could one begin? Some types of inquiry, with long histories, allow latecomers to participate in them at a later stage of development, but those inquiries, too, began with what was commonsensically known. Each participant, starts from a position in the daily world and moves from there. He continues: "some scientists . . . look for empirical data normally absent from ordinary experience." Who doubts that? That truth, though, does not get in the way of the fact that the scientists are humans like the rest of us. They, too, eat, sleep, talk, walk as others do. Their scientific endeavors are carried out within limited confines, making use of special techniques and distinctive languages. They, but the rest of us as well, know more and should know more than what common sense—or science, for that matter—does or could make evident. Self-reflection, discernment, creativity, appreciation, history, and speculation are among a host of topics to which we should attend. A comprehensive, well-grounded philosophic account must find room for many different kinds of knowledge.

Weissman asks "Will any bit of experience be the sufficient basis for

knowing all the categories of Being?" I am not sure that I understand what he means by "the categories of Being." No one 'bit of experience' could enable us to know all there is unless it were a compressed version of this. A study of thought, commitment, work, language, society, of pain, intention, the discerned, the ultimates, and what these presuppose, ends with a multifaceted comprehension of realities, both as they are apart and together.

"What are the kinds of realities known by adumbration?" Humans, subhumans, things. These are reached with different degrees as they are in themselves. Love, sympathy, and fear, are among the more conspicuous adumbrative ways we get below the surfaces of humans. Less charged, singular, intensive, penetrative moves enable us to pass beyond the appearances of other actualities. Discernment is the most penetrative and successful form of adumbration, limited to reaching other humans. Again and again we discern the characters of others with whom we have had little contact. Occasionally we seem able to discern something of the depths of subhumans, but just what is then reached is rather blurred and usually qualified by distorting humanizing intrusions.

Adumbration does not defy "precise formulation" though what it arrives at cannot be adequately expressed in conventional formal terms. It may be charged with sympathy, interest, or abhorrence, and ends with what is beyond capture in any formalization. We carry out adumbrations when we listen rather than just hear, are considerate rather than just reactive, becoming more and more involved and more and more resisted the deeper we penetrate. One can attend to words that are spoken, particularly if interested in discovering peculiarities in diction. Usually, we pass beyond them quickly in the effort to grasp what is intended. These observations may be "reminiscent of Hegelian notions and Platonic ideas." I would add, 'of the ideas of many others', since there is nothing singularly Platonic or Hegelian in them. More or less clear references to both can be found in many other accounts, each quite different from the others.

Weissman rightly remarks that "adumbration is not a kind of abduction," but it should also be noted that 'adumbration' is not used only with reference to 'physical objects'. Indeed, it is evident when we are interested in individuals. I doubt that there are many who need these clarifications. In any case, they may suffice to show that what I have tried to make evident with different examples over the years, is not as evident as I thought it was.

I see no harm but also no gain in substituting Weissman's 'rational intuition' for most cases of adumbration, particularly since 'intuition'

entrains a host of associations not relevant to the intensive moves by which one passes from the thin to the thick. Since the moves are more evidently assessive, affiliative, extensionalized, and coordinate than they are rational and dunamic, references to a 'rational intuition' will tend to mislead. It is right to emphasize a juncture of the rational and the dunamic—which Weissman's 'rational intuition' approximates—when one tries to pass to some other domain. It would, though, be a mistake to continue that emphasis when passing from one humanized object to another, when trying to penetrate toward an individual person, when occupied with understanding natural spans and, the purposiveness with which they are interinvolved, or when referring to the ways in which unit cosmic bodies are interrelated.

A good philosophic method, at the very least, enables one to become aware of the different methods that are needed if we are to deal well with different types of subject matter. As able to make this evident, a philosophy is evidently carried out in a different manner. Venturesome, self-critical, unsteady and persistent, it tries to achieve a single, comprehensive, coherent account in which every other inquiry and its achievements can find a base and warrant. The method is forged as it proceeds. Again and again, a stop is made to attend what is being presupposed or to accommodate what had been already learned. I have found it desirable to rest for a while at some stage of the inquiry, when insight failed and no clear way was found to push on. As has been true in the past, I think that the work that I am now completing moves beyond and yet preserves what had already been justified. There has been no blind leap into the dark. Positions previously arrived at have been questioned again and again, and their presuppositions sought. Abductions were followed through to reach what existed apart from their starting points, moving from an interlocked plurality of constituents to their sources, while exhibiting sustained transversals of the gap between where they begin and the ultimates where they end.

Weissman's 'rational intuitions' and cognate expressions radically simplify what occurs when one seeks to know what is, whether or not it comports with what is affirmed by others. If some expression is used as a replacement for 'adumbrations', another must be found to replace 'abductions'. I make no brief for these designations, but do insist that they or substitutes for them not be confounded.

Weissman says that "Nothing supports the claim that mental abilities are other than or more than activities of the brain or body." Does a brain or body speculate, hope, fear, lie? Is either responsible, guilty, concerned, or committed? Is either an individual? Is either good or evil? Does either

know anything? Does either have rights or a good or bad character? Does either think about brains and bodies? Does either feel, create, or engage in philosophic inquiries? Does either experiment, formulate theories, attend, observe, or claim that it is or is not real? Must there not be someone distinct from these, able to know them and how they are related? Must one not exist before it is possible to produce an hypothesis that one exists? Does one just hypothesize that one exists? If one did, would one get any further than to entertain a thought?

I have used both adumbrations and abductions in the course of my inquiries, primarily to check what I claimed to be true about actualities and their preconditions. Only lately, though, have I fully faced the need to account for the ultimates, as so many eternal realities that could have been different in number and kind, and could have acted in other ways than they have. Only lately have I seen that Being produced them in order to be possible, and that they can produce what need not be.

A satisfactory account of what is involved in the achievement of an adequate, coherent philosophic system will underscore its independence, but will not necessarily ignore the achievements of other enterprises. The object is to try to understand what reality essentially is in the little and in the large, how these comport with one another, and their essential differences. Insights, claims, doubts, surmises, and inferences are all to be challenged, but nothing is to be permitted to preclude an advance or to require that some particular discipline provide its method or preclude its answers.

No enterprise other than philosophy can tell one what Being is and does; no other can tell one whether or not there are ultimates and how they function; no other can tell us what the basic kinds of reality are and their bearings on one another; no other is appreciative of all and submissive to none. A philosopher is a scientifically tempered poet, a logician with imagination, an epistemologist who knows that there is a reality to be known in other ways, an ontologist who tests himself by seeing if what has been maintained can withstand the severest scrutiny. Alert to what is being presupposed, challenging what he had affirmed by what he had newly learned, always perplexed and confident, he is a sobered Dionysian, an oxymoron in the flesh.

I respect the earnestness that pervades Weissman's account. Unfortunately, it is so riddled with misconceptions of what has been maintained, so blind to what is intended, and includes so many unprotected, paradoxical claims, that I have not been able to benefit from it. I hope that my corrections of some of his interpretations of what I have written

will enable Weissman, and perhaps others, to become aware of what he misconstrued or overlooked in his vigorously presented study. We may then be in a position to learn from one another.

P.W.

14

Abner Shimony

THE TRANSIENT *NOW*

I. INTRODUCTION

In chapter 4 ("Time") of Paul Weiss's first book, *Reality*, there are many incisive phenomenological reports concerning time, among them the following:

> To specify the ordered moments of time as being past, present, and future is not to characterize time, but the picture of it, a time still undifferentiable from an eternal, unchanging structure. Passage is part of its essence.

> Suppose that the series 1,2,3 represents the moments of time, and that 1 is past, while 2 is present and 3 is future. There will be no time unless when 3 becomes present, 2 becomes past. Being present cannot then be an irrevocable, intrinsic character of these moments, for then they would all be present together.[1]

Weiss never revoked these early philosophical comments, but he did elaborate them. For instance, in *First Considerations* one finds the following: "That time is more than a line is also evident from the fact that it is lived through. A line has all its distinguishable parts co-present, but the 'line of time' is constantly being drawn and just as constantly erased."[2] The present paper is essentially an exploration of the ideas expressed in these three passages. I agree with them at the commencement of my analysis and continue to agree with them when the analysis is completed. However, my mode of analysis—which combines considerations from phenomenology, analytic philosophy, and natural science—is quite different from Weiss's, and I shall proceed without further reference to his texts. In a critical comment on Weiss's philosophical explanations I wrote: "Whether or not you like the compliment, I feel that you are a remarkable phenomenologist, and that is where you have

The research for this paper was supported in part by the National Science Foundation, grant no. DIR-8908264, and by a fellowship from the National Endowment for the Humanities in 1991.

made your greatest contribution to philosophy."[3] The present paper may be taken as an illustration of this remark, or it may simply be read as my exploration of a deep problem that Paul Weiss has thought deeply about, which is my best way of offering homage to him.

The following three sections of this paper will be devoted to three aspects of the problem of transiency. Section 2 will examine the famous paradox of transiency posed by J.M.E. McTaggart and will endorse the very thoughtful but little known solution proposed by David Zeilicovici. Section 3 will examine the claim made by Adolf Grünbaum, Rudolf Carnap, Hermann Weyl, and others that *transiency, becoming, present, now,* and cognate concepts are subjective in character. Section 4 will argue that Zeilicovici's solution is compatible with the space-time structure of special relativity theory.

II. McTAGGART'S PARADOX AND ZEILICOVICI'S SOLUTION

McTaggart[4] sharply distinguished two kinds of temporal discourse, and he has been followed with slight variation by many later writers on time (e.g., Broad, Gale, Schlesinger, and Zeilicovici).[5] The "A-series" divides the linearly ordered set of temporal instants into past, present, and future. Notions which rely essentially upon this division—such as *passage from past to present, now, becoming,* and *transiency*—are referred to as "A-determinations" in the literature influenced by McTaggart. The "B-series" is the linear ordering of temporal instants by the transitive, asymmetric, and irreflexive relation *precedes,* without any reference to past, present, and future; and the notions which depend upon *precedes* are called "B-determinations." When a temporal metric is introduced, it may be used to formulate further A-determinations, such as "being ten seconds earlier than the present." Likewise, further B-determinations can be formulated in terms of a temporal metric, such as "t_1 is ten seconds earlier than t_2."

McTaggart also introduced the "C-series," which consists of events, each located in a set of space-time points. Because of problems of ordering events which have temporal duration, it seems to me best to avoid this locution of McTaggart. The temporal language concerning events can be borrowed from the two types of discourse concerning instants themselves (A-determinations and B-determinations), without any commitment regarding the metaphysical question of the dependence or independence of time upon events and the converse. For simplicity, I shall restrict my attention mainly to idealized events located at temporal instants. If an event E is located at the temporal instant t, and t is

described by the A-determination "present," then E also is described as present; if E and E' are located at the temporal instants t and t' respectively, and t precedes t', then E and E' can also be described by the B-determination "E precedes E'."

McTaggart implicitly assumes much of Newtonian space-time structure, specifically that every space-time point has a definite temporal location t, so that the linear ordering of instants determines a partial ordering of space-time points (also designated by "precedes" without any danger of confusion). Hence, for each pair of space-time points P and P', either P precedes P' or P' precedes P or P and P' have the same time (i.e., are simultaneous). Likewise, there is a partial ordering of the instantaneous events. These assumptions will be maintained in the present paper until section 4.

McTaggart's paradox of transiency will now be formulated in a way that differs somewhat from his own formulation, in order to anticipate the analysis that follows.

(a) *A property of an event is not relative to the time of judgment or vantange point of discussion.* In this respect, an event differs from a persisting thing, which may have different attributes at different times. Indeed, the metaphysical category of event is introduced for the purpose of giving a changeless analysis of changing persisting things: that is, the career of a persisting thing is analyzed into instantaneous events, which may differ among themselves in various respects, but each of which is changeless, having exactly the properties that it has. The event as a particular entity may be identified by specifying its instant, but the properties of the entity thus identified are the same from any temporal vantage point of judgment. (It may be noted that even if we consider temporally extended events instead of restricting attention to instantaneous events, proposition (a) continues to hold, since the properties manifested at each instant of the extended event are independent of the vantage point of judgment, even though the properties at two different instants may differ.)

(b) *A-determinations of events are unusual properties* (differing, for example, from ordinary physical properties such as electromagnetic field strength and from ordinary mental properties such as sensations of tone), *and nonetheless, for all their peculiarity, they are properties.*

(c) *But A-determinations are relative to the time of judgment, for an event which is present when the time is t will not be present when the time is t' (t' being different from t).*

Clearly, the conjunction of (a), (b), and (c) is inconsistent, even though each of these three premisses is plausible. That is McTaggart's paradox.

Zeilicovici gives two different formulations of his solution to McTaggart's paradox, which he clearly intends to be equivalent, though they are unequal in lucidity.

The first formulation[6] consists in asserting that thesis (a) simply does not hold of A-determinations, because these are not "usual" properties. It was indeed noted in the statement of premiss (b) that A-determinations differ from ordinary properties. Nevertheless, it appears *ad hoc* to exempt them from the plausible premiss (a) without some deeper analysis.

The second formulation, which I much prefer, draws upon a famous argument that Kant uses in order to demonstrate the invalidity of the ontological argument for the existence of God.[7] Zeilicovici says, "The attribution of pastness operates somewhat like the attribution of existence in the Kantian sense: it applies to the event complete with all its properties, and only defines its status (for Kant existence, for us pastness)."[8] Zeilicovici's formulation is very illuminating. It utilizes the generally recognized profundity of Kant's treatment of "existence" or "being" in the following famous passage: " 'Being' is obviously not a real predicate, that is, it is not a concept of something which could be added to the concept of a thing."[9] Kant warns specifically against interpreting the subject-predicate form of the sentence "this thing exists" as a genuine instance of attribution of a property to the thing in question. He illustrates his thesis with some well-known homely and humorous remarks:

> the real contains no more than the merely possible. A hundred real thalers do not contain the least coin more than a hundred possible thalers. For as the latter signify the concept, and the former the object and the positing of the object, should the former contain more than the latter, my concept would not, in that case, express the whole object, and would not therefore be an adequate concept of it. My financial position is, however, affected very differently by a hundred real thalers than it is by the mere concept of them (that is, of their possibility). For the object, as it actually exists, is not analytically contained in my concept, but is added to my concept (which is a determination of my state) synthetically; and yet the conceived hundred thalers are not themselves in the least increased through thus acquiring existence outside my concept.[10]

Now if one examines some of the arguments against the objectivity of A-determinations, one finds striking similarities to the thesis that Kant analyzes. For instance, Grünbaum writes, "But I am totally at a loss to see that anything non-trivial can possibly be asserted by the claim that at 3 P.M. nowness (presentness) inheres in the events of 3 P.M. For all I am able to discern is that the events of 3 P.M. are indeed those of 3 P.M. on the day in question."[11] Zeilicovici's *tour de force* consists in recognizing the

affinity of the conceptual poverty of *nowness* (a recognition somewhat disguised by his earlier locution of "non-ordinary property") to the conceptual poverty of "existence" that Kant insists upon. There is indeed a kind of richness in both *nowness* and *existence*, but it is *existential* in character, entirely different from conceptual determination.

Zeilicovici's analysis can be carried one step further. He suggests only an analogy ("somewhat like") between an A-determination and the attribution of existence. In my opinion, however, there is nearly an identity. Suppose, for simplicity, that one takes a possible event rather than a thing as the subject of an existential statement (thereby departing from Kant's treatment of the category of substance in objective judgments). Specifically, let E denote a possible instantaneous event. Then to assert that E exists is to say that it is present at some time—in other words, to assert an existentially quantified A-determination. There is no other way for a possible instantaneous event to exist than to be *now* at some instant! The appropriate A-determination that is implicit in the assertion of existence of a possible temporally extended event can also be constructed, but it is somewhat more complicated than the one just given because of the complexity of structure of the subject.

One of the attractive features of Kant's analysis of *existence* is that his analysis does not depend upon the doctrinal framework of his critical philosophy, e.g., of his doctrines of "transcendental idealism" and "empirical realism." A non-Kantian philosophy that speaks freely of things in themselves and of our knowledge of them, whether direct or indirect, can incorporate Kant's analysis of existence statements, construing them in agreement with Kant as not asserting conceptual determinations, and yet construing existence claims in a "realistic" manner that is alien to Kant. Consequently, if a non-Kantian philosophy accepts Zeilicovici's proposal for assimilating the analysis of A-determinations to Kant's analysis of existence assertions, then it can regard the ascription of "now" or "past," etc. to a moment of time or to an event as objectively true or objectively false, without reference to a knowing subject.

III. The Thesis That A-Determinations Are Subjective

There have been attempts to do justice to the phenomenology of A-determinations by treating them as subjective. The most complete exposition of this point of view is by Adolf Grünbaum, who presents the following thesis: "presentness or nowness of an event requires conceptual

awareness of the event or, if the event itself is unperceived, of the *experience* of another event simultaneous with it."[12] He makes several commentaries on this thesis, of which the most important but also the most ambiguous is the following:

> I am *not* offering any kind of *definition* of the adverbial attribute now, which belongs to the conceptual framework of tensed discourse, solely in terms of attributes and relations drawn from the tenseless (Minkowskian) framework of temporal discourse familiar from physics. In particular, I avowedly invoked the present tense when I made the nowness of an event E at time t dependent on someone's knowing at t that he is *experiencing* E. And this is tantamount to someone's judging at t: I am experiencing E *now*. But this formulation is *non*viciously circular. For it serves to articulate the mind-dependence of nowness, *not* to claim erroneously that nowness has been eliminated by explicit definition in favor of tenseless temporal attributes or relations. In fact, I am very much less concerned with the adequacy of the specifics of my characterization than with its thesis of mind-dependence.[13]

The ambiguity that I find in this passage stems from an apparently deliberate abstention from a commitment concerning the ontological status of awareness, experience, and in general of mental events. I shall consider two extreme positions, neither of which can I ascribe with confidence to Grünbaum, for he may espouse an intermediate position or he may simply keep his opinion in abeyance on this philosophical problem. Nevertheless, it is illuminating to examine the conjunction of the thesis of mind-dependence of A-determinations with each of these two extreme positions, for the philosophical implications of the two cases are quite different.

Position (i) asserts that mental entities (minds, mental events, occasions of awareness) are ontologically fundamental, neither derivative from nor constructed from physical entities in any way (e.g., in the way that macrophysical systems are constructed from microphysical components). Of course, this position can be subdivided, notably into (a) a fundamental mentalism, like that of Leibniz and Whitehead, according to which the systems ordinarily considered to be physical are constructed in some sense from mental entities; and (b) a dualism, like that of Descartes and Locke, in which both physical and mental entities are fundamental, neither being reducible to or constructible from the other. This finer taxonomy is not important for the problem of the status of transiency. What is crucial is that if A-determinations are mind-dependent, and in addition mental entities are ontologically fundamental, then A-determinations have an uneliminable status in nature. To put the matter differently, if A-determinations are mind-dependent, they may indeed be subjective, but in position (i) the very concept of

subjectivity is cleansed of the pejoratives of illusion, derivativeness, and superficiality. I can make this point more forcefully by adopting the terminology of Whitehead's philosophy of organism.[14] According to Whitehead, the ultimate concrete entities in the cosmos are *actual occasions,* which are occasions of experience, though he construes "experience" so broadly that in some dim way even the minimal temporal events in the career of an electron have a kind of proto-mentality. Transiency is a fundamental notion for Whitehead. An actual occasion in its subjective immediacy is present, but when its moment of immediacy is completed (a process which has some temporal breadth according to Whitehead, but this point is not essential to the considerations of this paper) it remains objectively immortal; the occasion in its particularity can be *prehended* by subsequent occasions and serves as an ingredient in their immediate experience. As objectively immortal the occasion has all the content that characterized it in the last stage of its subjective immediacy. The difference between the occasion as present and the occasion as past does not lie in content, and in this sense there is no *property* of presentness. Whitehead's treatment of transiency can be subsumed, with one qualification, under Zeilicovici's, though of course with more metaphysical detail. The qualification is that according to Whitehead the occasions of the future do not exist as actualities but only as real potentialities with incomplete specification, and therefore the thesis that the content of an occasion is independent of its A-determination holds only with regard to presentness and the various degrees of pastness, but not with regard to futurity.

Position (ii) holds that physical entities are ontologically fundamental and that mental entities are reducible to or constructible from physical entities. There is, of course, a vast literature about the exact sense in which theories of mind are supposed to be reducible to physical theories and psychological concepts are definable in terms of physical concepts, but these complications do not affect our main line of analysis. The point is that when a purely physicalist ontology is conjoined with the thesis that A-determinations are mind-dependent, then it follows that A-determinations are as illusory and derivative as purely sensory *qualia.* Grünbaum says something similar: "assuming the causal dependence of mental on physical events, why is the mind-dependence of becoming more puzzling than the fact that the raw feel components of mental events, such as a particular event of seeing green, are not members of the *spatial* order of physical events?"[15]

The view that A-determinations are illusory does not stand up under analysis, whether or not it is based upon a physicalistic ontology. To

demonstrate this assertion, consider an event E in the career of a normal human being (ideally instantaneous, but the argument goes through even if E has temporal breadth τ centered about t). Suppose that the content of E is fully specified. If physicalism is correct, then the full specification of the physical properties of the organism specifies everything, and all mental properties will be automatically determined, whether or not there is an explicit linguistic definition of each psychological concept in terms of physical ones (for our concern is ontological rather than epistemological). If physicalism is not correct, then a complete specification requires mental and perhaps psychophysical properties in addition to physical ones. What concerns us at this point is the completeness of the specification, not the solution to the mind-body problem. By premiss (a) in McTaggart's paradox of transiency (not challenged by Zeilicovici) the complete specification of the properties of E is intrinsic to E, and is not relative to the time of judgment. Now an illusion at time t in the career of the human being under consideration is one of the properties of E. Hence, if nowness is an illusion of the subject at (or within $\tau/2$ of) t, then it is part of the complete specification of E and is not relative to the time of judgment. Thus *nowness as an illusion* applies to the event E as well when time t is long past as it does at t itself—and the singling out of a particular instant as *now, even as an illusion,* evaporates.

An elaboration of the foregoing argument may be enlightening. There is a very important principle linking epistemology and ontology that is pervasive in the literature of empiricism from Berkeley to the sense data theorists of the early twentieth century and implicit in other philosophical writings: that *even though the distinction between appearance and reality is maintained, a minimal condition on ontology is to recognize a sufficient set of realities to account for appearances qua appearances.* I cannot believe that no name has been given to this principle, but since I do not recall reading one, I propose "the Phenomenological Principle."[16] Applied to the thesis that A-determinations are illusory the Phenomenological Principle is devastating. Specifically consider Grünbaum's query, quoted above, "why is the mind-dependence of becoming more puzzling than the fact that the raw feel components of mental events—are not members of the *spatial* order of physical events?" The answer to this query is that the status of raw feel components *qua* appearances is not being challenged in the quotation, but only their status as attributes of spatially located physical things. By contrast, if an A-determination is nothing but an illusion, then it isn't even an illusion! An A-determination cannot function as an appearance without transiently singling out an instant of time (or more broadly, an interval of time). But if it is only an

illusion, then it cannot function this way as an appearance, by the argument given in the preceding paragraph. Nowness must either be more than an illusion or less than an illusion. If it is less, then no justice has been done to the phenomenology of time. If it is more, then either Zeilicovici's existentialist analysis is required, or something equally strong and explanatory, which I have yet to see.

Tangentially, I remark that another application of the Phenomenological Principle is to devastate pure physicalism. If awareness is nothing but an illusion, supervenient upon the physical state of an organism, then it cannot even be illusion. Consequently, the dialectical openness to pure physicalism that was granted in stating position (ii) must be short-lived.

IV. A-DETERMINATIONS AND RELATIVISTIC SPACE-TIME STRUCTURE

In this section I shall investigate whether the solution proposed by Zeilicovici to McTaggart's paradox of transiency can be maintained when Newtonian space-time is replaced by Einstein-Minkowski (or special relativistic) space-time. It is necessary first to characterize the structure of the latter.

According to special relativity theory,[17] space-time is an affine space associated with a vector space V (to be specified below) in the following sense: An ordered pair, P,Q, of space-time points uniquely determines a vector v belonging to V, which we may call *the directed vector from P to Q;* for any space-time point P and vector v there is a unique space-time point Q such that the directed vector from P to Q is v; if v is the directed vector from P to Q and w is the directed vector from Q to R, then the vector sum v + w is the directed vector from P to R; and the directed vector from P to Q is the null vector 0 if and only if P is identical with Q. V is assumed to be a real four-dimensional vector space endowed with a nondegenerate inner product (u,v), where nondegeneracy means that (u,v) equals zero for all u only if v is the null vector. Furthermore, V has the further property that if four of its members v_0, v_1, v_2, v_3 are mutually orthogonal (i.e., $(v_i, v_j) = 0$ if i \neq j) and if each v_i has a nonzero inner product with itself, then exactly three of the inner products (v_i, v_i) have one sign and exactly one has the other. We shall assume, as a matter of convention, that only one of the (v_i, v_i) is positive (and this one is taken to be i = 0), whereas the other three, with i = 1,2,3, are negative.

All the familiar concepts of relativistic space-time theory can be defined straightforwardly in terms of this simple and austere structure. Here are the most important concepts. If (v,v) > 0, then v is *time-like;* if

$(v,v) < 0$, then v is *space-like;* and if $(v,v) = 0$, then v is *null* or *light-like.*
If P is an arbitrary space-time point, then the set of all space-time points
Q such that the directed vector from P to Q is time-like constitutes the
interior of the light-cone of P. This set consists of two disconnected parts,
the interiors of the *forward* and the *backward* light cones respectively. If
Q belongs to the former and Q' to the latter, and v and v' are the directed
vectors from P to Q and Q' respectively, then (v,v') is negative; and also
one says that v is *forward directed* and v' is *backward directed.* The
boundary points of the interior of the light-cone are those points Q such
that if v is the directed vector from P to Q, then $(v,v) = 0$; and the
boundary points are said to be *on* the light-cone of P. The forward
light-cone of P consists of the points in the interior of the forward
light-cone or on it; and the backward light-cone is similarly defined.
Hence the forward and backward light cones intersect at the one point P.
Finally, the *exterior* of the light-cone of P consists of all those points Q
such that the directed vector from P to Q is space-like. Each of these
geometrical concepts has a straightforward physical meaning. If Q
belongs to the backward light-cone of P, then a signal can be sent from Q
to P; the signal can be carried by a means slower than light, such as the
motion of a massive particle, if Q is in the interior of the backward
light-cone, but only by some entity with the velocity of light if Q is on the
light-cone. If Q belongs to the forward light-cone of P, then a signal can
be sent from P to Q, by means slower than light if Q is in the interior but
only with the velocity of light if Q is on the boundary. Finally, if Q
belongs to the exterior of the light-cone of P, then no signal can be sent
from P to Q or from Q to P.

Space-time can be coordinatized by choosing a space-time point O as
the origin and a quadruple of mutually orthogonal non-null basis vectors
v_0, v_1, v_2, v_3. As noted before, it is implicit in the structure of V that exactly
one of these four is time-like, and this one is conventionally chosen to be
v_0. It is convenient to choose the v_i such that $(v_0, v_0) = 1$, and $(v_1, v_1) =$
$(v_2, v_2) = (v_3, v_3) = -1$. Every space-time point P is now assigned a
quadruple of coordinates in the following way: let v be the directed
vector from the origin O to P, and express v as

$$v = c_0 v_0 + c_1 v_1 + c_2 v_2 + c_3 v_3, \qquad (1)$$

where c_0, c_1, c_2, c_3 are real numbers; it is always possible to find real
numbers c_i which make equation (1) true, and this can be achieved in
only one way. The quadruple (c_0, c_1, c_2, c_3) constitutes the coordinates of P
relative to the specified origin and set of basis vectors. In particular, c_0 is
the *time-coordinate* of P. For aesthetic purposes the further condition is

imposed upon v_0 that it be forward directed. This condition implies that if P is distinct from O, it has a positive time-coordinate if (but definitely *not* only if) it belongs to the forward light-cone of the origin, and a negative time-coordinate if (but definitely *not* only if) it belongs to the backward light-cone of the origin.

We can now ask about the applicability of McTaggart's characterization of the B-series to relativistic space-time. The answer turns out to be complicated but clear. Once the time-like vector v_0 is chosen, the B-series is well-defined; but there is an infinity of allowable choices of v_0 with different consequences for the temporal ordering of space-time points, and nothing intrinsic to space-time structure singles out one choice from all the others. Consequently, there is no *natural* B-series. Some comments are needed.

(1) First, assume that v_0 has been chosen. It is easily shown that the specification of the three space-like vectors v_1, v_2, v_3 do not affect the time-coordinate of any space-time point P. Furthermore, even though the choice of the origin does affect the time-coordinates, it does not affect the *temporal ordering* of space-time points. If t(P) is the time-coordinate of P with O as the origin, and t'(P) is the time coordinate of P with O' as the origin, then

$$t'(P) = t(P) - t(O'),\qquad(2)$$

and hence the ordering of space-time points according to the magnitudes of the time-coordinates is independent of the choice of the origin. Thus, when v_0 is specified, each space-time point P determines an *instantaneous space* S(P) of space-time points simultaneous with itself, consisting of all points P' such that the directed vector from P to P' is orthogonal to v_0. When an origin is chosen, all members of S(P) are assigned the same time-coordinate as P itself. The instantaneous space S(P) can thus be considered to be an *instant,* and it follows from what has been said that the set of these instants is a one-dimensional linearly ordered continuum. Thus a B-series is determined, independent of the origin and of the choice of the space-like vectors once v_0 is specified, but dependent on v_0.

(2) Now consider the B-series associated with two distinct time-like vectors v_0 and v'_0 such that v'_0 does not equal cv_0 for any real number c, and again for convenience assume that both v_0 and v'_0 are forward-directed. Choose an origin O, and let t(P) be the time-coordinate of P relative to v_0 and t'(P) be the time-coordinate of P relative to v'_0. Then it is a simple mathematical exercise to find two space-time points P_1 and P_2 such that each is in the exterior of the light-cone of the other and

$$t(P_1) < t(P_2),\qquad(3a)$$

and

$$t'(P_1) > t'(P_2). \tag{3b}$$

The time of P_1 is earlier than the time of P_2 relative to v_0, and is later than the time of P_2 relative to v'_0. Hence, one cannot define an absolute or natural B-series that is independent of the choice of the time-like basis vector. Of course, another strategy for saving the idea of an absolute B-series is to try to find some intrinsic physical reason for one choice among the various possible time-like vectors; but to find such a reason is equivalent to giving a reason for a preferred inertial reference frame, which is contrary to the entire conception of relativity theory. It is beyond the scope of this paper to present the experimental reasons for rejecting a preferred inertial reference frame.

(3) The exterior of the light-cone of a space-time point P is sometimes thought of as consisting of "generalized contemporaries" of P, and in this sense all of space-time can be divided into three parts: the past of P, the generalized contemporaries of P, and the future of P (with no reference to transiency). However, it is impossible to construct a natural or absolute B-series in this way. The reason is that the relation of generalized contemporaneity is intransitive. It is a straightforward exercise to construct three points P, Q, R such that P and Q are outside each other's light-cones and hence are generalized contemporaries, and Q and R are outside each other's light-cones and hence are generalized contemporaries, but this relation fails for P and R. Although this fact is well known to students of relativity theory, there have been many conceptual tricks for evading or disguising it. I am spared the labor of commenting on the confusions engendered by these tricks, because Howard Stein has given penetrating critiques of them.[18]

(4) Instead of attempting to fit a B-series in an absolute manner to the entirety of space-time, a natural and physically significant construction of a B-series can be achieved by restricting attention to certain interesting subsets of space-time, viz. to *time-like world-lines.* A time-like world-line is a one-dimensional curve in space-time, any two distinct points P and P′ of which have the property of being in the interior of the light-cone of the other, and such that there exists no space-time point whose forward light-cone contains the entire curve and no space-time point whose backward light-cone contains the entire curve. Informally, a time-like world-line is the track in space-time of a particle moving for all eternity at speeds permitted by the special theory of relativity—i.e., less than that of light. Clearly the points of a time-like world-line are linearly ordered, with P preceding P′ if and only if the latter is in the future

light-cone of the former, and hence the time-like world-line has the order of a B-series without resorting to any coordinatization. Of course, if there is a coordinatization, and if v_0 is a future-directed time-like vector, then for any P and P' belonging to the world line $t(P) < t(P')$ if and only if P precedes P' in the sense just stated, and $t(P) = t(P')$ if and only if P = P'. It is also possible to parametrize the time-like world-line by choosing an origin 0 on it and computing the "proper time" $\tau(P)$ along the world-line:

$$\tau(P) = \int_0^P \frac{dt}{(1 - v^2/c^2)^{1/2}}, \tag{4}$$

where the infinitesimal of time dt along the world-line and the instantaneous velocity v both depend upon the coordinatization, but the integral $\tau(P)$ depends on O but not otherwise on the coordinatization. Then for any pair of points P and P' on the time-like world-line $\tau(P) < \tau(P')$ if and only if P precedes P' in the sense stated above, and $\tau(P) = \tau(P')$ if and only if P = P'.

After all of these preliminary considerations of B-determinations we can turn to the question of A-determinations. The most natural way to consider this question within the framework of Einstein-Minkowski space-time is to focus on a time-like world-line, which may be idealized as the track of a particle endowed with a mind. Hermann Weyl formulated his thesis of the subjectivity of A-determinations as follows: "The objective world simply *is*, it does not *happen*. Only to the gaze of my consciousness, crawling upward along the life line of my body, does a section of the world come to life as a fleeting image in space which continuously changes in time."[19] But this statement is inadequate in the same way as Grünbaum's thesis of the subjectivity of becoming. Whatever constitutes subjectivity is a set of properties of the organism—purely physical if the ontology is physicalistic, purely mental if it is mentalistic, and psychophysical if it is dualistic. At any point on the world-line there is a complete set of properties, including those that constitute the subjectivity of the organism with which the world-line is associated. Hence it is true from any vantage point, including any point along the world-line, that at any other point on the world-line the subjective experience is fully specified. Hence, no "fleeting image in space which continuously changes in time" can be ascribed to subjectivity. The phenomenology of a transient *now* can be accounted for only by something that is not encapsulated in a bundle of properties. The argument of Zeilicovici, based upon Kant's analysis of "existence," maintains that this something is existential. Something fleeting does

indeed traverse the world-line, but that something is not subjective; it is the transient *now,* which as a matter of objective fact is momentarily present and thereafter is past. Without this minimal amount of objectivity there cannot even be an illusion of transiency.

Even if one accepts the existential character of nowness, one may claim that it is relative to a specific world-line, thereby diminishing its objective status. In other words, if L_1 and L_2 are two distinct time-like world-lines, each being the track of some idealized unextended mind-endowed particle, it may be conjectured that the transient *now* on L_1 is uncorrelated with the transient *now* on L_2. There is, however, one important piece of phenomenological evidence regarding temporal correlations on two world lines: if the conscious organisms associated with L_1 and L_2 possess the usual means of communication and if L_1 and L_2 intersect at a space-time point P, then if one of the organisms judges P to be *now* so does the other. The ordinary sharing of experience depends upon this fundamental consensus about the fleeting present. But one can go a step further in view of the argument of the preceding paragraph that nowness cannot be attributed to subjectivity: the agreement between the two organisms associated with L_1 and L_2 rests on a fact independent of their consciousness. Stripping away the non-essentials leaves only the fact of intersection of L_1 and L_2 at the point P as the reason why the nowness of P on L_1 entails the nowness of P on L_2 and conversely. The conclusion is that A-determinations must be ascribed to the point P itself, not to P as associated with one or another world-line. I agree with Čapek's excellent statement that "on each particular world-line any particular 'now moment' divides unambiguously the past from the future,"[20] but his statement can be strengthened by the ascription of A-determinations to space-time points themselves.

Certain other A-determinations are corollaries of what has just been said. Suppose that P is *now* and Q belongs to the light-cone of P. If Q belongs to the backward light-cone then a signal can be sent from Q to P, and as a matter of physical fact an event at Q may have influenced an event at P, and therefore Q is past in the sense of an A-determination. Likewise, if Q is in the future light-cone of P, then Q is future as an A-determination. In sum, the attribution of nowness to a space-time point P, which is the central A-determination, can be combined with structural features of Einstein-Minkowski space-time (with no further reference to transiency) in order to generate an infinity of A-determinations.

If P_1 and P_2 fall outside each other's light-cone, then nothing can be

inferred about an A-determination of one from an A-determination of the other. Suppose the contrary. Suppose, for example, that the nowness of P_1 entailed the pastness of P_2. Then there would be a derivative B-relation between them—that P_2 precedes P_1 in a natural sense. Of course, by assumption this would not be so in the sense of P_2 belonging to the backward light-cone of P_1. It would then mean that somehow those time-like forward-directed vectors v_0 with the property of entailing a time-coordinate of P_2 smaller than the time-coordinate of P_1 would be distinguished from the other forward-directed time-like vectors, and this in turn is equivalent to selecting a privileged subset of the inertial frames of reference. This conclusion would not break the special relativistic thesis of the equivalence of all inertial frames as strongly as the singling out of a particular inertial frame, and nevertheless it definitely does break the equivalence. In other words, if an A-determination of a space-time point P implied an A-determination of a space-time point outside its light-cone, then the structural properties of Einstein-Minkowski space-time would be violated, even though that structure is neutral with respect to the status of transiency.

It may be objected, however, that the wrong conclusion has been drawn from the conflict between the structure of Einstein-Minkowski space-time and the proposition that there are relations of A-determination between space-like separated space-time points. Instead of holding on to the former and rejecting the latter, which was the conclusion of the preceding paragraph, one might claim that the phenomenology of temporal passage shows the inadequacy of Einstein-Minkowski space-time structure. The claim is that we have an experience of nowness that is not just here-now but is extended—an experience of a "unison of becoming"[21] or of extended contemporaneity. I am very skeptical of such arguments. When I introspect, I certainly find no direct experience of contemporary objectively existing distant events. There is indeed a presented visual scene in my experience, with a spatial organization, but the relation between the contents of this perceptual space and objectively existing distant events may be (and I think *is*) causal and indirect. As an objective entity in nature, the entire spatially organized visual scene may be located in a very small region of space-time. A stronger case may be made for the immediate experience of the presentness of the body, but the evidence of the finitude of signal propagation along the nerves shows that this phenomenology also must be subjected to careful critical analysis. What is particularly needed is an examination of the specious present, as contrasted with the idealized instantaneous present, and this project is beyond the scope of this paper.

Fortunately, Stein has given an important part of the requisite analysis, arguing that "the set of events contemporaneous with a specious present will always be a spatially extended one. . . . this spatial extent—though finite—is in fact *and in principle, as a matter of physics,* always, in a certain sense, immensely large."[22] The fact that Stein's analysis is carried out entirely within the framework of special relativity theory greatly strengthens the thesis that the phenomenology of becoming does not overflow this framework.

It has also been maintained that quantum mechanical nonlocality, as exhibited in the experimental violations of Bell's Inequality, entails causal relations between space-like separated events, in violation of the structure of Einstein-Minkowski space-time. This question, also, is beyond the scope of the present paper, but I have argued elsewhere that quantum mechanical nonlocality "peacefully coexists" with special relativity theory, because quantum mechanical correlations between spatially separated systems cannot be exploited for sending messages faster than light.[23]

A final remark is mainly historical. It is often maintained that Einstein exorcized transiency from nature by introducing the space-time structure of special relativity theory. That this conclusion is conceptually false is the main point of the arguments of the present section. That it is also historically false is shown by a remarkable reminiscence by Carnap of a conversation with Einstein at the Institute for Advanced Study between 1952 and 1954:

> Once Einstein said that the problem of the Now worried him seriously. He explained that the experience of the Now means something special for man, something essentially different from the past and the future, but that this important difference does not and cannot occur within physics. That this experience cannot be grasped by science seemed to him a matter of painful but inevitable resignation. I remarked that all that occurs objectively can be described in science; on the one hand the temporal sequence of events is described in physics; and, on the other hand, the peculiarities of man's experience with respect to time, including his different attitude towards past, present, and future, can be described and (in principle) explained in psychology. But Einstein thought that these scientific descriptions cannot possibly satisfy our human needs. . . . I definitely had the impression that Einstein's thinking on this point involved a lack of distinction between experience and knowledge. Since science in principle can say all that can be said, there is no unanswerable question left. But though there is no theoretical question left, there is still the common human emotional experience, which is sometimes disturbing for special psychological reasons.[24]

According to the present paper, there *is* a theoretical question about *now,* but it can be answered satisfactorily along the lines proposed by Kant

and Zeilicovici. I like to think that Einstein would be happy with this proposed solution, and I hope that Paul Weiss will be persuaded.

ABNER SHIMONY
DEPARTMENTS OF PHILOSOPHY AND PHYSICS
BOSTON UNIVERSITY
MAY 1992

NOTES

1. Paul Weiss, *Reality* (Princeton, N.J.: Princeton University Press, 1938), p. 226.
2. Paul Weiss, *First Considerations* (Carbondale, Ill.: Southern Illinois University Press, 1977), p. 154.
3. Abner Shimony, "Some Comments on Philosophic Method," in Paul Weiss, *First Considerations* (Carbondale, Ill.: Southern Illinois University Press, 1977, 187–89), p. 188.
4. McTaggart, John McTaggart Ellis, *The Nature of Existence* (Cambridge, U.K.: Cambridge University Press, 1927), ch. 33.
5. Charles Dunbar Broad, *Scientific Thought* (New York: Harcourt, 1923); Richard M. Gale, *The Language of Time* (New York: Humanities Press, 1968); George N. Schlesinger, *Aspects of Time* (Indianapolis, Ind.: Hackett Publishing Co., 1980); David Zeilicovici, "A (Dis)Solution of McTaggart's Paradox," *Ratio* 28 (1986): 175–95; David Zeilicovici, "Temporal Becoming Minus the Moving-Now," *Noûs* 23 (1989): 505–24.
6. Zeilicovici 1986, p. 188.
7. Immanuel Kant, *Critique of Pure Reason,* trans. N. Kemp Smith (New York: Humanities Press, 1950), pp. 500–507.
8. Zeilicovici 1986, p. 189.
9. Kant, p. 504.
10. Ibid., p. 505.
11. Adolf Grünbaum, "The Meaning of Time," in *Basic Issues in the Philosophy of Time,* ed. E. Freeman and W. Sellars (La Salle, Ill.: Open Court, 1971), p. 211.
12. Ibid., p. 207.
13. Ibid., p. 209.
14. Alfred North Whitehead, *Process and Reality* (New York: Macmillan, 1929).
15. Grünbaum, pp. 216–17.
16. The principle of "saving the appearances" has a quite different meaning: to order or explain or predict phenomena on the basis of a theoretical scheme.
17. More details about the space-time structure of special relativity can be found in many texts, an excellent one being Wolfgang Rindler, *Introduction to Special Relativity,* 2nd ed. (New York: Oxford University Press, 1991).
18. Howard Stein, "On Einstein-Minkowski Space-Time," *Journal of Phi-*

losophy 65 (1968): 5–23; "A Note on Time and Relativity Theory," *Journal of Philosophy* 67 (1970): 289–94.

19. Hermann Weyl, *Philosophy of Mathematics and Natural Science* (Princeton, N.J.: Princeton University Press, 1949), p. 116.

20. Milič Čapek, "Einstein and Meyerson on the Status of Becoming in Relativity," *Actes du XIe Congrès International d'Histoire des Sciences* (Varsovie, 1967), p. 138. See also, *The New Aspects of Time* (Dordrecht: Kluwer Academic Publishers, 1991).

21. Whitehead, p. 189.

22. Howard Stein, "On Relativity Theory and Openness of the Future," *Philosophy of Science* 58 (1991), p. 159.

23. Abner Shimony, "Events and Processes in the Quantum World," in *Quantum Concepts in Space and Time,* ed. R. Penrose and C. Isham (Oxford, U.K.: Oxford University Press, 1986), pp. 191–93.

24. Rudolf Carnap, "Intellectual Autobiography," in *The Philosophy of Rudolf Carnap,* ed. P.A. Schilpp (La Salle, Ill.: Open Court, 1963), pp. 37–38.

REPLY TO ABNER SHIMONY

Abner Shimony has two doctorates, one in philosophy and the other in physics—the latter written under the guidance of a Nobel Laureate. He backs his views with a modesty, gentleness, and friendliness that makes him both engaging and formidable. It is characteristic of him to attack hard questions, and to do so masterly. I am cheered by his basic agreement with my view of time, though I am not confident that I have well understood its relation to current physical views.

I know that Shimony intends to compliment me when he says that I am "a remarkable phenomenologist." I suppose that he is saying that I do considerable justice to what can be observed, and not that I am a member of a school that looks to Husserl as its master or guide. The school is too epistemic and insufficiently self-critical to answer the needs of one who seeks to understand as well as to describe.

There is not more I can add to his study than some footnotes and some questions expressing doubts and a failure to understand all that is being said or intended. Is it true that McTaggart's A-series has determinations relative to the time of judgment? Is it not to be understood independently of this, expressing what McTaggart takes to be an essential feature of time that is in conflict with another, expressed as the B series? Is it not McTaggart's intent to make evident the unreality of time by showing that it is a self-contradictory idea? Is it correct to say that 'being' is not a real predicate? It is, of course, not a concept to be added to a concept of a thing to change this into something else. But it can be added to what one conceives so as to make evident that the concept has an object distinct from it. "There *is* money in my bank account" makes good sense.

When a possibility is realized, it is not simply filled out or given a location. It is made determinate, subjected to qualifications operative in

a context other than that in which the possibility had been before it was realized. A realized possibility is possessed and subject to vicissitudes expressing powers and determinations not present in that possibility. The result can be abstracted, leaving behind what enabled that abstraction to be. Nothing that exists is impossible, but what is merely possible lacks the separations and connections it has when it is ingredient in something. When the separations and connections are introduced into a possibility, as apart from the source of these, they no longer separate and connect, but merely mark out distinctions. Reality would always escape our grasp and understanding were it not that we know more than what is conceptualized or what is identified as possible. We adumbrate while we fasten on what we might then treat as a possibility, thereby distinguishing what the possibility is in thought or prospect from what it is as an integral part of what is actual.

A real hundred dollars, as Kant remarked, does not contain more dollars than a possible hundred dollars. He did not note that the meaning of 'contains' is different in both cases. A possible hundred distinct dollars does not contain a possible two fifties, a possible five twenties, and so on. It allows for no subdivisions into distinct units that can be added to produce the hundred. We can, of course, imaginatively divide a hundred into any number of units, but those units were not nested within it. 'A hundred' is a single number; other numbers are not inside but alongside it, and as singular as it is. When we carry out a mathematical act of division we do not do anything to what we initially acknowledged. A hundred remains a hundred, while we report on the number of steps we might have to take in order to arrive at it from the position of some other number. When we tender a hundred to a cashier and receive two fifties in return, we give up the hundred dollars for the two fifties. The hundred dollars might then be lost or embezzled, but we will continue to have our two fifties. The actual hundred dollars were exchanged for an actual equivalent.

Our numerical system allows us to divide a hundred in many ways without affecting it in the slightest, but we can divide an actual hundred dollars only into whatever coinage is available. We could replace the number 'hundred' with an equivalent 40,000 smaller units, but we cannot provide American coinage for such units. Some other monetary system might allow for such an interchange. All the while, the same number of steps can be taken from the number 'hundred' to and from any other numbers, whether or not they can be re-presented in a monetary system. A real hundred dollars can be divided into two fifties only if these are available. A possible hundred can always be replaced by two possible

fifties whether or not there are any fifties available. A real hundred might be exhibited in various piles that together can be summed to a hundred dollars. A possible hundred, it might paradoxically be said, is more resistant, since nothing ever could divide it. Two possible fifties do not yield a possible hundred; two actual fifties make a hundred whether anyone adds them or not.

Kant's famous example is not as good as he thought it was, though it perhaps sufficed to make one aware of the weakness of one of the famous arguments intended to prove that there was a God. I, too, think that the ontological argument does not prove anything, but not for Kant's reason. A final reality can depend on nothing, not even a supposedly necessarily true premiss, unless it provides this, for what is necessary in itself is dependent on nothing that it does not itself provide. I am perhaps saying no more than what Shimony intends when he says that there is a "kind of richness in both *nowness* and *existence,* but it is *existential* in character, entirely different from conceptual determination." That truth need not be confined to temporal occurrences.

Shimony's criticism of Grünbaum is not only sound but definitive. It would though be more persuasive were it freed from a reference to a mind. I do not, though, think that his criticism of Whitehead is altogether satisfactory, for he overlooks the lure that Whitehead takes to be divinely put before actual occasions as they come to be.

I am too ignorant of modern physical theory to comment on Shimony's use of it. I doubt, though, that the problem and its solution require a reference to it. He is right, I think, in his criticism of Weyl about the nature and reality of objective contemporaneity. What I am not clear about is whether or not Einstein and Shimony deny that my body is now larger than, smaller than, or equal in magnitude to every other body that exists, no matter what the time frame. The main question with which Shimony deals and the answer he provides have a far wider import than what bears on modern physical theory. What both Einstein and Carnap had in mind, the one allowing it to trouble him, the other to disdain, can be so generalized that it has an unlimited application, and particularly on the questions of the natures as well as the relations of the transient, the adventitious, the 'accidental', the permanent, the substantial, and the essential.

In the course of his account Shimony raises a number of arresting questions. He objects to the analogy between the transitory and existence, and suggests instead that there is 'nearly an identity' of the two. I am not confident that I understand what 'nearly an identity' is. He goes on to say that a possible instantaneous event must be *now* at some

instant, I think he is trying to state what is perhaps a dogma or a tautology in modern physics. If so, he has gone beyond what he has justified.

I am not yet confident that I have found a satisfactory answer to the question whether or not possibilities exist independently of whatever might or might not occur. Some decades ago my death was possible. It is no longer possible for me to die at that time. Should we say that there was once a possibility of my dying at that time? If we said there was, we would have to acknowledge an endless number of possibilities that came to be and passed away, depending on what actualities there are. It seems more correct to hold that there is a single all-inclusive possibility, and that it is specialized by actualities in accord with what these actualities are, and could be or do at each moment. A plurality of possibilities would then be delimited versions of a grand possibility, each the correlative of what an actuality then was. Each possibility would be absorbed into the one possibility when it could not be realized. Is this what Shimony is affirming when he says that a possible instantaneous occurrence must be now at some instant?

I am puzzled by Shimony's interpretation of Whitehead's idea of 'transiency', but I don't think that if he has misconstrued it, it seriously affects his thesis. He is surely right to emphasize that a minimal condition for ontology "is to recognize a sufficient set of realities to account for appearances," once that remark is freed from the suspicion that the realities depend on us either for recognition or existence. I am not sure whether Shimony does or does not think that physical theory presupposes or warrants ontological claims. Surely he does not believe that current theories will always be accepted or that, when they are replaced, what he maintains will not still hold. If he thinks that what he maintains will hold no matter what turns physical theory takes, is that because he believes he has knowledge of what is presupposed by any physical theory? If he does, is he not a metaphysician who knows much that holds independently of what physics affirms now or later?

It is not clear whether or not Shimony takes the B series to have any reality, even if it is not 'natural'. His remark that "it is the transient *now* which, as a matter of objective fact, is momentarily present and thereafter is past" surely needs elaboration and defense. Is that now determinate? How does one now differ from another?

I am surprised to hear him say that he 'introspects' to find a direct experience of contemporary, objectively existing distant events. I would have thought that he would have had to do no more than look at the moon to have a direct experience of a contemporary, objectively existing distant object. He surely does not peer into the past to see the moon, or

find it in his brain or mind. He sees it when and where he sees it, no matter what photons and brain waves may do. Shimony does not exist alone nor does he believe that he does. Nor does he just hope that there is something else that also exists. Is the present specious? When then does one suppose that it occurs or is envisaged?

Shimony's report about the conversation between Einstein and Carnap is both humorous and illuminating. Einstein, the physicist, has questions where Carnap, who worships at science's shrine, has none. I join Shimony in thinking that Einstein was aware of what Carnap never did or could allow, given his dogmatic stand. Does not Einstein's perplexity require him to deal with basic issues by attending to what is outside the scope of physics? Shimony does this, but does not show that it is from a position that is justified and is to be maintained, no matter how current physical views change. He does, though, make evident that we know more about time than current physics acknowledges. I, for one, am happy to see that point defended by one who is at home both in physics and in philosophy.

P.W.

15

Jacquelyn Ann K. Kegley

IS ADVENTUROUS HUMILITY POSSIBLE?: THE ONE FOR THE MANY

The problem of the one and the many has been a persistent philosophical theme almost since the dawn of philosophy. It is an issue at once metaphysical and ontological and yet also profoundly central for every social, political, and ethical theory. The quandary of the one and the many, although perennial, is also peculiarly contemporary and made compelling by our present social and political reality, namely, the search for a multicultural, genuinely pluralistic, and yet unified society.

Throughout his philosophical inquiry, both in its bold speculative pursuit and in its imaginative practical application, Paul Weiss has grappled with a multitude of subtle nuances of this issue of the one and the many. In doing so, he has presented us with a rich realistic pluralism of independent, irreducible, unique actualities that function as contingent centers of action. Such a pluralism, I believe, captures the ambiquity and richness of reality while also providing a ground for the freedom and creativity which is essential to ethical, aesthetic, and practical human action.

However, while celebrating individuality and plurality, Paul Weiss is equally concerned about unity and relationship. One of his essential categories is Unity, and his system is a result of the interplay, interaction, and relationship of the five categories of Substance, Being, Possibility, Existence, and Unity. Further, for Weiss, humans are selves ontologically defined by a concern for the all-embracing, absolute Good. Human

freedom, for Weiss, is exercised within a framework of obligation to creatively will the Good, the *summum bonum* which he defines as "a totality in which each being was at its best in perfect harmony with all the rest" (Weiss, *Man's Freedom,* p. 199).

Weiss is concerned both about plurality and unity and about this issue as it impacts on human beings and their interrelationships. This essay will address one aspect of that one-and-many problem, the relationship of the individually good man and the community, particularly in terms of achieving the Absolute Good. Several questions will be addressed. First, given an essentially radical plurality of beings, each with a distinctive and unique ontological privacy, can there be more than superficial togetherness of human beings? Does Weiss's system provide the conditions for "genuine community" among these highly individualistic beings? In using the term "genuine community" we draw upon the analysis given by Josiah Royce in *The Problem of Christianity.* Genuine community is created by free, self-conscious, self-created, self-committed individuals and, in turn, that community supports and fosters the development of such individuals. In a genuine community there must be shared understanding and cooperation, a genuine intersubjective interaction and sharing. This kind of community is often called "unity-within-diversity" and an oft-cited example of such a community is the classic jazz performance where the basic 4/4 beat is flouted by each player through his own improvisation. A successful jazz performance might, in fact, achieve, at least to some degree, Weiss's vision of "a totality in which each being was at its best in perfect harmony with the rest."

Weiss's vision of the *summum bonum,* I believe, is similar to that of Royce's genuine community. The question to be answered, however, is whether Weiss's system provides the conditions whereby a plurality of individuals can achieve such a community. And can an individual, without this kind of community, achieve this goal of the *summum bonum?* In *Man's Freedom,* Weiss is concerned to demonstrate how man, through a series of free efforts, can become more complete and thereby more human (Weiss, *Man's Freedom,* p.v). But the demand is not only for self-perfection but to achieve perfection in the universe in general, to make "the good concrete without limit." Weiss writes of the "truly good man" as follows:

> He creatively wills, lovingly acts on behalf of the good. He is the creative man, par excellence, an artist who uses all his powers to make the good pertinent to and realized in all existents. He remolds himself, alters his pace, modifies his habits, varies his direction, shifts his emphasis so as to be at

once selfish and nonselfish, outgoing and restrained, to the greatest gain of all. (Weiss, *Man's Freedom*, p. 308)

This is certainly a highly admirable vision, but what mechanism allows individual centers of will and action to overcome their pursuit of self-perfection and what keeps them from indulging in self-seeking? What urges individuals to seek the good for all? For Josiah Royce it was community which provided individuals with both self-knowledge and self-development, social consciousness and self-transcendence, a concept of self-love and love for what is good for the whole. Weiss, in *Man's Freedom*, discussed various forms of perfection. Two of these seem related to beings seeking their own fulfillment. The first such is fulfillment in the sense of realizing individual promise as completely as possible. This type of perfection is within narrow limits, e.g., the perfect rose, or tiger, or thief. The second self-seeking form of perfection is that of perfect purity, e.g., free of all defect. The saint, writes Weiss, is "perfect both in purity and in fulfillment" (Weiss, *Man's Freedom*, p. 198). These perfections, says Weiss, fall short of the perfection of *composition,* which harmonizes subordinate entities, and the perfection of *scope,* which provides a place for all pertinent objects. The perfections of the saint, in other words, fall short of the *summum bonum,* the obligation placed on the "truly good man" by Weiss. How then does the truly good man go beyond the work of the saint? Jonathan Edwards, in discussing the "beautiful, true community," gives us a hint when he writes:

> If the whole universe were given to a saint separately he could not fully possess it. His capacity would be too narrow. The only way of appropriating it for his own good is through the instrumentality of the social organ. (Nagy, p. 103)

Edwards, like Royce, believed that the community was the means by which individuals could achieve both individual fulfillment and fulfillment of the *summum bonum.*

In what follows I shall explicate Weiss's analysis of the relationship of individual and community, particularly in terms of his analysis of the "I" and "we" in *You, I and the Others,* but also with reference to the vision of the "truly good man" in *Man's Freedom.* My contention will be that Weiss fails to give an adequate account of how community and individual constitute each other and how the community allows for self-transcendence and pursuit of the "good for all" ontologically required by Weiss's metaphysics. Further, although Weiss does acknowl-

edge the role of others in man's self-development and pursuit of the good, the role that community could play in this regard is not spelled out. A more developed view of community, I believe, would allow Weiss to give humans a route for mutual support in pursuing the Absolute Good in addition to or rather than the path Weiss seems to offer, namely, the lonely pursuit of this good by the morally courageous, humbly adventurous individual who despairs ultimately with a profound ontological guilt.

In reviewing Weiss's understanding of the relationship of the individual and others, the central work is *You, I and the Others.* Weiss identifies this work as "A systematic realistic study of man's primary dimensions and roles" (Weiss, *You, I and the Others,* p. xi). In probing the various meanings and relationships of I, me, my, mine, you, and they, Weiss's key motif seems to be that of privacy and publicness. In the preface to the work, Weiss writes:

> Each man has a complex private life, continuing into, supporting and supplementing a public one. Each expresses himself present in a world with other men and other actualities. Each has a self epitomized in an I; each is faced as a you, is one among others, and is encompassed by a common we. One of the main functions of this work is to clarify and justify and ground these claims. (Weiss, *You, I and the Others,* pp. xi–xii)

For Weiss, all actualities have a public and private dimension, an "inside" and an "outside." The public dimension of a being is that aspect of the being seen from the standpoint of others and which allows some relationships of togetherness with other beings. The private dimension is what the being is in and of itself. However, while there is also a private dimension of animals and things, there are crucial differences in this regard between humans and other beings. "Privately, animals and things are incipiently public; privately, men have dense distinguished unities with many divisions, engaged in many different acts, many of which are not directed toward the public world" (*You, I and the Others,* p. 7). Furthermore, unlike other beings, human beings "maintain their privacies in contradistinction to what they make public" (Weiss, *You, I and the Others,* p. 9).

The human person is, however, "publicly confrontable." You can be perceived and known in scientific and other ways. You, says Weiss, are "confrontable from a number of positions" (Weiss, *You, I and the Others,* p. 3). You are a subject of cognition in terms of space, time, and causality. "As public you occupy space." "You have a temporal span." "You have a predominantly bodily role." (Weiss, *You, I and the Others,* pp. 57–95). However, you also have a private dimension. You are more than your body. "You have a privacy only part of which is bodily expressed" (Weiss, *You, I and the Others,* p. 95). Further, although you are confrontable,

perceivable, and although scientific knowledge of you is possible, you are always private and that privacy has a "dense depth," a depth which cannot be exhausted by *what* I perceive, know, and encounter.

Weiss, however, does not hold that there is some privileged access to you or that we are dealing with a hidden you beyond any encounter or perception. Weiss is clear that there are occasions when I, in encountering you, do go beyond what is confrontable. Thus, "I confront you in sympathy, hate, fear or love" (Weiss, *You, I and the Others*, p. 6). It is not that privacy is inaccessible, but rather it is not fully penetrable. I can understand something of your privacy, but I cannot live through it. In this regard, Weiss makes a very interesting observation on understanding the difference that color and gender might make to another. He writes:

If they can be known to be present, the difference they make can be understood. One way is by imaginatively transforming one's own individualized traits into the individualized traits of another. It is not easy to do this, but it surely is not impossible. Novelists manage quite well; so do physicians and biographers. The actual encounter that each has with his own me, of course, will not be duplicated. Each will sustain the traits and his me in a distinctive way. And each knows this because each knows the difference between a you and me, and the fact that beyond all public qualifications, there is a private sustaining by each from within. (Weiss, *You, I and the Others*, p. 132)

There is accessibility to my privacy, but it is never complete. For Weiss, in fact, there is an aspect of reality he calls the "adumbrated lying beyond," a domain of ignorance. It isn't an unknowable aspect of reality, rather it is cognizable. However, cognition never embraces the vast extensiveness of reality, nor, in the case of being, the intensive privacy of beings can never be completely plumbed. This "recessive adumbrated" aspect of reality and of self, of course, allows Weiss to hold to a view of knowledge as fallible. It also raises the question of how an ignorant being can act on the Absolute Good.

It is clear, then, that for Weiss, the private and public aspects of a person are distinct but not unrelated. "You are confrontable in public," but when I attend to you, I attend directly to what is presented from a privacy which remains continuous with it" (Weiss, *You, I and the Others*, p. 5). A human being's privacy is both continuous with and distinguishable from what she or he is publicly. Every human being has a distinctive and unique ontological privacy. This is what human beings essentially are; they alone distinguish "what they are privately and what they are as present in a public world." Weiss presents a strong case for an essential radical plurality of human beings. Possessing a root ontological privacy each and every human being has intrinsic value, dignity, and inalienable

rights. Richard Bernstein argues correctly, I believe, that Weiss's radical plurality leads to a "radical egalitarianism." This egalitarianism is not one in which human beings are equal in strength, talent, intelligence, and ability. Rather, it is an egalitarianism because "every human being possesses a distinctive ontological privacy, is a free causal agent, and not only has value but a value which is at once absolutized and individuated" (Bernstein, 1981, p. 207). Further, concludes Bernstein, "any ethical, social or political theory that neglects or distorts this type of equality does violence to what we truly are—to what is essential to our being" (Bernstein, 1981, p. 207).

For Weiss, then, how are unique, egalitarian individuals related to each other? How are they together? Any society must, as Bernstein indicates, be founded on the respect for each and every individual which Weiss's philosophy so emphatically and cogently established. But, a properly functioning society must also have a unity and its members must be able to work together for common goals. The one-and-the-many question we are addressing is, as I have indicated, a crucial one for a contemporary society which seeks genuine plurality but also some unity.

Weiss assures us that "Men are affiliated" and that "Men are intelligibly together" (Weiss, *You, I and the Others,* p. 45 and p. 50). Individuals are not only publicly confrontable; they are also publicly together. Humans are "relevant to one another before they are aware of the fact; they have the status of affiliated 'you's' even before they are addressed" (Weiss, *You, I and the Others,* p. 45). There are constraining conditions that govern you and me in terms of space, time, and causality. "All men are directly subject to universal conditions, to various physical, chemical, biological laws and to those that govern their societies." "Common constraining conditions enable men to be present to one another" (Weiss, *You, I and the Others,* p. 53). However, once again the radical privacy of men asserts itself. "What men publicly are and what they do occur within the area where laws prevail, but the men enter there from unduplicable privacies and with a freedom of which laws take no account" (Weiss, *You, I and the Others,* p. 50). For Weiss, men are together, but they are also radically private and separate.

Humans are, says Weiss, together as a "we." 'We' has its own integrity, complexity, and character. It may have any one of three referents. It may refer to a *simple we,* a condition for a number of men; to a *factual we,* an interlinkage of men; or to a *complex we,* a combination of the simple and the factual (Weiss, *You, I and the Others,* p. 270). Unlike Whitehead, Weiss's actualities are affiliatively related and they are connected causally with others, both subjectively and objectively. Weiss

provides us with an interesting example of a complex, affiliative we, namely, a rowing crew.

By synchronizing their strokes, a rowing crew effectively propels a boat. The coxswain, on behalf of them all, presents a common condition dictating their speed and sometimes their direction. His beat allies them. As a result, the rowers form a single complex, an effective crew at some particular position on the river, to be followed by another complex, the crew at another better position. Were the crew not causally active, the beat would be a condition they might verbally and imaginatively repeat. Did they not to form a crew, they might still cause their boat to move, but not as well. It is because they are conjoint causes of the boat's movement and are conditioned by a common associative we implicit in the beat called out by the coxswain, that they are able to be a single, effective crew moment after moment. (Weiss, *You, I and the Others*, p. 286)

What is curious about this description of human togetherness is that the forces for cooperation seem to be external, e.g., the beat of the coxswain. There is no discussion of how internal forces such as common goals and motives might also make the group an effective crew. Crews certainly can form "genuine communities of mutual respect, interaction, and support and with common pasts and futures.

Weiss describes a variety of subtypes of the three basic 'we's', including an equitable single we, an organizational we, a distributive we, a synchronizing we, a sequential we, a transactional we, a processive we, and an assessive we. All of these are descriptions of the various ways humans can be together and function as a "we." It is clear that for Weiss humans are intended to be together, that an I, you, me presupposes a we and that a we presupposes a plurality of I's. Further, the integrity of both remains; neither the I nor the we dissolves into the other. Weiss has provided us with an incisive analysis of the various kinds of public togetherness humans may have. He has not, however, dealt with the concept of "community."

It is the case that Weiss recognizes that in order for an individual to achieve her ultimate end and fulfillment, others are needed. "No man can realize all his potentialities alone unaided. None can alone dynamically exhibit his native freedom to the full. To be fully human each needs the encouragement and support and the sympathy and help of others" (Weiss, *Man's Freedom*, p. 276).

In achieving the fulfillment of the Absolute Good, the individual also needs others. The most satisfying mode of reform for the good, Weiss tells us, is that which makes further reform unnecessary; and this type of reform "presupposes that the support of other men has been or will be won" (Weiss, *Man's Freedom*, p. 135). Cooperation, says Weiss, is a

preferable activity in achieving the good. Further, Weiss describes a "common good," namely, "the good of them all together" which men, in a common society, face. That good "prescribes that all men are to receive their due in harmony, that they are to be dealt with justly" (Weiss, *Man's Freedom*, p. 155).

For Weiss, it is the case that men are by nature together and that a common good and unity is a goal for all. However, as briefly indicated above, one does not find in Weiss's philosophical writings, the concept of the "genuine community" referred to earlier. Even where human togetherness is described and discussed, the emphasis always falls much more heavily on the individual rather than on the togetherness. For example, in describing the need for the support and encouragement of others in realizing individual potential, Weiss speaks of this in terms of a right or *principle of free kinship,* namely, the opportunity to make friends with any man." Though Weiss claims that cooperation is a preferable mode of activity for reform, he places the emphasis on the individual in bringing this about. "If we can do our duty only through the help of others, it is part of our duty to try to get them to help" (Weiss, *Man's Freedom,* p. 135). Finally, Weiss does speak of the common good and the pursuit of such through social organization, but again the emphasis is on the individual in the form of the *principle of personal equality,* namely, the recognition that each individual equally is a person and each is an ultimate and final source of decision and responsibility (Weiss, *Man's Freedom,* p. 275).

Undeniably, this emphasis on the unique and ultimate worth of each individual is correct and, as noted earlier, is essential to an adequate ethical, social, and political theory. However, communal cooperation and existence is, as Weiss states, essential to full individual development and fulfillment. Further, given the task which Weiss assigns to the ethical man, namely, "to make and remake himself and others to the limits of their capacities," community seems absolutely essential. Weiss's philosophical system, in my judgment, needs supplementation by a more adequate development of the notion of a community of genuine mutuality, where uniqueness and individuality are promoted, and where the interaction between individual and community promotes the development of each. Weiss, in fact, holds that the *principle of personal equality* requires a just and adequate society and its institutions to "help men become more aware of what it is to be a person and what it is a person ought to do" (Weiss, *Man's Freedom,* p. 276). However, nowhere in his work does Weiss give direction as to how social groups might achieve this goal.

Further, Weiss speaks often of the individual's inability to achieve the

Absolute Good. Part of that inability is due to ignorance, the inability to know the good or to know how it may be adequately achieved. In a long discussion of the Golden Rule, Weiss indicates that this is a good guide to ethical action, but that it assumes that a man has knowledge of what he wants done to self and that what he wants done to himself is good for him. The Golden Rule also assumes, says Weiss, that we know what is good for others (*Weiss, Man's Freedom*, p. 140ff.). Weiss also urges man to be "ethically sensitive," to grasp the "value things actually have" and to increase this sensitivity by "extending the range of interests and by taking advantage of available knowledge . . ." (Weiss, *Man's Freedom*, pp. 218–19).

Weiss does not, however, give us any guidance about how this might be done. The guidance, I believe, can be found in the philosophy of Josiah Royce. Like Weiss, Royce acknowledges the finite-infinite nature of human beings. For Weiss, man has an infinite obligation and a finite power. This is why man is inescapably guilty. "Men are inescapably guilty because to be human they must take upon themselves the realization of the absolute good. They must realize that good if they are to be complete men. . . . Man is perpetually guilty because he has infinite obligation and a finite power" (Weiss, *Man's Freedom*, pp. 260–61). For Royce, because of our finitude we are called upon to do two things, if we wish to be fully human beings: (1) to develop intensely our power of response to the universe around us, to maintain as much openness as possible, and (2) to recognize that the full truth and reality are still to be discovered. Man betrays these obligations, says Royce, and falls into two sins. The first is the "sin of irresponsiveness," a deliberate choosing to narrow our focus, to forget the ought that we already recognize (Royce, *The World and the Individual*, II, p. 357). Secondly, there is the "sin of pride," the lack of humility about our limited grasp of truth and of reality. It is an inordinate responsiveness to our own self-interests. It is interesting in this regard that Weiss, in response to man's finitude and infinite obligation, advocates "creative willing" which is "the virtuous balancing of adventure and humility, altruism and egoism" (Weiss, *Man's Freedom*, p. 263).

Royce's answer to overcoming the sins of irresponsiveness and pride is self-trancendence, a goal Weiss also promotes through sacrifice and love. Royce believes this self-transcendence can only be achieved through community and relationships. In Royce's view, we need our fellows to transcend ourselves and to gain insight into ourselves.

> The social world is wide, even if it is still full of conflict. It broadens our outlook at every turn. A man corrects his narrowness by trying to share his fellow's point of view. Our social responsibilities tend to set limits to our

fickleness. Social discipline removes some of our inner conflicts, by teaching us not to indulge our caprices. Human companionship may calm, may steady our vision, may bring us into intercourse with what is in general much better than a man's subliminal self, namely, his public, his humane, his greater social self, wherein he finds his soul and its interest writ large. (Royce, *The World and the Individual*, I, p. 55)

Further, Royce says, I cannot even judge my conduct without my fellows.

For he, as a solitary creature, would find no instance of conduct with which to compare his own. It is my knowledge of my fellow's doings, and of their behavior toward me—it is this which gives me the basis for the sort of comparison that I use whenever I succeed in more thoughtfully observing myself or estimating myself. (Royce, *The Problem of Christianity*, pp. 130–31)

In arguing for the role that others play in our achievement of self-transcendence, perspective, and ethical sensitivity, Royce was well aware, as is Weiss, of the dangers of the social order and togetherness for the individual. Royce was very concerned that communal togetherness not produce self-loss. Men can give in to the collective will and become a "they," a part of the crowd, rather than a unique self. One can refuse to take responsibility for one's own existence and the demand to be a self. Royce is in full agreement with Weiss on the ultimate value of the unique individual self as a center of choice. For Royce, self is an ethical category.

By this meaning of my life-plan, by this possession of an ideal, by this Intent always to remain another than my fellows despite my divinely planned unity with them—by this, and not by possession of any Soul-Substance, I am defined and created a Self. (Royce, *The World and the Individual*, I, p. 276)

To lose the self, for Royce, results in a deep sense of guilt: "the true sense of guilt in its greatest manifestation involves a confession that the whole self is somehow tainted, the whole life, for the time being, wrecked" (Royce, *The Sources of Religious Insight*, p. 66).

Royce indentifies a second error which socialization may foster in men, namely, the "sin of pride." This is an absolutizing of the self, which results in an attempt to mold the world and others according to its own self-will. It is a withdrawal into a world of self-sufficiency, and it also brings a deep sense of guilt, the "experience of guilt, anxiety, and inner conflict which results from the painful awareness of deeply rooted egoism." Royce would seem to part company with Weiss at this point, for he does not see "creative willing" on the part of the individual as adequate for achieving self-fulfillment or the absolute good. The answer for Royce rather is the loyalty and love for a united community and the

community's loyalty and love for the individual. The community which saves an individual from his sins of irresponsiveness and pride and from their accompanying guilt is one which truly loves the individual, i.e., values his uniqueness, and in which the individual truly values the community and each of its members.

> If the individual needs his social world as a means of grace and a gateway to salvation, the social order, in turn, needs individuals that are worth saving and can never be saved itself unless it expresses itself through the deeds and inner lives of souls deeply conscious of the dignity of selfhood, of the infinite worth of unique and intensely conscious personal life. (Royce, *The Source of Religious Insight,* p. 60)

Royce, in *The Problem of Christianity,* gives an extensive analysis of the conditions of genuine community including self-extension and self-transcendence of individuals, communication and shared interpretation of events, a recognition of cooperative efforts, and particularly the recognition that without the cooperative efforts of each person, the goal would not be achieved. It is not appropriate in this context to discuss these four conditions of genuine community in detail. However, the following can be said by way of a summary. First, for Royce, the building of community is a creative, active process which involves acts of self-will and commitment on the part of each self involved. Secondly, the selves are equal partners in the process—each in the sense that each contribution is seen as having intrinsic worth. Thirdly, all individuals retain their individuality. Even if conflicting interests or ideas are harmonized through the mediation of a third, all those interests or ideas remain irreducibly distinct. Fourthly, the commitment to build community is a moral commitment. For Royce, it is to spread and broaden community; the ultimate ethical goal is loyalty to loyalty, i.e., to community building.

In fact, there are several distinct levels of moral commitment. One commitment is to achieve an authentic selfhood, to carve out one's distinct biography against and within one's social context. Involved in this commitment are the sins mentioned above, namely, the sins of self-forgetfulness and pride. On the one hand, I must take my self-creation seriously and realize that I have individual worth as a unique person with my own distinctive contribution to make, both as a person and as a model to others. This involves self-love and a deep commitment not to become molded into a mere collective "we." On, the other hand, one must recognize one's narrowness and one's need to expand; one must not absolutize one's point of view into a world of self-suffciency.

A second level of commitment involved in the building of community, for Royce, is the commitment to reach out to others, to open oneself to communication. This involves trust and respect. It involves the

willingness to try to understand, in James's words, "what is significant to the other." This is also related to Weiss's notion of "ethical sensitivity." What is involved here is both a basic attitude-commitment and a commitment to a mode of interaction best exemplified in Martin Buber's I-Thou relationships, where genuine conversation and communication can occur.

In addition to these moral commitments, the building of community, in Royce's view, requires creative artistry. The unity to be achieved is "unity within variety." This recalls Edwards's description of the "beautiful community" referred to earlier as well as Whitehead's aesthetic understanding of the consequent nature of God. It is also certainly related to Weiss's *summum bonum*. What is sought is a unique blending of individual components so that the whole would be changed if one of the components is changed or eliminated.

For Royce, then, the individual without community is blind; community without the individual is empty. In achieving transcendence in a genuine community, there is individual self-fulfillment, the individual achieves his unique goal, and yet this goal is also affirmed by the community. The community truly loves the individual and values his uniqueness; the individual truly values and loves the community and each of its members.

Royce's vision of community, I believe, is close to Weiss's vision of the Absolute Good, namely, "the totality in which each being was at its best in perfect harmony with all the rest." However, Weiss would achieve this goal by placing the burden on the truly moral man who must achieve adventurous humility through his creative will. Such a man, further, is perpetually guilty because he has an infinite obligation and only finite power. I wonder how such an effort on the part of the truly moral man can escape the Promethean pride and loneliness and how it can succeed in balancing egoism and altruism, adventure and humility without the help of others. It is my judgment that the *summum bonum* so well described by Weiss can only be achieved by a cooperative effort of the kind envisioned by John Winthrop for the migrants to New England.

> We must delight in each other, make each other's condition our own, rejoice together, mourn together, always having before our eyes our Communion and community in the world, our Community as members of the same body. (Nagy, 1971, p. 96)

JACQUELYN ANN K. KEGLEY
DEPARTMENT OF PHILOSOPHY/RELIGIOUS STUDIES
CALIFORNIA STATE UNIVERSITY, BAKERSFIELD
MAY 1992

WORKS CITED

Nagy, Paul. 1971. "The Beloved Community of Jonathan Edwards," *Transactions of the Charles S. Peirce Society* 7 (Spring): 93–104.
Royce, Josiah. 1959. *The World and the Individual.* I and II. New York: Dover Publications.
Royce, Josiah. 1968. *The Problem of Christianity.* Chicago: A Gateway Edition, Henry Regnery Company.
Royce, Josiah. 1912. *The Sources of Religious Insight.* New York: Charles Scribner's Sons. (The Boss Lectures, Lake Forest College, 1911)
Weiss, Paul. 1950. *Man's Freedom.* Carbondale and Edwardsville: Southern Illinois University Press. London and Amsterdam: Feffer & Simons, Inc.
Weiss, Paul. 1980. *You, I, and the Others.* Carbondale and Edwardsville: Southern Illinois University Press. London and Amsterdam: Feffer & Simons, Inc.

REPLY TO JACQUELYN ANN K. KEGLEY

Jacquelyn Ann K. Kegley has made a great effort to deal sympathetically and generously with my views, acknowledging that I have tried to do justice to both the One and the Many, particularly when dealing with humans. She has not taken note of what is maintained in *Toward a Perfected State* where, I think, some of her criticisms were anticipated and met. What still remains is what appears to be an unbridgeable gap between her and Royce's view and my own, about what communities could be, and what humans can and ought to do. She fears that an "essential radical plurality of beings" will end with the acknowledgment of only a "superficial togetherness." There is, of course, a reverse risk run in placing an emphasis on the common: it could end with the acknowledgment of a "superficial separateness." A One and a Many need one another. On that truth, I think, we are in agreement. It is necessary, too, to show they are joined. I think I did that not only in *Toward a Perfected State,* but in *Creative Ventures* as well to which she does not refer. Still, what was achieved in earlier works suffices, I think, to overcome the difficulties she raises, and to expose serious limitations in the view she shares with Royce. First, though, it is necessary to recognize that the ultimates are not categories but realities, and that they jointly constitute whatever actualities there are.

Each human is an individual, with a character, privacy, and a possessed body. Through the use of these, each is able to be together with others, while continuing to be singular and apart. As together, they are able, with the help of the ultimates, to form various groups, of which societies (or "communities" as she and Royce call them) and states are conspicuous instances. No human is just a member of them. Most have

families, some have friends; some are tied closely to others through love, hate, submission, or domination. The Roycean "community" is no more than an airy abstraction if it does not take account of the cross-graining that these provide. Indeed, it will make it into the very kind of 'superficial togetherness' that she thinks endangers my view. Humans are together in various kinds of unions, some of which last for only short times. They are then sometimes with one another more intimately and firmly than they are when together in a community. There never is a time when any one is entirely cut off from all other, if only because they share a common language, needs, experiences, and practices. The problem of the One and Many is solved by each, apart from the solution they provide by interplaying with the traditionalized, conditioning community in which most live episodically.

Humans are also together with nonhuman beings. There never was a time when they were not with others, and never a time when they were not apart. The problem of the One and the Many has already been faced and solved in limited and unreflective ways by each, for each is a singular, encompassing individual, a character, and a possessed person and body. As joined in a community, they form one of a number of complexes, all of which are inseparable from a greater that encompasses all of them. The absolute idealism that controls Royce's claims led him to skip quickly beyond the actual small and fluctuating unions humans form and to attend to an ideal grouping that, I think, never was and never could be.

These observations seem to be pushed aside by Kegley's claim that a genuine community is created by free, self-conscious, self-created, self-committed individuals and that, in turn, the community supports and fosters their development. I must have missed something. Do infants belong to that community? Is the community created? If it is, who creates it? Could anything be self-created? Does the community support and foster the development of the supposedly self-created individuals? Will individuals not always be distinct, independent, obdurate, and unduplicable?

A community has a nature, history, and power of its own. It can mold a people. What it cannot do is to absorb them, make them into miniature versions of itself. Indeed, it needs them to be independent of it so that it and they can help one another. They will be at their best when, while remaining distinct, each maximally benefits the other. Conversely, an actual community has its own reality, enabling it to interplay with its members. That is possible, not because it is the Absolute miniaturized, but because it instantiates ultimate conditions and thereupon can

contrast with what it contains. If a "genuine community requires shared understanding and cooperation" then there never has been one, and there is no reason to believe that there ever could be one.

Let it be supposed, despite what has just been said about "we," that I acknowledge only separated individuals. That still would not preclude their control of or by a common tradition, language, or practices. Not necessarily intrusive or effective at every moment and in every place, a community qualifies and is qualified by individuals acting separately and together. They would form a united Many, while the community that supervened over the result would add another One that, with the Many, constituted another Many related to another One. All the while, the One and the Many would continue to have realities and functions apart from one another.

Kegley asks "what mechanism allows individual centers of will and action to overcome their pursuit of self-perfection and what keeps them from indulging in self-seeking?" They could try to be perfect. Their effort would not then be equatable with a 'self-seeking' if by that, one means to refer to what is good for oneself alone. One who is perfected is all she can be in a world where there are others who are both apart from and together with her. The perfections humans seek for themselves is made possible by their community, but it is pursued by them as individuals and is to be made to be integral to them as individuals. While in a community, each continues to remain outside it, converting what is obtained from it into what enriches what is apart from it. Must not the community be enriched by them? Yes, but not because it is nobler. They need one another so that they can realize a common ideal glory.

Kegley asks, "Can an ignorant being . . . act on the absolute good?" I am not sure whether or not she thinks that the absolute good is already real, nor am I sure what is meant by 'act on'. If by an 'ignorant being' she means me, and by the 'absolute good' she means an ideal, the answer is that I can act on it in one way and it can act on me in another. I can strive to realize it, and it can limit, guide, and contribute to what I do. She says, instead, that "what is sought is a unique blending of individual components so that the whole would be changed if one of the components is changed or eliminated." An Hegelian Absolute might be such a whole; is it what any one human seeks?

One may try to perfect oneself and help others perfect themselves. Often enough the nature of that perfection is misconstrued, unacknowledged, or obscured by more immediately attainable or attractive prospects. Some speak of trying to perfect a people, and believe that this is best done by perfecting the community, perhaps by insisting on its values, traditions, and prospects. Sometimes the people are ignored or

even injured in the attempt to produce a better community. We do make advances again and again, but usually by enhancing people and not the community. I think perhaps Kegley would agree. (Apparently, I misled Kegley in my reference to the coxswain when I spoke of him as though he were not part of the crew. He is.)

Kegley says, "Loyalty and love for a united community and the community's loyalty and love for the individuals is what is needed." Can a community be loyal? Can a community love? Can a community be loved? Should I love everyone? Could I? Is love not too precious to be spent on any but a few fellow humans? I cannot love many, not only because I haven't the energy, opportunity or interest, but because they do not deserve my loving them. I do not love Hitler or Stalin. In fact, I despise them. I despise bigots of all kinds though not to the degree that I despise those who kill children because of their dislike for their ancestry, color, religion, or parents. Were I the father of one who was responsible for such despicable acts, I would, I think, love him, but my love would be drenched with shame, sadness, and even a feeling of guilt. The love of which Royce speaks and Kegley apparently endorses, is at best just good will. It is not to be despised, but it still is not love, or within the power of a community to elicit. No community deserves to be loved; I doubt that any community ever has been or will be.

Is not Kegley's and Royce's reference to a beloved community just shorthand for the Absolute, and this a veiled way of referring to God? Despite the horrendous tales in sacred books about God having the innocent first-born of the Egyptians killed, as well as the unborn in wicked cities, or by a world-wide flood, it is conceivable that God might still love everyone and deserve everyone's love as well. No community, though, is a God, even in a miniaturized form.

Perhaps nothing more is intended than that we should respect the community, try to improve it, and limit our self-centered activities? Perhaps Kegley is urging that the community be sinuous enough to accommodate the faltering moves that its members make when they try to live well together? These surely are admirable objectives, but they must not be allowed to get in the way of individual occupations with what individuals can realize by and for themselves. They are not likely to do that if they do not individually commit themselves to realize it. A commitment to enhance the community is neither primary nor superior to all others. It can, and it should be added to other objectives or, better, it should provide a setting in which each strives to encourage and support the others.

In a spirit of reconciliation, Kegley remarks that "Royce's vision of community" is close to what I once referred to as "the absolute good."

She then goes on to wonder how one whom I would take to be truly moral could escape "the Promethean pride and loneliness . . . balancing egoism and altruism, adventure and humility without the help of others," and then (quoting Winthrop), become a member "of the same body." We have not become such members. That is why we are being exhorted. Nor should we try to be such members, if that means that we should deny ourselves and therefore the status of humans who can be individually perfected.

We need the help of others in order to be ourselves, but if we do not try to perfect ourselves apart from the rest, we will not be able to make maximum use of what they provide. Each needs the help of others. There would, though, not be much gain from an achieved good as there could be, if we did not individually embody it. The spirit of Kegley's account evidences that this is what she, too, believes. It is regrettable that Roycean slogans have been allowed to get in the way of her saying so.

P.W.

16

Eugene Thomas Long
PHILOSOPHY AND RELIGIOUS PLURALISM

During the past two decades we have moved into a new era in the encounter among persons whose religious faith has been shaped in different cultural, historical, and psychological contexts. It is often argued that the boundaries of our particular histories are being expanded so that some of the sharp lines previously drawn between religions formed in different historical contexts are becoming blurred. And more theologians and philosophers of religion argue forthrightly that there is no justification for any one faith tradition claiming that religious knowledge and salvation are its unique possessions or that it is the fulfillment of other religious claims and the standard by which they are to be measured. It is customary in these discussions to distinguish between religious exclusivism, inclusivism, and pluralism. On the exclusivist account, it is maintained that religious truth and salvation are present in one's own tradition, that religious truth claims are universal and absolute and that other claims to truth and salvation are false. An inclusivist is one who is open to the possibility that religious truth and salvation are present in other traditions but believes that these truths are corrected and fulfilled in his or her own tradition. Religious pluralism is the view that holds that different religious traditions reflect different cultural and historical approaches to or manifestations of divine reality, that all religious claims to truth are historically and culturally conditioned and that no one tradition can claim universal and absolute truth.

Paul Weiss addresses the issue of the competing claims of the world religions in *The God We Seek*. This book was published in 1964 at a time when many theologians and philosophers of religion were just beginning to get out from under the domination of the Barthians and the logical positivists. Karl Barth represented the exclusivist approach to the issue of religious truth and salvation. He and his followers insisted that religions represented sinful efforts of persons to grasp God, that salvation

and knowledge of God were fully dependent on God's revelation, and that God had revealed himself exclusively in Jesus Christ. Logical positivists argued that religious utterances failed to meet the tests of verifiability and falsifiability and hence were not assertions of truth. In *The God We Seek* Weiss separates himself from both the Barthians and the logical positivists. Weiss argues that religious utterances do make truth claims about reality and as such are subject to rational evaluation. He also recognizes what I would call the definitiveness of particular religious claims for members of a community of faith but insists that these claims are limited by the civilization and culture within which they appear. I would classify Weiss as a religious pluralist although there are, of course, different forms of religious pluralism.

Weiss argues that religious persons normally come to an understanding of themselves and God within the context of their particular communities of faith and that each community claims and, he says, must claim, that it alone is right and others wrong. But if this is so, how can we deal with the fact that different religions present conflicting truth claims? Weiss answers that we can deal adequately with this question only if we recognize that there is a knowledge of God independent of all particular religions. There are, he says, many ways to make contact with God apart from appeals to miracles and special revelations. Among these are proofs for the existence of God, experience of the ultra-natural, religious experience, meditation, religious faith, and particular dedicated communities. If we are to be able to deal with the issue of conflicting truth claims, we must attempt in these and other approaches to overcome the parochialism of the particular religions and seek "to isolate the pure undistorted relation men have to God; a relation which is diversely ritualized and specialized by the various religions."[1]

At times it sounds as if Weiss is suggesting that one should give up one's concrete religious faith in favor of an abstract religion of the philosophers. But that is not his intent. He says that what is sought is not a distillate or abstract dessicated element of the religions, "but something at least as rich and as concrete as the specialized forms of experience and concerns exhibited in particular religions—but without their bias."[2] Weiss acknowledges a distinction between the God of philosophy and the God of religious faith, but for him they are not two unrelated entities. They "are related as ground and consequence, whole and subdivision, being and role (persona). Their unity is sensed by the mystics and explicated by the systematic philosopher."[3]

Among the approaches to knowledge of God which stand apart from appeals to special revelation, there is the speculative and systematic approach which Weiss developed in an earlier book, *Modes of Being*. In

that book Weiss was primarily concerned with providing a rational speculative foundation for religion through the development of multiple proofs for the existence of God and an analysis of the nature of God in view of what else is known about reality. Weiss does not argue, however, that one can prove that God exists whatever the presuppositions one holds. In a later book, *First Considerations,* he refers to the arguments for the existence of God as parts of a single intensifying movement which begins with what is partial and moves towards an ultimate unity which the religions call God. He does believe that the speculative approach is necessary if we are to speak of knowledge of God in the strict sense and if we are to be in a position to provide an apologetic for a given religion. Unless one knows independently of religion what the reality of God is like, says Weiss, one is in no position to say whether or not some particular religion does justice to the nature and activity of God.

Speculative knowledge of God, then, is crucial if we are going to come to knowledge of God independent of appeals to special revelation, and this kind of knowledge is essential to our understanding and justifying the awareness of God appropriated within a particular faith tradition. However, in itself such knowledge is too unemotional to have much religious import. We need, says Weiss, more than a speculative knowledge of God "if we are to properly grasp what and that He is, and how He is involved with what lies beyond Him. We can be sure that there is a reality to be reached only if speculative knowledge (with reaching and representation) are matched by an enjoyment of and access to God."[4] Weiss's aim in exploring the various approaches to God, starting from data open to anyone, is to isolate what he calls the nucleal core of all religions. "Behind the Gods of the various religions," writes Weiss, "is an ultimate inescapable being which is irreducibly real and effective here and now, no matter what men may say, think, or do. This is not a mere being, a 'God beyond God', but God Himself freed from the particulars added by particular religions, but not freed from an involvement with man and other realities."[5] To find this nucleal core which is concrete and vital but also free of the bias of the particular religion and hence purer, Weiss says we must return to what he calls the ultra-natural and religious experience and use them "to guide a recovery of the essence of the dedicated community and a life of faith."[6]

The experience of the ultra-natural is contrasted with the world of common sense. Common sense, which is understood as the basic faith of mature persons is, according to Weiss, "at once real and artifactual. The objects in that world are in part the termini of sound perceptions and successful practice and in part the products of social opinion."[7] This is the world in which we normally live and it should be neither ignored nor

accepted uncritically. When we become aware of uncertainties in the world of common sense we withdraw and reflect in a more sustained way, and it is this that leads towards the sciences and the humanities. By the ultra-natural Weiss has in mind something like what the existentialists have referred to as the experience of anxiety. This experience is said by Weiss to have no direct religious import, to precede mature reflection, and to be available to children long before they may be called religious in a definite sense. In the experience of the ultra-natural we find ourselves cut off from the ordinary world of common sense in disturbing and unusual ways. We have the sense of being torn from the familiar and secure, of feeling threatened in the face of the unknown.

> It is because we are aware of the ultra-natural that we are so sure that, no matter how much we know, we do not know everything; that no matter how strong we are, we know that we are weak, inadequate and transient; that no matter how deeply immersed we are in daily affairs, we know that our daily world does not exhaust reality.[8]

In this experience, says Weiss, philosophers have referred to our encountering a number of distinct realities including a final good, an ultimate rationale and an environing nature. All are present in some way, according to Weiss, and it is when we feel abandoned and cling to something final that we may be said to catch a glimpse of God, albeit dim and interlocked with other realities.

By religious experience, Weiss has in mind something like that of which Schleiermacher and Otto speak. Religious experience, Weiss says, "brings us into relation with a felt power that assesses what we are and have attained."[9] And if "we open ourselves up to a religious experience, we will not only make contact with God, but will discern something of the nature and power He has outside the experience, making the experience possible."[10] In religious experience God is held to be constitutive of the experience itself, not merely an inference from it. Weiss acknowledges that mystics appear to speak of direct experience of God. But for most of us, he says, religious experience is not always clearly differentiated from aesthetic, ethical, and secular experience, and it is "mediated by concepts and beliefs, and known only with hindsight through the help of various guides, such as creeds, beliefs and speculations."[11]

If I understand Weiss correctly he is arguing that we have both speculative and experiential knowledge of God independent of a particular or concrete religious faith. Speculative knowledge in and of itself is too unemotional to have much religious import. And experience of God in the ultra-natural and even in religious experience in the more

distinctive sense are held to result only in a vague awareness of the reality of God. It is in participation in a dedicated community and in an act of religious faith that this understanding of God is filled out and given concrete content.

Religious faith in its various concrete forms is understood by Weiss to have a common core that tells us that an eternal power ennobles us. Religious faith is required if we are to reach God who is other than all other entities; it is required if we are to find a ground for the claim that God loves us, forgives and heals us. Religious faith combines many factors. "Together these make up an attitude of belief that one is eternally cherished and is so far of great value. It contains elements of hope, of conviction, and of confidence. All of these are oriented toward that which makes it possible for a man to be forever ennobled."[12]

Religious faith as Weiss understands it is belief-in. It involves trust and commitment. But he argues that religious faith cannot become this until it has acquired some of the virtues of true belief or belief-that. "True beliefs make faith possible, and faith in turn allows us to credit true beliefs with an unquestioning assurance no confrontation of fact would produce."[13] Religious faith, according to Weiss, transcends the boundaries of particular religious traditions and it is faith in the universal sense that is said to help provide the basis for a minimal nucleal theology. However few persons can be satisfied with such a minimal theology. Faith takes many forms and these forms are inseparable from decisions regarding what a person is and what a person ought to be, decisions that are at times culturally conditioned and at times condition the culture. Since religious faith takes different forms and is inseparable from its historical and cultural settings, we always fall short of a pure faith. Because of this, says Weiss, faith

> ought therefore to see itself as in an endless process of improvement, guided by what it has learned from a neutral study of God and religion. The neutral study lacks the drive and lure of any of the religions and will never by itself satisfy men. But it is indispensable if religion is to become more than the practice of men who disdain and sometimes try to destroy one another because they show their love of God in different ways.[14]

Although Weiss recognizes the historicity of particular religious claims he argues against pure relativism. Taken on its own terms each faith tradition is in some sense unique, incomparable, and final. But religious traditions go beyond this, compare themselves with others and often make absolute and universal claims setting their traditions above others. Each religion in this sense claims and, Weiss says, must claim, that it alone is right and the others wrong. A religion in this sense is said to be a dedicated community viewed from the outside. Its truth claims,

however, may conflict with truth claims of other religious traditions. Weiss recognizes that at times a religion may speak of itself as tolerant of others, willing to recognize the truth and value of other religions. In practice and theory, however, he believes that such religions mean that other religions are fragments of, anticipations of the truth and value which are actually present in their own religious traditions. No particular religion, he says, sees itself as part of some more inclusive religion or as merely one among equals.

Weiss recognizes a distinction between faith and belief and between faith and religion. For him faith transcends the limits of a particular culture and history. Nevertheless faith comes to expression in beliefs within particular historical contexts. And persons within different cultural and historical traditions often assert the universality and absoluteness of their beliefs in contrast to the beliefs of others. Weiss argues that since these claims make assertions about reality we cannot ignore the conflicts among beliefs. In order to deal with them, however, we have to stand outside any particular faith tradition. Looking from outside all particular circles of faith at the apparently conflicting claims of truth we face several options. We could, says Weiss, take up the position that all religions are equally or completely in error. There is some justification for this. The history of religions shows, for example, that religions are encrusted with superstitions and distortions, and religious reformers often call their own traditions into question. Weiss admits that it is possible that all religions are equally unsound, but this seems unlikely since some are more inclusive than others and some are more consistent with the prevailing morality, culture, and civilization. One might also consider that all religions are equally true. There is a sense in which all religions may be said to be satisfying a single religious drive and perhaps all religions could be said to be true in this sense. But even if this were the case this is different from saying that all religions are equally true. Each religion insists that this drive is fully expressed in its own doctrines and practices, some of which are in conflict with other practices and doctrines.

This leaves the option of maintaining that all religions are partly true and partly false. This alternative, however, can take several different forms. Weiss rejects several of these including the theosophist form. Theosophists begin with religions in their particularity and try to spell out the truth that they share in common. On their view all religions hold the truth in common but express this with different degrees of success. Weiss rejects this view on the ground that even if a common denominator could be discovered in all religions, the result would be a replacement of the life of living religions with a universal category which others then would see as merely one among many. Weiss also rejects the form of this

alternative that argues that different religions represent different roads leading to the same ultimate truth. On this view ultimate truth is beyond all religions and each religion is true to the extent that it points to this truth and false to the extent that it believes it has already reached this truth. This approach, says Weiss, is never able to tell us what this ultimate truth is. It also ignores the claim of each religion that it has more of the truth than other religions.

In saying that all religions are partly right and partly wrong, Weiss means that "all religions are right in their limited circumstances, right in just the time and place, the civilization and the culture in which they appear."[15] This does not mean, however, that particular religions are just different roads to the same mountain top. Each religion is understood to specialize and make concrete some absolute truth within its particular historical context and "It asserts what is true, not merely as a function of the context in which it is found, but as a consequence of looking at what is objectively true, though from and within that context."[16] Weiss allows that for the religious person the whole truth is grasped within the limits of his or her context and that, within the context of all other things that are accepted by persons in this society, this is the religion that person should have. "Just as a man ought to love his own mother or wife and not the others' so he ought to subscribe to his own religion and not to others, even though, in their own terms, they are not inferior to his own."[17] A religion errs only when it forgets that the truth with which it is concerned is the whole truth only within the limitations of its particular context.

If I understand Weiss correctly he is arguing that a person within the context of his or her particular faith tradition can and should claim what I would call definitive truth. That is, within the context of my own history the particular knowledge of God which forms the focus of my existence is held to be normative and perhaps even in some sense final for me. This is an affirmation of faith made within a particular historical context. This is not to say, however, that it is complete or universal or that it is the kind of knowledge one might have were one able to transcend the historical process in which one is engaged. What Weiss calls objectively valid knowledge is said to be attained only if one stands outside religious faith in any of its particular forms and evaluates religion in a neutral spirit.

Weiss argues that there is an objective or universal knowledge of God which is not limited in the way that the knowledge of a particular religion is limited. And this knowledge is available independent of appeals to the authority of the revelation of any particular tradition. This is the knowledge of God that can be had through philosophical reflection on

the various approaches to God. In this way we can cut away the specific details that one religion adds in conflict with others and seek to free religion from errors while recognizing the particular ways that persons turn to God and God to persons. The knowledge that the philosopher has is an idea of God which is a possibility to be specified in different ways in the different religions. "What the religions allow is actualized in a true philosophic characterization of God, and what the philosophy affirms is actualized in the shape of various relativizing religions, no one of which may be true. Each can offer a check on the other if independently developed."[18] And this neutral approach is said to provide a basis for evaluating the God concepts of particular religions. All religions are said to embody and point to God, but how do we evaluate them, how do we determine which religions do this best?

> This question cannot be answered except by first going outside all dedicated communities and getting to know God speculatively; second, by isolating the common indispensable nuclear components and referent of all religions; third by noting which religion distorts or obscures this the least; and fourth, by seeing which contributes to the fullest possible life for man.[19]

Weiss has more confidence than I in the objectivity and universality of the claims of philosophical systems. Philosophical systems, as we have become increasingly aware during the past two decades, also have to come to grips with the possibilities and limitations imposed upon them by their own cultures and histories. Philosophical truth is also historicized, and philosophies of religion also reflect a point of view. Nevertheless Weiss may be understood to offer a correction to those that have taken this idea too far. Weiss recognizes that there are competing philosophical systems and that each system has to be aware that it might be wrong, that it might fall short of its goal as a result of omissions, incompleteness, and incoherence. But unlike religion, he argues, the philosophical system stands open to a public community of critical and objective inquirers, the purpose of which is to see if it is the ultimately true philosophy doing justice to all reality. By contrast he argues that a religion rejects the view that it is subject to external tests and affirms its truths dogmatically.

Weiss is certainly correct to point out the difference between religious faith in God and philosophical faith in a particular system of philosophy. Religious faith is not merely tentative; it involves some kind of ultimate commitment. Nevertheless Weiss goes too far in claiming that religion "regards no evidence as ever capable of affecting its claims in any way," that "no religion allows that it might be in error," and that a particular religion "does not merely *claim* to be the true religion; it affirms this

dogmatically and brooks no denial."[20] One can certainly find examples to illustrate Weiss's claim, and perhaps these were even more prevalent at the time that he wrote *The God We Seek*. But it is not necessary that members of particular religious communities understand themselves in this manner. One can find examples to suggest that many religious thinkers view their faith traditions as providing what I have called definitive albeit not universal and absolute knowledge. Many major theologians also argue that religious conviction is in principle falsifiable and must be at least compatible with what we learn in other ways about reality. Many are also open to the possibility of truth and salvation in concrete religious traditions other than their own. Weiss himself acknowledges this possibility.

> Those who take religion seriously have the choice of looking at it in the neutral spirit which this work has attempted to exhibit, or of engaging in one of its biased, limited forms. In the one case there is objectivity, catholicity, but a failure to enjoy the presence and the living search for God; in the other there is vitality, concreteness, involvement, but a failure to do justice to the grandeur of God and the universal spirit of religion. He who is without faith must be content with the former; he who is convinced that only his religion is right will be content with the latter. A fortunate few will be members of particular religions who know that there are other legitimate though limited religions, each of which exhibits in a distinctive way the fact that God is and interplays with men in other parts of this world.[21]

Those among Weiss's "fortunate few" will know that there are other though also limited religions that exhibit knowledge of God in distinctive ways. These persons would not hold that any particular religion is the religion for all persons. From this point of view missionary efforts would be directed towards the members of one's own tradition.

> All religions on this view can be said to agree in that each grants that it and others have found legitimate, exclusive, and conspicuous avenues for getting to God. Each will claim no more than that it stresses only some occasions when God is rightly acknowledged, and it will claim no less than that there are other occasions when God is rightly acknowledged, and it will claim no less than that there are other occasions when God is rightly acknowledged by men who are committed in other ways.[22]

God, according to Weiss, cannot be confined within the limits of any one religious faith. God is richer in being than any one religion can express.

Weiss, as I understand him, does not draw as sharp a line between natural and revealed knowledge of God as did some classical thinkers. When natural and revealed knowledge of God are separated too far from each other, revealed religion is fenced off from the critical or philosophi-

cal intelligence. Weiss's approach allows the philosopher to articulate and examine the underlying beliefs that a particular faith gives expression to in the symbols and dogmas of the tradition. Philosophical speculation and the isolating of what Weiss calls the nucleal components and referents of the particular religions enable a person of a particular faith to come to a more critical appropriation of his or her faith and of the relation of this faith to other faith traditions. Weiss's approach, it seems to me, also opens up the possibility that the boundaries of one's religious history and culture might be expanded. He suggests that one religion can enter into the contexts of other religions providing it is willing to undergo a change in stress, pattern, and perhaps meaning. Yet Weiss does not believe that philosophical inquiry can replace concrete religious faith and the theologies which emerge from these faiths. "No philosophy of itself," he says, "will enable the individual and God to interpenetrate."[23] His aim is to avoid those positions which make philosophical knowledge of God merely a generalization of a particular religious faith and those positions which tend to impose a particular philosophical account of God on the interpretation of a particular religion.

> A philosophy should allow for a plurality of religions; it is to be tested by seeing if they all serve as beginnings for an intellectual speculation which arrives at just that philosophy. A religion should allow for a systematic philosophy; it is to be tested by seeing if the philosophy gives an account of God for which the religion provides further details, and which are in fact encountered in religious experience, in a religious community and in worship.[24]

Weiss is making an effort to preserve a subtle balance between philosophical and religious knowledge of God. Although he insists on the importance of philosophical knowledge of God independent of revelation and faith, he does not believe that this can be a substitute for or even a competitor with the several concrete religious faiths. Religion for him is more than an intellectual vision of God. Philosophical knowledge of God lacks both the convicting power and the particular knowledge of concrete religious faith. It is also the case, however, that on Weiss's account philosophical knowledge of God is not merely a propaedeutic to concrete religious faith which thinks of the truths of religious faith as beyond the scope of philosophical reason. Rather philosophical knowledge is understood to provide a philosophical framework within which one may better understand, critically evaluate, and in this context defend the truth claims of concrete religious faiths. Philosophy and concrete religious faith seem to be partners in a dialogue which helps make connections

between the worlds of religious faith and ordinary human experience and the worlds of concrete religious faiths which have been formed in different cultural and historical contexts.

EUGENE THOMAS LONG
DEPARTMENT OF PHILOSOPHY
UNIVERSITY OF SOUTH CAROLINA
MAY 1992

NOTES

1. Paul Weiss, *The God We Seek* (Carbondale: Southern Illinois University Press, 1964), p. 8.
2. *GWS*, p. 8.
3. *GWS*, p. 11.
4. *GWS*, p. 7.
5. *GWS*, p. 157.
6. *GWS*, p. 150.
7. *GWS*, p. 14.
8. *GWS*, p. 16.
9. *GWS*, p. 52.
10. *GWS*, p. 51.
11. *GWS*, p. 55.
12. *GWS*, p. 195.
13. *GWS*, p. 205.
14. *GWS*, p. 215.
15. *GWS*, p. 152.
16. *GWS*, p. 152.
17. *GWS*, p. 152.
18. *GWS*, p. 155.
19. *GWS*, p. 135.
20. *GWS*, p. 154, 156.
21. *GWS*, p. 157–58.
22. *GWS*, p. 158.
23. *GWS*, p. 108.
24. *GWS*, p. 156. Although in this essay I have suggested some places where I have differences with Weiss, my primary intent has been to provide a discussion of Weiss's own approach to the issue of conflicting truth claims. I believe in fact that I share many fundamental principles with Weiss although we begin at different points. I have attempted to deal with some of the questions raised in this paper in "An Approach to Religious Pluralism," in Alistair Kee and Eugene Long, editors, *Being and Truth. Essays in Honour of John Macquarrie* (London: SCM Press, 1986) and "Religious Pluralism and the Ground of Religious Faith," in J.F. Harris, editor, *Logic, God and Metaphysics* (Dordrecht: Kluwer Academic Publishers, 1992).

REPLY TO EUGENE THOMAS LONG

Eugene Thomas Long can always be counted on for a sober, clarifying exposition of whatever topic interests him. It is not surprising to find that most of his account of my examination of religion is objective, judicious, and sound. Nevertheless, I am disappointed to discover that he did not find time to examine such central issues as the nature of prayer and religious language. Others have taken them to be central and illuminating parts of my study of religion. There is still need of a discussion of them within the context and in the spirit of Long's present discussion.

Long takes me to be a 'religious pluralist'. Since I am not at all religious, it would have been more accurate to say that I tried to determine the warrant for religion, no matter what the form, creed, or practice through which it was expressed. I tried to take as full account of individual beliefs and acts of worship as of community practices and demands. The spirit quickening my study was also expressed in my examinations of art, sport, history, education, mathematics, etc., in not all of which I had firsthand experience. Not being a major contributor to any of them, whatever observations I made and my ensuing reflections were those of one who tried to understand, as free from preconceptions as I could manage. All can be taken to be explorations by one who struggled to be at once sympathetic and detached, trying to learn while testing the strength, comprehensiveness, and warrants for what was claimed.

I would say today that I am more sympathetic with and yet more skeptical about references to God than I have ever been, the one when I think of the pious, the other when I read what philosophers and theologians claim to know about His reality, nature, and acts. I have never seen a good, justified account of what God is, does, or knows, granted that He exists. So-called proofs of God serve mainly to show how

far earnest men will go in order to back what they firmly believe. If they are philosophers, they tend to take God to be the catch-all for the problems their views raise but cannot resolve. Contingencies are left unexplained. No advance is made if one says that God, or all his acts are also contingent. Recourse to an 'ontological argument' with its supposition that the existence of a necessary Being could be dependent on a conception, a formula, or an independently stated claim, a logical argument, or references to a 'self-cause' distress even some of those who would like to back their faith, whether this be weak or strong, with a proof that does not require them to act as if they were weak-minded. The most a philosopher could justifiably claim about God is that such a reality is not impossible and that a religious faith could conceivably terminate in Him as behind, within, or beyond whatever reason can reach.

Religions do not offer a check on the viability of a philosophy in any other sense than that of making evident that a philosophic rejection is no more willful than is an acceptance of religions' claims to reach God.

There is now a subsection of the American Philosophic Association devoted to 'Christian Philosophy'. Similar subdivisions devoted to 'Jewish', 'Islamic', 'Vedantic', and others should not be far behind, to be followed, with equal warrant, by societies for 'fat philosophers', 'atheistic philosophers', or 'one-eyed philosophers of Greek extraction'. Will these different societies try to adjudicate their differences, or will they just ignore one another? What societies would be excluded from enjoying the privilege of a room and a place on the program? Should not philosophers subject their most cherished beliefs to a questioning that might end in those beliefs being rejected because they lack sufficient warrant? Would any of the exclusively denominated philosophies permit that?

A philosophical study of religion is eminently desirable; if it is to be endorsed by the accepted official association of philosophers it should be open to any one, with no other precondition than that she be a philosopher. Surely it is not impossible for what is religiously terminated at to be understood by a philosopher if it is presented as a topic to be discussed without preconditions. A discussion of the merits of a religion should be left to synods. I am not here criticizing religion; I am just defending philosophic forums in which any relevant claim is open to honest examination, and nothing is prejudged by being limited to topics presupposing nonphilosophic affiliations or commitments.

Many a philosophic account of religion is little more than a feeble theology making careless use of philosophic terms. When the theologies are sheared off, it becomes painfully evident that recourse has been had to 'God' when one's thinking has stopped. What would have been lost in Whitehead's account had he replaced his reference to 'God' with a

reference to an eternal, unaccounted-for pivot? It is saddening to see some today using his view to support the claims of their different religions and exhibiting the dogmatic attitudes he deplored.

Victor Lowe traced Whitehead's concern with religion to his reaction to the death of a son in the First World War. That I think was not only an offensive intrusion into the personal life of one who suffered a great loss, but showed a disrespect for the intellectual viability of religion. An interest in religion does not indicate that one is religious or that the solace this may claim to provide is why religion was made the subject of a philosophic inquiry. Whitehead, in fact, had a life-long interest in religion. His references to 'God' in his cosmology have little or no relevance to a religious belief or commitment.

Long says that he does not have as much confidence as I have "in the objectivity and universality of the claims of philosophic systems." It would have been helpful had he revealed his reasons for his doubts. There can be little question but that various philosophers, and I as well, have made claims that deserve to be examined, to see if they have been adequately defended. No one, to be sure, achieves the position of a completely detached mind, no human achievement is without flaw, not even the skepticism and rejections that feed on these. It is a nice question to determine whether one is more likely to produce a defective work if one tries to be all-comprehensive or just focusses on some limited area encased within frames that are not examined. The latter I think exhibits a failure of nerve. A philosopher should put nothing beyond question, not even what he fervently hopes for and perhaps fears.

Long says that philosophic truth is "historicized." Is this not true of his claim as well? If it is, what weight is to be given to it? If not, how did he escape the presumed universal blight? How much trust does he expect us to put in his claims? Has he not begun to slide down the slippery hill at the bottom of which he will find those who are trying to "speak the language of mankind," though this has no known vocabulary or grammar, and is never used or addressed by anyone?

Long says I go "too far in claiming that religion regards no evidence as ever capable of affecting its claim," and also when I say that "no religion allows that it might be in error." I wish he had provided instances justifying his claims. I did not intend to deny that some condemnations have been withdrawn, some dogmas have been modified, that religions have fragmented, or that there have been ecumenical councils introducing changes in dogma and practice. I know, too, that there are theosophists who say that they accept all religions, but I also know that they add that only their accommodating view finds a place for all the others. One need not go that far to find expressions of accommodations. The Roman

Catholic Church now says it was wrong for it to have condemned Galileo's astronomical view. That has not led it to question its view of a divine creation or to account for when or how the first persons came to be. Errors are readily admitted by religions once the admissions are understood to leave the primary claims untouched. I think, in fact, that the Catholic Church is now as hasty as it was before, for the charge against Galileo was not that he made astronomical errors, but that what he said was not in accord with what the Bible was understood to say. That still is true.

Christians speak of preserving and carrying forward what is true in Judaism, but they withdraw in shock from the Muslim claim that it preserves and carries forward what is true in both Judaism and Christianity. All three speak warmly of Father Abraham, despite his determination to commit infanticide. The Muslims take Jesus Christ to be the greatest of the prophets who lived before and were superseded by Muhammed.

A particular religion's supposed open-mindedness is not well received by other religions, for these are not interested in being endorsed or accommodated by others on the terms those others provide. None could admit an error in its central doctrine, without ceasing to be that particular religion. No philosophers live behind such barriers.

I once asked a professor of theology whether he thought that he was able to do full justice to the import of the Buddhism that he was expounding? He said, "Of course. I read the literature with sympathy, visit the temples, speak to the leaders. . . ." I then asked him if he thought that a Buddhist could grasp the import of Christianity, if only the Buddhist were equally sympathetic, visited the churches, read the literature, and so on? He vehemently denied that that was possible. I have been at ecumenical councils; the participants were friends, respectful, and knowledgeable, but beyond convincing by members of other faiths. Show me someone who is acceptant of all religions, or even of one or two in addition to his own, and I think I would not find it hard to show you someone whose religion is no more than a cultural expression.

To be religious and not to be committed in a particular way is a contradiction in act as well as in idea. Only a mystic who belonged to no religion could avoid adhering to and accepting the claims and the claim-encrusted practices of some particular religion. Did he have no ties to any religion, he would obviously not be a religious mystic. It is hard to know whether he would be anything more than a metaphysician with a poor vocabulary and not well-focussed ideas.

Is it true that philosophy and religion are "partners in a dialogue?" How could they be? Who adjudicates the differences? Do these vanish

simply by putting questions and receiving answers? A dialogue can go every which way. Who will keep it on track? Who will decide that one side or the other has made an advance?

I tried to show in *Creative Ventures* that there is no likelihood that rulers and ruled would be equally occupied with the achievement of justice for both, and that the most that could be achieved is their submission to the guidance of a statesman who enables them to make different but compatible contributions to the realization of an ideal justice. If religions are to be reconciled, despite the different commitments and practices that they deem essential, one needs a similar guide, and surely more than a dialogue. Does Long think that any dialogue would convince orthodox Jews and Muslims that it is permissible to eat pork or that it is not blasphemy to invoke the name of God on behalf of dogs and ships? Philosophers can engage in a genuine dialogue, but they rarely do. It is not possible, even in principle, for those who accept one religion to carry out a dialogue with those who reject their affirmations and practices.

A Jew once saw his friend coming out of St. Patrick's Cathedral. He exclaimed in horror: "Jake, are you converted?" "Yes." "How could that possibly be?" "My doctor told me that I had a terminal cancer. So I said to myself, why should it be one of us? Let it be one of them." I am confident that there have been better motivated conversions, but I doubt that any came at the end of a dialogue.

I do not think it correct to say that I believe we have both speculative and experiential knowledge of God "independent of a . . . faith." I am sorry if I have been unclear on that point. In any case, I would today say that I (or anyone else) have either a speculative or an experiential knowledge of God, unless we identify Him with the Being at which speculative knowledge ends. That Being, though, is not the object of faith or something to be worshiped.

What is now needed is a philosophical examination of the essential components of religion, no matter what the creed. This will go beyond and perhaps rectify what philosophical explorations end with. I think Long could do that. I wish he would. If he did, I think he would find that not only I, but other philosophers as well, and perhaps some religious thinkers, would be much in his debt. There will still be many with a sure, unshakeable faith who will find need neither of him nor of me, unless it be to help them understand what presumably can be reached quite well without us.

P.W.

17

Robert Cummings Neville

PAUL WEISS'S THEOLOGY

At a graduate seminar of Paul Weiss's in the early 1960s, a student concluded a report on Weiss's theory of God with the criticism that the God of *Modes of Being* was not the God of Abraham, Isaac, and Jacob. Most of us during that period believed that Kierkegaardian pronouncements of this sort were marks of philosophical authenticity. To which Weiss replied:

> So? So? What about the God of *Pla*to? What about the God of *Aris*totle? What about the God of Spinoza? Do the religious guys have a monopoly on God? No!! The religious guys are biased by ritual language and by the special commitments of their group. That's OK if you want to *worship* or *serve* God. But if you want to *know* God, go to the philosophers. Only *speculation* allows you to move to God in all ways as neutrally as possible, correcting for bias. If Abraham, Isaac, and Jacob wanted to *know* their God in addition to serving and worshipping, they would have to study philosophy. Which they didn't!¹

In a strict sense, Weiss always held to the distinction between knowing God and dealing with God in other ways that might or might not have important cognitive bearing. In a general sense, however, he has been sensitive to the more dialectical relation between philosophical claims about God and the application and testing of those claims in common experience and in other specialized domains such as religion and ethics.² This essay shall focus on that dialectical relation, not as a matter of methodology but as a dialectical tool for knowing God.

Philosophical theology has not been a consistent interest of Paul Weiss. His first major book, *Reality* (1939), discusses God only in connection with the positions and arguments of other philosophers.³ The next book, *Nature and Man*⁴ (1947), continues that use but adds both a playful positive literary use, as in discussing the Garden of Eden, and also a positive hypothetical use, as in showing what an omniscient God could know of the future; nevertheless, Weiss still said "Philosophy is Godless cosmology" (*NM* 210). In the late 1950s and early 1960s, by contrast, God was a truly important part of his system, one of the four ultimates or

modes of being; the other modes are Actuality, Ideality, and Existence. During that period Weiss wrote a series of books about major areas of human life, each of which was interpreted in terms of one or more of the modes of being: *Man's Freedom*[5] (ethics), *Our Public Life*[6] (politics), *The World of Art*[7] (aesthetics), *Nine Basic Arts*[8] (art), *History: Written and Lived*[9] (historical significance), *Religion and Art*,[10] *The Making of Men*[11] (education), and *Sport: A Philosophic Inquiry*.[12] *The God We Seek* was one of these studies, and each of the other studies save that of sport makes positive reference to God as a direct or indirect condition for the activity in question.

In the 1970s Weiss rethought the whole system of modes of being and developed an ontology of finalities, each of which is a condition for the appearances of our world. This new theory was elaborated in *Beyond All Appearances*;[13] in its preface Weiss states that *Beyond All Appearances* can be read as the first of a two-volume work, with *Modes of Being* as the second volume (adjusted appropriately). But the adjustments are significant enough that Weiss has not sustained the connection with *Modes of Being*. One of the adjustments is that Being is added as a fifth mode or finality (*BAA* 233ff.). Another is that "Unity" is the word that is substituted for what in *Modes of Being* was called "God;" in *Beyond All Appearances* the word "God" is most often used to discuss divinity in other philosophers' theories, although its connection to Unity is still acknowledged. In *Creative Ventures*,[14] his most recent book as of this writing, yet another important shift has taken place. Weiss distinguishes between the modes or finalities, now called "conditions," and the Dunamis, "a primary, pulsating ground" (*CV* 4). Moreover, God is mentioned hardly at all, and then only in terms of an "idea of a god of whose reality no one can be sure and whose actions originate where no human understanding can reach" (*CV* 165). The metaphysics of *Creative Ventures* is far more complex than that of *Modes of Being* or *Beyond All Appearances,* and it is difficult to correlate its categories with those of the earlier works. Whereas in the earlier works God was identified with Unity, in *Creative Ventures* the functions of unity are divided among the ultimate conditions of stratification, affiliation, and coordination as well as the Dunamis; moreover, these conditions, plus the Dunamis, are joined by the individual and the ideal as independently operating items, although only the first two are what Weiss calls "Ultimate Factors" (*CV* 4–7). *Creative Ventures* has no serious metaphysical role for God at all and, in fact, the book explicitly aims to provide an account of various forms of human creativity without making any constitutive reference to God (*CV* 165).

What accounts for the temporary but pervasive prominence of the

philosophical idea of God in Weiss's theory? What accounts for his move from general skepticism about religion to profound analytical respect for religion back to skepticism? My hypothesis is the following. When Weiss took up the central problem of the one and the many, which he did in *Modes of Being* and the surrounding works, God became a significant category for him. Furthermore, the conception of God involved was directly related to both the philosophical and Western religious traditions so that religious phenomena became primary evidence commanding respect. But his solution to the problem of the one and the many, however original and brilliant, was faulty as he soon discovered. By the time he wrote *Beyond All Appearances* in the early 1970s, not only had Being been added to the previous four modes that together had constituted a balanced one-and-many, but the entire problematic of the one and the many receded from his published work.[15] From that time on his preoccupation was less with the metaphysics of the one and the many and more with a phenomenology of finalities. The finality he had identified with God, Unity, was not sufficiently connected, or exclusively connected, with the deep suppositions about God in the Western (or Eastern) religious traditions to sustain a respect for theology as such. Whereas Unity is indeed a theological bias of Hegelians (with whom Weiss has deep affinities), Actuality is such a bias for Thomists whose God is the Act of *Esse,* Ideality for Platonists whose Form of the Good creates the world, dynamic Existence for existentialists and pantheists, and Being for Tillichians. Secular or anti-supernaturalist philosophers such as John Dewey or Justus Buchler can deal with all these topics without a theological reference. If specifically theological concerns can be replaced by various categorial concerns for actuality, ideality, existence, unity, being, and dynamic power, then ancient doubts about God recommend dropping the category. Furthermore, if that is done, religious experience is susceptible to the hermeneutics of suspicion and no longer has much evidential dignity.[16] This, I believe, is the conclusion to which Weiss has come.

My argument in this essay will proceed in the following way. The first section will provide an exposition of Weiss's theory of God in *Modes of Being* as that idea is under the control of the problem of the one and the many and as it is also spelled out in *The God We Seek.* Section II shall criticize Weiss's solution to the one and many problem and shall argue that a conception of God as creator *ex nihilo* is a far better hypothesis, saving the rest of the system of *Modes of Being* and also the later systems, allowing their adjudication to be by an independent dialectic. The third section shall analyze Weiss's use of the idea of God to interpret religious and other phenomena. The final section shall argue that the emergence of

the category of the Dunamis in his latest writings reflects his felt need for a proper theology and shall suggest again the idea of creation *ex nihilo.*

I. GOD AMONG THE MANY

Weiss's metaphysics is a resolute pluralism; given his extraordinary consciousness of the problem of the one and the many during the period of *Modes of Being,* his is perhaps the most self-conscious metaphysical pluralism in Western philosophy, Leibniz notwithstanding. As I reconstruct it, there are two major steps to his pluralistic solution to the problem of the one and the many.[17]

The first step is to draw a distinction between what Weiss calls "essential features" and "nonessential features (*MOB* 280–81 and *passim).*[18] The essential features of a thing are those unique to itself that give it a position of its own and whatever continuity it has. The nonessential features are those a thing has by virtue of being with other things, accidents or descriptive features by virtue of which the thing is conditioned by other things. The nonessential features of a thing provide testimony to the nature and function of the other things. Everything whatsoever has both essential and nonessential features. If a thing had only essential features, it would not be sufficiently related to other things so as to be different from them or determinate with respect to them. If a thing had only nonessential features, it would reduce to the influences of other things and would not even have enough position of its own or continuity from one influence to another to be influenced. So every thing whatsoever is a plurality of at least some essential and some nonessential features. Moreover, there must be a plurality of things providing each other with nonessential features; without this plurality, not even one thing could be determinately what it is and not another thing. This is the most general stretch of Weiss's metaphysical pluralism.

What is true of any thing is of course true of the modes of being or ultimate finalities. There cannot be only one ultimate or one mode of being if it is to be determinate, for it would have nothing with respect to which it is determinate. If the single mode or ultimate were wholly indeterminate, it would be indistinguishable from nothing. Therefore there is a plurality of modes of being, finalities, or ultimates, and each has both its own essential features and the nonessential features each derives from the others.

In this first step of the argument, Weiss has produced an extraordinarily powerful metaphysical conception. For instance, given some basic set

of modes of being, say Actuality, Ideality, Existence, and God (Unity), Weiss can account for many domains of reality and human experience in terms of the interactions of their essential features. Art, for example, is particularly dependent on Ideality for form and Existence for dynamic structure, revealing these modes and how they interact; any artwork, of course, is both actual and unified. Ethics focuses primarily on the interactions of individual human actualities and the Ideal; insofar as ethics becomes politics and involves the interactions of groups of actualities, the existential structure of the space-time field becomes important, and so forth. One does not have to be limited to Weiss's initial list of modes of being in order to employ the explanatory device of showing how things are mixtures upon mixtures of more basic modes or finalities in connection. Weiss maintains the metaphysical power of the distinction between essential and nonessential features through all of his systematic shifts.

The second step in his solution to the problem of the one and the many is to elaborate a theory of relation, connection, and disjunction, a theory that depends rather much on the modes as listed in *Modes of Being*. At one level there are no relations other than those constituted by the specific characters of the modes. So, each mode is internally unified; God is essentially unified and Actuality, Ideality, and existence are nonessentially unified, deriving their unity from God. All the modes are existentially effective, Existence essentially so and the others derivatively from Existence. All the modes are both formed and valuable, Ideality essentially so and the others derivatively from Ideality.[19] All the modes have actuality, Actualities essentially so and the others derivatively.

To sum up what this means for Weiss's theology, God is essentially One and is not subject to the threat of dissolution from any of the other modes; God is thus the steady stillpoint of reality. The other modes have a derivative unity that can indeed be threatened. Actualities need continually to reassert their unity over against the divisiveness of existence and the alternate forms of Ideality. The Ideal is in constant jeopardy of not informing the actual. Existence is essentially perpetual self-division (*MOB* 185–90). But for Weiss, God's existence is nonessential, and therefore the ontological argument does not work in its classic form (although he has his own version of that and the other classical arguments for the existence of God; see *MOB* 287–331). For Weiss, God's actuality is nonessential, and therefore he would agree with Whitehead's famous claim that God apart from the world is deficiently actual. For Weiss, God's form and value are nonessential derivatives, and hence he would reject the view dominating several traditions that form

and value are God's essential wisdom, or the divine mind, or the immediate dyad deriving from the inmost essence of God rather than from other things with which God is connected.

Nevertheless, precisely because God is necessarily with the other modes, for Weiss God necessarily has form and value, necessarily is actual, and necessarily has existential efficacy. Furthermore, because God's unity is essential, the unity of form, value, actuality, and existence is essential, unlike the presence of those ultimate traits in other modes.

The question Weiss asks at this point is how the modes can be together so as to influence each other. Given that they do influence each other, and necessarily do in order for each to be itself, how is this possible? Weiss answers (*MOB* ch. 10) that any two modes are put in relation by the other two modes, one of which unifies them by comprehending them as one, as merged, and the other of which disjoins them as other to each other. Thus any two modes are related by virtue of being both merged and disjoined. Togetherness has two necessary modes, merger and disjunction.

Although the two modes of togetherness can be stated abstractly (as Weiss does in *MOB* ch. 10), they of course must be illustrated in specific ways by the modes of being. So, for instance, God and Existence are together as merged in Ideality insofar as ideal form both structures space-time and provides God an internal structured field in which to act. God and Existence are together as disjoined insofar as actualities always have a contingent relation between their own unity and their existence. God and Actualities are together as merged by Ideality insofar as actualized structure in both is coherent; they are together as disjoined insofar as Existence gives each its own separate position. God and Ideality are together as merged insofar as the divine actuality is structured and valuable and all the rest of the actual world has unified structure; they are together as disjoined insofar as Existence separates or places division between actualized and potential forms. Actuality and Ideality are together as merged by God functioning as the unity of actualities with possibility; they are together as disjoined by Existence which separates out some form for actualities as possibility. Actuality and Existence are together as merged by God who unifies actualities over the existential field and unifies existential self-divisiveness into a field; they are together as disjoined insofar as Ideality always registers the difference between possible and actualized form and value. Ideality and Existence are together as merged by God who unifies them into a dynamic structured existential field with both possible and actual modes; they are together as disjoined by actualities who punctuate the existential field with certain but not other forms and values.

In each of these instances, merger and disjunction mean something special to the merging or disjoining mode. But they always operate in appropriate tandem. For instance, if there were not the Ideal merger of God and Existence in a unified form for the existential field, there could be no Actual disjoining of God and Existence by contingent actualities because the contingent nature of actualities requires their own structured interaction. And vice versa: without actual contingent things, there would be no punctuation of the existential field that would require determinate unifying structure, merely self-divisiveness ready to be formed. And so on. Although the neat symmetry of requiring four modes for any two to be together is an aesthetic delight in *Modes of Being*, which acknowledges only four modes, in principle any number more than four could also illustrate the togetherness in the theory, with the extra modes being in derivative relations case by case. Therefore, the inclusion of Being as a fifth mode in *Beyond All Appearances* is less elegant than the earlier theory but does not contradict this step in the solution to the problem of the one and the many.

What now is Weiss's solution to the problem? There is no exclusive one for the many modes, says Weiss, but rather each mode is a one for the others as many insofar as it contains them as nonessential features of itself. Those philosophers who say that there is some univocal and exclusive thing such as relation would have to find a one that grounds the things related. But relation or togetherness means different things when each of the modes functions as the merger or the disjoiner. Furthermore, the differences in meaning of merger and disjoiner do not appeal to an untenable form of the analogy of being, but can be explicated univocally by the characters of the modes that do the merging and joining. Therefore, there is no need to have a single and exclusive one for all the many, only a one for any given many.

The modes are many only within the standpoints of their several realities. Thus Actuality, Ideality, and Existence are a many for God who unifies them with the divine essential unity. Ideality, Existence, and God are many for actualities who unify them by taking on form and value, existential position and power, and unity, unifying these with their own substantiality. Existence, God, and Actualities are many for Ideality that unifies them by giving them all a connecting structure and set of possible values. God, Actuality, and Ideality are unified by Existence that gives the first two agency as structured by the third. The analysis lends itself to endless complications and mixtures; *Modes of Being* traces out many of these complications, and the other books of that period spell them out in detail.

There is no standpoint from which the four (or more) modes

constitute a many that is not itself one of or a combination of the modes. Therefore, each many has its own one, and there can be as many ones as there are real manys.

What is the specific character of God in all of this? In one sense, God is no more the one for the many than is any of the other modes. In this respect Weiss departs from much of the Western tradition, especially that influenced by Neoplatonism. In another sense, however, God's essential nature for Weiss is unity, and therefore God is pre-eminently one for the others. Furthermore, although each of the other modes is a one for its many, that very function of unifying or "being one" is the divine derivative in that mode. So, actualities unify the other modes and themselves because of the presence of God in them; the same with the unifying functions of the other modes: the unification is their divine part as qualified by their essence. Each mode necessarily has unity as a nonessential feature from God (except God for whom unity is essential). Therefore, each mode necessarily is a one for the others as many. But God is pre-eminent unity, and the functional unity in the other modes.

This pre-eminence explains why *Modes of Being* discusses "proofs" in connection with God and not with the other modes. (Another explanation is that there is a history of having to "prove" God but not having to "prove" Actuality, Ideality, or Existence.) Proofs, in Weiss's account (*MOB* ch. 4), have to do with unifying chains of inference that move from the nonessential features contributed to one mode of being by another through the other two modes' contributions to togetherness to the contributing mode, and then detaching the conclusion as a reality of its own. Thus God can be proved starting from any unities in actualities, ideal form, or the existential field. But then again, Actuality could be proved starting from actual definiteness in the ideal, actual punctuations of the existential field, or the actuality of God; and the Ideal can be proved by starting from the form and value in actualities, in existence, and God; Existence is proved from the existence of actualities, from the difference between unactualized and actualized possibilities, and from divine existence. In *Modes of Being* only God is subjected to proof, although the others could be. Proof is most importantly a function of divine unity and the study of proof as such is a part of theology for Weiss. To think, as most philosophers do, that proof is most importantly a function of form is to mistake formal implication, which is not proof, from inference, which involves an existential move from premise to conclusion that requires overriding unity.

From a religious standpoint, which Weiss developed in *The God We Seek,* God is to be conceived as "concrete, self-identical, omnipotent, and concerned" (*GWS* 93). God is concrete because, relative to the

fragmented and existentially competitive actualities of the world, the divine unity provides an actual cosmos that fulfills the limitations of any given actuality by the others. God is self-identical in a formal sense because the divine essence is unity itself, but concretely God's unity is the one steady and impossible-to-jeopardize identity in the world. God is omnipotent because all powers of the existential field are unified within the divine nature; God is not omnipotent in being able to do the impossible or in being able to abscond with the powers rightly belonging to other things: yet there is no power exercised by anything that cannot be unified with the rest of the cosmos according to the divine unity. God is concerned because God unifies the ideal with the actual, if not in its preferred place then in a substitute; for any actuality, God unites it with its good as a desert and obligation, even if the actuality fails its good and is thus guilty.[20] In all these characterizations of God, even the more experientially based ones developed in *The God We Seek,* the determinative factor is the role of God as the ultimate mode of unity in the treatment of the problem of the one and the many. Weiss's theory is original and brilliant.

II. GOD NOT A MODE

Nevertheless, Weiss's solution to the problem of the one and the many is faulty, faulty precisely at the point of the role God is supposed to play as unity. The fault is vaguely felt in the question, what is the Being of which the modes are modes? The official answer, of course, is that there is no Being over and above the modes. Each simply is what it is essentially and as nonessentially conditioned by the others. Indeed, in his journal Weiss came to call the modes simply Beings.[21] But that does not help: what is it to be a Being? Weiss finally, in *Beyond All Appearances,* came to say that Being itself is another mode or finality. But neither does that help if the question is about the being of the finalities as such. The vague feeling of a need for an underlying unity or reality of which the modes are qualifications might, however, be due to the structure of our languages. A more precise objection needs to be formulated.

To be more precise, a single mode of being cannot be a one for the many other modes *at all* because it cannot encompass and unify the essential features of the other modes. The essential features are precisely what is beyond the reach and encompassment of other modes. If the essential features of one mode could be wholly contained with another mode, so as to be unified with others, then the contained mode would lose its reality. Essential features are what a thing has that cannot be

contained in another thing in any but a formal way; by virtue of essential features things, especially modes of being, are irreducible one to the other. Therefore, the most that any one mode can unify of the other modes is the nonessential features those modes have from one another. Never ever, from any standpoint nor from all the modal standpoints cumulatively, are the essential features of the modes unified.

The problem of the one and the many is to discern a unity sufficient to allow for the relevant multiplicity. How can the modes of being be different from one another if their essential features have absolutely no relevance to one another? One might answer that the nonessential features provide the mediating links. But that answer cannot be sustained because the nonessential features in any one mode come, at least in part, from the essential features of the other modes, not merely from those other modes' nonessential features. Thus, what the other modes receive from God is unity, not some nonessential divine feature. What they receive from Actuality is actuality, not just formed, existentialized, or unified actualities. What they receive from Ideality is ideal form, not patterns in things. What they receive from existence is self-division, Existence's essence. Therefore, for a mode to have nonessential features at all it must be together with the other modes in some way not constituted by the nonessential features but by that upon which the nonessential features themselves depend. Whereas the cosmological interplay of the modes might be unified from the standpoint of any one mode, their ontological togetherness that makes cosmological interplay possible cannot be contained within the unity of any one mode. No one mode contains the ontological reality of the essential features of the others.

What Weiss needs is an ontological context of mutual relevance in which is contained the whole of all the modes, essential and nonessential features alike. The essential features of the different modes must be relevant to one another if they are to contribute nonessential features. What can the ontological context of mutual relevance be? Several answers can be eliminated quickly.

It cannot be some kind of underlying being-stuff of which the modes are different forms. For if it were, the being-stuff would have to be determinate, with its own essential features; then the problem would be thrown back to find a deeper ground to unite the being-stuff with its modes. If the being-stuff were indeterminate, it would be indistinguishable from nothing, and hence no unifying context at all.

Nor can the context be a super-whole of the modes. If the super-whole were determinate, it would have its own essential features and an analogous problem to the above would break out. If the super-whole were

indeterminate, it would add nothing to the modes and hence could not be their ontological unity.

Nor can the ontological context be a pulsating creativity or Dunamis, as Whitehead's creativity or Weiss's latest category as he exposits it might be. Neither philosopher suggests that kind of existential ground as the ontological unity. Any such dynamic process would itself be dependent on actualities and forms to mark off the past and future and existential passage.

Each of these implausible suggestions comes from trying to make a mode of being something more basic than a mode, namely Actuality for the being-stuff, Ideality for the super-whole, and Existence for creativity or the Dunamis. We already saw that God as unity cannot be the ontological unity. What appears from this quick review is that the ontological context of mutual relevance cannot itself be determinate without positing a new essential feature that falls beyond the unity. Nor can the context be simply indeterminate if it is to do the unifying. What then can it be?

My own hypothesis is that the ontological context of mutual relevance is the creation *ex nihilo* of the world containing the modes, or whatever is ultimate. I say "creation" rather than "creator" to forestall the premature assumption that there is a determinate creator-God apart from the real creation of the world. If we were to say that, then the determinate God would have to have essential features and the old regress of the one and many would come up again. Rather, the determinate character of the creator comes from creating and whatever is involved in that. Given creation, the act of creation is the creator of the world with whatever characteristics derive from this. There are at least three.

The first characteristic of the creator, resulting from creation, is to be the source of the determinate world. The world is absolutely dependent on the source, and the source derives no character from the world except the function of being source that is its own creative act. So we may say that if it were apart from the world, which it is not, the source would be indeterminate, not even source.

The second characteristic of the creator, resulting from creation, is the world itself as the terminus or product of the creative act. This is like Spinoza's *natura naturata*. Of course, the world has whatever determinate character it has. Perhaps Weiss has adequately described that in *Modes of Being* as a character resulting from the interplay of four ultimate determinate modes. Whatever is determinately real is the character of the creator as that is self-given in the act of creation. Among the determinately real things are the self-reflexive characteristics of the creator resulting from the act of creation.

The third of those characteristics is the act itself which is the positive causal move from indeterminate nothing to the determinate world. The act is not itself a determinate thing, except insofar as an act has the form of its result. The act rather is a sheer making, a making of anything and everything determinate, not out of antecedent materials or potentials but out of nothing. There is an asymmetry in the act of creation that must be noted, for that distinguishes it from all determinate things (determinateness is always with respect to something, which presupposes a symmetry of relations). The creative act is not a thing or a category but a making. And it is precisely what makes the move from the indeterminate to the determinate.

Creation *ex nihilo* is the ontological context of mutual relevance by virtue of the fact that it creates things with their essential and nonessential features together. It is no "third thing" over and above them but simply their being made together. The creator does not compromise the integrity of the determinate things by changing or inhibiting their given nature. It is the creating of them in mutual relevance whatever they might be, according to my hypothesis.

Weiss rejects the idea of divine creation. Most of his rejections assume that God is a being who is supposed to create the rest of the beings; this objection is not relevant to the present hypothesis. There are two other objections.

One (*MOB* 345 and elsewhere) is to point out that if God gives things their being, they then have it regardless of God; this amounts to rejecting the presence of God as sustainer of things through time. But on the hypothesis that God is the creating of all determinate things, including time, this objection does not apply. How the creator is related to the individual things passing along through time is indeed an interesting problem. But the hypothesis here would say only that God is creator creating (like *natura naturans*) wherever, whenever, and however things are determinately real.

The second objection likens divine creation to Plotinus's theory of contraction, which Weiss calls "self-diremption" (*MOB* 505–6). On the contraction theory, the one acts to produce a many out of itself. Weiss objects that the one by itself is unintelligible. Perhaps so for Plotinus; but for the creation *ex nihilo* hypothesis God is not one except in creating the determinate things as the unifying context for their mutual relevance; both one and many come to be in creation. Weiss further objects that, if a one acts to produce a many, the one and its act already constitute a many, begging the question. But our hypothesis says that both one and many are the results of the act; the act itself is real only in its own coming to be as making the world. Weiss objects again that the one must allow the many

to be over against it if it truly is to produce a many. On the contrary, all that creation must do is to give rise to a multiplicity of determinations; they need have no independence from their own contingent being-made-togetherness. Weiss has further objections to the self-diremption theory but they amount to the objections to the one as determinate reviewed above.

In sum, Weiss's objections to the creation *ex nihilo* hypothesis are either irrelevant to this specific hypothesis or do not acknowledge the crucial idea of making. The creator is not another thing, but is the making of things; the making of things has traits derivative from the making itself but not antecedent to creation in any sense.

The hypothesis of creation *ex nihilo* has important positive contributions to make to Weiss's theory, of which two should be mentioned here. The first is that it is compatible with any metaphysical analysis whatsoever of basic categories or ultimate determinate realities. The arguments for one system or another of determinate categories need to be made on their own terms, not as derived from the creation theory. Anything determinate can be created. Other considerations must be brought to bear to discern just what is created.

Therefore, Weiss might be entirely right about Actuality, Ideality, Existence, and God-as-Unity. If there are good reasons for adding Being to those modes, the creator would be the source of that too, as related to the other modes by nonessential features, and so forth. Or if the entire system is changed to categories of conditions on the one hand, and the Dunamis on the other, with individuality and the ideal, as Weiss does in his latest philosophy, all those elements too can be conceived as created, so that they can be together, and then analyzed on their own terms. By the same token, Aristotle's system of categories might be right, or Whitehead's. Creation *ex nihilo* is compatible with any of these, and addresses only the issue of the one and the many, and also the issue of how and why there is anything at all; the creation theory does not address what things there are. Therefore, Weiss could accept it without compromising the rest of his philosophy.

The second advantage of the creation theory for Weiss's philosophy is that it relocates the question of God vis-à-vis the theistic religious traditions and Western philosophy.[22] God as creator is an ancient notion or family of notions in the West. It appears not only in the religion of ancient Israel but also in other semitic religions, in Hesiod's *Theogony,* and in Plato's famous Analogy of the Sun in the Republic. The idea was elaborated theologically by Jewish, Christian, and Muslim thinkers, and it was held in basic ways by the great figures of modern European philosophy, Descartes, Hobbes, Locke, Spinoza, Leibniz, Kant, Hegel,

and Peirce. Therefore, if Weiss wants to relate his philosophy to the great tradition of philosophical theology, it would help greatly for him to accommodate his system to some version of the divine creation dialectic.

Of course, the positive conception of the creator is in large measure a function of the conception of what is metaphysically basic in the created world. If there are a number of ultimate modes of being or finalities, then these are peculiarly revelatory of the God who creates things. It was mentioned earlier that Thomists, with their peculiar focus on existence, interpret the creator as the Act of *Esse*. Platonists, with their peculiar appreciation of value, interpret the creator in terms of the Form of the Good. Existentialists, with their emphasis on concrete particularity and decision-making, interpret God in terms of action or agency. Idealists, with their peculiar concern for the dialectic of unity, interpret divine creation as the development of a unified whole. Weiss's system in *Modes of Being* has all of these (and he picks up the Being theme of the Tillichians and Rahnerians in *Beyond All Appearances*). The modes would only have to be understood as the most basic elements that any created thing would have to exhibit, thus illustrative of what God creates in creating the world.[23]

I suggested earlier that Weiss lost interest in theology as a central part of philosophy when two things became apparent. One was that his solution to the problem of the one and many did not work, and that he could maintain the brilliant account of the interaction of the modes with essential and nonessential features only by backing away from the one and many problem. The other was that Unity is simply too thin a connection with the divinity of the philosophical and theological traditions of the West. If he were to accept the theory of creation *ex nihilo,* he would at once avail himself of a more adequate solution to the problem of the one and many and tie into a more central philosophical representation of God that is only reinforced, not threatened, by the divinity he once saw in Unity. Nor would he have to abandon any of the dialectical development of his own ideas about ultimate determinate realities. Much to gain and nothing to lose except the camaraderie of secularists who take all God-talk to be softheaded.

III. GOD AND RELIGION

Rationalist though he is, Weiss's philosophy is not all dialectic. Even in *Modes of Being* and more explicitly in *The God We Seek,* he paid attention to religious experience. If God is real, and even if God is no more than ultimate unity, then God must be involved somehow in every

experience. But God is especially involved in the experience of those persons and groups that attend to divine matters, that is, in religious experience. The issues that have been discussed in the preceding sections can now be re-approached through a discussion of Weiss's approach to religion. There are two main points to be made here. One concerns Weiss's contribution, made long ago, to a current debate about relations among the world's religions. The other concerns how categories are to be employed to interpret religions.

The debate about relations among the world's religions has been focused recently by a book edited by John Hick and Paul F. Knitter called *The Myth of Christian Uniqueness;* it has been answered by a volume edited by Gavin D'Costa entitled *Christian Uniqueness Reconsidered: The Myth of a Pluralist Theology of Religions.*[24] The problem is the old one of comparative truth claims. Is only one religion true? The affirmative answer to this question is called "exclusivism" in the contemporary debate, and it usually defines one as a "conservative." Is there truth in all religions that can be seen from the special vantage point of some one religion, as the Cosmic Christ of some Christians can be seen manifested in Buddhism, Judaism, and other "anonymous" forms of Christianity? The affirmative answer to this question, most magnificently developed by Hegel, is given today by many ecumenically minded theologians, especially Roman Catholics, and is called "inclusivism." Or are the religions simply different by virtue of history but in fundamental agreement about God when you get behind linguistic and liturgical differences? The affirmative answer here, called "pluralism," is supposed to be the most liberal approach. This debate is by no means new. About the time the ancient Hebrews were inventing self-conscious exclusivism, the Greeks were developing inclusivism, the Hindus pluralism, and Confucius and Gautama Buddha were warning against speculation in the matter as such.

Weiss's contribution to the debate begins by noting the biases of particular religions that are satisfied to make God present to their community in practice. But there are other communities, with different practices. Furthermore, there doubtless is more to God than bears upon any particular community, or than bears upon community life as such. Human beings, Weiss also notes, attend to God most usually in matters pertaining to salvation, and there is much more to God than bears upon human salvation. Therefore, the knowledge of God needs to be based on a plurality of approaches to God that stand back from special pleading and that correct one another (*GWS* 4–5). How is this knowledge, or search for knowledge, to be organized?

Weiss's answer is to use the philosophical conception of God to show

how any particular domain relates to God as the ultimate Unity, and how the domains collectively exhibit God in different ways. Put religiously, all of these ways are means by virtue of which people meet God or deal with God. Weiss's description of the plot of *The God We Seek* illustrates the point:

> There are a number of ways in which contact can be made with God. We can find Him everywhere. We can move to Him from anywhere. And our movements can traverse many different types of routes; from act to thought, from fear to faith. Apart from all special revelation, message, or miracle, there are no less than fifteen ways of making contact with God.
>
> God is an undifferentiated part of an ultra-natural domain of which we become aware, when in terror or surmise, we look beyond the conventional world in which we daily live (ch. 1). We also make contact with God in a religious experience (ch. 3). Here, severally and together, we ignore the categorizations of the daily world to attend to immediately encountered content, bearing the marks of His presence. Sometimes through the fissures (ch. 3) of that experience it is possible to glimpse God, the being who makes that experience possible. Sacred objects provide a fourth way of making contact with God (ch. 4). These are objects and events in the common-sense world, cut off from their practical use and seen to express a divine power. Such sacred objects also relate us (ch. 4) to the God which lies beyond them, in somewhat the way in which a work of art enables us to make contact with a reality external to it. Still another way of making contact with God is through the production of an adequate idea of Him (ch. 5). God is also publicly participated in; He is immanent in the dedicated community (ch. 6). An eighth way is ours when we turn away from the world and attach ourselves to an Other (ch. 9) which is more appropriate to us and steadier than any the world could provide. God is also immanent in every act of faith, satisfying it to some degree from the very start (ch. 10). He is a transcendent as well as an immanent being, referred to by the dedicated community (ch. 6), reached by faith (ch. 10), enjoyed in worship (ch. 11), lived for in service (ch. 12), arrived at by various proofs (see *Modes of Being* ch. 4), and mystically lived with (passim). (*GWS,* 5–6)

I quote this passage at length to indicate the richness of Weiss's analysis. Even from this outline of the book to come, it is apparent how the philosophical approach lends itself to the acknowledgment and legitimation of a vast and rich host of religious phenomena. Much is to be learned from Weiss's sympathetic philosophy of religion.

Weiss's position in the contemporary debate, therefore, is to say that theology, as the intellectual efforts of religious communities, ought to learn from philosophy or philosophical theology. Meanwhile, the questions of exclusivism, inclusivism, and pluralism remain to be decided by examination of each religion. It is conceivable but highly unlikely that truth is to be found in only one religion.[25] It is also conceivable but unlikely that one religion can include all the truth of other religions in its

own terms. Whether the various religions all affirm the same basic thing about the religious object is also an empirical matter; perhaps they do but perhaps not. But they do all deal with God, says Weiss, and they should be corrected or supplemented if they distort or leave out something important. Sometimes the debate about exclusivism, inclusivism, and pluralism is framed in the narrow terms of salvation; for instance, only one religion saves, or the salvation of one religion can also be found in others, etc. To this Weiss would reply that salvation is only one aspect of the human relation to God, and only a small part of the divine reality that can be known; a focus on salvation alone is likely to be highly distorting about what we can know about God.

Weiss's contribution is welcome to the debate because it asserts the power and authority of philosophy's contribution to theology. Philosophy is not often regarded as making a contribution today for two reasons. First, philosophical theology itself does not speak with a united voice. Second, empirical scholars of religion are gun-shy of a discipline that in the past has dictated what religions say and do without much looking, imposing philosophical categories over a field that has not been honestly investigated. Yet as Weiss clearly shows, a philosophy is as good as the arguments for it and philosophy provides categories that can be criticized on their own for classifying phenomena, thereby bringing critical discipline to the vagaries of inductive descriptions.

The limitations of Weiss's contribution, however, have to do with the independent authority of religious phenomena, precisely the point insisted upon by religious scholars who are skeptical of philosophy. Where there is a rich philosophical idea of God, say as the ultimate Unity interacting with the other three or four modes of being (or an idea of God as creator *ex nihilo*), then a vast field of religious phenomena can be accepted at face value and understood in new relations. But where that philosophical idea is abandoned, as Weiss did of his own idea of God and as he would urge upon those who recommend an idea of God as creator *ex nihilo,* do not the religious phenomena then become suspect? In fact, because Weiss shows in so many instances that the phenomena could not be what they seem without the reality of God contributing as their ultimate condition, when that reality is denied, then things cannot be accepted to be as they seem. Psychological, sociological, political, and other forms of reductionism then can redescribe religious phenomena and they have no more evidential force.

This brings my argument to the second point to be made about Weiss's theory of religions, how categories are to be used to interpret religious phenomena. Weiss would not disagree with Charles Peirce that philosophical categories and theories are large-scale hypotheses for inter-

preting the world and domains of phenomena within the world. On the one hand, the justifications of categories are dialectical, such as Weiss gives in *Modes of Being*. On the other hand, the justifications are empirical in the general sense that we need to probate just how well they do in making sense of phenomena. Determining whether the phenomena fit one set of categories better than another is never a simple thing. Even in the natural sciences, it is never the case that phenomena are theory-neutral. The crudest description reflects the antecedent cultural semiotics of the interpreter, all the more so in the case of religion or in the probating of metaphysical visions of all reality. Nevertheless, over the long haul the strengths and weaknesses of classificatory systems are revealed. Collingwood's insistence on "saving the appearances" means that systems are stronger the more they can take things as they seem.

In Weiss's approach to religion, religious phenomena are acknowledged and legitimated because the system says they should be there. But do the phenomena have any authority over the system? As Weiss's developing dialectic moved him away from God-talk to Unity-talk, and then to pluralize even the notion of unity in *Creative Ventures,* was that dialectic ever constrained by the empirical authority of religious phenomena he once acknowledged? Did he ever argue in the later stages of his dialectic that *because* religious people are in touch with a basic reality a philosophy without God or something very close to God is faulty? I believe he did not, and if that belief is correct then there was something *ersatz* about the descriptions in *The God We Seek* and other books of that period of religious people as actually dealing with God. My point here is not that Weiss was mistaken to abandon the philosophical idea of God, but that the relation between philosophical ideas and the realities they are to interpret was problematic from the beginning.

IV. GOD AND THE *DUNAMIS*

But perhaps my argument has missed the subtlety in Weiss's move from the straightforward philosophical theology of *Modes of Being* to the religious skepticism of the later philosophy of the Dunamis. Religious phenomena do not just sit there with positivist descriptions ready for comparison with theories. Perhaps the advance from God to Dunamis also has effected a true advance in the interpretation of religious phenomena. Perhaps religion is better interpreted in *Creative Ventures* at those places where it comes up.

But strangely religion hardly comes up at all in *Creative Ventures,* and religious phenomena are discussed only in ways that place them in

abeyance. Saintliness and religious sagacity, for instance, are discussed (*CV* 201–2) as candidates for the personal excellence of a person who has created a great character (in contrast to those who create great art, great government, etc.). And they are dismissed, the first because "God" is alleged to be the cause of the trait rather than the person's own creativity, and the second because sagely knowledge of the ultimate is insufficiently nuanced in concepts, articulation, and truth claims to qualify as excellent knowledge.

To be sure, the topic of *Creative Ventures* is human creativity, not God or religion. Yet is not creativity anywhere at least associated with God? Not if God is only unity. But if God is understood in terms of creation *ex nihilo,* then human creativity is interesting indeed for its religious dimension. The question to ask of *Creative Ventures* and other late writings such as *Privacy* and *Toward a Perfected State* is whether the Dunamis has brought in the creative aspects of God just when the divinity of unity has dropped out.

Although *Creative Ventures* is about human creativity, Weiss has appended an essay to the volume that deals with the Dunamis alone. He appeals (mentioning discussions in *P* and *TPS*) to a broad consensus in acknowledging the Dunamis, citing Plato's receptacle, Aristotle's prime matter, Whitehead's creativity, the Tao, the collective unconscious, the Will, and the élan vital, although each is to be rearticulated in terms of the conditions of the Dunamis. The Dunamis is the dynamic power or energy of pulsating creativity.

Perhaps the best way to understand the Dunamis is in contrast to Weiss's earlier mode of Existence. Existence too was a pulsing field of energy, the existential force by virtue of which things last, do things, and affect one another. But its unity comes from God, its form or structure from Ideality, and the endurance of existing things from their self-insistent actuality. By itself, the essential features of Existence have to do with perpetual self-division (*MOB* ch. 3). In contrast, the Dunamis itself is the unifying field of association. It is the great potentiality out of which every particular thing arises as defined by various conditions. Each particular thing has a privacy of its own which stands over against both external conditions and the Dunamis. But the Dunamis is the great underlying, subterranean reality, the vast power of doing and being that is configured by the conditions and individuals in it. The Dunamis is the source of contemporaneity.

Weiss distinguishes between passage and coming-to-be. Passage is "transition from one item to another of the same type" (*CV* 318). Coming to be means the arising of a thing of one type from what is not that type, either another type or the Dunamis itself. Because the

Dunamis is always articulated, there is always some collection of types of reality from which a person is born, and similar types into which a person decays upon death. But birth and death also mark the emergence of the privacy of a person from the Dunamis itself in which that privacy had not existed, and the return of the being into the Dunamis.

In many respects, the Dunamis plays a richer theological role than the God of *Modes of Being*. Like that God, it is unity and the source of unity in other things. It is also the ground out of which any actual thing arises and to which it returns. It is "subtle," as the Taoists would say, always operative but rarely if ever confronted head on; rather, the Dunamis is the associating condition of confrontation.

Weiss is clear that the Dunamis does not create anything. Actualities with inner privacies and outer conditioning natures condense and focalize the Dunamis, but are not created by it. Any particular actuality arises from the power of the Dunamis, but according to independent conditions and with an interiority that is not just more Dunamis.

Here is the point at which the question of creativity returns to the problem of the one and the many. For, if the Dunamis, the conditions, and the actual individuals are independent, none reducible to the others and each giving traits to the others, then each of those ultimates, plus the actual world, has essential features of its own, not shared by the others. Then it is a mystery how the togetherness of these ultimately independent and interacting things is possible. That it is actual, and therefore *must* be possible, we may accept on the basis of Weiss's dialectic. We all know that there is a many somehow unified. But *how* is it possible? That is the metaphysical question.

Recall again the philosophical situation that leads Weiss to the acknowledgment of ultimate realities. From *Reality* to the writings of the present time, the situation is this: he examines the affairs of human life and the world and asks what categories are instanced in providing a nuanced description. All his books start off with description, save *Modes of Being* which assumes the description and starts off with the categories of categories. Then he sorts the categories into types, and the types into simpler types, until ultimate differences appear. The ultimate differences relate to one another but cannot be reduced to one another. Whatever is actual in an actuality, it is not mere form, not perpetual self-division, nor pure unity. Whatever is formal in ideality, it is not per se actual, not perpetually self-dividing, and not pure unity. And so forth. Weiss's analysis *makes the ultimates appear* to philosophical dialectic. As appearing, the ultimates present what they are for us philosophical knowers, and they are always more than that. As Weiss customarily puts it, the ultimates are adumbrated by our analysis, but with an interiority

or privacy ("essential features," in the old language) deeper than the analysis. Precisely because of this resolutely phenomenological approach, acknowledging the essential features of the ultimates that are not constituted by interactions of other things, the question of the one and the many is not addressed. From the standpoint of this movement through appearances, the question of the one and the many must appear as merely abstract. One can look back at the discussions of it in *Modes of Being* as abstract in just that *mere* way.

Nevertheless, the cogency of a philosophy of interacting ultimates depends fundamentally on solving the problem of the one and the many. Weiss's philosophy is a metaphysical pluralism of a radical sort, brilliant, original, and I believe basically correct. But it must be able to account for the possibility of the unity it displays. I recommend the ontological monism of creation *ex nihilo* to undergird the metaphysical pluralism Weiss rightly affirms of the world. The arguments for this are rehearsed above.

My specific suggestion is to modify the notion of the Dunamis to become creation *ex nihilo*. The chief modification is to say that the Dunamis creates the ultimate conditions and the actual individuals so as to be together with their essential as well as nonessential features. Then the temporality of the individuals and actual processes must be emphasized. The genius of Weiss's notion of the Dunamis is its unexpected temporality.

Against the Whiteheadians, to whom Weiss rightly objects on this point, existence is not mere present time but the flow of time that embraces past, present, and future in a dynamic continuum. The true meaning of eternity is not static form nor a *totum simul* but the divine creation of the pulsing flow of time such that every present moment both comes to be as a finished past fact and also reshapes future possibilities. The essential features of the present have to do with spontaneity, change, and decision. The present receives (as nonessential features) actual facts from the past as its raw material or potentials for change, and it receives (as nonessential features) possibilities from the future. The essential features of the past have to do with fixed, actualized objectivity; the past has form and value as nonessential features from the future, and it has actual definiteness as the contribution from the present. The essential features of the future have to do with pure form; from the past the future receives actual things that need to be formed, and from the present the future receives the changes requiring shifting forms to keep abreast of what possibilities are for.

The dynamism of temporality affects all temporal modes equally. The past is always growing or accreting. The present is always actualizing.

The future is always shifting shape. And these are all coordinated so as to make time's flow possible. The divine creative act makes all these together eternally; the life of God is more dynamic than the life of any finite thing, because it includes all things in all modes of time.

Temporality refers to finite things within time. A temporal thing is something that has a future, happens, and then is past. The dynamic relations among past, present, and future as such cannot be temporal. Rather, their eternal togetherness constitutes the temporality of the world. For things within time, things constantly changing until they are past where the growth of the past no longer affects them, there is also a kind of eternal identity. Within the eternal life of the creator each moment in the thing's proper life is future, is present, and is past altogether. Within the eternal life of the creator we are eternally young with many options open for the future, eternally involved and responsible for decisions affecting many things, and eternally a finished life. Within time, of course we must wait for these stages of life to occur. But even within time there are intimations of the eternity of the pulsations of time's flow. A person on trial for a crime committed a year prior must somehow at once be the person as indicted and standing trial, the person who committed the crime, and also the person who had the capacity not to commit the crime the day before it took place; similarly, the person at the date of the trial must also be the one with the possibility of conviction and punishment who can have an actualized future of having paid the debt to society. None of moral responsibility would make sense if a person were *only* what is actualized in the present day. The eternity underlying time's flow is the togetherness—not in time to be sure—of all dates of the person's identity, each as future, each as present, and each as past.[26]

Is this not the underlying, more-than-temporal (analogously, more-than-spatial) unity coupled with the intrinsic power of creativity that Weiss seeks to articulate with the idea of the Dunamis? Does this not make good sense of the claims Weiss has long made about God as Unity? Does it not make good sense of his doctrine that God keeps the past in being (*MOB* 339) and makes the future relevant to the present (*MOB* 341)? Do not the distinctions between the temporal modes, marked by their separate essential features, allow Weiss to acknowledge the self-othering character of existence that he once spelled out as perpetual self-division? Yet does not the singularity of the act of creation, giving rise to a multiplicity of things distinguished by their essential features and interacting nonessentially, express the more basic coherence and coordination constituted by creation as the ontological context of mutual relevance? Does not the eternal immediacy of the act of creation, with no

medium through which the creator could be separated off from the world, answer Weiss's fears that a creator would have to give the created world a being of its own over against the divine being? The world lies intimately in the creator as *natura naturata* lies in *natura naturans,* yet does not the dynamic eternity of the divine act express the uncanny otherness Weiss has seen in the Dunamis lying behind things and their conditions?

I believe that Weiss has nothing to lose of his fundamental insights and dialectical phenomenological discoveries of ultimate things by adopting an ontological theory of creation *ex nihilo.* He has two important things to gain: first, a solution to the problem of the one and the many, a problem for which he is one of the few twentieth-century philosophers to be concerned; and second, a deeper tie than unity alone to the great theological traditions of the West so that he can continue taking religious matters to be evidential of ultimate things.[27]

My commentary here has attempted an analysis of the course of theological reflection through Paul Weiss's development. In the spirit of his own commentary on other philosophers I have offered suggestions for improvement that promise to add much and to detract little. That the analysis has been dialectical in this way, however, should not detract from the appreciation of Weiss's actual dealings with divine matters, regardless of his response to the suggestions. Weiss is one of the great systematic philosophers of our time whose reflections on theological topics are wiser than our theological movements and schools. It is an honor to have been his student and to be allowed to present this commentary.

ROBERT CUMMINGS NEVILLE

DEPARTMENTS OF PHILOSOPHY AND RELIGION
SCHOOL OF THEOLOGY
BOSTON UNIVERSITY
JULY 1992

NOTES

1. This conversation is a vivid memory for me, and I am sure I have it almost *verbatim.* In print, Weiss has made the point about knowing God through speculation, in contrast to the ways religious and other people relate to God, in the "Introduction" to *The God We Seek* (Carbondale: Southern Illinois University Press, 1964), hereafter referred to as *GWS.*

2. For one of the most concise statements of Weiss's theory of the relation

between philosophical speculation and common sense, see *First Considerations: An Examination of Philosophical Evidence* (Carbondale: Southern Illinois University Press, 1977), "The Task of Philosophy," hereafter *FC.* This book dates from a significantly later period in Weiss's philosophy than *Modes of Being* (Carbondale: Southern Illinois University Press, 1958), hereafter *MOB,* or *The God We Seek* (Carbondale: Southern Illinois University Press, 1964), hereafter *GWS;* although his views about many things changed over this period, those about philosophy and common sense did not. For my commentary on those views, see my essay "In Defense of Process" in *FC,* 212–22. Weiss responded to my criticisms in *FC,* 223–37, and taught me many lessons, the most remarkable of which is not to speak in the name of a school but in the name of one's own arguments.

3. *Reality* (Princeton: Princeton University Press, 1939), hereafter *R.* A revealing footnote indicates Weiss's position regarding the philosophical use of the idea of God:

> The references to God in this work refer not to the object of religious worship, but to a supposed metaphysical being whose nature is describable only in the most general speculative terms, where positively describable at all. Since Xenophanes, philosophical theologians have had, for the most part, only a negatively defined God who was acknowledged for philosophic, not religious reasons. When they referred to him as a God of passion, of virtue, of love, of salvation, etc., they added characters to their hypostatized metaphysical being which their systems did not necessitate and which were, as Spinoza remarked, inconsistent with his nature. Philosophical theologies are the last place to look in order to soothe a troubled spirit. (*R* 161)

4. *Nature and Man* (New York: Henry Holt, 1947); hereafter *NM.*
5. *Man's Freedom* (New Haven: Yale University Press, 1950). This book predated the formal structure of *MOB* but contains extensive discussions of the categories that became formalized as the modes; this is especially true of God. The topics of this book were revisited without the underlying references to the modes of being in *You, I and the Others* (Carbondale: Southern Illinois University Press, 1980), hereafter *YIO,* and *Privacy* (Carbondale: Southern Illinois University Press, 1983), hereafter *P.*
6. *Our Public Life* (Bloomington: Indiana University Press, 1959), hereafter *OPL.* The theory of politics was redeveloped without much reference to the modes of being in *Toward A Perfected State* (Albany: State University of New York Press, 1986), hereafter *TPS.*
7. *The World of Art* (Carbondale: Southern Illinois University Press, 1961), hereafter *WA.*
8. *Nine Basic Arts* (Carbondale: Southern Illinois University Press, 1961), hereafter *NBA.*
9. *History: Written and Lived* (Carbondale: Southern Illinois University Press, 1963), hereafter *HWL.*
10. *Religion and Art* (Milwaukee: Marquette University Press, 1963), hereafter *RA.*
11. *The Making of Men* (Carbondale: Southern Illinois University Press, 1967), hereafter *MM.*

12. *Sport: A Philosophic Inquiry* (Carbondale: Southern Illinois University Press, 1969), hereafter *SPI.*
13. *Beyond All Appearances* (Carbondale: Southern Illinois University Press, 1974), hereafter *BAA. First Considerations* also was an early systematic statement of this new approach.
14. *Creative Ventures* (Carbondale: Southern Illinois University Press, 1992), hereafter *CV.*
15. In *MOB* there are seventeen index references for "Many: and One" and twenty-two for "One, the: and many;" although there are many overlaps, the two entries nevertheless indicate a powerful theme. In *BAA* neither entry occurs at all, nor does a cognate. That Weiss backed away from discussions of the one and many in his published writings does not mean that he ceased to think about it, only that he ceased to be satisfied with his results. See, for instance, his philosophical journal *Philosophy in Process,* volume 7, part 2 (Albany: State University of New York Press, 1985), pp. 106–21, Dec. 3–7, 1977; hereafter as *PIP* 7ii, 106–21. Or see the later, May 11, 1985, entry in *PIP* 10, 272–76, where he tries to relate the *Dunamis* to the one and the many.
16. References to God continue in the journal entries through the 1970s and 1980s, but with less frequency; in *PIP* 3, March 7–November 25, 1964 (Carbondale: Southern Illinois University Press, 1968), there are twenty-one and one-half column inches of index references for God, whereas in *PIP* 10, April 15, 1984–January 18, 1986, there is only one column inch of references. In the later years the journal discusses God increasingly in terms of other philosophers' ideas; when Weiss uses the term positively, it is often hypothetical and qualified as a shorthand for Unity and set off against a religious notion of God. See for instance *PIP* 7ii, 131–32, December 10, 1977. He wrote on January 25, 1979:

> If I believed in a God, I would suppose him to be struggling to get to the stage where he was worthy of being worshipped. The world he was supposed to have created is so poorly organized that he must have been thinking of something else at the time. . . .
> Atheists are excessively occupied with God. It is better to be indifferent, to match the possible attitude of any God there might be. This, of course, is not a religious any more than it is an irreligious view. It is non-religious.
> If the devil were as clever and as powerful as he is claimed to be, he would speak through preachers, prophets, rabbis, priests.
> I reject the idea of the devil; that is why I can continue to respect those who are religious. (*PIP* 8, 171)

On June 2, 1984, Weiss discussed the empirical character of proofs for God and kept the discussion in a wholly hypothetical mode until he suggested that God might be identical with the Dunamis (*PIP* 10, 4–5).
17. I have been trying to understand and reconstruct Weiss's theory of the one and the many for a long time. For an analysis on my terms more than his, see *God the Creator* (Reprint edition; Albany: State University of New York Press, 1992; original, 1968). See also my "Paul Weiss's *Philosophy in Process,*" in *Review of Metaphysics,* 24 (December 1970), 276–301; and "Knowledge and Being: Comments on Griesbach and Reck," in *Review of Metaphysics,* 25 (June 1972), 40–46. For an assessment of Weiss's ontological pluralism in the context of

twentieth-century American metaphysics, see *The Highroad around Modernism* (Albany: State University of New York Press, 1992), chapter 3.

18. The origin of this distinction is to be found in *Nature and Man* where it is called the distinction between the inside and the outside of a thing. I find the distinction truly basic and in my own work refer to it in terms of essential and conditional features.

19. In *Modes of Being* Weiss claimed that Ideality is both form and value; any form as a possibility is a possibility for realizing some value or other. Yet he holds this view inconstantly. I have analyzed his position in "Achievement, Value, and Structure" in *Creativity and Common Sense: Essays in Honor of Paul Weiss,* edited by Thomas Krettek (Albany: State University of New York Press, 1987), 124–44.

20. One of the most unusual and interesting parts of Weiss's philosophy, only tangentially germane to his theology, is his claim that the good must always be actualized, if not where it should be, then in the making of amends or in the reality of guilt. See the discussions of this in *Man's Freedom,* 111–21, and *Modes of Being,* 116–20.

21. See, for instance, *PIP* 3, pp. 137ff. I analyzed this shift in detail in "Paul Weiss's *Philosophy in Process.*"

22. The situating of the question of God in non-Western religions and philosophies is more complicated, but I believe an analogous conclusion holds. I have explored this in *Behind the Masks of God* (Albany: State University of New York Press, 1991).

23. I have developed this idea with a slightly different set of metaphysically basic categories, derived from Plato's Limited, Unlimited, Mixture, and Cause of Mixture, in the Philebus. See my *Recovery of the Measure* (Albany: State University of New York Press, 1989); the point is developed theologically as a reconstructed conception of logos in *A Theology Primer* (Albany: State University of New York Press, 1991).

24. *The Myth of Christian Uniqueness: Toward a Pluralistic Theology of Religions,* edited by John Hick and Paul F. Knitter (Maryknoll, N.Y.: Orbis Books, 1987) and *Christian Uniqueness Reconsidered: The Myth of a Pluralistic Theology of Religions,* edited by Gavin D'Costa (Maryknoll, N.Y.: Orbis Books, 1990).

25. Weiss writes:

> One religion may focus on God better than others do, but each, if it deserves the name of religion at all, must deal with God somehow and to some degree. At the very least God is a referent of each and every one of them. If He is pointed at by one religion, He is pointed at by all. He is more than and other than that which any group takes Him to be. (*GWS* 4)

26. I have tried to spell this out at length in my own terms in *Eternity and Time's Flow* (Albany: State University of New York Press, 1993).

27. Because the theory of creation *ex nihilo* does not posit the creator as an individual, room is left for interesting comparisons with non-theistic religious traditions that represent the ultimate in terms of the Tao Principle, the Unconditioned Buddha-mind, and so forth.

REPLY TO ROBERT CUMMINGS NEVILLE

Those who have struggled to understand reality in its obdurate, diversified, and interconnected forms, take themselves to be willing to alter and even to abandon long-held and even cherished views when these are seen or shown to be untenable. Some positions will be held on to more firmly than others, but these will not be shielded from doubts and questionings. Usually, long before others do, a serious thinker will have taken note of what in his work needs correction, supplementation, and perhaps rejection. Sometimes the difficulties she sets before herself will be more vigorously defended than those raised by others. Although a Cartesian doubt is overly dogmatic and sweeping, it too will be entertained, if only to see how strong one's claims are.

I think I am a unique being who lives apart from and also together with others, that I can discern others in single intensional moves, and that I belong to various groups. Others hold no less firmly to a faith in the existence of a God. A few are willing to correct some of the assumptions that had been made about their God's relations to humans and the world in which they live, but if they have a genuine faith, the need to make those corrections need not shake their confidence in their own reality, the existence of others, and their ability to know themselves and others in a world they neither produced nor control.

Some theorists reject commonplace claims, but if they act in accord with those rejections, we will take them to be mad. Since others, who have been said to be mad at one time are honored at other times, we must be sure that what we find in their claims and acts are intrinsically self-defeating. When we find philosophers claiming what they also preclude themselves from claiming, we must be content to point up

where they went astray, and leave it to themselves or others to give up their odd posits, suppositions, and beliefs.

No occurrence about what is known about reality could ever compel anyone to give up what was held by one who had a religious faith, though the interpretation of what it supposedly ended at might be qualified and corrected to make it fit in better with what is otherwise known. The faith, in turn, could conceivably enable one to be aware of facets and meanings otherwise not noticed, but these could be fitted into a setting that will remain untouched, inevitably limiting a faith-backed claim to reinterpret or dismiss it.

Neville is one of the very few who is an authentic philosopher and an authentic theologian, with a wide knowledge of both fields. He commands respect when he reports on how each is to be understood by the other. He knows my work very well and, due to my failing memory and my interest in issues raised after I wrote *Modes of Being,* is a better authority on that work than I am. He has not yet understood *Creative Ventures,* in good part because he has not recognized the indeterminate natures and passive roles of unrealized ideals.

I do not think that God ever became 'a significant category' for me. I did, though, wrongly ignore the fact that 'God' is primarily a nonphilosophic term, loaded with a multitude of implications for those who are religious but ignored by philosophers who use the term. I should not have used 'God' to refer to a mode of Being having no intended religious import. Still, there is much, I think, that can withstand criticism in *Modes of Being,* once one gets over my misuses of such other terms as 'Actuality'. I think it is a strong book, marred by a poor vocabulary. It has little to do with religion and, despite its references to 'God,' little to do with what theologians focus on.

Neville is right to remark on the large role played in my views by the problem of the One and the Many. I think, as is made most evident in the chapter on mathematics in *Creative Ventures,* they are always involved with one another. If then, a beginning were made with the One, whether identified as Being or God, it would be found to be inescapably involved with a Many. I do not think that there could be a creation *ex nihilo,* if by that one means that there was a God who was alone and 'at some time' produced a Many. When and as God (or as I would prefer to say, Being) is, a Many is necessarily produced, necessarily sustaining Being's possibility and able to constitute actualities. Because the ultimates are realities distinct from Being, they are able to act independently of it, though always on its behalf. Angels are theological or humanized ways of referring to those ultimates, existing because they were produced as co-eternals by God, and able to act on their own.

Neville is a thoughtful and careful expositor. He gives a fine account of what he calls my 'metaphysical pluralism'. He expresses my view well when he says that the One "is not subject to the threat of dissolution." It is not, though, as I seem to have implied in *Modes of Being,* "a steady stillpoint of reality" except in the sense the ultimates are always dependent on Being. Once the ultimates are recognized as able to act on their own, it seems better to say that they always act on Being's behalf, always sustain Being's possibility, and are always able to convey Being beyond whatever they might constitute. Actualities are beings because they are the outcome of the conveyance of Being beyond the limited unions that the ultimates constitute.

I now think that the answer I offered in *Modes of Being* of the way the modes can be together is not satisfactory, due to the fact that I did not see that all the ultimates presuppose Being as that which is presupposed by all of them. I think much would be gained if one used the account of the interplaying of the modes, i.e., the ultimates, to understand how they yield actualities, and enable these to be because and so far as those ultimates convey Being through what those ultimates jointly constitute. An advance was made when I referred to Being in *Beyond All Appearances,* but I did not yet recognize how different it was from all the ultimates.

I do not think there is an incompatibility between the claim that there is one Being for a plurality of modes, and that each mode "is a one for the others as many." There are many distinct ones for many distinct manys. Each of us is a one for a character, a possessed and used privacy, and a body. As embracing all of these each is an individual. A society is a one for its members, so is a state. These ones and manys presuppose a final One—Being—that is always accompanied by the ultimates, a Many.

By and large I agree with Neville's criticism of what was maintained in *Modes of Being.* Like him, I also think much stands; like him, I think we must move beyond the point where that work stopped. That is what I have been trying to do over the years, but not before I dealt with more limited issues, such as art, sport, education, the nature of religion, privacy, politics, and creativity. *Being and Other Realities* benefits from these and enables me to move further along the path that *Modes of Being* more or less marked out.

I do not think that Neville does or could justify the alternative view he is here offering. Again and again, he fails to exhibit the critical spirit that enabled him to see the strengths and weaknesses of the *Modes of Being.* One is not justified in referring to God just because one's account was overly limited. It is one thing to know that it is necessary to move on; it is

quite another to take a wild leap when less heroic, better focussed, careful philosophic moves could be made. Neville is a reformed Whiteheadean, but still tempted to jump from the acknowledgment of actualities to a God he has not shown does exist, or provides the answer that he seeks. Examining various alternative ways of meeting the difficulties he rightly underscores, he misses the one that could be philosophically defended. There might well be a God beyond the Being that a philosopher finally ends with, preliminary to a return, via the ultimates to that at which he had begun, but Neville has given us no good reason for believing that there is such a God. If he had said that he had a faith that terminated in God, that this was sustained and perhaps rewarded, and that his religion celebrates the fact, I would wish him well, but then wonder why God is not as kind to me as He is to him. Perhaps Neville will say that this is a mystery? If he did, we would be back to hearing about what may not in fact exist.

All this is preliminary to Neville's sketch of his own view. He says "My own hypothesis [!] is that the ontological context of mutual relevance is the creation *ex nihilo,*" without presupposing that there is a "determinate creator—God," immediately adding that he wants to forestall the "premature assumption that there is a determinate creator-God apart from the real creation of the world," and that "the determinate character of the creator comes from creating and whatever is involved in that. Given creation, the act of creation is the creator of the world." It is not easy to understand what is being maintained. Is it that there is a creation by no creator, that creating is primary, and that it produces the source of a determinate world? What reason is there for believing that there is such a creating? Does it act just once and then disappear, leaving God the creator facing the created world, or is it always at work, giving God and the world their different roles? Could there be a creating by no one? Is the created co-eternal with its source? Why does it create a God rather than something else at one end and the rest of reality in the shape it now has? Is anything clarified by imagining a loose cannon set off by no one and aimed at nothing, but somehow yielding a God who can be credited with setting the fuse for something that is co-produced by the aboriginal creativity? Can what is indeterminate produce two kinds of determinates? Does the creating power provide a perfect match for the creator? Does it produce the creator just once or again and again? Is the latter a monotonous making, or does it improve as it goes on? Is it like an instantaneous 'Big Bang', but with both a backwards and a forwards thrust? Is an advance made if we substitute a creating God for what is not understood? Is that God not also what is not understood? Is the supposed

aboriginal creativity determinate? Does it make both God and the world determinate, presumably at the same time? If the creating power produces the created world, why call God a creator? Wasn't all the work of creation already completed? Apparently, what Neville intends to affirm is that the primoridal power, a kind of Whiteheadean process writ large, or a Whiteheadean creativity identified, enables God to be a creator, as well as the other terminus of a power or process to be made available for God to distinguish and make determinate. He does say that God creates all determinate things, but then adds that the creation includes time. What is a determinate time? If the time is created, the production of a creating God and created (or createable) world will have occurred instantaneously, together with the vanishing aboriginal creativity. I am not sure I have understood what Neville intends to say. These queries make that evident.

Neville says that "both one and many come to be in creation." Is not the creation one creation? Or is it many? Neither? Both? "All that creation must do is to give rise to a multiplicity of determinations" presumably in what was indeterminate. What is this indeterminate? Is the creation an act by which the indeterminate is converted into the determinate? It is not clear whether or not it would be correct to say that on his view determinations are the product of a dissolution of creativity into creator and created. After saying that, Neville goes on to hold that there is a 'contingent being-made-togetherness'. How did contingency get into his scheme of things? If the aboriginal creativity acted contingently there might well have been neither a creating God nor a created world. Did it act necessarily, the world would have had to be, thereby getting in the way of a need for God to do anything. These difficulties are in part the outcome of the typical defect of the theologian: a metaphysician in a hurry, he offers us a conclusion for which he produces no warrant.

Neville goes on to say that since "creation *ex nihilo* addresses the issue of the one and the many, and also the issue of how and why there is anything at all . . . Weiss could accept it without compromising the rest of his philosophy." This seems to imply that most of my account would stand even if the idea of a creation *ex nihilo* were rejected. Unfortunately, I cannot make any sense of the idea. Granted that it is not being supposed that there was a Nothing out of which created things were made, and that God freely acts and produces what is other than Himself, would it not have to be said that after the act of creation there was something real distinct from God, thereupon precluding Him from being perfect? To avoid the conclusion that God produced something that showed Him to lack some reality, one would have to say that God recovered what he had set apart, by adopting it in another way, to make it into a part of himself

on his own terms. In any event, could there be a creation *ex nihilo* if there is something distinct from God that is produced when and as God the creator is?

Neville says "if Weiss wants to relate his philosophy to the great tradition of philosophic theology, it would help greatly for him to accommodate his system to some version of the divine creation dialectic." I have no such desire. A philosopher does not try to accommodate his view to some other, no matter how strongly held, or by how many, though they should be considered, and an effort made to understand them. A philosopher does not want to fit it in; instead he seeks to know what must be, and why as well as how, what need not have been, is.

Many of the scholastics, to their ruin, tried to be good Aristotelians, hooking on to a pagan view the insights and truths they thought no pagan could have. Did they not get in their own way? Neville, instead, tries to bring his philosophy and theology into some accord. He carries each out with originality and insight, but when they get in one another's way he too allows his philosophic power to be paralyzed by his theological hopes and suppositions.

I have never lost interest in theology, for it is concerned with a primary question: What is the relation of an eternal, all-powerful, completely free being to what is contingent, feeble, and limited? I surely did not lose it, as Neville thinks, because my "solution of the problem of the one and many did not work," or because "Unity is simply too thin a connection with the divinity of the philosophical and theological traditions of the West." I gave up earlier views, or corrected them, when I found myself forced to do so in the course of pushing beyond the positions I had already reached. I am now more clearly focussed on the reality and nature of a single primal Being than I have ever been, but I have not found any reason to believe it to be endowed with the powers theologians attribute to their God.

I do not see how Neville's daring, ingenious, new ideas advance our understanding of reality. Unlike him, I do not see theology to be of any help to philosophy, unless it be that it keeps one focussed on basic issues. Nor do I see that philosophy can be of much help to theology, unless it be to point up its mistakes, unjustified claims, incoherences, and failures to answer the questions its claims raise. I don't take "all God-talk to be soft headed" nor do I think I tried to benefit from a secularism. I do, though, want to have questions answered by those who affirm that there is a God and a creation *ex nihilo*. I have nothing to say to those who are content with their faith, but if I am told that there is a knowable God, I am compelled to look at the suppositions made and the arguments offered. Neville is a fine philosopher until he begins to listen to his theological

self, and a fine theologian when he speaks to those who share his faith. When he tries to put the two together, he spoils both.

Neville is afraid that "religious phenomena" might become suspect if one accepted my view of God. The religious need not be disturbed. I do not have the faith they do, but I do not say that they are mistaken. How could I? On what grounds? Suppose you said that you enjoyed Mozart's *Magic Flute*. I do not. Suppose you said that it gives you an insight into the roots of things? Try as I may, I find the opera so ridiculous that I can hardly attend to the music or the singing. I will respect your judgment, but I cannot share it, or accept any judgment you make of Mozart based on that experience. I am not saying that religion is a matter of taste, but only that I do not experience what the religious do or perhaps recognize. Whatever the reason, I cannot warrantedly affirm or deny what others claim to have experienced, but if I am offered arresting suggestions and apparent arguments, I attend to them. If I find that they are incoherent, arbitrary, or raise more questions than they answer, I remark on the fact and move on.

Should not a philosophy be constrained "by the empirical authority of religious phenomena"? Not if it has not encountered any that make evident that there is a God, that He created the world, that He loves, hates, punishes, forgives, and so on. That will not preclude the acknowledgment of the fact that many believe and worship what they refer to as "God." It does, though, leave me with the question: "What is this to which they claim to have access?" "Why don't I?" "What is this to which they attend?" Theologians may proclaim that it is this or that but they are listened to only by those whose faith had already found its object.

A prophet tells others what they say a God demands. A preacher exhorts others, and aligns them so that they conform to what are said to be God's decrees. Who has the right to stand in their way, if all they claim is to shore up or clarify a faith, with reasons tailored to support it? When a theologian claims to know what there is at which some faith aims, and that presumably justifies that faith, or when he tries to back his claims with references to history or philosophy, he opens himself up to a critical examination by others. If it be claimed that a reference to a God presumably reached through faith must be made in order to know what a good man should do, what rulers may warrantedly demand, what in fact grounds all justified enactments, what rights slaves, women, and children have, and the like, those interested in the nature of persons, society, the state, and law will continue to carry out their self-imposed duty to ask whether or not what is claimed in God's name is needed, enhances, or distorts what is otherwise known. A philosopher, in

his own way does something similar, but I do not see how Neville keeps the two enterprises apart, or how he joins them.

I do not think it correct to take my 'skepticism' (?) to be due to the acknowledgment of the Dunamis. In the first place, I am not a skeptic, but in search of answers that can withstand criticism, and might illuminate what otherwise would remain in darkness. Were I a skeptic I would just wait for someone to say something and then be content to raise difficulties. The questions I ask of a theologian are not directed at his faith, but at the reasons he offers to those who do not share it.

I do not think that "the Dunamis plays a richer theological role than the God of *Modes of Being."* It has no necessary theological justification or use unless it be one similar to that which it has elsewhere. Although I have not yet fully grasped the nature and roles of the Dunamis, I know it has not been mastered by others who have touched upon it in one or another specialized form. There are some who claim that it was well-known to the pre-Socratics who presumably ignored all formalizations, but the fragments we have are too oracular, and the philosophy used to back the claim too undeveloped, that I do not see how the claim could be defended. We can know that the Dunamis is always present, and something of its nature and activity, while aware that it is constantly escaping from our grasp, spoiling all our rigidifications, and making evident that there is nothing merely rational, just a value, an extension, what is more or less congenial, or is merely alongside others. The Dunamis and the other ultimates, qualify one another.

Neville suggests that one modify the notion of the Dunamis to become a creation *ex nihilo.* I don't think it creates anything, though it surely is an important ingredient in creative acts, created works, and what these signify. I do not think that the Dunamis precedes all other ultimates, or antecedes Being, nor does it seem able to bring into existence what had no reality before, or constitute anything without the help of other ultimates.

I am not confident that I understand what Neville is claiming about the past, present, and future. He says that "the dynamic relations among past, present, and future cannot be temporal, but that they are eternally together." Is he referring to these as unrealized general features, or as characteristic features of what in fact occurs? The latter exhibits them in different limiting, transient guises; these, surely, are not 'eternally together'. He also says that there is no "pulsing flow of time in the absence of a divine creation," but it is not evident why he says this. If there is a creation, does it not occur in a passing time? Does creation occur only once? Such odd claims as that "the divine creative act makes all, i.e., past, present, and future together eternally," "the life of God is

more dynamic than . . . any finite thing," or an "eternal togetherness" of past, present, and future constitutes the "temporality of the world," are left hanging from no evident support nor provided with a sustaining ground.

Nothing that Neville maintained prepared me for the claim that "Within the eternal life of the creator we are eternally young." The claim is in keeping with theological tendencies to take the tiniest opening to a supposedly divine being to allow for any number of claims arbitrarily set down. They should trouble even those who look for backing for their hopes and fears. I who look back some seven decades remember how callow and confused I was. I'd rather be in my nineties. Fortunately, when Neville returns to consider what must be said about existing humans, he exhibits a refreshing, stubborn good sense about the failures of his once fellow travellers to find a place for 'moral' responsibility in actualities that finish their momentary coming to be by becoming inert data for other actualities and for an eternal pivot called 'God'.

Did one, following Neville's lead, take the Dunamis to characterize the divine, one would understand this in terms of some ultimate. To the degree that this is legitimate, it would also be legitimate to characterize God in terms of all the other ultimates as well though such characterizations could at best provide only a way of articulating the nature of what they all presuppose. A theology is blocked by the fact that the God with which it is concerned is beyond all articulations, all multiplicities, entirely in itself, unless perchance it produces what can sustain its expressions. To get to that God one must find a counterpart of the adumbrations by which one moves intensively into the depths of actualities. If a faith does in fact enable us to do this, it will be a faith exhibiting a penetrative adumbration, passing beyond what is manifested to its source.

A faith is inseparable from a hope that there is that which justifies it. Representatives of some religion may assure its adherents that their faith will be justified, but that assurance needs its own justification. How does anyone know that a faith is justified? Would not the assurance need its own justification? How does one know that the sincere expression of a faith terminates in a satisfying and perhaps rewarding God? Are not all reports of what is reached in faith, like the reports of one's love, hate, or fear, abstract and perhaps distortive recollections of an experience too rich, too strongly charged with emotion, desire, submission, and expectation to be well conveyed in theological or philosophic terms?

Such questions will perhaps be answered with another: Does not every report provide only an attenuated, disjoined representation of what is thicker and more inward? Yes. Suppose there were someone who

denied that, contenting himself with a reference to common language, intentionality, or 'animal faith'? If he addresses us, we will know that he passed beyond our appearances, just as we do when we attend to him. Denials of the effectiveness of adumbrations are themselves adumbratively directed at others. The fact, though, that we do get beyond the appearances of actualities does not warrant the supposition that we could get beyond Being itself to what might be within or beyond it, powerful, creative, wise, and good. Since, too, faith is exercised within the limits prescribed by a particular religion, one does not know if others who adhere to a different religion had also arrived at their objective.

There is no adjudicating the assurances that different religions provide for expressing one's faith in one way or another, or knowing whether or not one, or all, or no expression of faith arrives at its sought terminus. One has faith or does not have it, and that is the end of the matter. No one can be turned into a religious person by an argument. Saul fell into a ditch and Augustine hit on a passage in a book and great transformations apparently occurred. Others have fallen into ditches and have read the same passage, but nothing so cataclysmic happened. To say this is to show more respect for those who are religious than is expressed by others who rest with arguments and supposed proofs, or who construct systems that justify the religious views and practices of their group.

A theologian tries to be two-faced, but ends up wall-eyed. He wants both to remain in close accord with the faithful and to meet the philosophical demand for clarity, justification, coherence, and relevance to what is otherwise known. While Neville is one of the few who is at home in both fields, he, no better than the others, fails to be equally just to the demands they try to meet in their different ways, and for different reasons. His predilection is toward the philosophers, as his vigorous speculative account makes evident. I have addressed myself mainly to this, faulting it because it is not fully appreciative of what the faithful aim at and what many believe they reach and because it is not sufficiently well backed by a good set of philosophical reasons.

Neville, as a philosophically tempered theologian, is not satisfied with my treatment of the problem of the One and the Many, and thinks his God- (or Creativity) grounded view provides what is needed. I hope he has many other reasons than those he now presents and that he will try to back his present suggestions with better warrants—or perhaps better, that he will so revise what he has now offered that it will at least open up speculations about the theological-philosophical ideas he has presented. I think he can be counted on to face with honesty and vigor the kinds of challenges that are here offered. He has surely made conspicuously

evident that he is at home in both recent philosophic thought and in theological views, both East and West. I, without any faith whatsoever, wish he had been more attentive to what the faithful seek and what some of them claim to reach. If he did, I think he would find that a different philosophical view would fit in better with what is secularly knowable and still make room for those whose faith seeks only to reach what is superlatively good, forgiving, and powerful. This is beyond Being itself and, therefore, beyond all knowing.

The God of the philosophers is a place where they hide the problems they cannot solve; the God of the faithful dissolves what deeply troubles them. I eschew the first, while confessing not to know whether or not the other ever reaches what it so poignantly seeks. I do not think the difficulties he finds with my views are much more than indications that they do not meet some theological needs, as he understands them, or provide warrants for the leaps he makes, backed by no arguments and ending with what is quite irrelevant to true believers. He has made me more confident than I had been that I must remain where I now am, until reason and faith are better joined than he has shown them to be.

If Neville would like to do most justice to philosophic demands and theological acceptances he must find a position in between the two. Is there one? Can it enable us to evaluate them, make evident their necessary limitations, and show that they necessarily supplement one another? I hope that Neville will deal with such questions, and that I will be permitted to share in and benefit from the attempt.

P.W.

18

Robert L. Castiglione

WEISS'S EARLY SUBSTITUTIONAL LOGIC

I remember writing a paper criticizing the theory of types in *Principia Mathematica* and showing it to . . . [Whitehead]. He looked at it, began to laugh, and said, "I always thought there was something wrong with the theory of types." This is more typical of Whitehead than almost anything else. He did not urge his views; but they were more openings up, adventures in imagination, insights into the nature of things.

Paul Weiss (1974)[1]

Paul Weiss's earliest writings were rooted in his dissatisfaction with the arbitrariness of the logical doctrines propounded by Bertrand Russell. His critique and explanation of the self-referential paradoxes and his analysis of the limitations of the theory of types would disclose much about the universe that the philosophers of mathematics denied, especially those who believed that the paradoxes of set theory and of self-referential statements had proved that all metaphysical systems were self-contradictory. The essay, "The Theory of Types," was published in the English philosophical quarterly *Mind* in 1928 and republished as an appendix to the 1933 edition of *Science and Sanity* by Alfred Korzybski. In that paper Weiss undercut the illegitimate critical condemnation of metaphysical speculation that had been voiced by Russell and by the philosophers and logicians persuaded by Russell's views.

If Weiss had only been able to show that acceptance of the theory of types would radically reduce the significance of systematic philosophy or intelligible content of our ordinary discourse or that it rendered negligible a common form of logical refutation, his criticism of the theory of types would still have been a telling one. However, Weiss's criticisms

went beyond this, and explained how necessary it was for Russell (and Whitehead) to ignore their own theory in their explanations and speculations. In addition Weiss showed that the statement of the theory was flawed and that it did not resolve in a satisfactory fashion the self-referential paradoxes. The three of special concern to Weiss are the paradox of Epimenides the Cretan, who asserted that "All Cretans are liars"; second, the liar's paradox in the first person, "I am lying"; and third, the autological-heterological paradox of Weyl. This last paradox is an extension of the paradox of the class of classes that are not members of themselves to the case of words. Although Weiss does not explicitly resolve the paradox that all propositions are false, "(p) p is false," this one can easily be resolved using a variant of Weiss's substitutional resolution to the Epimenides paradox.

Weiss's use of a substitutional approach to predicative functions (which has some kinship to the interpretation of predicative functions and general propositions offered by F.P. Ramsey, with whose work he was familiar) and his resolution of Weyl's "heterological-autological contradiction" is most important in the elimination of the confusions that result in the theory of classes from a failure to distinguish between the differences in denotation of classes that arise when logical and mathematical modes of analysis are ignored or conflated. (In this regard, it is significant to note that as late as 1952, a student of metamathematics as perceptive as S.C. Kleene, was still construing his discussion of metatheory in accordance with Weyl's distinction.) Weiss considers the paradox of the class of all classes which are not members of themselves to be subject to the same confusion of linguistic usage as is present in Weyl's analysis. According to Weiss, instead of resolving these paradoxes, the application of the theory of types involved violations of principles of logic, violations (real paranoumena) that were best eliminated by rejecting the theory of types itself.

"The Theory of Types" is divided into two parts: the first part is a critique of the self-contradictory character of the theory as it was proposed by Russell; while the second part contains a criticism and resolution of the paradoxes that Russell had considered. In this essay I focus upon Weiss's resolution of the paradoxes.

Weiss handles the Epimenides paradox in two ways: first, he analyzes the paradox utilizing a categorical or ordinary language approach; and second, since his former analysis is subject to the criticism that he has moved from the domain of hypothetical statements to that of existential ones, he offers an analysis that does not make such a move, but utilizes a substitutional analysis which is not liable to such criticism. In the first

analysis, as Weiss explains the paradox of Epimenides, it is paradoxical only when it is presumed to be a true statement; for then its supposed truth rebounds upon itself and shows itself to be false. When it is recognized as a false generalization, it is meaningful and nonparadoxical. The falsity of Epimenides the Cretan's claim that "all Cretans are liars," does not mean that its contrary (the statement "no Cretans are liars"), is true, which was Russell's view. This claim, as Russell makes clear in his analysis of the Liar's paradox, is also paradoxical; for if the statement "no Cretans are liars" were true, then since Epimenides was a Cretan, his statement that "all Cretans are liars" would be self-contradictorily true. And the cycle would begin all over again.

The falsity of the Epimenides claim means instead that the original statement's contradictory ("some Cretans are not liars") is true. In this case Weiss has recognized that the denial of the truth of this universal affirmative proposition cannot be consistent if the denial is interpreted as meaning "no Cretans are liars"; instead, the only consistent denial of the truth of Epimenides's claim must take the form of the contradictory ("it is not true that all Cretans are liars," i.e., "some Cretans are not liars"). The ascription of truth to the original self-referential claim is what makes it paradoxical; it is not its self-referential character that is problematic. We recognize that the ascription of truth to this statement cannot be correct; and this recognition is possible because the self-referential character of this individual statement (i.e., when the statement is uttered by a Cretan) shows us not only that it cannot be true, but also that it is only meaningful when considered as false. Weiss states:

> The proposition 'All Cretans are liars' must be false if it applies to Epimenides as well, for it cannot be true, and only as false has it meaning. If it were true, it would involve its own falsity. When taken as false, no contradiction, or even paradox, is involved, for the truth would then be 'some Cretans tell the truth'. The truth could not be 'all Cretans tell the truth' [that is, 'no Cretans are liars,' which is the contrary of Epimenides's original claim] for Epimenides must be a liar for that to be true and by that token it must be false. Epimenides himself would be one of the lying Cretans, and one of the lies that the Cretans were wont to make would be 'all Cretans are liars'. Thus if Epimenides meant to include all his own remarks within the scope of the assertion, he would contradict himself or state a falsehood. If it be denied that a contradictory assertion can have meaning, he must be saying something false if he is saying anything significant. Had he meant to refer to all other Cretans there is, of course, no difficulty, for he then invokes a kind of theory of types by which he makes a remark not intended to apply to himself.[2]

As noted above, this maneuver is considered inappropriate by some logicians, because it involves a move from a hypothetical claim, "if any

Cretan makes a claim, then that claim is false," to an existential one, "there is some Cretan who makes a claim, and that claim is true." Weiss handles this objection by offering a logically more perspicuous, substitutional analysis immediately following the first. In this maneuver, Weiss (as he notes) is indebted to a notation offered by Whitehead, but he changes Whitehead's adjectival analysis in a fundamental fashion by applying it to propositions.[3]

In his second analysis of the claim, Weiss makes explicit that Epimenides's claim is one that is about the propositions of Cretans; to call someone a liar is to say that his statements are false. Consequently, Weiss takes the subject "Cretans" and the predicate nominative "liars" from the statement "All Cretans are liars" and correctly interprets them as categories adjectival to propositions. As Weiss notes, letting " 'CR' represent 'Cretanic' and p represent a statement or proposition, then for 'All Cretanic statements are false (or lies)', we have:

1. CR p .). $-$ p. "

Weiss will use this statement in two ways: first, as a particular assertion; and second, as a rule or formal implication. It can serve in both ways, because it is a general proposition, a definite, unquantified proposition, meaning 'Cretanic propositions are false propositions,' or 'if something is a Cretanic proposition, then it is a false proposition.'[4]

Weiss asks us to accept the use of an assertion-predicate, Ep! (which sounds like a subject, when the proposition in which it occurs is translated in the active voice, but is simply a predicative function like all the others) and joins it to the symbol for any proposition, p , letting "Ep! p represent 'Epimenides once asserted p '. . . ." Restated in the passive voice, this becomes, 'p is asserted by Epimenides'. Weiss then formulates the connection between Epimenides's being a Cretan and the assertions that he makes, namely, that what Epimenides asserts are Cretanic propositions: "as Epimenides is a Cretan, for any assertion he makes we have:

2. Ep! p .). CR p "

(This can simply be read, 'if a proposition is asserted by Epimenides [Ep! p], then the proposition is a Cretanic one [CR p]).

It is important to note here that Weiss has not generated an assertion logic in either Russell's, Wittgenstein's, or Rescher's sense. The symbol 'Ep!' could just as well be eliminated and replaced by any symbol which was recognizable as a predicational function, as long as it was interpreted

as signifying 'is asserted by some particular individual' or in some cases, simply as '. . . is asserted'; also, '−p' could be eliminated and replaced by "p is false," (which was Russell's and Whitehead's semantic reading of that symbol and which could be supplanted by the simple predicate 'F'.[5]

The next move that Weiss makes depends upon the fact that Epimenides's assertion (statement No. 1 above) that "All Cretanic statements are false (or lies)," can be taken as an instance of *p*, since Epimenides asserted it, and as such can be viewed as an argument to the function that is contained in statement No. 2: that "If Epimenides asserts a proposition 'p', then the proposition 'p' is a Cretanic one." All that needs to be done is to substitute statement No. 1 for 'p' in statement No. 2; as Weiss states, "As No. 1 is an argument to the above [proposition No. 2]—it being Epimenides's present remark—we get:

3. Ep! { CR *p* .). − p} .). CR { CR *p* .). − p}."[6]

(Statement No. 3 is read: If Epimenides asserts that Cretanic statements are false, then the statement that Cretanic statements are false, is itself Cretanic.)

This substitution is not an illegitimate one, because as Weiss notes, the substitution of statement No. 1 for 'p' in statement No. 2 is simply making explicit the content of the specific Cretanic statement (statement No. 1) that Epimenides asserted.

Weiss then recognizes that statement No. 1 is not only an argument to statement No. 2 (Epimenides's assertion), but is also in one very specific sense, an argument to (or a token of) the claim made in No. 1; statement No. 1 is a particular instance of the principle that is contained in statement No. 1: "No. 1, as a Cretanic statement, is an argument to No. 1 as a formal implication or principle about Cretanic statements, so that:

3A. CR { CR *p* .). −p} .). − { CR *p* .). −p}"[7]

(Proposition No. 3A is read: 'if the statement that Cretanic statements are false is a Cretanic statement, then the statement that Cretanic statements are false is itself false.')

Weiss explains that statement

> is an instance of the implication expressed by No. 1, and is this instance because of the particular argument it does have. It states the fact that " 'all Cretanic statements are false' is a Cretanic statement", implies that " 'all Cretanic statements are false' is false".

He notes that there is no infinite regress here because "the implication that is contained in its argument does not have instances." He continues:

"It is because any considered general proposition is at once an individual fact, and a formal implication or principle, with many possible arguments, that it is capable of being taken as an argument to itself."[8]

At this point in his analysis of Epimenides's claim, what Weiss offers us is a substitutional version of a hypothetical syllogism, not an immediate inference to an existential claim from a hypothetical one. He accomplishes this because he recognizes that different statements (whether universal, particular, singular, or general) can be, as statements, arguments to predicational functions; in this case the functions "is Cretanic," "is false," and "is asserted by Epimenides." In the case at hand, the fact that the general proposition "all Cretanic statements are false" is an argument to itself (a fact made formally explicit in statement No. 3) allows us to prescind from the internal relationships that such a statement has to other possible statements, e.g., "some Cretanic statements are false," "no Cretanic statements are false," etc. some of which are summarized in the traditional square of opposition. Consequently, there is no existential fallacy in the analysis that Weiss offers. As he explains:

> No. 3A is an instance of the implication expressed by No. 1, and is this instance because of the particular argument it does have. It states the fact that " 'all Cretanic statements are false' is a Cretanic Statement", implies that " 'all Cretanic statements are false' is false". Substitution of another argument would give a different instance; though of course of the same implication. The implication contained in its argument does not have instances. " 'Some Cretanic statements are false' is a Cretanic statement" or " 'This Cretanic statement is false' is a Cretanic statement" are not instances of " 'All Cretanic statements are false' is a Cretanic statement," but of "P is a Cretanic statement". These three propositions have different subjects; they are different values of the same propositional function.[9]

The Epimenides paradox is completely resolved when statements No. 3 and No. 3A are taken as the premises of a hypothetical syllogism. Its first premise is statement No. 3:

Ep! { CR p .). $-$p} .). CR { CR p .). $-$p}

(Read: If Epimenides asserts that 'all Cretanic statements are false', then the statement that 'all Cretanic statements are false' is a Cretanic statement.)

The second premise of the hypothetical syllogism is statement No. 3A:

CR { CR p .). $-$p} .). $-$ { CR p .). $-$p}

(Read: If the statement that 'all Cretanic statements are false' is a Cretanic statement, then the statement 'all Cretanic statements are false' is false.)

The conclusion of this hypothetical syllogism is:

Ep! { CR p .). $-$p} .). $-$ { CR p .). $-$p}

(Read: If Epimenides asserts that 'all Cretanic statements are false', then the statement 'all Cretanic statements are false' is false.)

Although the formulas that are used to explicate the paradox seem complicated, beneath the visual complexity there is a simplicity and conceptual clarity to the way that Weiss disposes of the apparent paradox of Epimenides's claim. Given its conceptual clarity, it is difficult to understand why philosophers have refused to recognize that in the case of this paradox and others, the extensional, object-centered analysis must give way to an intensional, substitutional analysis. In the categories of the older nineteenth-century logic, Weiss's resolution is an interpretation of propositions considered under the rubric of possession, i.e., where the predicates, in this case 'Cretanic' and 'false', are viewed intensionally.[10] A similar justification is offered by Ramsey in a number of essays. In the essay "Facts and Propositions" (1927) Ramsey writes: "What is novel about general propositions is simply the specification of the truth arguments by a propositional function instead of by enumeration. Thus general propositions, just like molecular ones, express agreement and disagreement with the truth possibilities of atomic propositions, but they do this in a different and more complicated way." As we shall see below, to attempt to handle them simply by using quantified formulas, instead of general ones, shows its own insufficiency.[11]

Weiss's handling of the liar's paradox is similar to that of Epimenides. He notes that there is an ambiguity regarding its precise meaning, specifically, does "I am lying" mean "I am lying about X" or "I always lie" or "I have always lied"? The first meaning, "I am lying about X" causes no problems, as it may be true or false, except in the case, as Weiss notes "where 'all my assertions' is made an argument to X, in which case it is equivalent to either the second or third formulation." The third formulation, since it refers to a totality in the past, and does not include the present statement, also causes no problems: "If what is meant is that 'I have always lied', that does not involve a contradiction, for what is intended is a restricted proposition, applying to *all* but the present one." The second formulation 'I always lie' is reducible to the same form as the Epimenides paradox and is always false.[12]

Weiss reformulates Epimenides's assertion in the first person: "If I assert *p, p* is my assertion"; consequently it is a simple maneuver to resolve the liar's paradox by recasting it in the form of the Epimenides paradox. Letting 'Mp' stand for 'p is mine (my statement)', and 'I!p' for 'I assert p', we can resolve the paradox in the following five steps:

1.　Mp .). −p

(Read: All of my statements are false; or I always lie.)

2.　I!p .). Mp

(Read: If I assert p, p is my statement.)

3.　I! { Mp .). −p} .). M { Mp .). −p}

(Read: If I assert 'I always lie,' then 'I always lie' is my statement.)

3A.　M { Mp .). −p} .). − { Mp .). −p}

(Read: If the statement 'I always lie' is my statement, then the statement 'I always lie' is false.)

3B.　From statements No. 3 and No. 3A we may conclude:

I! { Mp .). −p} .). − { Mp .). −p}

(Read: If I assert 'I always lie', then the statement, 'I always lie' is false.)

As we have seen in Weiss's resolution of both the paradox of Epimenides and the liar's paradox, the paradoxes result from a failure to recognize the legitimacy of a statement that is "at once an individual fact, and a formal implication or principle, with many possible arguments, that . . . is capable of being taken as an argument to itself."[13]

After his resolution of these two paradoxes, Weiss noted that Whitehead had pointed out to him that "wherever a conjunction of propositions results in a *reductio ad absurdum,* there is no way of determining on logical grounds alone which of the antecedents fails, or is false (although one at least must be)."[14] Using his analysis of Epimenides's paradox as an example, Weiss shows where the limitations of *reductio ad absurdum* argumentation and the confusions of the extensional approach to self-contradictions lie. It is because we continue to assume that the assertion truly occurred (i.e., that Epimenides asserted 'All Cretans are liars' or that I asserted 'I always lie') that we realize that the rule must be wrong. The problem of determining which antecedent is false itself becomes

problematic in the next paradox, '(p). p is false' where it seems that one proposition must serve both as premise and leading principle, i.e., both as a fact and as a rule governing the fact.

Weiss's substitutional approach to resolving the paradoxes is perfectly suited to the paradox involving the statement '(p).p is false' which Russell and Whitehead consider. Although Weiss did not explicitly analyze this paradox, applying Weiss's analysis to it will serve to explain how it was that, given their concern to explain mathematical notions in terms of extensional predicative functions, Whitehead and Russell were led to place unnecessary restrictions upon propositions involving self-referential totalities.

Russell's and Whitehead's presentation of the assertion, '(p). p is false' is indicative of the fact that they recognize that the usual formalization of this claim, '(p). p is false' [every assertion is false] in the form '(p) − p', is an inappropriate symbolization. If we attempt to utilize this latter quantified formula, we can see how unsatisfactory it is. If we take '(p).p is false' and symbolize it as a quantified formula '(p) − p', there is nothing that we can do with it, given Whitehead's and Russell's restrictions against substitutions. If they allowed nested substitutions within quantifications, we could substitute '(p). − p' for 'p'. Then since '(p). − p' is an assertion, we would obtain:

1. (p). − [(p). −p]

(Read: Every proposition that 'all propositions are false,' is itself false.)

As Whitehead and Russell were aware, even if they allowed such a substitution, this still wouldn't solve the problem; each time a substitution is made, the truth value of the resulting complex proposition changes, just as in the original paradox. Since statement No. 1 is itself an assertion, we could substitute it for 'p' and obtain:

2. (p). − [(p). − { (p). −p }]

(Read: The proposition that "every proposition that 'all propositions are false' is itself false" is always false.)

The original statement in its quantified form is not a rule; but there is a rule implicit in its meaning. If we make that rule explicit, we obtain:

'(p) [p .). −p]'

(Read: 'All propositions are false' or alternately, 'Any proposition implies its own falsity').

Yet here also, every substitution involves a change of the truth value of the resulting proposition; in this case, "is false" acts like simple negation. If we symbolize "(p). p is false," using a definite proposition, the root of the problem still remains:

1A. p .). −p

(Read: 'All propositions are false,' or 'Every proposition implies its own falsity').

Given the fact that this general statement refers to itself, we can substitute 'p .). −p' for p in No. 1A; when we do, we obtain No. 2A:

2A. { p .). −p } .). − { p .). −p }

(Read: 'All propositions are false implies that it is false that 'all propositions are false.').

Conjoining statements No. 1A (as the fact) and No. 2A (as the rule governing that fact), we obtain the following conclusion:

3A. − { p .). −p }

(Read: It is false that all propositions are false.)

However, this resolution is unsatisfactory, because it is simply a provisional one; if we substitute statement 2A for 'p' in statement 1A, we obtain a new leading principle:

4A. [{ p .). −p } .). − { p .). −p }] .).

 − [{ p .). −p } .). − { p .). −p}]

(Read: IF "all propositions are false implies that it is false that 'all propositions are false'", THEN it is false that "all propositions are false implies that it is false that 'all propositions are false'"; or more briefly, . . . THEN it is true that all statements are false.)

When we conjoin this leading principle (4A) to statement 2A, we may conclude: "It is true that all statements are false."

But when we formulate Russell's and Whitehead's paradox in this way, we can recognize that the original proposition (No. 1A) is being used in three ways: first, as a formal rule to govern an inference; second, as a fact which serves as a premise; and third, as a formula to generate a substitution instance of itself (statement No. 2A) which can serve as the leading principle for this particular argument.[15] What is missing in this new formulation of the paradox of '(p). p is false' is the recognition of the

unanalyzed (or implicit) argument of which '(p). p is false' is the condensation.[16]

Russell and Whitehead ignore the fact that '(p). p is false' is a principle that results from condensing two implications, one that is not self-referential (it does not serve as an argument to itself as a function) and one that is self-referential. This can be seen most clearly if we analyze what '(p). p is false' means when it is used as a rule. Following this rule, we can infer that if something is not false, then it is not (and cannot be) a proposition; this formulation is the self-referential portion of the rule. But there is a further inference that we can make: if something is not a proposition, it is not (and cannot be) asserted. This latter rule is the unanalyzed portion of the paradoxical rule, and it is not self-referential.

Where '(p). p is false' is written, it is a quantified statement, and as such is asserted to be true; since the quantification is universal, it is claimed to be true for all values of p, not simply for some values of p. Consequently, following Weiss's earlier analysis of the paradoxes of Epimenides and the Liar, we can analyze this situation into two parts: first, the assertion of the proposition in question; and second, the application to itself of the self-referential principle contained in the proposition. Letting 'F' stand for 'is false,' 'P' for 'is a proposition,' 'A' for 'is asserted,' and 'e' for 'any entity,' we can symbolize the situation as follows:

(i) − Fe .). − Pe [and its equivalent: Pe .). Fe]

(Read: 'If an entity is not false, then it is not a proposition.' Its equivalent is 'All propositions are false.'); and

(ii) − Pe .). − Ae [and its equivalent: Ae .). Pe]

(Read: 'If an entity is not a proposition, then it is not an assertion.' Its equivalent is 'All assertions are propositions.').

Principle (i) is self-referential; it can serve as an argument to itself as a function, since the statement of the principle 'Pe .). Fe' is a proposition; consequently we can substitute 'Pe .). Fe' as the statement of the rule for 'e' in 'Pe .). Fe' to obtain:

(iii) P [Pe .). Fe] .). F [Pe .). Fe]

(Read: If 'all propositions are false' is a proposition, then 'all propositions are false' is false.)

Since Russell and Whitehead did propose a universally quantified statement, '(p). p is false' as true (if only to have it turn upon itself and have its value reversed), they treated such a claim as asserted; conse-

quently, we can substitute 'Pe .). Fe' for 'e' in principle (ii) 'Ae .). Pe' to obtain:

(iv) A [Pe .). Fe] .). P [Pe .). Fe]

(Read: If 'all propositions are false' is asserted to be true, then 'all propositions are false' is a proposition.)

In addition, we can treat their communication of their belief that the claim '(p). p is false' as an instance of 'Ae' and obtain:

(v) A [Pe .). Fe].

(Read: 'All propositions are false' is asserted.)

The resulting sortie that follows from conjoining (v), (iv), and (iii) as premises, has exactly the same pattern as that proposed in Weiss's resolution of the Epimenides and the Liar's paradoxes. From (v) and (iv) we obtain:

(vi) P [Pe .). Fe]

(Read: 'All propositions are false' is a proposition.)

And from (vi) and (iii), we obtain:

(vii) F [Pe .). Fe]

(Read: 'All propositions are false' is false.)

There is no paradoxical reversal of values reiterated infinitely many times, because the assertion of the principle 'for all values of e, e is false', is not self-referential, although the principle that 'all propositions are false' is self-referential.

In the case of this paradox, analyzing the denial of the conclusion of this sortie (in a manner similar to the analysis Weiss offered in reference to the Epimenides paradox) is enlightening, because it uncovers the presuppositions that are present in the formulation of this kind of paradox. If we deny the conclusion (vii), we must deny at least one of the original premises; i.e., if we assent to proposition viii,

(viii) − F [Pe .). Fe] .).

(This is the claim " 'All propositions are false' is true," which is the denial of the original conclusion vii),

then we must assent to at least one of the following propositions:

either (a) − A [Pe .). Fe] .v.

(This is the claim " 'All propositions are false' is not asserted," which is the denial of premise v)

or (b) – { A [Pe .). Fe] .). P [Pe .). Fe] } .v.

(This is the claim " 'All propositions are false' is an assertion, but not a proposition," which is the denial of premise iv)

or (c) – P [Pe .). Fe] .v.

(This is the claim " 'All propositions are false' is not a proposition," which would also entail case (a) above, and which is the denial of premise vi)

or (d) – { P [Pe .). Fe] .). F [Pe .). Fe] }

(This is the claim " 'All propositions are false' is a proposition, but not a false one," which means that it would be an exception to the rule that 'all propositions are false', and which is the denial of premise iii).

Although such a reconstruction of the original paradox is tedious, it shows us, as Weiss noted, exactly what options are available to philosophers who wish to reject the substitutional resolution of the paradox of the claim 'for all values of p, p is false.' There would have been no paradox in the proposal that 'for all values of p, p is true,' even though it is asserted to hold for all values of p, and the latter part of the claim "p is true" is self-referential. As Weiss explained in regard to the Epimenides and Liar's paradoxes, it is when the rule [in this case, 'Pe .). Fe'] is applied to itself that it produces alternating truth-values. To assert the rule [here asserting the rule is symbolized as, 'Ae .). Pe'] is not self-referential; but the assertion that " 'p is false' holds for all values of 'p'," shows us that the rule is self-contradictory, and thus, either meaningless or false.

Although there is no extended reflection on particular paradoxes of set theory in this essay, Weiss did offer an incisive analysis and resolution of Weyl's paradox (which is structurally equivalent to that of the class of all classes that do not contain themselves) and proposed a comprehensive approach to the notion of classes that is an answer to the paradoxes. The equivalence between these two paradoxes will be proposed below; for now it is sufficient to state that the paradox of a class of classes that do not contain themselves reduces upon analysis to two questions: "Can we legitimately utilize an intensional equivalent of a class (a universal of some sort that refers to collections of entities as collections) or must we maintain that any such notion like or equivalent to class must be interpreted extensionally?" If our answer to the first question is yes, we

must ask "Which combinations of intensional or extensional classes (i.e., extensional class of extensional classes, intensional class of extensional classes, extensional class of intensional classes, or intensional class of intensional classes) are subject to the paradoxical results?" Once we formulate the paradox of the class of classes in these terms, it is easily translated into the categories of heterologicality and of autologicality. The key to the explanation of the paradox of the Russell class, as Weiss shows in his resolution of Weyl's paradox, is the difference between the denotation of a class on the basis of a class name which "expresses a property" and one "which expresses a relation between a property and the substantive [that is denoted by the class name]."[17]

It was Whitehead's and Russell's desire for a completely extensional method of determining classes, one that they believed was necessary to support their program of explaining the notion of number and mathematical operations in purely logical terms, that is at the root of the presumed impossibility of resolving self-referential paradoxes. To see this, we must consider the nature of classes, and the peculiarity not simply of the predicative function "is not a member of itself," but also the limitations involved in any predicative function that utilizes a reference to a membership criterion as a defining predicative function, e.g., in the case of the predicative functions "is a member of a specific class" and "is not a member of a specific class."

According to Whitehead and Russell, a class is a range of values that is identical with the arguments which satisfy a predicational function, e.g. "is an a." The predicational function determines the class. The class contains the entire range of the referents of the individual terms which, when put in the open argument-place in the predicational function "is an a," make a completed statement that is true. In addition, they claim that for every predicational function which determines a class, there must be some formally equivalent predicational function which that same range of values satisfies. This is their principle of reducibility; and under Weiss's scrutiny, the illegitimacy of this principle as a rule for logical (as opposed to mathematical analysis) becomes evident. In the case of the Russell class, the class of classes which do not contain themselves as members, there are two issues that must be addressed: first, the manner in which this class of classes is denoted; and second, how the self-referential character of this class is expressed.

Russell's formulation of the paradox of the class of all classes that are not members of themselves involves a substitutional approach. Russell stated: "Let w be the class of all classes which are not members of themselves. Then, whatever class x may be, 'x is a w' is equivalent to 'x is

not an *x.'* Hence, giving to *x* the value *w,* '*w* is a *w'* is equivalent to '*w* is not a *w.'* [18]

The normal rule of extensional classes can be formalized straightforwardly using the substitutional procedures that Weiss had outlined in his treatment of the other paradoxes. If we accept the principle of extensionality, we are assenting to the view that the class is not an entity over and above the entities which are its members; where a class is referred to as "containing" or "including" itself, what must be meant is that the "class name" is a member of the class of entities which it denotes. If we mean anything else by "including itself" than we have simply rejected the principle of extensionality, and are using the word 'class' to mean *either* a group (of individual entities) that has a status over and above its members *or* an intensional relation among members of the class, which has some kind of entitative status of its own. In our treatment of the class of classes which do not contain themselves, only the first of these alternatives must be rejected. Class membership is denoted by the class name; and in non-self-referential classes, the class name is not a referent of itself. If we let the symbol 'CN' mean "is the class name (of a particular class)"; let the symbol 'RN' mean "is a referent of that particular class name; and use 'x' as a variable, we can formulate this principle (the principle of extensionality) in the following way:

1. CNx .). – RNx

(Read: If any entity is the name of a particular class, then that entity is not a referent of that particular class name.)

If we were to deny this principle of extensionality, then we would have generated a self-referential class, i.e., a class whose class name was included in the denotation of itself. As Weiss himself notes in this essay, all of the names of entities which are broadly intensional, e.g., sign, signification, meaning, concepts, do refer to themselves. A class name such as "word" would include itself among the entities it denoted. Normally, however, the class names of those classes whose members are not intensional objects are not members of the classes they name.

The second aspect of classes that is important to clarify is the fact that whatever the class name denotes, i.e., whatever entities are referents of the class name, are by that fact members of the class determined by the class name. In the theory of classes, the notions 'referent of the class name' and 'member of the class' are equivalent. If some entity were a member of a particular class, this is equivalent to saying that the entity is a referent of the class name of that particular class; and if an entity is a

referent of the class name of a particular class, it is by that fact a member of that particular class. Letting the symbol 'MC' mean "is a member of a particular class," we can formulate the rule of equivalence between membership and reference for classes:

2. [MCx .). RNx] & [RNx .). MCx]

(Read: All members of a particular class are referents of the class name of that particular class, and all referents of a particular class name are members of the class determined by that name.)

Since these notions are equivalent, we can reformulate this principle negatively: [− RNx .). − MCx] & [− MCx .). − RNx] (Read: If an entity is not a referent of a particular class name, then that entity is not a member of the class, and if an entity is not a member of a particular class, then that entity is not a referent of the class name.) Given this equivalence, we can reformulate the principle of extensionality in a slightly different way:

3. CNx .). − MCx

(Read: If an entity is the name of a particular class, then that entity is not a member of the class it names.)

In addition to being the statement of the principle of extensionality, this formulation, 'CNx .). − MCx' is also the name of the paradoxical class, the class of all classes that do not contain themselves. Calling it the name of the class of all classes that do not contain themselves, means that this formula denotes entities that are the members of this particular class of classes, i.e., classes that do not contain themselves. Since the determination of classes is founded on predicational functions, if we keep the discussion limited to class names and recognize that the functions "is a referent of the class name" and "is a member of the class" are equivalent, it will be easier to recognize the problems latent in the paradox, specifically an extensional interpretation of meaningful reference to intensional collections or universals.

What Russell terms 'the class of classes that do not contain themselves' is accurately symbolized in terms of the second order predicational function which uses the notions of 'is the class name' and 'is a referent of the class name':

3A. CN [CNx .). − RNx]

(Read: the phrase 'class name not a referent of itself' is itself a class name; or alternately, 'all names that do not refer to themselves' is a class name.)

The question that arises in Russell's formulation of the paradox is whether this class of classes, whose class name is "class name not a member of itself," will behave like a normal extensional class is supposed to; i.e., is this class of classes one that is a member of itself or one that is not a member of itself? As Russell noted, it does not seem to behave like a normal extensional class. Using these predicational functions, the proposal, "the class of classes that are not members of themselves is not a member of itself," takes the following substitutional form:

4. CN [CNx .). − RNx] .). − RN [CNx .). − RNx]

(Read: If the phrase "class name not a referent of itself" is a class name, then that phrase, "class name not a referent of itself" is not a referent of itself; in Russell's terms, the class of classes that do not take themselves as members is not a member of itself.)

Statement No. 4 shows that the correlation of the functions "is a class name" and "is not a referent of this class name" (which denotes the class of classes which do not have themselves as members), can be an argument to itself. And it is at this point that the interpretations offered by Weiss differ significantly from those proposed by Russell. Russell argues that since the class of classes which are not members of themselves is not a member of itself, then this class is a member of itself; i.e., Russell would claim that on the basis of the structural relationships exhibited in proposition No. 4, we can attach an additional consequent and form the new statement:

5. { CN [CNx .). − RNx] .). − RN [CNx .). − RNx] }
 .). RN [CNx .). − RNx]

(Read: IF whenever the phrase 'class name not a referent of itself' is a class name, the phrase 'class name not a referent of itself' is not a referent itself, THEN the phrase 'class name not a referent of itself, is a referent of itself; in Russell's terms: IF the class of classes that do not take themselves as members is not a member of itself, THEN the class of classes that do not take themselves as members is a member of itself.)

Statement No. 5 is the hub of the paradox. Formulated in this way it shows how Russell could interpret the class of all classes that are not members of themselves as self-contradictory. The antecedent of statement No. 5,

{ CN [CNx .). − RNx] .). − RNx [CNx .). − RNx] }

is the whole of statement No. 4. But the consequent of statement No. 5, 'RN [CNx .). − RNx],' is the denial of the consequent of No. 4, and as such, negates the principle on which statement No. 5 is based: if the class of classes that are not members of themselves is a member of itself, then it is not a class. From the conjunction of statements No. 5 and No. 4, we can conclude with Russell, that the class of all classes that are not members of themselves is not a class:

6. CN [CNx .). − RNx] .). − CN [CNx .). − RNx]

(Read: If the phrase 'class name which does not refer to itself' is a class name, then it is not a class name.)

Weiss explains in his analysis of the Weyl paradox how Russell's view (as represented by statement No. 5) is flawed; it is flawed because it conflates a third-order function to a second-order one. Since this discussion of Russell's paradox of classes has been accomplished in terms of the reference of names, it is a simple matter to translate Weiss's resolution of Weyl's paradox into Russell's.[19] Weiss summarizes Weyl's paradox as follows:

> Briefly stated it is: all words which express a property they possess are autological; all words which express a property they do not possess are heterological. If 'heterological' is heterological it expresses a property it possesses and is thus autological; if it is autological, it expresses a property it does not possess and is therefore heterological.[20]

Weiss resolves this paradox by explaining that a word is a multifaceted entity: its character in use in one context (e.g., that it denotes the possession of some property by some other entity but does not refer to itself) does not preclude the possibility that in some other more complex context, its normal referential use could be the subject of additional characterizations. Summing up his analysis of heterological words, Weiss states:

> Now if heterologicality were a property that a word could have, and if the word 'heterological' had that property, it [the word 'heterological'] would be a member of the autological class, for it would then possess a property that it expressed. But it would also be a member of a class of words which had the *property* of heterologicality. This class is determined by taking the properties of words, and if it be called 'heterological,' must be distinguished from that class which was determined not by properties, but by the relationship between properties and substantives. . . .
> Thus if 'heterological' had the property of autologicality, it would be in the heterological class owing to the *relation* which held between the property and substantive (or between a property it possessed and the property it expressed); but it would be in the class of autological words, owing to a

property it possessed. [See 'Second Case' No. 5B, below.] If it had the property of heterologicality, it would be in the autological class on the basis of the *relation,* and in the class of heterological words on the basis of *property* classification. [See 'First Case' No. 5A, below.] There is no difficulty in considering something as a member of two distinct classes, owing to the employment of different methods of classification.[21]

Weiss's statements here can be clearly presented in terms of the substitutional formulas that were used in statements No. 4 and No. 5, when No. 5 is properly reformulated. Russell's formulation (and Weyl's also after translation), as presented in No. 5, fails to account for a significant difference. Is the class of classes that do not have themselves as members to be considered a member of itself on the basis of a direct ascription of the property "being-a-member-of-itself" [autologicality] to this class of classes? Or is this class of classes to be considered a member of itself because the *relation* between a directly ascribed property of this class of classes, its not-being-a-member-of-itself [its heterologicality], and the directly ascribed property of its member classes, their not-being-members-of-themselves [their heterologicality], exhibits the property "being-a-member-of-itself" [autologicality]? Statement No. 5, which is the heart of the paradox, is wrong, because it eliminates the nested functions; without these nested functions, the statement is actually a misreading of the original question.

The conclusion that "the class of classes which are not members of themselves is a member of itself" excludes the provision that is essential; explicated fully, the statement should read: "when the class of classes which are not members of themselves [they are heterological] is considered not a member of itself [it is heterological], this class of classes has a relation [autologicality] to its component classes that is the opposite of its own class name." What this means is that the final *consequent* in statement No. 5,

RN [CNx .). – RNx]

that "the class of classes which are not members of themselves is a member of itself," is ambiguous: (i) does it refer to a property that is directly attributable to this class of classes; or (ii) does it refer to a property that is only indirectly attributable to this class of classes? Using the substitutional approach of Weiss, we can clearly distinguish between these two different senses in the ambiguous phrase "the class of classes which are not members of themselves, is a member of itself." Does the final consequent, that "the class of classes which are not members of themselves, is a member of itself" mean:

(i) Direct Property Attribution

CN [CNx .). − RNx] .). RN [CNx .). − RNx]?

(Read: The class name of those class names which are not self-referential is a self-referential class name.) This conclusion cannot be deduced from the original antecedent of statement No. 5, because it is an unwarranted derivation from the complex predicational function of the original antecedent of statement No. 5:

Antecedent of Statement No. 5

CN [CNx .). − RNx] .). − RN [CNx .). − RNx]

(Read: The class name of those class names which are not self-referential is not a self-referential class name.)

The formulation in (i) is of the same order as this original antecedent; yet the meaning of statement (i) is a completely different premise from the antecedent of statement No. 5. (The meaning of this new antecedent is presented in the SECOND CASE below.)

But if the formulation in (i) is not a proper reading of the consequent of statement No. 5, then we are left with (ii):

(ii) Indirect Property Attribution

RN { CN [CN .). − RN] .). − RN [CN .). − RN] }

(Read: The class name of those class names which are not self-referential, and which is itself not self-referential, is self-referential).

This formulation (ii) involves a new order of predicational function; it shows us that, if we wish to keep clear the precise kind of reasoning that leads to Russell's conclusion, that the principle of reducibility does not apply to this case. This formulation (ii) is more adequate to the precise statement of the paradox than Russell's interpretation is. Statement No. 5 must be reformulated to show the provision that is nested in the question of whether the class of all classes that are not members of themselves is a member of itself or not. If we analyze this case, separating the antecedent and the consequent of the new proposition (No. 5A), the paradox evaporates:

FIRST CASE: where what is 'heterological' has the character of *heterologicality* and is *autological* because of the relation between nested functions:

Antecedent of No. 5A:

{ CN [CNx .). − RNx] .). − RN [CNx .). − RNx] } .). . . .

(Read: IF the class of all classes which are not members of themselves is a class that is not a member of itself [i.e., it is heterological]. . . .)

Consequent of No. 5A:

RN { CN [CNx .). − RNx] .). − RN [CNx .). − RNx] }

(Read: . . . THEN the class of all classes which are not members of themselves, which is a class that is not a member of itself [i.e., it is heterological], has the relation to its member classes of being a member of itself [i.e., it has a relation to its member classes that is autological].)

SECOND CASE: where what is 'heterological' has the property *autologicality* and also is *heterological* because of the relation between nested functions. (Although I have not analyzed this case, it is referred to in (i) above. Since it is mentioned in a statement by Weiss that I have quoted, the formulation below is offered to illustrate that such nesting of functions and their arguments is part of Weiss's approach.)

Antecedent of 5B:

{ CN [CNx .). − RNx] .). RN [CNx .). − RNx] } .). . . .

(Read: IF the class of all classes that are not members of themselves is a class that is a member of itself [i.e., it is autological]. . . .)

Consequent of 5B:

− RN { CN [CNx .). −RNx] .). RN [CNx .). − RNx] }

(Read: . . . THEN the class of all classes which are not members of themselves, which is a class that is a member of itself [i.e., it is autological], has the relation to its member classes of not being a member of itself [i.e., it has a relation to its member classes of being heterological].)

As indicated in the first case (No. 5A) above, the antecedent of principle No. 5 has as its highest function two second-order predicational functions; but the consequent has a third-level predicational function. This shift is unusual, but it is not illogical. In fact, it is what is demanded

by a logic that keeps the differences between arguments and functions clearly in mind.

At this point a caveat is called for. We cannot reduce statement 5A to the simpler form, '[CNx .). − RNx] .). RNx' without eliminating the intelligibility of the original question, and thus making the original argumentation unnecessarily self-contradictory. It is the supposition that the class of classes that do not contain themselves is an extensional class, that leads to the conclusion that such a class of classes in one very special sense has a property which is the opposite of that possessed by its own members. The expression of this relation as formulated in the consequent of statement No. 5A is a third-level function: RN { CN [CNx. . . .] }. If we wish to treat it as if it were a second-level function, we could conjoin it to the statement No. 4, and conclude that this class of classes is not an ordinary extensional class:

No. 6 − CN [CNx .). − RNx]

(Read: The phrase 'class name not a referent of itself' is not a class name.)

But if we do this we have missed an opportunity to recognize that this paradox is simply the opportunity to generate a new sign. If a sign that is self-referential in this peculiar way is an intensional sign, then we should simply admit that: what results from keeping the levels and kinds of functions clearly distinguished is, in this case, an intensional sign.[22]

Russell went too far and imposed a restriction upon all self-referential classes, when he should only have stipulated that an extensional class of classes that are not members of themselves, a second-order class with a governing predicational function subject to the principle of reducibility, could not exist without contradiction. The reasoning that I have elaborated is only part of the original proposal. The original proposal should be stated as a disjunction: either the collection of classes that do not contain themselves as members is an extensional class (and thus not self-referential) or it is an intensional entity. We have seen how Russell generated the contradiction that arises from the supposition that this class is simply an extensional class; but he did not consider the other alternative: that the collection of classes that are not members of themselves is not an extensional entity, but as self-referential in this particular way, an intensional sign.

Because Russell refused to consider the case of predicational functions interpreted intensionally (predicational functions abstracted from what Weiss calls "intensive propositions") he analyzed only one of the alternatives that presented itself in this case. He rightly concluded that if

the collection of classes that are not members of themselves was simply to be treated as an extensional class, then it was a self-contradictory class and could not exist. But he seemed to go farther than this, and made it look as if he denied that any self-referential relations within a collection were allowed: "It must under all circumstances be meaningless to suppose a class identical with one of its own members." When we enter the realm of discourse concerned with classes of classes, we have to make explicit our stipulation that the analysis is to be restricted to these entities interpreted extensionally, and as subject to the principle of reducibility. To fail to do so restricts the intelligibility of the logical tools (intensional and extensional) that are at our disposal.

Weiss makes this point in his essay:

> A class is other than its members, and a relation, like all universals, transcends any given instance or totality of instances. As they have characters of their own, universals can be described in terms of other universals, which in turn transcend them. Arguments are of a different 'type' than functions, just so far as they have different logical characteristics, i.e., are different kinds of logical facts. The class which is an argument to a function about classes has, as argument, a different logical import than the functions, and its arguments have a different import from it. This is true of all functions, restricted [extensional] and unrestricted [intensional] alike, for it means simply that they are discriminable from their arguments. They can, despite this difference, have characteristics in common with their arguments, and are to that extent unrestricted [when interpreted intensionally]. Thus in the case of 'the class of those classes which are identical with themselves,' the class of classes can be taken simply as a class, without logical embarrassment. Yet a class of classes differs from a class, and must therefore be capable of a different characterisation, and thus also be an argument to a function of a different type. With some classes, it may not be possible to consider them as arguments to their own functions, without uncovering a contradiction. In such cases (e.g., the class of those classes which are not members of themselves, and the relations which are connected by their contradictories), it is the difference between the function and the argument that is of moment. That *some* functions cannot take themselves as arguments does not indicate that *all* functions are restricted in scope, but simply that they are *nonrestricted.* Some classes and functions are restricted and some are not. To say that all are restricted because some are is an obvious fallacy.[23]

Once Weiss had explained the multiple sources of the paradoxes that Russell elaborated and the presumed contradiction that Weyl believed that he had discovered, he could proceed to focus upon a conception of logic that was not vitiated by false analogies between logic and mathematics, i.e., by restrictions that might be necessitated by mathematical subject matter, but which are not appropriate to the meaningfulness and verifiability of ordinary language and logically precise philosophical

claims. Mathematicians interested in the foundations of their own discipline would later reject Russell's approach to the self-referential paradoxes and opt for another kind of restriction upon the self-referential character of classes, in part because they did not think Russell's restriction appropriate to their work. But in the academic community, specifically in philosophy departments in American, English, and German universities, Russell's views and their progeny (e.g., the syntactic and semantic theories offered by Carnap and his followers), nurtured an unwarranted skepticism and misunderstanding of metaphysics, both by those knowledgeable in mathematics and those ignorant of it. Because Weiss's alternative to Russell's arbitrarily restrictive interpretations not only makes it possible to understand and resolve these paradoxes, but also salvages what is significant in complex human discourse, its elaboration is sorely needed by philosophers today.

ROBERT L. CASTIGLIONE

DEPARTMENT OF PHILOSOPHY
RHODE ISLAND COLLEGE
MAY 1992

NOTES

1. "Recollections of Alfred North Whitehead," by Paul Weiss, as interviewed by Lewis S. Ford, *Process Studies* 10 (Spring-Summer 1980): 47.
2. "The Theory of Types," *Mind* XXXVII, N.S. no. 147 (1928): 341; this essay was also published as Supplement II in Korzybski's *Science and Sanity* (1933), pp. 739. The pagination of references to the "Theory of Types" essay will normally be to both versions, followed by (M) for *Mind* or (S) for Supplement.
3. Encouraged by Whitehead's own proposal of a symbolism adequate to the problems, Weiss accepted an expanded role for predicative functions in his clarification and dissolution of the Epimenides paradox. This maneuver is very similar to an analysis that Whitehead later offers in *Process and Reality,* New York: Harper and Row, 1960, p. 404. The original publication was by Macmillan in 1929. Weiss expands this predicative mode of analysis in a significant manner by correctly interpreting the propositions contained within the Epimenides paradox as propositions about propositions. There is no illicit shift from use to mention in Weiss's analysis because the Epimenides paradox centers on the mention of propositions about a Cretan.
4. "The Theory of Types," 340–41(M), 739–40(S). In the quotes that follow, I have taken the liberty of replacing the Greek letter phi with the upper case letters 'CR'; the letters 'CR' make it easier to read the sense of the propositions. There is one point that may cause readers a problem with Weiss's formulation: he interprets the negation sign intensionally, as equivalent to 'the predicational function 'is false'. The interpretation of the symbolism " $-p$ " as

meaning "p is false" is sometimes considered questionable as a shift from the syntactic level of analysis to the semantic; but it actually is legitimate, because "truth-values" are simply predicational functions of propositions (second-order predicates interpreted extensionally). Weiss clarified this matter in his essay, "Relativity in Logic," published the same year as his essay "The Theory of Types." It was a common interpretation of the meaning of negation by Russell and Whitehead; and C.I. Lewis frequently interpreted " − p" as meaning "p is false." In Lewis's 1932 essay, "Alternative Systems of Logic," he writes: "Suppose we represent the fact that any proposition, p, is true by writing p = 1, and the fact that p is false by writing p = 0. These two properties, truth and falsity, represented by 1 and 0, constitute the basic categories of this system, and are called its 'truth-values'. . . . All the logical 'functions' which figure in the system are definable in terms of these two values. For example, the negation of p, 'not − p' or 'p is false,' may be defined by the fact that when p has the value 1 (truth), not − p has the value 0 (falsity, and when p has the value 0, not − p has the value 1." (*Monist* XLII, no. 4 [October 1932]: 485.)

5. "The Theory of Types," 341(M), 740(S).
6. Ibid.
7. Ibid.
8. Ibid. In clarifying this point, Weiss eludes the problem that Russell had so carefully analyzed. Russell had stated: "such a proposition as 'all the judgments made by Epimenides are true' will only be prima facie capable of truth if all his judgments are of the same order." (*Principia Mathematica*, p. 46.) Weiss's interpretation of the relation of statement No. 1 to statement No. 2 and of statement No. 1 (as an instance or fact) to itself as an implication or rule, here seems quite compatible with Quine's later view of truth in *Methods of Logic*: "Strictly speaking, what admit of truth and falsity are not statements as repeatable patterns of utterance, but individual events of statement utterance." (*Methods of Logic*, 4th edition, p. 1)
9. Op.cit., 341(M), 740(S).
10. William Turner, *Lessons in Logic* (Washington, D.C.: Catholic University Press, 1911), p. 90.
11. On the usefulness of general propositions in this regard, Weiss was familiar with the work of Frank Plympton Ramsey. For Ramsey's account of general propositions, see *The Foundations of Mathematics and Other Logical Essays* (London: Routledge & Kegan Paul, 1931), p. 153.
12. "The Theory of Types," 342(M), 741(S).
13. Ibid., 341(M), 740(S).
14. Ibid., 342(M), 741(S).
15. On this point, see Ralph Monroe Eaton's *Symbolism and Truth* (Cambridge: Harvard University Press, 1925), especially pp. 229–30. The use of a proposition in these three ways was recognized as legitimate by Whitehead and Russell. First, they recognize that a rule can be exhibited in a proposition which is an instance of that rule: "The proofs of the earlier of the propositions of this number consist simply in noticing that they are instances of the general rule given. . . . In such cases, these rules are not premisses, since they assert any instance of themselves, not something other than their instances." (*Principia Mathematica*, p. 98) That a rule can be exhibited in a proposition which asserts instances of itself clearly means that a rule can be viewed as a proposition, as is done in (2A) above.

They also clarify this distinction between a proposition that serves as a rule and a premise, which is the same as the distinction between the pair (1A) and (3A). However they claim that "The use of a general principle of deduction . . . is different from the use of the particular premisses to which the principle of deduction is applied. The principle of deduction gives the general rule according to which the inference is made, but is not itself a premiss in the inference. If we treated it as a premiss, we should need either it or some other general rule to enable us to infer the desired conclusion, and thus we should gradually acquire an increasing accumulation of premisses without ever being able to make any inference." At this point Weiss disagrees with their interpretation. The statement of the rule can itself be an argument to the rule. What they claim is that the rule of inference cannot itself be a premise in the argument without that new premise needing a rule of inference, *ad infinitum;* but in this case, their claim is simply the rejection of a substitutional approach. (See *Principia Mathematica,* p. 106.)

16. I use this term in a sense close to that of Ralph Monroe Eaton in *Symbolism and Truth,* p. 234.

17. "The Theory of Types," 343(M), 742(S).

18. *Principia Mathematica,* p. 60.

19. To effect such a translation we need do only three things: first, put 'W' (for 'word') into the formulas wherever 'CN' (for 'class name') had occurred; second, put 'H' (for 'heterological') wherever ' − RN' (for 'is not a referent of the class name') had occurred; and third, put 'A' (for 'autological') wherever 'RN' (for 'is a referent of the class name') had occurred.

20. "The Theory of Types," note 1, 343(M), 742(S).

21. Ibid., 344(M), 742–43(S).

22. For an explanation of this point, see Weiss's *Reality* (Carbondale and Edwardsville: Southern Illinois University Press, 1967; originally published in 1938 by Princeton University Press. Weiss refers to two basic kinds of derivations: "A premiss can be made to yield an extensionally or an intensionally entailed conclusion—one which contains the premiss as a disjunctive component [extensional], or one which is contained in the premiss as a component meaning [intensional]. When we proceed extensionally, we are interested in knowing what can be necessarily concluded if no consideration is paid to the internal nature of the premiss" (p. 137).

23. Op.cit., 344–45(M), 743–44(S).

REPLY TO ROBERT L. CASTIGLIONE

Robert L. Castiglione is completing a two-volume study of my work and life, of which the present essay is, I think, to be a part. He knows more about my life and my work than I do. Not only have I forgotten much, but I am too caught up in my present thoughts and daily life to find it possible to grasp exactly what I had once done or thought, or even to see how earlier discussions of a possible topic are related to present ones. I do not remember ever having been alert to all the nuances and implications he makes evident.

Castiglione's essay is the evident result of careful reading and hard thinking. If he is right, I was a better logician than I remember thinking myself to be. He has shown, in a way that no one else seems to have done, some of the untenable presuppositions that were, and apparently are still made by those who think that formalizations could capture all that is tenable in thought or possible in fact. Wittgenstein revolted against that idea in one way, and Whitehead in another. Castiglione makes evident that there are better ways of learning what there is than can be obtained by accepting the current tenets of logic, and that if logic is to progress, it must overcome some serious limitations. I did not have that objective in mind during the time I concentrated on issues in logic, but I may well have surmised it in a rather inchoate form. I don't believe, though, that at any time I could have provided as acute an analysis and seen the implications of my studies as well as he has.

I became acquainted with the problems he discusses through the teachings of Lewis, Langford, and Russell. All seemed to me to ignore some central issues, to misuse such terms as 'individual', 'class', 'implication', and 'inference'. I learned more from my reading of Peirce's daring and original thoughts in the field, and from his awareness that logic was but one of many areas to which a philosopher should attend. I began to

concentrate on nonlogical issues only after I began teaching at Bryn Mawr. Dealing with many topics that had not been noticed or mentioned in Cambridge—the nature of language, mechanism, art, Deweyan pragmatism, and the like. Then I saw how mistaken I was in thinking that logicians were like mathematicians, ready to have their errors made evident by others in a common effort to carry on the continual effort to learn and understand.

Logic is a distinctive enterprise, deserving one's full attention. One who remains occupied only with its problems, though, will not know what it presupposes, what it can and cannot clarify, or why and how it must be supplemented. Castiglione makes evident how a fresh look at some logical problems can open others, and thereby make it possible to break through the boundaries within which too many logicians confine themselves. It is not necessary, I think, to read my original discussions, for Castiglione has here focussed on the central claims, pointed out the presuppositions, and shown how one might benefit from a criticism of prevailing unexamined views. He here attends primarily to problems that had been unknowingly raised, but which could not be solved under the assumptions that had been tacitly made or allowed.

His examination of "classes" should, though, be supplemented by what is said of them in "The Logic and Metaphysics of Classes," and be tailored to make it germane to current discussions of sets. In *Creative Ventures,* I have tried to do the latter, referring there to some of the problems on which Castiglione focusses in another way.

I hope that Castiglione's study will reawaken an interest in intensional logic. This, to my knowledge, has not been dealt with systematically and in non-self-defeating ways, avoiding the formulations that are singularly appropriate to an extensional logic. We could also benefit from the studies and developments of logic in the East, particularly since some thinkers there are appreciative of the important role played by the vitalizing, fluid, omnipresent Dunamis. The result could be a logic that was at once formal and pulsative, and from which one could abstract a purely rigid 'extensional' logic. The more malleable 'intensional' logic is always involved with it to some degree.

One need not have to attend to an intensional logic, or an intensional component in extensional logic, in order to agree with Peirce, that different philosophies ground different logics. Two instances: the *Principia Mathematica* presents a Leibnizian logic; Hegelians acknowledge a different kind, brilliantly presented by Bradley, using an Aristotelian vocabulary.

No logic prescribes to reality. The most it could do would be to formalize the inescapable factors that are exhibited everywhere. The law

of contradiction, as Peirce noted, does not hold of the vague, nor does the law of excluded middle hold of the general. Were all items incomparable, the law of substitution would have no application. A Heraclitean flux has no place for the law of identity, or the needed terminations of inferences.

A logic prescribes only to what is amenable to it. This is not that logic concretionalized or localized; it has its own status and way of being and functioning. If so, the application of a logic must alter it while it alters that to which it is applied. Perhaps, better: use should be made of a plurality of logics, each appropriate to one kind of reality—actualities, ultimates, ideals, and Being—and understood to be articulating a single logic which showed how they were related to one another. The result would deserve Peirce's title, a 'Grand' logic, with subdivisions pertinent to the creative, the mechanical, the rigid, and the quivering, what is outside and what is inside, what is on the surface and what is below it. Could one break Hegel's hold on the Absolute, he could be understood to make use of different logics at different stages of his dialectic. Each and all would fall short of the reality they were expressing.

Castiglione has made evident that:

a. The solution to some of the paradoxes to which it addressed itself are beyond the power of the 'theory of types' to solve. What is not clear is just what Castiglione means by 'intensional', and whether or not his solution applies only to paradoxes of a certain kind, or to every one. I never faced that question. We are in need of a determination of the possible, basic types of paradox, and a knowledge of their bearing on what else is or could be known. At the very least, it would help us to know if the solutions of the paradoxes to which Castiglione and I addressed ourselves are relevant only to items of a particular kind. If there are other kinds to which they are irrelevant, we would have to ask how they differed from the ones now known. A good beginning could be made by examining, classifying, and trying to solve them along the lines now so well laid out.

b. No known logic's affiliations and rejections are absolute. Ayer said that he was an atheist because 'God' was not a word in his language. That language was his logic. Why did he not change it, or at least why did he not try to show that it alone was legitimate? Were any or all of a logic's (or a language's) limits absolutely unbreakable, it would still be legitimate to ask what could fit inside them and if, what could not, might perhaps be dealt with in some other way.

c. The distinctions, made in the course of the dissection and resolutions of the paradoxes to which Castiglione attends, are compelling. What is the source of the compulsion? Is the old two-valued logic being used by Castiglione and by me to point up the need to consider that to

which the logic does not apply? What is presupposed in the solution of these paradoxes? Are the distinctions finally made ones that had to be present from the very beginning of the examination? Is a demonstration, such as that which Castiglione provides, just a process of making explicit what was always implicit? If it is, is thinking here just a process of making explicit what was implicit and operative? If so, the logic we use would help make evident what it is for us to be, facing that which is other than ourselves. If we are persistent enough, will we not find ourselves still facing paradoxes, not only in what we might affirm about classes and the like, but everywhere and in every thing? Will the resolutions of the paradoxes then be anything more than ways in which we could be in better accord with what else there be, whether it be expressed in words or acts? I think so, but proof is needed. They will not satisfy unless they are couched in acceptable terms. That would still allow one to note that something else is needed than what current logics provide if our adumbrations and abductions, our interinvolvements and evidencings, our commitments and creations are to be well understood.

e. There is a difficulty latent in every refutation: can any be more than a replacement of the weaker by the stronger, the less by the more coherent? If we end in the self-contradictory, could this be known? Must not a refutation grant some legitimacy to what it would replace. Must not the replacement then accept what it had rejected, though perhaps in a chastened form?

f. A logic is doubly qualified, by its user and by that to which it applies. The formulae set out so neatly in the texts would be just marks on a page did they not represent actual structures. We do manipulate them as though they were attached to nothing, but only because we ignore what holds them in place and that to which they refer. To make a case for some logic as being superior to another, one must show that it is more in consonance with what is apart from it than some other is. Groundings for a primal logic should be found everywhere. An attack on an extensional or any other logic is properly made from a position that is better warranted and steadier than that possible to what is being attacked.

g. Logic limps behind mathematics. It tries to tidy up the theoretical world of science, usually after this has been embalmed in textbooks, and the scientific world has moved on to deal with new problems and to offer new solutions. The mathematics that is used in the sciences is not the mathematics with which mathematicians are occupied, but the husks of old problems and solutions no longer at the center of their concerns.

h. We do, we should reason. Logic shows antecedents as necessarily related to consequents. The two are co-present. When we reason we act, beginning with a present, and then leave this behind to arrive at a

conclusion, presumably in accord with the relation connecting anteced-
ent and consequent. Logic's necessities do not necessitate what is
supposed to conform to them. Should not what Castiglione makes
evident be extended, so that it applies even to the most innocuous of
rules and the inferences that supposedly conform to them?

i. Sooner or later, reference must be had to the outcomes of
philosophical speculation, i.e., to an understanding of reality in its
primary subdivisions and interinvolvements. Not until this is done will it
be possible to arrive at a controlled understanding of the nature of logic.
The effort, as Castiglione makes evident, itself requires sound, logically
certifiable reasoning. We must make use of a logic to find the logic that is
always operative. If we do not know what this is, could we be sure that we
are using it properly? Could we know whether or not we are distorting it
in the course of our trying to understand it? To avoid endlessly traversing
a circle, use should be made of the evidenced ultimates. Castiglione and I
have been relying on more than we made evident in our mastery of some
paradoxes, and in our rejections of other supposed solutions to them. As
he has made evident, the resolutions of them entrain new ones. Conceiv-
ably that might show that they are as unacceptable as those that had been
offered by Russell and others.

Castiglione has clearly heard a voice crying out some six decades ago,
and has understood what it was saying. His study is meticulous and
persuasive. I, for one, am much in his debt.

P.W.

19

Eugenio Benitez

PAUL WEISS, METAPHYSICS, AND THE PROBLEM OF INDUCTION

I. THE CASE FOR METAPHYSICS

The philosophy of Paul Weiss has always been recognizably metaphysical in its broad outlines. Whether the inquiry at hand is metaphysics as such—as in the case of reality, persons, or God—or whether it is conceivably distant from metaphysics—as in the case of sport and state, or arts and associations—an intensive move to the real is a predictable feature of his work. In its detail, however, Weiss's metaphysics is marked by an extraordinary departure from historical, institutional, and even avant garde approaches to philosophy. From virtually every frame of reference Weiss remains a persistent if inadvertent outsider: his metaphysics is idiosyncratic. Perhaps this should not trouble us so much. Weiss affirms that privacy is an ultimate, ineluctable feature of persons. This he discovered through explorations into himself, though he discovered it as already carried into his inquisitiveness, for it is a privacy neither he nor anyone else can dispense with in thought or in expression.

Yet persons are obviously not only private, they reach out to and are with others, they can understand and be understood. What they cannot do is make everything of themselves palpable in mere words. T. S. Eliot seems to have despaired of this, in his melancholy way, when he wrote that "We have only learned to get the better of words for the thing which we no longer have to say, or the way in which we no longer have to say it."[1] But his despair was unwarranted. We never *get the better* of words. We cannot train ourselves to become "fluent even in the wintriest bronze" (as another poet put it); our *logoi,* if you will, "occur as they occur."[2] This is not to say that philosophy is accidental or careless, any more than poetry is. It is to stress Socrates's point of resisting the verbal battle, which was never so much the battle against his interlocutors as the battle against words themselves. This much Socrates understood of

ignorance: so long as one attends only to words one is and will remain ignorant of the world. Weiss took the point to heart and has never shied of it.

Weiss's insistence on metaphysics, especially in subjects where metaphysics is typically unexpected or unwelcome, marks a personal insight into the requirements of understanding in general, one which has repercussions for the way philosophy is written, taught, discussed, and considered. Yet that insight remains difficult to penetrate because of an overwhelming, unwarranted tendency to try and wring it straight from his words. The difficulty stems from a belief that we must have an epistemological justification for everything; that we must be shown how to see. This belief has afflicted twentieth-century thought with an old malady, for it is really just a form of Meno's Paradox. Rorty diagnosed the illness when he noted that "it is difficult to imagine that any activity would be entitled to bear the name 'philosophy' if it had nothing to do with knowledge—if it were not in some sense a theory of knowledge or a method for getting knowledge, or at least a hint as to where some supremely important kind of knowledge might be found."[3] So far, however, no one has found a very successful treatment.

The predilection for epistemological justifications is especially clear in the central role assigned to the problem of induction by some philosophers. Their presuppositions are roughly and generally as follows: philosophy aims at knowledge about the world; the world consists of contingent facts; knowledge of contingent facts proceeds from an inductive method; an inductive method must have an adequate justification. A good deal of intelligence has been spent attempting such a justification, yet the most promising contender to date supports a weak-kneed fallibilism, which adopts the unpalatable view that "it is never rational to be certain of any observational statement."[4] Weiss has a stronger antidote for the problem of induction in his article "Induction: Its Nature, Justification, and Presuppositions,"[5] one which points the way out of Meno's paradox, into the realm of metaphysical ultimates.

Such strong medicine should be administered cautiously, especially as its side effects are never fully understood. I will begin by setting Weiss's view in a historical context, and in particular by associating it with ancient philosophy, primarily in order to mitigate the peculiarity of his treatment of induction. In the first place, then, Weiss simply bypasses modern solutions to the problem of induction and has consequently failed to command attention. The consensus that induction is an exclusively epistemological concern makes his contribution seem marginal, but it would not always have seemed so. Socrates was incessantly

making inductions based on the activities of shoemakers, potters, carpenters, and the like.[6] These inductions were epistemologically puerile, but dialectically muscular, insofar as they led Socrates, or at least Plato after him, to a profound involvement with being. Is it believable, then, that Socratic *epagoge* was just a crude attempt at reasoning? Similarly, induction was not primarily an epistemological problem for Aristotle, though that has been obscured by the treatment of his *Posterior Analytics* as a work of logic. We should pay attention to the fact that Aristotle begins and ends the *Posterior Analytics* by dissolving the learner's paradox. Like Plato before him, Aristotle reminds us that we do indeed learn, thus his remarks that "therefore we must possess a capacity of some sort" and "the soul is so constituted as to be capable of this process."[7] The serious philosophical questions that flow out of Aristotle's view of induction are metaphysical; they are concerned with the soul and with realization (*nous*).[8] In fact, the chief difference between ancient and modern views of induction is summed up in this: modern philosophers view induction as concerned with knowledge (*episteme*), ancient philosophers viewed it as concerned with realization (*nous*).

It is striking to notice how much more Weiss resembles the ancients than the moderns when it comes to induction. He uses the word "knowledge" only three times in his article, each time in a passing remark, and he avoids by-words of contemporary epistemology.[9] Weiss is a most scrupulous writer, so the avoidance would appear to be intentional. When he says that "induction has proved to be an intractable problem, in good part because it has been conceived too narrowly,"[10] the narrow conceptions he has in mind are those of epistemology. To appreciate his contribution, then, we must set aside these conceptions. But how can we do that?

An analogy, again taken from ancient philosophy, may be of help. At a certain point in Plato's *Theaetetus,* after he has gotten everyone baffled as to the implications of Protagoras's man-measure doctrine, Socrates offers to clear things up: "Perhaps you will be grateful," he says, "if I help you to penetrate the truth concealed in the thoughts of a man of such distinction."[11] He then reinterprets Protagoras's views in terms of a Heraclitean metaphysics that leaves his interlocutors more confused than they were before. Their confusion stems from the fact that, being mathematicians, Theodorus and Theaetetus expect Socrates to bring a certain *kind* of clarity to Heraclitean metaphysics. Theodorus, for instance, thinks it would be best to treat Heraclitean aphorisms as if they were problems in algebra.[12] From a mathematical point of view, one can only surmise that the Heraclitean thesis is utterly obscure. But the

mathematical point of view is incapable of justifying itself as the standard of clarity and obscurity—an ironic result of its judgment against Protagoras and Heraclitus.[13] What Socrates does by baffling his interlocutors in the *Theaetetus* is to show them what stands in the way of appreciating, and not merely for the sake of criticism, the sages from Homer to Heraclitus. In doing so, he introduces his rigid interlocutors to a philosophy that is far more supple than they had imagined. He thus shows them how a philosopher meets the familiar and the foreign on its own ground, and hopes in such way to light upon what is.[14]

It may help us to dispense with some narrow conceptions if we follow the dialectical lead of the *Theaetetus* and begin by expecting Weiss to have the usual concerns about justifying induction, for on that expectation what he says is baffling. Let us start with Weiss's basic statement about the nature of induction: it is a means of "introducing established claims into new situations."[15] At first, this appears to be merely a point of departure, a statement of only the most general characteristic of induction. We expect Weiss to specify ever more precisely its philosophical nature and function, a sound methodology, it would seem. In fact this expectation is wholly disappointed. To be sure, Weiss acknowledges some traditional, commonsense views about induction (it is "embodied in the dispositions and habits that keep us walking, eating, writing, experimenting and playing for a while"[16]), adds restrictions ("strictly speaking, of course, one is warranted in dealing inductively with new cases only in the very way one had dealt with some other"[17]) and shows a tendency to treat a familiar difficulty (that "an induction is always at risk"[18]) along well-established pragmatic lines ("induction is reasonableness in action"[19]). But far from limiting the situations into which induction warrants carrying established claims, or how it warrants doing so, Weiss declares that induction is a way of introducing into a new situation *any* claim that had been accepted for *any* reason, the only warrant necessary being that one actually does carry the claim from one situation to another.

If our concern is to derive any assurance of knowledge from induction, then this view is no guide. It does not care whether what is accepted is true or false, clear or obscure. Nor does it care whether a claim is accepted by many or few, whether it is accepted for sound, deceptive or irrelevant reasons, or whether its acceptance is momentary or longstanding. Were Weiss just beginning to describe induction, perhaps we would as yet have no significant objection. Generally speaking, inductions range widely from weak to strong. Weiss might accept such characterizations as "weak" and "strong" for inductions, so long as those characterizations

are externally grounded; strong inductions are successful ones, weak inductions fail to be sustained. As it stands, however, he does not acknowledge any intrinsically grounded degrees of inductive strength: "Once a claim has been accepted it may be carried over into a new situation with just as much warrant and ease as any other."[20]

To see how radical this view looks, consider the following example. Suppose I have been reading aboriginal stories about a huge malevolent thing called Turramulli, whose approach is betrayed by the sound "wonk." Suppose further that one fateful day I hear a wonking sound, accept that Turramulli is nearby, and run for cover. I then adopt the cautionary maxim "Run when it wonks" (a practical expression of my belief "Wonking presages Turramulli"). Now it does not matter for induction whether or not my maxim is rationally adopted; it only matters that I carry it successfully into new situations and I can clearly do that any number of times without the induction being upset. On Weiss's view my superstition is just as warranted as the inductions expressed in "Where there's smoke there's fire" or "Dark clouds bring rain."[21] Of course, the conventional wisdom may be more successful, for longer periods of time, and in more situations than my superstition. But inductive failure shows only that the previous claim is "inappropriate to the new situation," and inductive success may "do no more than reinstate an error in judgment, logic, or attitude."[22] Induction is not reasonable as a means to confirm truth, but reasonable only because "we live in a world where most of our inductions work for a while."[23] For Weiss this situation describes all inductions, from those that guide ordinary belief and behavior, to those that ground social institutions, to peripheral and core scientific inductions, and even to the inductions of mathematics and logic[24]; these contexts, according to him, belong to a single totality of endeavors.

All of this is exasperating perhaps, but familiar, since (as far as epistemological value goes) it closely resembles inductive skepticism, especially the position taken by Hume. What is baffling about Weiss, at least initially, is that he claims to be offering a *justification* of induction. I think it is important to observe the difference between Hume and Weiss here, otherwise we are likely to miss Weiss's sense of justification altogether. Both see induction as a habitual but more or less fortuitous contiguity between expectation and action, acceptance and theory. Unlike Weiss, however, Hume allowed his polemic against institutional philosophy to establish his inquiry in such a way that when he saw induction as having no epistemological value, he thought it could not be of further interest to a philosopher. His accession to orthodox epistemo-

logical requirements for philosophy is reflected in his odd [rhetorical?] distinction between human agent and philosopher, for he says that as an agent he is quite satisfied that his practice refutes doubts about the future resembling the past, but that as a philosopher he must "learn the foundation of this inference."[25]

It was up to twentieth-century successors like Nelson Goodman to find in Hume's penetrating discussion of custom a recognition that "the traditional smug insistence upon a hard-and-fast line between justifying induction and describing ordinary inductive practice distorts the problem."[26] Weiss seems willing to travel this far with Goodman, since his justification begins emphatically by describing ordinary inductive practice. The two part ways over what sort of description could count as a justification of induction. For Goodman, justification of inductions proceeds along the same lines as justification of deductions: a deduction is justified by showing that it conforms to rules of deductive inference, and these rules in turn are justified by their conformity with accepted practice. The task of constructing rules of inductive inference which conform to accepted practice is analogous to defining a term with an established usage; that is, the rules must first and foremost accommodate themselves to what is accepted.[27] Thus an adequate justification-description of induction is itself inductively grounded. This view is circular, as Goodman readily admits, but the circle is virtuous in his opinion.

Weiss shares Goodman's view that the justification of deduction is grounded in accepted practices; that is, in inductions.[28] But he has an elegant argument that applies against extending this view to the justification of induction:

> Is every theoretical and practical enterprise inductively sustained? Were an affirmative or negative answer to this question itself the outcome of an induction grounded on the knowledge of the ways in which the enterprises are conducted, the answer, like the outcome of any other induction, might not be sustained at some time.[29]

In Weiss's view, an adequate justification-description of induction would have to speak about all inductions truthfully and steadily, and therefore must be grounded in some non-inductive activity. It is at precisely this point that Weiss finds it necessary to dissolve Meno's Paradox: "We know some truths, make some claims, deal with certain problems non-inductively. Indeed we have to do this in order to have something to reinstate in inductive moves."[30] The price for this recognition, as we shall see, is metaphysics, just as it was for Plato and Aristotle. Although that

price is too heavy for the epistemologists to pay,[31] their prejudice in this matter resembles that of Thrasymachus, who insisted that Socrates say what justice is without appeal to the beneficial. If the correct description of induction involves metaphysics, to metaphysics we must proceed.

II. Evidences of Ultimates

To see that an adequate justification-description of induction involves metaphysics obviously does not require us to adopt the specific views of Paul Weiss,[32] but it is a sort of progress, and moreover it puts us in a position finally to appreciate the idiosyncrasies of Weiss's approach (not only to induction but to other enterprises). If deduction is inductively grounded, and induction can only be justified by the noninductive activity of metaphysics, then obviously this activity has no recourse to the standard sorts of arguments and explanations owned by philosophers; one must enter, as it were, what Kant called "the empty space of pure understanding."[33]

Of course, Weiss has a comeback: even empty space is "powerful and positive" and changes in "tonality, nuance, and weight."[34] This response exemplifies the treacherous necessity of befriending metaphors once one has ventured beyond accepted practices and formal argument. The "weight" Weiss speaks of is not physical, the "tonality" not acoustic (one has to listen to it as one would listen to the logos of Heraclitus). Furthermore, since most metaphors already have well-entrenched, stale, or inductively based interpretations, extending those interpretations to new situations is a hazard. The metaphysician's images must be fresh or at least freshened-up; to use Plato's terms, they must be eikastic rather than fantastic.[35] Thus, Weiss observes, "a philosophy is a discontinuity of inference and insight, sudden movements and rests, definitions and metaphors, much of its power and importance being often contained in the very portions which are least clear and precise."[36]

Accepting this point necessarily increases the gravity of our situation. We have moved to a domain where for the most part it is possible only to characterize what is confronted, but Weiss asserts that we may characterize "directly and correctly." A great deal hangs on understanding this remark.

One thing Weiss does *not* mean by "direct and correct" characterization is that it is possible simply to "state the disclosure."[37] This may be shown by returning briefly to the analogy of defining a term with a common usage, mentioned above in connection with Goodman's discus-

sion of induction. Goodman adopts a broadly Wittgensteinian approach according to which meaning is use. The polar opposite to Wittgenstein in this matter is Hegel, for whom "the absolute necessity of the concept" is the principal thing to be grasped in defining a term with common usage.[38] Only with the concept firmly in hand can we proceed to adjust and conform our ordinary notions to it. I think that in Weiss's view we never quite have something like the absolute necessity of the concept, we are always part of what we observe and as such we are a limitation on it. Thus he argues that we never confront a "given," that we are "not able to deal with anything without bringing something established to bear."[39] Does this concede to Wittgenstein and Goodman that all of our characterizations are grounded in accepted practice? Does it dilute to the evaporating point the significance of "direct and correct"?

There is a course between the two poles. Weiss admits the difficulty of suspending inductive guides and impositions. There is quite a difference, however, between suspending inductions and dealing in an established way with what is confronted. Suspension is a preliminary activity or passivity; dealing is a consequent of confrontation, possible only insofar as the confrontation itself is possible. Once a confrontation occurs, any characterization of it involves a transformation, either in terms of a previous induction or into the ground of a new induction, but that *does not entail that we cease to be involved with what was confronted.* A relation has been established between confronter and confronted, of which metaphor is the embodiment, and that relation can be used again repeatedly to carry one to the other.

We can illustrate the point by means of an analogy with aesthetic experience. Consider the following example. Two children run out to a field and take up a game of catch. There are countless "controlling guides," as Weiss calls them, in operation: the ground will remain stable, the sun will continue to shine, the ball will not lose pressure, decide its own trajectory, or disappear. Should the children confront all that surrounds them they would be dumbfounded and immobilized, but they may be able momentarily to confront some things. Blanket inattention, of course, can extend away from the episode in both temporal directions. The game, let's say, is cooperation: its goal is to complete as many consecutive toss-catch sets as possible. For a long time the children are stuck at twelve. Then one time the ball is bobbled, but caught: thirteen. Intense concentration and exhilaration then support a series of wild throws and amazing catches. No one is counting; for a while it is possible just to play. Finally, a stunning question dawns—What just happened? —and reflection swiftly ensues. The game ends. The language of the

children's characterization of what happened may be creative or it may be conventional, in either case its temper will reflect the freshness of the event. It is very likely, however, that their characterization will be in concrete terms, which therefore must be and readily are treated as metaphors. Perhaps not even a philosopher's child would venture that their initial failure and subsequent, remarkable progress signifies an intrinsically human response to obstacles.

The ontological high point of the game is the aesthetic experience that follows catch thirteen. It is then that the players are most intensively confronting a part of the real. Yet that experience lacks expressive content. On the other hand, once they have thought and expressed an idea of what has happened, they have already moved beyond what is confronted, not inexorably, since no characterization is so dull that there is no correctness in it, but it would probably be difficult to use their characterization to return to the confronted. Everything of the directness and correctness of their characterization lies in the moment that passes between experience and expression.

Aesthetic experiences can be far richer than this, but not essentially different. All aesthetic experiences show what the directness and correctness of a characterization consist in, but they depend on something deeper, which enables us to make such characterizations in the first place. Plato saw this in the *Symposium* when he made the richest aesthetic experience, the vision of Beauty itself, depend on something even more ultimate. For "it is only when he discerns beauty itself *through what makes it visible* that a man will be quickened with the true, and not the seeming, virtue."[40] For Plato the Good makes all beauties visible, it sustains everything from blazing fires to gentle laughter. Weiss is not so grand, monolithic, or religious to espouse this view of the Good, but he speaks like Plato when he says that "every occurrence whatsoever evidences irreducible ultimates."[41]

Notice that with this statement Weiss's justification of induction is complete. If every occurrence evidences the ultimates, then it is always possible to reach steady, universal truths by focussing just on the evidence. We do not have to move to the ultimates, say what their nature is, how many there are, or what relations obtain for them in order to make use of their evidence to speak about all inductions. This conclusion seems hollow, but why? Is it because the only thing Weiss says about *all* inductions on the basis of the evidence just described is that they introduce established claims into new situations? Surely we could have said that long ago, without an appeal to metaphysics. We could not, however, have said it with assurance. Does a persistent spirit of

verificationism then haunt the air? That is a destructive spirit which blocks the genuine progress already made. I think the reason for the hollow ring to the present conclusion lies in its being inarticulate (it does not seem necessary at this point to illustrate *how* it is inarticulate).

We have come round again, finally, to T.S. Eliot's difficulty: shall we make a raid on the inarticulate? The desire to have metaphysics made articulate in more literal, staler terms should be resisted. Not to resist would be to lose our hold on what is evidenced, moving ever backward from it to what was inductively established and made acceptable. In addition such a move would almost certainly discount the use of emotion, which despite its shabby image is, in colligation with reason, essential to philosophy. Nevertheless, philosophy differs from poetry, perhaps not so much in its aesthetic as in its communicative aim. The burden of communication has lain with philosophy since Gorgias's famous sophism that "nothing exists; even if it does it is incomprehensible; and even if it is comprehensible it is certainly not expressible and cannot be communicated to another."[42] Part of the solution lies in this argument itself. Obviously, Gorgias was mistaken, for if he were not, he could not communicate this argument. The possibility of communication, then, emerges only if there is a relation, (but *not* an identity relation) between communication, comprehension, and existence.

Still it is difficult to make a virtue of necessity here. Perhaps there are some things that simply can't be communicated at all. In *Beyond All Appearances* Weiss claims that knowledge extends beyond the boundaries of articulation. I agree with him. Still I cannot articulate the content of such knowledge, and my agreement itself is based on an experience, or depth-vector of experience that I cannot articulate. Such inarticulate involvement with ultimates does have one promising consequence, however, since it allows us access to a sort of Socratic ignorance. There are many accounts of Socratic ignorance, of course. A traditional account, based on the refutational side of Socratic elenchus, makes ignorance a result of inadequate suppositions and arguments. That is not the sort of ignorance I mean here, nor am I speaking of some supernatural ignorance, bestowed on Socrates by his *daimon,* which might allow him to be confident from the start that he would remain ignorant. What I have in mind is admirably described by Seth Benardette, in his book *The Being of the Beautiful:*

> Socratic ignorance must consist in knowledge of the structure of such ignorance. It must be ignorance that has been fully informed by knowledge. And yet this informing cannot be due to a methodology that would predetermine what was a permissible answer; rather, the informing must be

due to the recognition that something 'out there' is perplexing. The Socratic question has to be encountered . . . it must be an object of wonder.

The direct recognition of this sort of ignorance is, of course, a refutation of fallibilism, for the ignorance is observed (it is not ideal or a priori), and we can be quite certain of it. But more than that, it leads us on, further into the inarticulate, where there is no present sign of boundary. Such ignorance is therefore a necessary component of dialectic.

If Weiss were to agree with this claim, perhaps he would address it further. Given that we are directly aware of our ignorance, what must hold for communication, dialectic, and philosophy?[43]

EUGENIO BENITEZ

DEPARTMENT OF TRADITIONAL AND MODERN PHILOSOPHY
UNIVERSITY OF SYDNEY
JUNE 1992

NOTES

1. *Four Quartets,* "East Coker", para. 1.
2. Wallace Stevens, "The Sense of the Sleight-of-Hand Man."
3. *Philosophy and the Mirror of Nature,* (Princeton: Princeton University Press, 1979), p. 357. Rorty argues that the predilection for epistemology extends back all the way to Plato, for whom "action not based on knowledge of the truth of propositions is 'irrational' " (p. 356), but this erroneous statement is actually symptomatic of twentieth-century preoccupations with knowledge.
4. B. Skyrms, *Choice and Chance: An Introduction to Inductive Logic,* 2nd edition (Belmont, Calif.: Wadsworth, 1975) p. 195. See generally B. Skyrms, *The Dynamics of Rational Deliberation* (Cambridge: Harvard University Press, 1990).
5. *Journal of Speculative Philosophy,* n.s. 1 (1987): 6–23. On my reading, Weiss has here the limited aim of removing the obstacle that induction poses to philosophy. Once that is accomplished he merely points us in the direction of metaphysics (see p. 20).
6. For that he was sometimes criticized, see *Republic* I, 343aff., *Gorgias,* 491a–b. Recent scholars have tended to sustain the criticism: See Richard Robinson, *Plato's Earlier Dialectic* (Oxford: Clarendon Press, 1953), and Terrence Irwin, *Plato's Moral Theory* (Oxford: Clarendon Press, 1977).
7. Aristotle, *Posterior Analytics,* II.19, 99b33, 100a13, Mure translation.
8. The term *nous* is especially significant of Aristotle's metaphysical emphasis. In the Presocratics, especially Parmenides and Anaxagoras, it is already brimming with ontological import.
9. He uses the phrases "theory-laden" (p. 11), "crucial experiment" (p. 14), and "paradigm" (p. 18), but each time in the context of criticizing a

contemporary view, and in each case he places the terms in scare quotes, indicating that they are not part of his own account but the accounts of others.

10. Weiss 1987, para. 1, p. 6.

11. *Theaetetus,* 155d, Cornford translation.

12. See 180e. For the sort of problem Theodorus has in mind, see the mathematical epigrams in W. Paton, *Greek Anthology* (London, 1913).

13. For the unmathematical judgment on Heraclitus see Nietzsche's *Twilight of the Idols,* chapter 3.

14. See *Theaetetus,* 172d9 and 200e7–201a2. Compare Weiss, 1987, para. 6, p. 15: "for what exists outside the domain of logic has a rationale of its own, which it exhibits at its own pace and in its own way, leaving only an aspect of it pertinent to the outcome of purely logical moves."

15. Weiss, 1987 para. 1, p. 6. I take this to be Weiss's core statement about induction. It is repeated, with slight variations, on pp. 7, 8, 10, 11, 15, 16, 18.

16. Ibid., 17.

17. Ibid., 10.

18. Ibid., 7.

19. Ibid., 8; cf. "reasonableness in practice," p. 15.

20. Ibid., 6. Here my earlier comparison of Weiss with Protagoras may no longer seem superficial.

21. "Inductions are as well grounded in errors, myths, and superstitions as they are in sound and careful observations." Weiss, p. 7.

22. Ibid., pp. 7–8.

23. Ibid., p. 8. Later Weiss emphasizes the value of inductive success in a more conventional way: "Each of us lives his life in a more or less coherent way by making inductive use of what had proved to be successful for him on other occasions." (Weiss, 1987, p. 13). Compare Skyrms's understanding of coherence, following F.P. Ramsey (*Foundations of Mathematics,* London: RKP, 1978), as reflected in the updating beliefs by conditionalization. See *The Dynamics of Rational Deliberation,* chapter 5: "Dynamic Coherence."

24. Weiss shows little hesitation to treat mathematical and logical inductions as fundamentally similar to empirical inductions, even though they are "carried out with minimal risk—a risk so slight it would not be amiss to equate it with zero" (1987; p. 17, cf. p. 15). The "absence" of risk, in his view, is due only to the way discrepancies and untoward results are handled in mathematics and logic as opposed to other enterprises.

25. Hume, *An Enquiry Concerning Human Understanding,* §IV.

26. *Fact, Fiction and Forecast,* 4th ed. (Cambridge: Harvard University Press, 1983), p. 64.

27. Goodman is quick to point out that the situation is more complex than this—that "we may decide to deny the term 'valid induction' to some inductive inferences that are commonly considered valid, or apply the term to others not usually so considered" (pp. 66–67)—but he does not say what is the source of these uncommon decisions.

28. See Weiss, 1987, p. 15: "The use of deductive logic in practice depends on the induction that established logical rules will not be gainsaid. If the conclusions are not sustained in the same way and to the same degree that the premises are, some logical rule will have been ignored or misconstrued." Compare Goodman, pp. 63–64: "If a rule yields inacceptable inferences, we drop it as invalid."

29. Weiss, 1987, p. 19.

30. Ibid., p. 19.

31. "Logical Heaven," insists Putnam, will not solve the problem of induction. See the foreword to *Fact, Fiction and Forecast,* 4th ed., p. xi.

32. One might attempt a description such as Carnap's "On the Application of Inductive Logic," *Philosophy and Phenomenological Research* 8 (1947): 133–47.

33. *Critique of Pure Reason,* Introduction, A = 5, B = 9. Kant has Plato in mind in this passage, but what he says applies equally to Weiss. I do not accept Kant's judgment here, of Plato or Weiss, but his is the most eloquent and forceful criticism from the point of view of epistemology.

34. *Nine Basic Arts* (Carbondale: Southern Illinois University Press, 1961), p. 4.

35. See the *Sophist,* 235d ff. "Eikastic" images are *real likenesses,* "fantastic" images are familiar semblances. Of course, from the familiar viewpoint eikastics seem monstrous, unintelligible.

36. Paul Weiss, *Reality* (Princeton: Princeton University Press, 1938), p. 12.

37. See Wallace Stevens, "Thinking of the Relation Between the Images of Metaphors."

38. See the *Philosophy of Right,* Introduction, para. 2. I have used Knox's translation here.

39. Weiss, 1987, p. 11.

40. *Symposium,* 212a, Michael Joyce translation. Other translations are more literal, but few translators have captured the sense of this passage as well as Joyce.

41. Weiss, 1987, p. 20. Weiss adds that the ultimates are "insistently present everywhere in the guise of constituents inseparable from their sources." I think by sources here he means particular occurrences. If so, then here he differs from Plato, for Plato would not say that the forms are inseparable from particular occurrences.

42. See Sextus Empiricus, *Adversus mathematicos.* vii 65 (I have used Robinson's translation).

43. Most of the ideas in this paper stem from conversations with Paul Weiss and others, especially Kevin Kennedy and William Desmond, during 1990–91. Some of the remarks about metaphor revise the very mistaken comments I made to Weiss on the occasion of his birthday, 1991.

REPLY TO EUGENIO BENITEZ

There are some Greek scholars who not only read their texts with care, but who are enriched by what they study. There are not a great many who also find enlightenment and joy in speculations carried out independently of the Greeks. Benitez is one of them. In the end, though, he is strongly tempted to pull what he so willingly acknowledges into the spacious discussions that Plato provided. I am delighted to learn that my view of induction is found to have some resemblance to an ancient view. At the very least, it shows that I am an "outsider" who is thought to fit together with those who were outsiders at their time. I cannot think of better company.

What Benitez sees clearly, but others have missed, is that transitions from one item to another depend on the acceptance of what is not only distinct from both, but enable those who are at one end to arrive at what is at another. He does not, though, take sufficient account of important differences distinguishing abductions, adumbrations, and inductions.

Abductions are modes of evidencing the ultimates; they move from instantiations to what is instantiated. Dialecticians take them to form a sequence, ending at what is final. I see no need to make more than a single move to what all actualities presuppose, and another to what this in turn presupposes, matched by a reverse move that finally takes one back to where one began, with oneself purged, enlightened, enriched, and astonished. Adumbrations, instead, penetrate into actualities, toward what there are in themselves, accommodative, rectifying, and subjugating what intrudes on them. Inductions, the ostensible subject of Benitez's essay, in contrast with both, take us from known occurrences to others yet to be known.

Plato had a better understanding of abduction than Aristotle had, but Aristotle, particularly when he dealt with ethics and politics, had a better

understanding of induction. Neither, nor apparently any other Greek, was sufficiently alert to what adumbration was and could achieve. That is one reason, perhaps, why Plato could work for a tyrant, and why the fact of slavery, the status of women, the rights of the lower classes, and the humanity of workers did not seem to bother him. A good grasp of the nature and outcome of abductions that arrive at ultimates, enables one to know that adumbrations move through the ultimates as instantiated together to end at what is more inward, intensive, and powerful, able to possess and use what the ultimates constituted.

Everyone adumbrates, moves intensively from surface to depth, particularly when attending to humans, trying to know what they intend and whether or not they are sincere. Everyone, also, carries out inductions, using what had already been learned to guide expectations. Conceivably, as one progresses abductively toward what is beyond appearances, evidences for inductively grounded thrusts may be noted. One may also carry out an incidental adumbrative move into oneself. All three moves, the abductive, adumbrative, and inductive, deserve detailed examinations. I have never gone much beyond offering separate accounts of these different processes, and making use of them when I dealt with the ultimates, actualities, and what might be encountered in a future involvement with actualities. It is not ignorance that prompts one to make use of any one or a combination of these procedures, but the fact that, wherever one is, one is involved with what is beyond this— abductively with the ultimates, adumbratively with what is inward, and inductively with what is about to be.

Inductive moves—what perhaps Benitez has in mind—can be taken to be components of abductive and adumbrative ones, thrusting beyond these in the directions these provide. There is such a great difference among these different procedures that it would, I think, be better to say that both abductions and adumbrations are distinctive ways in which one moves beyond any specifiable point and lays hold, if only in a feeble way, what is more basic or more intensive.

It is not ignorance that prompts one to make use of any of these three ways to get beyond where one is. The sought outcomes, as already existing, provide one's governed moves with a direction, and thereby enable the beginnings of these to terminate in what accommodates them. The fact is quite obvious when abductions and adumbrations are carried out. Ultimates enable one to end at themselves, while their constitutive instantiations make it possible to move to what can possess and use them. A related observation is pertinent to inductions, when these are confined to purposed acts, though inductions can also be successfully used in other situations. All are enriched by the ultimates, enabling them

to pass from a beginning to an end. In their absence inductions, abductions, and adumbrations would have neither termini nor power, and would so far be indistinguishable from surmises, hopes, beliefs, longings, intentions, and the like, all confined within those who entertain these.

We are attracted, challenged, and sometimes wary of what we surmise, when and as we fasten on what is distinct from us. Our answers are attached to our questions, because and so far the ultimates are operative in these three and in other ways of passing from what is accepted to what is abductively presupposed, what is adumbratively intensified, or what seems to be inductively warranted.

Our answers are attached to our questions. Did we arrive at a final answer in one direction, this should provide a prelude to questions directed backwards, and in other directions as well. The blank in a question, *"x* is . . ."* exhibits an incomplete assertion, with the *"x* is" marking out limits within which the answer is to be exhibited. If this be granted, we will be well positioned to reply to Benitez's questions, and to modify some of his claims.

Benitez rightly condemns the tendency to seek epistemic justifications for everything. After all, it is a human who knows, and there surely is no knowing were there no knowers. He thinks, though, that my treatment of induction needs to be in an historic context. I do not see why this must be done. Were he right, one would be confronted with the problem of knowing the past and how this could affect the present. Historians—even historians of philosophy—construct a past in such a way that they can account for the present where warrants for inferences to that past can be found. Benitez risks setting his Plato and Aristotle in a Greece that never was or could be. His Greece is too clean, too neat, too well-bounded to be part of a real world.

Benitez confounds abduction with induction when he says that "inductions . . . are dialectically muscular" and that they led Socrates, or at least Plato after him, to an involvement with Being. One moves toward the ultimates, and finally toward Being, abductively not inductively, though there may well be an inductive component in every abduction. He does distinguish ancient and modern philosophic views of abduction, and the process of evidencing the ultimates and finally Being, but also seems to suppose that he is doing no more than attending to inductions.

What is learned by making abductive moves can help us understand how inductions pass from one occurrence to another. Those inductions are never reducible to abductions; instead, they take advantage of what

can be abductively known, and which can guide, control, and direct the inductions we make. His error is, in part, traceable to me, for I never did make sufficiently evident the roles that the ultimates play in inductions. I should have stressed the fact that they there keep within an ongoing time, itself instantiating one dimension of an ultimate. This can be abductively reached and in any event, can be instantiated in the time that inductions traverse.

Abductions escape the bounds of the empirical to reach what is always presupposed. Inductions do not. As the abductions move closer and closer to the ultimates, these take over. There is also a taking over by inductive and adumbrative outcomes, but the one remains time-bound while the other becomes more and more singularized. In both, what is carried forward is more and more accommodated and that with which one begins is turned into a minor component.

Benitez thinks my view of induction warrants superstitions as well as well-grounded suppositions or beliefs. I think he is mistaken. Part of the meaning of 'superstition" is that it is unwarranted, and that sooner or later it will be blocked by fact. He has conflated the justified view that one who is superstitious may carry out inductions in the same way others do, with the mistaken idea that the superstitious and others may begin from equally good standpoints and arrive at the same termini. Benitez would be right if one disregarded the beginnings from which different inductions take their start, but that would require our separating them off from their different warrants.

Benitez throws a new light on Hume and his epigone. He then asks if "all of our characterizations are grounded in accepted practice." If we change "accepted practice" to "accepted or acceptable beginnings," an affirmative answer not only becomes evident but unavoidable. We can begin nowhere else than where we are, that is, with what is imbedded in our speech, habits, attitudes, practices, values, beliefs, characters, and skills. Those who begin their philosophic accounts with references to ideas, sense data, theories, categories, intentions, and the like, have taken great leaps for which no warrant is provided.

I am perplexed about what Benitez has in mind when he discusses the difference between "suspending inductive guides and impositions." The cited "aesthetic (!)" experience does not help. The most I have been able to extract from his comments is that there is an important interval between "experience and expression," and that it is on this that 'aesthetic experience', among other things, focusses. His reference to Plato leads me to believe that what he intends to remark is that we make contact both with the depths of things and with what is presupposed. With this I, of

course, agree. The two are not to be identified, for the one directs us inward into what was confronted, while the other takes us toward what every occurrence presupposes. Both have an 'emotional' tonality, the one reflecting a concern, the other awe. Neither the Platonic Forms nor the Being beyond them is loveable, beautiful, good, hateful, ugly, or bad. An upward move should not be confused with a move to what is alongside or prospective.

Benitez ends with the question: "Given that we are directly aware of our ignorance, what must hold for communication, dialectic, and philosophy?" In the light of his supposition that ignorance involves a knowledge of a structure, does he not here return to a consideration of the nature of questions, with their inescapable attachment to and qualification by what sustains them? "Communication, dialectic, and philosophy," and much else besides, depend for their grounding in what, while already known, is incomplete. It is the incompleteness that, while remaining adjectival to what is already known, requires us to look further. This is not where it is sustained, enriched, fulfilled. To find this, we must allow the answer, the filling in of the blank, to encroach on what provides it with a beginning.

We always ask for more than we think we do. I hope this is what Benitez (and Benardette) mean when they refer to Socratic (or better, any) ignorance as that which has been "fully informed by knowledge," though "fully," I think, spoils what is sound in the observation. So does the restriction to "knowledge." It would be more correct and more cautious to say, that every question, whether expressed by a Socrates or a child, offers an opening into what is pertinent to every question about anything.

"Communication, dialectic, and philosophy"—and much else—can be successful because their questions are invitations to realities to take over. The better the question, the more evident this will be. If, now, it is added that every distinguishable item is also a question *in concreto,* it will become evident that whatever there be in thought or fact is a question that is not fully answered until account is taken of what else there is. This claim may be made more acceptable, perhaps, if we distinguish a request for information from a question charged with wonder. The former provides a spot to be filled out in a limited way; the latter provides a place for many meanings and realities. When that place is filled, the line expressing the wonder becomes an underlining, underscoring the fact that a wondering question has become a wondrous answer. Abductions refer the underlining to constant possessors; adumbrations exhibit it as more and more accommodated; and inductions

express it as a constant, desirable part of experience. I am one with Benitez in spirit. I do not think that the various distinctions here emphasized should do less than tighten the bond.

P.W.

20

Richard L. Barber

REAL POSSIBILITY AND MORAL OBLIGATION

I

Can you be morally obligated or have a duty to do something that cannot be done? Or even something which might be able to be done by someone else, but which you are unable to do?

Taking this question in its apparent or obvious meaning, and applying common sense and ordinary logic to it, the answer given by most of us would surely be in the negative.

Duties to act in a certain way, or to do something, must fall within the realm of the possible, the likely response would run, and that must be the really possible, not just the logically or conceivably possible.

In 1949, Paul Weiss gave a very different response to this question, in a conversation with a doctoral candidate who proposed to write a dissertation under his direction. He contended, or proposed the thesis, that moral obligation is, if not indeed absolute or a priori, at least independent of or above such considerations; any such limitation would undermine or destroy the authority and force of the obligation. A duty is a duty, no matter what limitations the natural world may place upon the moral agent who has this duty.

How can this be so? Could it mean that there is a duty to try, to attempt to do what the agent believes, or even knows, to be impossible? Or could it mean only that there is a duty to *will*—or to wish—that it be done, if even the attempt, or trying, cannot be made?

No, he said, the duty remains, as it was, the duty to do. Even if it is impossible. Even if it is not even logically or conceivably possible.

But does this insistence mean that "duty" has become so detached from the realities of the natural world of our being and doing that it has become merely a quixotic or heroic concept, rather than a moral force bearing upon the moral agent? No, again. It retains all of that force, and the agent bears and must acknowledge the obligation as his own, he said.

II

Right and Wrong—A Philosophical Dialogue Between Father and Son[1] has been seen by some as one of Weiss's lighter works—or the Weisses', Paul's and Jonathan's. It is cast in accessible and deceptively simple dialogue form, not all that different in style from some of those of Plato, Berkeley, and Hume.

I have looked there for some of Weiss's own and later ways of dealing with this paradoxical position thinking these might clarify the meaning.

Chapter 1 is entitled, "The Person and His Obligations." Posing an example of a hypothetical student caught in a web of conflicting values—forced to choose between two evils, or to select among incompatible goods—Paul has himself say (p. 6),

> Now we have a conflict of ethical principles. We have a dilemma which no one can resolve except by taking one of two evil courses. Similarly, in connection with an ethical good, one may find it impossible to accept it and another good as well. This I would say is what makes for the tragedy of human existence. . . . In all these cases we have difficulties where a man feels he cannot and yet must choose between two right actions. When he is faced with these situations, he must make a decision one way or another and be responsible for not having done that which, as a matter of practicality, he could not have done. This is another way of saying that man is a sinner, that man cannot avoid guilt, or that this is a tragic life.

Is this then the nature of the overriding of considerations of possibility by the forces of moral obligation? If the premises be given that a moral agent has a duty to do A, and a duty to do B, and that A and B are incompatible or mutually exclusive, then indeed he cannot do (A and B). But does he really have any duty to do (A and B)? Is this not a form of the logical fallacy of composition? To hold that obligation is simply additive or summational is to beg the very question at issue. Is it not more reasonable, given the three premises, to draw the inference that the agent has the duty to do *either* (A but not B) *or* (B but not A), that is to do (A *or*

B)—the exclusive *or*—but not both. This interpretation would save the understanding of common sense or ordinary logic; it would also leave no need for Weiss's conclusion that life is inevitably tragic and sin unavoidable.

Weiss himself notes—with some degree of acceptance—the utilitarian principle (pp. 8, 13–14) of seeking to achieve the greatest good of the greatest number, a balancing or synthesis of goods which has long been recognized as a process of selecting some and foregoing others in the moral attempt to maximize or optimize;[2] here he notes the frequent difficulty of knowing just what or which courses of action *will* maximize the good, or of seeing two or more courses of action as equally likely to do so. But there is little sense of life's tragedy or man's sin in such utilitarian thinking; in the latter case, the agent's obligation would clearly be to pursue *either* course of action, not (even) to try to pursue both, or all of several whose differences are indiscernible.

III

Paul notes briefly (pp. 12–13) the support available in Kantian ethics, asserting that for Kant an obligation stands regardless of its consequences or the consequences of dutifully fulfilling it.

> Whatever is right to do is absolutely right, says Kant; whatever is wrong is absolutely wrong, regardless of its instrumental value. No circumstances will change it. The good is determined away from the nature of the world. It is something absolute, something universal and necessary for all mankind. (p. 12)

But while this interpretation of Kant could lead to some of the points made earlier, no such inferences are pursued immediately. Instead Paul says, apparently speaking for himself,

> If you are faced with two courses of action which seem to be more or less equally desirable or undesirable, there is nothing to do but to make a decision. Recognize the fact that there is something wrong in what one is doing, and try eventually to make up for the wrong that one is now compelled to do in choosing this particular way rather than the other. (p. 13)

But this, by itself, gives little support to the paradox of impossible duties, or to the thesis of the tragic life of sinful man.

After long excursions into the proprieties and objectives of amateur athletics, the improprieties of violating established rules and principles

of sportsmanship, college loyalty oaths, reporting income tax evaders or other cheaters, breaking laws to permit or enhance self-development, political or criminal activity or civil disobedience by students, and 'ostensible' sexual activity on the part of the young, the dialogue concludes chapter 1 ("The Person and His Obligations"), and moves on to consider as chapter 2, "The Family and Its Members."

Most of the topics touched upon in the latter part (pp. 13–45) of the first chapter *could have* provided examples of the paradox of our duties to do the impossible; that none is explicitly drawn upon for this purpose does not justify a strong negative inference about Paul's seriousness in proposing this, but it does leave that question still open.

IV

Will it be then in the discussions of "the family and the individual responsibilities of its members," "the meaning of family loyalty," "the respect and obedience owed," and "the question of punishment" (p. 45, foreword) that we shall find further argumentative support for and exemplification of the paradox? Some suggestion of this is found in the preliminary definitional statement offered (p. 47):

> The family is in one sense a rather paradoxical unity. It is something recognized as important by the state. The law and our ethics recognize the importance of a family as a unit, as opposed to every other. But this very recognition of it as a very special unit puts it in opposition to the very state that officially maintains and protects it. The loyalties of the family are not the loyalties of the nation as a whole, so that every member of a family who is devoted to his family is caught in a kind of tension between his family and the greater world he must grow into. And, in the end, the young person moves away from his family to start a family of his own.

While contrast, tension, and even paradox are significant terms in this description of goals and loyalties, there is little to put us in mind of the larger paradox of asserting our moral obligations to do the impossible.

The example of tension involving a maturing son who is forbidden by his father to follow the natural path of his own development is character-ized as "an almost impossible question because there are here two conflicting goods of an equal value" (p. 52, Jonathan's terms). This seems a likely occasion or example, an opportunity to affirm the son's duty to achieve the impossible—to obey loyally his father's injunctions and still pursue his education and development. Instead, Paul finds himself saying (p. 52):

The father is wrong to prohibit his son's participating in activities that are characteristic of the age and the educational system. Should the father insist, we must point out that the father himself is contradicting his own declared intentions since he wants his son to have an education but is now denying his son that education. In this conflict the son must make a decision. I would say he should continue his education. At this point the demands of family loyalty break down.

Thus is missed a splendid opportunity to offer an example of the paradox, to affirm that the son's duty of loyalty and obedience to his father stands as a duty regardless of its consequences in the natural world; that his duty to himself and to the pursuit of his education and self-realization stands similarly and with equal strength, regardless of its consequences; that *the composite* duty then to accomplish both ends, although they are incompatible, is to be affirmed, and thus the son's life is tragic and his sin unavoidable.

But no such paradoxical or heroic resolution is offered: common sense and ordinary logic prevail. Either the father's intransigence must be moderated by his enlightenment, or the son should make his decision and override it. By the earlier premises, the "wrongness" (of the specifics) of the father's demands for loyal obedience would not have attenuated the rightness of those demands being made, and being honored.

After further dialogue on family loyalty under strain from developing sons and authoritarian fathers of differing ideological persuasions, and daughters asked to date or marry sons of influential persons who might advance their father's career, I find no example to resolve my hypothesis. The intervening discussions are worth reading for themselves, but I am pursuing a narrower question. Will Weiss, in the real or natural world, hold fast to or exemplify the thesis that moral obligation overrides considerations of real possibility? Do we in fact have duties to achieve impossible actions?

For the record, the recommended course of action (autonomy) for the daughter is much the same as that for the son, but for a different reason. The wrongness of the father's request lies this time in the fact that he "would be using the child as a means to something else . . . The child should not do it" (p. 62). There is really no conflict of incompatible goods or choices among collectively unavoidable evils involved. The father is simply failing in the perception of his own duties to act for the well-being of the daughter, and the daughter has her own rights, of self-determination, and to be considered as an end, not merely as a means.

On the other hand, less demanding requests or even trivial ones, may well impose a duty on the child to act loyally or obediently (pp. 65–67).

The "more difficult area" of parents' competing for the love or loyalty of the child, by divisional or conspiratorial action, seems a more likely example. Paul says,

> First, the parent should work with the other parent, or work on the other parent, so that they might arrive at some unified position. *Suppose this is impossible.* [My underlining.] Suppose the parents are irreconcilably in opposition. What should the child do? Well, since they are in opposition, whatever the child does will be wrong. The only thing the child can do is to make a decision of its own and use the support of one parent in such a way that it does not increase the alienation of the other. (p. 68)

Note that what the parents *should* do is posited as being impossible. What then does it mean to say that they "should" do this? "Should if they could"? "Should, but can't"? "Should, and would if they could, but can't, so won't"? In any case, they can't, and don't.

After looking in somewhat greater detail at the dilemma of the child, Paul says, "I think the proper thing for the child, the ideal thing for the child, would be to try to persuade the recalcitrant parent. Not being able to persuade the recalcitrant parent, the child can only hope that the other parent would be able to do so" (p. 68).

In this generic case, and in the exemplification of it which follows (pp. 68–74), we encounter again a series of sensible and reasonable accommodations to the tensions arising from parent-child and parent-parent conflicts. Throughout adjustments and modifications of the basic scenario, common sense and ordinary logic prevail. No heroic paradox, no transcendence of real possibility by moral obligation. The *operative* duties are achieved by compromises within the realm of the possible. Of course, the initial obligations and values are still a part of the script, but they are now part of the background, the history; the resolution of the initial duties to actions which prove incompatible with each other produces a summary duty to do something which *can* be done.

Another level of conflict is that in which parents refuse, for their child, goals or values required by the state, as being (in the state's view) for the child's well-being. Whether the reasons for such refusal are religious, ideological, or idiopathic, Paul would resolve them, sensibly, in favor of the child's well-being, overriding the parents' authority if necessary, and absolving the child of the duty of loyalty in such matters.

Discussions of appropriately rewarding a child for work or good behavior, and of punishment for bad behavior or breaking rules, eventually involving the mutual realization, by family members, of each other's rights, do not present examples germane to my present inquiry (pp. 76–82).

Filial obligations are held by Paul to be intrinsic or essential aspects of the family, not just created by gratitude or contract for services and support rendered by the parents. Again, this thesis generates no example of the paradox under examination.

Chapter 3, "Politics and the State" (pp. 87–119), offers a fairly extended discussion of obligations—of the individual to his culture, his society, his state—and to his nation so far as that is different from these. The obligation of loyalty to "those who share one's heritage" seems closely to parallel the loyalty to family—both have contributed to and supported the individual in his childhood and his growth; whether he sought such support or not is irrelevant. Loyalty to mankind is a reasonable extension of the concept, as well as a dilution. Intensity of loyalty is a function of proximity, an inverse function of distance, with these terms used metaphorically, according to Paul (pp. 90–93). Conflicts among loyalties may be resolved partly on this basis.

A discussion of capitalism, democracy, communism, and pluralism ensues (pp. 98–107). There is much in all these discussions that is perceptive and, I think, often wise. No explicit examples are given, however, of the kind of enduring paradox I have attempted to find, despite the rich and complex webs of competing values. In fact, the discussion of pluralism in America, and the distinctions drawn between pluralism and democracy, present a kind of contrary or antidote to the basic paradox. Not only are we absolved from duties to do impossible things, but the doing of different yet compatible things is to be permitted and promoted in a pluralistic society.

Turning more directly to the individual's putative "obligation to participate in a political state" (p. 108), we find Paul saying, "I would say that many people should not involve themselves in politics. I'm thinking of creative thinkers, creative workers, and religious men whose orientation is elsewhere" (p. 109). This view seems to rest upon the incompatibilities of such work with political activism, but it does let stand the obligations to vote and to express concern, even including civil disobedience and conscientious objection. The criteria seem to involve recognition of compatibilities, which is to confine the force of obligation to the realm of the possible.

This chapter too ends without an example which would instantiate the heroic paradox.

Chapter 4, "Society" (pp. 120–54), will examine the obligations arising from or inherent in our membership in the human race, and in a civilization. Paul holds the view that all men "owe an obligation to all [of humankind]" we are told in the foreword (pp. 120–21), and that these

obligations go beyond the demands of the state and our public institutions. Our interdependence is asserted, not just at the biological or sustenance level, but all the way up to the teleological or aspirational dimensions of our being. Our debts of gratitude for the achievements of our predecessors, and our responsibilities for making our own contributions to this growing fund—"the sharing in a common treasury of values and achievements. . . . All these together make up the content of civilization" (p. 123).

Surely this array of obligations could present examples of such scope that they could transcend the limits of the possible. But that is not the direction taken by the conversation. Vast and complex as the network of related duties is claimed to be, it is not asserted that any one or the sum of them lies outside the realm of possibility, without that fact or condition forcing a resolution similar to those already described. Whether by sheer magnitude, specific incompatibilities, or other impediments, when the obligations of the first order would individually require us to do what we cannot do, the obligations of the second order—realistically resolved—now bear upon us to do what is so much a part of the common-sense ethic—the best we can.

Let me formalize the relationship I think I see emerging:

A has an obligation to do X; as far as we know, this, in itself, is possible. Concurrently, B has an obligation to do Y, also possible in itself. But X and Y, we learn, are in reality incompatible, i.e., the conjunction, XY, is impossible. Dividing this, if A does X, it will be (really) impossible for B to do Y; the same relation exists inversely; if B does Y, A cannot do X. This structure parallels that noted above involving one moral agent bearing two or more incompatible obligations, and permits of a similar resolution. Given the two duty-premises and the premise of the incompatibility of X and Y, the resolution asserts that *either* A must do X, preventing B from doing Y, *or* B must do Y, preventing A from doing X.

The duty-premises are first order obligations, part of the history; the second-order resolution, recognizing both them *and* the incompatibility premise, presents us with an either-or proposition, not with a both-and. As with the individual agent earlier, the original duties were, separately, both intrinsically possible; only their conjunction is impossible. But *neither* moral agent has a duty to achieve that conjunction, so it would be impossible to claim logically that they, conjunctively, have such an obligation. No one has such an obligation, so no such obligation exists.

The obligations which are posited are duties to do possible things, and again we find throughout this chapter and those which follow, nothing to support or instantiate the heroic and tragic paradox. Again and again, resolutions using common sense and ordinary logic prevail.

However complex and involved are the examples of obligations in the remainder of the book, I submit that they do not escape this kind of analysis and resolution. My proposed interpretation of Weiss's paradox is, therefore, that for both individual moral agents and for sets of two or more such agents, there may exist in the first order of moral obligations certain duties, really possible of achievement in themselves, which, when considered in conjunction, are found to be incompatible with each other. When this occurs, it is not necessary either to deny the reality of these duties of the first order, nor to assert a new obligation of the second order which morally binds the agent, or each agent, to the conjunction of the incompatible ends. What *is* done consistently by Weiss in *Right and Wrong,* is to formulate a resolved obligation of a second order which *does* fall within the realm of the possible, doing as much good and as little harm as possible. The missed opportunities, the good choices that had to be foregone in order to make better ones or others equally good, can still justify our regret. We can see in them the basis of a sense of tragedy if we will, but I am not so clear about sin, which has been more associated in my understanding with the willful choice of lesser good or greater evil, particularly involving self-preference. It is indeed to be regretted that not every good choice can be made, for whatever reason.

It seems to me that the force of our moral obligations is enhanced by this approach, not weakened. I am glad that Weiss does in fact take it, in the examples noted. If he had translated the original paradox into second-order obligations to achieve the really and logically impossible, I feel he would have given the morally lazy among us a quasi-despairing opportunity to avoid doing *either* of the incompatible alternatives, and this is of course precisely what his examples exhort us to do—one or the other of the good choices, or the best we *can* do. The regret for not having done what we in fact could not do is still real and reasonable, but it is nowhere near as strong as the remorse we should feel for not having done all that we *could* from among those that we should. This I believe to be a reasonable resolution of Paul Weiss's paradox.

RICHARD L. BARBER

DEPARTMENT OF PHILOSOPHY AND
SCHOOL OF MEDICINE
UNIVERSITY OF LOUISVILLE
JUNE 1992

NOTES

1. (Carbondale and Edwardsville: Southern Illinois University Press; London and Amsterdam: Feffer & Simons, 1967).

2. Jonathan's distinction between maximizing the good and achieving the greatest good of the greatest number (p. 13), is noted.

REPLY TO RICHARD L. BARBER

Richard L. Barber has stated a fundamental moral paradox very well, but I am not entirely confident that I have understood his solution. I would like to restate what I think is the solution, hoping that it is what Barber is maintaining. There are, though, a number of important observations that Barber makes along the way that should be examined:

1. Barber asks: "Can you be morally obligated or have a duty to do something that cannot be done?" To answer the question one must first distinguish between morality and ethics, the one referring to the accepted social norms of what is right and wrong, the other referring to what ought to be done if humans separate and joined are to be perfected. Both raise questions that are not easily answered. Moralities change from time to time, and place to place, where ethics is a constant, applicable to all humans. There is one morality for cannibals and another for soldiers. If we condemn those moralities because they conflict with a morality that we accept, we will be met with equally insistent counter-thrusts. There will be no way of adjudicating the differences except by using force, or by appealing to an ethics subtending them. Sometimes moralities are altered so that they fit in better with the morality of an admired people; sometimes an ethics is defended though there are few who meet its demands. One way to adjudicate among different moralities, is to have recourse to the principles of ethics.

"What cannot be done" is an ambiguous expression. If it means what is self-contradictory, it surely does not obligate anyone. If it means, instead, that circumstances preclude the fulfillment of a number of equally binding obligations, it refers to what often occurs. A raging fire may preclude one from saving both parent and child, or one child rather than another. Though we ought to tell the truth, we also ought not to betray the whereabouts of an innocent, hunted person.

2. Barber reports me as having said "A duty is a duty, no matter what limitations the natural world may place upon the moral (!) agent who has this duty." It is not, of course, enough to think of a duty without taking account of the objective it should help us realize. We ought to promote the good, the beautiful, the true, the glory of humans together, and justice. We ought to make good the losses we have brought about, help our fellowman increase and make full use of our abilities, I would not say that a "duty remains . . . even if it is not logically or conceivably possible." There is no duty to produce contradictions. It may, of course not be possible to fulfill a number of equally warranted obligations at the same time. The one cannot be carried out, no matter what the circumstances; the other that cannot be done today because of the prevailing circumstances, might possibly be done tomorrow, under different circumstances.

One might try to order all obligations in a hierarchy, perhaps maintaining that, if a choice must be made, the older are to be preferred to the younger, males to females, siblings to strangers, rulers to ruled. Even then, one might be faced with deciding between younger males and older females, or between strangers who rule and siblings who are ruled. Presumably, even such combinations might be arranged in an order of desirability, but there would still be circumstances, likelihoods, and possible effects that were not considered. We live in a world where the future is dim, much is beyond our control, and a multitude of unnoted items play a role in determining what can be done.

3. It is not clear whether or not Barber thinks that all duties have the same weight. I do not think they do. One's duty to a person outranks one's duty to a pet. The fact still leaves one faced with the problem of deciding between different people, another of deciding between different pets, and still another of trying to do maximum justice to both at the same time. Twist and turn as we like, we are finite, limited beings who exist in a large world most of which we cannot control. Again and again, we are required to make decisions because of circumstance, and thereupon make the performance of one duty give way to another. Even when we have no initial conflict of duties, we are forced to decide when, to what degree, and for how long one obligation is to be carried out in the light of the rightful claims of others.

4. Barber asks if one has a duty to do A and a duty to do B, has one a duty to do both? There is an ambiguity contained in the 'and' joining the A and the B. There can be no duty to do both A and B, if that cannot be done, but if there is a duty to do A and another duty, equally strong, to do B, there could be a duty to do both only if it were possible to do this.

Everyone of us blunders, falls short, is overmatched by incompetence, ignorance, an imperfect character, and lack of insight. We misconceive, err, misjudge, preventing us from doing all that we ought to do, but what we might have otherwise been able to do. We are also sometimes faced with problems no one can solve in the context in which they are presented.

Barber thinks that I should have remarked that a conflict between father and son should be understood to be tragic, or at least regrettable. I did suppose that. A problem still remains: What should then be done? Without in any way reducing the wrong involved in making a decision favoring one or the other side, it makes sense to decide to do what promises to produce more good on the whole. This does not reduce the ethical dilemma, but it does derive some good from it. The solution is reasonable, not ethical, making evident that, while in its own realm, ethical decrees are absolute, they may have to be evaluated from other positions. Forced to decide between two exclusive, equal, ethical alternatives, one should have recourse to a third in which a conception of possible benefits may give new weights to otherwise equal alternatives.

How should such a decision to move beyond ethical issues be viewed? Is it required by ethics itself? Does ethics require that one ought to have recourse to what is reasonable to do when duties come into conflict, the 'reasonable' being understood to be that which assesses conflicting duties in terms that permit a decision in favor of one of them? I think it does. Ethics dictates that humans are to become and to act as perfect beings. When there is a conflict of duties, one has the duty to adopt the one that promises to produce the greater good. That greater good does not here come into play unless a conflict of duties requires a solution on new terms.

When a son's decision involves a violation of a duty to a parent, the violation can be partly compensated for by carrying out another duty, in another context. An ethics that does not ignore the demands of reasonableness, requires that if a decision in one context cannot be made, the issue should be placed in another, where it will be likely that more good will be produced than could otherwise be obtained. One should fulfill one's obligations, but when one cannot, a decision must be made that takes account of the degree of good that would follow if one or another decision were made. The 'tragic' aspect of the decision will not thereby be extinguished. One will do wrong in deciding in one way rather than the other, but that wrong can be cushioned, though not eliminated, by fulfilling another duty to choose a better over a lesser good. Subsuming an ethics of rigid opposites is an ethics for reasonable persons who are

sometimes faced with the need to decide in favor of what, in a particular context, cannot be accepted without failure also to do what should be done.

6. Barber asks, "Will Weiss, in the real or natural world, hold fast to or exemplify the thesis that moral obligation overrides considerations of real possibility?" Do we in fact have duties to achieve "impossible actions?" Putting aside the difficulty I have with understanding what is meant by "real possibility" and "impossible actions" he seems to be saying if one can carry out only one of equally strong duties, one does what is both ethically right and ethically condemnable. The decision to violate a duty is of course wrong, but the wrong can be reduced by being made part of the achievement of another desirable objective. Evidently, we have a duty, when violating a duty in order to carry out another, to compensate as much as we can for the failure to do what we ought to have done.

We must try to meet our obligations. If that is impossible, we must do the best we can. If one likes, one could say that our primary obligation is to produce as much good as it is possible for us to produce. It makes little difference whether we say that this obligation is just a maxim of an obligatory common sense, or is an ethical command within which more limited duties are to be compared.

There is no need to frame ethics within a more comprehensive reasonableness. References to this need not be made, except when we are confronted with otherwise unresolvable ethical problems. Even in the best of circumstances, there will be some slighting of some of the possible alternatives. If ethics be taken to state inviolable principles, it will rarely be applicable to actual humans in a world they had not made.

7. Barber asks, "what does 'should' mean?" If one could, though one can't, or what one can't and won't. In the case cited, where parents cannot reach an agreement, 'should' means try to do what ought to be done. And that is what is required of everyone.

8. Barber concludes this part of the discussion by saying that incompatible duties produce "a summary duty to something which can be done." That is only partially true. There is such a 'summary duty' only to do what both should and can be done.

9. In a pluralistic society, Barber notes with approval, "the doing of different yet compatible things is to be permitted and promoted," but he then spoils the observation by saying when we are (on what he takes to be my view,) apparently "absolved from duties to do impossible things," with 'impossible' left hovering between logically and practically possible. We have no duty to do impossible things. We have a number of duties that we sometimes find we cannot fulfill. Our finitude and circumstances,

not the duties themselves, here preclude their being completely satisfied at certain times.

10. Barber rightly affirms that "it is not necessary . . . to assert to a new obligation of the second order which morally binds the agent, or each agent, to the conjunction of the incompatible ends." He is right, too, I think to question the relevance of 'sin' in this discussion. What is not evident to me is whether a reference to 'second-order obligations' clarifies anything and if "remorse we should feel for not having done all that we *could* from among those that we should" is "nowhere near as strong." I think it continues, and should continue. I would not say, as a student once said to me on hearing my ethical views that to hear me is to become "a sadder and Weisser man," but it surely should make one wiser because sadder, or sadder because wiser, or best of all, sadder and wiser together. We do not extinguish a wrong when we find a way to use it to promote some good.

I think Barber is right to focus on this problem, for it pulls ethical discourse out of the rut into which it has fallen and frames it in a more comprehensive view. In the absence of this, duty, tragedy, reasonableness, the perfecting of individuals, and the consideration of particular duties would have unduly subordinated places.

P.W.

21

Antonio S. Cua

REASONABLE PERSONS AND THE GOOD: REFLECTIONS ON AN ASPECT OF WEISS'S ETHICAL THOUGHT

Perhaps the most striking characteristic of Weiss's philosophy is its openness to continuing self-critical inquiry.[1] Indeed, philosophy for Weiss is a creative adventure: "A philosophy is a creative work. It must be quickened by insight; it must adventure, dare, be imaginative and free. If it is to contribute to thought it must break new ground and by its very presence raise questions about itself and other accounts" (FC 1977, p. 25).[2] In most of Weiss's works, there is recurrent concern with metaphysics of ethics, with the interdependence of ethics and metaphysics. More generally, according to Reck, "Weiss's works illustrate that, while metaphysics furnishes the foundation of ethics, the completion of metaphysics involves consideration of ethics."[3] However, for a moral philosopher today, it is difficult to pin down Weiss's contributions.

It is difficult to see the thread that runs through the numerous, "diverse, and intricate ramifications of Weiss's metaphysics in its premodal, modal, and postmodal formulations."[4] Even if this thread is discernible, its relevance to moral philosophy may be queried, for Weiss shows little interest in theories and contested issues in normative ethics and metaethics.[5] Likewise for moral philosophers sympathetic to the recent revival of virtue ethics, metaphysical speculations seem a remote, extraneous burden in ethical inquiry.[6]

Nevertheless, for a moral philosopher concerned with the problem of the unity of virtues, Weiss's metaphysical vision of the good, insofar as it can be distinguished from his specific metaphysical theory, is worthy of attention. For his vision of the good human life may well provide a unifying perspective for our understanding of the interdependence of basic virtues.[7] It is significant that Weiss's most recent work stresses the important role of commitment to ideals, e.g., beauty, truth, the good,

glory, and justice in different creative ventures. Says Weiss, "an ideal is prescriptive, making demands on one who has committed himself to realize it," and the commitment to the good "requires one to produce determinations for it" (CV, pp. 264, 194). I take it that "determinations" have to do with attempts on the part of committed persons to specify *in concreto* the significance of the ideal of the good human life. And any such specification (or specialization in Weiss's favored term) must be deemed reasonable. In this essay I offer some reflections on the role of reasonableness in the context of commitment to the ideal. For this task I rely mainly on Weiss's extensive remarks in *Man's Freedom* and *Toward a Perfected State,* but freely elaborate them by appropriating resources provided by other philosophers and my own studies in Confucian ethics.[8] Such a task inevitably requires abstracting an aspect of Weiss's ethical thought from his ongoing ontology. In this way I hope to reconstruct in a coherent and plausible fashion some key insights of Weiss's that are not tied to his metaphysical theories.

For Weiss, the good human life, or the good, is an ideal of what life ought to be in some absolute sense, that is to say, a life that is complete or perfect and thus not limited by exceptions or restrictions. Indeed, ethics "deals with what absolutely ought to be, and with man's actions as assessed by anyone." (PIP:9, p. 163). "The good," "excellence," and "perfection" are correlative, or interdefinable terms. In the Glossary written in 1981, where our citation occurs, "the good" is defined as "a final end in which all items are included," and "perfection" as "what is complete, lacking nothing with all subordinates enriched and harmonized," and "excellence" as "perfection, that which ought to be." While there are, of course, varieties of excellences, say, in different creature ventures (CV), "beyond them all is a final excellence, a prospect which all other prospects specialized" (PIP: 9, pp. 171, 198, 164).[9]

Weiss has a holistic vision of the good human life, encompassing all existing things, reminiscent of Wang Yang-ming's vision of the universe as a moral community.[10] In this vision of the good every existent being, animate or inanimate, has an intrinsic value and should be respected and cared for regardless of their relation to humans. But the good remains an ideal, a prospect, a possibility to be realized by earnest efforts of the committed agent. Indeed, Weiss's conception of the good—not unlike ordinary usage of the term—is Janus-faced.[11] On the one hand, the good is a sort of *ideal norm,* providing "a number of hierarchies of possible goods, in some of which the realization of lower forms stands in the way of the realization of others which are higher" (TAPS, p. 353).[12] Thus Weiss would urge moral philosophers to accept the distinction between

"absolute, final ideal good" and the limited, relative goods. "The limited is a form of that ideal, absolute good, for it is a prospective excellence but realizable in some facets or items at a price of necessary loss to others" (ibid.). On the other hand, Weiss is insistent throughout his works, that something like the good itself is more an *ideal theme,* much like a theme in literary or musical composition, amenable to polymorphous, creative expressions, depending on the committed persons' interpretations of the significance of the ideal for their own lives.[13] Thus the ideal of the good human life is a more or less *indeterminate* ideal theme.

Indeed, the possibility of ethics depends on an acknowledgment of man's freedom. This freedom is "an intelligible process by which the indeterminate, the future, *the good,* is made determinate, actual, present; it is an activity by which the general is specified, specialized, delimited, given one of a number of possible concrete shapes" (MF, p. 71). While an individual would tender a biased specification of the ideal good in accordance with an understanding of its concrete significance for his or her own life; yet in their community, they would focus on the common good. "The common good of a community of sensitive beings, when freed from an exclusive reference to that community, is one with the idea of perfection, of excellence, with the idea of an *absolute good,* and thus with the final principle of a universal *ethics,* having application to the subhuman as well as man" (MF, p. 176).

Weiss focuses on the empirical world as a setting for the exercise of human freedom in determining, specifying the abstract ideal of the good. Every man or woman autonomously engages in self-exploration regarding the significance of the ideal in his or her own life. While the ideal provides a common *unifying perspective,* every one committed to its realization will specialize its significance, adapting to a specific environment and to changing circumstances. More importantly, the specialization is an outcome of the exercise of the creative will. As Weiss insightfully put it:

> By means of the creative will a man exhibits the absolute good in diverse acts and places as a harmony for them to illustrate severally and together. By means of that will he *reconstitutes* his body and the world freeing them from the limitations characteristic of preference and choice. By means of that will he determines himself, forging a fresh, unpredictable course of action whose very essence is beyond the grasp, until produced, even of omniscience. (MF, p. 277, emphasis added)

Perhaps we may restate Weiss's insight on the role of creative will in terms of the language of self-interpretation inasmuch as his notion of self-reconstitution is reminiscent of similar concerns of Royce and more

recently of Charles Taylor.[14] In this conception every human being engages in self-reconstitution through making decisions, "The result cannot be known in advance of the act of deciding and thus in advance of going through the process of remaking ourselves as *reasonable* or unreasonable men" (MF, p. 85, emphasis added). If we assume that moral agents are reasonable in their specifications of the good life as an ideal theme, it is proper to inquire into Weiss's notion of reasonableness. This inquiry is important also for any ethical theory that recognizes the integrity of personal decision, choice, or preference in relation to normative principles and ideals of the good human life.[15]

'Reasonableness' is a critical, appraisive word, a special commendatory word for ascribing practical judgmental virtues. As Aschenbrenner points out, "[practical] judgment concerns decisions in reference to particular cases: procedures to be followed, diagnosis, classifications, discriminations, decisions, applications, choices of courses of action, and the like. To be endowed with judgment is to have good judgment and poor judgment is simply want of judgment."[16] In our reconstruction of Weiss's conception of reasonableness, we shall sketch a profile of what may be called 'reasonable persons'. Notably, our reconstruction is an ideal explication or characterization of desirable qualities or personal merits relative to the exercise of practical judgment.[17] Reasonableness is a context-variable notion, an adjuster word in Austin's sense, "that is, by the use of which other words are adjusted to meet the innumerable and unforeseeable demands of the world upon language."[18]

A. *Being rational.* For Weiss, "He who is reasonable is always rational: he uses his reason to realize some higher good" (MF, p. 81).[19] But being reasonable and being rational are quite distinct characteristics. Rationality is "a readiness to accept what is logically necessitated" (TAPS, p. 427, n. 5), more especially to follow rules and principles that govern one's inquiry into "the rationales of different objects and subject matter" (MM, p. 53). Reasonableness, on the other hand, "harnesses the mind to expectations grounded in habit and justified by experience" (TAPS, p. 427, n.5).[20] These remarks suggest that being rational consists of a disposition to employ rational methods of inquiry,[21] principally to follow rules and principles of inductive and deductive logic; and being reasonable is a disposition to follow established expectations rather than rules or principles. As Weiss insists, "reasonableness cannot be expressed in rules or formulae. Like a living language, it is carried over in the course of adjustment to the presence, actions, and requirements of others in changing circumstances" (TAPS, p. 329).[22]

In light of the foregoing distinction, we may say that a reasonable

person is also rational in that he or she is willing to employ rational canons of inquiry whenever these are considered to be relevant to the evaluation of practical judgment. For example, the reasonable person would avoid logical inconsistency and attend to evidence that supports normative claims in the light of established causal laws and/or statistical generalizations.[23] In the absence of such knowledge, an appeal to plausible presumptions regarding common knowledge would be made in argumentative discourse, as these presumptions, while defeasible, represent normal grounds of practical judgment.[24] It is, perhaps, in this sense that reasonableness pertains to the satisfaction of expectations, or in Weiss's words, "reasonableness harnesses the mind to expectations grounded in habit and justified by expectations" (TAPS, p. 429, n.5).[25]

B. *Respect for tradition.* Perhaps the most salient characteristic of reasonable persons committed to Weiss's vision of the good is their respect for tradition. While the word 'reasonableness' has different uses in discourse concerning distinct social complexes such as union, society, or state, there is "a single core meaning pertinent to all decisions, preparations and, most important, to actions carried out in accord with a present that has been enriched by traditions and ideals" (TAPS, pp. 327–28). In general, "the existence of reality in the present is inseparable from a partial determination and connection with a past and a future" (TAPS, p. 115).[26] For reasonable persons, the present is the point of departure in thought and judgment, but it is always enriched by the past, the tradition, and the future, the ideal prospects or objectives.[27] For Weiss, a living tradition is more than a *traditum,* that is, "anything which is transmitted or handed down from the past to the present," e.g., material objects, beliefs or ideas, practices, and institutions.[28] The past of an established tradition is not the *noumenal* past, the ineluctable, unchanging, and unfathomable; but the *perceived* past deemed relevant to present problems and perplexities.[29]

In Weiss's words, "tradition is the past of a community effectively and habitually making a difference to what is done in the present" (PIP:9, p. 210). As a brute fact of existence, humans need to collaborate with one another in order to meet common challenges (TAPS, pp. 10–11). Tradition will furnish guidance by providing resources in the form of ideas, knowledge, and skills, for resolving the present predicament of members of the community. While not always helpful in arriving at an adequate solution to the present problem, the shared past, the tradition provides a guide. "Past effective practices provide some justification for what is now to be done" (ibid., p. 17). Tradition in this light may be seen as a repository of insights derived from the past exercise of practical reason.[30]

Thus in collaboration in meeting common challenges, reasonable people would appropriate the resources of the tradition.[31] Our earlier emphasis on the role of plausible presumptions in practical judgment implicitly refers to the notion of tradition as a repository of valuable resources. Of course, the relevance of tradition is always subject to interpretive judgment, and consequently, subject to change and modification. In this sense, we may properly regard tradition as an *interpretive concept*.[32]

In Oakeshott's felicitous term, reasonable persons, in respecting their tradition, would engage in "the pursuit of intimations." Much like the art of seamanship, "the enterprise is to keep afloat on an even keel; the sea is both friend and enemy; and seamanship consists in using the resources of a traditional manner of behaviour in order to make a friend of every hostile occasion."[33] At any given time, the tradition may appear as no more than a congeries of fragments of an earlier coherent tradition.[34] Says a recent writer, "The ethical tradition is the ethic of the day: a collection of evaluations. The collection is not necessarily internally coherent even within a homogeneous and slowly changing culture. In a heterogeneous and rapidly changing culture, the likelihood of coherence within the collection is remote and, in modern Western culture, is absent."[35] This observation seems an exaggeration with respect to Confucian or Christian traditions with focus on *jen* or *agape* as the ideal theme.[36] Even if this observation were acceptable, reasonable persons' respect for tradition, informed by Weiss's vision of the good, would have a unifying perspective for viewing the coherence of a tradition. Coherence of a tradition, in Weiss's words, is a matter of ideal prospect. At any given time, it is an achievement and not a given; a successful outcome in "the pursuit of intimations" and not a mere inheritance of the wisdom of the past.

Within a community, reasonable adherents of a tradition, à la Shaftesbury, may be said to be actuated by *sensus communis*, have a coherent, though inarticulate, sense of a tradition, as displayed in their concern with the common good or public interest. Reasonable adherents of a tradition may thus be described as sharers in "a common affection" informed by "a sense of partnership" in dealing with problems that affect them all.[37] They are persons who care for one another as their lives are, so to speak, interwoven in terms of well-being, fortune, and misfortune.

The preceding notes on the ideal of the good as providing a view of the coherence of tradition seem to be consonant with Weiss's remark on the social aspect of morality: "genuine *socially moral* men [are] men who work to realize a good which has a place for order and variety, for tradition and change, men who do not merely conform or merely revolt,

merely repeat or merely innovate, but who creatively try to give to themselves and other members of their society what they all deserve and need" (MF, p. 101). Informed by *sensus communis,* by a sense of partnership, reasonable persons in argumentation would value agreement rather than disagreement. And when disagreement occurs, it would be viewed as an occasion for exploring the possibilities of agreement provided by the common tradition.[38] Even more fundamentally, especially in dealing with peoples of other cultural traditions, reasonable people would appreciate what Hampshire calls "the two faces of morality": "The rational and articulate side and the less than rational, historically conditioned fiercely individual, imaginative, parochial, the less than fully articulate side."[39] The first "face" of morality may be viewed as a focus on those aspects of a mature, moral tradition, those aspects that appear to an external spectator to have transcultural significance, especially those that can be formulated as principles of adjudication, as ground rules for discourse on intercultural ethical conflict.[40] The second "face" of morality points to the native home of the consensual background of ethical discourse, which varies from culture to culture. It is a setting in which "a reasonable person takes account of established practices, pertinent objectives, and likely responses" (TAPS, p. 155, #12). Reasonable persons would thus pay special attention to local ethical considerations. Their respect for the common tradition would be exemplified in "due regard for the agreed goods and goals" of the fellow members of the community.[41]

In the light of their commitment to the good as an ideal unifying perspective, reasonable persons' respect for tradition may be properly considered *conservative* in two different but related senses. First, they will show concern for and orientation toward conservation of the tradition as a repository of resources for resolving present problems. Secondly, they will also want to conserve those feelings and dispositions, whether natural or acquired, that are deemed conducive to the acquisition and promotion of cooperative virtues, those virtues that are seen to be internal, constitutive goods in the pursuit of the vision of the good human life.[42]

C. *Open mind and impartiality.* Both characteristics of reasonableness, rationality and respect for tradition, are perhaps best exemplified among persons who are open-minded and impartial. Indeed, the concern with the relevance of rational methods of inquiry presupposes that the agent has an open-mind, that he or she is attentive to the evidential grounding of belief and judgment. As Pepper points out, unlike the dogmatist, the reasonable person "will seek to make his attitude exactly

proportional to the balance of weight in the grounds of belief." Moreover, the reasonable person is "eager to find more grounds for belief if more are available and to modify his attitude constantly in relation to these."[43] And in interacting with fellow members of the community, the reasonable person will be receptive to new ideas and arguments, as well as friendly and cooperative, as these dispositions are conducive to maintaining the respect for the shared tradition.[44] Ethical argumentation would be viewed as a cooperative enterprise oriented toward resolution of problems of common concern.

Very much in the spirit of a diligent student of inquiry, the reasonable person will want to learn from others, especially from those better informed and competent in dealing with practical problems. This is perhaps the rationale of Aristotle's focus on the wise man's opinions as a source of dialectical reasoning, or of Confucius's recurrent teaching on the role of *chün-tzu* or paradigmatic individuals in moral education.[45] In like manner, reasonable persons will also want to learn from people in other, alien traditions. As Winch reminds us, "the concept of *learning from* which is involved in the study of other cultures is closely linked with the concept of *wisdom*. We are confronted not just with different techniques, but with the new possibilities of good and evil, in relation to which men may come to terms with life."[46]

Since tradition is an interpretive concept, an open mind is also required in considering alternative, competing interpretations of the import of the tradition. While the exercise of freedom is unrestricted in the sense that "any alternative can be preferred over all others" (MF, p. 82), the commitment to the vision of the good does impose a basic constraint. Recall that the vision expresses a concern for the integrity of both human and nonhuman beings, any interpretation that condones deliberate infliction of injury or suffering on the innocent would be unacceptable to reasonable agents. This is one plausible basis for Weiss's response to the biblical story of Abraham and Isaac (Genesis, chapter 22). Here is a hard case, within the Hebraic tradition in which Abraham was "faced with the alternative of helping his son or killing him." Weiss comments:

> The most repugnant of alternatives was here converted into a preferred one by being freely made into the best means to the goal of remaining with God. . . . Abraham intended to kill his son because he took the words of his God in such a spirit as to require this intention. But he could have given a different interpretation to the words he thought he heard. He could have treated them as a code, as the words of a devil, as part of a hallucination, or as irrelevant to what he was to do. . . . He could, without abandoning his goal of obeying God, have rejected whatever his God was supposed to ask

him literally to do. And this would have been eminently reasonable, for true obedience to the divine entails a refusal to make the innocent suffer. (MF, p. 82)[47]

Nonetheless, being open to consideration of alternative interpretations of traditional normative requirement implies that the agent is *impartial* in weighing the alternatives. The ethical notion of impartiality may be elucidated by its contrary, partiality. Two different but related senses of partiality are involved. One may be partial in failing to appreciate the holistic import of the good, encompassing all animate and inanimate beings. This is a failure to consider the integrity or intrinsic value of those beings which may be affected by consequences arising from one's practical judgment. Also, one may be partial in centering one's deliberation on self-interested concerns without regard for the desires and interests of one's fellows. It does not follow, however, that an impartial concern for others would preclude prudence or concern for one's immediate or long-term desires or interests. At issue, to paraphrase Hsün Tzu, is a matter of employing one's sense of rightness from an impersonal point of view before yielding to one's natural inclination to follow self-regarding desires. And this sense of rightness crucially involves self-examination in weighing alternative courses of action in terms of benefit and harm as affecting oneself and others.[48]

Weiss's extensive discussion of the Golden Rule,[49] commonly formulated as "Do unto others as you would have them do unto you," may be viewed as a useful guide in achieving impartiality.[50] Weiss stresses the wide acceptance of the Golden Rule in quite different cultural traditions, e.g., Confucianism, Judaism, Christianity, Hinduism, and Buddhism. "It is part of the inheritance of the West as well as the East" (MF, p. 139).[51] Apart from being a means for achieving impartiality, the Golden Rule, properly interpreted, is an effective aid for preserving important values. It enjoins interacting persons to take account of "the value which things actually possess" and attend to what they need and require (ibid.). This singular insight on the ethical function of the Golden Rule is commonly neglected by moral philosophers. We can better appreciate Weiss's insight about conflict of interest in competitive situations. While impartial weighing of the interests of different individuals may result in some loss of value, the Golden Rule assists us in minimizing the loss of values. It also enables us to understand better Weiss's companion insight that reasonable persons bear a responsibility to restore the values lost or their functional equivalents as a result of their past decisions and actions. This insight is implicit in Weiss's conception of the backward character of human choice. To make a choice is not just to elect an alternative, but

also an "obligating objective." It is to recognize that "what is to be done demands a compensation for the losses that some previous decision involved" (*Privacy*, p. 133).[52]

Let us briefly attend to Weiss's analysis of the positive formulation of the Golden Rule. According to Weiss, it comprises a command and an evaluation. The command "do to others" urges us to adopt an active attitude, "to try to penetrate to others, to reach to them." Further, "as we would have them do to us" contains a standard for evaluation, which enjoins us "to put ourselves in the place of others." More fully,

> The Golden Rule commands that we assume the attitude of an agent; by means of the evaluation it asks us to view ourselves in the position of a patient. The command also asks us to acknowledge someone else as a possible patient, while the evaluation asks us to look at that patient as a prospective agent. It urges us to be agents having the others as patients and to guide ourselves by what we see when we view others as agents having ourselves as their patients. . . . Its effect is to ask us to act on others as though they were like ourselves, with an active and a passive side, imperfect but capable of being perfected. (MF, p. 148)

The foregoing passages forcefully bring out the ethical significance of the Golden Rule, especially as a principle of "estimable value."[53] They draw our attention to a necessary condition of role reversibility, that is, "the behavior in question must be acceptable to a person whether he is at the 'giving' or 'receiving' end of it."[54] Notably, this is an exercise of creative imagination in "the dual roles of agent and patient," taking account in some central way the desires and interests of others. In this way the Golden Rule secures impartiality through "the elimination of self-partiality and inward dishonesty."[55] The agent's desires involved, however, are not occurrent or first order desires, but rather second order desires, that is, desires mediated by reflection; and this reflection is made from the standpoint of the commitment to the good. In terms of the Confucian *jen* or ideal of humanity, as I have remarked elsewhere, the problem of formation of second order desires has to do with the standard governing the satisfaction of one's first order desires. Right action requires that I subject my present desires for assessment in terms of the standard I am personally committed to. For a Confucian, to be a man of *jen* is to engage in reflection which brings the ideal of *jen* to bear in actual conduct, and this obviously implies a desire or willingness to make others's desires a relevant consideration in the light of *jen*.[56] More fundamentally, Weiss points out that an adoption of the Golden Rule is an acknowledgment of the integrity of every human being as a self-determining agent. In Kantian idiom, the acknowledgment expresses a

concern for self-respect and respect for others.[57] Weiss concludes his discussion on the ethical significance of the Golden Rule by reminding his readers that it would be a mistake to construe it as a precise action guide or precept. For the Golden Rule functions as a general principle, requiring interpretations adaptable to varying, changing situations. Says Weiss:

> It is a principle of sympathetic service, having different applications and meanings in different contexts. He who follows it intelligently will be *decent and reasonable,* attending to what others are and requires, and thus one who keeps losses in value at a minimum. . . . It is a rule governing the art of dealing with beings properly, analogous to a rule of prosody, or of lighting or perspective in painting; it offers a blueprint, an outline, not the substance of what is to be done. If we fill in the outline properly we will make possible a realization of an excellent community of cooperative, considerate men . . . (MF, pp. 153–54, emphasis added)

Apart from being a useful means for "the elimination of self-partiality and inward dishonesty," the Golden Rule, especially its negative formulation, may also be viewed as a counsel of moderation and humility in making claims concerning one's knowledge of the good.[58] Recall that the vision of the good is an indeterminate ideal theme, and as such it is subject to diverse specifications within the lives of committed agents. Inevitably, then, a reasonable person will always have a preferred specification, and at any given time, such a specification will be based on a partial knowledge of the significance of the holistic vision. The ideal of impartiality, as opposed to partiality of the knowledge of the good, serves as a reminder of one's imperfection or incompleteness of ethical knowledge.

The negative formulation of the Golden Rule, say, in the *Analects* of Confucius ("what I do not desire, I ought not to impose on others"[59]) may be construed as a counsel of modesty and humility. Modesty pertains to the moderation of one's claims or demands upon others. One ordinary sense of 'reasonable' indicates that a reasonable person will refrain from making excessive or extravagant demands on others.[60] As Baier remarks, "We say of demands or requests that they are excessive if, though we are entitled to make them, the party against whom we make them has good reasons for not complying, as when the landlord demands the immediate vacation of the premises in the face of well-supported pleas of hardship by the tenant."[61] More fundamentally, in the light of the vision of the good, we would expect reasonable, committed persons to be modest in making their demands and requests, because no one possesses the knowledge of all possible, appropriate specifications of the significance of the good for individual human life. I take this to be a corollary of Weiss's

distinction between absolute and limited goods (TAPS, p. 353). As a result, one's specification of the good will always be conditioned by a limited perspective. The negative formulation of the Golden Rule may thus be construed as a counsel of modesty, which stresses the importance of being aware of one's limited perspective. Accordingly, the reasonable person will be moderate in imposing his wishes and desires on others. His or her sense of modesty or moderation will be displayed in a concern for the mean between excess and deficiency. Such a concern, however, presupposes that the agent exercises moral discretion. As Mencius reminds us, "Holding on to the middle [*chung*] is closer to being right, but to do this without moral discretion [*ch'üan*] is no different from holding to one's extreme. The reason for disliking those who hold to one's extreme is that they cripple the Way. One thing is singled out to the neglect of a hundred others."[62]

Hume justly observes that modesty, in the sense "opposed to *impudence* and arrogance" is one personal quality that is agreeable to others, for it "expresses a diffidence of our own judgment and a due attention and regard for others."[63] The inner significance of modesty, however, is best appreciated in terms of humility, in the sense that the reasonable persons know their place in relation to others's thoughts and affections, informed by a just awareness and estimate of the limited character of their importance in relation to others. This attitude of humility is compatible with self-respect or even pride in one's achievement.[64] Moreover, humility, in the light of commitment to the good, is an acknowledgment of "the lack of knowledge about what is good [for oneself and another] and its consequent attitude of not claiming to be or thinking oneself as good."[65] Deprived of complete knowledge of the specification of the concrete significance of the good for all humans, a reasonable person will be humble. For any claim to knowledge about one's good and another's is at best a plausible presumption but always defeasible. Although every human may possess "knowledge of his own humanity," in Weiss's words, "each knows himself to have a mind and a body, sensitive, finite, and active, and that all must eat and drink, that all, to be fully men, must have shelter, friendship, and cooperation, training, beauty, and truth" (MF, p. 145), such general knowledge provides no justification to claims to complete knowledge of the specification of the good. The possibility of negation of such claims furnishes a basis for the adoption of humility. As my colleague Dan Dahlstrom would put it, "There is humility in every moment of negation." The ethical value of humility also provides a way of appreciating the Confucian stress on the observance of *li* or rules of propriety, as well as Cicero's on decorum.[66]

On the basis of the foregoing, it should be clear that the negative

version of the Golden Rule imposes a more stringent requirement than the positive version (analogous to that of negative moral rules or precepts). Imagining oneself in "the dual roles of agent and patient," while expressing self-respect and respect for others, does not provide a reasoned justification for imposing one's conception of the good. This is perhaps the force of Confucius's saying: "To say you know when you know, and to say you do not when you do not, that is knowledge."[67] One's claim to knowledge about what is good for oneself and another must be proportional to accessible information and experience. While such a knowledge may provide grounds for a claim for its significance for future conduct, reasonable persons would avow their sense of fallibility, in expressing modesty and humility. Sagacious or judicious judgments will also be informed by a sense of timeliness, that is, an adaptation to the current situation in order to achieve equilibrium and an adjustment to varying, changing circumstances.[68]

The above reflections present a constructive interpretation of Weiss's vision of the good in terms of the notion of reasonable commitment. We offer a profile of reasonable persons as consisting of such dispositions as rationality, respect for tradition, open-mindedness, impartiality, and the significance of the Golden Rule as a means for achieving impartiality. In the spirit of Weiss's notion of self-reconstitution, I have sought to articulate some insights of Weiss's ethical thought independently of Weiss's metaphysical theories.[69]

Antonio S. Cua

School of Philosophy
The Catholic University of America
May 1992

NOTES

1. As Reck points out, Weiss's "philosophy has manifested from the beginning the dynamic movement of inquiry toward truth which is consistent with and often demands that specific theses be revised or discarded." Indeed for Reck, "Weiss's work is a singular intellectual experience without comparison in recent philosophical literature. The system itself is an exhibition of open thinking." Andrew Reck, *The New American Philosophers: An Exploration of Thought Since World War II* (New York: Delta Books, 1970), p. 342.
2. Abbreviated citations in the text of this essay refer to the following books: (FC) *First Considerations,* (MF) *Man's Freedom* (1950), (MM) *The Making of Man* (1967), (MB) *Modes of Being* (1958), (TAPS) *Toward a Perfected*

State (1986), (CV) *Creative Ventures* (1992), and (PIP) *Philosophy in Process.* For philosophy as a critical enterprise, see also MF, p. 181; PIP:9, p. 198.

 3. Andrew Reck, "Paul Weiss's Metaphysics of Ethics" in Thomas Krettek, ed., *Creativity and Common Sense: Essays in Honor of Paul Weiss* (Albany: State University of New York Press, 1987), p. 114. This essay provides an informative account of all of Weiss's relevant works until 1980. For some of my queries and Weiss's responses on the ethical aspects of his works published in the 1970s, see "Queries and Replies" in Krettek's volume; and my later study of *Toward a Perfected State* in "Structure of Social Complexes," *Review of Metaphysics* 41, no. 2 (1987).

 4. Reck, "Paul Weiss' Metaphysics of Ethics," p. 115.

 5. In TAPS, Weiss occasionally responds to Rawls's *A Theory of Justice* and utilitarianism; and in *Creative Ventures* his valuable chapter on the good life appears to be a response to MacIntyre's *After Virtue,* though there is no explicit statement to that effect. The earlier *Man's Freedom* seems oblivious to Anglo-American ethical theory, though again, as we shall see shortly, it does contain valuable ethical insights of interest especially to proponents of virtue ethics.

 6. For a general survey of recent virtue ethics, see Gregory Pence, "Recent Works on Virtues," *American Philosophical Quarterly* 21, no. 4 (1984); and Gregory Trianosky, "What is Virtue Ethics All About?" *American Philosophical Quarterly* 27, no. 4 (1990).

 7. For attempts to construe the Confucian vision of *tao* or *jen* as a unifying perspective, see A.S. Cua, *The Unity of Knowledge and Action: A Study in Wang Yang-ming's Moral Psychology* (Honolulu: University Press of Hawaii, 1982), pp. 75–78; and *Ethical Argumentation: A Study in Hsün Tzu's Moral Epistemology* (Honolulu: University of Hawaii Press, 1985), pp. 160–63. For a general discussion of Confucian ethics, see "Confucian Ethics" in Lawrence C. Becker and Charlotte B. Becker, eds., *Encyclopedia of Ethics,* vol. 1 (New York: Garland, 1992).

 8. See for example, Cua, *The Unity of Knowledge and Action,* pp. 91–100; "Ideals and Values: A Study in Rescher's Moral Vision," in Robert Almeder, ed., *Praxis and Reason: Studies in the Philosophy of Nicholas Rescher* (Washington: University Press of America, 1982); and *Ethical Argumentation.*

 9. See also MF, pp. 217, 222; and TAPS, p. 353ff.

 10. See Cua, "Between Commitment and Realization: Wang Yang-ming's Vision of the Universe as a Moral Community," *Philosphy East and West* 43, no. 4 (1993).

 11. The word 'good,' as Nowell-Smith points out, is "the Janus-word *par excellence,* it is often used to do more than one job on one occasion and the logical connexions between the various jobs are what they are because the facts are what they are." P.H. Nowell-Smith, *Ethics* (Oxford: Blackwell, 1957), p. 146. See also R.M. Hare, *Freedom and Reason* (Oxford: Oxford University Press, 1963), p. 75.

 12. For my critical remarks on Weiss's conception of hierarchy of values and his response, see Krettek, *Creativity and Common Sense,* pp. 236–37, 241–42, and my *The Unity of Knowledge and Action,* pp. 39–42.

 13. For the distinction between ideal norm and ideal theme, see my *Dimensions of Moral Creativity: Paradigms, Principles, and Ideals* (University Park: Pennsylvania State University Press, 1978), chap. 8.

 14. See, for example, Josiah Royce, *Problem of Christianity,* Lectures IX

and X (Chicago: University of Chicago Press, 1969); and Charles Taylor, "Interpretation and the Sciences of Man," *Review of Metaphysics* 25, no. 1 (1971).

15. It must be noted that I limit my inquiry to Weiss's notion of the indeterminacy of the good as an ideal theme. For the construal of the good as an ideal norm, one must attend to Weiss's primary ethical principle (i.e., "It is absolutely wrong to kill a friend wantonly") and his complex conception of the "rights of man" in *Man's Freedom* (chaps. 14 and 19). The latter is given in an incisive treatment in terms of six principles (human equality, respect for every man as having an intrinsic dignity and worth, free kinship, familial autonomy, equal opportunity, and social freedom or freedom of speech and of the press.) These principles and the rights which they assure "to the means to become members of a single-inclusive community of ethical men—together define the good life" (MF, p. 280). I assume that Weiss would agree that the application of these principles is subject to assessment in terms of reasonableness. Thus our discussion below would also be relevant to Weiss's notion of the good as an ideal norm whether construed as a set of principles or hierarchy of values. (For Weiss's later conception of rights, see his *Privacy* [Carbondale: Southern Illinois University Press, 1983] and TAPS.)

16. Karl Aschenbrenner, *The Concepts of Value* (Dordrecht: Reidel, 1971), p. 304.

17. Our procedure may be viewed as guided by Aristotle's in his explication of *phronesis* or practical wisdom: "We may approach the subject of practical wisdom by studying the persons to whom we attribute it." See *Nicomachean Ethics,* translated by Martin Ostwald (Indianapolis: Bobbs-Merrill, 1962), 1140a. A similar procedure is followed in my explication of the Confucian notion of reasonableness relative to the question of vindicating the adoption of the Confucian vision of *tao* or *jen*. (*The Unity of Knowledge and Action*, pp. 90–100.) For the notion of personal merits, see David Hume, *Inquiry Concerning the Principles of Morals* (Indianapolis: Bobbs-Merrill, 1957), p. 7. We may note that Weiss regards his account of reasonableness as "quite close to what Aristotle spoke of as 'practical wisdom'" (TAPS, p. 427, note 5).

18. J.L. Austin, *Sense and Sensibilia* (Oxford: Clarendon Press, 1962), p. 73. There is a sense that an absence of any of the qualities relevant to a particular case would constitute a ground for imputation of unreasonableness. In this sense, we may say that it is "unreasonable" that "wears the trouser," again in Austin's sense. Cf. Max Black, *Caveats and Critiques* (Ithaca: Cornell University Press, 1975), p. 21.

19. Elsewhere, Weiss seems to espouse a contrary view (MB, p. 132).

20. Recent philosophers draw the distinction between rationality and reasonableness in different ways, depending largely on their conception of rationality. Perelman and Rescher, for example, seem to construe rationality more as a formal or theoretical notion, stressing, in particular, compliance with canons of inductive and deductive logic. Others like Rawls, Sibley, and Richards would instead focus on means-end rationality of agents. More recently, Gewirth, on the contrary, seems to collapse the distinction in regarding reasonableness "as an application of deductive inference." My remarks below, following in part Perelman and Rescher, assume that rationality, in the minimal sense, consists of compliance with the canons of inductive and deductive logic. See Chaim Perelman and Anna Olbrechts-Tyteca, *The New Rhetoric: A Treatise in Argumen-*

tation (Notre Dame: University of Notre Dame Press, 1969), p. 197; Perelman, "The Rational and the Reasonable," *The New Rhetoric and the Humanities: Essays on Rhetoric and Its Applications* (Dordrecht: Reidel, 1979), p. 117; Nicholas Rescher, "Reasonableness in Ethics," *Philosophical Studies* 5, no. 4 (1954); Rescher, "Reasoned Justification in Ethics," *Journal of Philosophy* 55, no. 6 (1958); Rescher, *An Introduction to Value Theory* (New Jersey: Prentice-Hall, 1969), p. 79; John Rawls, "Outline of a Decision Procedure in Ethics," *Philosophical Review* 60, no. 2 (1951); Rawls, *A Theory of Justice* (Cambridge: Harvard University Press, 1971), p. 142; Rawls, "Kantian Constructivism in Moral Theory: The John Dewey Lectures 1980," *Journal of Philosophy* 77, no. 9 (1980): 528–30; W.H. Sibley, "The Rational versus the Reasonable," *Philosophical Review* 62, no. 2 (1953); David A. J. Richards, *A Theory of Reasons for Action* (Oxford: Clarendon Press, 1971), pp. 75–77; and Alan Gewirth, "Rationality vs. Reasonableness" in Becker and Becker, *Encyclopedia of Ethics*, vol. II, p. 1069.

21. Rescher, "Reasonableness in Ethics," p. 61. For further discussion of Rescher's view, see my "Ideals and Values" cited in note 8.

22. Differently put, "reasonableness has no antecedently determinable extent, content, penetrative reach, or involvement with other ways in which people are together" (TAPS, p. 331).

23. In Weiss's words, the reasonable person "makes use of available knowledge and good habits to help him focus on that alternative which will realize the goal in fact" (MF, p. 84). See also entry on "reasonableness" in PIP:9, p. 203.

24. For further discussion, see Nicholas Rescher, *Dialectics* (Albany: State University of New York Press, 1977), p. 38.

25. It must be noted that Weiss, like Perelman, acknowledges the interplay or dialectics of the rational and the reasonable. For just as being reasonable involves rationality, being rational may also involve reasonableness, for the latter is pertinent to pursuing inquiries, "since inquiry begins and continues in a world where people act in established ways, not only with reference to one another, but with reference to what else they confront. It will always allow for contingencies and novelties" (TAPS, p. 331). See also TAPS, p. 411, n.2. Compare Perelman: "It is the dialectic of the rational and the reasonable, the confrontation of logical coherence with the unreasonable character of conclusions, which is the progress of thought." ("The Rational and the Reasonable," p. 120.) For contrary views, see Rawls, "Kantian Constructivism," pp. 528–29; and Gewirth, "Rationality versus Reasonableness."

26. This seems to be a key mediating principle in Weiss's metaphysical account of social complexes, e.g., union, society, and state. For further discussion, see my "Structure of Social Complexes" cited in note 3 above.

27. Succinctly put, "the present is enriched by the past and the future" (TAPS, pivotal point no. 8, p. 3).

28. Edward A. Shils, *Tradition* (Chicago: University of Chicago Press, 1981), p. 12.

29. Ibid., p. 195. For an extensive discussion of the concept of living tradition as an interpretive concept based in part on Shils's instructive work and its application to the notion of Confucian tradition, see my "The Idea of Confucian Tradition," *Review of Metaphysics* 45, no. 4 (1992).

30. This incidentally is Chu Hsi's conception of wisdom. For further discussion of this conception in relation to Confucian cardinal virtues such as *jen*

(benevolence), *i* (rightness), and *li* (ritual propriety), see my "Hsün Tzu and the Unity of Virtues," *Journal of Chinese Philosophy* 14, no. 4 (1987).

31. Though he focuses on rationality rather than reasonableness, what Black says about chess playing is relevant here: "The accessible tradition supplies defeasible general maxims, standardized routines for accomplishing particular subtasks, detailed models for the initial deployment of pieces ['the opening'], and much else. Such deliverances of a rich tradition can function as premises of the requisite 'practical reasoning' and usually need not be questioned, but any of them can be questioned and perhaps rejected in special cases." Max Black, *Perplexities* (Ithaca: Cornell University Press, 1990), p. 108.

32. See note 29 above. For a general discussion of interpretive concepts particularly in the philosophy of law, see Ronald Dworkin, *Law's Empire* (Cambridge: Harvard University Press, 1986), chap. 2.

33. Michael Oakeshott, *Rationalism in Politics and Other Essays* (Indianapolis: Liberty Press, 1991), p. 60.

34. See Alasdair MacIntyre, *After Virtue* (Notre Dame: University of Notre Dame Press, 1981).

35. Garrett Barden, *After Principle* (Notre Dame: University of Notre Dame Press, 1990), p. 33.

36. See, for example, my discussion of *jen* and agape as ideal themes in *Dimensions of Moral Creativity*, pp. 129–30, 149.

37. Shaftesbury, *Characteristics* (Indianapolis: Bobbs-Merrill, 1964), vol. I, p. 72. For further discussion, see my "The Idea of Confucian Tradition," Section I.

38. Thus we may say with Lucas that there is "a social structure" of reasonableness in that reasonable persons "tend to agree more than they disagree." J.R. Lucas, "The Philosophy of the Reasonable Man," *Philosophical Quarterly* 13, no. 51 (1963): 100–101.

39. Stuart Hampshire, *Morality and Conflict* (Cambridge: Harvard University Press, 1983), p. 2 and esp. chaps. 6 and 7. Cf. John Kekes, *Moral Tradition and Individuality* (Princeton: Princeton University Press, 1989), pp. 7–9, *passim.*

40. See my "Reasonable Challenges and Preconditions of Adjudication" in Eliot Deutsch, ed., *Culture and Modernity: East-West Philosophical Perspectives* (Honolulu: University of Hawaii Press, 1991); and "The Status of Principles in Confucian Ethics," *Journal of Chinese Philosophy* 16, nos. 3–4 (1989).

41. Rescher, "Reasonableness in Ethics," p. 61.

42. For further discussion of the notion of conservatism in Confucian ethics, see my "The Possibility of Ethical Knowledge" in Hans Lenk and Gregor Paul, eds., *Epistemological Questions in Classical Chinese Philosophy* (Ithaca: State University of New York Press, 1993). For the notion of internal goods, see MacIntyre, *After Virtue,* pp. 176–89.

43. Stephen C. Pepper, *World Hypotheses: A Study in Evidence* (Berkeley: University of California Press, 1942), pp. 12–13.

44. William Dennes, "Conflict," in Sidney Hook, ed., *American Philosophers at Work* (New York: Criterion Books, 1956), p. 337.

45. See Aristotle, *Topics,* 100a, and the focus on the roles of *phronimous* or *spoudaios* in practical deliberation in *Nicomachean Ethics,* 1113a–1114b; 1140–1144. For the Confucian view, see my *Dimensions of Moral Creativity,* chap. 5; and "Concern, Competence, and the Role of Paradigmatic Individuals (*Chün-tzu*) in Moral Education," *Philosophy East and West* 42, no. 1 (1992).

46. Peter Winch, *Ethics and Action* (London: Routledge & Kegan Paul, 1972), p. 42. See also Alasdair MacIntyre, *Whose Justice? Which Rationality?* (Notre Dame: University of Notre Dame Press, 1989), pp. 394–95.

47. Thus Weiss rejects Kierkegaard's view on the "teleological suspension of the ethical." (Søren Kierkegaard, *Fear and Trembling and Sickness unto Death* (Princeton: Princeton University Press, 1954), p. 68ff. Religious faith, like other beliefs, are subject to reasoned assessment, especially in the light of the vision of the good. Indeed, such an assessment, as in the case of Abraham, must be made in conformity with a basic ethical injunction: that no innocent person should be subject to deliberate infliction of pain or suffering. Although Weiss frames the injunction differently: "It is wrong to kill a friend wantonly—unqualifiedly, absolutely wrong" (MV, p. 209), I take it that the "friend" here pertains to any human of ethical concern, rather than to the more usual sense of one who is involved in personal relationship.

48. See *Hsün Tzu*, Books 2 and 3; John Knoblok, *Xunzi: A Translation and Study of the Complete Works,* vol. I (Stanford: Stanford University Press, 1989), pp. 158, 80. For further discussion of Hsün Tzu's notion of impartiality, see my "Some Aspects of Ethical Argumentation: A Reply to Daniel Dahlstrom and John Marshall," *Journal of Chinese Philosophy* 14, no. 4 (1987), pp. 502–3. See also a recent, similar emphasis in terms of the Humean notion of "an informed, impartial, sympathetic spectator" in Sibley, "The Rational versus the Reasonable," p. 559.

49. It may be noted that Weiss is among the few contemporary philosophers to take seriously the ethical significance of the Golden Rule. The following remarks focus on some key aspects of Weiss's positive account rather than his critique of other interpretations. For a brief critical survey of philosophical issues concerning the adequate interpretation of the Golden Rule, see Marcus Singer, "Golden Rule" in Becker and Becker, *Encyclopedia of Ethics,* vol. I (1992), which supplements Singer's earlier "Golden Rule" in Paul Edwards, *Encyclopedia of Philosophy* (New York: Macmillan and Free Press, 1967). For parallel studies of the Golden Rule, see Herbert Fingarette, "Following the 'One Thread' of the *Analects,*" *Journal of the American Academy of Religion* 47, no. 35 (1979); and my "Confucian Vision and the Human Community," *Journal of Chinese Philosophy* 11, no. 3 (1984).

50. As one recent philosopher put it, the Golden Rule is "best regarded as a recommendation on how to achieve impartiality." Bernard Gert, *Morality: A New Justification of Moral Rules* (New York: Oxford University Press, 1988), p. 77.

51. More generally, we may say with Singer that "the near universal acceptance of the Golden Rule and its promulgation by persons of considerable intelligence, though otherwise of divergent outlooks, would therefore seem to provide some evidence for the claim that it is a fundamental ethical truth." Singer, "Golden Rule," *Encyclopedia of Philosophy,* vol. 3, p. 366.

52. See also MF, p. 112ff; TAPS, p. 133. For the principle of rectification in Weiss's social and political philosophy, see my "Structure of Social Complexes," pp. 340–41, 353.

53. See Singer, "Golden Rule," *Encyclopedia of Philosophy,* vol. 3, p. 202.

54. While Baier proposes the principle of reversibility as an interpretation of the negative version of the Golden Rule, he is also insistent that the principle also imposes certain positive injunctions. "It is, for instance, wrong—an

omission—not to help another person when he is in need and when we are in a position to help him. The story of the Good Samaritan makes this point." See Kurt Baier, *The Moral Point of View* (Ithaca: Cornell University Press, 1958), pp. 202–3. We may also note here that Weiss would accept Singer's "general interpretation" of the Golden Rule; that what it requires of me is "that I should take account of the interests and wishes of others in my treatment of them. I am to treat others *as* I would have them treat me, that is, on the same principle or standard as I would have them apply in their treatment of me. And the same principle or standard in application to differing circumstances or interests can lead to widely divergent particular results. The Golden Rule, then, is clearly compatible with differences in tastes, interests, wishes, needs, and desires." See Marcus Singer, "Defense of the Golden Rule" in his *Morals and Values: Readings in Theoretical and Practical Ethics* (New York: Charles Scribner's Sons, 1977), p. 121.

55. See "Memoir of Kant" in Thomas Kingsmill Abbott, trans., *Kant's Critique of Practical Reason and Other Works on the Theory of Ethics* (London: Longmans, Green & Co., 1948), p. lii.

56. These remarks were proposed as an interpretation of Confucius's notions of *chung* (loyalty, doing one's best) and *shu* (consideration of others). (Cua, "Confucian Vision and the Human Community," p. 233.) For a more extensive, complementary commentary on *shu,* see Fingarette, "Following the 'One Tread' in the *Analects,*" esp. p. 383ff. For the distinction between first order and second order desires, see Harry Frankfurt, "Freedom of the Will and the Concept of a Person," *Journal of Philosophy* 68, no. 1 (1971): 10; and similar distinction implicit in Hsün Tzu in my "Dimensions of *Li* (Propriety)," *Philosophy East and West* 29, no. 4 (1979): 380–81.

57. In Weiss's view, "both Mill and Kant restated and revitalized parts of the Golden Rule. . . . And it is the Golden Rule alone that holds them together. It asks us to consider another as an instrument at the same time that we regard him as self-determining end. The utilitarian principle of fair play or equality follows from it when we think of another as a mere intermediary, without reference to his individual needs and nature. Kantian respect follows from it when we think him as a self-determining being and pay no regard to his functioning with respect to us. To the factor of equal return the Golden Rule adds the element of consideration for the individuality of the other, spicing justice with mercy" (MF, p. 149).

58. The following remarks on modesty and humility are inspired by Allinson's perceptive essay on the negative version of the Golden Rule or *shu* in the *Analects.* However, my claim here is stronger than Allinson's. In my view, if the Confucian *jen* is brought in as the background for interpreting the negative formulation of *shu,* it is not merely consonant with the Confucian attitudes of modesty and humility, but more fundamentally, constitutive of reasonable commitment to *jen* as an ideal of the good human life as a whole. See Robert E. Allinson, "The Confucian Golden Rule: A Negative Formulation," *Journal of Chinese Philosophy* 12, no. 3 (1985). For a discussion of reasonable vindication of the adoption of *jen,* see my *The Unity of Knowledge and Action,* pp. 94–100.

59. This is an emendation of Lau's translation, *The Analects,* 12:12; 15:23.

60. See entry "reasonable," no. 5, *Oxford Dictionary of the English Language.*

61. Baier, *The Moral Point of View,* p. 316.

62. D.C. Lau, *Mencius* (Middlesex: Penguin Books, 1970), 7A:26 with minor emendation. For more discussion of moral discretion, see my "The Idea of Confucian Tradition," Section III. For the notion of the mean, see *The Doctrine of the Mean* in Chan, *A Source Book in Chinese Philosophy,* chap. 5. Compare Aristotle's *Nicomachean Ethics,* Book II.

63. Hume, *An Inquiry Concerning the Principles of Morals,* p. 85.

64. See Arnold Isenberg, "Natural Pride and Natural Shame," *Philosophy and Phenomenological Research* 10 (1949): esp. 7–8.

65. Allinson, "The Confucian Golden Rule: A Negative Formulation," p. 206.

66. For the Confucian notion of *li,* see my *Dimensions of Moral Creativity,* chap. 4; "Dimensions of *Li* (Propriety);" and more generally, "The Concept of *Li* in Confucian Moral Theory" in Robert E. Allinson, ed., *Understanding the Chinese Mind: The Philosophical Roots* (Hong Kong: Oxford University Press, 1989); Fingarette, *Confucius: The Secular as Sacred* (New York: Harper & Row, 1972). For Cicero, see John Higgenbotham, *Cicero on Moral Obligation: A New Translation of Cicero's 'De Officiis' with Introduction and Notes* (Berkeley: University of California Press, 1967), chaps. 27–28.

67. Lau, *Analects,* 2:17.

68. For further discussion of timeliness in Confucian ethics, see my "Reasonable Action and Confucian Argumentation," *Journal of Chinese Philosophy* 1, no. 1 (1973): 59–65.

69. I am grateful to Daniel Dahlstrom and Gregory Reichberg for valuable suggestions in preparing this paper for publication; and to Eunice Rice for her untiring efforts in providing adequate typescripts of all my writings these past six years.

REPLY TO ANTONIO S. CUA

A.S. Cua exemplifies the virtues he endorses. He is eminently judicious, modest, and appreciative. No one should want himself or another to be less than this. A composer, mathematician, scientist, philosopher, and anyone else engaged in carrying out an inquiry or other work, should have those virtues. Unfortunately, that would not be enough. Each should also be daring, imaginative, not too ready to fit in with what tradition, fellowman, or society might require or demand.

We need not look to those who are eminently reasonable to tell us what reasonableness is, presupposes, endorses, or requires. The Confucius whom Cua admires was an educator and a guide, precisely because he knew what reasonable people often miss—the nature and rights of individuals, the duties of leaders, and the respect one owes others. One looks, not to him and the life he led, but to his observations and insights, nourished by his ability to take a stand outside the place where the reasonable remain, pointing up issues all live with and do not satisfactorily resolve. Like Confucius, Cua and most of those who today concern themselves with moral and ethical issues try to deal with these independently of metaphysical considerations. As a consequence, he and they inevitably accept a position whose warrant and nature they do not examine. Conceivably, the position assumed might be indefensible. What have they to say to those who ignore or reject what is being claimed? There is a brute dogmatism exhibited by those who refuse to ask whether or not their limited accounts can withstand criticism.

Those who are reasonable do not ask for a warrant for being reasonable. Instead, they build on what tradition and experience have endorsed. They live their reasonableness. Is it right for them to do so? Is the answer to that question to be provided by one who is reasonable, or must not the nature, the place, and the consequences of reasonableness

be judged on other terms? What does Cua have to say to those who say that they do not want to be reasonable? Are heroes reasonable? Are mystics reasonable? Is it reasonable to spend one's life expounding or defending the views of some sage? An examination and defense of reasonableness is best conducted by one who attends to it in a different spirit, critically examining what had been taken for granted, looking for what is presupposed, and trying to justify it. I accept a good deal of what Cua endorses, but he cannot reasonably expect anyone to rest with whatever he says should be accepted.

I know that I have made a mistake somewhere if what I say precludes what is reasonable for me to say and do in daily life. I also know that if I am just reasonable, I will not see things with equal clarity all the time, and that there are occasions when I will be beset with problems I cannot solve. Reasonableness does not mean that one should not look for justifications, should avoid all doubts and probings, be content with the words of some sage, or refuse to ask about what is being presupposed. A philosopher, in any case, will not antecedently exclude anything from examination. If she is confident that nothing could undermine what she takes to be unreasonable, she will be all the more willing to look for a warrant for that confidence. It is not wise to refuse to find a warrant for what reasonableness affirms without offering any explanation or defense.

The virtues that Cua exhibits, and which he endorses, are envisaged by him from a position outside the confines of his reasonableness, as his sharp criticisms reveal. Nevertheless, just as one may benefit from the *obiter dicta* of a poet, statesman, or sage, so one may benefit from such a reasonable account of reasonableness as Cua provides. Following that recommendation, I can do little more than raise some issues and add some footnotes to his perceptive observations, to end with references to what he ignores, and with indications of why one should attend to them.

After I tried to understand the nature of creative work, as exemplified in a number of fields, it became more and more evident that philosophy was not a creative enterprise—a fact that I already noted in the autobiographical remarks that precede these essays and replies. A philosopher may here and there exhibit the virtues that creators have, but he seeks to do no less than report what is at the root of all knowledge, inquiry, answers, and doubts. He allows nothing to be sealed off as beyond questioning. The reasonableness which he exhibits at the beginning of his quest, and never abandons, will still have its borders defined and its relation to other attitudes and practices determined by what is not in his control. A readiness to use what is available, requires that reasonableness be exercised by each in considerable accord with similarly warranted moves by others.

No one wants physicists or mathematicians to think as reasonable persons might, though they will not be compelled to give up what they daily do and know for what they learned by carrying out their specialized ventures. A philosopher respects what both the reasonable and specialists do and achieve, but only within the limits where they are authorities. No one has the right to preclude a philosophic study, and surely not someone who refuses to do more than carry out some specialized work. It is not reasonable for someone to take himself to be a philosopher and then refuse to entertain any doubts about the legitimacy of the quest, method, or objective, or to the need for one to pursue it beyond the boundaries of some particular study. Cua himself looks for "the thread" that runs through my view. No merely reasonable man would think that was a worthwhile pursuit.

A philosopher is not unreasonable because he asks questions the ordinary reasonable person does not. When he asks and tries to answer such questions as: Why should one be reasonable? Where? When? He helps those who attend to some limited topic by trying to know what conditions must be satisfied when one carries out successful creative work. It is he who seeks to know the good that all should try to realize. Is it indeterminate or determinate? How is it related to other objectives, such as beauty, glory, and justice? Are these projections, imaginaries, or real?

How does reasonableness differ from a complacency made respectable? Is it needed in a study of morality or ethics? Does it provide a clear or consistent guide for resolving difficult ethical or moral dilemmas?

What is more reasonable than the remark that we cannot look back into the past? Yet how few among the educated are willing to affirm that the perceived is neither in the brain nor the mind of the perceiver but instead is external to and contemporary with it? It would have been reasonable for Confucius to say that the sun goes round the earth. Does Cua agree that it does? Or is reasonableness respectable only if it is confined to what is to be done in ethical or moral situations?

Is "honor thy father and mother" only a reasonable request? If it were, would it not lack the bite and force that it needs to have if it is to compel acceptance as a command or guide? Is it reasonable to preclude studies into what is outside one's interests or reach? Do not other enterprises provide needed qualifications and limits otherwise not available? Will they not help Cua know himself, others, and the world in which he is, thereby enabling him to be reasonable only where he should be.

No philosopher can justifiably say that he will not ask about what any of his specialized studies presupposes. Was it not reasonable people who

at one time accepted slavery, the denigration of women, superstitions, alchemy, and magic? We know that they were mistaken, not because our reasonableness differs in kind from theirs, but because we know, better than they had, what it is to be human, the nature of rights, responsibility, accountability, the environment, and the dubiety of some of the dogmas unreflectingly accepted at different times and places. How does one adjudicate quarrels among reasonable men? Are all Confucians free of bigotry, prejudice, narrowness of vision, an obeisance to rulers? Do they all refuse to examine their presuppositions? Should they?

Cua would like "to reconstruct in a coherent and plausible fashion some key insights of Weiss that are not tied to his metaphysical theories." Were this done, one would, I think, lose the reasons behind those insights and the ways they could be defended, expanded, modified, and supplemented. What is gained by tearing the 'insights' away from what clarifies, locates, grounds, tests, and frames them?

He says that Wang Yang-ming thought of the "universe as a moral community." What warrant is there for that rather startling idea? It surely is not reasonable. How could one know whether to accept or to reject it, without having some knowledge of the universe? I am also perplexed by the remark that "tradition is an *interpretive concept.*" With some strain I can see how it might be taken to be 'interpretive' but try as I may, I cannot see why he takes it to be a 'concept', though one can of course have a concept of it. Nor am I always clear as to whether or not he uses 'ethics' and 'Confucian morality' as interchangeable terms.

There are, Cua tells us, in accord with Confucius, paradigmatic individuals who set the standards for moral education. Are they paradigmatic for all humans everywhere and at all times? There have been periods in history when the warrior, the athlete, or the pious had pride of place. Would it have been right for one living at their time and place to challenge the prevailing standards and practices? Is a Nietzsche to be dismissed as just aberrant? Is a lonely or despised thinker necessarily a wrong-headed one? Would it not be better first to try to understand what humans essentially are, what they lack, what they could obtain, what else there is, and how all fit together, before one rests with widely acknowledged paradigms?

Just as one can study the nature of sport, know what it is in essence, examine the place of gender differences, the possibility of standardization, the effect it has on individuals, and the demands that must be met if it is to be well-pursued, so one can understand morality from a position distinct from any and all its specialized forms. Were there only moralities, and no ethical requirements there would be nothing more to do than to see how to get the deviant to conform a little better than they had or

otherwise might. The question, whether or not all moralities are equally legitimate cannot be answered except by attending to what is outside the reach of those who refuse to carry out a relentless search for presuppositions, or to examine all the different kinds of realities there are and how they are interrelated.

I sometimes wonder whether the Confucian concern for others refers to all humans, the good and the bad, the weak and the strong, the privileged and the unprivileged, the fat and the lean, or whether it is content with showing how people might be able to live peacefully together. Could such questions be answered if one did not care to know what it is to be human, no matter when or where, what the good is, how it is to be realized, and whether or not the attempt to realize it is compatible with the attempt to know what holds always? Does it have a place for the life of a monk, for unfettered inquiry, or free speech? Does it encourage or even allow for an attempt to know what holds always, and what ought to be? Do reasonable persons have an interest in these? Do they not sometimes condemn the effort as foolish? Does the Confucian want one to live his edicts or just talk about them? Is the teaching of Confucianism a Confucian act, or does it not require that one live the life he recommends? More important, can a philosopher say that he will concentrate on just one part of the discipline, as if this were a disjunction of specialized studies?

Cua prefers the negative Confucian form of the Golden Rule, since it can be "construed as a counsel of modesty, which stresses the importance of being aware of one's limited perspective." Could he legitimately say this if he had not achieved a position from which all perspectives could be compared or ordered? He seems to hold that one should be moderate in imposing one's wishes and desires on others, and then only if they are on a footing. Since they are presumably equals as humans, they are evidently to be differentiated because of age, worth, station, gender. Why these? Are there any others? How will one know what the right answers to these questions are? Do we now have all the admonitions we need? Is there any way of determining whether or not one or some of them should override others? How could such questions be well answered if one keeps within the limits set by tradition, practice, or the words of those said to be wise?

Cua says that because one does not have a "complete knowledge of the specification of the concrete significance of the good for all humans, a reasonable person will be humble." Perhaps, but will not a philosopher take the lack of a complete knowledge to present him with an unavoidable challenge? He does not seek nor could he obtain a detailed knowledge of all specific occurrences, but he certainly could benefit from a "meta-

physical" grasp of man and the other realities as they are apart and together in inescapable ways. He says "any claim to knowledge about one's good and another's is at best a plausible presumption but always defeasible . . . general knowledge provides no justification to claims to complete knowledge of the specification of the good." Do the Confucian maxims escape that criticism? Does anyone interested in metaphysics look to it for "complete (!) knowledge of the specification of the good?"

Humility is a desirable trait, and a desirable accompaniment of any endeavor, not because one does not know all one should, but because a successful inquiry and its goal require it. That should not be permitted to preclude our forming bold suppositions, exercising our imaginations, or testing and justifying what is accepted.

It is a rare composer who thinks of the way he may be benefitting others. His main concern is with the creation of an excellent work, though he would undoubtedly be pleased to hear that others had been enlightened or enriched by what he produced. A philosopher, though no creator, is somewhat like him. Wanting to know what always is, and why what need not have been is, he seeks to learn what will incidentally provide a frame in which the wisdom of a Confucius finds a place and thereupon perhaps will be corrected, extended, or contracted. No one can learn from an examination of a desirable objective exactly what its realization will be like. Even reasonable humans in familiar, stable situations are sometimes surprised to see what they had wrought.

Cua seems to allow little or no room for daring, adventurous reaching beyond the familiar. Like so many others, he has little interest in creative ventures. It is hard to know what place daring artists, mathematicians, scientists, the heroic, leaders, and statesmen could have in his world of companionable men.

Cua ends by saying that he is offering "a profile of reasonable persons as consisting of such dispositions as rationality, respect for tradition, open-mindedness, impartiality, and the significance of the Golden Rule. . . ." That, I think, he has done quite well, while leaving in its wake many serious questions. In the absence of answers to these, he cannot, though, be sure of the limits within which his account is carried out, and whether or not what it ignores does not seriously qualify it. It is, of course, often desirable to attend to some limited inquiry. I have done this again and again, but without denying myself the need and the right to remain aware of what I am presupposing that must sooner or later be dealt with, and possibly require revisions in what I had already acknowledged. I did not, though, after I turned from logic, concentrate on limited inquiries until I had dealt with broader issues. I was therefore able to answer some of the questions I have now put to Cua. If he refuses to look

outside his limited field, he cannot deal with and therefore cannot know whether or not, or to what degree, what he now affirms can be maintained.

The good with which reasonable humans are concerned is a limited form of a more basic ideal that has other specialized forms, such as the beautiful, the true, justice, and glory. In the absence of a knowledge of these, and what they have in common, no one can be sure that the good that interests some humans is more than an idle projection or something just imagined.

Ethics, like every other important subject, is worth examining on its own. Like every other, it presupposes what is not then examined. Those who deal only with it will remain within limits whose nature, strength, and presuppositions are not examined. One of the major outcomes of a metaphysical inquiry is to see what major claims can be justified, and what is being presupposed.

Whether or not the good is just an apparition or a real prospect, humans might organize their thoughts and acts with reference to it. If they were to do no more than that, the pronouncements of an ethics and a morality, even if widely acclaimed, would remain questionable. The metaphysics that Cua and his fellow workers in contemporary ethical and moral studies cavalierly set aside is needed if they wish to know what they sought to realize was in fact realizable in a universe where there were other desirable objectives besides the Good. Those others rightly claim to be as legitimate as and no less basic than one devoted to ethics. They make one ask what relation they have to an ethics. To know that, one would have to know what none of them is comprehensive enough to provide.

Cua is a covert metaphysician. Now is a good time for him to come out of the closet and openly practice what he surreptitiously did there. The ethics he cherishes will, I am confident, then be both enriched and cushioned, extended and well-bounded, set within a needed, comprehensive, philosophic whole.

P.W.

22

Thomas Krettek, S.J.

PAUL WEISS AND THE FOUNDATIONS
OF POLITICAL PHILOSOPHY

I. Introduction

R obert Nisbet sets out three features of modern America that he thinks would most strike the Framers of the Constitution.[1] One is the prominence of war and the military in American life. Another is "the Leviathan-like presence of the national government in the affairs of states, towns, and cities, and in the lives, cradle to grave, of individuals."[2] A third is the significant number in American society of what he designates as "loose individuals."[3]

Nisbet's sociological analysis is important because he suggests that the absolute, yet democratic, political state resulting from the First World War is the empirical counterpart of the state designed by Rousseau in *The Social Contract* and the *Discourse on Political Economy.*[4] According to Nisbet, Rousseauian social contract theory stipulates that each individual, including all his or her own power, rights, liberties, and person, be sublated to the absolute sovereignty of the general will, which is purged of any evidence of individual wills.[5] According to Nisbet's sociological analysis, however, the "freedom to be free" offered in the Rousseauian social contract and typified in "the loose individual," is not genuine freedom.[6] Nisbet's analysis is ominous because the predominant model for the foundation of contemporary civil society is the social contract.[7]

Nisbet holds that these problems are all subject to arrest and reversal because they are "at bottom dynamical patterns of ideas, bad ideas but ideas nonetheless."[8] He claims that a revolution in ideas is needed.

One contemporary author who proposes to lead such a revolution is Alasdair MacIntyre. MacIntyre's scrutiny of the contemporary emotivist moral landscape and its Weberian and Goffmanesque sociological embodiment leads him to conclude that "our society cannot hope to achieve

moral consensus."[9] This entails "that modern politics cannot be a matter of genuine moral consensus. And it is not. Modern politics is civil war carried on by other means. . . ."[10] Given this assessment, MacIntyre draws the following conclusion. "It now becomes clear that [my argument for upholding the virtue tradition in ethics] also involves a rejection of the modern political order. . . . Modern systematic politics, whether liberal, conservative, radical or socialist, simply has to be rejected. . . ."[11] Because MacIntyre holds that practical agreement on a conception of justice is a necessary basis for political community, he seeks to provide the foundation for a systematic account of justice by discovering what counts as rationality.[12] The adequacy of MacIntyre's account, however, is suspect because he seeks to maintain the Aristotelian tradition, while rejecting its metaphysical foundation in favor of a "socially teleological account."[13] MacIntyre's proposal, insofar as it relies on a social-historical-narrative concept of self, encounters, as will be seen, a difficulty identified by Charles McCoy.

McCoy claims that there has been a dramatic and potentially dangerous reversal in the way human beings understand their relation to reality.[14] Prior to the seventeenth century, human speculation about reality recognized a "givenness" to things and a teleology to nature. This givenness and teleology provided an archetype for thinking about human beings and human community.[15] The scientific revolution of the seventeenth century asserted the autonomy of nature and looked upon human reason as part of nature and nature itself as an originative formative principle.[16] According to the new science, both nature and human nature lack a given purpose, end, or reason. Both exhibit infinite potentiality and formability.[17] According to McCoy, this changed understanding of nature and human beings is at the root of totalitarianism, modern liberalism, and modern conservatism.[18]

James Schall examines the consequences of this changed understanding.[19] He argues the necessity of preventing politics from becoming a metaphysics, "which, if put into existence as a 'political metaphysics,' would deprive man of a real intellectual or spiritual life apart from the complete control of the polity."[20] Without some givenness to nature and human beings beyond the human will both nature and human beings are subject to infinite and arbitrary manipulation by anyone with the power to do so.

Unless humanity finds itself situated as part of a whole and among realities that are not entirely subject to its will, there is no givenness to reality that offers a limit and a guide to human social and political activity, which must be present if human freedom and integrity are to be

preserved. A givenness to reality beyond the human will grounds ends and purposes for human life that are not subject to manipulation. MacIntyre's proposal is faulty because it cannot preserve this "givenness" beyond the human will.

McCoy and Schall make complementary suggestions regarding the way in which this reversal and its inherent dangers can be addressed. McCoy argues for a recovery of "the thread of tradition in political philosophy."[21] For Schall, revelation is essential to genuine political philosophy.[22] However, both the thread of tradition and revelation have failed to halt the forward march of this so-called "modern project." Moreover, Schall's appeal to revelation is not universally accepted, even by apologists of revelation. "According to Christian belief there are no truths that are relevant for living the natural political life that are only available to those who adhere to Christianity. The truths dealing with political life and with virtue are available through the exercise of reason and choice."[23] This claim by Robert Sokolowski clearly is at odds with Schall's view that revelation is necessary for resolving basic problems of political philosophy.

In light of the foregoing considerations, the necessary revolution in ideas asserted by Nisbet would have to provide a more adequate account of the richness and complexity of human life and society than the one offered by apologists of the social contract model. Avoidance of the specter of bureaucratic, albeit democratic, absolutism and headway on the difficult problems of freedom, justice, morality, and politics require attention to the ways in which humans exist as both together and apart and the preservation of the integrity of social forms intermediate between state and individual. Such a revolution in ideas would have to be ontologically rooted rather than theologically sanctioned or politically motivated, rooted in thoughtful reflection on the being of humans rather than in divine revelation or the changing movements of the human will.

II. PAUL WEISS AND POLITICAL PHILOSOPHY

Paul Weiss develops several themes that, as indicated in the first part of this paper, are vital to an adequate political philosophy, namely, (A) the givenness of reality beyond the human will, (B) the basic sufficiency of human reason and action, without appeal to revelation, to shape the human polity, and (C) the fundamental otherness yet togetherness of individuals that preserves the integrity of social forms intermediate between the individual and the state. Weiss's social and political thought,

in its essence if not in its details, may provide the basis for the revolution in ideas that the present age requires.

A. The Givenness of Reality

According to Weiss, "A study of society and state . . . should come after one has engaged in the boldest speculative adventures."[24] Consequently, Weiss's understanding of the task of social and political philosophy is founded on a metaphysics that discovers the daily world to be constituted and governed by the ontological interplay of more ultimate realities.[25] These primary realities are "unitary and self-maintained, distinct from what is given to it and what is accepted by it," thus precluding anything becoming identical with it.[26] "A thing in itself is radically obdurate, self-centered, and in retreat before every attempt to know or to penetrate it. . . . It is what we can know as that which always leaves more for us to know."[27] Things in themselves have their own integrity[28] and necessarily exist because they are presupposed by everything else.[29] Weiss asserts that "It is necessary to acknowledge things in themselves, realities which exist apart from all qualification by anything else."[30] There also must be more than one. For Weiss, there are three sorts of things in themselves: actualities, finalities, and the dunamis.

1. Actualities and Privacy. Weiss takes the existence of individuals to be a fundamental datum of reality.[31] Actualities, especially the human actuality, are individuals, and their origin, according to Weiss, is accounted for through the action of the other ultimates. The intelligibility and functioning of an actuality also depends on acknowledging the presence of an insistent privacy for it.[32] Without an unduplicable, individual privacy, there would be no individual.[33] Human privacy also grounds the social status that is characteristic of the human individual.[34]

2. Finalities and Conditions. Weiss begins *Toward a Perfected State* with the modest assertion that "It is eminently desirable to know if and how humans can act together in better ways than they now do."[35] The book endeavors to articulate how acting together in better ways is possible. For Weiss, this articulation requires a recognition of certain objective truths that refer to the nature of conditions as directed at the members of a society.[36] The conditions that control appearances (e.g., societies and states) and actualities (e.g., human individuals) have little intrinsic power but are able to be effective by virtue of being attenuated versions of finalities.[37] Finalities are "irreducible permanent realities" that intrude on particulars.[38] They are "a plurality of subordinating and subordinated, but ultimately real conditions and sources of contexts which

enable particulars to be together."[39] Finalities are important in clarifying political action, political philosophy, and their relationship.[40]

3. Dunamis. According to Weiss, the dunamis is the common ground out of which individuals originate and the common ground on the basis of which individuals are able to be in intimate contact with others.[41] Because people are inescapably involved with one another through the dunamis, the dunamis is foundational for all human association.[42]

The ontological interplay between (1) actualities with their privacies, (2) finalities or transcendents specialized in common conditions, and (3) the dunamis is correlatively manifested in forms of social togetherness in the commonsense world.[43] These ontological ultimates found, guide, and assess individual achievement and social forms. They are not, according to Weiss, susceptible to human manipulation because they are ontological rather than epistemological realities. They constitute rather than interpret reality.

B. The Sufficiency of Human Reason

Weiss affirms the basic sufficiency of human reason and action to shape the human polity by locating himself among those who "follow the lead of the evidence that is condensed in the commonplace,"[44] and then moving adumbratively from societies and states as "objective appearances" to the ultimate realities at their core. The ontological difference between objective appearances and ultimate realities involves an epistemological distinction between "reasonableness" and "sophisticated reasonableness."

At its core "reasonableness" involves the ability to acknowledge traditions, current circumstances, practical considerations, and their interplay.[45] "Reasonableness" is prudential rather than procedural thinking. The successful functioning of a state requires "reasonable" citizens.[46] "Sophisticated reasonableness," on the other hand, joins the "reasonableness characteristic of mature people in daily life to an understanding of the structures, natures, and relations characteristic of ultimate realities. . . . One is then in a position to know why and how to progress from society to state, and from there to what lies ahead."[47] Sophisticated reasonableness is human intelligence submitting itself to the commonsense world as constituted by the ontological ultimates. For Weiss, commonsense, reasonableness, and sophisticated reasonableness are all characteristically human abilities that allow individuals to participate in and to shape their social and political world.

C. The Fundamental Otherness yet Togetherness of Individuals and the Integrity of Intermediate Social Forms

According to Weiss, the human individual is not essentially social but does have the status of a social being.[48] This distinction is important because by it Weiss preserves the integrity of the private individual, while not precluding the togetherness of private individuals. Were the human individual essentially social, it would be essentially public. Were the human individual essentially private, it would be isolated.[49] Since neither society nor privacies in isolation from each other constitute the essential nature of the human individual, the human individual must be both private and public, apart and together.

Weiss demands that the human individual "be perfected, made excellent as a private and a public being."[50] A human individual, to be at its best, is to be made excellent both in itself and with respect to social groups.[51] The perfection of the human individual as a public being involves making that individual excellent, both as existing independently of others and as existing together with them. As existing independently of others, perfection requires that "a harmony in his privacy, in his body, and between his privacy and his body" be achieved.[52] This demand for the excellence of the human individual is the Weissian norm for evaluating both the individual and social groups.[53]

According to Weiss, neither societies nor states are objects in nature.[54] He claims that "Societies exist, not because humans have recognized their desirability or have been forced into them, but because their unions are subject to inescapably effective pertinent conditions sustained by portions of objective time and space."[55] Societies are formed through the interplay of an insistent union (i.e., collaborative and associative people who are effectively conditioned by enriched regions of time and space and sustained by a primal ground) with an insistent condition.[56] That condition is the product of an ideology and a territory, the synthesis of which constitutes a homeland.[57]

Unions are essential constituents of society and state and make common public life possible.[58] Unions, as distinct forms of human togetherness, originate in and emerge from human collaboration and association.[59] Unions have their own natures and careers distinct from the natures and careers of the collaborations and associations upon which they are founded.[60] Such unions are inevitable because collaborative and associative human action is inevitable.[61] To maintain its excellence, although not to constitute its identity, a union requires society and/or a state.[62] For Weiss, individuals, conditions, and the common ground are all required for a society to be present, however, a

society possesses its own distinctive nature and career that are not identical to the natures and careers of the conditions, unions, and individuals that comprise it.[63]

A state is "constituted by a union of people interplaying with a common government."[64] A distinctive state emerges only when a government actually interplays with a people. Although its nature and career depend on a ruler/ruled interplay, a state is not reducible to a union of people and government.[65] A state has its own reality, nature, authority, and rights.[66] A state, like a society, is needed for people to become moral, as well as effective and well-habituated beings.[67] It is also needed in order to insure the continued harmony of human actions.[68] The function of the state, according to Weiss, is to harmonize appropriate human action, (i.e., action grounded in society), and moral human action, (i.e., action grounded in unions), and, thereby, make possible reasonably right human action.[69] In effect, the function of a state is to confirm the integrity and autonomy of the social forms intermediate between itself and individuals by preserving and enhancing the independent and interrelated functioning of unions and societies.

The bipolarity of public and private is displayed in Weiss's treatment of rights. According to Weiss, all rights that adhere to the human individual are ultimately grounded in privacy/mankind.[70] The rights that are native to the human individual are correlative with the primary epitomizations of human privacy and are articulated in the discovery of these epitomizations.[71] These rights provide nonpolitical grounds for assessing states and societies.[72] Even though states have "independent groundings, careers, and standards," they are assessed as just or unjust on the basis of whether the public ways by which they promote the equality of independently existing human individuals are appropriate to these same individuals as privately grounded.[73]

According to Weiss, societies and states, like individuals, have distinctive natures and rights[74] that deserve to be satisfied. These rights are maintained against individuals.[75] Legitimacy grounds the rights of government and state with respect to individuals.[76] Legitimacy is either inherent or derived.[77] Acquired legitimacy ultimately depends on inherent legitimacy.[78] For Weiss, legitimacy is a function of a reasonable justification for demands, which reasonable justification is based on the nature of that which is making the demands.[79]

Weiss rejects the claim that all authority in a society, government, or state is solely from the people or that they derive their rights solely from the consent of private individuals.[80] He also rejects the suggestion that such authority is solely due to the unions or governing conditions that are involved in such forms of togetherness. Each has a nature and integrity of

its own that is distinct from the natures of its constituent elements. The distinctive nature that characterizes each of these forms of human togetherness is the ground of the authority and rights that it possesses.[81]

Because people, society, state, government, and sovereign all possess their own distinctive natures and legitimacy, none can be reduced to a mere function of the others.[82] Each is a means for the others, but each is also to be accorded the rights that adhere to it as a means.[83] State and people are mutually assessive of one another. A state is evaluated in terms of the ways it enhances people and their privacies, while people are assessed in terms of the ways they enhance the state.[84] Each is called to contribute to the perfecting of the other.[85]

Both the atomic, autonomous individual and the democratic, absolute state are political fictions that derive from faulty political metaphysics. Weiss's alternative to the social contract model rejects the either/or relation between the individual and the collective and substitutes a both/and relation. Both the individual and social forms have legitimate rights based on their respective natures. Both have to submit themselves to guidance and assessment by the other and the realities that constitute them. Both the individual and social forms are necessary to the excellent functioning of each.

III. POLITICAL ACTION AND POLITICAL PHILOSOPHY IN WEISS

The foregoing insights are discovered through an application of what Weiss calls the cosmological and the metaphysical methods. The cosmological method involves accepting "the cosmological character of the commonsense world" and redefining it.[86] It is the method of and for human action through which individuals and societies are able to achieve excellence by interplaying with attenuated versions of finalities and the dunamis.[87] The cosmological method would employ sophisticated reasonableness. The metaphysical method involves analyzing the world of common sense in terms of surface and depth, employing what Weiss terms "adumbration." This method is the way to the discovery of finalities, actualities, and dunamis as those primary realities that make the daily world possible and are the ontological foundations of the individual and social groups.[88] The metaphysical method is the method of philosophy. The cosmological method depends on the metaphysical. The difference between the cosmological and the metaphysical method brings out the difference between political action and political philosophy.

The political good and excellence of states and individuals are nested in and concatenated with other goods and excellences. "What people should be and do is what they politically should be and do, enriched by what else should and ought to be. Each is to be perfected individually and together with others, under common, effective conditions, inseparable from an ideal in the guise of an ought pertinent to all."[89] Political and social action thus occur between a "should be" and an "ought to be."[90] The "should be" falls short of the "ought to be." The "should be" directs action as an excellence that is realizable, given the limits within which actualities and actions take place. The "ought to be" presents a standard that functions as an excellence that "could be exhibited" were it not for the limitations that constrain actualities and actions.[91] The good that is of concern to political philosophy transcends the good of a particular state, but the presence and realization of the good that concerns political philosophy depends on individual states being perfected. While political practice involves discovering how people can become more excellent through being together, than they could be otherwise, political philosophy appraises the interplay between the "should" and the "ought" and directs attention to an end that is beyond the sphere of political action.

Since each individual, society, state, and government possesses its own rights in virtue of its own nature, the rights adhering to one cannot be identical with the rights possessed by the others and, as a result, the rights of each must be harmonized.[92] While the idios performs this harmonizing function for the individual,[93] such harmonization with respect to the state is effected in a number of ways. One is by the state itself. Another harmonizing element identified by Weiss is Law. Law is a common condition that possesses its own nature and yet instantiates a primal justice, which justice specializes the finality Being.[94] Justice is a third harmonizing element. It, like Law, is a common condition specializing the finality, Being, and is embodied in judicial acts.[95] A final harmonizing element is the Ideal.[96] When it serves as the basis for reconstructing societies[97] and the ought for the state,[98] Weiss identifies it as the Commonhealth.[99] This serves as a neutral court for conflicting claims not only within but between and beyond states. The Commonhealth in turn is assessed by an ethics.[100]

Ethics considers the larger world in which unions, societies, and states, both actual and ideal, are nested. This larger world consists of not only those realities that are pertinent to human concerns, but also the remainder of the universe with all its other realities and their relations. Consequently, ethics requires attention "to the natures of the ultimate realities and the ways these interplay."[101]

IV. Questions and Conclusions

Weiss's endeavor to offer a credible philosophical alternative to the social contract model depends upon whether his ontology cogently grounds the claims that he makes on its basis. For Weiss, individuals, conditions, and the common ground are all necessary for, because constitutive sources of, Weissian social groupings. However, both Weiss's descriptive and his ontological account indicate that common conditions, i.e., attenuated versions of Weissian finalities, ultimately determine the nature of such groups.[102] Daniel Dahlstrom raises serious questions regarding some of the evidences Weiss claims for finalities.[103] However, he leaves as a suggestion the evidential power of basic emotions with respect to finalities. Because of the central role that finalities play in the constitution of social unions and in the harmonizing of social life, the cogency of Weiss's argument that they are ultimate ontological realities is of crucial importance for the credibility of his political philosophy since it is unclear whether Weiss's claims for the sociality of privacy and the dunamis alone could sustain a givenness to reality beyond the human will and the fundamental otherness yet togetherness of individuals.

Another consideration that bring to the fore the crucial importance of a credible Weissian ontology is the central role that "reasonableness" and "sophisticated reasonableness" play in Weiss's account. Unless commonsense appearances are actually continuous with their ontological sources, there is no Weissian escape from the danger of knowledge as a manipulative power. Nor is there the possibility of achieving clarity about the proper relation between individuals, social groups, and the state. Therefore, a heavy burden falls on Weissian epistemology and his notions of symbolization, adumbration, and lucidation.

Repeatedly throughout his philosophic career Weiss has returned to the above issues to further clarify and support his position. While they remain under discussion, Weiss has succeeded in reminding us of the importance of ontological and epistemological issues for political philosophy. Weiss's distinction between political action and political philosophy and his treatment of political action as nested in broader considerations bring out other metaphysical issues relating to the foundations of political philosophy.

Political action, political philosophy, and metaphysics mutually influence each other. In connection with any political philosophy (or any philosophy for that matter), "What are its basic metaphysical presuppositions?" is a legitimate question to pose when the kinds of questions that are asked shape the kinds of answers that can be found. The importance

of asking such a question is further brought out by looking at three ways in which Weiss differs from much of contemporary political philosophy.

Weiss's political theorizing does not begin with the question of "How does the state originate?" but with the question of "How do states move from where they are now to where they might be?" Insofar as contemporary political philosophy presumes some form of the social contract theory of the state, it asks about origins. However, the question about the origins of the state requires access to a kind of knowledge that is unavailable to the inquirer. As a result, any social contract theory runs the risk of being a creation in the image of the interests of the one who proposes it. Feminism's criticism of the notion of a literary canon is founded on this insight.[104] The correctness or adequacy of such theories can never be checked because of the impossibility of possessing the kind of knowledge that would be needed to do so. Weiss, on the other hand, asks about the ends of political life. To ask about the ends of political life, about how a state might be different than it is now, and about how that change can be effected are all questions that involve knowledge that is publicly accessible or can be made so. It is to look to the future and the possibility of improvement rather than to the past and the preservation of the status quo.

A second key difference between Weiss and much of contemporary political philosophy is discovered by looking at the kind of terminology they employ. Weiss speaks of a Commonhealth rather than a Commonwealth. A question arises as to the difference that it makes to the kind of political theory and action articulated if the human polity is conceived of in economic images rather than in medicinal ones. What happens to our understanding of the common good when it is thought of as an issue of health rather than an issue of wealth?

Book I of the *Republic* contains some interesting observations in connection with money-makers and physicians. The interlocutors' first attempt at a definition of justice using an economic model leads to contradictions and so they must shift to other categories. If a noncontradictory conception of justice cannot be found on the basis of an economic model, then another foundation has to be laid if an acceptable conception of justice is to be achieved. Weiss's use of Commonhealth carries with it the kind of moral and medicinal associations that are found in the *Republic* and may provide a better foundation for addressing the complex of issues surrounding the philosophical and practical meanings of freedom and justice in the present age.

A final noteworthy difference is that Weiss's understanding of the human individual runs directly counter to the "modern autonomous

534 THOMAS KRETTEK, S.J.

individual." While he affirms the ultimately real and irreducible character of the human individual, and the native rights consequent on that character, he also argues that the excellence and end of the human individual are nested in and related to the achievement of excellence by other individuals, social groups, and the cosmos. Elizabeth Fox-Genovese asserts that there must be a way of "grounding the idea of liberty in the collectivity—in the recognition that there has never been and cannot be any individual freedom unrooted in community discipline."[105] Weiss's articulation of the relation between the private and the public, between individuals and social groups, indicates a way that this grounding can be accomplished.

Weiss's basic insights about (A) the givenness of reality beyond the human will, (B) the basic sufficiency of human reason and action to shape the human polity, and (C) the fundamental otherness yet togetherness of individuals that preserves the integrity of social forms intermediate between the individual and the state, give evidence of providing a more adequate framework for the revolution necessary to address the social, political, and moral concerns of the present age.

DEPARTMENT OF PHILOSOPHY
CREIGHTON UNIVERSITY
MAY 1992

NOTES

1. Robert Nisbet, *The Present Age: Progress and Anarchy in Modern America* (New York: Harper and Row, 1988).
2. Ibid., p. xi.
3. Ibid., pp. 84, 134–35.
4. Ibid., p. 52.
5. Ibid., pp. 52–53.
6. Ibid., p. 57.
7. John Rawls's *A Theory of Justice* (Cambridge: Harvard University Press, 1971) and Robert Nozick's *Anarchy, State, and Utopia* (New York: Basic Books, Inc., 1974) would typify this model.
8. *Present Age,* p. 135.
9. Alasdair MacIntyre, *After Virtue* (Notre Dame: University of Notre Dame Press, 1981), p. 252.
10. Ibid., p. 253.
11. Ibid., p. 255.
12. Alasdair MacIntyre, *Whose Justice? Which Rationality?* (Notre Dame: University of Notre Dame Press, 1988).

13. MacIntyre, *After Virtue*, p. 183.

14. Charles N. R. McCoy, *The Structure of Political Thought: A Study in the History of Political Ideas* (New York: McGraw-Hill Book Company, Inc., 1963), p. 4. This same reversal in its relation to individualism is noted by Elizabeth Fox-Genovese in her work *Feminism Without Illusions: A Critique of Individualism* (Chapel Hill: University of North Carolina Press, 1991, pp. 122–23).

15. Ibid., p. 3. See also Diogenes Allen, *Philosophy for Understanding Theology* (Atlanta: John Knox Press, 1985), pp. 34–35, 186–87.

16. Ibid.

17. The assertion of the autonomy of nature with its claim of infinite potentiality anticipates Sartre's assertion that existence precedes essence.

18. McCoy, *Structure of Political Thought*, p. 6.

19. James Schall, *Reason, Revelation, and the Foundations of Political Philosophy* (Baton Rouge: Louisiana State University Press, 1987).

20. Ibid., p. 11.

21. *Structure of Political Thought*, p. 7.

22. *Reason, Revelation*, p. 239.

23. Robert Sokolowski, *The God of Faith and Reason* (Notre Dame: University of Notre Dame Press, 1982), p. 158.

23. Paul Weiss, *Toward a Perfected State*, corrected edition (Albany: State University of New York Press, 1986); pp. 432, note 3; x–xi. Other works pertinent here are *Beyond All Appearances* (Carbondale: Southern Illinois University Press, 1974); *First Considerations* (Carbondale: Southern Illinois University Press, 1980); *Modes of Being* (Carbondale: Southern Illinois University Press, 1958); *Privacy* (Carbondale: Southern Illinois University Press, 1983); "The Dunamis," *Review of Metaphysics* 40 (1987): 657–74; and "Things in Themselves," *Review of Metaphysics* 39 (1985): 23–46.

25. Weiss, *Privacy*, pp. 8, 250–51; *State*, p. 105.

26. Weiss, "Things in Themselves," pp. 32, 44.

27. Ibid., pp. 43–44.

28. Weiss, *First Considerations*, p. 67.

29. Weiss, "Things in Themselves," p. 23.

30. Ibid.

31. Ibid., pp. 23–24; *Philosophy in Process*, vol. 9 (Albany: SUNY Press, 1986), pp. 117, 308; *Privacy*, pp. 17, 110; *You, I and the Others* (Carbondale and Edwardsville: Southern Illinois University Press, 1980), p. 216; *First*, pp. 48, 235; *Beyond*, pp. 51–3, 77, 309–12, 317–18; *Modes*, pp. 10–11, 33, 69, 289; *Reality* (Princeton: Princeton University Press, 1938), pp. 176–84.

32. *Privacy*, p. 262.

33. Ibid., pp. 262–63.

34. *State*, pp. 20, 74–76; *Privacy*, p. 103.

35. *State*, p. ix.

36. Ibid., pp. 87–88.

37. *First*, p. 21.

38. Paul Weiss, *Beyond All Appearances* (Carbondale: Southern Illinois University Press, 1974), pp. 232, 233.

39. Paul Weiss, *Philosophy in Process*, vol. 9 (Albany: SUNY Press, 1986), p. 167.

40. *Beyond*, p. 95.

41. *State,* pp. 394 note 1; 21, 22, 24.
42. Ibid., pp. 23–24, 394 note 1.
43. Ibid., p. 30.
44. Ibid., p. 110.
45. Ibid., pp. 327–28.
46. The central place of "reasonableness" in Weiss's social and political thought is clarified in Anthony Cua's "The Structure of Social Complexes," *Review of Metaphysics* 41 (1987), pp. 335–53.
47. *State,* p. 153.
48. Ibid., pp. 74–76, 87.
49. The individual can never be essentially private for Weiss because a privacy never exists without a body. Being initially epitomized as a person, privacy must always have some public character. Even acts of privacy that go contrary to the body are bodily sustained (*State,* p. 37).
50. *Privacy,* p. 190.
51. Ibid., pp. 122, 317.
52. Ibid., p. 190.
53. Ibid., pp. 109–10, 162.
54. *State.,* pp. 30, 67.
55. Ibid., p. 60.
56. Ibid., pp. 60, 61, 65; *Privacy,* pp. 106, 107; *Beyond,* pp. 196–97.
57. Ibid., pp. 60, 65–66.
58. Ibid., p. 28.
59. Ibid.
60. Ibid., p. 42.
61. Ibid., p. 31.
62. Ibid., pp. 42, 58.
63. Ibid., p. 68.
64. Ibid., pp. 258, 337.
65. Ibid., pp. 155, 161.
66. Ibid., pp. 155, 168, 209.
67. Ibid., p. 58.
68. Ibid., p. 143.
69. Ibid., p. 79.
70. *Privacy,* p. 309; *State,* p. 369.
71. Ibid., pp. 301, 310.
72. *Beyond,* pp. 320–21.
73. Ibid.
74. *State,* pp. 4, 62, 209, 249; *Beyond,* pp. 322, 325.
75. Ibid., pp. 4, 324.
76. Ibid., pp. 207–8.
77. Ibid., p. 226.
78. Ibid., pp. 209, 226, 257.
79. Ibid., pp. 202, 203, 226.
80. Ibid., pp. 62–63, 207–9, 257, 396 note 7.
81. Ibid., pp. 209, 68.
82. Ibid., p. 210.
83. Ibid., pp. 136, 138, 140, 175, 178.
84. Ibid., p. 290.
85. Ibid., pp. 4, 71–72, 158, 300.

86. Paul Weiss, *Philosophy in Process,* vol. 2 (Carbondale: Southern Illinois University Press, 1966), p. 3.

87. *Privacy,* p. 263; *State,* pp. ix, x.

88. This is the inquiry that Weiss undertook in "The Task of Philosophy" in *First Considerations* (Carbondale: Southern Illinois University Press, 1980) and chap. 1 of *Beyond All Appearances* (Carbondale: Southern Illinois University Press, 1974). See also *Philosophy in Process,* vol. 7, part 2 (Albany: SUNY Press, 1985), pp. 2, 592–95.

89. *State,* p. 159.

90. Ibid.

91. Ibid.

92. Ibid., pp. 178, 249, 337, 341, 351.

93. *Privacy,* pp. 271, 274, 282.

94. *State,* pp. 176–77, 419 note 9.

95. Ibid., pp. 277–78, 419–20 notes 9 and 10.

96. Ibid., p. 169.

97. Ibid., pp. 142–43.

98. Ibid., pp. 159–60, 192, 236, 361.

99. Ibid., pp. 382–84.

100. Ibid., pp. 384, 356, 289–90.

101. Ibid., pp. 356–57.

102. Ibid., pp. 9, 11, 16, 19–20, 21, 28, 30, 58–60, 67–68, 77.

103. "The Appearance of Finalities," in *Creativity and Common Sense: Essays in Honor of Paul Weiss,* ed. Thomas Krettek (Albany: SUNY Press, 1987), pp. 55–75.

104. Elizabeth Fox-Genovese, *Feminism Without Illusions: A Critique of Individualism* (Chapel Hill: University of North Carolina Press, 1991), pp. 192–98.

105. Ibid., p. 111.

REPLY TO THOMAS KRETTEK

Although *Toward A Perfected State* has been well received and has been backed by splendid endorsements, no attempt seems to have been made to determine its place in the ongoing philosophic study of the nature of society and state. Krettek's is the first to make one. I hope that his essay will lead others also to examine the issues, using his sympathetic, well-grounded study as a guide.

The view presented in *TAPS* was subsequently enriched by the examination in *Creative Ventures* of the role of the statesman, the basic types of law, and the creativity required if justice is to be well-realized in a state. The difference between abduction and adumbration was not overlooked, with the one exhibited in processes of evidencing the ultimates, and the other characterizing penetrative moves passing from appearances to what appears.

I am not familiar with the writings of the authors Krettek examines and assesses, nor do I know whether or not he has provided a good sample of the leading thinkers in the field. It would have helped had references been made to some classical works. Despite their absence, he has nevertheless successfully focussed on a central problem. The natures of unions and societies, are, however, only touched on, although they are not only worth examining on their own account, but help promote a better understanding of the nature of the state. Also, what Krettek says about the Dunamis should be modified in the light of my later examinations of the idea.

I have not yet grasped the full import of the Dunamis. I now think that it should be taken to be one of the ultimates (initially termed 'finalities' and understood in a somewhat different way), and is to be joined to the Rational and, with this, seen to have a distinctive dominant role in mediations linking items in different domains. Like the other

ultimates, it is presupposed by every actuality and the fields in which these interplay. Like the others, it always is; like them, it is the necessitated product of Being's need for a sustainer of Being's possibility. With them, it is Being's agent and, like every agent, must have a status apart from the principal it serves. Compelled to sustain Being's possibility it exists apart from Being and can, therefore, do more than that.

Krettek's reference to my discussion of "sophisticated reasonableness" points up a way to correct and subtletize the 'reasonableness' to which Cua referred in his essay. The fact raises a problem in the understanding of the writings of anyone who presents a number of works having integrities of their own. Each should be taken to occupy a stage in an ongoing attempt to understand what is actual, what is necessarily presupposed, and how the two are interinvolved. I think that what is maintained in later works rarely conflicts with what was held in earlier, and that they often subtletize, enrich, and move beyond them.

Krettek rightly remarks on the importance of recognizing that humans are both individuals, apart from all else, and that they are together with other humans. They are also together with other actualities, both when they are members of unions, societies, and states, and when they interact with and make use of what is not human at all. Although each of us knows that humans are unduplicable individuals, with characters, persons and living and organic bodies, that each lives through pains and pleasures no others can fully share in, and that each can adumbratively pass beyond what others appear to be toward what they are as apart from all else, it is hard to find a ready acceptance for a view that takes account of all of them. I have tried to provide one.

Humans are together with one another in various groups. Personalism so exaggerates the separateness that it can find no way to understand how they could address one another. It is opposed by other views that allow for nothing hidden, inchoate, lived-through beliefs, hopes, fears, or responsibilities. Krettek has avoided both self-defeating views.

One can be moral without being well-habituated or being effective and living in accord with well-established customs or effective laws. The fact is made evident in the warranted eruptions of individual oppositions to long-established, regrettable attitudes, customs, and demands. The fact would have been made more evident had an unreflecting practice of cooperation and respect been clearly distinguished from a practice that improved over time. Both contrast with ethical demands whether or not anyone tries to or succeeds in meeting these. Such an ethics cannot, as Krettek has noted, be successfully dealt with if one has not understood the nature of various kinds of reality, including those that are not

particularly pertinent to human concerns. That demand is not well met either by Aristotle or by Kant.

I am not confident that I have understood Krettek's claim that "Unless commonsense appearances are actually continuous with their ontological sources, there is no Weissian escape from the danger of knowledge as a manipulative power." I hope I am facing the issue he is raising when I remark that I have always held, more and more firmly and evidently as time went on, that what daily is and daily known is never sealed off from the ultimates, or from the individuals that appear. The ultimates always and everywhere are instantiated in multiple and variable ways, all the outcome of contingent joinings of those ultimates.

Krettek takes 'Commonhealth' to refer to an 'issue of health', contrasting with 'commonwealth' as referring to an 'issue of wealth'. Both terms, allow for qualifications of these primary stresses; each allows a place for the interests of the other. The 'health' in Commonhealth refers to much more than the 'medicinal'. Its primary reference is to good functioning, "an ideal awaiting the maturation of a people to the point where they know and accept accountability. . . ." I am pleased to be thought by Krettek to have my view of the Commonhealth seen to carry "with it the kind of moral and medicinal [?] associations that are found in the *Republic* and may provide a better foundation for the complex of issues surrounding the philosophical and practical meanings of freedom and justice in the present age," though I did not have these in mind.

At the end of his essay, Krettek summarizes his interpretation in three claims:

1. There is a "givenness of reality beyond the human will." This statement is too compressed, hiding from us the fact that there are various kinds of reality. 'Givenness', in particular, also needs clarification. I think we also should add that we must not only distinguish individual humans from the unions they form, the societies in which they live, and the states they help constitute, but from what is instantiated and presupposed. That will take one away from the study of societies and states; if this is not done, the study of humans together will rest on what is unexamined, and could jeopardize what had been maintained.

2. "The basic sufficiency of human reason and action to shape the human policy" would not be possible did it not acknowledge the presence and actions of realities that human reason and action presuppose, exhibit, and utilize.

Human reason and action would be powerless were they not joined to what have natures and powers of their own. The Rational is and must be vitalized by the Dunamis, and qualified by other ultimates. It is better,

therefore, to continue to speak of "the eminently desirable use of human reason and action." That will not exclude, but will in fact make use of other irreducible factors. In the state, the Coordinator has a dominant role, operating on ruler and ruled, and enabling them to make an ideal justice prevail.

3. The otherness of individuals, as Krettek rightly remarks, is joined to their togetherness. Each of us, as I have already noted, is always alone and always together with others. Krettek points to the fact that both individuals and their groups should be acknowledged. Individuals exist in contradistinction to their societies and states and are intermediated by 'special forms', i.e., by unions, and other groupings.

Of great importance are references to intermediaries connecting individuals and the state. They should provide a warning and a guide for those who fasten on such pairs as language and its users, knowers and the known, subject and object. The members of those pairs can be bridged only by agencies that are distinct from both—the ultimates themselves qualifying and qualified by what they join.

What a tradition is for a society and its people, laws are for a state and its citizens. The tradition and the laws are effective when they function as controlling relations and thus so far as they exhibit the ultimates as effective connectives joining a people or citizens. Both a society and its people, and the state and its citizens, are subject to the ultimates, and are thereupon enabled to make a difference to other societies and their people, and other states and their citizens.

Although individuals are irreducible and ultimates always are, both serve to convert what they receive into what they provide. Conversely, though what Krettek calls "social forms" are intermediate between individuals and the state," they too have realities of their own. Intermediation is not idle; it makes it possible for items to be relevant to one another in ways they otherwise would not. What has a status of its own is not isolated, it changes what it receives into what is receptive of it as so qualified.

The primary intermediaries are the ultimates. They jointly operate in limited situations in specialized forms and are affected by what they relate, Krettek's sensitive, generously toned account should enable others, as it has me, to see this truth better than before. The recognition that traditions and laws are effective intermediaries because they are empowered by the ultimates should also make evident that there are related intermediations between the knowers and known, the dead past and the impotent future, premiss and conclusion, hypotheses and the realities to which they refer, as well as between what is and the experience of it. Krettek has underscored the fact that both society and state provide

splendid illustrations of how affiliations in the one and assessments in the other govern, connect, and control how humans in a society and state can make a difference to one another.

I hope that these observations will serve to underline what Krettek is maintaining, for I think that he states my view as well as it could be expressed in the space of a short essay.

P.W.

23

William Desmond

CREATIVITY AND THE DUNAMIS

I

Paul Weiss thinks that philosophy is not essentially marked by creativity. This is thought-provoking from one who has spent a life creatively in pursuit of philosophical understanding. He wants to understand the truth, he will say, and the truth is not the *product* of a creative venture. The truth is something we quest and find. Philosophy is knowing, not making. Yet Weiss's quest and finding have resulted in the production of an outstanding portfolio of philosophical works. These works span an extraordinary range of themes, showing not only singular ambition, but high daring and risk in the venture of thinking. Not least of these books is his recent work *Creative Ventures*.[1] If there is a philosopher who might lay claim to tireless thinking, issuing in an ensemble of "created" works of philosophy, it is Paul Weiss.

The theme under consideration—Creativity and the Dunamis—is chosen as a persistent concern of Weiss, as well as a fundamental philosophical issue. I chose this theme and title before *Creative Ventures* had appeared, sensing an important connection between creativity and the dunamis. On the appearance of *Creative Ventures* I was gratified to see that Weiss's article on the dunamis was reprinted in the book as an appendix. Is there any significance to the fact that Weiss singles the dunamis out for special mention among what he sees as the ultimate conditions? At least I was on the right track, I thought.

Weiss has always been concerned with the nature of creativity, most especially as applied to the arts. This is evident in books like *The World of*

Art, Nine Basic Arts, Cinematics, Religion and Art, and again most recently *Creative Ventures.* But this concern with creativity is not confined to its artistic specialization. This is very clear in *Creative Ventures.* The title of the work already signals a recognition of the *plural* manifestation of creativity in a variety of different ventures.

We might stress the term "venture" as well as "creative." The adventuring spirit of the human being, the being of the human as a venture, is at stake, at stake in its intertwining with our creative potential. To venture is to make an attempt, to take a risk and strike out into the unknown and the possibly new. To undertake an adventure is also with the hope of coming to something, coming upon something that is not initially known as determinate from the outset. The preposition *ad* signifies a certain going towards something, a movement from an origin towards something that, at the outset, may not be known with clear determinacy. There is risk in this going towards. At the outset one does not explicitly know where one will end. One has to throw oneself forward into the hazard of the initially unknown.

Of course, the process of going towards becomes more determinate as the adventurer proceeds. The venture seeks an initially indeterminate goal towards which it aims its creative power; in the process of actualizing this power, we may become more and more determinate as to what it is that draws the creative venture forward. The goal is a determinate work which is the incarnation of an ideal, dimly sensed at the outset of the process, capable of being lost or betrayed or deformed at each stage in the process of making the ideal concretely determinate. Nor does this exhaust the venturing self in its transcending dynamism. The created work offers an actualization of this dynamism but not an exhaustion, and the creative venture renews itself in its transcendence of its individual stabilizations.

What I have just said is very close to what Weiss says. We find ourselves involved with a certain energy of creative transcendence. Here the theme of "creativity" comes to appearance, not as particularized in the arts, not as pluralized in a host of human ventures, as in art, mathematics, science, leadership, and so on, but as an ontological principle ingredient in the constitution of all concrete realities. The creativity evident in human venturing is not a human creation simply but invokes "creativity" itself as something to which we must appeal to understand the nature of all being. This is especially clear if we wish to do justice to the dynamic and originative dimensions of reality as in process of becoming. The creative becoming of the human being cannot be abstracted from the becoming of creativity in all being. There is no understanding of human transcendence apart from an understanding of

the energy of transcendence at work in all being, and singularized in unique and often astonishing ways in the human being.

The reference to becoming will call to mind process philosophy, and though Weiss is not a process philosopher, he was shaped by his friendship, philosophical and human, with the father of process philosophy, Whitehead. Whitehead has his principle of "creativity," not just to explain human creativity, but to acknowledge what is universally at work in all becoming. Weiss's view of creativity is not Whitehead's, though there are affinities to which I will return. Yet both share the recognition that the creativity of the particular occasion or actuality cannot be fully understood apart from a more englobing sense of the work of creativity, not confined to the human being.

Hence an adequate study of creativity, even when it seems to focus exclusively on the human being, must invoke a metaphysical reflection on the nature of creation in the most embracing sense. Weiss's concept of the dunamis is important for this requirement. I will come to a more extended discussion of the dunamis, but we can say immediately that, among other things, it is invoked to explain the character of universal ongoingness that marks all processes of becoming. The energy of transcendence, as I see it, is not necessarily exhausted by this universal ongoingness, yet the latter is one manifestation of a basic dynamism at work everywhere in being. Weiss baptizes this simply, elementally with the name: the dunamis. Though the name is simple, elemental, what it names is enigmatic and perplexing. Or rather it points to something that perhaps is more perplexing, as I shall try to indicate.

For the moment I paint in broad strokes some of Weiss's procedures and claims in *Creative Ventures*. Weiss gets to work immediately *in medias res*. The lame reader will sometimes find himself limping behind. Initially one is puzzled, for his strategy is to progressively build up complexity and concrete richness through a multifaceted unfolding. This strategy seems to mirror philosophically his own description of a creative venture as a movement from an initially indeterminate ideal through a complex process of concrete determinate realization. Weiss claims that his method is reconstructive. It traces what is available in daily events back to their sources and ultimate conditions. It then claims to show how such sources and conditions enter together into the process of a creative venture. The creative venture is not confined to artists. In addition to artists, there are creative mathematicians and scientists, persons who create great characters for themselves, creative leaders, creators of states.

In all creative ventures five ultimates or conditions are variously at work. These Weiss singles out as the voluminous, which is most pertinent to the arts; the rational, which is most important for creative mathemati-

cians; what he calls the stratifier which is an ordering, assessing power, most relevant to the creation of a good character; what he calls the affiliator which allows the supportive interinvolvement such as we find in creative leaders; finally the coordinator which is prominent in the creation of states. All these conditions are at work in every occurence, but they receive distinctive expressions in the different creative ventures.

In addition to these conditions, any creative venture involves the primary pulsating ground called the dunamis. There is also the privacy of the creator and obdurate material. The creative venture also requires an ideal which is initially indeterminate, but which the progressive unfolding of the creative venture makes more and more determinate, and this through the joining together into a harmonious interinvolvement of the conditions, the dunamis, the privacy, and the material. The outcome of creative ventures is the production of a work of excellence which as a rich whole concretizes a new complex togetherness of all these factors.

II

I will now try to put two questions to Paul Weiss, the first reflecting the particularization and pluralization of creativity in human ventures, the second concerning the ultimacy of "creativity" itself relative to the ontological happening of being in its actuality. The first one deals with the use of the term "creativity" in contemporary culture and what restrictions, if any, ought to be placed on its use. The second, not unrelated to the first, has to do not only with the radical nature of genuine creativity, but its participation in the ultimate origin of creation which cannot be called human creativity.

Relative to the first question, I begin with this contrast of imitation and creation.[2] Here I will have most to say about art, even though Weiss is also interested in mathematics, science, the good life, leadership, and the state, each as a distinctive creative venture. In reflection on the aesthetic, we find a dominance of the first idea of imitation in ancient and medieval thought, and a certain ascendancy of creativity in modernity. Of course, in the premodern world, mimesis entailed much more than some facile naturalistic copying. Among other things, it implied participation in the original power of being, understood in its otherness to human subjectivity. It also implied the recognition of a certain metaphysical dangerousness in man's ascribing of creative power to himself. The latter ascription always carried the risk of a kind of blasphemy: one mistakes the creative power for one's own possession, and this was thought to be fundamentally mistaken.

Modern selfhood is far less loathe to take seriously this dangerousness of sacral power. It is a well recognized theme in aesthetics that beginning with the Renaissance the ascription of some kind of "creativity" to the human self becomes increasingly common and also increasingly unmoored from its previous theological and metaphysical anchorings. In line with the overall desacralization of being, we find a desacralization of the powers of creativity. A first question to be put is: Now at the end of modernity has not our use of the term "creativity" become too indiscriminate?

I am not accusing Weiss of this lack of discrimination. Quite the opposite; his work is finely attuned to differences. Yet there seems little doubt that it is the *pervasiveness* of the creative impulse that interests him in *Creative Ventures.* This emphasis on its pervasiveness risks certain ambiguities. What I mean especially is a kind of democratization of "creativity" such that its impact ceases to be felt. I think here of Shaftesbury's pithy and prescient statement relative to human beings: "We have undoubtedly the honour of being originals." Shaftesbury was still bound to a version of Platonism (he calls the artist "a just Prometheus under Jove"—even the Titanic artist stands under the justice of a higher god). But what has happened in the last two centuries is that this honor has been seized by all. Now no one wants to be a "mere imitator"—this is almost an ontological insult to our very being. In Emerson's famous words: "imitation is suicide."

We all now can claim the privilege of being putative originals. Creativity and originality have been democratized. The question is whether this democratization has also led to a flattening of the idea. Now all one has to do is tie one's shoelaces, or cock one's cap, or brew coffee and one claims to be creative. One hears of creative lifestyles, creative budgeting, creative blah blah blah. . . . Culturally speaking, has creativity now become a catchall for conceit?

My point is not to deny genuine creativity. Nor does Weiss offer us a vision of creativity so all pervasive that it loses its outstanding marks. Let me cite two thinkers to further the question. First, Nietzsche hated the flattening effect of modern democracy, and his entire philosophical demeanor was a kind of call for aristocratic creativity. Yet, Nietzsche produces the hyperbole of creativity, and his emphasis has been taken up, not by the few but by the many. Quasi-Nietzschean rhetoric lies in the current indiscriminate use of the term creativity. Nietzsche himself implied that you could not have a full conceptual analysis of creativity: like Archibald MacLeish's poem, the creator was to be, not mean. Acting is superior to thinking, being creative is superior to the analysis of the intelligibility of creations.

For all his hyperbole about his own uniqueness, Nietzsche is himself heir to a *tradition* that emphasizes the figure of the hero, aesthetically incarnated as the genius. In this respect, our contemporary use of the term "creativity" conceptually bobs in the backwash of the great originals of high romanticism; but the spiritual robustness of these great originals has been vulgarized. Again my question is: Does not genius imply the uniqueness of a certain creative self? Yet if this very uniqueness has been democratized, the consequent egalitarian flattening is at odds with the original stress on uniqueness: everyone now is to be creative, absolutely original, unique—that is to say, everyone is absolutely the same, indifferently the same. Does not genuine creativity vanish in this situation?

It seems to me that the thrust of Weiss's account in *Creative Ventures* is diffident about any view tinged with Nietzschean aristocratism. There is the strong confidence that the nature of a creative venture can be analyzed in terms that are publicly available to all. On the whole Weiss tends to see any reference to the enigmatic nature of creation as an abdication of the philosopher's duty to make articulate sense of things. As I indicated above, he offers us an account in terms of the ultimate conditions, the dunamis, the privacy, material. The creative venture makes a prospective ideal, which is initially indeterminate, progressively more and more determinate, by joining together in a work of excellence the harmonious interinvolvement of the conditions, the dunamis, the privacy, and the material. But he says that a "creator does nothing that is not in principle possible for anyone to do" (*CV,* 30).

One may sympathize with the democratic principle, but how helpful is it in enabling us to understand the difference between, say, a Salieri and a Mozart? The aesthetics of democratic commonality is indifferently applicable to the mediocrities and the greats. Yet it is the Mozarts, the Shakespeares, the Rembrandts that continue to attract us and baffle us, and the more so the more we determinately know about them. In fact, there are no Mozarts; there is the entrancing and yet mysteriousness of a singularity. There was one Mozart and only one.

For all his diffidence about Nietzschean singularity, Weiss shows an uncompromising recognition of the *unduplicable* nature of human privacy. This is something Weiss has always stressed from his earliest writings. While the privacy can be and is given public manifestation, it is never completely manifested. In language that Weiss does not himself use, there is a certain inward otherness to the human being that is inexhaustible. This does not mean incommunicable, but it does mean that there remains a reserve of inwardness that is not completely communicated. The creator moves more intensively into this privacy the better to more

richly express it and anchor it in a determinate work. Yet there is a singularity to this process which cannot be duplicated. As Weiss insists, a creation is a creation, while a copy is always a copy (*CV,* 9).

There is also something about the dunamis that resists complete determination, as we shall see. Weiss is no Nietzsche, but the aristocratic creativity that Nietzsche confined to the few Weiss sees as available as a promise in all selves in virtue of the powers of their unduplicable privacy. Weiss sees "more" in the many, the singularized presence of the energy of transcendence, a "more" that Nietzsche denies to what he contemptuously calls "the many too many."

The second thinker I invoke is a strange bedfellow for Nietzsche: I name Thomas Aquinas. Aquinas and Weiss would have more to talk about as metaphysicians, than either would have with Nietzsche as aesthetician. I name Aquinas because he has less an aristocratic concept of creativity as, so to say, a monarchical view. The privilege of being creative belongs to God alone. Aquinas is quite explicit about this, and one of the reasons is his mindfulness of the notion of creation *ex nihilo.* Creativity names an unconditional origination, the real origination of the essentially other or new. To God alone belongs this radical act.

Weiss is given to deprecating statements about anything smacking of creation *ex nihilo* (see *CV,* xiii). "There is no creation from nothing; each created work is the outcome of the utilization of available factors again and again in the effort to make an ideal excellence become a determinate unification" (*CV,* 74). Why not then just call the process one of production or making? There is in Weiss an insistence on *work,* on the effort to master through one's concentrated effort. But is it simply within one's will or power to will to be a creator? One has to will and work, yes, but there is something given prior to will and work, the gift of being able to create, a promise of the vocation of the creator. This gift is not democratically distributed. I do not find a strong sense of the giving of creative power, the sense that there is gift in creation that is not to be described in terms of work simply, nor the product of work. There is an activist strenuousness to his account that does not pay enough attention to the divine lightness of origination, the gratuity of creation as given to us out of the generosity of being in its otherness.

Weiss also says: "If anyone could unite the various ultimates as they are in their full, independent majesty, he could produce a universe. Our finitude denies us that privilege" (*CV,* 7). Later I will ask about the possibility of such a "unity" of the ultimates and in terms not irrelevant to the notion of creation from nothing. But it seems to me that Aquinas would broadly agree with Weiss's statement. This kind of creation is not the privilege of the human being. The qualification for Aquinas would be

that the work that utilizes already available conditions is not properly creation but making. Creation proper is the privilege of God.

There is here a peculiar kind of mirroring between Aquinas and Nietzsche: God's being and act are one, for Aquinas; and the meaning of that "unity" remains resistant to conceptual analysis. One is reminded of the Nietzschean emphasis on being a creator rather than on the analysis of being creative, and the recalcitrance of that being creative to philosophical conceptualization. Aquinas, as it were, gives us an austere kingly limitation of creativity, Nietzsche an aristocratic privileging, and the question both raise is: In today's cultural climate should we speak more quietly, with more nuance, about creativity, now that its popularization and indiscriminate use have almost emptied the word of meaning? The point would not be to depreciate creativity but precisely to refresh our sense of its astonishing occurrence—astonishment which is paradoxically domesticated, even lost, because of our excessive facility with the familiar language of "creativity."

This question does not charge Weiss, for his work bears testimony to a delicate carefulness to the immanent intricacies of the different creative ventures. His attentiveness to their nuances is admirable. Nevertheless, he does dominantly stress the continuity of the creator with all humans, and hence would reject both the Nietzschean aristocracy of creation and the Aquinian monarchy.

III

There is a second question, which takes us beyond the specification of creativity with respect to the human being. Turning from vulgar culture to philosophical ontology, I ask in what sense, if any, is the primary dunamis a creative source? The notion of primary dunamis conjures in my mind, perhaps against Weiss's intentions, the notion of primordial originative power which is not devoid of echoes of the notion of radical origination. In Weiss's account, the primary dunamis must intertwine with the conditions, the privacy, obdurate material and a prospective ideal before an instance of creation is to eventuate. The question this raises is how primary then is the primary dunamis. What weight are we to give to the term "primary"?

If the primary dunamis cannot be spoken of as creative without its coalescing with the conditions, privacy, and so on, then it cannot be the unconditional origination I mentioned. "Creation" then would be the fabrication from the pre-existent of a product with at best a conditional newness, rather than the bringing into being (*poiesis*) of an original

without prior precedent. For if it were an unconditional origination, then the conditions would themselves be derived from the primary dunamis, and Weiss does not want to say this. If they are not derived from the primary dunamis, then any outcome will always be conditioned. This is significant because a crucial issue with respect to the notion of creativity is the implication of a radical newness, an emergence that cannot be accounted for fully in terms of a set of prior determinate conditions. If the primary dunamis were an absolute original,[3] then the conditions would themselves be conditioned products, and the dunamis would be the unconditioned condition of all finite creations. Alternatively, the dunamis would not be itself unconditional, but one of the conditions derived from a more ultimate origin. I am treading close to the notion of creation *ex nihilo* again, and the reason I do so is not just theological (this is not negligible) but because of the metaphysical stress in the ideal of creativity itself.

Weiss does *not* want to speak of the primary dunamis as a creative source, for on occasion he compares it to Plato's receptacle and Aristotle's prime matter. He speaks of it as simply ongoing. But these are comparisons to things that are essentially passive, not dynamic; it is unclear if they *do* anything, undertake any work. To that extent they are significantly at odds with the implication of the primary dunamis as *dynamic*. Weiss *does* want to emphasize this aspect. Dunamis implies the presence of power, and hence, even if only potentially, some slumbering *activity*. The dynamic cannot but carry some trace of "creative activity." If Weiss's comparisons are well chosen, we suppress these traces, I think; if they are not well chosen, then ought we not to radicalize the dynamic power, say, by unifying the primary dunamis and the conditions in one originative source, which would indeed be the primordial dunamis?

Suppose we bring my two questions together and ask: Should we not be extremely cautious about ascribing creativity to human acts because of the implied radical nature of the ascription? The point is not simply with Aquinas to keep creativity in God's safe keeping, nor with the vulgarized Nietzscheans to throw the portals of creativity open to all. It is to ask (in relation to the human being, and indeed being as such) about the essential possibility of genuine newness, its character and its rareness. Or is there nothing really new under the sun? With the Nietzscheans we are tempted to be metaphysically conceited. With some theologians (I do not include Aquinas) we are inclined to be metaphysically abject. How does the primary dunamis help us avoid these two extremes of philosophical inflation and deflation?

Let me make one further remark. If we say that determinate rules are

the outcome of a prior indeterminate source, and that the latter source is "creative," does not this mean that creativity cannot be completely intelligible in terms of determinate principles of explanation? Thus the radical newness of a genuine creation always looks absurd, unintelligible when it first comes on the scene. It gives the rule, but is not itself generated according to rules. Kant implied this about the genius: through genius nature gives the rule to art. Kant was wary of genius precisely because something about his originative activity could not be completely rule-bound. There is something anarchic here. There is a similar issue with the notion of productive imagination. After Kant the issue persists, for instance, in Schelling's idea of the unconscious, in Schopenhauer's view of the metaphysical Will as what elsewhere I called the dark origin,[4] in Nietzsche's affirmation of the creative chaos of the Dionysian will to power.

A similar consideration might be applied to Weiss's notion of the conditions and the primary dunamis: Is there not something about the primary dunamis that must be recalcitrant to rules of intelligibility, not because it is necessarily metaphysically absurd, but because we have to consider a source of principles of determinate intelligibility that itself is not one more determinate principle alongside others? If the primary dunamis is a principle, is it perhaps so in the sense of a *principium*—an originating power? As I understand Weiss, he does not want to go in this direction. But if we were to speak of such an originating power, this could not be absolutely determinate, I think.

In any case, do we not find in the democratic Weiss something similar to what we find in aristocratic Nietzsche and monarchical Aquinas: that something about creativity resists complete conceptualization? This does not mean we have to be resigned to an absurdist silence or celebration, but that our philosophical speech does reach a certain limit wherein it experiences a certain *aporia:* determinate categories no longer suffice; for creativity, while manifested through the determinate, can never be exhausted by determinacy.

I cite two illustrations of the point: first, the resistance of a great art work to exhaustive analysis and the need for its ever renewed interpretation and reappropriation; second, the analogous recalcitrance of a great work of philosophy, e.g. Hegel's *Phenomenology of Spirit.* It is ironical, and to the chagrin of all our Cartesian propensities, that the great work of the philosophical concept seems to resist one definitive, finalized conceptualization. This reraises the question about creativity in philosophy itself. There is a sense in which the really creative philosopher does not know what he is doing—and this is not a limitation or objection. Granting that our analytical tools have been sharpened a little over the

last two millennia, granting that Weiss himself has given us an account of admirable intricacy and insight, when all is said and done, has anyone improved much on Plato when he spoke of divine madness?

IV

Let me make one final approach to the issue, this time by recalling some of Whitehead's views of creativity. Weiss claims that the dunamis, unlike Whitehead's creativity, does not make anything its creature (*CV*, 314). Nevertheless, there are some suggested affinities that help us think about the matter.

For Whitehead creativity is one category of the ultimate; it is the universal of universals by which the many enter into complex unity; it is also the principle of novelty; creativity introduces novelty into the content of the many such that there is creative advance from disjunction to conjunction; "the many become one and are increased by one." Whitehead identifies creativity with Aristotelian "matter" or what he calls the modern "neutral stuff." Moreover he indicates that creativity is without a character of its own in exactly the same way as Aristotle's matter. God Himself is a creature of the creativity and hence a determinate being. It is hard not to find some echoes of the dunamis: this too is indeterminate in itself, though it enters into the realization of determinate occurrences as a necessary constituent. Recall that the dunamis is described in terms of kind of a *prima materia,* albeit one that is *pulsating* in itself rather than a static stuff.

Is Whitehead's "creativity" really "creative" in the sense of radical origination? Is there a more ultimate sense of origination beyond "creativity" in Whitehead's sense? This is the question I have already put with respect to Weiss's dunamis in asking about the possibility of the originary source of the plurality of "ultimates." In asking about the "unity" of the plurality of ultimates, I ask about the nature of the ultimate of ultimates. I ask whether Whitehead's creativity and Weiss's dunamis remain tied to what elsewhere[5] I have called an erotic absolute in distinction to an agapeic absolute. I agree with Weiss that it makes sense to try to understand a divine creation having tried to understand human creation (*CV,* 16). Even then we must be extremely careful not to conflate differences. Let me briefly indicate what I mean.

An erotic absolute is modelled on the metaphor of desire as initially lacking in itself and driven beyond itself in a process of determinate self-becoming by which it concretely becomes and completes itself. I think of Hegel's absolute as erotic in that sense: in the origin in itself,

there is nothing but a lacking indetermination; the absolute as origin determinately becomes itself by externalizing itself in the world; but this creation is *itself* in its own otherness; it completes itself as an absolute whole by dialectically mediating with itself in the otherness of creation, which is really only its own self-creation. There is no final otherness between the origin and creation; nor is there any radical creation in a sense that gives the created other its being irreducibly for itself; everything is for the return of created things to the absolute. We end with a necessary dialectical monism of the whole, precisely because the origin *in itself* is thought of as a lack, an indefiniteness that in itself lacks actual determination.

By contrast what I call an agapeic absolute—and I think of the absolute original in these terms—is modelled on the idea of being that is already a *plenitude for itself*, being that is overdetermined in the sense of being in excess of determinate being; it is not the indefinite as less than determinate being. Real, radical creation is the outcome of this excess of plenitude; it is the creation of the irreducibly plural. Moreover, it is the creation of the finite other, not for the sake of the agapeic original, but for the finite creation itself, which is let be in its genuine otherness. Any relation between the first origin and the creation is not that of the dialectical self-mediation of the monistic totality. There would be a sense in which human creativity, when it genuinely occurs, would also show forth the possibility of agapeic creation in finite being. That is, creation would be from an excess rather than from a lack; it would not simply be from an initial indefiniteness to a final determination of an ideal excellence; there would be a prior plenitude of original being at work, making possible the creative venture of the human being.

As I understand Whitehead, God in his primordial nature is himself a creature of creativity, understood as nothing determinate in itself, except as a dynamic nisus towards determination. Is this not close to what I mean by an erotic absolute? God's consequent nature completes the initial lack of determination in God's primordial nature. Whitehead describes God's immanence in the world in respect to his primordial nature as an urge towards the future based upon an appetite in the present. This appetition also refers to a principle of unrest, seeking the realization of what is not and may be. So it is not surprising that towards the end of *Process and Reality,* he echoes Hegel—wittingly or not I do not know—in suggesting that just as the world would not be what it is without God, God would not be God without the world. Is not all creativity reduced to self-creativity in this erotic view, self-creativity traditionally named in terms of God as *causa sui?* So for Whitehead every entity is like God as *causa sui.* The universe is either a creative

advance into novelty or a static morphological world. But is our choice exhausted by that between stasis and dynamic origination modelled after self-creation as erotic *causa sui?* Where then is the genuine creation of the other as other for itself? This latter is what the idea of agapeic creation tries to think, beyond static morphology and circular *causa sui.*

Is not Weiss's view of creative ventures suggestive primarily of the above description of erotic becoming: from an initial indefiniteness, through a process of determination, to a final realization of an ideal excellence? Can we then grant creativity—and again I do not mean just human creativity—as an excess of transcendence that allows for real otherness? As I say, some of his descriptions of the dunamis are not unlike Whitehead's "creativity." Moreover, he suggests a comparison of the dunamis with Schopenhauer's Will. Yet Schopenhauer is explicit in comparing Will as the ultimate source to a kind of blind erotic striving. Are all three—Schopenhauer, Whitehead, Weiss—within the circle of the erotic absolute that creates the determinate other in order for itself to be as determinate? Is there any real otherness here to the finite creation or is the latter only the ultimate in its own otherness?

For the difference of an erotic and agapeic origin concerns the nature of *relation*s between a beginning and its creation; whether this relation is a going from one to the other that is for the other as other; whether this going towards the other is not amenable to articulation in terms of reciprocal mutuality or any logic of self-determination; whether there is a priority and excess to the beginning that is not defined by or exhausted in its relativity to its own creation.

The thrust of transcendence in Weiss is primarily a going towards a perfection, not a coming from. He offers primarily a teleology of creativity, not an archeology. Though he claims to return to ultimate sources, in the end these sources are understood in terms of the end. It is no accident that the title of one of his books is *The God We Seek.* The venture adventures towards, always seeking. There is a sense that perfection, the good, completion is always in the end, not in the beginning. We always work for and towards the end we perhaps will never absolutely reach.

At times one gets the sense of an infinite task, never quite reaching absolute perfection. This, I suggest, has some relation to Weiss's own tirelessness as a thinker. But what if there were a sense of the good of the beginning? Such a perfection of the origin would relate to creation as the generosity of being, the plenitude of the excessive good. Such a perfection would have to be conceived as in excess of any finite perfection, as more than perfection in the finite determinate sense, as a creative pluperfection. There is no sense of the absolute origin in this sense with

Weiss. As always future-oriented with respect to the good, the eros of creative becoming seems to be a self-mastery in overcoming otherness. There is no agapeic origin that creates the other as other.

The problem of the one and the many crops up here too. Is the many the self-pluralization of the one? Or is there another sense of the otherness of the plural to the original one itself? Does the one create the finite other in a manner that is not reducible to the originating one, and hence other in a stronger sense? Is the one nothing until it generates the many which are its own self-determinations? Or is there a creation of the finite other as for itself and as given its being for itself and not for the self-determination of the original one?

The dunamis, as Weiss describes it, is not the ultimate in the sense at issue. If we are not careful, and take our sights from it to talk about the ultimate of ultimates, we will risk characterizing the latter in terms of the erotic absolute that really is nothing in itself except a nisus to self-externalization. As I suggested with Whitehead, the shadow of a kind of "Hegelianism" hovers over this way of thinking. This is an outcome that Weiss certainly wants to avoid since he is a metaphysical pluralist, not an idealistic monist. This appears very clearly in his account of creative ventures. But just this account raises the question of an enigmatic "unity" that is more than a unity, a "one" that is more than a one, an "origin" that is more than "creativity," one that makes possible finite creation as other, real plurality and the irreducibility of unduplicable privacy which we especially find in the magnificient singularity of the human being.

Weiss defends the latter against the encompassing embrace of any idealistic totality. To this end he offers us the vision of a sextuplicated universe. The vision brings to mind the pluralism of ultimates in Plato's *Timaeus:* demiurge, the intelligible paradigms, the receptacle, necessity, soul, the good. The question I have been pressing moves towards a view of ultimacy that is more "monotheistic," but not in any sense that conforms to the caricatures of "ontotheology," so prevalent today. The perplexities of metaphysics still remain before us. The ultimate of ultimates would have no other ultimate besides itself, on a par with itself, to limit its radical ultimacy. The ultimate of ultimates would generate "derivative ultimates" that, in turn, contribute to the conditions of the possibility of the intelligibility of given being. Nor must we let the word "ultimate" get in our way; the issue is the origin beyond "creativity" of the "ultimates," the unoriginated origin beyond origination that is the ultimate of ultimates.

To my knowledge Weiss is now at work on a book on Being. Being is understood by him in a manner indicative of this source of the ultimates.

Again I press the perplexing question: Does Being do more than duplicate or pluralize itself? How does Being do more than duplicate itself? Is the pluralizing of *itself* the same as the generation of a real plurality of beings as other to Being in itself? How does Being possibilize beings *other than itself,* genuinely other than itself, and not just as duplicates of itself? What must Being as source or ultimate origin be like for there to be beings as irreducibly plural and other to the origin itself?

We must wait for the outcome of this latest creative venture of Weiss's philosophizing to hear and understand his answer. And as we all know, it is easier to raise such questions than answer them, easier to start hares rather than catch them. But in dealing with "creativity" something more than the clearing job of Locke's underlaborer is appropriate for the philosopher. Weiss is no underlaborer but a bold, risk-taking metaphysician. Indeed, the undergrowth of Paul Weiss's writings always teems with philosophical wildlife. And when all the conceptual bushes have been beaten, even when the soaring birds of thought have been downed and encased for analytical display, does not something about origin and "creativity" always remain wild?

WILLIAM DESMOND

DEPARTMENT OF PHILOSOPHY
LOYOLA COLLEGE
MAY 1992

NOTES

1. Paul Weiss, *Creative Ventures* (Carbondale: Southern Illinois University Press, 1992). Hereafter cited in the text as *CV.*
2. On this contrast of imitation and creation, see my *Art and the Absolute: A Study of Hegel's Aesthetics* (Albany: SUNY Press, 1986), chap. 1. Also *Philosophy and its Others: Ways of Being and Mind* (Albany: SUNY Press, 1990), p. 87ff.
3. On what I mean by the absolute original, see my *Desire, Dialectic and Otherness: An Essay on Origins* (New Haven: Yale University Press, 1987), chap. 8. See also *Beyond Hegel and Dialectic: Speculation, Cult and Comedy* (Albany: SUNY Press, 1992).
4. "Schopenhauer, Art and the Dark Origin," in *Schopenhauer,* ed. Eric von der Luft. (Lewistown: Mellen Press, 1988), pp. 101–22.
5. *Desire, Dialectic and Otherness,* pp. 190–91. The contrast of the erotic and agapeic conception is worked out in criticism of Hegel in *Beyond Hegel and Dialectic.*

REPLY TO WILLIAM DESMOND

William Desmond is the leading philosopher of his generation. He also writes brilliantly, has a sure grasp of the history of thought, knows a religion from the inside, and is appreciative of the efforts others make to the unending attempt to know what is, what must be, and what can be known.

I use 'creative' in a more limited sense than Desmond does when he refers to what humans do, and I am not as ready as he is to speak of a divine creation. I use the term to apply only to the acts of those humans who are committed to and try to succeed in realizing an ideal beauty, truth, the good, glory, or justice. To do that they must also use resistant material and the ultimates, so as to produce an excellent finite work. Philosophy is not a creative venture because it seeks to do no more than to expose what actualities essentially are, what they presuppose and how this bears on what is but need not be, and to understand what a necessary Being is, does, and uses. No philosophy could justifiably endorse what is commonly held solely because it is commonly held. If it does what it should it will try to discover what cannot be, and how what could have been otherwise could be. Trying to do justice to the fact that there are contingencies, it traces these back to a source that both had to be and is able to act in ways it need not have acted. The apparent pretentiousness that haunts the endeavor is chastened by a respect for what others have achieved, and by an awareness of what still has to be clarified and justified. A philosopher is not a creator, no matter how novel the account and spectacular the achievement. Each is occupied with inching a little further in coming to see what everything presupposes and is perhaps dimly known.

I would be pleased to be a creator, even one of low rank. I know, when I look at what I accomplished in painting, sculpture, poetry, and in other

areas, that I have fallen far short of what minor figures have achieved. When I dealt with philosophic issues I made some bold leaps, have sustained my efforts with a strongly held commitment, and have carried out something like a making encased in language.

The denial that I or any other philosopher is creative is intended to underscore the fact that a philosopher provides ways of understanding realities in ever better and bolder ways, attentive to what is presupposed, and the ways that different kinds of reality and the knowledge of them both fit together and enrich one another. No attempt is made to produce something new; nothing, ideally, is affirmed if it cannot be justified.

It does not disturb a philosopher to find that what he affirms had or had not been maintained by others. No dismissal of the entire history of thought backed by a questionable philosophy, no post-Hegelian despair at being unable to do anything more than point out what others have taken for granted, no skepticism because some favored view has been discovered to be faulty, will deflect a philosopher from trying to learn what the primary types of reality are and how they fit together. Alert to what are unwarranted affirmations or denials, she will at least try to produce a guide for and a warning to others who seek to know what a human is apart from and together with others, what other kinds of actualities there are, what all these presuppose, the final Being that enables all other kinds of reality to be, and how they are related to one another. I am here—obviously—abstracting from the weakness of the human spirit, in order to emphasize what is ideally done.

The denial that philosophers are creators should help sharpen the distinction between them and those who spend their energies working against the resistance of materials, so as to enable indeterminate ideals become functioning unifications. Different classes of creators do not differ primarily in their awareness of the ultimates they utilize in making an excellent work, but in the ways they realize different ideal excellencies. No philosopher tries to fit in with an ongoing community of inquirers. One human among others, he is both bold and chastened, daring and guided, independent and willing to be helped, alert to what has been achieved in other attempts to understand what reality is and how it could be well known.

Desmond says "The creative becoming of the human being cannot be abstracted from the becoming of creativity in all being." Why not? Humans are different in kind from other realities. Only they commit themselves to realize ideals, are responsible, speculate, and are able to create. Apparently, Desmond thinks that there is a creative component or activity in every reality. If so, why does he object so strenuously to the

widespread use of the term? Why not, instead, refine it, as one does other basically sound but poorly used references to hope, responsibility, the past, probability, and the like?

I know that Desmond intends it as praise, but I cannot accept as my own the credited view that there is a "more englobing sense of the work of creativity, not confined to the human being." His reference to Aquinas perhaps indicates what he has in mind. If so, that is one place where it can be seen where I differ radically from Desmond. I have already noted that I think Aquinas's early study of essence and existence is brilliant, but I haven't learned much from his multivolume textbook. Philosophy has made a considerable advance since Aquinas's day. So have other enterprises. I read what he says about slavery, women, sovereigns, obedience, rationality, the different times when God provides fetuses with souls depending on their gender, his attitude toward rape, his proofs of God, and his accounts of art and mathematics, and wonder how anyone could be a Thomist today. It would be ridiculous for me to object to the Domnicans' obeisance to Thomas Aquinas or to the exploration by anyone of some of the theses he maintained. If Thomas Aquinas is to be taken seriously as a philosopher, he should be dealt with as every other is, both critically and sympathetically.

Desmond has an independent mind. I speak on his behalf when I question what seem to be his too ready acceptances of Thomistic views. I do so again when I question his quick moves beyond Being to God. Try as I may I find no reason to make that move, and can find nothing in his writings to help. A keen master of Hegel's writings, he has found serious failures in Hegel's account of the absolute spirit, particularly in the way Hegel treats it as other than all else. When Desmond speaks of that spirit as though it were a poor way of referring to a creative God, he begins to blur the point where philosophy stops and theology begins, to make its boldest, unconfirmable claims.

Were there a God and did he create, He would do what human creators could not. These meet resistances, and what they achieve will be cross-grained by these. Desmond speaks of a "creation *ex nihilo*", but does not stop to show that the idea is coherent, and perhaps self-contradictory. It surely needs to be explicated and freed from the suspicion that it is not intelligible or warranted. Is there nothing and then something made of it, or does it mean only that God produced all else? Apparently the latter. Did he produce all else when and as He was, i.e., always? If He did, there always was more than God and He, so far, would lack some reality and therefore not be perfect. If He did not, there is an inexplicable contingency in Him, for there would be a period in which

He created nothing, and then created something. The problem is well known. Why doesn't Desmond deal with it?

I, too, think that a necessary reality is the source of all else, but see no reason to credit it with a mind, will, purpose, or a concern for us. Necessarily when and as it is, it produces what serves as its agent, initially to sustain its possibility always, and then to serve Being in other ways when the agent acts on its own. Like every other agent, the sustainer of the possibility of Being exists apart from and is therefore also able to act independently of it.

Is human creativity a gift, as Desmond seems to believe? Prodigies may tempt one to agree. Those who create in a frenzy, apparently not knowing what they do, also help support the view. So do jazz performers, improvisers, and others who seem to be all spontaneity, in a frenzy, apparently not knowing what they do. They, of course, had their predecessors and teachers, foreshortening the process they otherwise would have had to go through, and then perhaps fortuitously arriving where others had arrived by engaging in practices that may have been carried out for generations. Occasionally, a Bach might make a sudden break with the past, but unless that break is a mystery, it will have a reason, carrying the past forward in a new way. Desmond believes that creativity is a gift of God. If so, why are some favored and not others? Why did he deny me the ability to be a great painter? No, dear Desmond, the fault lies not in God but in me; I lack the ability.

It bothers Desmond to see how 'creativity' is used in daily life. Why not be equally squeamish about the way 'God', 'love', 'good reasons', and the like are used? He thinks the common use carries the "risk of a kind of blasphemy." It might if one accepted the idea that the term properly applies to God, who in fact exists. Should those who have no faith not be permitted to speak of creativity? Granted that there is a God and that He creates, might that creation not be altogether different from the creation humans carry out? Why must the term have only a primarily theological use?

It is a philosopher's task to use his terms with precision. That does not mean that what he says will be just a debased version of theological uses of those terms. Let it be granted that there is a God and that he forgives; would this not be a distinct kind of 'forgiveness'? Desmond's God is not one that all other theologically tempered thinkers accept. I wish he told us why Jewish, Muslim, Hindu, and Buddhist theological views of God are not tenable.

Desmond seems to be of two minds about humans. Some, apparently, are taken to have or to have been the recipients of 'gifts' and thereupon

enabled to stand out over against the rest. Is that just? Are all of us divinely enriched, or only some of us? He says that "Creation proper is the privilege of God" but offers no backing for that startling claim. Desmond recognizes that Mozart and Rembrandt differ from most of those who try to compose or paint. Is the work they do, nothing but a humanization of a divine act? Is what they do, God's work? If so, why mention, why honor, why refer to them?

Desmond goes on to ask how 'primary' the Dunamis is. I initially supposed that it had to be understood in contradistinction to the ultimates that I had already distinguished. I was right in the sense that I then half-recognized that each ultimate contrasts with all the others. I would now say that the Dunamis is one of the ultimates, each of which not only can be set in contrast with all the others, but is able to interplay with them. The Dunamis is not the source of anything; instead, it joins the others to constitute actualities and the fields in which they interplay. Nor is it passive as Plato's Receptacle and Aristotle's prime matter are, or unintelligible as Schopenhauers's Will and Bergson's *élan vital* seem to be, though its activity is novel and unpredictable, both qualifying and being qualified by the others.

Desmond's challenges are at the forefront of his more developed views that he obviously could not express in the limited space of his essay. Nor can they be adequately met in a similarly condensed reply. Nevertheless, I think it is now sufficiently clear that human creators make use of powers and abilities latent in all, and that these can be understood without making reference to a God. A God, if existing and reachable, can be reached only through an act of faith. Theologians, speaking in the name of some particular religion, characterize that God in quite different ways. A semblance of agreement is sometimes obtained when they accept what they can from those who speak on behalf of other religions, and suppose that it can be detached and transferred without serious loss. That is one reason they characterize those who speak in the name of other religions as 'blasphemers', and even as 'atheists'.

I have strayed some from an examination of creativity as exhibited by humans, in the attempt to understand what Desmond is trying to say. Let it be supposed that there is a God and that he is the perfect creator. Does that require the denial of the title 'creator' to Bach, Yeats, Picasso, Molière, etc.? Must these be understood to create in a sense related to that of a supposed producer of a universe, who acts without effort, meeting no resistance, looking to no Ideal that, until He acts, would remain indeterminate and unrealized?

Philosophy stops short of what one or all religions acknowledge. If it

were true that creativity could not be made completely intelligible in terms of determinate principles of explanation—it still might be understood without recourse to one report about the nature of an unknown God acting in ways no one understands. No principles suffice to account for a creating God. The nature of the essential components and the ways they interplay in human creative acts, in contrast, can be understood. No account of creativity cannot rightly claim to reproduce a creative act. It can, nevertheless, expose its essential components, and show how they are brought together by those humans who commit themselves to produce what is excellent.

Must the Dunamis "be recalcitrant to rules of intelligibility?" Recalcitrant, yes, but not only to 'rules'. It is recalcitrant to all the other ultimates and the material used—and these to it.

Does a reference to a "divine madness" clarify anything? In what sense is the 'divine' mad, or the mad divine? Why join these two terms? Is Desmond's 'ultimate of ultimates' a God who is acknowledged in all or just one religion? Could it be known apart from all religions? Will any act of faith do, no matter what the religion or the practice?

Desmond is a renowned expert on Hegel. His account of Hegel's view, unfortunately, makes even more obscure what I had found to be difficult to understand in Hegel's account. Could Hegel's Absolute "externalize itself in what is its own otherness." Is the otherness of creation part of it? Are there any contingent occurrences in that system, or only a category of contingency that is necessarily connected with all the others? Is the Hegelian dialectic inside or outside the Absolute? If we end (and presumably begin) with a "necessary dialectical monism of the whole" can there be a Many? If there is a Many, what is its status? If there is no 'this' for Hegel, could there be anything distinct from his Absolute? Would the Absolute be able to do anything more than breathe in and out, never make anything be in contradistinction to itself? Both Hegel and Desmond, who know the Absolute, are surely different from it. So am I, who do not claim to know and do not acknowledge it. With his knowledge of the Absolute, is not Desmond still one of us? The most knowledgeable of philosophers continues to be a finite being. Thomist or Hegelian, he is just one among us.

Perhaps Desmond's and my views are not as disparate as the present discussion seems to indicate? If so, I missed something, for when I try to take hold of what he seems to be maintaining, I find it not to be as acceptable as it promised to be. His discussion, nevertheless, permits me to glimpse the future. If only he would allow human creativity a place in it, whether or not there is a God, and whether or not that God creates. I

would not feel that he has unwarrantedly pushed me outside the place where creativity can be understood, or found me to be inside the gates he has erected, so overawed that I cannot think straight.

I have heard that God helps those who help themselves. I hope that is true of the God who Desmond apparently thinks alone can create.

P.W.

24

George Kimball Plochmann

SYSTEM, METHOD, AND STYLE IN A PHILOSOPHY OF ART

THE TREATISE OF 1992 AND THE SYSTEM

Because Professor Paul Weiss has said more than once that his later works seek, where desirable, to correct and improve upon his earlier, it seems reasonable to choose the very latest, *Creative Ventures,*[1] as my subject. The book, shorter than *Modes of Being* (1958) but longer than most of the others, commences and concludes with statements of metaphysical principles that the author[2] believes affect the ventures that he takes up. In placing it in the Weissian system at large one can, of course, do little more than refer to a few features of the enormous and greatly diversified sets of ideas expounded in the past five decades by this indefatigable thinker. I must therefore restrict this to remarks concerning the nature of the system,[3] not its details, not even its main outline, if one capacious enough could ever be devised. After these, a brief sketch of the new book will be followed by a survey of the principles put forward in it. To keep this essay within decent bounds, a single venture, the arts, will be examined, leaving aside four others. The dialectical method used by Weiss needs more than a passing glance, and I shall also have some comments on the rhetoric of philosophic exposition. The latter is a topic often passed over by critics who drop a sentence or two of praise or blame regarding style in their reviews and histories, and by general readers inclined to dismiss philosophers as hopelessly inept.

The five principal chapters of *Creative Ventures,* one for each venture, are framed by an introductory account of what Weiss formerly called the four modes of being, then, with some alterations, the five finalities, and now the ultimates,[4] and by an appendix[5] giving some clues to the most elusive of those ultimates, the Dunamis.[6] The ultimates underlie the five very different ventures treated: the arts (fine, together with writing), mathematics and physics, the good life, powerful social and political

leadership for change, and finally, the administration of states. An unusually bold juxtaposition and synthesis.

The differences in strategy between groups of his books obtrude so that one is inclined to say that Paul Weiss has hatched a number of philosophies. Three observations can be made. First, there seems little essential change between the earlier writings and the latest if one considers method in the broadest sense: That method begins in experience and private consciousness—as it must, even if the consciousness never makes its explicit way into the finished treatises. In the case of Professor Weiss a very short time is needed before he elicits general principles from the experience, arranging these in a pattern to bring out their differences and potentialities for interconnection. What are selected for discussion are subjected to several processes—separating, reorganizing, partial merging, uniting, or again separating.

Second, I discern no change in the general structure of the various books from *Modes of Being* onward: The author thinks in terms of arrays of concepts—squares or more often rectangles having an indefinite number of rows in one dimension,[7] or else hierarchies bounded at top and bottom and, within each treatise, not subject to extra insertions.

But third, there are a host of changes in particular methods and concepts—orders of appeal to the more comprehensible—and particular structural arrays. Continuing searches for the best concepts and sets of concepts[8] and for the best methodic structures mark the philosophizing of Professor Weiss, giving the many books so much distinctive character that the reader is inclined to say that each one represents a different point of view, or, less radically, that the books fall into a handful of groups where affiliations are closer within than between their numbers. My own impression, one that would require a major study to document and prove, is that there are indeed groups but not ones distinguishable from others by fixed sets of diagnostic features, rather a patchwork of features: A given treatise would belong now to one group, now to another. The objection that there is no unity in the system, that the succession of books resembles a palimpsest in which, after erasures, only the final writing is readable and counts, is at least questionable if made to apply to the broader meaning of philosophy. It is possible, given the treatises as they are, to discover an interlocking, first vertically from the exhibiting of metaphysical principles that intrude into temporal subject matters, and then horizontally, between the boundaries marking divisions in those subjects. If the patterns were dendritic, with branches headed by single categories literally defined, there would indeed be many systems; but the author has foresworn that plan in order to erect multiple

analogies (of which more later), analogies that he finds between separate ultimates, ventures, and natural things.

The question, then, whether there is one philosophy or many cannot be answered in a single unqualified statement. This need for a distinction has an unmistakable influence upon the interpretation of the books. A man who has written so many on closely related or even heavily overlapping topics has neither need nor right to point to pages in one of them, claiming that it is the first chapter, or last, or any other, for the books begin to merge, not through confusion but through happy connections, and the many volumes become churned into a compounded yet never altogether homogeneous body of work. The edges of each book tend to melt, in the sense both of connected concepts and of directions of arguments.

THE ULTIMATES

The ultimates resemble the four humors of long yesterdays ago, humors once said to be easy to distinguish in essence but scarcely to be found unmixed in the body; when one clearly dominates, its owner is of a certain temperament, and when two are combined to rule, that temperament combines with a different one accordingly. The humors are causes, the temperamental behaviors are effects. Although one never sees any of them entirely clear and free of the others, still they are distinguishable, and their number is not indefinite. The ultimates are variously grouped in *Creative Ventures,* privacy (something at times acting much like a transcendental self) at times being placed with the other "conditions" and at times separated from them. The conditions act as boundaries to all powers and contingencies. The Dunamis[9] is likewise an ultimate, but differs markedly from the conditions, though it interacts with them somewhat but not quite as they interact with each other.[10] As a group, the ultimates are marked off from other kinds of things, which are sometimes labeled actualities. In earlier volumes "actualities" became a mode of being, but not in the book under review. What we see and touch are always actualities, not other conditions.

The ultimates are partly understood from their bondings with the five ventures, placed in a five-by-six rectangle that pairs "voluminosities" (space, time, causality) with art,[11] the rational (form) with mathematics, the stratifier (ordering) with character, the affiliator (intermingling) with society, and the coordinator with the state. In a larger sense, the conditions are by reason of their purity the active agents finding their way

into the unique creations occasionally making an appearance in a world cluttered with misalliances, failures, substitutes, a world that in relation to the conditions is dead clay. More vital still than the conditions is the Dunamis, and this is doubtless the first and last activity against which all else must be partly resistant and partly pliant. The Dunamis itself takes on different aspects: vibrancy, synthesis, insistence, fraternity, and flexibility, according as each of the five ventures is considered. In addition there are five characteristics of the creator, five ideals, and five materials entering into the ventures. Beauty, truth, the good, glory, and justice are the respective ideals. I leave the rest of the scheme to one side.

Like many dramatists and novelists for whom their scenes and characters are more real and more individual than their own friends and acquaintances, Paul Weiss presents the life of the ultimates—and he has given them life!—more vividly, uniquely, than he does the movement of the artists named in his book, artists who are embodiments of those ultimates.

> Not itself a topic or a theme, a created work is a self-effacing means for confronting a permanent, operative condition. Read again and again, in diverse ways, the final outcome of the reading of a work could reach the condition on a very deep level. Since, however, the various levels of a condition are not neatly divided from one another, it is difficult for anyone to be sure that it was encountered at a depth not reached before. (p. 35)

Despite the difficulties, this at least brings the conditions up close to the person who "reads" (scrutinizes, studies, reflects upon) the works of creation. The question is, whether the rational aspects of the work can be read in the same way as the nonrational. In the books by Weiss there is always an important role reserved for some kind of surd, expressed in very different ways—things adumbrated,[12] or God, or Dunamis, or whatever suits the analysis best. No one with his concern for logic, for proof and refutation, for structure, could properly be called a mystic in a narrow sense, but he does participate in a kind of mysticism neverthe-less, and it shows in his view of art.[13] In art works of exceptional importance there is this vibrancy: not necessarily hectic colors, loud brasses, heroes rescuing heroines threatened by antiheroes and all engulfed by ocean waves, but rather a steady pulsation manifesting the Dunamis as it moves to synthesize the other conditions as they enter human life and work.

Weiss offers six characterizations of the Dunamis (pp. 322–25): It provides a grounding for individuals and privacies; it is fluid, so laws of contradiction do not hold, for it is oceanic, limitless, self-maintained, pulsating, making and unmaking distinctions within itself; it insists upon

itself; it is internally self-fractionating (this is adumbration); it mediates privacies and conditions, and is mediated by them in turn. If one adds to these qualities the remark (p. 76) that "the Dunamis, like the conditions and the privacy, has depth, [and that] layer upon layer, one more intensive and inward than its predecessor, can be successively distinguished within it while still continuing to be unseparated dimensions in a single pulsating undivided intensity," one sees that the old contraries of one and many, inner and outer, same and other, motion and rest, being and becoming, cannot be held fast and applied to it. The Dunamis is a capacious portmanteau in which oppositions do not flourish opposed. It lends some of this character to the works of art.

A question immediately arises, one regarding the means whereby one comes to know the Dunamis and other conditions, and here the author is unusually laconic about the course taken. He says that he had arrived at the ultimates by "attending" to what entered into actualities, natural and man-made.[14] The classic evasiveness of this assuredly belies the comparing and cross-referencing, the false starts, in setting out fundamental categories, and indeed the history of his changing lists of modes and ultimates testifies to the truth of this supposition. A trait of Paul Weiss is an enormous openness; his eyes, ears, and touch are perpetually open to the "insistencies" of actual things, their characteristics and changes in size, qualities, places, and subsistence. He is open, furthermore, to the presumed existence of the grounds of these visible and tangible things. This second openness requires synthetic power, intellectual acumen; differences of dimension and shape are generalized to conceive space, of dates and durations to make up time, of billiard-ball caroms to make causality; then these are put together to gain a conception of voluminosity, which in turn becomes one of the conditions, these now becoming linked with the raw power to constitute the ultimates: a four-stage train of ever higher categories.

CREATIVE ACTS AND CREATED THINGS

A system can either strengthen a theory of art (or any other subject) or weaken it, depending upon the way the system is conceived. If its metaphysical principles and logical regulae are broadly and flexibly set out, with allowances for major distinctions between the parts of the system, then the weight of those principles can lend force, cogency, and interconnectedness with other parts, but most of all the particularity that each subject matter deserves. If, on the other hand, the metaphysics is erected to dictate the major concepts and method of a theory of art, the

latter is bound to suffer from constriction, for its analogy, point by point, with every other division of the system will be the determining factor, the direction, for the conclusions of each inquiry. The difference is one between an open and a closed system. There are features of both if one considers single books by Paul Weiss, but by viewing the works as a series one sees how the system opens out, removing from the metaphysical principles any constraining power that they might otherwise exercise.

The message in the Weissian theory of art is, of course, its dependency upon those principles and the guidance offered by the conditions and Dunamis. His reader is not invited to follow intricate psychological analyses such as those of Coleridge or Freud, or studies of the reactions of audiences proper to rhetoric, as given (in rudimentary form) in Horace's so-called *Ars Poetica,* and in Tolstoy's *What is Art?* with his theory of the moral enhancing of the populace through literature and other art forms. In *Creative Ventures,* there is a twofold perspective from which every work of art should be looked at. In *Modes of Being,* God, the fourth mode, was on a footing different from that of the other three, as a unifying power. His place is now taken by the Dunamis, which together with the conditions enters into kinds of actualities at three levels: first, different combinations of them distinguish types of one sort of venture from each of the other four; second, different dominances among them distinguish types of works (e.g., music, poetry, architecture) within each venture; and third, different insistences of the ultimates are manifest in individual works falling under those types.

The fundamental pronouncement regarding creation adds a possible excellence to the combinations just now outlined. "Creative work turns a prospective excellence into a single unification of a plurality of separately produced parts. Initially indeterminate, the prospect is made more and more determinate until at the end it is no longer distinguishable" (p. 1). There are plenty of other ventures that are not creative—they may be innovative, ingenious, they may be spontaneous and inventive, but still they need not be truly creative, for that must differ from the rest in having special "intent, course, content, and outcome" (p. 1).

Professor Weiss's emphasis is not on the character of the creative artist, nor is it on the individuality of the created work; rather it is on the act of creation itself. "A creator begins," he says, "by so withdrawing into his privacy that he is maximally free of his habits and other established limitations to fresh moves" (p. 45). This personal withdrawal, once accomplished, enables the artist to focus on the ideal prospect that is eventually to be realized. The ultimates are now introduced, but only in ways especially relevant to the ideal prospect.[15] The work of art is thus more complex than one might think, for in a sense it is poised between

two worlds. This shows itself in the fact that the ultimates are not taken into the work full-bodied. "Endlessly nuanced, rich beyond anyone's capacity to exhaust, a creation is the outcome of an individual's specialized use of conditions and the Dunamis, as joined again and again under the guidance and control of an ideal that a creator has committed himself to realize. The result is sustained and grained through the use of recalcitrant material" (p. 7). The excellence that the artist hopes to realize in the finished work is, in its earliest stages of fabrication, obviously faint and even somewhat variable, but the last stages ensure the attainment of the beauty that is an ideal though not a theme of the creative process (pp. 8, 93, 34).[16] The process is less a matter of setting pieces of material one next to the other than of establishing relations between them—tensions, vibrancies that are manifestations of the Dunamis (p. 72), and are imbued with feeling[17] rather than emotion, which is exterior to the work but present in the artist or audience (p. 40).[18]

Rather than being a quality of a work, beauty is "the need to read it as an irreplaceable singular with mutually enhancing diverse functions" (p. 9). The work is thus the focus of three things, the ultimates, the creative arts, and the auditor or spectator. It is a center of active operations, and this is why any so-called art object that is not unique, not original, not at bottom unreproducible, cannot really be a work of creative art at all. Copies, forgeries, and whatever of the sort may float to the surface of the art world, no matter how skillfully accomplished, are simply beyond the pale, and Weiss has little use for them.

This seems to be the gist of his theory of art in *Creative Ventures*. He went further in *The World of Art* (1961) and *Nine Basic Arts* (the two were originally planned as a single volume, but were separated and published in the same year); but attempting to bridge the dialectical gaps between that earlier pair and the latest would carry this essay a long way beyond its proper confines. The printed pages of *Creative Ventures* are short of examples that would enlighten the discussion, for although many names and titles are offered along the way, there is scant insight in them: Rimbaud's post-poetic career (p. 12), the altering of Mark Rothko's original colors (p. 85), and so on. There is almost no analysis clarifying interactions of the Dunamis and conditions in their determining of the character of a painting, sonata, or play, except some generalizations that in good part I find somewhat questionable.[19] Professor Weiss shows a wide knowledge of twentieth-century painting, for example, in his own painterly endeavors; I am certain that he could have carried out penetrating accounts, based on his warm understanding, of any of dozens of literary or architectural works as well, but he has contented himself

in the main with "The artist recognizes . . ." and "There is in sculpture . . ." and more of the sort.

THE DIALECTIC OF *CREATIVE VENTURES*

At the close of his sixth and last extant treatise on logic, Aristotle remarks on the long time that he was kept working on his new instrument of the sciences.[20] This rather bland declaration reflects only the tidied-up results of these labors, not the philosopher's expressions of frustration and disappointment, his wrongheaded forays and happy unanticipated solutions, his struggles to organize an untried and almost grotesquely intricate new discipline. This kind of hiding is, of course, common, indeed almost universal. Professor Weiss has partly filled the gap between efforts and finished results in his mammoth *Philosophy in Process* (1966–),[21] a day-by-day recording of his thoughts as they have evidently first occurred to him. We see *Creative Ventures* chiefly as a finished work in which his own procedures for determining what ultimates should be fixed upon and what fields—three? four? five? why not six?—should be given boundaries and rendered fertile by those ultimates, and procedures for devising ways that the fertilizing takes place; these are mentioned, but hardly more than that. The uncovering of the ultimates must therefore be put to one side, and a fresh topic reviewed: How terms are related to the things they designate and to each other.

My simple assumption is that things—objective things—named and made prominent in a philosophy dictate the fashion in which their names will be used. If such things are conceived as discrete, unyielding, the words naming them cannot decently be allowed to change meaning and become fluid, slipping into and out of identity with each other and with compounds into which they enter. But the terms naming those entities that are now identical, now overlapping with each other, and now distinct would necessarily behave as do their designata. Both kinds must be kept in focus for the study of *Creative Ventures*. To my mind, philosophy must eventually offer theories about languages, but it neither begins nor ends with them. It is proper to talk along the way regarding the words with which a philosophy is constructed, while still insisting that the philosophy is concerned chiefly with nature, morals, government, and the other, aspects of immediate existence, not the habits, which fluctuate widely, guiding the ways we talk about them. It follows that an account of dialectic is an instrument of knowledge, not knowledge itself.

Two chief orders are presented in *Creative Ventures,* the major one in

being, the minor in understanding. The movement in being from ultimates to the created things that we perceive is answered and reversed by the movement from experience to that insight into the ultimates, for we must disentangle these general factors from the tangible and visible things that both exhibit and conceal those underlying factors. Clarifying ways that the subject's powerful, essential workings are recognized, the appendix on the Dunamis is actually a much-needed propaedeutic or at the very least a parallel to the entire discussion. As correlatives of the Dunamis, the conditions are more nearly self-explanatory, closer to and in one instance (mathematics) identical with the rational. Both orders are presented baldly in the rectangular map. What method, then, will enable the intellect to move from one to another phase of the process whereby the ultimates merge, separate, and rejoin, without confusing them?

In the chapter on mathematics Weiss summarizes (pp. 150–55) a six-step method for the sciences: abduction, induction, observation, experimentation, prediction, and the producing of a special set of claims (in other words, theory). He offers no such finite series for his philosophy, and I doubt that this omission could ever be supplied, for his philosophy is so complex an enterprise, dealing with such a variety of subject matters, that to pretend that it derives from a single method would court falsification. I believe, however, that some description of Weissian habits of thinking will hold, but would discourage efforts to apply them to other philosophers without making extensive allowances.

Among its other accomplishments, philosophic method confers individuality upon formulations of doctrine. Different methods make statements sounding alike to be different in meaning—sometimes very different. Such methods can be divided according as they show a predominance of literal predications (individuals and species, species and genera, and properties harnessed to each); or analogical (degrees of likeness). Doubtless no philosopher has yet employed one or the other exclusively throughout his system.

We find several traits in the methods of Professor Weiss, no one of them being altogether new although their use cooperatively is, I think, his chief methodological contribution. Terms that if literally used would be only incidentally relatable to others are grouped with companions to which they are made to bear varied affinities. The literal predications, in plenty for describing sensible objects and human activities, are alternatives to these analogies. But in the rectangular map, terms can spill over into other columns without actually leaving their own, through the affinities of the ultimate factors that they designate. Likeness is the criterion for linkages, of course, and because there are the aforementioned degrees of such likeness, all the terms can enjoy some degree,

affiliating them more or again less, with their partners across the rows, even if not down the columns that are headed by the individual ventures. The upshot is that two selected terms (not *any* two) would in one connection have a relation of identity, in a second a near-approximation or overlapping, and in a third a relation of mutual exclusion, depending upon shades of meaning conferred on each term by the contexts presenting them together.

There is a second feature of the method. The separations, limitations, contacts, partial mergings achieved by the ultimates are all stated through analogies, while the operations of creative persons (I say "persons"; Weiss says "men" almost everywhere) are described in very literal manner. The creators introduce the ultimates into their work, but they also mix paints or put words on a page, and this calls for adjustments in the dialectic. The ultimates can be presented as analogous to what I shall dub the literal proximates that name concrete things, qualities, and actions; and afterward there is the adventure of relating these two very different levels—which can only be by analogy, as is self-evident. The literal names remain literal in their proximate applications to actualities, the analogical stay as they are when merely being listed, but in merging both they must somehow become analogically related to each other. In consequence, the author can state the bleeding and merging of the ultimates at the same time that a combinatory method would seem to commit him to a doctrine of fixed entities, fixed terms. Results of combinations can then be given to all distinct creative ventures, and events and the "outcomes" of creative processes can be described as caused, measured, timed in their finite circumstances.

As well as the terms naming the ultimates and the proximates, the author employs many that serve as intermediaries—words designating qualities, relations, actions of the ultimates and at the same time the actualities. It is these words that, in performing their dual function, bind the two levels together, but a glance will show that they can be taken in the two ways appropriate now to one level, now to the others (the forms given here are those most often used in *Creative Ventures,* though Weiss often gives them slightly different inflections to suit his needs): subsistence, nature, stratifications, textures, grained, aggregation, layered, mediated, grounded, sustain, operative, complexes, evidenced, individuating, transformative, insistence, intrusiveness, adumbrateds, intensive, excellence, nuanced, occupied, pulsating, paced, harmonized, muted, vibrant, enhance, create, read, experienced, embed, purge, prospective, accommodation, obduracy. With this enriched vocabulary the author can concentrate here upon a doctrine of interacting, somewhat fluid ideal

aspects, and there upon a theory of hard-nosed entities to be sorted, juxtaposed, associated, resorted. But for reasons already stated, a fixed division between these is not possible.

The analogical method in general, and that of Paul Weiss in particular, has advantages and disadvantages. One strength is that it requires the philosopher to reach out and find new likenesses and perhaps even new entities hitherto unsuspected, entities bearing the likenesses. Because of this, the search for a broad scope is strongly encouraged, a breadth not otherwise likely to be found or even sought. Second, it suggests the *right*—or should it be "right"?—entities to be placed in an array conveying the set of likenesses; it is easier to identify entities inappropriate because they set up false relations with those already established. Third, it offers some assurance that what is found acceptable is truly so; a good philosophic sense can quickly discern which ones are suitable, which not.

There are possible drawbacks as well. First, a large array may lull a philosopher into a false sense of security: he has, he believes, achieved a completeness when in truth it may be tissue-thin. Again, it makes suggestions on a verbal level when entities alleged to correspond to names do not really subsist. A category can seemingly reflect reality when in fact it lacks any objective basis, pretty as the verbal array may be. Third, it makes rigid the investigations and the solutions to problems by laying out the natures of things before they are really explored independently. Fourth, it allows solutions to be explored and formulated entirely in terms of closeness of the resemblances rather than essential inherence of properties.

On the whole, Professor Weiss has avoided these pitfalls. He does not claim completeness; he deals with kinds of actions and properties of things throughout the book, thus sidestepping any taint of verbalism; his treatment of these is sufficiently different (brought about by his literal terminology at the lower level) that suspicion of an a priori pattern governing and hampering inquiry is allayed; and last, he looks to uniqueness first and likeness only second. The chapter on art, for example, is about art alone, with no more than bare mentions of mathematics, human character, revolution, or legal institutions, so it is unlikely that they determine his views on painting, poetry, architecture, or music.

There is a quite different question to be confronted, one that a theory of dialectic is best able to answer, referring to self-reference, self-fulfillment in any work on communication, logic, rhetoric, or art. To put the issue briefly: Is the discourse itself an illustration of the very theories

that it upholds? If not, then what *does* it illustrate? And again, what of the very qualities of both theory and discourse, in either case?

Creative Ventures does indeed follow the theory of art that it propounds. The use of the ultimates to constitute and illuminate the five ventures applies the doctrine that one must acknowledge the conditions and Dunamis in every last undertaking of man or work of nature. The book itself begins with those final factors, combines and recombines them as the theory recommends, and holds a prospective excellence before the reader, despite the fact that the book itself is not a work of poetry, fiction, drama, or any other literary dress. There is, it goes without saying, a question whether the same strategy of combination of these Olympian factors can be successfully applied to the widely diverse ventures that this book embraces. Is it not true that either the factors—or in their nominal aspect categories—must be reshaped in each case or the several pursuits will become so standardized as to lose much of their initial life and verve? No doubt the enthusiasm, suffering, triumphant exuberance, self-flagellation, reasonable pride, and all the other emotions attending acts of artistic or scientific creation can be much the same for the several ventures, the creative acts required for solving mathematical problems where new entities must be devised (one, zero, minus-one, one-point-one, and roots of these, all of them major discoveries in their day), is different from what is instinct in the making of a new poem or play or concerto. If it were not so, there would be a far longer list of artists who were also scientists or political leaders than history has afforded us. When we narrow the entire theory to the fine and liberal arts, even then there are differences between their techniques, as dictated or suggested by materials and symbolisms. The painter may add gesso, pigments, glazes in an order recommended by physical chemistry and color optics, and the composer may place notes and other symbols upon a staff, representing tones and intervals provided by instruments obedient to the mathematical proportions of sound waves; but the two additions are not at all the same. If the ultimates do enter into these creative works, the meanings of combination and recombination change from one art to the other, as they must, for without the pigments or words they can refer to nothing real any more than can the materials without the ultimates.[22] The art of writing, which would obviously be the book's exemplification of its own theory, is indeed a matter of combining parts, but these are not dumb paints, and the rhythms of words differ as we move from sentence or paragraph to waltz or march or wide-flung cadenza. Regardless of alleged regularities of feet and their ictuses, one must strain energetically in voicing them if musical rhythms are to be even roughly approximated.

Paul Weiss may have taken his theory of combinations as a point of departure for his writing style, or he may have felt from his long practice in composing treatises that he could safely erect, through simple induction and generalization, a theory growing out of that practice. More likely than either it is that as with so many other philosophers, he used both approaches, checking one against the other to insure some harmony. At any rate, this harmony exists, and because I believe the theory sets too great store by adding and arranging of units, I think that some of the formalism, the impersonality, the remoteness, and the hammering home of opinions with which few thinking men would disagree is responsible for certain characteristics of a book by an author whose life and intellect have been anything but withdrawn, monochrome.

Rhetorical Aspects

Self-reflection, desirable or undesirable, is a dialectical consideration, and it raises some stylistic questions as well. A working definition of dialectic makes it the art of choosing the leading entities of a system or part of it, and then discovering and displaying their relations of sameness and difference, inclusion and exclusion, superordination and subordination, and so on. Rhetoric has for its task the arranging of the names for these entities in a suitable order of before and after and the use of the names in a way compatible with both their subject matter (dignity and indignity) and the anticipated audience (familiarity and remoteness). These aims of rhetoric accord with matters of arrangement and style, and, more roughly with what have been called the strategies and tactics of writing. Philosophers, whether born writers or writers through hard practice, promote two intentions, to clarify for themselves and to clarify for others. Regarding the first, there need be no limit to the number of neologisms, awkward phrasings, cluttered paragraphs, obscure references. For the second, however, rhetorical constraints limit the modes of expression. Philosophic writers are heavily bound to these constraints, for most readers will simply turn away from their work as stylistically hopeless. Not required, like lawyers, doctors, and governmental functionaries, to be read by their peers for professional reasons but only for interest, philosophers must keep their readers constantly in mind. If a philosopher chances not to meet his obligations of communicating to his readers in one treatise, he can always compose a parallel that does. Unlike Berkeley, Hume, Kant, Whitehead, Russell, and many others, Professor Weiss has not seen fit to write deliberately popular books,

although his publisher has on occasion advertised one of the volumes as being "aimed at the general reader."

Even if first principles should by nature be relatively simple and easily grasped, the old Aristotelian notion, that we are like bats that see well enough except in the full light of the sun, seems to hold.[23] Hence metaphysicians are generally thought to be their own enemies as communicators to the public, and many are thought as well to be their own enemies because of a habit of passing on to details of near-zero magnitude. Paul Weiss is a most persistent and painstaking author. Experienced, energetic, prolific as he is, in communicating in print he may sometimes stand in his own way. There is, as I have said, the strongest possible tendency to apply his principles to statements of lesser width that are still general in reference, and an equally strong reluctance to exemplify the principles better than do the minor generalizations. Many of the latter happen to encounter the danger inherent in statements of that kind—their very vagueness of concrete application despite the narrowness of scope and meaning, together with the fact that it is easier to make questionable statements when referring to classes that may for all their narrowness be too sweeping. *Creative Ventures* is double-edged: It testifies to its author's industry, his devotion to philosophy that has already passed into a proverb, and to the admirable way he has bucked the recent tendencies to think of his discipline as one biting off small gobbets of problems and doing away with the grand system. There are, however, two questions that must be faced if the book is to be given the praise that seems, from its breadth and seriousness, to be its due. One of them refers to matters of style and tone, the other, a broader one, to the value of any philosophic approach to art.

A critic for the New York *Times* long ago described the face of Joe E. Brown as having "the raw beauty of the Maine coastline"; and this could be said of the prose in *Creative Ventures*. Words, or at least their inflections, are coined, so that "ultimates," "adumbrateds," "nuanced," and others turn up, along with the "voluminosities." Many philosophers have by invention added expressions to their native languages, sometimes benefitting those languages but only after the literate public has sifted out and kept the words harmonious with the ordinary flow of speaking and writing. The neologisms in the book under review are not capricious but are introduced to dispense with repeated periphrastic constructions. Yet their superiority is often questionable. True, the vocabulary of the Weissian treatises is in large part traditional, the smaller part being very distinctly the author's. A strong point is that many expressions, ordinary or innovative, are used at both the higher and lower levels of the system because of the analogical method

described just now; this gives them a conjugation and narrows any possible chasm between them.

Some readers of *Creative Ventures* will be put off, however, by adverbs that turn up repeatedly in odd places, and by a heavy reliance on the passive voice.[24] But these are trifling objections. More noticeable are the truisms[25] and commonplaces.[26] (Despite W.E. Johnson's remark that truisms are just the sort of propositions that we want as illustrations in logic, they extend the exposition well beyond the essential when incorporated into the substance of a treatise such as this one.) More likely still to be caught are repetitions and near-repetitions that give the impression that the author may feel he has not driven home his lessons sufficiently the first time around. The reader, however, must be able to acknowledge that not all such repetitions are manufactured by mere verbosity born of inattention. Instead, they may well stem from the author's combinatorial method, whereby a single leading proposition is placed, more or less as first enunciated, in different contexts arising from the need to make successive joinings; this may remove the objection that they are otiose. It would hardly do to impugn the combinatorial method merely in order to show that its use leads to stylistic problems.

Perhaps it is expecting too much from a writer on the nature of beauty himself to write beautifully, from the standpoint of either due length or melodious phrasing. Paul Weiss does not insist that philosophers are creators in the same sense as are poets and painters, and this may give such thinkers more leeway in writing. But it raises two related questions regarding *any* books undertaking to explain the arts and account for their unique qualities. These questions have to do with completeness and with tone of treatment.

Confucius is made to say in translation, "When I give my pupil one corner of my lesson and he does not get the other three corners for himself, I do not repeat my lesson"—a prime instance of the very lesson it sets out to teach. But we must ask whether the best interests of any reader derive from the unabridged treatment of its subject. The truth is, the philosopher often seeks for and claims a completeness, an exhaustiveness, for his work, especially in dealing with topics metaphysical and logical, those most nearly independent of history and observed facts. The claim of completeness also flies in the face of the continuing, almost relentless evolution of art forms of every kind, and in order to prove itself adequate to them, the theory must either be couched in very broad generalizations or else become divided and subdivided in a host of proliferating distinctions.

I have no concern to adopt or even discuss the slogan, The medium is the message, or the wildly capricious uses of language customarily

brought forward in supporting it, but the fact is that, given the medium of words arranged to represent as accurately as possible the concepts as they manifest themselves in the mind of the writer, one must consider how any *particular* use purveys insights into subject matters. This rests partly upon the dialectic of the choice of concepts and their relations, partly upon the way the resulting structures are set forth for the reader to be instructed, annoyed, stimulated, delighted. One can always ask, if a little writing cast in universal terms is good, is more always better? There is, of course, no pat answer, for neither the dialectic nor the rhetoric of literary presentation consists of rules alone. Yet it can be said that filling in all combinations, taking care of all possibilities, can damage the spontaneity of the inquiry, and with that its apparent closeness of fit to the accomplishments of the artistic life. At some point the rhetorical considerations are to be disregarded, but the problem of conceptual—dialectical—strenuousness remains. On this latter account, it can be said that each of the published works by Paul Weiss is a rich offering, a river of ideas wide and deep, not to be judged harshly if occasionally it overflows its banks a little. It never meanders. Despite the flaws of detail, a powerful, inventive, and well-versed mind puts forth and organizes the philosophic patterns.

Now to the tone of philosophic composition. It is all but self-evident that a philosophy of art should not—cannot—be written with all the flourishes, all the winds of emotion, the rampant images or vagrant sounds of the art that it sets out to explain. But one wonders how much at variance the explanation and the explained can be without becoming an obstacle to understanding. Two proper Englishmen were standing on a hill, gazing at a glorious sunset. "Not so dusty, what?" said one. Replied the other, "No use to rave like a damned poet, old man!" It could be that both these worthies turned aside, softly to shed surreptitious tears for the ephemeral sublimity of their wondrous countryside; but the conversation, on the face of it, indicates that some adequation to the real circumstances is lacking. Neither man could be accused of speaking at too great length, for they were not philosophers of the first rank, one can be sure. It was instead a formality, a coolness, a remoteness separating them from the objects of their twilight vision. Only a few philosophers who have written on beauty or love have been able to bring their topic closer to their readers; no doubt Plato would come first to mind. But the classic calm usually demanded of theorists on any philosophic subject matter is unlikely to induce the very grasp of works of art that the theory is intended to convey and promote. To write well on such subjects one must be able to suffer and rejoice, and to let this *show,* not necessarily

where their creators would have envisioned, but *somewhere*. Professor Weiss is right, I think, to separate the feelings intrinsic in a composition from the emotions lodged in the hearer or beholder. The only question remaining, however, is this: How can one engage the reader of the text so that he becomes the ardent, loving "reader" of great music, fiction, great drama, and all the other arts?

GEORGE KIMBALL PLOCHMANN
DEPARTMENT OF PHILOSOPHY
SOUTHERN ILLINOIS UNIVERSITY AT CARBONDALE, AND
MEDICAL HUMANITIES
SIU SCHOOL OF MEDICINE, SPRINGFIELD
MAY 1992

NOTES

1. Carbondale and Edwardsville, Illinois: Southern Illinois University Press, 1992 (Philosophical Explorations Series). This Press has published or republished nearly all of the more than two dozen volumes written by Professor Weiss, and unless indication is to the contrary, I shall simply reduce publication facts in this essay to the dates of appearance. I was fortunate in having read *Creative Ventures* in a typescript version, not very different from the one printed. Page numbers of the book will appear without further notation. I thank the Southern Illinois University Press for permission to quote from *Creative Ventures*.

2. By "the author" I do not mean that dreary pleonasm so customary in papers by men of science, law, and other professions; I am referring to Paul Weiss. For myself, a lonely personal pronoun suffices.

3. I attempted a small part of this task in "Methods and Modes: Aspects of Weissian Metaphysics," in *Creativity and Common Sense: Essays in Honor of Paul Weiss,* Thomas Krettek, ed. (Albany: State University of New York Press, 1987), pp. 15–42.

4. The number of ultimates in *Creative Ventures* occasionally changes from five to six, depending upon the way one of them is counted. Five is the number that will be used in this essay, as the variations do not appear to alter the doctrine. *Beyond All Appearances* (1974) is from this standpoint a pivotal work in the transition, for although three of the old modes are retained, actuality, the fourth, now divides into two, substantial inwardness and being. A thorough account of this is provided by Daniel O. Dahlstrom in "The Appearance of Finalities," in the Krettek volume (see note 3), pp. 55–75.

5. This appendix (pp. 311–25) is a modified reprint of an article, "The Dunamis," that appeared in *The Review of Metaphysics* 40 (June 1987): 657–74. Since the manuscript of the book was ready by late 1990 the difference between them was not large, and few if any discrepancies in doctrine are to be found.

6. Persons seeking enlightenment in dictionaries will have better luck consulting cognates of "dynamism" and *its* transliteration of Greek *upsilon.*

7. The author has saved his readers many hours' labor in discovering the overall pattern of *Creative Ventures* by providing a chart—he calls it a map—of the interrelations of its chief terms. It appears on an unnumbered page preceding the text.

8. One striking example is the shifting importance of the concept of appearance. There are a very few passing references to it in *Modes of Being,* but it forms the subject of an entire book, *Beyond All Appearances* (1974). In *Creative Ventures* it retreats again, almost into oblivion. But there are corresponding shifts of subject matter and method to account for this. *Modes of Being* is about what is real, and appearance is coupled with error; the second book takes up the possible conflict between appearance and knowledge, and also the ways appearances can lead to five finalities. The finalities are not quite the modes, dressed up all over again. What I find a trifle odd is that appearances are scarcely mentioned in *Creative Ventures* despite the role that copies, imitations, forgeries, and other near-likenesses play in the discussion.

9. "Power," "potency," and "dynamism" are offered as surrogates for the word "Dunamis" (p. 314; cf. p. 6).

10. Power and the Dunamis are mentioned in *Privacy* (1982), and some of the conditions of *Creative Ventures* can be found in less august roles in the books on ethics intervening.

11. In *Nine Basic Arts* (1961) the arts are classified in a three-by-three square by means of these three aspects of voluminosity, but referred to as space, time, and energy. This square can be fitted into, but not made co-ordinate with, the five-column rectangle of *Creative Ventures.*

12. Adumbration receives scant mention in *Creative Ventures,* but is a much more pervasive concept in earlier works. A careful and sagacious essay, "Weiss on Adumbration," by Robert E. Wood, appears in the Krettek volume (note 3), pp. 43–54. It traces the use of this term throughout a number of the treatises, beginning with *Reality* (1938).

13. Active mysticism requires special regimens, long meditations, stark silences. A passive, intellectual mysticism involves study of the knowable and its separations from what cannot be known by the same means, and the recognition that one must relax the demands to make wholly explicit the nature of the latter. There is a rational decision to let reason give way, though not altogether, to emotion or intuition as ways for reporting the unbounded and inexpressible. I see few traces of active mysticism in the publications of Paul Weiss, no assumption of a psychic union with all reality, no urge to pursue the inscrutable farther than to know *that* it is but not precisely *what* it is.

14. The ultimates are "reachable through distinct, intensive moves" (p. 5). "One arrives at the ultimates by freeing what is initially acknowledged from the limitations that their specializations and meaning introduced" (p. 6).

15. Readers of *Creative Ventures* may at this juncture ask whether William of Ockham should not be invited here, whether there are not two sets of entities where one would suffice. It is true that this metaphysics skirts the very edge of multiplying entities too liberally. It can be said in defense of the ultimates, however, that although they are treated as having real being and are hence things when considered in isolation, they function mainly as qualities or other properties when invoked to explain differences in objects made by art.

16. Elsewhere it is said that the parts of every created work are held together, "interlocked," by an ideal, namely beauty (p. 7). For beauty, he says, arises from "mutually enhancing, diverse functions, words, shapes, numbers, colors, and other units are there turned into stresses, separations, connections, climaxes, and backgrounds without thereby destroying their different natures. . . ." (p. 9).

17. Feelings are the clusters, combinations, separations, and distancings to the work owing to the presence of beauty or to some other excellence (p. 41).

18. There are three kinds of emotion "germane" to creative work: (1) private thrusts into what is external to but countered by the body; (2) oppositional natures and mutual qualifications of the individual's privacy and body; (3) what is encountered that seems beyond complete conceptualization and is hence brute and resistant to understanding. The creator must achieve some control over each of these (p. 50).

19. A sampling of these generalizations follows: (1) Creators do not give an exact account of "what they presuppose and utilize, how they proceed, or the nature of that with which they end, in good part because their examinations were not preceded by a successful attempt to know what all the ultimate factors are and how they are and could be joined" (p. 3); (2) "Seldom are creators interested in the nature of what they use or in the ways they use it" (p. 29); (3) "When a creator studies the biography and practices of another, he does so, not mainly to know about him but to benefit from possible hints pertinent to what is to be independently produced" (p. 46); (4) "Artists do not usually acknowledge their contributions to a prospective beauty. Most of them would say they were not interested in and know nothing of beauty, that they are never aware of it. . . ." (p. 56); (5) "Works of art are not agencies enabling one to make contact with their creators. They do not send messages from them to others" (idem); (6) "A composer can indicate, suggest, but he cannot fixate or exhibit what the performer will do" (p. 68; I would bet that few fiddlers would try to play the Mendelssohn concerto finale on their G-string); (7) "The number of colors or shapes in a painting might be counted by the very numerals used to count toes" (p. 92).

20. *On Sophistical Refutations* 34.184a9–b9.

21. Volumes I–VII were first published by the Southern Illinois University Press. Two subsequent volumes were published by the State University of New York Press in Albany. Other volumes are in preparation.

22. If a sculptor executed a statue of the emperor using only ultimates in his work, spectators could well say that not only did the emperor wear no clothes but there was practically no emperor on the pedestal at all.

23. *Metaphysics* II. 1. 993b9–11.

24. Passive voice and adverbs: "The gain in communicability that they thereby achieve is offset by a failure to make evident what in fact was done and how the result is best read" (p. 45); "All references stand apart from, are attached to, and are transformed into their referents. When it is claimed that all facts are theory-laden, one still leaves the facts untouched" (p. 313n).

25. Some truisms: (1) "A creator needs multiple skills; he must be able to distinguish the unpromising from the promising, failure from success, insight from imaginings" (p. 46); (2) "A commitment is realized by doing what it requires" (p. 55); (3) "Some readings will be better than others, making a reader more easily and readily aware of the excellence of the whole and what it signifies"

(p. 81); (4) "The high note that is transmitted through some device and shatters a glass with a dramatic crash is a different note from one not so transmitted" (p. 87); (5) "The second act of a performed play, like the second act of a written one, affects the meaning of what occurred in the first act, and conversely" (p. 90). Some of these shade into commonplaces.

26. Some commonplaces, with which it is almost as hard to disagree as it is with truisms: (1) "There are no known ways by which we can measure precisely the difference between the perfect, the almost perfect, and what is just less than these" (p. 44); (2) "There is a big difference between . . . an envisaged work and an actual one; only in the latter can items be lived with and through, satisfying commitments and grounding others" (p. 54); (3) "Creators are never certain that their acts will be fully in accord with what a prospective excellence requires, with what has already been planned, and with what seems to be called for by what is next to be done" (p. 56); (4) "Beautiful works are often created only after much work has been done" (p. 61); (5) "A number of those who choose the life of an artist are willing to make great sacrifices if only they could thereupon produce something great" (p. 61); (6) "Creators have periods when they seem unable to create. Some of those who never create commit themselves to working on important projects" (p. 62); (7) "Skilled musicians read the notes of a composer the way sensitive readers read the words of a poem" (p. 70); (8) "Like a seasoned driver who is aware of the road, his hands on the wheel, his speed, and the pedestrian about to cross the street, a creator focuses on this factor or that so far as he must in order to make the best use he can of all" (p. 78). This is not a new trait; I found myself complaining of the same tendency to include commonplaces in *History: Written and Lived* (1962).

REPLY TO GEORGE KIMBALL PLOCHMANN

George Kimball Plochmann was the editor of the series in which *Creative Ventures* appeared. He read the entire work with care, made many excellent suggestions, and enabled me to make it clearer.

I have reread his essay a number of times, but each time I found what he says to be more perplexing. Reluctantly but finally, I have come to the conclusion that he has misunderstood what *Creative Ventures* says and intends. He does not seem to have understood why it has the style and organization that it does, what it tried to do, and perhaps what it succeeded in doing. I trace the difficulty back to two errors: the supposition that what is said in the chapter on art does not clarify and is not clarified by the discussions of other kinds of creations, and his taking the map that was placed at the beginning of the book to be a primordial set of manipulatable units to be used woodenly in a plurality of ways. The second error is more serious than the first.

The chapter on art could be read and, I think, be understood without making references to what is done when dealing with other creative ventures, though such references would provide considerable help. I wrote and rewrote many drafts of that chapter as well as the others, and then thought that it would be helpful to the reader to see how the different creative ventures made use of the same primal factors. I wanted to put the map at the back of the book. Wherever it was placed, it should help one to check for omissions, and to become aware of areas that might have been slighted in this or that creative venture.

McKeon, Plochmann's mentor, apparently did have a set of categories into which whole systems of philosophy were shoved, usually with a head or a leg still left outside, and a multitude of other systems just

ignored or reinterpreted so that they could fit inside the a priori frame. Apparently, Plochmann thought I was doing something similar but in a poor way. I have already noted that even the categories listed at the end of chapters in *Reality* served as summaries. I do think that many will be led astray by their listing and I hope that the misplacement of the map will not mislead others as badly as it has misled him. I also think that, without it, the nature of creativity and its primary applications would not be so easily or so well understood, either separately or together. References to analogies, manipulations, and the like seriously misconstrue what was intended, and get in the way of understanding what had been achieved.

Plochmann, in contrast with Reck, rightly remarks on the constancy of my view when method, in the broadest sense, is considered. What Reck makes evident though is that different stresses are not the result of simple manipulations of empty forms, and that I have never been interested in playing such elementary games. Had Plochmann first attended to my discussion of a creative venture with which he was not familiar, he might have had a better understanding of what was being done when I dealt with a topic he understood very well—the arts, particularly music and painting as completed and enjoyed.

The discussion of art can be understood without it being necessary to refer to what is said about other creative ventures; what is maintained when dealing with these others can, in turn, be understood without referring to what is said about art. Each examination, though, helps make more evident the major similarities and differences.

At no time did I make an attempt to use analogies. Instead, I tried hard to make evident the distinctive natures of the different kinds of creativity, referring to others only when I thought that would help one to see what was evident if one approached the same issue from different angles. If I ever used analogies to bolster an argument, I made use of a poor rhetorical device to do what could have been done in a better and in a better-grounded way. In any case, I never did think that the map pointed up analogies among different creative ventures in any other sense than that of showing that they could be well-understood if one took account of the different ways in which creative work could be carried out. The map should help one see in one place some major similarities and differences among the primary creative ventures.

I do not think that a "philosophic method confers individuality upon formulations of doctrine." I cannot imagine how it could do this, since a method is general and individuals are unique. It surely is not true that I laid out the natures of things before they are really explored independently. Plochmann kindly says that I avoided 'pitfalls' but does not show that they were ever there for me to avoid. Nor is it true that I was in

constant search for the best concepts. Attention has always been directed by me at what I thought were realities created or noncreated, eternal or transient, and attempts then made to articulate and communicate what I thought I had learned.

The ultimates are close to what some medievals called 'transcendents', but which they misnamed as though they were super-genera or ideals that one might strive to realize, rather than realities that were and could be jointly instantiated in many different ways. The Dunamis is not a 'surd' or one of many ways in which such a surd is addressed. Its acknowledgment cannot warrantedly be taken to express a mysticism. If it could, mysticism would be an inescapable aspect of everyone's experience.

It is a serious error to refer to the ultimates as 'categories' and to suppose that there is a "train of ever higher categories." I can't think of anything I have said that would warrant that supposition. It would have helped had Plochmann provided references when he made those claims, or, at the very least, if he showed that his conclusions were the inevitable outcome of what I had maintained. As they now are presented, they are not only unjustified but irrelevant. I have not been able to understand how such a careful and thoughtful scholar could have made these strange mistakes, particularly when they are quickly followed by his observation that I could be credited with having both "an open and a closed system."

What I once misleadingly called 'God' in *Modes of Being* (but not in *The God We Seek*) was not replaced "by the Dunamis." I have become more and more convinced that a reference to a God is to be properly made only by those who are religious, and that a philosopher has nothing to say for or against the use. All that a philosopher can maintain, I think, is that if there is a God, He is either in the interior of Being, or exists beyond it altogether and, in any case, is beyond the reach of thought.

Plochmann thinks that some of my "generalizations" about art are "in good part . . . somewhat questionable." He lists some of them, but does not indicate what is questionable about them. I wish he had taken some time to make the fact evident to those who need help in seeing that what seems to be illuminating is dubious, or perhaps trivially obvious. Apparently, he is primarily concerned with understanding "How terms are related to the things they designate and to each other." I have dealt with that issue in a number of places; it is not singularly appropriate to what is discussed in *Creative Ventures,* and particularly in the discussion of art.

Along the way, Plochmann put his finger on a much neglected question: "What method, then, will enable the intellect to move from one to another phase of the process whereby the ultimates merge, separate,

and rejoin . . . ?" That is a basic question, to be addressed, in special forms, to every philosopher. It was incidentally addressed at various places in *Creative Ventures,* but it surely deserves to be isolated and dealt with head-on. I try to do so in the work now in progress. Had I addressed the issue in *Creative Ventures,* I would perhaps have made more evident the purpose served by the map. This should help one understand the roles of the ultimates as so many transforming powers enabling one to pass from one position to another, but only if one moves beyond the consideration of creativity to what constitute every finite entity, created or not.

Plochmann seems to think that a "six-step method for the sciences" should be matched by another "such finite series" for an entire philosophy. Why he thinks what is true of the sciences—if it is—should be true of anything else is not clear. Each enterprise has its own distinctive method. I do not find his suggestion about the ways different methods can be divided to be helpful, mainly because he thinks of them as having a primary literary or grammatical tonality, and because he unduly limits in number, and seems to require the use of his all-purpose 'analogies'.

For my own purposes, I have again and again made private use of a 'combinatory method', mainly to see whether or not I had neglected some possible alternative. It has not, I think governed any of my inquiries or discussions, serving primarily as a check, not as a guide or precondition. My focus has been on realities and how they are known. I am sorry that I did not make this sufficiently evident, though there have been some who have understood the fact quite well. Plochmann though, seems at times to glimpse at what others have well understood, saying, for example, "suspicion of an a priori pattern governing and hampering inquiry is allayed."

Plochmann asks: "Is the discourse itself an illustration of the very theories that it upholds? If not, then what *does* it illustrate?" There is also "a question whether or not the same strategy of combination of these Olympian factors can be successfully applied to the widely diverse ventures that this book embraces. . . ." He then spoils the question by going on to say that I may have taken my "theory of combinations as a point of departure in composing. . . ." But, then, at last, he rightly remarks that I may have used more than one approach "checking one against the other. . . ." Yes, that is what I did.

Perceptively noting that philosophers "promote two intentions, to clarify for themselves and to clarify for others." He writes that I have "not seen fit to write deliberately popular books." I am not sure what he means by 'deliberately' and am surprised to find Kant on his list of

popularizers. If he belongs there, I would think that my books on sport, education, religion, the various arts, film, and ethics might qualify me for a place on his list.

Once Plochmann's asides have been put aside, his identification of what others seem to have found illuminating as no more than 'truisms and commonplaces' questioned, his suppositions that my method is primarily 'combinatory' dismissed, and his supposition that the claim of completeness in a philosophy of art flies in the face of a continuing, almost relentless evolution of art forms of every kind rejected as being based on a misconception of the relation of essentials and the instantiated, it is possible to consider his claims and questions without being distracted by irrelevancies. He asks if what is written should not exhibit "a closeness of fit to the accomplishments of artistic life" and wonders "how much of variance the explanation and the explained can be without becoming an obstacle to understanding." I think there need be no such 'closeness', and that explanations and the explained have no predetermined degree of permissible 'variance'. I wish Plochmann had told us why he thought otherwise.

Plochmann says that only "a few philosophers who have written on beauty or love have been able to bring their topic closer to their readers . . .", and then asks: "How can one engage the reader of the text so that he becomes the ardent, loving 'reader' of great music, fiction, great drama . . . ?" I never tried to help readers to become ardent and loving, but only to understand specific subject matters and how these fitted within the whole of things. I never, when I wrote on sport or religion, tried to increase an enthusiastic participation in them, but only to make their natures evident from a position that was able to deal with them objectively and reveal what they essentially were. I dealt with art and other enterprises, in a similar spirit and with a similar aim. Should he not have asked me to write the chapter on mathematics in formulas that might make a contribution to the subject or awaken an interest in it? Should he not have asked me to write the chapter on the noble, wise, and heroic in aphorisms, the chapter on leadership in exhortations, and draw up a constitution when I dealt with the state?

Others, besides Plochmann, have found *Creative Ventures* hard going. Some have been more acceptive than he is. I am pleased to find that there are mathematicians who have found the discussion of their subject to make an advance on long-accepted views. I say this, not as a defense, or as a way of protecting the book from criticism, but to get the study back into focus. Despite the many shrewd and discerning observations with which Plochmann's essay is peppered, I think it does not provide a good

guide to what was attempted or achieved, mainly because of his misconstrual of a misplaced map and a misconception of what was attempted and perhaps achieved.

Whether or not one accepts his account as correct and his criticisms as relevant, Plochmann does provide a good critical study, tangentially related to my own. It would have been stronger, were it freed from his mistaken assumptions about the nature of the method used, the objective in view, the status and nature of the ultimates, and the style required of a philosopher writing about art or other matters. Plochmann is at home in a number of arts. I wish he had used his experiences as occasions for helping us obtain a better grasp of the creativity that ended in the production of so many incomparable works. Instead, we have the expression of an annoyance for which no good reason is afforded. Too bad.

P.W.

25

Carl R. Hausman

PAUL WEISS'S ACCOUNT OF THE DYNAMIC STRUCTURE OF CREATIVE ACTS

I. THE STUDY OF CREATIVITY: ITS LIMITS AND PROSPECTS

The study of creativity can take at least three forms. It may treat its subject as a kind of phenomenon that simply is to be described and compared with other phenomena; it may try to explain creativity by subsuming it under laws and associating it with circumstances so that it could be made predictable; or it may approach creative outcomes as achievements, human or natural, that should be located within a comprehensive system developed through critical speculation. This third approach does not exclude explanatory considerations, but it does exclude the conception of explanation that implies predictability of specific consequences. Paul Weiss's account of creativity fits squarely into the third form of study, although this approach necessarily includes some of the concerns of the first, which limits itself to description. At the same time, his account is original within its kind because of its steady and intricate focuses on each of the basic human ways in which creativity is expressed—in the arts, mathematics, the sciences, morality, leadership, and statesmanship.

An argument to justify avoiding the second kind of inquiry is not given explicit attention in Weiss's discussions, although I suggest that Weiss regards such inquiry as misguided and fruitless. I think that he believes—and rightly, it seems to me—that the aim of making creative achievements predictable is unrealizable, unless creativity is regarded as

reducible and redefined in terms of processes or events that do not radically advance human knowledge and do not add new components to what is real at the cosmic level.

Undergirding Weiss's view of creativity, then, are two assumptions with which I am in complete agreement: (1) there is what may be called "radical creativity," which is to say that creative acts include spontaneity and newness and are not explicable by the reduction of them to antecedent, necessary and sufficient conditions (laws and circumstances), and (2) the understanding of creative acts is properly undertaken by attending to their achievements—or, in keeping with his terminology, by attending to the evolution of excellences as well as the activities that actualize them, thus specifying the ultimate conditions, or, more broadly, what he calls "ultimate factors," all providing a conceptual framework for creations. I do not mean to suggest that these assumptions are formulated as I have stated them or that Weiss discusses them as foundations of his thinking. I have drawn them from my understanding of what he says explicitly about creative activity, particularly as he has set forth his view in his latest published book, *Creative Ventures.*[1] His ideas in this work, of course, were anticipated in the pages of much if not all his earlier writing—as we might well expect from so systematic and comprehensive a thinker. I shall have occasion to mention several indications of these anticipations, although it is not my intention to attempt the formidable task of tracing his thoughts on creative ventures through all his work.

A. Radical Creativity

It is important here to offer a bit of support for my claim that the two assumptions, that there is radical creativity and that our philosophical aim should be to understand creative acts and creations within a system. One earlier statement in a glossary offered in *Philosophy in Process* (volume 9) is explicit.[2] Creativity is distinguished from spontaneity, novelty, and originality. Creativity is more than any and all of these, because it involves achieved excellences. However, it does include these as moments. Furthermore, in *Creative Ventures,* there are several places where the affirmation of radical creativity seems clear. Let me cite three. First, an explicit expression of Weiss's commitment to radical creativity is found in his discussion of abduction, or hypothesis formation in science. In pointing out that abductions are not necessarily creations, he says that creations "make something radically new by joining ultimates under the guiding control of a gradually realized excellence" (p. 140). A second indication of radical creativity lies in Weiss's conception of the

excellences that are determined by creative activity. An excellence is not a perfection. It is a norm that is open and must receive specification during the process in which a creator works toward it. The excellence emerges within an emergent (what Charles Peirce proposed under the name "developmental") teleology. (See pp. 28, 53, 93–94.)[3] Thus, the futures within which excellences function for both creators and noncreators are indeterminate. And, for creators, what is present at the beginning can be altered, which again shows Weiss's conviction that the excellences at which creators aim themselves undergo change. This understanding of possibilities and the mutability of excellences is of utmost importance and will be considered more carefully later.

Still further evidence of Weiss's commitment to the more radical conception of creativity is his insistence on the irreducibility of creations. For instance, in discussing created states, he refers to the way different kinds of creations "remain irreducible excellences" (p. 261). And in discussing creative leadership, he says, "What is created cannot be reduced to concepts" (p. 208). Finally, in his account of creativity in the good life, he says, "Something entirely new will be produced that is not reducible to or explicable by reference to any of the factors utilized" (p. 199).

The second reason for saying that Weiss views creativity as yielding radical novelty points to what might be called a deeper consideration, a concern for one of the underlying ultimate factors in the realization of new excellences. We find this factor in Weiss's ultimate, the Dunamis. The idea of the Dunamis is not new to *Creative Ventures;* it emerged in an earlier work. In a passage in his earlier book, *Privacy* (quoted in the appendix to *Creative Ventures*), he explains that the term "Dunamis" refers to a dynamic power that is effective not by virtue of a structure it exhibits or any intrinsic characteristic, but by virtue of being a potentiality. It is indeterminate and does not act on or within human action in prefigured ways. The specification it takes is a function of its interaction with other ultimates, which Weiss calls "Conditions." The Dunamis is at least in part suggested by Plato's receptacle, if it is regarded as self-dividing, and by Aristotle's prime matter, if it is seen as insistent rather than passive. Perhaps it is more appropriate to see the Dunamis as what is in part intended by Bergson's Vital Impulse—a suggestion Weiss himself makes. Be that as it may, the question arises as to why such a term suggests radical creativity? The answer is that the power of the Dunamis as the pulsating source of creations is not a prefiguring or predetermining and predeterminate cause. It is sheer power.[4] Out of such a source, novelty can emerge—intelligible novelty that is attributable to excellences that are outcomes of creative acts.

B. A Philosophical Account of Creativity

The second assumption that undergirds Weiss's view concerns the sense in which an account of creativity is appropriate. As already noted, an attempt to explain creative activity by proposing a system within which creations could be predicted is not his aim. Nor is his aim to construct a set of categories and description of reality such that creative activity could be subsumed as a reducible product of necessities at work in the universe. Nevertheless, he obviously does offer a systematic account. And what he says about creativity, especially in *Creative Ventures,* develops a complex framework within which creative acts fit. I shall not attempt to summarize or give an exposition of this vast systematic account. What I shall do instead is pursue the question of just how such an account is the most appropriate way to treat the topic of creativity. What conceptions and their relations can give a rational framework within which there is room for radical newness? Must we admit into the system an irrational increment? In my pursuit of this issue, I shall raise some questions about the puzzles Weiss's view raises—puzzles that I think are unavoidable for any systematic discussion of creativity. In considering these puzzles, I shall also suggest some ways in which Weiss's account is related to, and, I think, influenced by, certain metaphysical persuasions found in the thought of Charles Peirce.

II. The Appropriate System

The placing of creativity within a metaphysical framework should begin with a recognition of creative achievements—achievements recognized for what they are as creations and not events that are fully understandable in terms of natural science. But where should we look for these achievements? In proposing how a study of creativity must start, Weiss refers to "an acknowledgement of its components, procedure, and products" (p. 3). However, where inquiry moves, Weiss points out, is to what the sciences "are not in a position to tell us about," which are "the nature of privacies, individuals, values, or transcendents, or about beauty, truth, and other excellences," recourse to which require different methods, if they are not to be "set apart" in "a separate, detached realism" (p. 3).

In noting the special character of human creativity (as distinct from technical making and divine creativity), I do not mean to direct attention away from Weiss's insistence that what must be examined includes phenomena and conditions within the broadest scope that inquiry can

take: "It is better to look for the components that are present in any and everything and trace these back to their sources, for if successful, one will then be in a position to understand creative works in terms appropriate to all other occurrences . . ." (p. 3). This is to affirm the approach that aims at constructing a system that at least "surrounds" the understanding of creativity with an intelligible structure. Development of this surrounding, however, gravitates toward key components, components that connect with what is neither exclusively divine nor constituted exclusively as mechanical processes.

A. The Key Conditions

As I have indicated, my main concern is with Weiss's ultimate factors insofar as they function in creative ways regardless of the different media or forms of experience in which creations are found. There are six ultimate factors: five "conditions" consisting of the *voluminous,* the *rational,* the *stratifier,* the *affiliator,* and the *coordinator.* The other ultimate is the Dunamis (pp. 5–6). The voluminous has to do with spatiality and temporality and is most directly related to creating in the arts. The rational has to do with intelligibility or form and relates to mathematical creative achievement. The stratifier concerns ordering power and relates to moral character, to nobility. The affiliator promotes compatibility and supports connections among things and functions in creative leadership. The coordinator brings things together and is essential to the creative construction of the state. All five conditions have the stability of structure sufficient to give character to created achievements. However, the dynamic source underlying the achievements that are given form by one or more of the five conditions is the Dunamis, which in Weiss's system seems to play the most fundamental role with respect to the source of the power to bring about creations. The Dunamis provides the energy needed by all five conditions in order for them to structure the energy of creative activity. And most important for the considerations I am highlighting, it is this ultimate factor that is crucial for what is necessary to accommodate radical creativity—unpredictable achievements that come from processes that include moments of originality, spontaneity, and novelty—as distinct from a formed power that energizes in routine ways. Why is the Dunamis an appropriate ultimate for radical creativity?

B. The Dunamis

The Dunamis is "a primary pulsating ground" (p. 4); as pointed out earlier, it is something like Plato's receptacle, Aristotle's prime matter,

and Bergson's élan vital. What is important is that Weiss's Dunamis is especially appropriate to a system that includes radical creativity, because of its function as a source the expression of which is unpredictable in special instances. The results of the interactions of it with other factors are irreducible; they are individualizations, which are unpredictable and unduplicatable. The Dunamis is a general ground that is spread out under processes (all processes) and that gives them their energy force or expressiveness as they yield particular results. However, "were it alone dealt with, one would be caught up in a sheer flow, a single, ongoing in which nuances could be distinguished without being set apart from one another" (p. 6). What gives specificity to the expressions of the Dunamis, what sets them apart, and in turn sets apart the various creative ventures, are its interactions with other ultimates under the aegis of a "privacy" or subjective source, a creative agent. In the case of creative results, the features of these specific expressions are found in the excellences that are realized by the creative acts. These specific features are distinguishable with respect to the domains of achievement that Weiss discusses in the various chapters of Creative Ventures: mathematics, science, moral character, leadership, and statesmanship. Yet the one ultimate source of these is the Dunamis, and more attention needs to be given to this factor and its relation to the excellences that result.

As an ultimate, the Dunamis pervades all occurrences, whether they are specified in excellences or in worthless outcomes. The Dunamis itself, as already pointed out, is not responsible for created outcomes. As a necessary condition of all activity, it is necessary for creating. It is the propulsive origin, the power, that anything needs in order to be. Yet it is indeterminate as a dynamic force and varies by virtue of its interactions. Through interactions with other factors and prospective excellences, the Dunamis varies in degrees as well as in ways of expression. The Dunamis, for example, is less intense in instances in which it interacts with rationality and is expressed in mathematics.

The intimacy of the Dunamis with other factors and its variations in accord with its intimacies is essential to the difference between Weiss's conception of a fundamental ultimate and comparable conceptions held by others in the history of philosophy. It will be useful to summarize Weiss's comments on the most basic of these other conceptions in order to highlight what gives the Dunamis its appropriateness for radical creativity.

In general, Weiss distinguishes his Dunamis from assumptions distinctive to the rationalists and the nonrationalists and both of these from the neo-Hegelians. Rationalists expect reality to be determined by a

stable ultimate to which all change can be traced and either made illusory or subordinate to the fixed ultimate. The opposers of rationalism, nonrationalists, see change and an inherently changing ultimate as of at least equal order of ontological importance as any foundation found in eternal, invariant conditions, which the nonrationalists regard as abstractions from reality. We are told, however, that the nonrationalists presuppose the same conception of intelligibility as the rationalists so that the changing ultimate, the fundamental condition of change that opposes stability, is conceived as an extreme, irreconcilable opposite. Thus, nonrationalists repudiate structure. The source of things is "unintelligible"—it is "brute," "matter" (p. 312). In contrast to both rationalists' and nonrationalists' are the "neo-Hegelians," who insist that experience is directed by "practice," "history," "language," or a set of conventions as primitive (p. 311); yet neo-Hegelianism, like nonrationalism, shares with nonrationalists the rationalists' assumptions about intelligibility. Weiss contends that the rationalists are wrong because they detach their foundational sources from the outcomes of these sources; yet both nonrationalists and neo-Hegelians assume rationalist staples in order to formulate their opposition to rationalists' formalism.

Weiss's Dunamis functions in such a way as to undercut and undergird the assumptions of these oppositions. It mediates between the rationalists' and nonrationalists' views and diverges from the alleged mediating position of the neo-Hegelians. It differs from neo-Hegelianism in its metaphysical affirmations, going to sources more fundamental than history, language, and convention. Anticipation of this point is anticipated in his statement in *Philosophy in Process* that the Dunamis refers to what is passive, what is readied, and what is active, having characteristics that lie deeper than history, language, and convention.

The distance of the Dunamis from foundational conditions proposed by rationalists, nonrationalists, and neo-Hegelians is crucial for affirming radical creativity. However, this advantage is accompanied by the presence of a paradox. The paradox-conducive features of the Dunamis are reflected in the etymological origin of the idea of the Dunamis in the Greek language. As early as Homer, it referred to power and strength and with Aristotle it suggested capacity and productivity. Yet for Weiss this power must be understood in terms of an inner tension. As Weiss puts it, there is a contrast between the active and the passive. And crucial to this active-passive tension is the presence in the Dunamis of an essential vagueness—an independence from the law of noncontradiction while there is also an apparent tendency to move in some although no particular direction. This inner tension is, I think, essential to a view that

acknowledges radical creativity. The active aspect is needed to provide the pulsating energy; the passive side is needed to admit divergences effected when the source is expressed in its interaction with other factors.

It has been hinted already that the importance of the fundamental or foundational (in a nonfixed sense) role of the Dunamis suggests a question at the heart of a system that "surrounds" radical creativity with an intelligible structure. If the system is not to fall prey to the reservations Weiss expresses about rationalism, nonrationalism, and neo-Hegelianism, then we must understand this structure as itself embedded in what it renders intelligible, and because what it renders intelligible is driven by inner transformations, the ultimate source—the Dunamis— must be immanent to the intelligible structuring insofar as it is provided by the other factors.

Another way to put the issue is to ask how much, if any, determinacy the Dunamis has within its indeterminacy as it energizes processes that are driven by virtue of its interactions with other factors—the voluminous, the rational, etc. The indeterminacy of the Dunamis is to be understood as vagueness or as the indeterminacy to which the law of noncontradiction does not apply. Thus, contrasts, oppositions, and all differentiations are unrestricted. Insofar as this indeterminacy is vagueness, it seems that the Dunamis itself cannot be disposed in any special way to interact with other factors. To expect more of its indeterminacy would be to fall into the rationalists' trap. To expect it to have no relevance to structure or to be wholly unintelligible would be to give over to the nonrationalists. To refer it to structures informed by language, history, etc., would fall into neo-Hegelianism.

The determinacy that evolves from the Dunamis and its interactions is expressed in the excellences that structure created outcomes. What relevance might evolving excellences have in bringing about this determinacy? Is the location of the origin of structure found in the outcomes of interactions of the Dunamis to be a condition of the role of prospective excellences in the creative process? Excellences, I think, are just as fundamental to accounting for the specifications of the Dunamis in concrete expressions as are the other factors. I am not sure that Weiss would put the point quite in this way, but I do think that the inseparability of excellences and the active side of the Dunamis, at least in creative processes, is clear in his view. Each of the five factors functioning in creative interactions has its own distinctive excellence, and a closer look may disclose perhaps the most deeply rooted articulation of Weiss's assumptions about the function of the Dunamis.

C. Excellences

The importance of the function of excellences as factors in the creative focusing of the Dunamis can be brought to the fore through some observations about the relation of prospective excellences to final causes or normative ends, to possibilities and to the indeterminacy understood as vagueness.

1. Excellences and Final Causes. Prospective excellences should be distinguished from final causes or ideal norms that determine the proper development of a process. Excellences are not telic determinants that compel creative agents. There are two ways in which these excellences and teleological determinants vary. Even though they do lure the creator, drawing the agency involved in the interacting of the Dunamis with other ultimate factors as the creative act evolves toward a unification, excellences are not prefigured. They do not have antecedently formed structure and content that waits to be actualized. Thus, Weiss distinguishes them from perfections. Excellences themselves evolve as the creative process develops. At the beginning, they are indeterminate, faint, and weak. Only at the end are they realized as the unifications that constitute them for what they are in their specificity. And even though they are ideals, their determinacy is only gradually elicited and their special structures are spread out, merging throughout the whole of the outcome that they inform. And in this immanence, they are distinguished from Platonic Forms that would be exemplified by outcomes that approximate them. Indeed, excellences are self-determining; they are dynamic, self-controlling, apparently in cooperation with the Dunamis and the other ultimate factors.

This is not to say that prospective excellences are in no way characterizable. They can be classified in terms of the broad transcendental ideals of truth, goodness, and beauty, as Weiss shows in his discussions of the distinct domains of achievement—mathematical creativity falls under the achievement of truth, artistic creations fall under the achievement of beauty, etc. Yet with respect to the irreducible manifestation of a truth or a beauty, Weiss's view is consistent with the principle accepted by the conception of creativity represented by philosophers such as R.G. Collingwood and S. Alexander that the creator does not know until the creative act is completed just what its determination will be or precisely how it will be effected. This account of the way excellences differ from determinate teleological compelling conditions suggests the other condition with which they may be compared: possibility and the consequent associated condition, vagueness.

2. Excellences, Possibilities, and Vagueness. If excellences are not deter-
minate ideals, neither are they possibilities, at least in the sense that
possibilities are future results waiting to become actual. However,
although excellences do not, as do possibilities, wait to be "filled in,"
they are conditions, prospects, that become realized. This point is
expressed in the striking sentence, "A created truth is not possible, yet it
can be realized" (p. 142). How then can they influence the evolution of
the processes that culminate in them?

In the first place, excellences do constrain, even if only faintly and
weakly at the outset. Possibilities do not constrain. Possibilities have no
power and require no external agent to be realized. However, it is not
clear that Weiss sees excellences as containing their own self-generated,
inner power. And, if they do not, in this respect, they are themselves like
possibilities.

Excellences, then, would constrain only on condition of their associa-
tions with the ultimates and a privacy that functions in interactions. This
cannot be said of possibilities, because possibilities are not in themselves
normative; consequently, they lack whatever constraining function nor-
mative prospects have. Perhaps more important, however, is that possi-
bilities in themselves are empty—they have no actuality of content. As
Weiss says, possibilities are not altered if they are realized. Instead, they
are "filled." Excellences are prospects, not conditions ready in waiting.
In that sense, they are potentialities—"real possibilities." They are
altered as they come into being, which is to become determinate.
Further, they contribute to affecting—presumably through the presence
of the Dunamis—what makes their realization possible. In any case,
there is an intimate connection between excellences and possibilities,
and there is an inherent tension, acknowledged by Weiss, in the way
excellences do their jobs. Both these points need to be developed.

As suggested, the tension present in the function of excellences lies
between the indeterminacy of excellences before they are realized and
their guiding role in bringing about their own realization. How can
excellences guide if they are not already determinate so as to direct in one
way, or set of ways, rather than another? How can something indetermi-
nate control anything? Granted, excellences become determinate, but
this is a consequence of their evolution, not a consequence of their
structure. The answer must be that the dynamism necessary to effect
both the constraining and evolving function of excellences must have its
locus at least in part in the Dunamis. However, this dynamic condition
can work only if excellences are present as possibilities.

One way to pursue this point is by considering more closely the

condition of indeterminacy, which both excellences and possibilities share. With respect to indeterminacy, it seems, excellences are only different from possibilities after the moment at which they begin to evolve. With respect to what is unstructured and thus indeterminate, possibilities are "empty" and remain "empty." It is only in the initial state, then, prior to creative change, that the relevance of the conception of vagueness can best be seen. The relevance of vagueness is an underlying insight in Weiss's account—an insight anticipated, I think, by some of Charles Peirce's considerations of evolution. Its significance is that vagueness is indeterminacy that has no disposition, no tendencies that are initially specified; indeterminacy that is not vagueness is generality or tendency, although it is still potential. Thus, an account of creativity should include a conception of indeterminacy that is both vague and general—vague so that evolution is open to change that is not prestructured and general so that once evolution occurs, tendencies, specific directions, can grow, and the possibilities we regard as operative are projected ex post facto on the past. It is after we see ideals formed that we say that they were possible. Vagueness, then, is prior to possibilities, and excellences supercede but developmentally constrain the transformation of vagueness into determinacies so that what is possible emerges. And this interaction is suggested by several ways in which Weiss treats excellences, possibilities, and vagueness. Before continuing with this point, a brief digression is appropriate because of a larger issue implied by the tension faced in our account.

Acknowledging the paradox of the point that a created truth is not possible even though it can be realized, Weiss says that the paradox can be assuaged on the assumption that possibilities are "derivative from ideals" (p. 142). Further, he directs us back to the question whether there is after all a prefigured, complex (or simple) structure that compels creative acts in predeterminate ways. And he acknowledges that there could be such a condition but that we need not be bound by it, because we cannot be sure of it: "A cosmic teleology might then be operative, but we have no evidence that there is such a teleology, either latent or effective. This, I think, is a Peircean response and one that seems to me correct. I assume that in saying that there is no evidence for a cosmic teleology, Weiss means by "no evidence" either that there are no data sufficient to justify the hypothesis that there is a cosmic teleology or that there are no data even relevant for such hypotheses. Claims about the whole of things are not conclusively established by any sort of empirical evidence. The question whether there is a cosmic teleology, even if it cannot be demonstrated, is relevant to the general approach that has guided my

consideration of Weiss's system for creativity, and I shall return to it before my remarks are drawn to a close. However, the issue at hand concerns the interrelations of possibilities, excellences, and vagueness.

I have just referred to Weiss's proposal that the assumption that possibilities are derivative from ideals assuages the paradox of created outcomes that are not possible. This assumption shares an insight in Bergson as well as in Peirce. Comparisons might also be suggested by Plato's Receptacle and Aristotle's Prime Matter—as they are in the case of the Dunamis—but both conceptions are tied to general metaphysical systems that presuppose that there is no intelligible radical creativity. And the kinship of Weiss's view to the more recent insights of Bergson and Peirce seems more apt in the present context. In any case, if possibilities are derivative, they must have origins in a state of indeterminacy that is more fundamental and lacking in any specificity of the "empty" determinacy of possibilities.

This fundamental origin of possibilities, I think, is what Bergson refers to as the condition that precedes possibilities that may be made actual in the future. Commenting on his response to questions about his prediction of what possibilities lie in the future in the evolution of literature, he says that these questions are meaningless; all that can be said is that what is possible is what is not prevented from occurring. This answer, of course, reflects the minimal conception of possibility according to which something is possible if its contradiction is not necessary. In Bergson's view, however, the minimal kind of possibility is not attributed to particular things, events, or thoughts—sentences or propositions —but to reality in the most general and pervasive sense.

More sharply drawn is the conception entertained by Peirce, and already mentioned, that there are two kinds of indeterminacy, vagueness and generality. As Weiss himself points out, vagueness is indeterminacy to which the law of noncontradiction does not apply. And on Peirce's view, generality is indeterminacy to which the law of the excluded middle does not apply. Peirce's generality is something like Weiss's possibilities except that for Peirce generals are real possibilities that are not empty but are dynamic dispositions to be instanced in resistant moments or particular actualities. However, it is vagueness that is crucial. This is a primordial condition that is open in an absolute sense, not having any specificity or particular tendency that pushes or pulls change in one direction or another. I think it is out of such a state or condition that possibilities, empty or dispositional in the sense of generals, can be said to be derivative.

What is particularly significant, however, is that such a primordial condition must have some dimension of dynamism about it. If anything

is derivative from it, even though it is in no way in itself disposed in terms of any specific tendency, then it must still be subjected to some kind of power. Is power-giving not the office of the Dunamis? If so, we return to the paradox that Weiss said was assuaged by the idea of derivative possibilities. What accounts for the specificity of derivative possibilities? In Peircean terms, what accounts for the tendencies that turn vagueness into generalities? For Peirce, one answer—that I cannot defend here, but which I have defended elsewhere—is that what accounts for the derivation of possibilities and in turn for creative achievements is agape. We need not reduce the idea of agape to a doctrine of Christian love, although there are reasons to think Peirce himself had this doctrine in mind. What we need is the introduction of a dynamic source that must be generative but without requiring its generated creatures to develop in any predeterminate way. This is not the place to elaborate on this way of accounting for the mediation between absolute indeterminacy or vagueness and the evolution of excellences. The point in bringing it up, however, is of utmost importance for the account of creativity that Weiss has proposed. I do not see such a mediating condition in his account. It is here that I think a further stage in his systematic framing of radical creativity needs consideration. Before concluding this discussion, I should like to suggest a way in which this task might be undertaken.

There is one factor introduced by Weiss that might serve the function of a condition of emergent evolution or agape, what he calls "privacy." Privacy may be an agapistic source for four interdependent reasons: privacies express themselves most typically in human expressions, which is where creative activity is most obvious; privacies are unique individualizations of active units; as Weiss puts it, the term "privacy" is used to refer to the "initial source of man's activities"; and when expressed as human selves, privacies are sources of responsibilities or accountability.[5] Privacies are epitomized in distinct ways. In describing these, Weiss's account suggests that privacies share characteristics with the Dunamis. In fact, he refers explicitly to accounting for privacies as unique sources "by showing each to be a condensation of a primal, insistent continuum, primitive, unbounded, and indeterminate," which he characterizes and suggests be called the "Dunamis." And he says that "the most elementary condensations of it [the continuum] are the privacies of irreducible unit actualities, each fragmenting it in a distinctive way, and leaving untouched most of it."[6] Now, what accounts for the condensation and for its being able to be expressed so that it is a unitary being? The answer could not be "the Dunamis," because this is what undergoes the condensation and, insofar as it is also active, because the Dunamis does not have predeterminate dispositions to congeal in this way or that.

Neither could the answer be that the sources of condensations and expressions are excellences, for at the initial stage of expression an excellence is prospective. The answer must lie in the privacy that is "the initial source" of activities, which is to place the locus in an agapistically functioning source from which the evolution of excellences originate.

I suggest that this source is agapistic because it is originative in specific and individuating (private) ways without requiring or luring what it originates in predeterminate ways. Thus, if we ask about a source for these individual sources or privacies, either we face the prospect of concluding that there is no such basis of origin and that we must admit that evolution is at bottom the outcome of accidents or we face the admission into our system of the presence of an irreducible, paradoxical condition—a cosmic agapistic source of indeterminate but self-determining power. And if we are willing to admit the irreducible limiting condition into our system at this point, then we choose the Peircean cosmological outlook, which, I think, should be most acceptable to Weiss if he were to pursue his account of creativity in the direction I have suggested. Let me conclude my remarks, then, with a brief consideration of the cosmological underpinnings of these suggestions about the agapistic possibilities of privacies. Is there a cosmic teleology that is not prestructured but that is agapistic?

III. Opposing Metaphysical Underpinnings

Although we cannot amass evidence to determine conclusively whether there is a cosmic teleology, we still may ask about the consequences of either alternative for a system such as Weiss suggests for understanding creativity. And what we find to be the consequences that are more coherent with the bulk of our assumptions and conclusions or beliefs, including all dimensions of experience—moral, religious, aesthetic, scientific, etc.—will be the consequences that support reasons for accepting or rejecting the conception of a cosmic teleology. I shall only touch the surface of this issue.

Suppose that there is no operative teleology. If there is not, then there is no fully prestructured system of conditions that compel creators to express themselves in specific ways. There is spontaneity and novelty, and the excellences that lure and also evolve are free. They are emergent in an ongoing evolutionary reality. Suppose that there is an operative teleology. Excellences then are compelled to constrain in the specific ways they do. There is no recalcitrant spontaneity, but only moments of

change that are not understood by an intelligence that does not have full access to the teleology.

Must we conclude that only the first of these alternatives is consistent with Weiss's account of creativity? Does an operative cosmic teleology conflict with his account of emergent excellences? If a cosmic teleology is assumed to be fixed, that is, as structured by a set of invariant laws and basic conditions that hold without exception under all circumstances, then there certainly is an apparent difference between Weiss's account of creativity and the teleological account that would trace all change to the underlying preformed structure. There is, however, a way of overcoming or at least softening the severity of the conflict between the teleological alternative and Weiss's account. This way requires pointing toward the idea of a special kind of world view that, as indicated earlier, is consistent with Weiss's account; this special world view is grounded in what has been called "developmental or emergent teleology."

One could answer that at bottom it does not matter, because even if the determinist teleology is affirmed, finite inquirers remain in the same epistemic condition with respect to knowledge that they do on the first alternative. Everything that is said about emergence and unpredictability of the specificity of excellences to be realized can be couched in terms of the discovery of what was not known before it was there to be known.

It seems to me, however, that there is reason to conclude that it does matter whether creating is or is not discovering details required within a cosmic teleology. First, there is a pragmatic or heuristic dimension to the two alternatives of discovery or radical creation. If there is an operative cosmic teleology, then no creative agent is responsible for creative achievement, at least at the fundamental level assumed by the teleologist. I do not see why it then would make sense to refer to created outcomes as achievements. Even to regard an individual act as creative or uncreative would be misguided. Only the cosmos could be creative, and I do not see how even it could be creative if its changes are compelled by a prestructured system of conditions. Or to put the point in a way that might be proposed by the determinist, the idea of creativity, from the standpoint of this metaphysics, simply is not what those who affirm the idea that there is no fixed operative cosmic teleology, take creativity to be. Creating would simply be doing, and the only difference between creative and uncreative doing is a function of what we inquirers are compelled to admire (find creative) or take for granted (find uncreative). Even the idea of achievement loses all its bite as a cosmic event.

The heuristic aspect of this alternative follows from this consequence that value is empty and that there is no metaphysical distinction between

routine doing and creating. The exclusion of responsibility and funda-
mental achievements of value makes it questionable whether one who
believes such a determinism has any reasonable justification for expend-
ing an effort to act in any way, much less creatively. Indeed, even the
study of the topic is pointless insofar as it is simply an activity compelled
by the cosmos—the hope that the study will result in conclusions that are
true or false, correct or incorrect, right or wrong, would be futile.

It also may be suggested in response to the point that for finite inquiry
it is irrelevant whether there is a cosmic teleology that if a philosopher's
task is to press onward and speculate about fundamental questions, then
it is indeed relevant whether determinism or antideterminism is to be
affirmed. What considerations are then appropriate to support the
acceptance of one or the other? One answer to this, and one I think is
most consistent with the demands of empirical as well as metaphysical
inquiry, has been given by Charles Peirce in an important paper in his
Monist series: "The Doctrine of Necessity Examined."[7] Weiss of course,
knows this paper and I mention it because I think it, as well as some other
thoughts found in Peirce that have already been noted, do relate to some
of Weiss's assumptions underlying his account of creativity. However, I
shall not attempt to set forth the argument in that paper. I shall only refer
to what seems to me to be the essential reasons for studying creativity
under the guidance of the first, antideterminist view. The first reason is
that the view that there is a fixed cosmic teleology is not an empirical
claim but is a hypothesis based on the assumption that all the laws of the
cosmos and the conditions of their application were given in "one dose"
at the beginning of time. Presumably, today, this initial presentation of
the ways of the cosmos would be located in the "Big Bang." This
assumption seems less intelligible than the assumption that laws and the
conditions of their application are introduced in "little doses" over the
course of time from the beginning until the present and on into the
future. The second reason is that the phenomena we encounter within the
cosmos are consistent with the idea of laws and conditions being given
over time. Scientific laws or regularities as we understand them are
subject to small deviations (margins of error) and to occasional major
divergences. We find evolution in natural phenomena, no matter what
hypotheses and laws we articulate to explain them. The conclusion to be
drawn, then, is that the hypothesis of the antideterminist, which here
may be called "emergent" as distinct from "predetermined cosmic
teleology," is explanatory, not with respect to individual divergences
from regularities, but in the general sense that it accounts for growth in
laws. In fact, Peirce says, it is not divergence or spontaneity that need
explaining, but law. If a new law emerges, this is to be expected

on the emergent teleologist's assumption, and our task is to place it within a larger system that itself has been changed by virtue of the new law. The cosmic teleology that can be defended in this way, then, does have a kind of evidence that does not demonstrate but does support it. And this emergent teleology surely must be operative in Weiss's cosmos.

Carl R. Hausman

Department of Philosophy
Pennsylvania State University
July 1992

NOTES

1. *Creative Ventures* (Carbondale and Edwardsville: Southern Illinois University Press, 1992).

2. *Philosophy in Process,* volume 9 (Albany: State University of New York Press, 1986), p. 155.

3. References to *Creative Ventures* will be included within parentheses in the text.

4. In this respect may be likened to Charles Peirce's category of secondness, at least if this category has incipient tendencies toward the intelligibility of the triadic relational movement of the category of thirdness.

5. *Privacy* (Carbondale and Edwardsville: Southern Illinois University Press, 1983), xii.

6. Ibid., p. 20.

7. This paper is most readily available in *The Collected Papers of Charles Sanders Peirce* (Cambridge: Harvard University Press.)

REPLY TO CARL R. HAUSMAN

Carl R. Hausman is a recognized authority on the nature of creativity, meaning, and Peirce's thought. He has revived the *Journal of Speculative Philosophy*. Under its auspices it is on its way to becoming a leading philosophical quarterly. Remarkably receptive to a wide variety of ideas, generous in his appraisals, he here provides a corrective to Plochmann's account, supplementing the criticisms I have offered in an independent attempt to place my study within a larger context. While I think that others, as well as I, would have gained much had Hausman dealt with the issues raised by the different creative ventures I distinguished, I am glad to have this no less important and needed examination of some of the issues at the root of all of them. What follows are little more than footnotes to his account.

Hausman rightly remarks that I think creative achievements are not predictable, and that the aim of making creative achievements predictable is unrealizable. It is not, though, correct to say that I was interested in "understanding creative acts . . . by attending to the evolution of excellences," or even in providing a "conceptual framework." The emphasis was more on what occurred within 'a framework', but then as a reality, not as something conceived.

He begins his examination of the Dunamis with an overemphasis on its status as a potentiality, thereby making possible a ready identification of it with Plato's Receptacle and Aristotle's prime matter, and rightly correcting it with a reference to Bergson's *élan vital*. What I find perplexing is his association of the Dunamis with Peirce's Secondness, since this is primarily reactive rather than vital, and pulsative, with an unlimited range. The Dunamis is closer I think to what Peirce took to be an aboriginal, unhabituated, cosmic mind. The idea, as the references to Plato and Aristotle indicate (a reference to Heraclitus as well would not

have been inappropriate), and accounts of Tao, Schopenhauer's primal Will, and even Whitehead's primal Creativity underscore, is not entirely new. I do not know of any place, though, where it has been dealt with on its own, and as inter-involved with other, no less basic realities. My discussion of it could have provided a good opportunity to mark out similarities and differences between it and these other views, and perhaps then have made possible a rectification of or at least a comparison between those and my characterizations.

It seems likely that "framework" does not convey exactly what Hausman has in mind, for he seems to be concerned with making evident the nature of the reality within which creative and other activities occur. That, I thought, I did provide in *Creative Ventures* and, as he notes, in earlier works as well. In any event, I will try to view his references to a 'framework' in those terms, particularly since he does take it to require an acknowledgment of the ultimates.

One is always inclined to exaggerate the importance of some newly noted, examined, and used primary factor. It is quite possible that I did this when I referred to the Dunamis, and thereby misled Hausman into thinking that the Dunamis is "the one ultimate source of the different creative ventures." The Dunamis is not a source. While distinct from, it is not more basic than other ultimates, and interplays with all of them. Hausman does seem to recognize this at times, and thereupon makes it difficult to understand him when he speaks of it as the one "ultimate source of creative achievements" or of "domains of achievement." I agree with his observation that the Dunamis must be immanent in an intelligible structuring, though his reference to the 'intelligible' may misleadingly tempt one to suppose that 'structuring' is essentially or primarily rational. The Dunamis interplays with, qualifies, and is qualified by all the ultimates.

The observation that 'indeterminacy' is to be understood as 'vagueness' is bound to confuse or mislead. The Dunamis is an operative factor; 'vagueness' refers to an expression. Similar distinctions should be made between other characterizations and that to which they apply. In addition to the vague (and the general), to which both Peirce and Hausman refer, there are, as I have noted, occurrences where other laws of logic do not hold. Substitution does not have application if we are dealing with unique beings, implication if with the undivided and unending, and so on. By taking account only of the areas Peirce noted, one does less justice to his genius than it deserves. His brilliance becomes more and more evident and his achievements more and more important, the more one follows along some of the paths he opened up, but did not traverse.

Hausman's account of prospective excellences is, on the whole, both sound and helpful, but I do not understand why he thinks they are 'self-determining', or what would be gained by supposing that they were. In his listing of them, incidentally, he ignores glory and justice, and thereupon precludes a good understanding of creative leadership and the co-creativity of rulers and ruled. His discussion of excellence and possibility is illuminating, but I think that the role of an ideal excellence in creative work should have been emphasized, since otherwise the distinction between prospective excellences and sheer possibilities would be blurred.

Peirce, at last, is being recognized, at the very least, to be the greatest of American philosophers. The observation is not intended as a slight to others, but I do believe that the more his achievements are recognized, the more surely will these be seen to be the work of an amazing polymath, a daring thinker, a mine of brilliant ideas, one who has opened a considerable number of new inquiries. The temptation to suppose that his contributions to semiotics or pragmatism are his only major achievements needs to be blocked. It will then become evident that his failure to deal with creativity in the arts, mathematics, humans, society, or state point up inadequacies in his method and regrettable limits in his interests.

Hausman thinks that Peirce's "considerations of evolution" might help one make progress in the areas he had minimized or neglected. Peirce did envisage a number of alternative ways of viewing evolution that have yet to be subjected to an imaginative, critical examination, and possible applications. Even if this were not done, or found to be unneeded, it should point up the fact that a confinement to the vague and general unduly limits the contribution that Peirce could make to the study of creativity. Still better, I think, would be an attempt to understand the nature of reality without limiting the effort by subjecting it to antecedent limitations or by making it conform to the needs of special inquiries.

Hausman is always in danger of being caught in a circle, dealing with the whole of things in the light of creativity, and with this in the light of what he had understood the whole to be. What anyone says about creativity should comport with what is said about other realities, and about all of them together, but the acts should be carried out independently, and then checked against one another. A cosmology cannot encompass all realities—surely not humans with their distinctive persons, characters, commitments, speculations, uniqueness, and their existence, both inside and outside the humanized world.

The 'frame' Hausman provides for creativity is not inclusive enough to do justice to a creativity that makes use of the ultimates. These always are what they are, and can be exhibited in an evolutionary process, as well as in other ways. Whether or not there were a creative evolution, human creativity would be what it now is—a realization of an indeterminate excellence through work by committed humans who make use of different ultimates in dominant roles, depending on the kind of excellence they try to realize with the help of graining material.

Hausman's discussion of possibility is both exciting and illuminating. I hope that he and others will follow up on the leads he has provided. I do, though, find his remarks about "the evolution of excellence" in its present form, not to be helpful. Is a prospective excellence anything more than a precondition resulting from the common convergence of all the ultimates at a common point? If it were not this, would it be possible to account for it, its lure, and its compatibility with what the ultimates jointly constitute, both on their own and when we make use of them in the course of creative acts? He rightly remarks that he cannot find agape in my account. I don't see that he has shown that "it is of utmost importance," or see that it and privacy are related. Does not the supposition that they are get in the way of the acknowledgment of the commitments creators exhibit?

There is an urgency, a desire, an effort to produce and cherish, expressed in all creative acts. Does a reference to agape clarify them or show how they fit together? Is it not too general or too indifferent to particulars to be of much help in understanding particular acts of creativity? Must it not be instantiated together with other factors that both resist and add to it? Could it be instantiated? If it could, could there be, anything more than a multiplicity of instances of it? Would not that turn resistances to it, qualifications of it, and repressions of it into unresolvable mysteries? Whatever a supposed cosmic love might do, it could have only a limited role in particular occasions, and then would seem to be able to produce excellent works in the absence of a creator. Unlike it, a creator is committed and technically competent. Creative work is charged with uncertainties, leaps, retreats, and a need to make the material used become a component in what is finally achieved.

Let it be granted that privacies are condensations of the Dunamis, and allow this to be identified with agape. We would still have to account for the roles that the creator, the material, the ultimates, and actual work play in every creative venture. Hausman does recognize that creativity operates in distinctive ways on different occasions. But is that

enough to warrant something being 'termed creative'? Is agape orig-
inative in specific and individuating ways? Hausman seems to think so
provided that it is an essential part of an 'operative teleology'. Is there
any reason for believing that there is such a teleology? Is it purposive,
a tendency, or does it express the purpose of some supra-reality? Does
its acknowledgment help one understand why or how humans are
creative? I wish Hausman had indicated that it does, or how it might
do so.

Hausman suggests that "a developmental or emergent teleology" is
consistent with my view. I agree. But is it needed? Why assume it? What
does the assumption clarify that would otherwise be unintelligible or
inexplicable? The dogmatic rejection of such suppositions by Hausman
reveals a timidity not worthy of a metaphysician. That, though, does not
justify the acceptance of what does not clarify, what need not be
acknowledged, or what leaves inexplicables in its wake. Speculation
outraces inductions, generalizations, hypotheses, but does so legitimately
only if it is guided and controlled by what must be, and what illuminate
what else there is and could be known.

Today, when bold, controlled thought is looked at with astonishment
and is even condemned by those wielding negation signs, it is a great
pleasure to read the writings of Hausman, who is both thoughtful and
bold, careful and imaginative, critical and sympathetic. I think, though,
that he moves too quickly, and also too far beyond where the evidences,
dialectic, and a consideration of creativity requires. As a result, he leaves
one expectative, perplexed, not convinced, and worried whether or not
his excesses have counterparts in one's own account. My suspicions are
heightened when he says that "Only the cosmos could be creative." What
has happened to artists, mathematicians, scientists, those who seek to be
noble, to leaders, and to statesmen?

Hausman needs a pinch of Plochmann's absorption in particular
creative works and their producers, just as surely as Plochmann needs to
be alert to the issues that led Hausman to refer to a cosmic teleology.
Better still, would be a reining in of their different but equally insistent
steeds, and more attention paid to finding out where they are, where they
should go, and why. I never thought I would find myself somewhere
between their extremes.

With Hausman, I know that creativity cannot be understood unless
attention is paid to the nature and roles of the factors that creative work
uses in but a few of many possible ways. Some of these are realized by
carrying out other enterprises. Metaphysics attends to all of them, as not
necessarily confined or used in limited ways. It is the task of basic

inquiries into the nature and import of other enterprises to see how primary realities have diverse specialized uses in different major areas. I think that on that truth Hausman and I—and I think quite a number of others who have contributed to this volume—are in accord.

P.W.

26

Robert E. Wood

PAUL WEISS:
METAPHYSICS AND AESTHETICS

Paul Weiss is first and foremost a metaphysician, founder of the Metaphysical Society of America and of *The Review of Metaphysics,* author of the comprehensive *Modes of Being,*[1] whose fundamental notions he developed further in *Beyond All Appearances,*[2] in *First Considerations*[3] and, most recently, in *Creative Ventures.*[4] But in applying his metaphysics, the realm of aesthetics has been of special concern, the object of four of some thirty books. His approach to art is ontological: for Weiss art reveals the texture and pulse of that mode of being he termed *Existence* (MOB, 2.85). Given that, our approach to the general theme, metaphysics and aesthetics, will be in three steps: (1) we will briefly lay out the general features of Weiss's metaphysics and say something of his own engagement with art; (2) we will develop to a greater extent his peculiar notion of Existence; and (3) we will comment upon key features of his notion of art as it displays the character of Existence so conceived.

I

Paul Weiss's thought has been governed by the dictum of his teacher, Alfred North Whitehead, that philosophy is the search for "the complete fact" from which, in our daily lives and in our specialized disciplines, we make particular abstractions. Without a comprehensive view of "the complete fact," we are affected by one or the other version of what Whitehead called "the fallacy of misplaced concreteness."[5] Weiss taught that lesson consistently through some thirty books. Consequently, his approach to any region of inquiry—whether it be history, ethics, politics, human existence, nature, God or, in the case of our inquiry here, art—treats the region comprehensively as it exhibits the comprehensive or transcendental features ingredient in all entities.

Weiss's first work, *Reality*,[6] distinguished, for each encountered entity, an indicated ("this"), a contemplated (statement of a type or kind), and an adumbrated (a whole only partially revealed by the indicated and contemplated components in any judgment) (R, 78–79). Weiss went on in his central work, *Modes of Being*, to distinguish four modes or regions of being which he then termed Actuality, Existence, Ideality, and God, correlated with his earlier realm of reality in which the indicated, contemplated, and unified appeared (MOB, 1.60–1.68). The modes correspond roughly to the Platonic notions of things (and souls), the Receptacle, the Forms, and the Demiurge. (On the Receptacle, see MOB, 3.01, on the Forms, 2.09, on God, 2.15, 4.19 and 4.63.) For Weiss these four modes are transcendental properties, found in every actuality.[7] With the possible exception of Actuality, each is a region apart from the things which participate in it (MOB, 1.09, 2.11, 3.01, 4.87). Being itself is the togetherness of the modes (MOB, 1.96).

Later, in *Beyond All Appearances* (arguably his best book), the modes are renamed "finalities" and Actuality is no longer a mode but the name for the plurality of entities which interplay with the finalities. Ideality gets renamed Possibility (following the alternative usage in *Modes of Being*); God and Existence remain the same in name, while Substance and Being get added as two additional finalities (BAA, 232). Being is "the equalizer," presumably minimal being-outside-of-nothing in which all things share (BAA, 275–77). Substance is matter or stuff, but, curiously, as having a kind of encompassing inwardness reached, according to Weiss, by the Taoist sage (BAA, 267ff. and FC, 114, no. 52). In any case, modes of being or finalities are present in individual actualities and stand over against them as encompassing wholes. The latter claim is correlated with various kinds of "mystical" or quasi-mystical experiences of one's being encompassed by a kind of totality. Where one might be inclined to view the experiences as in some sense equivalent, Weiss distinguishes them by their objects which he views as differing finalities: Taoist (Substance), Parmenidean (Being), Platonic (Ideality), religious (God), and aesthetic (Existence).[8] Weiss's general method is to isolate a finality opened up by its corresponding experience of encompassment, determine its intrinsic properties, and then display the way its relation to the other modes or finalities affects its structure. He then applies the analysis to differing types of actuality. In the case of our present interest, he applies it to to art.

Art has been a special object of his attention, not only as an object of philosophical analysis, but also as an object of practice. Shortly after the publication of *Modes of Being*, Weiss obtained a sabbatical leave during which he gave himself over to the practice and the study of the arts. He

moved into Greenwich Village, took courses in painting, acting, poetry, and ballet and saw enough plays, as he said, to last him for five years! He took up painting with a passion and has continued to turn out canvases ever since. One room of his apartment contains a bolt of canvas, a staple gun, a pressedwood board as an easel, and a set of paints and brushes. Next to the easel, to the right and to the left, are piles of finished canvases which continue to pile up as he vigorously explores the relation between color and form in mostly abstract works.

From this immersion emerged four books dealing with art: *The World of Art,*[9] *Nine Basic Arts,*[10] *Religion and Art,*[11] and *Cinematics.*[12] The first two were published together, one exploring the basic features of the art-world, the other various art-forms. In terms of Weiss's general metaphysics, as we have said, the world of art belongs in a special way to the mode of Existence, to which art provides a privileged access. While we may come to know something of the properties of Existence abstractly in philosophy, according to Weiss it is in art that we come to apprehend the texture and pulse of Existence itself as benign or threatening to human existence (NBA, 26).

II

"Existence" is correlated with 'this' as the indicated in a judgment of the form "This is X." It is consequently linked to the spatio-temporal location of mutable particulars. However, this is only the surface of Existence. In a general definition, Weiss says that "Existence is being, as engaged in the activity of self-division" (MOB, 3.01). It is thus the principle of plurality both among and within entities. For Weiss, following the etymological derivation of 'existence' from *ex-sistere,* "to exist is to stand out or away from; it is to be engaged in an act of opposition which is self-opposing. . . . Existence is opposed even to its own unifying essence" (MOB, 3.01).

But division also establishes relations, and Existence is thus said to make things present, to set them over against one another, to interrelate them as well as to render them dynamic (MOB, 1.01, 1.22, 3.103). "Making present" presumably involves both spatiality and temporality, i.e. being here and now. As self-dividing, Existence grounds the otherness involved in space, in time, and in what is variously called energy NBA, 33–34), process (C, 72), becoming (WOA, 79), dynamism (NBA, 23), flux (MOB, 1.10) causality (CV, 65), transformation (CV, 64) and vitality (MOB, 3.01). Space, time, and causality are general features of any entities involved in encounter. In the language of *Modes of Being,* which

is the language governing the first two volumes on art, space is involved in the relation of Existence to Actuality (MOB, 3.06, 3.09, 3.12), time in its relation to Ideality (MOB, 3.07, 3.10, 3.12), and energy in its relation to God (MOB, 3.08, 3.11, 3.12). Space is the medium of separation and connection between actual entities; it is subdivisible ad infinitum. Time generates a future insofar as entities are related to realizable prospects in the realm of Ideality; time's relation to space seems to account for contemporaneity (MOB, 3.09); presumably its relation to God as unifier accounts for pastness. It too is endlessly self-divisible. Energy is more problematic.

First of all, "energy" does not seem equivalent to the other terms used to describe this third feature of Existence. "Process" is passage, while energy is the source of passage, that which makes it possible. "Causality" involves a relation between the source and the process derivative from the source. "Vitality," literally applying to what has life, can only be used metaphorically here as an equivalent to the other terms. "Process," "becoming," and "dynamism" are more closely equivalents. "Transformation" is the result of causality. As specifications of Existence, all terms involve continual othering.

Secondly, whatever the term employed, it is not so clear how what is designated by "energy" is a feature of self-divisive Existence in its relation to God as unifier, as we have noted above. How is the unification of Existence as othering to be viewed as "energy"? As perpetual othering seeking identity, as "the restlessness of space-time" attempting to mirror the One?

By way of comparison with Weiss's claims here, in the ancient and medieval traditions, the various functions Existence is made to bear by Weiss are distributed through different principles. "Matter" is the principle that makes change both possible and necessary; it is existent negativity, nonbeing within being. It is simultaneously the principle of the multipliability of an intelligible form in many different times and places. Space and time follow from matter. Time is the measure of relative rates of change between entities. And space follows from having parts outside of parts that itself derives from materiality as existent capacity not to be. Indeed, having parts outside of parts is what allows things to come apart and also to come together in the time-process. Both space and time display the negativity of their underlying principle: space is a kind of existent emptiness, time the movement out of the no-longer into the not-yet. "Energy," derived from Aristotle's *energeia,* follows from form as specification oriented toward its full unfolding, but as informing matter in such a way that the informed entity must change in order to come into full possession of itself.[13] In Aquinas, "existence" is

the positing in actuality of entities whose essence, based upon different relations of form to matter, limits the extent to which a thing exists. Such limitations of existence by essence are made possible by reason of their being caused by one whose essence does not limit but is identical with existence, namely, God. The function of the copula in the judgment of existence refers proximately to the fullness of a given entity and ultimately to God as pure existence.[14]

In Weiss's view, the function of the copula refers to the unified wholeness of a given entity as drawn into unity by God; but for him the notion of Existence, as we said, is correlated with the ostensive term 'this' as indicating spatio-temporal presence. For Weiss also absolutely everything participates in Existence whose basic characteristic is "othering"— and that to such an extent that it is other than its own essence, which requires the existence of God to impose that essence (MOB, 3.102, 4.21). It is not fully clear whether space, time, and energy are necessary features of Existence so conceived, since God is conceived as existing, needing space, time, and energy to *manifest* Himself, but apparently not to *exist*. God is not in space and time but is capable of entering them (MOB, 1.09). It is Existence that makes God "explicit, exteriorized beyond His pure potentiality" (MOB, 4.64). Indeed, *all* the modes of being exist— even Existence exists (MOB, 3.59). There seems to be some confusion between the functions of Existence as interrelating and as making present, and between modes of interrelating which are spatio-temporal and those which are not, e.g. in coherent relations between meanings in the realm of Ideality. In Weiss's thought there are transtemporal and transspatial modes of interrelation (Ideality) and presence (God), so that spatial, temporal, and (physical) causal relations are not the only ways of being present or of interrelating. Existence is thus made to do double duty vis-à-vis the Aristotelian tradition: to account for change and multiplicity under a form, and thus for space, time, and dynamism, as well as to account for an entity's being at all. It would seem to make more sense to transcendentalize existence as englobing being-outside-nothing, and to locate space, time, and (physical) causality as expressions of enmattered form, as in the classical tradition, and indeed, *mutatis mutandis*, in the tradition of German Idealism. In distinguishing regions of being, each region would then have its own principle of plurality: materially grounded beings, intelligibles (whether concrete or abstract forms), and God. We would not then have "existence" carrying the multiplicity of functions Weiss would have it perform.

In his more recent work, *Creative Ventures*, there is both a terminological and conceptual shift in his consideration of the realm of Existence. The term 'Existence' is no longer employed. The region is now called

'voluminosity', having the articulations of space, time, and causality (source of transformations) which were the defining properties of the earlier Existence. And, set over against the five modes or finalities or what are now termed "conditions" or "ultimate conditions" is "the Dunamis" (cf. esp. CV, 311–25). Things and ultimate conditions together are rooted in the Dunamis, which now takes on part of the earlier role of Existence (CV, 4–6). Contrasted with ultimate conditions, the Dunamis is becoming, process, transition (CV, 72, 96). Like earlier Existence, it is self-fractionating (CV, 324). Through it things are made to pulsate, to vibrate. Even static things exhibit its vibrancy (CV, 72) as well as its connectivity (CV, 75). Weiss is now separating causality and consequent transformation as expressions of voluminosity from energy, becoming, process, vitality, vibrancy, pulsation as expressions of the Dunamis. The Dunamis is now said to be that which Chinese painters seek to contact before beginning their painting (CV, 78)—something he had previously associated with Substance. However, though the Dunamis is revealed in a special way in the arts, it is also revealed in creative endeavors in all the regions of experience.

The verbal transformation from "Existence" to "voluminosity" fixes attention upon magnitude: on the extensive magnitude of spatial and temporal volumes or spans, and the intensive magnitude of causal "volumes." The term seems to have been transferred from the spatial to the other parameters. The peculiar vibrancy of such volumes shows the deeper dimension of the Dunamis.

Since all the conditions or modes or finalities participate in each other and are found in everything, it is difficult to see why the Dunamis is set over against all of them and not located, following his earlier view of Existence, as the depth beneath voluminosity. But the all-encompassing character of the Dunamis, in distinction from the all-encompassing character of each of the conditions, seems to underscore for Weiss the outstanding importance of what he variously describes as energy, vitality, creativity, vibrancy, pulsation. Perhaps this move is the fruit of his own distinctive mysticism: the experience of the creative energy which suffuses the totality and which perhaps constitutes the peculiar basic attunement of Weiss's own psyche. And for him the Dunamis expresses itself in such an overwhelming way that everything else—God not excepted—pales in comparison. Here, at any rate, he seems to return again to his teacher Whitehead for whom everything, God included, is in the grip of a primordial creativity that seems to make it more God than "God."[15] One wonders what happened to the function of Existence which was to make present as well as to interrelate contemporaries. The Dunamis is said to ground the latter, but what grounds the former? Is it

Being (along with Substance a precipitate out of the former Actuality)? Each thing is a being, it exists, insofar as it stands out of nothingness and is thus other than any other being. Since the concept of Existence had its three features of space, time, and dynamism derived from its relation to the other three modes of Being in the earlier view, should not Weiss's later account lead to the derivation of other features or show why there are no new features revealed? And since, as we will explore a bit below, Weiss's treatment of the forms of art depends upon the three basic features of Existence in the earlier version, that should have, but has not, impacted upon his division of the arts.

III

The human being is able to have access to the encompassing regions of being because the human alone is able to internalize being and thus to have access to the whole and to the wholeness of any being or region within the whole (R, 144ff. and 284). In his earliest work in metaphysics, art is said to open up for humans "the whole of reality as inward and substantial" (R, 116). In his later, more sustained treatment of art, its scope is restricted: it operates in relation to Existence or voluminosity-cum-Dunamis (which we will henceforth refer to as Existence/voluminosity for short). Art allows us to move from sensory surface into the ontological depth of that which underlies the space, time, and energy of the things that appear in our sensory field. The artist "adumbrates what lies below by reorganizing what lies above" (WOA, 59; MOB, 1.88). The work he creates is an icon of the environing region indicated by Existence/voluminosity which allows us to participate in it more profoundly (WOA, 147). In human experience, though not explicitly focused for the most part, there is always a move from the encountered individual to the type and to the whole of being. But, as Dewey also indicated,[16] in the work of art we are brought into explicit contact with the whole as a world behind the world of our everyday dealings—only for Weiss it is the whole of its region and not the whole of being that is rendered focal in the work of art.

Because he takes this to be the case, Weiss relegates ordinary conceptions of representation to a purely secondary place. "Familiar objects will in fact often make one miss the underlying reality which the painting [e.g.] is to exhibit" (RA, 59). The familiar world is relatively superficial, with the depths of being covered by conventional understandings and relations (NBA, 61). But no work of art, qua work of art, is

representational in the ordinary sense, simply mirroring the convention-
alized appearance of things (WOA, 153). In a profounder sense, however,
it is representational—or we might better say *presentational*—of its
ontological region as a whole. For, like Dewey, Weiss does not consider
this depth-dimension as merely referred to, but as exhibited in the very
sensuousness of the work of art. Weiss cites with approval Walter Pater's
remark that all art seeks the status of music which typically does not
represent an object in the world (NBA, 51). Yet, as Aristotle noted, music
is, in another sense, the most mimetic of all the artforms because it
presents us, in its effects, i.e. in the emotions which it arouses, with
"imitations" of emotions indistinguishable from those aroused by natu-
ral objects.[18] And for Weiss, human emotion is our peculiar way of
participating in the region of Existence/voluminosity.

The location of artworks within the three basic features of Existence/
voluminosity is linked on the one hand to the character of the media with
which artists work and, on the other, to the emotions which are drawn
upon and appealed to in artworks. The media are sensory in quality and
sensa are the primary locus of the appearance of space, time, and energy.
In an artwork the sensa are like metaphors: "they are juncture points
where the external world meets and infects his [the artist's] expressions
and our interpretations" (WOA, 152–53). They point beneath them-
selves to Existence as underlying both objects (natural and fashioned)
and subjects (creative and appreciative), welling up in our emotional
stances and responses. However, unlike metaphors, they make present
what they signify.

Though the theme of emotion appears throughout his treatment of
art, Weiss gives special attention to it in the "Philosophical Interlude" of
his *Cinematics*. Art in general employs the peculiar texture of different
materials by drawing upon and appealing to emotions that lie beneath
the emotional levels of everyday life and thus awakens our awareness of
what underlies the everyday surface of the objects correlated with our
everyday emotions (C, 150). Emotion for Weiss belongs to the core of a
person: "a man at his center is an undifferentiated emotional continuum
of varying density" (C, 133). Emotion is a fundamental way in which a
person participates in Existence, the way in which its dynamism is
manifest interiorly. "Man's creative powers and emotions . . . are them-
selves but guises which Existence for the moment assumes" (WOA, 8;
NBA 33, 55).

"Given articulation and pace, definiteness and direction by works of
art, those emotions are fully terminated by the very existence from which
they issued" (C, 149–50). In this way, emotions are "purged" in every
artform, and not simply through tragedy as originally emphasized by

Aristotle (WOA, 95; NBA, 199). And this purgation is understood, not simply as a calming of otherwise unruly emotions, but as simultaneously involving a manifestation of the depths of Existence. Such a purging, deepening, and focus is what makes artworks superior to the beauties of nature itself (Cf. WOA, 7, 141, 155).

Weiss distinguishes four levels of emotion, which allows him a basis for distinguishing works of art by their potential effects. Arranged from the most superficial to the most profound, there are feeling, attitude, mood, and tone. *Attitude* is more enduring and encompasses and directs the surface phenomena of feelings. It is subdivided into *dominant* and *deep*, with *basic* attitude as the ultimate term of a deep attitude. The subdivision indicates emotional stances that approach the core of a person, the deeper allowing one to judge and transform the more superficial. 'Mood' is employed more technically and somewhat against common usage to refer to the depth of a person who has adjusted to a given culture, whereas 'tone', again technically precise in its meaning, refers to that central emotional stance that allows oneself to be measured by nothing less than the full character of what is (C, 132–50).

Based upon this stratification of the emotional life, Weiss distinguishes popular, "dramatic," classic, and innovative artforms.[18] Popular works appeal to feeling, dramatic works to attitudes at various levels of depth, and classical works to mood. Like the terms 'mood' and 'tone', 'dramatic' is used in a seemingly arbitrary way, for drama in the ordinary sense can function at any level. As far as the classic is concerned, Weiss views it here more as an effect of culture than as revelatory of final reality. It is innovative arts that affect our basic tone, bringing us beyond convention to the depths of Existence (C, 155). That claim may seem odd, since one would have thought that the classic was such, not because of its conventionality, but because it most deeply draws those sensitive to it into the depths of what is. But Weiss, relentless seeker, is particularly sensitive to the kind of stodginess, inertia, complacency, and resistance to novelty that frequently characterizes the devotees of classics who forget that classics themselves were once innovative. Weiss is also sensitive to the limited character, tied in with the culture within which it emerges, that afflicts any disclosure. Innovative work breaks through closure and, if it is successful, brings us into deeper contact with final reality. Note the proviso, "if it is successful," since novelty is no guarantee of depth but may be an indication of the contrary. The fundamental tone most correspondent to what is involves the fusion of opposite stances: bold submissiveness and critical sympathy along with creativity—a fusion constituting the dispositional ground of the truly speculative thinker (C, 146).

Applying this synthesis of opposite attitudes to the artworld, one can see two strains running through Weiss's account of the arts. The dominant strain is the attempt at *mastery* of Existence both in artistic creation and in appreciation, as part of a general project of "conquering reality" (WOA, 37, 38, 40, 52, 73). And yet, in relation to finalities in general, we are invited to move beyond grasping and controlling to being apprehended (BAA, 87, 89ff.). It is vigorous, creative activity, impelled by the will to power, that can lead us to a real openness to what lies beyond our control. One sees here a parallel with Heidegger's comments on the work of art: only the vigorous can come to a disclosure which commences in mastery and culminates in "letting be."[19]

In *Nine Basic Arts* Weiss attempted a systematic classification of artforms based upon the three basic features of Existence: space, time, and dynamism. He interrelated that division with a distinction between enclosing, occupying, and epitomizing an area to yield a nine-fold division (NBA, 13–26).[20] Thus we have the *spatial* arts of architecture, sculpture, and painting, the *temporal* arts of musical composition, story, and poetry, and the *dynamic* arts of musical performance, theatre, and dance. The distinction between the temporal and the dynamic seems hard to sustain until we realize that the temporal seem to involve writing and "internal" reading, whereas the dynamic involve external performance, the employment of energy. The division allows one to think through the difference between composition and performance in music and between script writing on the one hand and acting and directing on the other. But then one should also distinguish preliterate storytelling, which may perhaps be viewed as truncated theatre or as that which has its fullness in theatre. And one should above all consider oral performance in poetry whose sonorousness is essential to its character. It is indeed music in words.

Weiss conceives of the enclosing arts as laying out the operating region for the other artforms under their respective existential domains. Thus architecture lays out the spatial domain which sculpture occupies and painting epitomizes; musical composition lays out the temporal domain which story occupies and poetry epitomizes (NBA, 123); and musical performance lays out the dynamic domain which theatre occupies and dance epitomizes (NBA, 183). These claims are perhaps the most difficult to see and thus to accept. Perhaps it is more evident in the case of architecture in relation to sculpture and painting because it is a matter of historical fact that buildings house paintings and create locations for sculptural pieces. But Weiss seems to have something more in mind than that simple historical fact. It is the way space is manifest

emotionally as having import for human beings that is the focus in his account.

How does musical performance establish the dynamic domain that theatre occupies and dance epitomizes? For dance it is clearer, since dance is typically accompanied by music. For theatre, however, there can be, but usually is not, musical background. When lacking in such background, how is theatre's dynamic domain laid out by music? Perhaps only in the sense that our sensibility has already been affected by music, but then is there reason to restrict its effect and does not that affected sensibility operate in all the artforms? In film, the musical soundtrack is frequently evident. But might one not also claim the reverse, that it is our sense of dramatic dynamism that creates the real domain that musical performance articulates in its own way? Aristotle, as we noted above, claimed that music is the most imitative of the artforms insofar as it produced emotional states indistinguishable from their real counterparts.

Most problematic is the way musical composition is said to enclose the temporal domain occupied by story and epitomized by poetry. This returns us to the general problem with the distinction between the temporal and the dynamic forms. At least in the cases of musical composition and script writing (and, as we have contended, the writing of poetry), writing is oriented toward performance. Perhaps one should think of choreography as the parallel temporal art oriented toward dance as performance, but then where do we put poetry? As we noted previously, it seems that what is common to the so-called temporal arts is the fact that they are written and thus can be read silently rather than performed externally. However, with the exception of the novel, silent reading is truncation: musical composition, dramatic script, and poetic composition are oriented toward external performance.

We might note further, there are no apparent parallel relations between the spatial arts and the others as there is between the temporal and the dynamic, performing arts—at least Weiss does not make such relations explicit. There are, however, general relations insofar as every artform, though focused upon one of the three basic features of Existence/voluminosity, has spatial, temporal, and dynamic aspects (NBA, 34–35). Even music has a spatial aspect, not only filling space but also exhibiting farness and nearness, contraction and expansion in high and low notes (NBA, 173–74). In *Nine Basic Arts* this spatiality of musical performance is what Weiss termed "voluminosity," which explains his transfer of this term to the entire region explored by the arts. But it is the dynamic, the pulsating, the energetic, found in spatial and

temporal tensions and their resolution—the feature ultimately expressive of the underlying Dunamis—that is, for Weiss, a special feature of all the arts. One sees clearly that the space, time, and dynamism involved in the arts is a far cry from the equivalent notions in Newtonian mechanics. The arts give articulation to the space, time, and dynamism of the human lifeworld. Only the artworld as a whole brings us into the full richness of the manifestation of Existence/voluminosity (NBA, 223).

There is an artform which cuts across the proffered division and includes space, time, and dynamism in a focal way: film. Weiss was dissatisfied with his treatment of it as a compound art in *Nine Basic Arts*, considering it an independent art form that has equal footing with the nine he treated.[21] Twelve years later he devoted an entire book to it: *Cinematics*. He approached it basically in terms of the several kinds of artists that are involved in its creation: scriptist, performer, "cinemaker" (cameraman), "montagist" (editor), and director, apparently correlated with the five finalities he had explored in *Beyond All Appearances,* a work that appeared the same year as *Cinematics* (C, 127). He judged that "film, because of its involvement with all the external dimensions of actualities and existence can challenge expressions of established attitudes and feelings from more sides than anything else can" (C, 163). Film takes us more surely and directly to existence than any other art form (C, 35). The appeal of film is broader than any other artform because it deals with basic values of vital interest to all and with a directness and vividness available in no other medium (C, 17). Yet Weiss also claimed that film has been largely popular and dramatic, too young a medium to have produced real classics and thus significant innovation.

Because of the employment of sensuous media, the arts reveal what underlies space, time, and dynamism as a single encompassing region. But because the modes or finalities or ultimate conditions are transcendental, other modes appear also in art. Their appearance, however, occurs under the modification that Existence imposes upon them. Thus in film, in story, or in theatre, e.g., Ideality displays itself as it is brought into the dividedness of Existent reality. The artforms present the lure of human possibility and the demands of obligation as they impact upon the spatio-temporal domain of human action. In religious art the various domains display different properties of God: in the spatial domain it is God's omnipresence that is displayed, in the temporal His omniscience, and in the dynamic His omnipotence (RA, 76). Because of a tendency toward preference by religious people for representationalism, and because of the general problems of emotional superficiality correlated therewith which we have noted above, religious art may profit more from

modern abstract art which Weiss views as "singularly appropriate" for religious expression (RA, 60).

Weiss claims a difference in treatment of religious themes and even secular themes by a religious artist and one who is not religious, but without specific examples it is difficult to see what that might really mean (RA, 38, 79). Indeed, one of the problems with the abstract and systematic level at which Weiss operates lies precisely in the dearth of specificity that might both better clarify his claims to the reader and test them in themselves. But no matter what the relation to the other regions that artworks embody, the very character of their display, provided we are properly attentive, brings us primarily into the depths of what underlies spatiality, temporality, and dynamism. Indeed, one of the problems with our failure to appreciate the arts properly is our tendency to view them in terms of their relation to other regions, and thus to obscure their real function.

As I said previously, the shift of focus in Weiss's recent work, correlated with a terminological shift, separated off the creative ground, the Dunamis, from voluminosity. This involved, I claimed, the need to relocate the function of existence, ordinarily understood, to the region of Being. But perhaps something may be lost for the arts in the shift: it is the notion of *presence,* the expression of existence as being-outside-nothing. The emotional tone which it both articulates and evokes is one of *awe,* of *astonishment* before existence. The spatial arts in particular bring that presence to stand as they confront us with the demand: cease your alienative flight to what is elsewhere and learn to be present! Beyond the flowing Now they present us with a standing Now and introduce us to the fringe of eternity. But maybe they can do this insofar as we have learned, perhaps through the performing arts, to gather time and create an encompassment in the Now, both through the nonrepresentative character of music and through the representations provided in both the verbal and the spatial arts. But whether accompanied by representation or not, the arts mediate the immediacy of deepened presence by the employment of sensuousness and the spatio-temporal dynamism belonging to sensuousness. Along these lines we might be enabled to think the unity of the arts further, following the direction which Weiss has provided.

Paul Weiss's works draw their fundamental inspiration from persistent and comprehensive explorations in metaphysics. Boldly submissive and critically sympathetic, he has creatively explored every nook and cranny of human experience and what it entails. His works have exhibited the fundamental energy that drives this truly speculative man.

And it is perhaps because of this energy within that Weiss has had a special appreciation of the arts as the locus of the primary display of the Dunamis. Through four books and the continual practice of painting, he has come to fundamental insights into the ontological depth of the artworld. I have provided but a glimpse of that depth. I offer this bit as a token of my appreciation for a truly exemplary thinker.

ROBERT E. WOOD

DEPARTMENT OF PHILOSOPHY
UNIVERSITY OF DALLAS
JUNE 1992

NOTES

1. *Modes of Being* (Carbondale, Ill.: Southern Illinois University Press, 1958). Henceforth MOB, followed by section number.

2. *Beyond All Appearances* (Carbondale, Ill.: Southern Illinois University Press, 1974). Henceforth BAA.

3. *First Considerations: An Examination of Philosophic Evidence* (Carbondale, Ill.: Southern Illinois University Press, 1977). Henceforth FC.

4. *Creative Ventures* (Carbondale, Ill.: Southern Illinois University Press, 1992). Henceforth CV.

5. On "the complete fact" see *Adventures in Ideas* (New York: Free Press, 1967), pp. 146 and 158; on "the fallacy of misplaced concreteness," *Process and Reality: An Essay in Cosmology* (New York: Harper, 1960), p. 11.

6. *Reality* (Carbondale, Ill.: Southern Illinois University Press, 1938). Henceforth R.

7. For a comparison of Weiss's modes of being or finalities with the traditional notion of the transcendentals, see Daniel Dahlstrom, "The Appearance of Finalities," in *Creativity and Common Sense: Essays in Honor of Paul Weiss* (Albany: SUNY Press, 1987), pp. 55–75.

8. See my "Weiss on Adumbration," in *Creativity and Common Sense,* p. 52.

9. *The World of Art* (Carbondale, Ill.: Southern Illinois University Press, 1961). Henceforth WOA.

10. *Nine Basic Arts* (Carbondale, Ill.: Southern Illinois University Press, 1961). Henceforth NBA.

11. *Religion and Art* (Milwaukee: Marquette University Press, 1963). Henceforth RA.

12. *Cinematics* (Carbondale, Ill.: Southern Illinois University Press, 1975). Henceforth C.

13. For a grounding and development of these notions and for their classical textual loci, see my *A Path into Metaphysics: Phenomenological, Hermeneutical, and Dialogical Studies* (Albany: SUNY Press, 1990), pp. 125ff. esp. pp. 155–74.

14. See *A Path into Metaphysics,* pp. 181–89.

15. *Process and Reality,* p. 11. One might add that God virtually disappears from *Creative Ventures,* being mentioned in passing but six times, once to indicate, along with His not being needed to account for the distinctiveness of human souls, that of the reality of the idea of God no one can be sure (CV, 165)—and this after Weiss's having indicated in *Modes of Being* that there are a plethora of proofs for His existence, only a few of which have been explored by the tradition (MOB, 4.50–4.60).

16. *Art as Experience* (New York: Putnam, 1934), pp. 193–95.

17. *Politics,* 1340a 20.

18. Though in the context of *Cinematics* from which this analysis is drawn the distinctions are made with respect to film in particular, it should be applicable to all artforms.

19. "Origin of the Work of Art," in A. Hofstadter and R. Kuhns, *Philosophies of Art and Beauty* (Chicago: University of Chicago Press, 1964), pp. 686–87, 689–90.

20. Beyond Weiss's mere listing of three artforms under each of the three features of Existence in terms of an unexplained and underived distinction between enclosing, occupying, and epitomizing, Kenneth Schmitz has attempted a "deduction" of the subdivisions of the arts of space, time, and dynamism through the interplay under each of the other two. ("Art and Existence: Reflections on Paul Weiss's Modal Philosophy," *Review of Metaphysics,* Supplement, [June 1972]: 79ff. and 93.) It was an effort whose value Weiss did not recognize ("A Response," ibid., p. 157).

21. "A Response," p. 157.

REPLY TO ROBERT E. WOOD

Robert E. Wood knows how to read carefully, and knows what he reads—not a small accomplishment. His examination of the idea of adumbration is becoming more and more recognized to be a definitive examination of the subject. I have already dismissed the claims by others that I hold a mystical or quasi-mystical view. Wood leads me to suppose that the attribution is a consequence of my referring to the ultimates. Would a mystic accept the claim that these are evidenced through acts that begin with instantiations of those ultimates and move intensively to them? Would it not be more accurate to say that a mystic is supposedly transformed by an eternal being to which he gives himself, in which he loses himself, and which he confessedly cannot understand? While a philosopher might turn in the same direction as a mystic does, he continues to insist on the distinctiveness of himself and the realities he understands. Evidencing the ultimates that are instantiated in every domain, he moves beyond where he daily lives with the help of distinctive emotions. He never does or even tries to lose himself in anything else; instead, he continues to remain apart from all, while that with which he begins becomes more and more involved with or perhaps turned into outcomes he can understand. Evidencing the ultimates that are instanced he moves beyond where he daily lives; expressing distinctive emotions, he never tries to and never does lose himself in anything. Instead, he continues to remain apart from all else, while that with which he begins becomes more and more turned into outcomes that he can understand.

I am sorry to see that Wood takes no account of what is said about art in *Creative Ventures*. Although that work does not diverge radically from what is maintained in the works he cites, it does move beyond them, and makes it possible to see how art is both like and unlike other creative

ventures. Had this been done, 'aesthetics' would not, I think, have appeared in the title of his paper, particularly since aesthetics has more to do with the appreciation of art than with its warrants and production. Wood is right to take my use of 'energy' in *Modes of Being* to be questionable. I soon abandoned it, together with references to 'God.' Somewhat in the spirit of Plato and Peirce, but without their genius, I have taken up topic after topic without much regard for what had been maintained before; although I did not use crucial terms in the same ways on all occasions, I did try to avoid giving crucial terms different weights and roles in different works, perhaps accompanied by qualifiers.

An unexamined question: What are the constraints to which one is subject, if one tries to tackle basic issues afresh each time they arise, particularly in different contexts and when approached from different angles? The issue becomes complicated once it is realized that some of the older usages may not be appropriate to what is maintained in new, previously unsuspected areas. The answer perhaps is already indicated in the question: different terms relating to the same topic, and the same term applied to what are quite different ones must be understood in their contexts.

"How is the unification of Existence as othering to be viewed as 'energy'?" Most of what had been designated by 'energy' I would now take to be expressive primarily of the Dunamis. I would not look to a God as its source or ground. God, I have maintained again and again in the last decades, is the concern of pious men, of whom I am not one. The closest I come to a reference to such a God is in the acknowledgment of Being, as that which necessarily is; it is, though, no more and no less than the uncreative source of the ultimates and, through their aid, of whatever else there be.

Wood offers a fine condensed account of the traditional meaning of 'matter'. That does not mean that he has made it more intelligible or acceptable, nor shown how, though primarily inert, it could make change both possible and necessary. I wish he had made evident what he meant by an 'existent negativity' and a 'nonbeing within being'. Is a 'nonbeing' real? Could it be a locus for or a sustainer of anything? Why hold that the copula refers to the unity of an entity produced by God? Don't actualities have their own unities?

The difficulties that Wood finds with the account of Existence in *Modes of Being* were avoided when I finally escaped from the limits within which modern logic had confined itself. As a consequence, it is now possible to read what is said about Existence in that work and avoid the difficulties to which Wood refers.

To whatever extent it is true that actualities are 'rooted in the

Dunamis' it also is true that they are rooted in the other ultimates. Wood recognizes that there is something amiss in setting the Dunamis over against all the others. What also should be affirmed is that the Dunamis, with the Rational, plays a major role when one passes from one domain to another, or from any actuality to the ultimates.

The reality of an actuality, or of anything else, is not maintained against a nothingness. A nothingness does nothing; there is no need to take a stand against it. If anything ceases to be it is because some other reality did not permit it to continue.

What I once maintained about art some decades ago needs to be corrected in the light of what became manifest in *Creative Ventures*. The Dunamis, most evidently, but the other ultimates as well, are reached in depth at the end of an appreciation of created works in different ventures. The acknowledgment of that fact carries forward the insight of Aristotle's understanding of tragedy, and reinforces the romantic (and surprisingly, Dewey's) awareness of the revelatory power of created works of art.

Was Aristotle right to take music to be the most mimetic of all art forms? Does it present to us "in the emotions which it arouses intimations of emotions indistinguishable from those aroused by natural objects?" The sadness I feel when I see Othello kill Desdemona is worlds apart from the anger, terror, and shock I think I would feel were I to see a man actually kill his wife in a fit of jealousy.

I don't think that 'imitation', even when used broadly and flexibly could ever do justice to the novelty of what is creatively produced, even though it may help one become aware of what an appreciation of a work of art will finally signify in such a way that we will become caught up in it. No account of art will ever satisfy, if it does not recognize the commitment of the artist, the ideal of beauty to be realized, the use of the ultimates and material in the production of what had never been before, and that which would not have been had the artist not produced it. An artist does not try to imitate anything; a kind of Aristotelian imitation of reality would at best be the incidental result of the successful completion of an excellent work, or of its appreciation.

My examinations of art in different works supplement one another. They shore up Wood's perceptive remarks that a purgation of emotions is to be understood not as a 'calming of otherwise unruly emotions," but as manifesting the depths of Existence—or more precisely, of a voluminosity qualified by the other ultimates.

In the course of his excellent exposition, Wood remarks that the classic is what "most deeply draws" those who are sensitive into the depths of what is, though it must be quickly added that the essential

sensitivity is one that is aroused on the completion of a work or of an appreciation of it. It also enables one to recognize the radical commonality of what artists do and achieve in every epoch.

I do not believe as Wood does, that Heidegger was right in thinking that a disclosure "commences in mastery and culminates in 'letting be'," unless what is meant is that an artist at the completion of a work, like the appreciation of one who reads it well, opens up into a voluminosity conditioning whatever there be. Is that what is meant by saying that we let it be? Would it not be more precise to say that an excellent work enables one to become aware of what always is, beyond all particulars?

Achievements in art, and other creative ventures, supplement those of a philosophy that arrives at the ultimates through a process of evidencing. What they enable us to signify intensively, philosophy reaches through an evidencing; what is known through an evidencing is enjoyed at the completion of creative and appreciative acts. Apparently, as Plato maintained, something similar occurs in mathematics, though, I think, only if it is made the object of a creative activity rather than made the terminus of a dialectic arriving at what is already real. A Platonism in mathematics denies genuine creativity to mathematicians. It strains credulity to believe that the multiple types of numbers, algebras, geometries, and the like that we now know, could be known by a dialectician who had no knowledge of mathematics.

Wood, apparently, is no Platonist. What is not clear is how genuine creative work is seen by him to be related to realities beyond, and to be quite different in nature and status from them. Nor is it evident whether or not he thinks that only creative work in the arts allows one to become acquainted with an ultimate. One good reason it is desirable to study creativity in other fields besides that of art is to see how one can make immediate contact with ultimates other than the one that art takes to be prominent.

Wood raises the question as to whether preliterate storytelling is a kind of truncated theater, and whether read poetry is a music in words. I think he here verges on a confusion of genres. He is conflating two different kinds of storytelling, and two different ways of reading poetry. A shift in medium is not to be identified with a shift from one art to another.

Examining the nine basic arts that I had arranged in a diagram in *Nine Basic Arts,* Wood asks "how musical performance establishes the dynamic domain that dances epitomizes?" Music can provide an area that dance fills out. Cage and Cunningham, in their collaborative works, tried to make that fact evident. The question, "Might one not also claim . . . that it is our sense of dramatic dynamism that creates the real

domain that musical performance articulates in its own way?" This opens up a new line of inquiry, if it is understood to ask whether or not there is a primal, dramatic dynamism that the various arts make evident in distinctive ways. If there were something like art in itself, prior to or presupposed by all the different arts, this is what should be maintained. Should we then not also say that there is a mathematics, science, ethics, morality, and politics in itself that is specialized in different engagements in limited areas and ways? If we did, we would have to look for a single creative impulse instantiated in all creative activity. In effect, we would take what was common to a plurality of activities to specialize a common activity. Would we not then have to go on to envisage a primary impulse that was specialized in all creative and noncreative acts? In effect, would we not thereupon take all activities to specialize a single activity? Would we not then have to envisage a primary impulse that creative and noncreative diversely specialized? This is perhaps what Schopenhauer, Nietzsche, Bergson, and process philosophers have in mind. What stands in their way is the fact that we find humans and other actualities involved in particular activities, all of which, while instantiating the ultimates, have their own real, distinctive natures and activities, directed toward different objectives. There are large movements in which humans participate. If they did not have distinctive natures and powers of their own, how would they be able to specialize the primal power? If they were distinctive only in having the capacity to produce such specializations, how would they differ in fact and act from one another, particularly since a power to specialize would presumably be identical in all? Were it distinctive in each, we would already have what was more than incidental uses or specializations of a primal power. Although every actuality is constituted by joined instantiations of the same ultimates, each is also able to possess the result on its own. Were actualities no more than loci, never users or makers, none could ever be responsible or have the ability to create.

I offer no defense for the ways in which I had related nine basic arts; the scheme was offered as a guide. As such arts as opera and film make evident, there are also compound arts that do not fit within that nine-fold frame. Just as there was a time when there were no operas or films, so there will likely be a time when entirely new arts will be produced. It is hard to determine how to classify the masks of aboriginal tribes, Japanese acting, and Spanish bull fights. Maps should be used as aids, not as marking out an exhaustive set of sealed-off areas. As good teachers know, the title and outline of a course are just occasions for allowing teacher and student to inquire and reason together, until some official hears about it.

These comments verge on providing escape hatches, helping one avoid serious criticism. They should, instead, be understood to make manifest the fact that any limited inquiry, precisely because it is limited, is an over-specialized position in a much larger enterprise where other items make a difference to what had presumably been well marked off. The best we can hope to obtain is a justified, all-inclusive account of what there is, and where every other inquiry and its achievements find a place. None can be hermetically sealed off from all others, or be well-understood without making an at least tacit reference to the totality in which they have their separate roles. The major types of reality—Being, the ultimates, ideals, and whatever actualities and fields there be— require a better understanding than has so far been achieved by anyone. Were the philosophic enterprise completed, it would allow for no essential additions or subtractions. Both the constant and the changing would still deserve further exploration, the one to reach the fixed points from which the transient could be understood in principle, the other to provide occasions for arriving at final positions. Categories cannot keep what is from slipping out of control. One should use them to make it possible to study particular enterprises and their achievements in their primary relationships. Philosophy is always in process within the compass of what is and what must be.

Wood moves too quickly to the view that existence is outside nothing. What is this nothing? What does it mean to be 'outside' it? Do the arts "introduce us to the fringe of eternity?" Is this the point where Wood has grown tired of dealing with vexatious difficulties? If it is, it would have been easier and wiser for him to have begun and to have ended with his eternal solvent of what perplexes him.

He ends on a gentle, kind note. I thank him in the most generous way I can manage: the questions, doubts, and difficulties he raises are to be faced not only by me, but by him and everyone else.

I have been chiding Wood for not doing what he should have done or for not doing it well, and therefore, incidentally, for not showing where and why I have failed, and what I should have done instead. He provides a good beginning, but I do not think what he then affirms is as wide-ranging, or as well grounded as it should be, mainly because he does not stop long enough to examine creative activity in detail, before making his breath-taking leap toward what may not exist, no matter how splendid its title.

P.W.

27

Daniel A. Dombrowski

WEISS, SPORT, AND THE GREEK IDEAL

I. Introduction

Largely because of Paul Weiss, one no longer has to apologize for taking a philosophical interest in sport. If this were his only contribution to philosophy of sport he would deserve praise. But, in addition, he has left us with one of the classic conceptions of the nature of sport with which those interested in this field must contend, a concept which, as we shall see, relies heavily on Greek philosophy. Philosophers have come to realize that "The sporting world offers to many people the context of their hopes, the locus of their momentary reprieve from a burdensome reality, or the repository for the only kind of heroism which they can appreciate at this moment in history."[1] Strong as this claim is, it may be an understatement in that sport not only offers an enormous number of people their primary loci for heroism, hope, and an escape from ennui, but also their primary means for aesthetic and (yes) religious experience and, as we shall see, an important source of their joy.

My procedure in this article will be to summarize briefly Weiss's major insights regarding sport and then to put them in dialectical tension with the thought of some of his followers, most notably Randolph Feezell, who both amplify and criticize these insights. This dialectical tension, I allege, can result in a friendly resolution because Weiss and Feezell both are engaged in thinking through the consequences of certain Greek concepts which are integral to an adequate understanding of sport and because Weiss's followers are largely engaged in an attempt to think through in a consistent manner certain ideas presented in rough outline

and sometimes confusedly by Weiss himself. I shall divide the analysis of Weiss's ideas into three parts, which deal, respectively, with the Greek ideal of moderation, with sport as propaedeutic to the development of moral character, and with the connection between sport and the meaning of life.

II. Weiss on Excellence in Sport

Weiss complains that none of the Greek philosophers discussed the nature of sport, a neglect which became the norm for subsequent philosophers (5–6).[2] Yet Weiss is convinced that the Greeks *could* have written a treatise on sport, a treatise supplied by Weiss himself (7). That is, Weiss thinks of sport in Greek terms in that it is a source or instance of larger truths or first principles (8). The interest human beings at all ages and in all walks of life have in sport is due, according to Weiss, to a concern for bodily *excellence*. Human beings have the ability to appreciate the excellent and they want to share in it. The Weissian clue which reveals the essential nature of sport as a concern for bodily excellence is the fact that it is primarily young men who are *most* absorbed in sport. His argument is that there are many ways in which people can become excellent (intellectually, morally, or in terms of some *techne*), but young men have neither the maturity nor the experience to become excellent in these more profound ways, so they turn to sport. No longer boys, but not yet men, if young men want to fulfill themselves *now* it is easiest to do so through their bodies, unless, perhaps, they are prodigies in mathematics (12). Achieving one's *telos* as a human being entails the Greek commonplace that one be perfected both physically and mentally (13). Weiss, who admits at the outset that he is not an athlete (vii), views athletes as representatives of all mankind such that the (merely) mentally adept, like Weiss himself, can vicariously be completed human beings (14). The athlete gives us an idealized portrait of ourselves; the athlete is excellence in the guise of a human being (17).

There is nothing apologetic in Weiss's tone and he offers no excuses for his method. He points out that he who immerses himself too soon in the world will too soon get lost in particularity. There is much to be gained, he thinks, in first standing away from sport in order to get one's bearings (81). When Weiss vicariously reenters the practical world of sport he does so armed with Greek concepts like *arete, eudaemonia, telos,* and *dynamis.* For example, Weiss uses Plato's famous definition of being in the *Sophist* (247E) as dynamic power (*dynamis*), specifically the power

to affect or to be affected by others, in order to explain how athletes occupy a middle position with respect to the possibilities regarding human activity and passivity. One extreme is exhibited by the "naturalistic mystic" or Stoic who passively gives up all discrimination and seeks only to be in harmony with whatever is. The other (foolish) extreme is the aggressive attempt to subjugate all realities which offer us resistance. In reality, every human action has something of both activity and passivity in it (as Kant realized), with excellence in athletics consisting in knowing when and how to violently subjugate one's own body or that of others, and when and how to accept one's own bodily limitations or those of others as they are (35–36). Or again, the athlete and his coach learn the art of actively strategizing, without which one passively leaves the outcome of a game to the opponents or to luck (86–94). The athlete learns his role largely by determining when to receive and give and wherein lie his rights and duties (161). One cannot live a life solely of the mind for very long, hence sport offers an excellent agency for unifying human beings (46, 90). Training not only allows one to accept one's body as oneself, but also to actively habituate the body properly. But there is not only the danger of leading a life which is too intellectual in that the athlete, who comes to accept his body as himself, runs the opposite risk of giving up altogether the attempt to allow his mind to dwell on objectives that are not germane to what his body is (41). Weiss's hope is that a coach could be more than a drill sergeant, that he could be a model human being or a sage who could help his athletes lead lives of moderation (50–51).

If we do not take it to be our main task to have athletes become excellent, we come to treat them as workers or as appendages. The body is to be accepted, but only subject to conditions which seek excellence. Athlete and thinker differ only in the relative attention they give to mind and body (53). The thinker inevitably unites himself with his body, but passively so, such that bodily influences are not exactly within his control. That is, the thinker's acceptance of his body is only partial. Weiss is intent on defending the claim that the athlete is not wasting his time even if he does not achieve a full life; it will always be noble work to become a body, to direct the body toward a realizable end. Of course athletes often fall short of their noble ideals, as do philosophers (think of the career of Heidegger), but, as we shall see, sport may be just as important in its ability to *reveal* at least temporarily character (or lack thereof) as in its ability to build it (84–85, 99). Weiss's view is as follows:

> An athlete can, nevertheless, be treated as offering one step in a progress toward the state of being a full, matured, i.e., a completely healthy, man.

Having achieved a bodily excellence, the athlete can go on to try to master the other dimensions of himself, and so eventually become excellent on every side. Occasionally we hear of men who have done this. But for most it is more than enough to achieve the state of being excellent in some more limited area. For the young man there is nothing he is likely to do as well as make himself be an excellent functioning body. And there is hardly a better opportunity for doing this than that provided by contests and games. (99)

Much of Weiss's thought on sport consists in relating his concept of excellence to (and sometimes forcing it on) the phenomena. For example, a race or an endurance contest is designed to show one aspect of "the best" in human beings because these contests show them up against the limits of exhaustion (121); likewise sports which test accuracy pit human beings against an implacable, powerful nature (130); public sporting events and team sports are meant to expose defects in character that might not be noticed in private (168); professional athletes run the risk of degenerating into mere entertainers when they are no longer engaged in the task of building character (206–7, 209); colleges which in effect become "farm teams" for professional sports run the danger of perverting themselves (208–9); women athletes compete in order to become self-complete, albeit not necessarily in the same way men do; perfection is a consequence of sport only when properly pursued; etc. Both the scholar and the athlete are directly related to that finality called "Actuality" by Weiss, with the athlete constituting a localized version of perfection not inferior to that attained by the mathematician (244, 247).

Paul Kuntz is correct in noting that by philosophy of sport Weiss means an account of sport as it reveals a human being's encounter with the four modes of being in Weiss's metaphysics, modes which are largely derived from Plato and Aristotle: Existence, the Ideal, Actuality, and God. Obviously the tension between Existence and Actuality, on the one hand, and the Ideal (of excellence), on the other, constitute the core of Weiss's theory. But Kuntz notices in his reading of Weiss's *Philosophy in Process* that the athlete is at least implicitly religious in his bodily reliance on a supreme being. It is interesting to note that in order to criticize the theory of sport as play, to be treated in the following section of this article, Kuntz largely relies on bullfighting, which is far from play in its ominous, adumbrated meaning. But the fact that bullfighting is far away from play—if indeed this is a fact—seems to be what makes Weiss classify bullfighting as an art rather than as a sport. In any event, Kuntz is correct to alert us to Weiss's belief that the *perfect* athlete, who takes both mind and body seriously, is Plato's state in the *Republic* writ small and the embodiment of justice and temperance in Aristotle's uses of these terms.[3]

III. A Moderate View: Sport as Play

There is much that is tempting in Weiss's view of sport, as is evidenced by the enormous amount of literature that has been generated in philosophy of sport because of him. But it should be noted that his philosophical mode of appropriating sport is not the only one, nor even the only one influenced heavily by Greek thought. For example, perhaps the most persuasive alternative to Weiss has been developed in the thought of Randolph Feezell, whose six essays in philosophy of sport constitute with Weiss's work a unity-in-difference, a friendly-yet-argumentative version of what sport is or should be from the perspective of Greek thought (to be specified later). For example, it might be alleged that Weiss's theory, as insightful as it is, is only a partial truth in that it accounts well for the display of bodily excellence found in some of the Olympic games, but not for other athletic displays. If this criticism is correct then Weiss has made a mistake analogous to that made by aestheticians like Suzanne Langer, who develop a theory of art (as iconic symbol) which is appropriate for one art (music), but which can only fit other arts with a shoehorn. Feezell thinks we can improve on Weiss's view by taking seriously the first-person lived experience of athletic participants: some identify themselves with the pursuit of bodily excellence, as Weiss alleges, but others with the maintenance of health, etc. The closest we can come to universality, according to Feezell, is to describe sport in terms of the enjoyment it brings. Most athletes participate in sport, quite simply, because it is immensely fun to do so.[4]

The role Weiss tries to play as an ideal spectator of sport, a role integral to his method, is commendatory if we emphasize "ideal" and defective if we emphasize "spectator." Weiss asks the following questions:

> His days are numbered, his successes rarely momentous, and his glories short-lived; he works hard and long to prepare himself for what may end in dismal failure. Why? Why are athletes ready to give up so much that is desirable to accept what involves a good deal of wasted motion and boredom? Why are they willing to risk making their inadequacies evident, instead of enjoying the struggle of others from afar, or instead of plunging into a game without concern for how they might fare? Why do they subject themselves to the demands of a severe disciplining? Why are they so ready to practice self-denial or to sacrifice their interest in other pursuits to prepare themselves for what may prove disastrous? (18)

Feezell's response to Weiss here is ambivalent. On the one hand he admits Weiss's genius, but he sees it as a curious genius. Weiss, he thinks, is "genuinely puzzled" regarding why most people participate in sport. If

there is little of intrinsic worth or little enjoyment in sport, why do terrible golfers golf or aging basketball players play in pickup games or ex-baseball players take up slow-pitch softball? None of these players has any chance at excellence.[5] From the perspective of the vast majority of persons who participate in sport, and even from the perspective of the person who is trying to achieve bodily excellence, sport appears to be a type of play. Viewed from the outside, the athlete appears to perform an economic or a biological or an excellence-producing (Weissian) function. But if we bracket the assumption that play serves something which is not play, if we view sport from—for lack of a better word—a phenomeno-logical standpoint, we see an enjoyable activity: "As a spectator, it might be difficult to believe that the sweating, straining faces of pick-up basketball players express some deep sense of enjoyment and identifica-tion; but from the standpoint of the lived experience of the players, there is little doubt about this point."[6]

Weiss is thoroughly familiar with two philosophical classics on play: Johan Huizinga's *Homo Ludens* and Roger Caillois's *Man, Play, and Games*.[7] And he largely agrees with their characterizations of play (especially Caillois's): it is a free activity engaged in for its own sake which is utterly enjoyable. But very often Weiss indicates a split between frolicking play, on the one hand, and more serious competitive activities like sport or athletics, on the other.[8] And herein lies a point concerning which there is considerable tension between Weiss and Feezell. Feezell and several others[9] wish to emphasize the playful element in both pickup basketball players, weekend golfers, and joggers, on the one hand, and in the dedicated athlete, even the professional athlete, on the other. It is a commonplace in professional athletics to have "players" (nb.) retire not when they no longer command a large salary but when the game is no longer fun for them.[10] The split between play and sport-athletics found in Weiss and in James Keating[11] is often defended on the grounds that playful diversions have as their immediate *telos* joy, whereas athletics has as its end victory, making the two radically different. One is ludic and cooperative and the other is agonistic. In the Weiss-Keating view diversion, amusement, recreation, and generosity are largely alien to athletics, wherein one is only required to pursue one's self-interest, a self-interest which leads to bodily excellence.

It might be wondered at this point what is "Greek" about this dispute regarding whether or not sport should be seen as rooted in play. It should be noted that both sides in this dispute are looking for an Aristotelian mean between extremes. Weiss claims a judicious place for sport (142–51) between the frivolity of play as described by Huizinga and Caillois (92, 134–42), on the one hand, and war (176–85), on the other.

But despite the fact that Weiss's detailed treatment of the differences between sport and war is carefully done, it is only the beginning of the effort to determine what a moderate view of sport would be. Indeed there are coaches (especially in boxing or in American football) and sportscasters who use battle metaphors in order to get players pumped up or to heighten fan interest, but in the effort to understand what sport *is* it is not too helpful to say that it is not war. Of course it is not war! That is, Feezell continues Weiss's effort to develop a moderate view of sport by refining the description of what sport is and should be. Even intensely competitive players and coaches agree that there is something magical about the sport they love, something which sets it apart from ordinary reality such that even one's opponent is not ultimately an enemy, but a friendly competitor whose challenge is necessary for there to be a sport at all. Note how opposing football players hug each other *immediately* after a game. There is a false exclusivity between "the player" and "the athlete" when these two are seen as utterly different. The seriousness of a sporting event *enhances* its enjoyment: an athlete refuses to play frisbee at a picnic not because it is play but because it is not playful enough, it is not terribly fun.[12]

Feezell explicitly refers to Aristotle in his version of a moderate explanation of sport:

> the good sport feels the joy and exuberance of free, playful activity set apart from the world, and feels the intensity of striving to perform well and achieve victory. Sportsmanship is a mean between excessive seriousness, which misunderstands the importance of the play-spirit, and an excessive sense of playfulness, which might be called frivolity and which misunderstands the importance of victory and achievement when play is competitive. The good sport is both serious and nonserious. . . . Many, if not most, examples of bad sportsmanship arise from an excessive seriousness that negates the play-spirit because of an exaggerated emphasis on the value of victory.[13]

The policy of winning at all costs *or* of pursuing excellence at all costs is what prevents an easier appreciation of sport as play. These policies actually brutalize sport to the point where it is even considered necessary to distinguish it from war.[14] The play-spirit moderates the intensity with which one pursues victory or bodily excellence in sport: the good sport does not cheat, nor does he hurt or taunt his opponent. Aristotle is helpful not only in directing us to an understanding of the mean in a virtue like sportsmanship,[15] but also to a sense of moderation with respect to the degree of precision we should hope for in our inquiry into what sport is or should be.[16] The truth about sport can only be indicated in outline at least in part because the term "sport" and the behaviors exhibited in sport are various enough to render some intelligibility both

to Weiss's and Keating's views as well as to the view of sport as play. Feezell puts it this way:

> To see the virtue of sportsmanship as a mean between extremes is not to be given a precise formula for interpreting acts as sportsmanlike or not, but to be given an explanatory and experiential context within which we can learn and teach how we ought to conduct ourselves in sports. . . . I cannot see that the moral philosopher is required to do more.[17]

The person engaged in sport is both a player and an athlete; his purpose is both to win the contest and to experience the playful; and his opponent is both competitor and friend (only very rarely do even boxers want to seriously hurt their opponents). Inclusive phenomenological accounts of sport as play see sport as a competitive variety of play. Or better, mere frolic (one type of play) and sport are on a continuum from less formal, spontaneous, animal-like behavior to more formal activities guided by rules. The latter sort of play in sport indicates a partial transcendence of the natural world meant to exhilarate and celebrate, hence there is some similarity between sport and religion or art.[18] The nonseriousness in sport as play is due to the recognition that there are more important things in life than improving sporting skills, a recognition which all athletes acquire eventually. Young people (or parents of young people) may have an especially difficult time handling the attitudinal complexity of being player-athletes in sport. The complexity lies in sport being internally serious, where the activity of competition demands the pursuit of victory, and externally nonserious. This external perspective provides an aperture through which we can see that competitive sport is, after all, not ultimate reality.[19]

It may well be that Weiss would be bothered by the theory of sport as play, but this is by no means clear. In many instances (70, 133, 139–42, 175–76, 185) he insists that it is rare that an adult can, without self-consciousness, retreat far enough back into childhood where he can really play. If he is self-conscious, then he will not really be playing. Adults can be at ease or without a care, he thinks, but it is very difficult for them to play. Weiss does notice athletes enjoying themselves, but strangely only in sports like diving, swimming, golf, and tennis. Play is so childish that all of it and no work prevent Jack from becoming a boy at all. A child is best when it plays, on Weiss's view, whereas a man who plays is less than what a man might be: the young man is between these two extremes. Weiss the nonathlete observes (incorrectly, Feezell thinks) that there are only rare moments of pleasure in sport; play is only at the fringe of the idea of sport. It makes sense, Weiss thinks, for *agon* to be the root of our "agony," hence he has little sympathy for those who would

romanticize the Greek view: the Greek athletes (again, from *athlein,* to contend for a prize) wanted to win and often received lavish gifts, including an income for life. The Greeks even left room for trickery and cunning in athletics.[20] Sport, although not the same as war or aggression, nonetheless is a constructive activity wherein aggression has a role. But in several other instances (21–22, 192–93, 198) Weiss sings what at least seems to be a different tune. He says that athletes practice at sport because such activity satisfies them in a deep and special way: "Athletics gives them a surplus of joy no matter what they do. Their failures and frustrations merely accentuate the inextinguishable glow that is theirs when they give themselves fully to a life of sport" (22). Further, he indicates that an amateur athlete is an "amator," a lover of sport who enjoys himself and is free when he strives to be as good as he can be in athletics.[21] This is *very* close to the conception of sport found in Feezell, Schmitz, Hyland, Algozin, and Novak, as is Weiss's claim that athletes play their games for no other reason than to play them. That is, the "alternative" to Weiss offered in this section of the article is not so much an alternative as a refinement of, and an attempt to render consistent, Weiss's own view(s).

IV. SPORT AND CHARACTER

In addition to an Aristotelian concern for moderation regarding the nature or definition of sport, Weiss and other philosophers of sport are concerned with the connection between sport and the development of character. Feezell explicitly develops some of the ideas sketched by Weiss in this regard. Feezell relies on Alasdair MacIntyre's well-known view that the home of the virtues lies in a historical "practice" rather than in an ahistorical rationalization. By a practice MacIntyre means any coherent and complex form of socially established cooperative human activity; he mentions football and baseball in his discussion. There are goods which are internal to a practice (as in becoming a line-drive hitter) and external to it (as in fame, education, money). A practice has standards of excellence internal to it embodied in tradition, standards which will require athletes to be honest about their own abilities and to develop courage in the face of failing to achieve those standards. The same could be said of practices in the arts and crafts and sciences or of the practice of learning a foreign language. The important point to notice here is that it is crucial for young people to commit themselves to some practice or other, not necessarily one in sport. Through commitment to a practice a young person avoids a brooding self in that he gives himself

over to the reality of the world and forgets his obsessions.[22] Moral judgment involves seeing things correctly, and to the extent that sport enables us to do this, especially regarding our defects, it aids in the development of moral character. But seeing things correctly requires not only an escape from fantasy regarding our abilities, it also requires an intimate knowledge of the sport in question. Little League parents often do not see things correctly because of an unhealthy sort of fantasizing they engage in, and philosophers of sport like Weiss sometimes do not see things correctly because of a lack of significant first-person acquaintance with sport either as spectator or, even better, as a participant.

Weiss would agree with Feezell, however, that when the focus of a practice is on contingent external goods, which is not an uncommon occurrence in an age of massive commercialization of sport, then wealth and fame and power may well tempt one to cheat or at least to see winning as the be all and end all of sport. It is easy to be dislocated by glamour. Weiss is at his best in the following observation:

> But it is . . . true that some of the comments offered in defense of athletics imply that the right spirit means little more than an enthusiastic submission to the ideas set up by generals, politicians, and business executives. . . . If these observations are justified, they point up, not the desirability of increasing the time which young men spend in athletics, but in the need to improve the rest of the educational process. (28)

An athlete, as opposed to a gambler, should not hope for luck to save him. Like a good Greek, the athlete should not hope that the cosmos will make things right *for him* (19, 30, 186, 190). Rather, he should concentrate on the internal goods of the practice generated by tradition, for to deemphasize these is to trivialize sport, it is to see it as just one more path to wealth and fame rather than as an enjoyable, consummatory good in its own right. The cliché that "it is not whether one wins or loses, but how one plays the game" is only partially true. Winning, or at least trying to win, is important, but if the value of winning is overemphasized there is a tendency to deemphasize the goods internal to the practice, hence it becomes more difficult to become good. That is, it is true that the development of moral character is a good largely external to a sport practice, but to see winning as the only thing important in sport is far more tied up with achieving external goods than is the attempt to develop moral character in sport. Some goods internal to a sport practice may be relatively trivial in comparison with other important human activities, e.g., being able to dribble a soccerball with either foot as opposed to being generous with one's disposable income. But other goods internal to a sport practice are not so trivial in the attempt to understand the narrative course of one's life, as in learning not to whine

about one's playing time if a coach—sometimes mistakenly—thinks another player can do a better job.[24]

It is no easy task to reconcile the goods associated with the multiplicity of practices in which we participate in life. But this effort is facilitated if particular goods appropriate to particular practices are conducive to a unified life, to a pursuit of *the* good. To the extent that intellectual or philosophical virtue is needed to bring about such unity, sport does not help much in that there is no intrinsic connection between virtues or goods in sport practices and intellectual virtue. As Feezell puts the point, "learning how to turn a double play or when to squeeze bunt appears to have nothing to do with answering Socrates's fundamental question."[25] It is a rare coach indeed who *asks* his players to ask themselves what the place of sport is in the reticulative effort to put together a life, but such a function for a coach is not impossible and is actually called for by Weiss. Courage, magnanimity, patience, and self-control are in fact virtues both internal to sport practices and propaedeutic to intellectual virtue; and the absence of these virtues (think of out-of-control tennis players) is very often a vice. In sum, sport can build *part* of moral character, especially if parents and coaches are good moral educators, but it can also encourage vice. We should expect a mixed moral result from sports participation largely because athletes can either get a (healthy) diminished sense of their own importance from sport *or* they can be lionized or encouraged to fantasize about their own abilities.[26]

The overemphasis of external goods, like pleasing alumni or fans through school sport programs, is well understood by Weiss. He observes that the only distinctive good which a school has to offer is an education (31, 203, 205, 210). And Weiss is well aware of the fact that sport is not the best place to find *sophia* (44). But his awareness of internal goods in sport is largely restricted to the value of ascetical training and dedicated conditioning (43, 66, 82).[27] Nowhere is the need to understand the connection between internal goods in sport and moral character more crucial than in a consideration of cheating. Feezell argues persuasively that examples of cheating include deliberately miscounting one's score in golf or in player-refereed tennis or in pickup basketball, bribing players or referees, etc. In these cases there is the intention on the part of players, coaches, or interested personnel to gain an unfair advantage, and usually this is done in a deceptive manner on the analogy of a tax cheat. But beyond these obvious cases one needs to "know the game" in order to determine if cheating has occurred in that some types of deception are integral to, and are part of the tradition of, some games, as in a bluff in poker. In golf it is cheating to rub the face of one's driver with vaseline to keep the ball on the face of the club slightly longer, to hide an extra club

in one's bag if only fourteen are allowed, etc. Golf is a game of honor and the prescriptive tradition of the game makes these actions scandalous. However, Feezell emphasizes that the ethos of baseball actually requires some sorts of deception, as in giving signs to a runner and as in the opposing team trying to steal those signs.

As before, Feezell cites Aristotle to the effect that we should not expect mathematical certainty regarding our judgments concerning cheating. But we only need despair about this fact when we do not know a particular sport from the inside out. Most potential cases of cheating can be dealt with in a rational manner. Hitters are expected to wipe away the back line in the batter's box, managers are expected to water down the base paths if a Lou Brock sort of player is on the visiting team. Disputes arise only with the hard cases, but even here most who "know the game" of baseball agree that using a corked bat is unfair and reprehensible whereas throwing a spitball is against the rules and deserving of punishment but is nonetheless a part of the game. No one is really bothered that Gaylord Perry is in the Hall of Fame.[28] In order to gain an unfair advantage over the opponent (i.e., in order to cheat) one must do something illegal *and* something contrary to the *expectations* of the participants. John McEnroe's behavior on the tennis court was uncivil, unsportsmanlike, and childish, but it was not cheating. That is, in order to understand the partial connection between sport and moral character, and in order to understand *how* sport can lead in Weissian fashion to excellence, one needs a thorough grasp not only of the goods internal to a particular sport practice but also a grasp of the historically conditioned expectations which help to determine when cheating has occurred. Feezell, relying on Craig Lehman, rightly notes that most of sport lies between angelic obedience to the rules and wholesale violation of them. Or better, the avoidance of cheating does not necessarily demand angelic obedience to rules.[29]

V. Sport and the Meaning of Life

Despite the fact that sport can only be partially constitutive of moral character, and may actually harm the development of character, it nonetheless may have a more expansive role in the effort to achieve *eudaemonia* than many have noticed, and this despite the fact that *sophia* is not one of the goods internal to sport practice. In the attempt to argue for sport as play one runs the danger of playing into the hands of those who would denigrate sport by saying that sport should not merit serious consideration if it is so much fun. It is precisely this sort of imperious-

ness that Weiss's theory of sport is meant to counteract. But sport is not only fun, it is also liberating. There are obviously many different meanings to the word "freedom," but one of the standard ones consists not so much in an agent having choices as in identifying oneself with one's actions. Freedom in this sense is a matching of one's outward life with one's identity. The absence of strain or friction—which can either be called play or freedom or unalienated labor—is not always easy to come by in life. The opposition between "play" and "work" only makes sense if the latter refers to alienated labor.[30] Once again, first person experience is crucial. Those times when one *feels* most free are those moments of exhilaration when we are involved in something like playful activity. We would all like our jobs to be both productive and light-hearted. Free activity, on this Feezellian account, which relies heavily on the work of Fritjof Bergmann, is that work which we would do even if we did not have to work.[31]

Without necessarily accepting the Marxist account of labor in capital-ist society, it should be rather noncontroversial to notice that most people in the contemporary workplace would not do what they do if they were not forced to do so. Even for those who have, through technological progress, been relieved of the burdens of backbreaking, unhealthy labor there is not much lightheartedness or sense of liberation in the work-place. But there is in play and in sport (even dangerous sport) based on play. Feezell makes a distinction between pure play, which is aimless and without fixed boundaries or rules, as in some types of jogging, and impure play, which is rule-bound and structured, as in chess or hockey (but chess is not a sport because it does not test bodily ability). The point to notice here is that even impure play is liberating for its participants, a point which is Platonic when put in the terms used by Feezell: "Thus the lover of sports need not apologize for his love affair; if this were required he might as well be required to apologize for what he is. We can only insist that he love the *right* things, the best in sport."[32]

Robert Ehman points out that Weiss is stronger in his attempt to reveal the distinctive value of sport than in trying to reveal why the general neglect of sport by philosophers is a serious loss for philosophy. I will try to indicate why there might be such a loss when sport is neglected. In the previous two sections of this article I considered issues integral to Weiss's thought: how to reflect philosophically *on* sport and how sport is propaedeutic to the development of moral character. In this final section I will again use the thought of some of Weiss's commenta-tors, and again most notably Feezell, to expand on Weiss's few thoughts regarding how one's attitude toward life in general may imitate one's attitude toward a sporting event, much as the claim that life imitates art

has become as familiar a cliché as the claim that art imitates life. Thus far we have seen how our understanding of freedom can be enhanced through experience of (nb. not "analysis of") playful, unalienated, liberating athletic activity. Scepticism regarding the worth of moving from sport to "the meaning of life" might be based on the unproductiveness of sport. It might be alleged that sport consists in an endless series of pointless and adolescent tasks, with each succeeding game resembling yet another Sisyphean trip up and down the mountain. But Feezell argues, and presumably Weiss would agree, that the dissimilarities between sport and Sisyphean labor are more prominent than the similarities. Sisyphus is condemned by the gods to his task whereas the athlete willingly chooses to compete. Partly because he chooses to compete and partly because he enjoys the competition, the athlete, as we have seen, *identifies* with his intrinsically valued actions and hence is liberated through them. Further, there is no consummation to Sisyphus's activity, yet each sporting event, as Weiss often notices, has a *telos* which is at the center of all the activities in the event.[33]

There is nonetheless *something* absurd about sport, and herein lies the grain of truth found in the animus some people have toward sport. By "absurd" I mean the use of the term found in Feezell and in Thomas Nagel: a conspicuous discrepancy between pretension or aspiration and reality.[34] What Feezell and Nagel have in mind here is that we always have a point of view available to us from which the serious parts of our lives seem gratuitous. The clash between the internal seriousness of sport and a point of view external to sport which sees its nonseriousness is what makes sport somewhat absurd. We act *as if* sporting events are really serious. Once we realize that ultimately they are not serious, however, there is no reason to despair even if there is reason to take sport with a certain degree of irony or with a grain of salt. This ironic sense of detachment prevents wise persons from ever allowing sport to be too much with them:

> So we arrive at a curious dialectic within the experience of play, between the serious and the non-serious. We play our games with abandon and intensity as if nothing mattered more than making this basket, winning this game, overcoming this challenge. Yet this attitude of seriousness is undermined by the reflection which insists that it is "only a game," with something less than world-historical import or even the more limited importance of job, success, and material well-being.[35]

Weiss is correct in emphasizing that in the sport world the ordinary is bracketed such that an internal world of meaning is created. The always available region outside the world of sport from which we can see its nonseriousness is, of course, the ordinary world, which is supposedly

really serious. One plays intensely in sport with the absurdity arising in the "incongruous collision between the singleminded aspiration of the player and an ontology of play which undermines the reality of the pursuit."[36] To become too serious about play (as in Vince Lombardi's famous attitude toward winning) is to negate the irony at the heart of sport as play. Equally abusive would be, as we have seen, the trivialization of sport found when it is seen *merely* as the instrument of moral education or of the pursuit of excellence.

There is something bothersome, however, about the "real serious-ness" of life. Or at least this real seriousness is more problematic than is usually admitted. It is difficult not to be nostalgic about the world of sport as play when we are mired in the ordinary world. If life is lived *in extremis* in sport, if life is exciting there, we might, Feezell suggests, begin to wonder about what really counts in life: "Now, perhaps, we experience the *undermining* of the ordinary."[37] The point here is not to suggest that a death in the family is not more serious than a loss in a racquetball match, but rather that the "as if" character and the irony of sport as play may begin to infiltrate life in general, and it is by no means clear that this has to be a bad development. That is, not only sport but also "real life" can be seen as absurd. "In-life, as well as in play, we must pursue our goals *as if* what we did *really* mattered, knowing full well that we are also precisely that person who *can* take a standpoint from which such seriousness is undermined."[38] If we *really* had "real seriousness" about ordinary life we would never return to it in a sane manner after a death in the family or after romantic hopes had been dashed through alcoholism or adultery. We do return to our ordinary lives after sport as play with seriousness, but *this* seriousness is, like the seriousness in sport as play itself, a seriousness laced with irony. And here we can see how we ought to respond to Ehman's question regarding how the traditional neglect of sport constitutes a loss for philosophy. Sport, it seems, contributes something which neither art nor religion can contribute to our under-standing of how to respond to the absurdity of (the game of) life: the intensity and the competitiveness of the goods internal to sport, when seen against the background of the obvious nonseriousness of sport, provides a sharper contrast than is offered in the analogous attitudinal complexities found in art and religion.

In effect, Weiss's effort to balance *homo gravis* with *homo ludens* has been enhanced by Feezell, a balancing wherein the detachment of *homo ludens* and the tendency toward despair in *homo gravis* hold each other in check. And in effect both of them have kept alive (or revitalized) the ancient hope that as philosophers we could "enter the stadium . . . striving for the most glorious of all prizes, the Olympia of the soul."[39] The

very attempt to balance *homo ludens* and *homo gravis* might also help us to avoid the various types of sophistry associated with sport in the contemporary era, sophistry with which Plato, at least, would think worthy of our consideration,[40] and to understand better than we have in the past what Aristotelian moderation means concretely. Aristotle, it should be remembered, considered it essential to *phronesis* to steer a dexterous (*epidexios*) yet buoyant (*eutrapelos*) course between the boorish and morose (*agroikoi kai skleroi*) life of *homo gravis* and the overly playful (*paidias*) life of buffoons (*phortikoi*).[41]

DANIEL A. DOMBROWSKI

DEPARTMENT OF PHILOSOPHY
SEATTLE UNIVERSITY
FEBRUARY 1992

NOTES

1. See Randolph Feezell, "Sport: Pursuit of Bodily Excellence or Play? An Examination of Paul Weiss's Account of Sport," *Modern Schoolman* 58 (1981): 259.

2. This claim is not exactly true. See my "Plato and Athletics," *Journal of the Philosophy of Sport* 6 (1979): 29–38; and "Asceticism as Athletic Training in Plotinus," *Aufstieg und Niedergang der Romischen Welt* 36 (1987): 701–12. Numbers in parentheses in the present article refer to page numbers in Paul Weiss, *Sport: A Philosophic Inquiry* (Carbondale: Southern Illinois University Press, 1969).

3. See Paul Kuntz, "Paul Weiss: What is Philosophy of Sport?" *Philosophy Today* 20 (1976): 183–84, 186. Kuntz relies here on Weiss's *Sport* as well as on his *Philosophy in Process* (Carbondale: Southern Illinois University Press, 1971), especially vol. 5 and to a lesser extent vol. 1. Feezell criticizes Kuntz's use of *Philosophy in Process* because Kuntz, he claims, makes Weiss sound too tentative; Weiss's *Sport* is anything but tentative.

4. See Feezell, "Sport," 259, 263–64. Regarding the definition of "sport" see William Morgan, "Some Aristotelian Notes on the Attempt to Define Sport," *Journal of the Philosophy of Sport* 4 (1977): 15–35, who argues against the non-essentialist argument that sport cannot be defined because of the multiple meanings it carries. Using the middle books of the *Metaphysics,* Morgan argues against the supposed dichotomy between universal and equivocal predication.

5. Feezell, "Sport," 268–69.

6. Randolph Feezell, "Play, Freedom and Sport," *Philosophy Today* 25 (1981): 169. Also see 167–68. Joseph Ullian's review of Weiss in *Journal of Philosophy* 70 (1973): 299–301, points out Weiss's trading "unrestrainedly in abstractions and generalizations" without much first person experience even as a spectator, and he also indicates problems with Weiss's attitude toward women's bodies as lures and with Weiss's hope for standardization in sport through

handicapping blacks and whites in different events in which each excels. But Ullian's review is so decidedly negative and vitriolic that it is not much use in determining the strengths and weaknesses of Weiss's book. Weiss followed up his chapter on standardization with the article "Records and the Man," *Philosophic Exchange* 1 (1972): 89–97.

7. Johan Huizinga, *Homo Ludens: A Study of the Play-Element in Culture* (Boston: Beacon Press, 1955); and Roger Caillois, *Man, Play, and Games* (Glencoe, Ill.: Free Press, 1961).

8. Etymology is of some use here, but not to the extent that the serious philosophical issues can be resolved. "Play" comes from the Old English *plegan*, to frolic. "Athletics" comes from the Greek *athlein*, to contend for a prize. Thus far a clear contrast can be maintained. But is sport to be put with competitive athletics or with play or both? Weiss usually puts it with athletics, Feezell with both, as we shall see. The word "sport," however, comes from the Middle English (and Medieval French) *disport*, to divert or amuse, hence etymologically its meaning is closer to *plegan* than to *athlein*.

9. In addition to Feezell, those who use the theory of play in Huizinga and Caillois and that in Eugen Fink, "The Ontology of Play," *Philosophy Today* 18 (1974): 147–61, to base a theory of sport include Kenneth Schmitz, "Sport and Play: Suspension of the Ordinary," in *Sport and the Body,* ed. Gerber and Morgan (Philadelphia: Lea and Febiger, 1979), 22–29; Drew Hyland, "Athletics and Angst: Reflections on the Philosophical Relevance of Play," and "Competition and Friendship," both in *Sport and the Body,* op. cit.; Keith Algozin, "Man and Sport," *Philosophy Today* 20 (1976): 190–95; and Michael Novak, *The Joy of Sports* (New York: Basic Books, 1976).

10. Feezell, "Sport," 266–67. Robert Ehman's view of Weiss's book in *Dialogue* 8 (1970): 750–53, points out that Weiss's view of sport as pursuit of excellence is, in one sense, an Aristotelian one (concerned with the virtue of moderation), but in another sense it exhibits an un-Aristotelian apriorism or abstractness.

11. James Keating, "Sportsmanship as a Moral Category," *Ethics* 75 (1964): 25–35. Although Keating's terms differ from Weiss's, his stance is nonetheless close to Weiss's in contrast to the authors listed in note 9 above. Also see Keating's *Competition and Playful Activities* (Washington, D.C.: University Press of America, 1978).

12. Randolph Feezell, "Sportsmanship," *Journal of the Philosophy of Sport* 13 (1986): 3–5.

13. Ibid., p. 10.

14. Schmitz, pp. 27–28.

15. *Nicomachean Ethics* 1106b.

16. Ibid., 1094b.

17. Feezell, "Sportsmanship," 11.

18. Schmitz, p. 23. Games are like sports in being varieties of play which are formal and are guided by rules, but they are not necessarily, like sports, tests of bodily ability so much as they are tests of luck or intellect. Once again, etymology is of some but not much help in that the Old English (related to Old High German and Old Norse) *gamen* stands for diversion or play.

19. Feezell, "Sportsmanship," 6–9.

20. Weiss relies here on Erich Segal, "It is Not Strength, But Art, Obtains the Prize," *Yale Review* 56 (1967): 606–8.

21. Weiss's perceptive way of making the distinction between amateur and professional athletes is that the former are unpaid members of a privileged class whereas the latter are paid members of an underprivileged class. But even here an amateur can be an *amator.*

22. Feezell relies here not only on Alasdair MacIntyre, *After Virtue* (Notre Dame, Ind.: University of Notre Dame Press, 1984), especially 187, 190, but also on Iris Murdoch, *The Sovereignty of Good* (N.Y.: Schocker Books, 1971).

23. See Randolph Feezell, "Sport, Character, and Virtue," *Philosophy Today* 33 (1989): 206–11.

24. Ibid., 211–13.

25. Ibid., 215. Also see p. 214.

26. Ibid., 216–19.

27. On the athletic origin of the Greek *askesis* once again see my "Asceticism as Athletic Training in Plotinus."

28. Randolph Feezell, "On the Wrongness of Cheating and Why Cheaters Can't Play the Game," *Journal of the Philosophy of Sport* 15 (1988): 57–61.

29. Ibid., 62–67. And "Sportsmanship," 2. Also see Craig Lehman, "Can Cheaters Play the Game?," *Philosophic Inquiry in Sport,* ed. Morgan and Meier (Champaign, Ill.: Human Kinetics, 1988).

30. For a Marxist view of sport see Laurence Hinman, "Marx's Theory of Play, Leisure, and Unalienated Praxis," *Philosophy and Social Criticism* 2 (1978): 193–228. Algozin also defends the play of the athlete as unalienated activity.

31. See Randolph Feezell, "Play, Freedom and Sport," *Philosophy Today* 25 (1981): 170–72. Also see Fritjof Bergmann, *On Being Free* (Notre Dame, Ind.: University of Notre Dame Press, 1977).

32. Ibid., p. 174. Also see p. 173. David Roochnik rightly claims that play does not consist in a list of activities but in a stance taken toward activity, "Play and Sport," *Journal of the Philosophy of Sport* 1 (1975): 36–44.

33. Randolph Feezell, "Play and the Absurd," *Philosophy Today* 28 (1984), 319–23.

34. Ibid., 324. Also see Thomas Nagel, "The Absurd," in *Mortal Questions* (N.Y.: Cambridge University Press, 1979).

35. Ibid., p. 325.

36. Ibid., p. 326.

37. Ibid., p. 327.

38. Ibid. See Francis Keenan, "The Athletic Contest as a 'Tragic' Form of Art," *Philosophic Exchange* 1 (1972): 125–36, who notes that plot is central to both an athletic contest and Aristotelian tragedy, as is recognition and reversal. In one sense an athletic event is more "tragic" than tragedy in that it is not known beforehand in an athletic event who will lose.

39. See Porphyry's *De abstinentia* (31), translated by Thomas Taylor as *Abstinence from Animal Food* (London: Centaur Press, 1965). It should also be noted that the detachment required by engaging in sport as play is not too dissimilar to the religious detachment of the great mystics, e.g., see my *St. John of the Cross* (Albany: State University of New York Press, 1992), chap. 1.

40. Once again, see my "Plato and Athletics" on Plato's treatment of athletics and sophistry in the *Gorgias.*

41. *Nicomachean Ethics* 1128a–b.

REPLY TO DANIEL A. DOMBROWSKI

Daniel A. Dombrowski's examination of my writings and other writings dealing with sport reveals a master of the subject who is also a sensitive, able thinker. I am pleased to have been the occasion for his fine study. He has helped me to see the subject from a new perspective, leaving me with little more to do than add some asides and corrections, serving to clear up some misconceptions, and to add some comments and questions intended to promote further inquiries.

Perhaps no philosopher today has been uninfluenced by the great Greek thinkers—or by the rise of modern science, the spread of democracy, and the great advances made in technology. It is an unexplored question as to just how any of these has been affected by or has affected philosophical thought. Philosophical lucubrations interest few; while what occurs in various specialized enterprises is usually known by philosophers through reports and not from experience.

Before I tried to understand the nature of sport, I made an effort to learn about the production, constitution, achievements, and the presuppositions of various artistic ventures, speaking to artists of all kinds, and trying my hand at painting, drawing, poetry, playwriting, sculpture, and talking with composers, choreographers, actors, and painters. As the prefaces and references to books in which the arts are discussed make evident, I owe a great deal to many practitioners. I did not learn much about sport, with which I later dealt, from any philosophers, ancient or modern, though I think that with Dombrowski's help, I now understand them a little better than I had. What I wanted, I did obtain—a better grasp of philosophic truths—but only because I was able to elicit them when I attended to what was involved in carrying out other activities expertly and well.

The subjects in which humans are seriously involved, as well as those to which they should attend or in which they are caught up without

reflection or effort, are worthy of a philosopher's interest. One reviewer of the book on sport asked, "Why might one not just as well study plumbing?" Why not? It illustrates the use of techniques, craftsmanship, remedial work, and the like. More evidently, in addition to the respected inquiries philosophers have carried out in education, religion, politics, history, science, and ethics, we should add studies of the nature of family life, popular art, practical politics, and presumably any number of others. There need be no duplication of the reports of participants or of the work of historians, social scientists, reporters, or psychologists, since what is to be sought are illuminating instances of general principles by means of which what was hidden or neglected can be understood, and the different enterprises shown to illustrate the same fundamental and constant dimensions of humans, the major subdivisions of the world in which they daily live and how many can and some do splendidly realize limited ends.

One should attend, not only to 'experience' but to particular types of experience, particularly those in which dedication, commitment, and ideals play major roles. Nothing is to be ignored because it has not been dealt with before, or because its practitioners do not belong to the 'upper classes'. One would be lost in minutiae and not be able to obtain a satisfactory understanding of the range and distinctiveness of what occurs in particular areas were one not protected by a prior understanding of what humans essentially are, what they seek to be and do, the world in which they live, and what is then presupposed. The disdain that so many thinkers have for those who engage in sport has prevented them from attending to a very interesting subject. At the very least, it could help them sharpen distinctions already made in the course of dealings with such general questions as to what one ought to do, how the mind and body interplay, the nature of well-governed action, and appealing objectives; it should prompt inquiries into what is being presupposed. For so-called 'professionals', sport is work; for spectators, it provides a distinctive opportunity to see what masters in the field can do; for reflective men, it raises questions about the nature of motivation, commitment, mastery, the use of space, time, and techniques, the application of rules, and a host of other issues best exhibited in activities in which limited objectives, expertise, and accomplishment play great roles.

"How alike and how different are frolicking play and competitive activities?" Dombrowski treats them as correlatives. That perhaps is a little too neat. There is, though, a seriousness exhibited even in the simplest and most innocent of games and play, and a freshness and spontaneity exhibited in most competitions. Both are subject to limiting conditions. Were there no such conditions to which even the most idle

play conforms, there would be nothing amiss with children cheating, maiming, or doing whatever they like, when they play. Their playing may again and again ignore accepted rules; it will inevitably fit into a larger social context, sharing in some of its values, at the same time that it exhibits those values in distinctive, limited, and sometimes undesirable forms. Its moments of exuberance, spontaneity, and unreflecting enjoyment all occur within unnoticed larger contexts, and both qualify and are qualified by these. The competitive activities exhibit unexpected openings and individual emphases, impulses, and decisions that no rules or plans could cover. Not all effective limits are antecedently defined, but also, nothing is so isolated that it is not conditioned by what has a wider scope. It may effect even the most innocent expressions. Rules, commands, prescribed limits, make a difference to one another, and to that to which they apply.

I take Dombrowski to be pointing toward what is far richer and more complex than the acknowledgment of two extremes and a need to balance them. A balance is not necessarily always desirable. No one wants to balance good and evil, right and wrong, the true and the false, nor even to check the one by the other. As soon as we ask "Why check them?" we begin to see that there is an unstated objective that a 'balancing' promotes. Sometimes one extreme should be emphasized, sometimes the other, with the 'mean' making evident the kind of habit that should be formed if a desired objective is to be effectively promoted over a considerable time. The result is play restricted, law-abidingness quickened in fluctuating ways.

Is there not "something absurd about sport?" There is. Anything is absurd, if viewed from an alien position. I cannot imagine an area completely closed off from a humorist or satirist. Violence, massacre, hunger, fear, idiocy, and tyranny, as surely as generosity, kindness, nursing, teaching, and working have their absurd aspects. The fact becomes evident when one looks on human concerns, efforts, and achievements with the eye of a detached observer, asking how important it is to do this or that in a short life in a world outside one's control. A philosopher is more appreciative than satirists are of the values that are exhibited and cherished in limited settings. Those who seek to understand what interests large numbers or a few should not forget that Aristophanes has baskets waiting for us and, indeed, for everyone who seeks to know anything, say anything, or be anything. He is in one, too.

Since the charge of absurdity is made from a position tacitly assumed to be invulnerable, the basket Aristophanes occupies should be seen to be one provided by Socrates. Dombrowski perceptively remarks that sport "can contribute to our understanding of how to respond to life." The

claim is not to be equated with a response to the "absurdity of life." Life is not sport, and sport is not life. Like everything else, it is absurd from a position that refuses to consider anything on its own terms. What is needed is a recognition of the strengths and limits of both the mean and the extremes.

It is not correct to say that I do not take account of first person experience, but I certainly do not think that it suffices if we are to know what sport presupposes and why it attracts so many participants and spectators. Coaches know what players do not; reflective persons know what neither has the ability or equipment to know or to defend. Who knows more about politics, Hobbes or the King? The latter might know what must be done in this situation or that, but the former knows what is an essential part of every needed kingly act. Neither is to be faulted because he does not also know or do what the other knows or does.

In note 6, Dombrowski refers to a common criticism directed at my "attitude toward women's bodies as lures, and with Weiss's hope for standardization in sport through handicapping blacks and whites in different events." Knowing what I think about women—my mother was one, so was my wife, and so is my daughter—and what I have known about discrimination, I was so troubled by the reference that I decided to reread the chapters. They were not well read by Dombrowski and others. I not only referred to distinctions made or reported by various investigators, and stated by women as well as men knowledgeable in the field, by scientists and other investigators as well as officials, but I also noted some of the ways in which women in sport had shown themselves to be superior to men. What seemed to shock so many was the statement that women could be viewed as 'truncated males', overlooking the observation that it was this view that dictated the different rules men and women follow in basketball, fencing, golf, tennis, etc., and that I went on to remark that "scaling women in relation to men only in terms of their physical features and capacities can lull us into passing over a number of important questions. . . ." I noted, too, that both males and females seek to become self-complete, and listed some of the reasons many have offered to determine what women are allowed to do in different sports. The chapter was mainly descriptive and exploratory. I explicitly rejected the idea that women were men *manqué,* or were females without femininity.

The discussion of the differences and similarities of men and women was followed by an inquiry into the problem of standardization. I explored a number of the ways in which standardization might be carried out—by seedings, handicaps, taking account of the velocity of the wind or the difference between indoors and outdoors, etc., and then went on to

say that "we need a statement of ideal conditions and a formula for assigning handicaps." I also remarked that *if* there is a difference in the bodily capacities of blacks and whites, we ought to handicap the one or the other.

This attempt to set the record straight is of little importance, for 'political correctness' will soon pass away, and texts read without fear and trembling. I know that Dombrowski knows how to read well and perceptively; I wish he had been a little more careful in thinking about what his footnote was conveying to a reader who did not have the text.

Dombrowski offers a number of excellent distinctions and comparisons in his examination of play. I tend to think play has a smaller role in sport than he does, but the difference between us is not large enough to be important. As he notes, I refined my initial view of play; it is not entirely clear whether or not he thinks the refinement sufficed to counter the criticism made by Feezell. I think it does. He also repeats Ehman's question as to whether "the general neglect of sport by philosophers is a serious loss for philosophy." To answer that question satisfactorily, one would have to know if there are any enterprises that could be neglected without suffering such loss. May a philosopher ignore, not just sport, but any activity other than the determination of the nature of knowledge and the understanding of what is real? Let that be granted. Is it wrong to test one's philosophic views by seeing how well they hold up when one tries to understand the warrant, essentials, objectives, and worth of enterprises to which many give themselves without reserve? Is one warranted in ignoring what may have been ignored for centuries? Should one deal only with those subject matters that interested Plato or Aristotle? Suppose the Greeks had not dealt with politics, would this suffice to make inquiries into its nature, presuppositions, values, and the like, illegitimate or trivial? Must a philosopher of art eschew an interest in film because there were no films in ancient times? It would be interesting to have an account of what special domains a philosopher should or may examine.

Dombrowski makes evident the value that a study of sport has for philosophy, but then spoils his insight by what is not a satisfactory understanding of the absurd. Fortunately, he quickly overcomes the defect by his acute observations of the 'seriousness of life', and the contribution that a study of sport can make to our understanding of how to respond to life as perpetually problematic.

I said, when dealing with sport, that it was occupied with an achievable excellence by making masterly use of the body. What was not clear to me at the time—and became evident in *Creative Ventures*—is that the perfecting of a human is primarily exhibited in the enhancement of one's character. The acceptance of that view gives a new life to the

common claim of athletic directors and coaches that a participation in sports builds character, presumably by compelling the athlete to subject herself to discipline, to accept victory and defeat with grace, to be cooperative, fair-minded, and so on. These are not possible, though, unless there already is a character to be enhanced. Evidently, implicit in this claim on behalf of sport is the idea that a character already is effectively operative on, in, and through the body, as able to be strengthened as well as enhanced.

A bad character can be strengthened as well as a good. What is presupposed in an endorsement of sport as a means for enhancing character is the idea that a participation in it involves the use of a character that is already good to some extent, and can be both strengthened and enhanced. One must, then, expand the view presented in *Sport* to accommodate the fact that what is enhanced through athletic activity is an embodied character, oriented toward a prospective excellence that is to be realized through a character-controlled body. I did not clearly see that when I was occupied with understanding the nature of sport some decades ago. Dombrowski has helped me to understand it in a way that I might not otherwise have been able to do. I am grateful to him for his sensitive examination of this topic, and hope that it will elicit others.

 P.W.

28

S.K. Wertz

THE METAPHYSICS OF SPORT:
THE PLAY AS PROCESS

To know what happens in a game one must see it, live through it, be part of the process by which indeterminacies and contingencies are used to produce single, definite plays.

Paul Weiss

Throughout his long, productive career, Paul Weiss has developed a philosophy which integrates knowledge into significant wholes—whether it be art, history, morality, politics, reality in general, science, self, or sport. Professor Weiss's understanding of these wholes has contributed to the debate on the nature and domain of sport in various ways.[1] In this essay, I shall examine his philosophy *retrospectively*, i.e., I shall begin with his last contribution in a series of three articles published in the *Journal of the Philosophy of Sport* in the early eighties. They are: "Games: A Solution to the Problem of the One and the Many" (1980), "The Nature of a Team" (1981), and "Some Philosophical Approaches to Sport" (1982). Weiss's last article (1982) is the product of thirteen years of reflection on the subject after his book, *Sport: A Philosophic Inquiry* (1969), and exhibits notable growth in its ideas. This is reason enough to begin with this and the other two articles for the best possible perspective on Weiss's philosophy of sport.

Of diverse philosophic views, he says, "Let us *apply,* not their doctrine or conclusions, but their outlook and procedures to help us obtain a better understanding of training, play, game—in short, whatever is pertinent to the world of sport" (p. 90; emphasis added). So Weiss sees sport philosophy as a species of applied philosophy. But he is quick to add that the views' outlook and procedures are *modified* by their *substantive* interaction with the world of sport: "the concepts it [process philosophy] employs can be freed from their application to cosmic occurrences and so specialized that they are pertinent to the eventfulness

of a single play, the event of a series of related plays, and the course of a game. The initial ideas will then undergo modification. But this is what is to be expected from a concentration on a world of sport and the examination of it in the spirit and under the guidance of key ideas in a strong philosophy" (p. 92). Since process philosophy (via Whitehead) is an extrapolation from human experience, its re-entry into the domain of sport should not prove to be insurmountable. Below, I shall develop Weiss's insights into a process philosophy of sport, but first let me lay out his conception of sport. "The world of sport," he rightfully declares, "is essentially a world of action; *a world in which new events are being produced in fresh unions* of what had been achieved and what is sought" (p. 92; emphasis added). These unions are the significant wholes I mentioned above. Weiss seeks unity in the midst of diversity; where others see difference, he perceives identity.

Weiss then looks at the world of sport as a speculative metaphysician, "whose primary thesis is that there are a number of irreducible final *realities* which, by *interplaying* with finite *actualities,* constitute the world we know every day" (p. 93; emphases added). The Weiss of the *Modes of Being* (1958) is speaking here. This thematic paragraph contains a good summational statement of Weiss's metaphysics of sport. His argument is worth quoting in full.

> It is almost commonplace that every situation and complex, every occurrence and encounterable being is a composite of a common unifying condition and a plurality of governed entities. A *team* has a structure limiting the activities of a number of players; a *game* is a rule-governed set of events. What a metaphysical pluralism prompts us to ask is whether or not there is not just one but a number of conditions present in these and other cases, all governing the same plurality. An affirmative answer, I think, is forthcoming if we ask the kind of questions of sport that we ask of experience and daily life when we wish to discover their underpinnings. *The world of sport is primarily a world of conditioned interplaying men [and women], functioning at their best.* It would not exist were there no relations of relevance determining priorities and roles for the different players; if there were no equalization, making men [and women] be on a footing as members of a team and making teams be coordinate participants in a game; if there were no governing rules; if there were no bounded fields of play; and if there were no measures of excellence, all affecting and being affected by what men [and women] are and do. Perhaps there are other effective conditions as well. Whether there are or not, if one is to take proper account of the ongoing interaction of such conditions with men [and women], one must supplement phenomenological, analytic, and other approaches with an effort to isolate and understand the essential constituents of an ongoing set of activities, all directed to bringing about the best outcome that training, discipline, resolution, and effort can produce. (p. 93; emphases and inserted brackets added)

The understanding of these essential constituents come from process philosophy. Consequently, let me flesh these out from Weiss's brief suggestive sketch. One of the most important concepts is that of *event*. Its ambiguity has generated many paradoxes and dialectical oppositions. Let me illustrate.

What is *baseball?* The rules in the official rulebook? The rules played out in a given game? The pitcher-batter duel? The interplay between offense (the batter) and defense (the infielders and outfielders)? The whole ballpark, with spectators, music, and all the other activities besides what goes on down on the diamond? These questions and the puzzlement they generate come from an assumption about games. Sporting events—games—are understood as "objects" whose characteristics or properties may be abstracted and compared in order to form generalizations and definitions. Games are many things rather than one thing. These events are conceived of as discrete, separate, isolatable, and atomistic in nature. Hence, under this model—an atomistic model—games appear to be accountable for only by a metaphysical pluralism (to use Weiss's term). This is a common understanding of the nature of an event. But events may also be conceived of as forms of temporal process that explain concretely the indeterminate conditions from which they arose. Sporting events have temporal durations and an internal developmental pattern that is best reflected in narrative form: the play or a series of plays, like a double play or a shut out in baseball, best exemplify this concept. Under this model—a process model—a new paradigm emerges in understanding the nature of an event. Weiss first articulated this insight in regard to the domain of sport. The ontology for sport is the play. Weiss's "interplaying" is best exemplified by plays.

How does process philosophy understand an event? And how does that understanding shed more light on a sporting event, like *baseball?* To answer these questions we need to examine theoretical terms like "process," "emergence," "development," "change," "perceptions," and "event." To capture the dynamic and structural features of events, process philosophy was developed by Whitehead, Hartshorne, and Weiss earlier in this century in response to the breakdown of positivism and its paradigms. Positivism's atomistic model of an event could not deal with the complex temporal developments discovered in nature by natural and social scientists. Indeed, process philosophy is also called philosophy of organism by Whitehead.[2] The lines of demarcation the positivists drew were grossly inadequate. Process philosophers began to draw new lines of demarcation. Here are some of them.

In *Adventures of Ideas,* Whitehead gives one of his many characteriza-

tions of process—one which has affinities with sport, since it is described in civil terms:

> The foundation of all understanding of sociological theory—that is to say, of all understanding of human life—is that no static maintenance of perfection is possible. This axiom is rooted in the nature of things. Advance or Decadence are the only choices offered to mankind. The pure conservative is fighting against the essence of the universe. This doctrine requires justification. It is implicitly denied in the learned tradition derived from ancient thought./The doctrine is founded upon three metaphysical principles. One principle is that the very essence of real actuality—that is, of the completely real—is *process.* Thus each actual thing is only to be understood in terms of its becoming and perishing. There is no halt in which the actuality is just its static self, accidentally played upon by qualifications derived from the shift of circumstances. The converse is the truth.[3]

These shifts in circumstances are eloquently noted by Weiss in the "bunches" (1980, p. 14) or "unions" (1982, p. 92) or "wholes" within the world of sport. When he speaks of these, we need to be mindful of process philosophy and its insights into change and the notion of an event.

In "The Nature of a Team," Weiss questions an earlier constituent he attributes to games. "An actual game," he recalls, "is autotelic, self-enclosed, with its own beginning and ending, set off from all else" (1980, p. 9). This constituent we tend to apply to *all* the activities that occur within a game, and consequently "a number of important factors have never been properly distinguished or adequately dealt with" (1981, p. 47), because "Well *before* a game is played and *after* the game is over, the members of a team continue to make a difference, not only to one another's actions but to their attitudes as well" (pp. 47–48; emphases added). If we looked at teams just within the actual game with its autotelic character, Weiss reminds us here, we would miss this important temporal feature in the nature of a team. The temporal structure paves the way for another process idea—that of *change:*

> At the very least, a team embraces a number of individuals in a constantly changing set of relationships. Some of these are due to changes in the attitudes that the players undergo in the course of the game; others are produced in the course of the public interactions that the players together produce. . . . Both types of change, the privately initiated and the publicly produced, must be acknowledged. (p. 48)

These two types of change parallel Whitehead's two modes of process. There is the internal concrescence in which the various components of an actual occasion or entity achieve a complex unity. When a final unity is achieved—like the end of a game or the success of a given play—concrescence ends and the occasion of experience has realized its

"satisfaction." The second mode of process is external and is described by Whitehead as "the fluency whereby the perishing of the process, on the completion of the particular existent, constitutes that existent as an original element in the constitutions of other particular existents elicited by repetitions of process. This kind I have called 'transition'" (1929, p. 243). So completion of earlier plays helps shape and condition what plays are in the making or are to come. Transitions are seen in plays of games, especially the more interesting, exciting games. (We shall look at a few such games below.)

Once more, Whitehead defines his terms: "'Concrescence' is the name for the process in which the universe of many things acquires an individual unity in a determinate relegation of each item of the 'many' to its subordination in the constitution of the novel 'one'" (p. 243). Elsewhere (1980), Weiss writes: "At every moment, the energies of the players, while expended with reference to each other, keep within the limits and follow the patterns dictated by the rules, thereby enabling the end, that they will more or less adequately realize, to become One that in fact makes them all players in a rule-governed game" (p. 12). Sport actions, especially the plays which are the determinates of a game, are Whiteheadian concrescences for Weiss. Games and their plays are unique and differentiated (and so display novelty) because "Each actual occasion," Whitehead writes, "defines its own actual world from which it originates. No two occasions can have identical actual worlds" (1929, p. 243).

Nor is the notion of change exhausted with the above distinction. Weiss adds: "A unit team depends on the occurrence of constantly changing relations among a number of players" (p. 48). And earlier (1980), he affirms that an actual game "is directly related . . . to other games in a world of sport. A game is a self-bounded whole related to other games" (p. 9). But this is not all: "We take account of what is not a game to enable us to locate the games in a larger world than that of sport. But once the games are located, they are found to have their own boundaries, prescriptions, and acting individuals and to be directly related to other games which are located at various distances in the larger world" (pp. 9–10). Weiss, like Whitehead, fights static conceptions, and whenever he finds them, he replaces them with ones which reflect Whitehead's concept of actuality. This backdrop for Weiss's metaphysics of sport enables us to appreciate his line of thought that might otherwise go unnoticed. "Forms" (like rules), Whitehead (1929) proposes, "suffer changing relations" (p. 34). The problem that Weiss finds in the previous accounts of rules is that:

They view both rules and people *statically,* and they neglect a *vital* factor. . . . In the course of a game, players are focused on making signal moves, interacting with one another, attempting to bring about limited results. Giving the rules and the players the status of distinctive members of a single Many, the end makes possible both its own realization and *the transformation of the players and the rules* in a game well played. *The vital energy* required to realize the end is provided by the players. The limits of their activities is specified in the rules. The end provides the direction. Games unite them all. In a game, a number of players act in accord with rules to realize on a particular occasion what ought to be, but which no one may have considered or sought. (1980, pp. 11–12; emphases added)

With such an emphasis upon rules, it might be tempting to label Weiss a formalist when it comes to games, but this is a temptation to be resisted. He appreciates much that lies beyond the rules of a game. The process concept of *actuality* can be seen at work in Weiss's understanding of games. "A game is a domain or field, in the *making,"* he notes (1980, p. 13; emphasis added). "Plays *produce* limited portions of it," Weiss elaborates, "while thrusting beyond themselves to set conditions for other plays to be made there" (1980, p. 13; emphasis added). So if there is a basic building block of games for Weiss, it would be *plays,* because "The application [of the rules] and realization [of the end] occur only in the game, produced by *playing* it" (1980, p. 12; emphasis added). Whitehead clarifies what he means by *an actual entity:* "An entity is actual, when it has significance for itself. By this it is meant that an actual entity functions in respect to its own determination. Thus an actual entity combines self-identity with self-diversity" (1929, p. 30). Weiss (1980) establishes this conclusion for games. But this obviously applies to *plays* within games. Indeed, plays may be the smallest "unit" within the world of sport which is analogous to an actual entity in Whitehead's sense. It is here that the concept of an actual entity will need to undergo modification from its concentration on the world of sport (1982, p. 92). Consequently, the elaborate description Whitehead gives of actual entities can provide conceptual clarification of plays and their role in games. Plays take on a telos or end of their own from the roles which players (or actual entities) consciously carry out. They form "families" or "societies" within games and sport, and to know them—as Weiss points out in the prefatory note—is to live through the game or sport. The plays are not random—they are ordered and display patterns, plans, and strategies. This is where the thinking process is most evident in sport.

In a rare, phenomenological attitude, Weiss gives the following description of a game:

Abstracted from a game, a *play* reduces to a series of moves. Each of these is ultimately understandable, through a number of intermediaries, in purely

physical terms. What will then not be understood is why such and such moves, the various intermediaries, and the final units they encompass, are bunched in their different ways. To know that, one must attend to *the plays,* and then to the intermediaries, until we finally come to what has only the final units as parts. Though the intermediaries have their own constitution and dictate how what they contain is to be related, *the plays* must still be taken into account. *Their occurrence makes a difference to where some ultimate parts will be, with which others they will be joined, and from which others will be distanced.* (1980, pp. 13–14; emphases added)

So the "new events," which "are being produced in fresh unions" (1982, p. 92) *are* the plays. They make up the game both on the surface and in the structure. The plays are the actual occasions—the game's process. They are the novelty (advance) and order (decadence); they are the flux of a game. The embryo of this idea can be seen in *Sport: A Philosophic Inquiry:* "playing is a process subject to the unexpected." And even more in the spirit of process philosophy: "No process is ever reducible to a pattern; the dynamic always adds something not expressed in any structure" (p. 137). Again, Whitehead (1929, ch. 10) is helpful here in clarifying these ontological metaphors. But before we turn to such matters, let us generate some instances or cases for further study—this time from the game of American football.

Michael Novak illustrates what Weiss has in mind with his conceptions of plays, teams, and games:

For example, a sportscaster can say from the booth, "If the Giants want to win today, they have to pass short." Then, indeed, the Giants may pass short. So said Howard Cosell on October 20, 1975, when the Giants startled everyone, including Cosell and Alex Karras, but not Frank Gifford, who predicted it, by beating the Buffalo Bills 17–14 in the last six seconds. But how many short pass plays do the Giants have? And what, precisely, is the weak spot in the Buffalo defense that will make the short pass work—and where? Which blocking patterns are emerging that allow the Giants to run around end successfully, as they had not been doing for weeks? *On a football field [or any sport's area], things don't just happen. Someone is thinking about them, probing, trying to make them happen.* The writer, after the game, can formulate the critical questions and get the solid answers—if not necessarily from the principals, then perhaps from a scout observing such matters for next week's opponent.[4]

Novak's questions are telling, and he gives us some concrete details of what it means to describe plays of a game as process. The process is the essential ingredient that makes up the "reality" of the game. Another example makes this point clear. Again in 1975, Missouri played Alabama. Missouri dominated a powerful Alabama team. People couldn't figure out how they were doing it. "Two or three offensive plays they used," Novak recalls, "seemed extraordinarily interesting; they worked

with such brilliance that I wanted to know the secret" (p. 558). And, "The next day, I looked in vain in the relatively long accounts of the game in the New York *Times* and *Newsday* for an account of those plays, and of the defensive formations that kept Alabama contained as they had seldom been in five years" (p. 558). Consequently, sweeping generalizations, like "play . . . is a nonrational activity" (Feezell, p. 269), are at best highly misleading, if not downright false, because they fail to account for observations like those of Novak.

Plays are not discussed in any sustained fashion in *Sport: A Philosophic Inquiry*. The emphasis on the nature of sport is on the rules which make up the game in question, its space and time, and its ceremonies and rituals. The closest Weiss comes to analyzing the concept of plays or the play is in his discourse on strategy and tactics. There he writes:

> There is no strategy for parts of a game, any more than there is a tactics for the whole of it. Tactics is strategy divided into steps and specified in the form of particular acts which give the strategy body and vitality. Strategy envisages an entire enterprise. It refers one to the anticipated pace of the venture, and points up the vital joints in it. Tactics, instead, concerns itself with the producing of effective means for realizing the strategic plan. Since tactics are determined partly by the different situations in which one is, they must be constantly changed, but strategy needs to be changed only when it is discovered that it is making victory more and more difficult to attain. (p. 87)

But in his account of the game (ch. 10), he does say: "The players together constitute a team which, with the other team, produces the unit occurrence, a play in a game" (p. 161). And later he adds:

> In sport the largest present is the present of the game. In this we can isolate plays and moves only conceptually. The bunt [in baseball] and any other play is an organic, integral factor in the present indivisible whole of the game. The plays are, of course, also distinct units—as are the moves they encompass— each with its own present. (p. 164)

Here we find the germination of games as a solution to the problem of the one and the many (1980). However, this brief account is nothing like what we encountered above. The language and metaphors of process led Weiss to an altogether different understanding of sport by seeing that the play is the key concept in the process or reality of a game—of sport generally. The short pass and the bunt are some of the focal points of those sports and they act as their signatures; i.e., they express each game's uniqueness and what Whitehead calls its "real actuality" (1933, p. 274). At times, Weiss sounds like Novak: "To know what happens in a game one must see it, live through it, be part of the process by which indeterminacies and contingencies are used to produce single, definite plays" (1969, p. 168). Novak seeks answers to the questions that the

games raise, but that process is one appreciated by Weiss; the games' immediacy isn't there because of his metaphysical stance. As Weiss observes: "From their time [the ancient Greeks] to our own, sports have not been taken seriously enough as a source or instance of large truths or first principles" (1969, p. 8).

One of those first principles is the play as process. As Whitehead says in the opening of his chapter entitled "Process": "That 'all things flow' is the first vague generalization which the unsystematized, barely analysed, intuition of men has produced. . . . Without doubt, if we are to go back to that ultimate, integral experience, unwarped by the sophistications of theory, that experience whose elucidation is the final aim of philosophy, the flux of things is one ultimate generalization around which we must weave our philosophical system" (1929, p. 240). Clearly, Weiss shares this orientation when it comes to the realm of sport. "That ultimate, integral experience" that Whitehead speaks of is Weiss's focus on the plays of the game. The aim of the philosophy of sport is to elucidate those experiences. Their description he leaves for others, like Novak, to make, whereas he seeks the "one ultimate generalization around which we must weave our philosophical system" of sport, and that is the play as process. The flux or flow of a game is not the mere succession or summation of events, but those events that make up the plays or a series of plays. These are what makes games special, as Novak reminds us in his artful descriptions. Weiss sees this, too; it is only on a higher level of generality—like that of Whitehead's scheme.

Let us return to Whitehead's two species of process (p. 247), the macroscopic process of the whole and the microscopic process of things. He describes the two as follows:

> The former process effects the transition from the 'actual' to the 'merely real'; and the latter process effects the growth from the real to the actual. The former process is efficient; the latter process i[s] teleological. The future is merely real, without being actual. . . . The present is the immediacy of teleological process whereby reality becomes actual. The former process provides the conditions which really govern attainment; whereas the latter process provides the ends actually attained. (1929, p. 247)

Likewise there are two processes going on in a game. The plays of the game are the microscopic processes, and the game itself or the play or series of plays that are decisive or determine the outcome is the macroscopic process. The two occur together. Yet the plays of the game may be complete, finished, but the play or series of plays may be incomplete lying in the future to be realized in some other game or season. The macroscopic process keeps games from being finite, static,

and self-contained. Games are measured by other games, and plays by other plays. "It is a process," Whitehead adds, "proceeding from phase to phase, each phase being the real basis from which its successor proceeds towards the completion of a thing in question" (1929, p. 248). Plays and games may be viewed as such an expansive, ongoing process. "Process," Whitehead earlier remarks, "is the growth and attainment of a final end" (1929, p. 174). A play may represent "growth," but it may also, if the conditions are right, be the attainment of a final end for a player or contributing team members. A rather tragic example is seen in Irwin Shaw's short story, "The Eighty-Yard Run," where the writer depicts an aging athlete whose life is summed up in one brief moment:

> Christian Darling sat on the frail green grass of the practice field. The shadow of the stadium had reached out and covered him. In the distance the lights of the university shone a little mistily in the light haze of evening. Fifteen years. Flaherty even now was calling for his wife, buying her a drink, filling whatever bar they were in with that voice of his and that easy laugh. Darling half-closed his eyes, almost saw the boy fifteen years ago reach for the pass, slip the halfback, go skittering lightly down the field, his knees high and fast and graceful, smiling to himself because he knew he was going to get past the safety man. That was the high point, Darling thought, fifteen years ago, on an autumn afternoon, twenty years old and far from death, with the air coming easily into his lungs, and a deep feeling inside him that he could do anything, knock over anybody, outrun whatever had to be outrun. And the shower after and the three glasses of water and the cool night air on his damp head and Louise sitting hatless in the open car with a smile and the first kiss she ever really meant. The high point, an eighty-yard run in the practice, and a girl's kiss and everything after that a decline. Darling laughed. He had practiced the wrong thing, perhaps.[5]

Shaw shows us that the attainment of a final end may be the wrong one or one not properly placed within the scheme of things. Darling lost sight of the macroscopic process. Darling represents a curious moral twist on Weiss's "A Metaphysical Excursus":

> The world of sport intensifies the meanings which any man in the course of his life inevitably expresses in his judgments and decisions. The athlete is sport incarnated, sport instantiated, sport located for the moment, and by that fact is man himself, incarnated, instantiated, and located. (1969, p. 248)

Darling is so located in a moment that subsequent moments become "lost" or insignificant. Darling is an example gone awry.

The macroscopic process is also important in understanding plays, because they are continually being re-described and their significance re-evaluated in light of later plays or information. In other words, plays

are through and through *historical.* The significance of a play cannot be seen until the game is over (see, e.g., Novak's episode). We can say something to that effect of which participants would have no inkling or awareness. So the macro sense of process is a *narrative* process. Weiss suggests this in "Games: A Solution to the Problem of the One and the Many":

> Apart from the structure and more particularly the rules of a game, the players are already related. They are not only ready to be in the game, but have similar backgrounds, incomes, training, are members of the same society or state, and the like. The rules also place limits on the activities of owners, judges, and recruiters. Not until we come to a final condition and a plurality of ultimate units is there ever anything which could be just a One or just a Many—and these are themselves involved with one another. Final condition and ultimate units together constitute a single cosmic field within which every other occurrence takes place. A game fills out a specialized limited part of that cosmic field. (1980, p. 9)

Two points need to be made at this juncture. First, Weiss exhibits an awareness that players are culture bound and social specific,[6] even though he, unlike Novak, declines to "instantiate" sport with specific games and plays (1980, p. 9). If Weiss had instantiated his metaphysics of sport, it would have had a more receptive audience,[7] but I am attempting to do some of that here. The best constructive criticism of Weiss on this point to date comes from the pen of Hans Lenk.[8] Like many others, Professor Lenk suggests: "The integration of the phenomena of sporting achievement with the ideal-typical social constellation of sports contests, and the culturally developed interpretations, might diminish some of the abstractness, individualistic restriction, and isolation of this interpretation" (p. 441). The reason why, Lenk offers, is that "He [Weiss] abstracts from the social modelling situation only in the structure of which, and by the impregnation of which, achievements can be accomplished and compared with each other" (p. 441). This can be corrected "By extending the lines of Weiss's interpretation, [where] the athlete can be interpreted as representing the 'myth,' instantiating a sort of 'mythical' figure of a Herculean-Promethean kind; he is a *cultural god,* capable of extraordinary feats which can only be accomplished by complete devotion" (p. 441). Lenk extends the "mythological" interpretation from the spectator's point of view to the athlete's. Such an enterprise Lenk thinks is especially important because these modern secular "myths" have gone unanalyzed and their "social significance of top level sport in mass media societies is growing even larger" (p. 445). Sixteen years later the latter reason is still true, but the "myths" have been analyzed by Lenk, Gunter

Gebauer, and others.[9] The USA's "The Dream Team" of the '92 Olympics is an excellent example of this semiotic or mythic concept. The basketball team needed special housing at the games, were swamped by other Olympic athletes at the Opening and Closing Ceremonies at Barcelona, and so on. So Lenk's conception of the athlete as a cultural god is not an unrealistic interpretation of the present sportsworld.

Second, Weiss's conception of a game filling out a part of a cosmic field is analogous to Whitehead's macroscopic sense of process. This gets us to look beyond the game or the play at hand. But we must begin there in the concrete as Novak convincingly demonstrates for metaphysical ideas. "Large truths," as Weiss (1969, p. 8) calls them, are not a matter of being cut down to size, but finding the proper space for them.[10]

Roger Angell is one who has found them their proper space. Let us briefly look at the play in baseball. In "The Interior Stadium," he describes a play in the fifth game of the 1968 World Series where the Tigers were down 3-2 against the Cardinals. The Cards are up, and

> the throw comes in chest-high on the fly from Willie Horton in left; ball and baserunner arrive together; Brock does not slide. Brock does not slide, and his left foot, just descending on the plate, is banged away as he collides with Freehan. Umpire Doug Harvey shoots up his fist: Out! It is a great play. Nothing has changed, the score is still 3-2, but everything has changed; something has shifted irrevocably in this game.[11]

One cannot talk about the nature of momentum and how it affects games at the moment it happens. Momentum shifts, as the Brock-Freehan play illustrates, are usually detected towards the end of games or afterwards when they are "storied" or narrated. Most, if not all, "the great moments" in sport are plays. They are what are *written* about; again, we are reminded of writers like Roger Angell. They make sport into a *text,* so that we too may *read* those plays which make up a game.[12] As Angell declares: "Any fan, as I say, can play this private game [this inner game which restores and discovers baseball's mysteries], extending it [baseball] to extraordinary varieties and possibilities in his [or her] mind" (p. 149). The metaphysician should engage in this inner game so that "we may . . . penetrate some of its [sport's] mysteries" (p. 148) or "secrets" as Novak calls them (p. 558). Perhaps Weiss will do so in his reply. The question at issue is how is metaphysics to be *practiced* in the philosophy of sport? Weiss made no substantial changes in his initial attempt (1969); it is a traditional philosophic inquiry. Some changes were made in his last attempts (1980, 1981, 1982). But these changes are not enough, as Lenk and I have suggested, for the metaphysics of sport to be truly *applied* philosophy in the sense that Weiss later recommended (1982, p.

92). I hope the recommendations I make here are ones with which Weiss will agree.[13]

S.K. WERTZ
DEPARTMENT OF PHILOSOPHY
TEXAS CHRISTIAN UNIVERSITY
MAY 1992

NOTES

1. One of Weiss's more sympathetic critics—Paul Grimley Kuntz—has discussed some of these wholes; consult his "Paul Weiss: What Is a Philosophy of Sport?" *Philosophy Today* 20, no. 3 (Fall 1976); and, "Paul Weiss on Sports as Performing Arts," *International Philosophical Quarterly* 17, no. 2 (June 1977). And in a more critical spirit, Randolph M. Feezell, "Sport: Pursuit of Bodily Excellence or Play? An Examination of Paul Weiss's Account of Sport" (Notes and Discussion), *Modern Schoolman* 58 (May 1981). I shall cover different ground in this essay than Kuntz and Feezell have in their studies. For another study in Weiss's philosophy of sport, see my book, *Talking a Good Game: Inquiries into the Principles of Sport* (Dallas, Texas: Southern Methodist University Press, 1991), pp. 18ff., 61ff., 122ff.

2. Alfred North Whitehead, *Process and Reality* (New York: Free Press, 1929/1969), preface, p. v, and throughout.

3. Alfred North Whitehead, *Adventures of Ideas* (New York: Free Press, 1933/1967), pp. 274–75.

4. Michael Novak, "Jocks, Hacks, Flacks, and Pricks" [from *The Joy of Sports* (1976)], in *Sport Inside Out: Readings in Literature and Philosophy,* ed. David L. Vanderwerken and Spencer K. Wertz (Fort Worth: Texas Christian University Press, 1985), p. 558; emphasis added.

5. Irwin Shaw, "The Eighty-Yard Run" (1941), in *Sport Inside Out,* p. 19.

6. For a criticism along this line—that Weiss isn't aware of this—see Sidney Gendin's review of *Sport: A Philosophic Inquiry* in *Philosophia (Philosophical Quarterly of Israel)* 4, no. 4 (October 1974): 622. For the most unsympathetic review of Weiss's book, see Joseph Ullian's in *Journal of Philosophy* 70, no. 10 (May 24, 1973): 299–301.

7. An anonymous reviewer for *Book World* writes "I cannot recognize the realities I have experienced [my perceptions of the athletic world] in the abstractions he [Weiss] presents" in *Sport: A Philosophic Inquiry* (Arcturus Books edition; Carbondale: Southern Illinois University Press, 1969/1973), backcover. Sidney Gendin claims the same thing (see note 6).

8. Hans Lenk, "Herculean 'Myth' Aspects of Athletics" (1976), in *Sport Inside Out,* pp. 435–46.

9. See e.g., *Sport-Eros-Tod,* ed. Gerd Hortleder and Gunter Gebauer (Frankfurt am Main: Suhrkamp Verlag, 1986), and *Korper-und Einbildungskraft: Inszenierungen des Helden im Sport,* ed. Gebauer (Berlin: Dietrich Reimer Verlag, 1988).

10. This is an idiomatic expression I have borrowed from Stanley Cavell, see *Talking a Good Game*, p. 12.

11. Roger Angell, "The Interior Stadium" (1971), in *Sport Inside Out*, p. 154. This wonderful piece first appeared in *The New Yorker* and a year later in *The Summer Game*, a collection of reflective essays on the game of baseball.

12. For the textuality of sport, see the last chapter (9) in *Talking a Good Game*, pp. 199–216.

13. This chapter was presented at the annual meeting of the Philosophic Society for the Study of Sport in October 1992 at the Free University of Berlin, Germany. For interpreting process philosophy, I have found the following two different studies helpful: Dale H. Porter, *The Emergence of the Past* (Chicago: University of Chicago Press, 1981), and Randall C. Morris, *Process Philosophy and Political Ideology* (Albany: State University of New York Press, 1991). Dr. Morris, my colleague, also assisted with an earlier draft of this paper. I thank him for those comments and for tolerating my drop shots on our Tuesday afternoon doubles matches which usually get us into trouble on those points where they are attempted.

REPLY TO S.K. WERTZ

When an inquiry is viewed from the position of some—here Wertz's process view—philosophy, a number of questions soon become evident:

1. Was the inquiry conducted from the position of that philosophy?
2. Does the inquiry confirm, strengthen, or just illustrate what is maintained in the philosophy?
3. Does the philosophy illuminate, enrich, or clarify what the inquiry achieves, as well as the inquiry itself?
4. Are there aspects of the inquiry or of its results that the philosophy mistakes, distorts, or neglects?
5. Does the accepted philosophy have serious defects?
6. Might other philosophic views enable one to understand the inquiry and its results in better ways?
7. What is 'applied' philosophy?

Answers to these questions will make evident the strengths and weaknesses of Wertz's interpretation of my account of sport, his view, and the manner in which he applies it.

1. I did not approach the subject of sport from the position of process philosophy, either in the form that Whitehead gave it, or in those into which his followers have tried to mold it. As I have already remarked, I wrote my thesis under Whitehead; I thought he was the greatest of living philosophers; I benefitted immeasurably from many conversations with him. But, as my paper in *Philosophical Essays for A.N. Whitehead* makes clear, I thought his view had grave defects. I have never seen my criticisms of the process view, either in its original or modified versions, dealt with squarely. Process philosophy never did consciously guide, control, or provide a background for any of my studies.

2. Wertz provides a way of taking process to be illustrated and

perhaps confirmed by an understanding of the nature of sport. I do not see how he could finally succeed, just by taking that approach, for it challenges and points up limitations in the process approach. No study of sport, though, could do more than test and partly illustrate some philosophic account. Perhaps that is all that Wertz is doing? Any subject worthy of a philosopher's attention—what subject is not?—illuminates wide-ranging principles. What is then said presumably will be tested by seeing if and how it allows for what is essential to what is being studied.

3. Can, not this or that, but every type of inquiry and its achievements be adequately dealt with from the position of some particular philosophy? Not unless this is all-comprehensive and does not misconstrue what it examines. The process view does not meet that demand. It cannot do justice to ethics, politics, art, history, religion, or education, mainly because it allows for no persistent beings able to commit themselves and carry out tasks in which obstacles are overcome and an objective gradually realized by humans struggling over time. Wertz does not try to show that process philosophy is able to understand sport in a better way than any other philosophy does, contenting himself with suggesting analogues for some basic process ideas. I do not see how process philosophy does or could advance our understanding of anything that requires commitment, habits, and plans.

I now see, decades after the publication of the book on sport, that I misused the term 'excellence' when I referred to what was sought by those who engaged in it. 'A perfecting of oneself' would have been a less misleading way of referring to what might be sought and achieved, a 'testing' of oneself would be a good way to refer to what serious sport activity promotes, and a 'sought satisfaction' a promising way to refer to what keeps one involved in an activity that is sometimes painful, and may end embarrassingly. Most justice to a study of sport will be done if it is concentrated on, with a philosophy prompting one to attend to aspects of it, such as space, time, and rules, on terms that have different weights and guises in other enterprises. The study of sport, in the end, cannot be well-understood if it is not dealt with on terms more general than those it illustrates, but so qualified and confined that they are singularly pertinent to it. The study of sport cannot be sealed off from all else, but its distinctive nature must still be marked off and its essential dimensions exposed and explored. If we approach it from the vantage point of some philosophy, we will inevitably take it to be an instantiation of this; if we ignore all general issues, we will not understand what is instantiated and interrelated in a distinctive way. A study of sport, like every other specialized inquiry, instantiates quite general principles.

4. Many aspects of sport do not fit easily within a process philosophy.

There surely would be no sport were there no individuals who dedicated themselves to long-ranged efforts, who existed for just a moment, who are not committed to doing the best they could, and who are not subject to rules. All athletes struggle; all act, all want to achieve something. They affect one another, making use of their bodies over stretches of time so as to realize prospects in a way that is beyond the ability of most others.

5. Process philosophy is so obsessed with becoming that it can find nothing persistent except a mysterious God and an inexplicable Creativity. It does not recognize that its societies have no power to constrain or to interplay with their members or with other societies. Nor does it have a place for living, enduring, responsible, and accountable humans, with responsibilities, able to commit themselves, and to possess and use their bodies, persons, and characters. I do not see how it could allow for someone to lift a bat, wait for a throw, hit, and then run, and an inning or so later, come up to bat again.

6. Dombrowski is a strong defender of Greek thought—Aristotelian as well as Platonic—as Wertz is of process philosophy. Even if one agreed that Whitehead was right—I do not think he was—to take the whole of the history of philosophical thought to be essentially Platonic, it would still be desirable to approach the study of sport from other perspectives. It would be even better to attend to sport itself and to try to deal with it on its own terms, while allowing the investigation and outcome to challenge one's antecedent suppositions, and to lead to the entertaining of others.

The tests to which a philosophy submits are strong only if independently devised and used. An account, such as the one I tried to provide, asks to be questioned and tested; it therefore welcomes challenges from every side. A process view is too riddled with arbitrary assumptions and unsupported claims to be able to provide the tests, probings, and openings needed if one is to understand any enterprise where some of the past is lost, and the next moment may not contain lures enabling one to become better. Could a process view ever be shrunk from its original size so that it was appropriate to what humans are and do? How much confidence can be placed in a view that has a sure knowledge of what is forever and such a poor grasp of humans that it can speak of no one who lasts for more than a moment? Can any athletic act be well understood if it is viewed as no more than a sequence of such moments?

7. The nature of 'applied philosophy' still awaits a careful, systematic study. What can now be said is that a philosophy should help one understand limited occurrences and pursuits in ways otherwise not possible. Since a philosophy approaches particular subject matters in terms having wide application, it cannot rightly command that every-

thing be expressed solely in its terms. Instantiations are not just localized forms of general principles; they are grained and utilized by what the principles do not constitute.

To apply a philosophy is also to test it. One who applies it should therefore be ready to see it being modified and corrected; he should also be prepared to abandon it if there are avenues it cannot enter. In one sense, there is no other philosophy than such an 'applied' one, since it is always addressed to and is always subject to correction by realities distinct from itself. When it focusses on some particular area, its claimed universality will be tested. Sport tests every philosophy in many limited ways.

Both Wertz and Lenk ask that a greater account be taken of the "social modelling situation" in sport. An acknowledgment should also be made of the role of tradition, custom, convention, and daily practices. None of these factors enjoys a privileged place except in special circumstances. What I have remarked about them deserves explanation. So do others: the status of rules, the ways they are applied, realized, and serve to evaluate what is done; the warrant for engaging in sport; what sport means and what it does to participants, spectators, and others; the relation it has to other enterprises to which humans give themselves, as well as those in which humans participate without much thought or preparation. These, among many others, are but a few awaiting philosophic study. I detect a tendency in Wertz and Lenk to sink game, play, and sport within a setting that keeps one from approaching it in other ways. No area can be justifiably excluded, or be limited to an examination on terms provided by views that are themselves not well grounded.

Wertz takes process thought to fight against static conceptions. I, too, object to these, but only if their roles are exaggerated and taken to preclude all ongoings. There is the fixed as well as the fluid, the constant as well as the changing. I don't think he does justice to Whitehead's view, though, when he says that "plays are actual occasions." At the very least, plays are more like Whiteheadean societies, since they are not self-caused, and stretch over a period of time. I think they are even more than that, occurring in a public world where they are worked out with others usually over a considerable time.

If there is an undue emphasis in *Sport* on rules, the error should be corrected, but I don't think the characterization is warranted. Evidently, I should have made more evident that sport involves action, interinvolvements, novelty, spontaneity, retreats, advances, and combinations of these. Wertz does say that I did take note of them. Still, I do not agree that for "experience . . . the flux of things is one ultimate generalization around which we must weave our philosophic system."

That claim does not even fit well with the idea that there is an eternal, Whitehedean God, even one who is always active.

Lenk, whose view Wertz here endorses, takes the athlete to represent a kind of Herculean-Prometheus myth. This might well be true in certain high moments in such grand competitions as the Olympic games. It is hard to see how it applies to the large number of athletes who never come near living up to such grandiose characterizations, and never even intend to do so. What Lenk and Wertz emphasize deserves to be noted, but it is just one of many, and important only at some times and on some occasions. To grasp the nature of sport, one must attend to more common, omnipresent factors, with footnotes remarking on those arresting occurrences that are affected by the kind of great myths to which they might refer.

It would be interesting to read a Kantian or an Hegelian, or even a Cartesian, Husserlian, or Wittgensteinean account of sport. What is needed, though, is an examination of it not antecedently defined or categorized by any philosopher. I tried to do that. If I failed, progress still could be made if what I maintained were tested by a knowledge of what is real and can be known, no matter how antecedently accepted ideas suffer.

P.W.

PART THREE

BIBLIOGRAPHY OF THE WRITINGS OF PAUL WEISS

Prepared by Fr. Thomas Krettek, S.J.

PREFACE TO THE BIBLIOGRAPHY OF PAUL WEISS

Broad, original, dynamic, and imaginative, Paul Weiss is a great philoso-
pher with important contributions to metaphysics and most of the
standard branches of philosophy. This bibliography is concerned primar-
ily with his writings in philosophy; but he has also written popular essays
for general readers and is convinced that philosophy can make significant
contributions to our understanding of a wider range of human activities
and cosmic topics than most philosophers have tackled.

He comes in for discussion, of course, in Andrew J. Reck's *The New
American Philosophers: An Exploration of Thought Since World War II*
(Baton Rouge: LSU Press, 1968). Reck maintains that "Better than any
of his contemporaries, Weiss has articulated a metaphysical system of
philosophy" (Ibid., p. 341).

The best biography of Weiss is Robert Castiglione's as yet unpub-
lished but enormously helpful manuscript on "The Offense and the
Vision: The Life and Work of Paul Weiss."

The main collection of Weiss's letters and papers is in the Special
Collections of Morris Library of Southern Illinois University at Carbon-
dale. There is also a collection of his letters in the Pusey Library of
Harvard University.

I am grateful to Father Thomas Krettek for making available his
compilation of the writings of Paul Weiss.

<div align="right">

Lewis Edwin Hahn
Editor

</div>

Department of Philosophy
Southern Illinois University at Carbondale
August 1995

PUBLICATIONS OF PAUL WEISS

I. BOOKS

Collected Papers of Charles Sanders Peirce, vol. 1: *Principles of Philosophy* (co-editor). Cambridge, Mass.: Harvard University Press, 1931.

Collected Papers of Charles Sanders Peirce, vol. 2: *Elements of Logic* (editor). Cambridge, Mass.: Harvard University Press, 1932.

Collected Papers of Charles Sanders Peirce, vol. 3: *Exact Logic* (editor). Cambridge, Mass.: Harvard University Press, 1933.

Collected Papers of Charles Sanders Peirce, vol. 4: *The Simplest Mathematics* (editor). Cambridge, Mass.: Harvard University Press, 1934.

Collected Papers of Charles Sanders Peirce, vol. 5: *Pragmatism and Pragmaticism* (co-editor). Cambridge, Mass.: Harvard University Press, 1935.

Collected Papers of Charles Sanders Peirce, vol. 6: *Scientific Metaphysics* (co-editor). Cambridge, Mass.: Harvard University Press, 1935.

Reality. Princeton, N.J.: Princeton University Press, 1938.

Nature and Man. New York: Henry Holt and Co., 1947.

Man's Freedom. New Haven, Conn.: Yale University Press, 1950.

Reality—A Selection. Hebrew translation by Yehuda Landau. Jerusalem: Magnes Press, 1955.

Modes of Being. Carbondale, Ill.: Southern Illinois University Press, 1958; paperback 1968.

Our Public Life. Bloomington, Ind.: Indiana University Press, 1959.

The World of Art. Carbondale, Ill.: Southern Illinois University Press, 1961; translation into Hebrew. Tel Aviv: Yachad United Publishing Co., 1970.

Nine Basic Arts. Carbondale, Ill.: Southern Illinois University Press, 1961; paperback 1966.

History, Written and Lived. Carbondale, Ill.: Southern Illinois University Press, 1962.

Religion and Art. Milwaukee: Marquette University Press, 1963.

The God We Seek. Carbondale, Ill.: Southern Illinois University Press, 1964.

Philosophy in Process, vol. 1. Carbondale, Ill.: Southern Illinois University Press, 1966.

Our Public Life. Carbondale, Ill.: Southern Illinois University Press, 1966. Paperback.

Philosophy in Process, vol. 2. Carbondale, Ill.: Southern Illinois University Press, 1966.

Right and Wrong: A Philosophic Dialogue between Father and Son. New York: Basic Books, 1967.

Man's Freedom. Carbondale, Ill.: Southern Illinois University Press, 1967. Paperback.

The Making of Men. Carbondale, Ill.: Southern Illinois University Press, 1967; paperback 1969.

Reality. Carbondale, Ill.: Southern Illinois University Press, 1967. Paperback.

Philosophy in Process, vol. 3. Carbondale, Ill.: Southern Illinois University Press, 1968.

Philosophy in Process, vol. 4. Carbondale, Ill.: Southern Illinois University Press, 1969.

Sport, A Philosophic Inquiry. Carbondale, Ill.: Southern Illinois University Press, 1969; paperback 1971. Also in Japanese and Korean.

Philosophical Interrogations. New York: Holt, Winston, Rinehart, 1970.

Philosophy in Process, vol. 5. Carbondale, Ill.: Southern Illinois University Press, 1971.

Beyond All Appearances. Carbondale, Ill.: Southern Illinois University Press, 1974.

Philosophy in Process, vol. 6. Carbondale, Ill.: Southern Illinois University Press, 1975.

Cinematics. Carbondale, Ill.: Southern Illinois University Press, 1975; London: Feffer and Simons, 1975.

First Considerations. Carbondale, Ill.: Southern Illinois University Press, 1977.

Philosophy in Process, vol. 7. Carbondale, Ill.: Southern Illinois University Press, 1978.

You, I and the Others. Carbondale, Ill.: Southern Illinois University Press, 1980.

Privacy. Carbondale, Ill.: Southern Illinois University Press, 1983.

Philosophy in Process, vol. 8. Albany, N.Y.: State University of New York Press, 1983.

Philosophy in Process, vol. 7, part 2. Albany, N.Y.: State University of New York Press, 1985.

Toward a Perfected State. Albany, N.Y.: State University of New York Press, 1986.

Philosophy in Process, vol. 9. Albany, N.Y.: State University of New York Press, 1986.

Philosophy in Process, vol. 10. Albany, N.Y.: State University of New York Press, 1987.

Philosophy in Process, vol. 11. Albany, N.Y.: State University of New York Press, 1988.

Creative Ventures, Philosophical Explorations, A Series Edited by George Kimball Plochmann. Carbondale and Edwardsville: Southern Illinois University Press, 1992.

Being and Other Realities, Chicago and La Salle: Open Court, 1995.

II. ARTICLES

"Relativity in Logic," *Monist* 38 (October 1928): 536–48.

"The Theory of Types," *Mind* 37 (1928): 338–48.

"The Nature of Systems," *Monist* 39 (April and July 1929): 281–319; 440–72.

"Entailment and the Future of Logic," *Seventh International Congress of Philosophy.* Oxford, 1930, pp. 143–50.

"Two-Valued Logic—Another Approach," *Erkenntnis* 2 (1931): 242–61.

"The Metaphysics and Logic of Classes," *Monist* 42 (January 1932): 112–54.

"The Metaphysical and the Logical Individual," *Journal of Philosophy* 30 (1933): 288–93.

"On Alternative Logics," *Philosophical Review* 42 (September 1933): 520–25.

"Metaphysics, The Domain of Ignorance," *Philosophical Review* 43 (1934): 402–6.

"A Memorandum for a System of Philosophy," *American Philosophy Today and Tomorrow*. Edited by Kallen and Hook. New York: Furnam, 1935.

"Time and the Absolute," *Journal of Philosophy* 32 (1935): 386–90.

"The Nature and Status of Time and Passage," *Philosophical Essays for A.N. Whitehead*. New York: Longmans Green, 1936.

"Toward a Cosmological Ethics," *Journal of Philosophy* 35 (1938): 645–51.

"The Self Contradictory," *Philosophical Review* 48 (1938): 531–33.

"Books That Changed our Minds," *New Republic* 97 (December 1938): 205.

"The Locus of Responsibility," *Ethics* 49 (1939): 349–55.

"The Year in Philosophy," *New Republic* 101 (December 1939): 204, 206–8.

"America and the Next War," *New Republic* 100 (June 1939): 210.

"The Meaning of Existence," *Philosophy and Phenomenological Research* 1 (1940): 191–98.

"The Essence of Peirce's System," *Journal of Philosophy* 37 (1940): 253–64.

"An Introduction to a Study of Instruments," *Philosophy of Science* 8, no. 3 (July 1941): 287–96.

"The Golden Rule," *Journal of Philosophy* 38 (1941): 421–30.

"Midway between Traditionalism and Progressivism," *School and Society* 53 (1941): 761–63.

"Adventurous Humility," *Ethics* 51 (April 1941): 337–48.

"God and the World," *Science, Philosophy and Religion* 1. New York: Columbia University Press, 1941.

"Charles Sanders Peirce," *Sewanee Review* 50 (1942): 184–92.

"Beauty, Individuality and Personality," *Personalist* 23: 34–43.

"Pain and Pleasure," *Philosophy and Phenomenological Research* 3 (1942): 137–44.

"The Ethics of Pacifism," *Philosophical Review* 51 (September 1942): 476–96.

"Habits, Instincts and Reflexes," *Philosophy of Science* 9, no. 3 (July 1942): 268–74.

"The Purpose of Purposes," *Philosophy of Science* 9, no. 2 (April 1942): 162–65.

"Morality and Ethics," *Journal of Philosophy* 39 (1942): 381–85.

"Cosmic Behaviorism," *Philosophical Review* 51 (July 1942): 345–56.

"Sources of the Idea of God," *Journal of Religion* 22 (1942): 156–72.

"The Logic of Semantics," *Journal of Philosophy* 39 (1942): 169–77.

"Freedom of Choice," *Ethics* 52 (January 1942): 186–99.

"Democracy and the Rights of Man," *Science, Philosophy, and Religion* 2. New York: Columbia University Press, 1942.

"Determinism in Will and Nature," *Journal of Liberal Religion* 4, no. 4 (1943): 206–11.

"The Social Character of Gestures," *Philosophical Review* 53 (March 1943): 182–86.

"Issues in Ethical Theory: Some Presuppositions of an Aristotelian Ethics," *American Journal of Economics and Sociology* 2 (1943): 245–54.

"Scholarships Through Faculty Eyes," *Bryn Mawr Alumnae Bulletin* 23 (1943): 10.

"In Quest of Worldly Wisdom," *Approaches to World Peace*. New York: Harper and Row, 1944.

"The Human Nature of Man," *The Title* 1 (May 1945): 13–21.

"The Universal Ethical Standard," *Ethics* 56 (October 1945): 38–48.

"Art and Henry Miller," *The Happy Rock*. Edited by Bern Porter. Big Sur: Porter Press, 1944.

"The Universal Ethical Standard," *Ethics* 56 (October 1945): 38–48.

"History and the Historian," *Journal of Philosophy* 42 (1945): 169–79.

"Peirce's Sixty-Six Signs," with Arthur Burks. *Journal of Philosophy* 42 (1945): 383–88.

"The Quest for Certainty," *Philosophical Review* 55, no. 2 (March 1946): 132–51.

"The True, the Good, and the Jew," *Commentary* 2, no. 4 (October 1946): 310–16.

"Philosophy and Faith," *Journal of Religion* 26, no. 4 (October 1946): 278–82.

"Et Tu Shimony," *Yale Literary Magazine* (May 1947): 12–13.

"Social, Legal and Ethical Responsibility," *Ethics* 57, no. 4 (July 1947): 259–73.

"Being, Essence and Existence," *Review of Metaphysics* 1, no. 1 (September 1947): 69–92.

"Existenz and Hegel," *Philosophy and Phenomenological Research* 8 (December 1947): 206–16.

"Immortality," *Review of Metaphysics* 1, no. 4 (June 1948): 87–103.

"Job, God and Evil," *Commentary* 6, no. 2 (August 1948): 144–51.

"Alfred North Whitehead, 1861–1947," *Atlantic Monthly* 181 (May 1948): 105–7. Reprinted from *The Harvard Crimson.*

"Otis H. Lee," *Review of Metaphysics* 2, no. 2 (December 1948): 1–2. Appeared also in *Philosophical Review* 58 (September 1949): 465–66.

"Sacrifice and Self-Sacrifice," *Review of Metaphysics* 2 (March 1949): 76–98.

"Alfred North Whitehead," *Philosophical Review* 58 (September 1949): 468–69.

"Good and Evil," *Review of Metaphysics* 3 (September 1949): 81–94.

"Some Epochs of Western Civilization," *Et Veritas* 4, no. 2 (December 1949): 8–18.

"Law and Other Matters," *Review of Metaphysics* 4, no. 1 (September 1950): 131–35.

"Freedom and Rights," *Perspectives on a Troubled Decade, 1939–49.* Edited by Lyman Bryson, Louis Finkelstein, and R. M. MacIver. New York: Harper and Row, 1950.

"Science, Superstition and Precision," *Freedom and Reason.* Conference on Jewish Relations, 1951, 309–21.

"Cosmic Necessities," *Review of Metaphysics* 4, no. 3 (March 1951): 359–75.

"The Prediction Paradox," *Mind* 61, no. 242 (April 1952): 265–69.

"The Nature and Status of the Past," *Review of Metaphysics* 5 (June 1952): 507–22.

"Some Theses of Empirical Certainty," *Review of Metaphysics* 5 (June 1952): 627.

"The Perception of Stars," *Review of Metaphysics* 6 (December 1952): 233–38.

"The Logic of the Creative Process," *Studies in the Philosophy of Charles Sanders Peirce.* Edited by P.P. Wiener and F.H. Young. Cambridge: Harvard University Press, 1952.

"Some Neglected Ethical Questions," *Moral Principles of Action.* Edited by R. Anshen. New York: Harper and Row, 1952.

"On the Responsibility of the Architect," *Perspecta 2, Yale Architectural Journal* (1953): 51–55.

"The Contemporary World," *Review of Metaphysics* 6 (June 1953): 525–38.

"Grünbaum's Relativity and Ontology," *Review of Metaphysics* 7 (September 1953): 124–25.

"The Past: Some Recent Discussions," *Review of Metaphysics* 7 (December 1953): 299–306.

"Persons, Places and Things," *Moments of Personal Discovery.* Edited by R.M. MacIver. New York: Harper and Row, 1953.

"Man's Inalienable Rights," *Ixyun* 5, no. 1 (January 1954): 129–30.

"The Four Dimensions of Reality," *Review of Metaphysics* 7 (June 1954): 558–62.

"Guilt, God and Perfection, I," *Review of Metaphysics* 8 (September 1954): 30–48.

"The Gita, East and West," *Philosophy East and West* 5 (October 1954): 253–58.

"Guilt, God and Perfection, II," *Review of Metaphysics* 8 (December 1954): 246–63.

"The Right of Might," *A.R. Wadia: Essays in Philosophy Presented in His Honor.* Madras: G.S. Press, 1954.

"The Paradox of Necessary Truth," *Philosophical Studies* 6, no. 2 (February 1955): 31–32.

"Real Possibility," Colloquium No. 6, *Review of Metaphysics* 8, no. 4 (June 1955): 669–70.

"Greek, Hebrew and Christian," *Judaism* 4, no. 2 (1955): 116–23.

"The Paradox of Necessary Truth Once More," *Philosophical Studies* 7, no. 6 (1956): 88–89.

"The New Outlook," *American Philosophers at Work*. Edited by Sidney Hook. New York: Criterion Books, 1956.

"The Nature and Locus of Natural Law," *Journal of Philosophy* 53 (1956): 713–21.

"On the Difference between Actuality and Possibility," *Review of Metaphysics* 10, no. 1 (1956): 165–71.

"The Fortunate Philosophers," *Yale Alumni Journal* (June 1956): 20.

"The Real Art Object," *Philosophy and Phenomenological Research* 16, no. 3 (1956): 341–52.

"On Being Together," *Review of Metaphysics* 9, no. 3 (1956): 391–403.

"A Reconciliation of the Religions: A Non-Irenic Proposal," *Journal of Religion* 26, no. 1 (1956): 36–44.

"Ten Theses Relating to Existence," *Review of Metaphysics* 10 (March 1957): 401–11.

"Eighteen Theses in Logic," *Review of Metaphysics* 11 (September 1957): 12–27.

"Philosophy and the Curriculum of a University," *Journal of General Education* 11, no. 3 (1958): 141–45.

"The Semantics of Truth Today and Tomorrow," *Philosophical Studies* (January-February 1958): 21–23.

"The Paradox of Obligation," *Journal of Philosophy* 55, no. 7 (March 27, 1958): 291–92.

"Common Sense and Beyond," *Determinism and Freedom*. Edited by Sidney Hook. New York: New York University Press, 1958.

"Love in a Machine Age," *Dimensions of Mind*. Edited by Sidney Hook. New York: New York University Press, 1960, pp. 193–97.

"Art, Substance and Reality," *Review of Metaphysics* 12, no. 3 (1960): 365–82.

"Man's Existence," *International Philosophy Quarterly* 1 (1961): 547–68.

"Thank God, God's Not Impossible," *Religious Experience and Truth*. Edited by Sidney Hook. New York: New York University Press, 1961.

"History and Objective Immortality," *The Relevance of Whitehead*. Edited by I. Ledere. London: George Allen and Unwin, 1961.

"Elements of the Physical Universe," *Review of Metaphysics* 15, no. 1 (September 1961): 1–18.

"Historic Time," *Review of Metaphysics* 15, no. 4 (June 1962): 573–85.

"Weiss Asks Coffin: 'Is Christianity Necessary?'," *Yale News and Review* 1, no. 1 (September 1962): 8–9.

"Twenty-Two Reasons for Continuing as Before," *Philosophical Studies* 13 (October 1962): 65–68.

"Religious Experience," *Review of Metaphysics* 17, no. 1 (September 1963): 3–17.

"Natural and Supernatural Law," *Political Science and the Modern Mind.* Detroit, Mich.: Sacred Heart Seminary, 1963.

"The Explanation of Man," *International Congress of Philosophy.* Mexico, 1963.

"The Use of Ideas," *Review of Metaphysics* 17, no. 2 (December 1963): 200–204.

"It's About Time," *Philosophy and History.* Edited by Sidney Hook. New York: New York University Press, 1963.

"The Religious Turn," *Judaism* 13 (Winter 1963): 3–27.

"Our Knowledge of What is Real," *Review of Metaphysics* 18, no. 1 (September 1964): 3–22.

"The Right to Disobey," *Law and Philosophy.* Edited by Sidney Hook. New York: New York University Press, 1964.

"C.S. Peirce, Philosopher," *Perspectives on Peirce.* Edited by Richard J. Bernstein. New Haven: Yale University Press, 1965.

"Types of Finality," *Journal of Philosophy* 64, no. 19 (October 5, 1967): 584–93.

"The Economics of Economists," *Human Values and Economic Policy.* Edited by Sidney Hook. New York: New York University Press, 1967.

"Equal and Separate but Integrated," *Proceedings of the American Catholic Philosophical Association* 29 (1967): 5–17.

"Sport and Its Participants," *Science* 161 (September 1968): 1161–62.

"A Philosopher's View of Sport," *Yale Banner* (1968): 186–94.

"Some Paradoxes Relating to Order," *The Concept of Order.* Edited by Paul Kuntz. Seattle, Wash.: Washington University Press, 1968.

"The Nature of Violence," *Seventeen* (August 1968).

"What is Man?" *This Week* (November 2, 1969).

"Paul Weiss' Recollections of Editing the Peirce Papers," *Transactions of the Charles S. Peirce Society* 6, no. 3–4 (1970): 161–87.

"Introduction to Metaphysics," *The Future of Metaphysics.* Edited by Robert Wood. Chicago, Ill.: Quadrangle Books, 1970.

"On What There is Beyond the Things There Are," *Contemporary American Philosophy.* 2nd series. Edited by J.E. Smith. London: Allen and Unwin; New York: Humanities Press, 1970.

"Age is Not a Number," *New York Times* (January 1, 1971).

"Architecture, The Making of a Metaphor: Notes from a Symposium," *Main Currents* 29 (September-October 1971): 9–12.

"The Distinctive Nature of Man," *Idealistic Studies* 1, no. 2 (1971): 89–101.

"Science and Religion," *Evolution in Perspective.* Edited by G. Schuster and R. Thorson. Notre Dame: University of Notre Dame Press, 1971.

"The Possibility of a Pure Phenomenology," *Value and Valuation: Axiological Studies in Honor of Robert S. Hartman.* Edited by J.W. Davis. Knoxville, Tenn.: University of Tennessee Press, 1972.

"Records and the Man," *Philosophic Exchange* 1 (Summer 1972): 89–97.

"A Response," *Review of Metaphysics* 25, no. 4 (June 1972): 144–65.

"Wood in Aesthetics and Art," *Design and Aesthetics of Wood.* Edited by Erica Anderson and George Earle. New York: State University of New York Press, 1972, pp. 19–25.

"The Philosophic Quest," *Mid-Twentieth Century American Philosophy.* Edited by P.A. Bertocci. New York: Humanities Press, 1974, pp. 240–45.

"Bestowed, Acquired, and Native Rights," *Proceedings of the American Catholic Philosophical Association* 49 (1975): 138–49.

"The Policeman: His Nature and Duties," *The Police in Society.* Edited by E.C. Viano and J. Rowman. Lexington, Mass.: Lexington Books, 1975.

"Reason, Mind, Body and World," *Review of Metaphysics* 30, no. 2 (December 1976): 325–34.

"Substance and Process, Today and Tomorrow," *Philosophy Research Archives* 2, no. 1204 (1976): 111–41.

"The Game as a Solution to the Problem of the One and the Many," *Journal of the Philosophy of Sport* 7 (Fall 1980): 7–14.

"Recollections of Alfred North Whitehead," *Process Studies* 10 (Spring-Summer 1980): 34–38.

"Some Pivotal Issues in Spinoza," *The Philosophy of Baruch Spinoza.* Edited by Richard H. Kennington. Washington, D.C., Catholic University of America Press, 1980, pp. 3–13.

"The God of Religion, Theology, and Mysticism," *Logos: Philosophical Issues in Christian Perspective,* vol. 1, 1980.

"Truth and Reality," *Review of Metaphysics* 34, no. 1 (September, 1980): 57–69.

"Second Thoughts on First Considerations," *Process Studies* 10 (Spring-Summer, 1980): 34–38.

"The Nature of a Team," *Journal of the Philosophy of Sport* 8 (Fall 1981): 47–54.

"The Joy of Amateur Sport," *The National Forum, The Phi Kappa Phi* 63 (Winter 1982): 14–17.

"Nature, God and Man," *Existence and Actuality.* Edited by John B. Cobb and Franklin I. Gamwell. Chicago, Ill.: University of Chicago Press, 1984, pp. 113–21.

"Things in Themselves," *Review of Metaphysics* 39, no. 1 (September 1985): 23–46.

"Dunamis," *Review of Metaphysics* 40, no. 4 (June 1987): 657–74.

"Induction: Its Nature, Justification and Presupposition," *Journal of Speculative Philosophy* 1, no. 1 (1987): 6–23.

"On the Impossibility of Artificial Intelligence," *Review of Metaphysics* 44, no. 2 (December 1990): 335–41.

INDEX

(by S. S. Rama Rao Pappu)

abduction, 277, 327, 472f., 475; and adumbration, 292, 319f., 326, 538; and induction, 474; as hypothesis, 316; scientific, 316
Abel, Gunter, 60, 62f.
Absolute, 563; agapeic, 554; erotic, 556
act(s), 299, 400; creative, 400, 569ff., 591ff.
action, human, 639; impossible, 492; right, 504; political, 532
actual entity, and games, 666
actuality (ies), 21ff., 58f., 123, 128f., 149, 155f., 237ff., 259, 272, 360, 398f, 631; and Being, 45; and Dunamis, 128; and finalities, 147f.; and modes, 396; and necessary realities, 147; and privacy, 526; and probability, 227; and realities, 250; athletic, 640; defined, 394; existence of, 121; hypostatized, 58; meaning of, 93; theory of, 146f.; two kinds of, 143; unity of, 125
adumbration, 246f., 253ff., 269ff., 300, 314ff., 325, 472f., 530, 630; and abduction, 254, 258, 262, 317, 319f., 326, 538; and realities, 261, 326; and reductionism, 270; and speculation, 255; explained, 315; limits of, 318f.
adventure, 544
aesthetics, 611ff.
agape, 500, 611
Alexander, S., 599
Algozin, Keith, 645, 653n
Allen, Diogenes, 535n
Allinson, Robert E., 513nf.
American life, features of, 523f.
Angell, Roger, 672, 674n
"animal faith," 424
animals, and humans, 74f., 80ff., 125

appearance(s), 236; and reality(ies), 233, 315, 338; evidenced, 57; objective, 55ff., 260, 527; subjective, 55ff.
apprehension, types of, 232f.
Aquinas, St. Thomas, 197, 211, 255, 550ff.
Aristotle, 22, 26, 28, 43, 66, 105, 114, 120, 124, 129, 134, 140, 144, 154ff., 168ff., 174nf., 178, 181, 198n, 203, 205, 211, 255, 257, 267n, 275f., 284, 287n, 291, 401, 407, 461, 469n, 472, 474, 502, 524, 540, 551, 562, 593, 595, 597, 602, 608, 618, 622f., 625, 632, 640, 643, 648, 659
art, 19ff., 571, 575f., 586, 616; and arts, 634; and emotion, 622f.; and eternity, 635; and imitation, 632; and reality, 621; as representational, 622; dynamic, 624; generalization of, 587; life imitates, 649f.; philosophy of, 580
arts, spatial, 624, 627; temporal, 624
artforms, 623, 625f.
Aschenbrenner, Karl, 509n
asymmetry, 122
athletics, and spectators, 642; and thinkers, 639; not gambling, 646; women, 640
atomism, 272
Augustine, St., 160, 205, 424
Austin, J.L., 509n
Ayer, A.J., 268n, 455

Baier, Kurt, 505, 513n
Barden, Garrett, 511n
baseball, 663
beauty, 467, 571
Becker, Charlotte B., 508n, 512n
Becker, Lawrence C., 508n, 512n
behavior, 299; and passion, 299f.

Being, 23, 25f., 32, 39, 127, 135, 140ff.,
　184, 202, 230, 249, 328, 334, 391, 397,
　401, 417, 556f., 559, 635; and
　actualities, 39; and beings, 146; and
　modes, 124, 402, 417; and reality, 135;
　and ultimates, 23ff., 67; as generic, 141;
　as power, 638f.; bifurcation of, 142;
　category of, 140f., 143, 157, 326;
　exalted, 261; four modes of, 197; idea
　of, 121; internalization of, 621;
　meanings of, 146; nature of, 123f., 148;
　possibility of, 66f., 539; proof of, 25f.
being-itself, 424
Bell's Inequality, 346
Benardete, Seth, 468
Bentley, Arthur, 268n
Bergmann, Fritjob, 649, 654n
Bergson, H., 10, 22, 104, 171, 562, 593,
　596, 602, 608, 634
Berkeley, George, 338, 577
Bernstein, Richard, 222, 360
biography, and history, 191
biology, 280, 282, 284
Black, Max, 509n
Bloom, Harold, 106n
body, and mind, 302ff.; athletic, 639f.
Bradley, F.H., 14, 171, 183, 454
Braeckman, Antoon, 176n
Braithwaite, R.B., 101
Braudel, Fernand, 198n
Broad, C.D., 332, 347n
Brown, Joe E., 578
Buber, Martin, 366
Buchler, J., 285, 287n, 391
Buddhism, 387
bullfighting, 640

Caillois, Roger, 642, 653n
Capaldi, Nicholas, 176n
Carnap, R., 101, 281, 287n, 332, 346,
　351, 353, 450, 471n
Cassirer, E., 58, 62, 62n, 68
categorial natures, 229
categorial schemes, 280
categorial systems, 120
category (ies), 134, 142f., 255, 270, 280,
　401, 408, 587, 635; justification of, 406;
　primary, 143; ultimate, 25, 141
category mistake, 124
causal processes, 104f.

causality, 100ff., 106nff., 123, 618; as
　necessary connection, 100
causation, 102f.; and Dunamis, 113f.; as
　process, 113; formal, 114ff.
cause, 99, 212; as constant conjunction,
　114ff.; efficient, 112
"cement of the universe," 99f., 102
certainty, metaphysical, 70
Cua, Anthony, 536n
chance, 190
chaos, and cosmos, 117ff.
Chu Hsi, 510n
cinematics, 626
classes, 428ff.; class of all, 428ff., 442ff.;
　extensional, 440; intensional, 440; logic
　of, 454; predicational function of, 440;
　reference of, 441f., 448; Russell's
　paradox of, 444
coach, 639
Cohen, Morris R., 12, 279, 287n, 293
Collingwood, R.G., 10, 169, 172, 175n,
　599
"common good," 362
common sense, 313f, 375f.; rational, 275
commonwealth, 540
community, 357ff., 369; and individual,
　357ff., 366; and tradition, 500;
　conditions for, 365; genuine, 356, 362;
　loyalty to, 371; perfection of, 370
concept, meaning of, 256; necessity of,
　466
Confucius, 403, 502, 505, 515f., 579
concrescence, 665
consequences, causal, 100
constant conjunction, 114
constructivism, interpretations of,
　59f.
contextualism, 96, 107n
contradiction, category of, 141; law of,
　143, 255; theory of, 400
Cook, Patricia J., 174n
cosmology, 172
cosmology, philosophic, 134
cosmos, and chaos, 117ff., 132n; and
　ontology, 142; and order, 122; and
　reality, 121; and structure, 119; as
　law-abiding, 121; categorization of, 129;
　faith in, 118; finalities of, 129
creation, 550; and imitation, 546f.; divine,
　422

creation *ex nihilo*, 392, 399ff., 409, 411, 418f., 422, 549, 560
creative achievements, 608
creativity, 19ff., 408, 545, 543ff., 561, 570ff., 591ff.; and concepts, 593; and the Dunamis, 543ff.; and excellence, 592; and explanation, 563; and God, 407; and novelty, 593; and originality, 547; and self, 547; and ultimates, 553, 576; human, 407; philosophical, 552f., 594ff.; radical, 554, 592ff.; teleology of, 555; varieties of, 591ff.
"critical commensensism," 278
Cusanus, Nicholas, 169

Dahlstrom, Daniel O., 506, 512n, 514n, 532, 581
Danto, Arthur, 198n
Darwin, Charles, 292
data, objectified, 213
D'costa, Gavin, 403, 414n
de Certeau, Michel, 192f., 200n
decision, moral, 491
deduction, justification of, 464
democracy, 547
Dennes, William, 511n
Dennett, Daniel C., 306n
Derrida, J., 165
Descartes, 60, 66, 170f., 177f., 180, 256, 270f., 280, 298, 401
Desmond, William, 471n
detachment, 650
determinate, and indeterminate, 137
determinations, 496
Deutsch, Eliot, 511n
Dewey, John, 8, 10, 37, 64f., 213f., 222, 224f., 240n, 242n, 247, 249, 257, 264, 267nf., 285, 287n, 391, 621f., 632
dialectic, 30, 572, 575f.
discipleship, and philosophy, 164ff.
Dostoevsky, Fyodor, 16
doubt, Cartesian, 256ff., 270f., 415
doxography, 167
Dray, William, 198n
Dru, Alexander, 199n
dualism, 264
Dworkin, Ronald, 511n
Dunamis, 22, 24, 42, 94ff., 103ff., 110ff., 123, 129, 136, 148ff., 241n, 243n, 250, 260, 268n, 322, 390, 392, 399, 401,

406ff., 422, 454, 527, 538f., 549, 567ff., 587, 595ff., 609ff., 620, 626; and actualities, 128; and creativity, 543ff.; and human beings, 524; and metaphilosophy, 94f.; and Rational, 596, 632; and ultimates, 112ff., 556, 567f.; as energy, 631; as power, 551; as unity, 408; characteristics of, 568f.; dynamics of, 105; explained, 96; foundational, 598; idea of, 563; indeterminacy of, 598; primary, 550ff., 562
duty, 487ff.; nature of, 490; operative, 484

Eaton, Ralph Monroe, 451n
Edwards, Paul, 512n
egalitarianism, 360
ego, 310
Ehman, Robert, 649, 653n
Einstein, Albert, 294, 346, 351, 353
elements, nature of, 567f.
Eliade, Mircea, 131n
Eliot, T.S., 16, 459
emotions, 632; and art, 622f.; levels of, 623
empiricism, 235, 258f.; British, 259
energy, 618
entities, mental, 337; physical, 337
Epicurus, 169
"Epimenides Paradox," 428ff.
epistemology, 234f., 247f.; and ontology, 140f., 338
equality, personal, 362
"essential features," 392, 397f.
eternal life, 410
"eternal objects," 140
"eternal togetherness," 423
eternity, 217, 410; not static, 409
ethical sensitivity, 366
ethics, 282f., 293, 393; and evolution, 283; and metaphysics, 495; and modernity, 489ff.; Confucian, 496; Kantian, 481; naturalistic, 283
events, 237, 332, 346; instantaneous, 333; nature of, 663
evolution, 278, 285; and freedom, 283; theory of, 74ff., 87
Ewald, François, 200n
excellence(s), 599, 604, 676; and final causes, 599; and indeterminacy, 601;

and possibility, 600f., 610; bodily, 638, 640; evolution of, 611
exclusivism, 403; religions, 373ff.
existence, 105, 121ff., 144, 149, 154, 239, 335, 343, 624; and actualities, 239, 396; and ideality, 394; and nowness, 351; and sport, 640; and unity, 407; and voluminosity, 620; as being, 617; as energy, 407; definition of, 619; dynamism of, 105; God's, 619; intelligible, 144; nature of, 617ff.
existentialism, 37
experience, 218f., 224ff., 235ff., 248, 253, 313; aesthetic, 218f., 221, 467; analysis of, 215; and adumbration, 262; and consciousness, 213; and nature, 213f.; and perception, 211f., 214, 219f.; and possibility, 211ff., 220f.; and potentiality, 220ff.; and process, 225; and sense-data, 256; cognitive, 213; continuity of, 260; instantaneous, 219; levels of, 212; nature of, 235; primary, 234; primordial, 249f.; pure, 234; reinterpretation of, 259f.; religious, 215ff., 375f.; synthesis in, 212; types of, 216; ultra-natural, 376
explanation, 35, 110ff.; and regularity, 102; as argument, 101; asymmetry of, 102; causal, 99f., 102ff., 111; inferential, 101; meaning of, 97ff.; metaphysics of, 103ff.; nature of, 110f.; nomological, 101f.; scientific, 97, 103ff., 112ff.
extensionality, principle of, 441f.

fact, fulcral, 117ff.
faith, 416, 424; and hope, 423; forms of, 377ff.; religious, 377ff.; tentative, 380
fallibilism, 271, 460, 469; and foundationalism, 257ff.; contrite, 258
family, loyalty to, 482ff.
feeling, 234, 247
Feezell, Randolph, 637, 641, 645, 648, 650, 652, 654n
Feyerabend, Paul, 268n
Fichte, 310
film, 626
"final cause," 188, 204; and excellences, 599
finalities, 58f., 66, 122, 128, 135, 147, 231f., 260, 315, 392, 616; and

actualities, 147f.; and conditions, 526f.; quest for, 127; seeking, 124
finite, 39
Fink, Eugen, 653n
Foucault, Michel, 194f., 198n, 200n, 208
foundationalism, 61, 69f., 232, 235, 271; fallibilistic, 257ff.; formal, 265
Ford, Lewis S., 450n
Forms, 155, 175n, 665; Platonic, 476; theory of, 169
Fox-Genovese, Elizabeth, 537n
Fraenkel, Abraham, 13
Frankel, Charles, 199n
Frankfurt, Harry, 513n
Frankfurter, Felix, 11
freedom, 282f., 497, 502, 523, 649; and evolution, 283; and necessity, 188
Freud, S., 570
functions, predictional, 448f.

Galileo, 387
games, and fun, 642; and plays, 665ff.; and war, 642ff.; inner, 672; meaning of, 663; process in, 669ff.
Gassendi, 169
Gebauer, Gunter, 673n
Gendin, Sidney, 673n
Gert, Bernard, 512n
Gewirth, Alan, 510n
Gilson, Etienne, 8, 10, 13
Gleik, James, 130, 132n
God, 24, 38, 85, 118f., 121, 143ff., 156, 214f., 217, 249, 270f., 298, 313, 334, 351, 371, 374, 376ff., 392ff., 415ff., 502, 521, 549f., 560f., 563, 619, 626, 631; Absolute, 356; and Being, 144, 418; and creation, 418; and creativity, 407; and Dunamis, 406, 587; and elements, 423; and Existence, 394f.; and faith, 381; and many, 392ff.; and philosophy, 421, 425; and religion, 380, 402ff.; and salvation, 403; and transcendence, 380; and unity, 404; as significant category, 416; as creator, 400f.; as ideal, 496ff.; as one, 393; as unity, 399, 410; contact with, 404; experience of, 376ff.; form of, 391, 402; inwardness of, 122; knowledge of, 374ff., 389ff.; nature of, 375, 396; not a mode, 397ff.; proofs for, 385; unity of, 397

"Golden Rule," 363, 503f., 519
good, 144f., 162, 225f., 297, 466f., 495ff.;
 Absolute, 358f., 361, 363, 366, 371; and
 self, 305; community, 497; definition of,
 496; knowledge of, 506, 519f.; political,
 531; vision of, 505
"good man," 356ff.
Goodman, N., 285, 287n
"grand logic," 455
Griffin, David Ray, 267n
Grube, G.M.A., 266n
Grünbaum, Adolf, 332, 343, 347n, 351
guilt, 364

hagiography, 167
Hahn, Lewis E., 130n, 174n
Hampshire, Stuart, 511n
happiness, 43
Hare, R.M., 174n, 508n
Harris, J.F., 383
Hartshorne, Charles, 12f., 120, 130n, 167,
 266n, 277, 663
Hegel, G.W.F., 9f., 26, 29, 65f., 76, 107n,
 117, 129, 134, 141, 156, 171, 176n,
 177, 183, 187, 198n, 205, 212, 214,
 276, 278, 287n, 292, 401, 403, 552f.,
 560, 563
Heidegger, Martin, 10, 16, 268n, 624, 633
Hempel, Carl, 101
Hendreckson, Paul, 152n
Heraclitus, 462, 608
hermeneutics, 57
"heterological-autological contradiction,"
 428
heterological words, 444ff.
Hick, John, 403, 414n
Higginbotham, John, 514n
Hinman, Laurence, 654n
"historic ought-to-be," 187f., 195, 198
historicity, 191; existential, 193
historiography, 185, 193
history, 151, 161, 163, 167, 219; and
 biography, 191; and chronology, 187;
 and community, 179; and narrative,
 192f., 206; and philosophy, 161, 163,
 166, 170f., 186, 196; as evaluative, 196;
 committed, 197; dialogue with, 162;
 objective, 186; philosophy of, 177,
 183ff., 201ff.; post-structuralist, 194;
 tout court, 186; written and lived, 185ff.

"history-ought-to-be," 204
Hobbes, Thomas, 30, 401
Hofstadter, Douglas R., 306n, 629
holocaust, 16
Homer, 462
Hood, Sidney, 8
Hope, R., 287n
Hortleder, Gerd, 673n
Hsun Tzu, 503
Hudson, Deal W., 200n
Huizinga, Johan, 642
human nature, 73f., 76ff., 190f.; and body,
 82; and social process, 79; as social
 product, 84; inclusive, 82
humanism, 76
humanity, as objective condition, 77f.;
 standard of, 78
humans, reproduction of, 75ff.
Hume, David, 28, 100, 107nff., 103, 115,
 170ff., 180, 267n, 463, 509n, 577
humility, 506, 520
humors, 567
Husserl, Edmund, 10, 215
Hyland, Drew, 653n
hypothesis, 37, 137, 190, 245f., 322;
 scientific, 401

Idea(s), 22ff., 37, 262, 496; Platonic, 315,
 326
ideal, and reasonableness, 496
ideal objects, 189
idealism, objective, 17; transcendental,
 335
ideality, 143
identity, 143, 264
inclusivism, 403; religious, 373ff.
indeterminacy, 609
individual(s), and rights, 529f.; and
 society, 86f.; and species, 80; and state,
 541; autonomous, 534; otherness of,
 528, 541; perfection of, 528
individualism, 84, 573ff.; and community,
 357ff.
individuality, and plurality, 355ff.
induction, 459ff., 472ff.; and truth, 463;
 and ultimates, 475; justification of,
 462ff.; suspension of, 466
inference, 102, 257, 262; deductive, 317f.,
 464; inductive, 464; law of, 143; valid,
 115

intellection, 319
intelligence, critical, 25
intensionality, 191, 205, 226
interpretation, 62, 65ff., 245; as reality,
59, 68; conception of, 60; ontological,
61; principle of, 59; schema of, 57;
transcendental, 56f.
intuition, 88, 319f.; rational 318, 320f.,
326f.
Irwin, Terrence, 469n
Isenberg, Arnold, 514n

Jaeger, Werner, 131n
James, William, 64, 171, 213, 215, 234,
240n, 242n, 259, 264, 267n
Jastrow, Robert, 132n
jen, 500, 504
Johnson, W.E., 579
Joy, Lynn, 169
Joyce, Michael, 471n
justice, 524, 531

Kant, Emmanuel, 10, 28, 36, 65f., 68,
125f., 129f., 134, 154, 156, 171f., 176n,
180, 195, 198n, 203, 205, 212, 214,
275, 278, 334f., 343, 346, 401, 481,
540, 552, 577, 639
Kaufmann, Walter, 200n
Keating, James, 653n
Kee, Alistair, 383
Keenan, Francis, 654
Kekes, John, 511n
Kennedy, Kevin, 471n
Kepler, Johannes, 101
Kierkegaard, Søren, 183, 187, 199n
Kingsmill, Thomas, 513n
kinship, principle of, 362
Kleene, S.C., 428
Klein, Jacob, 13
Kline, George, 198n
Kneale, W.C., 100, 108n
Knitter, Paul F., 403, 414n
Knoblok, John, 512n
knowledge, 234f., 256, 264f., 273, 476;
and ignorance, 468; and philosophy,
460f.; boundaries of, 265; Confucian,
507; empiricist, 258; religious, 381;
spectator theory of, 263f.; two kinds of,
261; valid, 379
Korzybski, Alfred, 427

Krasner, Saul, 132n
Krettek, Thomas, 268n, 287n, 288n,
323n, 414n, 537n, 581n
Kuhn, Thomas, 160, 172
Kuhns, R., 629
Kuntz, Marion L., 131n
Kuntz, Paul G., 130nff., 640, 652, 673n

Langer, Suzanne, 641
Lau, D.C., 514n
law, 531
Lehman, Craig, 654n
Lenk, H., 62nf., 245, 511n, 673n
Leibniz, G.W., 13, 56, 61, 66, 155, 171,
318f., 401
Lee, Edward N., 198n
Lewis, C.I., 9, 240n, 451n
Lewis, C.S., 267
Lewontin, R.C., 83n
Livingston, Donald, W., 176n
Lucas, J.R., 511n
"Liar's Paradox," 428ff.
Locke, John, 171f., 280, 297, 401
logic, 10, 12, 127, 141, 454ff.; and
mathematics, 456; category of, 157;
intensional, 454; substitutional, 427ff.;
symbolic, 281; world of, 126
Long, Eugene, 383
Lovin, Robin W., 131n
love, evolutionary, 292
Lowe, Victor, 386, 156
Lucas, George R., 176n, 177

MacIntyre, Alasdair, 160, 163, 174nf.,
511n, 523f., 534nf., 645, 654n
Mackie, J.L., 100, 102ff.
man, and nature, 284ff.; as symbolic
being, 58
Mancini, Matthew J., 200n
Mandelbaum, Maurice, 198n
Maritain, J., 195, 197
Marshall, John, 512
Marx, Karl, 195, 198n
mathematics, 633
matter, 155n, 229, 618, 631
McCoy, Charles, 524, 535n
McHenry, Leemon, 176n
McKeon, R., 585
McTaggart, J.M.E., 332, 339, 341, 347n
Mead, G.H., 233, 240n, 242n

meaning, 263; as use, 466; experiential, 262; pragmatic, 261f.; theory of, 262, 273

Megill, Allan, 200n

men, and animals, 296

"Meno's paradox," 460, 464

metaphysics, 61, 64f., 117, 140, 202, 275, 391, 459ff., 615ff.; and ethics, 495; and nature, 285; and post-modern metaphysics, 253f.; idealistic, 260; political, 524; post-pragmatic, 265f., 273; systematic, 278

method, 313ff.; combinatory, 588; cosmological, 530f.; metaphysical, 530f.; philosophic, 313ff., 325, 327, 573, 575, 586; scientific, 316

Mill, J.S., 76

mind, as historical, 194; computational model of, 295

mind-body problem, 302ff., 338

"misplaced concreteness," 280; fallacy of, 615

modes, 229, 395; and God, 397ff.; as beings, 397; togetherness of, 145, 261, 394; unity of, 396

moderation, 638

modesty, 506

monads, 56, 61

monism, 124; neutral, 171

Moore, G.E., 183, 198n

moral obligation, 477ff.

morality, 142; and ethics, 489ff.; face of, 501

Morgan, William, 652

Morris, Charles, 243n

Morris, Randall C., 674n

Murdoch, Iris, 654n

Murphy, Arthur, 243n

music, 622, 625f, 632, 634

mystic, 630; naturalistic, 639

Nagel, Ernest, 8

Nagy, Paul, 367

narrative, 209, 302; and history, 192f., 206

narratology, 192

naturalism, 229

nature, 21, 247, 289; and action, 285; and experience, 213f.; and man, 284ff.; and purpose, 276, 278, 291; and teleology, 524; consequent, 554; philosophy of, 276ff., 286; primordial, 554

necessity, logical, 100; natural, 100

Nelson, Everett, 156

neo-Hegelianism, 95

Neoplatonism, 396

Neville, V., 63n

Neville, Robert, 165, 174n, 285, 287n

Newton, Isaac, 28, 130

Newtonianism, 172

Nietzsche, F.W., 60f, 133, 166, 183, 547ff., 549f., 552, 634

Nisbet, Robert, 523, 534n

nonbeing, 631

noncontradiction, 60

nonrationalism, 95

Northrop, F.S.C., 285, 287n, 293

Novak, Michael, 645, 653n, 667, 673n

nothingness, 632

now, 346ff.

nowness, 335; and existence, 351; as illusion, 338; definition of, 336; transcendence of, 335; transient, 352

Nowell-Smith, P.H., 508n

Oakeshott, Michael, 214, 500, 511n

obligations, filial, 485ff.; and persons, 480; hierarchy of, 490f.; moral, 487; political, 485

observation, 34

Occam's law, 26

Olbrechts-Tyteca, Anna, 509n

One, and the many, 40, 355ff., 369ff., 391ff., 408f., 411, 416, 419f., 424, 556, 671

"one world," 196

ontological argument, 380

ontology, 140ff., 237; and cosmology, 142; and cosmos, 122; and epistemology, 140f.; five, 150, 153ff.; modal, 142; post-modal, 145ff.; pre-modal, 140ff.; second order, 493; second pre-modal, 142

order, and disorder, 119; discovery of, 119; philosophy of, 120; prescriptive, 119

Ostwald, Martin, 509n

"ought," and "can," 145

"Owl of Minerva," 96

pains, and pleasures, 303
paradoxes, self-referential, 450; solution
 of, 456; source of, 449
passage, 407
passion, and behavior, 299f.
past, 193; and future, 250, 409f.; and
 present, 205f., 250, 409f.
pastness, 334
Pater, Walter, 622
Paton, W., 470n
Paul, Gregor, 511n
Peirce, Charles S., 10, 12, 14ff., 37, 64ff.,
 129, 154f., 181, 205, 231, 233, 240nff.,
 244ff., 257, 259, 261f., 266n, 275, 277f.,
 285, 287n, 323n, 402, 405, 453, 455,
 594, 601f., 606, 609f., 631
Pellauer, David, 200n
Pepper, Stephen C., 131n, 134, 511n
perception, 232, 317, 319f.; and
 experience, 219f.
Perelman, Chaim, 509nf.
person, 21; political, 530
personalism, 539
phenomenological method, 230
phenomenological principle, 338
phenomenology, 136, 282, 289f.
'philoanalysis,' 316
philosophical systems, 380, 386
philosophical strategies, 95
philosophy, 30ff., 94ff., 111, 133, 169ff.,
 177ff., 186, 206, 275f., 294, 332, 465,
 543, 558ff., 572, 633; analytic, 159ff.;
 and history, 161, 163, 178; and
 discipleship, 164ff.; and exegesis, 166f.;
 and hagiography, 167; and history,
 180f., 186; and jurisprudence, 180; and
 knowledge, 460f.; and private vision,
 163; and rhetoric, 169f.; and religion,
 382, 385ff.; and science, 231, 322; and
 theology, 405, 420; as competitive, 168;
 as creative, 495; as historical, 172f.; as
 warfare, 170; audience in, 164;
 creativity in, 38f.; death of, 27f.; end of,
 73; evaluation of, 40; explanation in,
 31; false, 170; history of, 160ff., 170ff.;
 intelligibility of, 41f.; margins of, 165;
 method of, 163, 314ff.; nature of, 15,
 35ff.; political, 523ff.;
 post-metaphysical, 185; post-modern,
 191; practical, 197; process, 236f., 675;

reasons in, 162, 180; reflection in, 33;
 stages in, 43; study of, 127; substance,
 236; systematic, 40f, 183; systems of,
 34ff.; task of, 44; theories of, 168; unity
 of, 559
physicalism, 338
Plato, 22, 66, 85, 131n, 143, 154, 156,
 162f., 168ff., 181, 191, 266n, 291, 318f.,
 407, 461, 465, 467, 469n, 472ff., 551,
 556, 562, 580, 593, 595, 602, 608, 631,
 633, 652, 659
play, and sport, 642ff., 656, 659; and
 games, 665ff.; and work, 649; as actual
 occasion, 678; as process, 667, 669;
 experience of, 650
Plotinus, 400
pluralism, 40, 405, 485; metaphysical,
 392, 417; ontological, 56; religious,
 373ff., 384, 403
plurality, 352
politics, and revelation, 525; modern, 524
Porter, Dale H., 674n
positivism, logical, 256
possibility (ies), 121, 149, 237ff., 611; and
 actuality, 227; and excellences, 600f.;
 and experience, 220f.; and
 potentialities, 238f., 250; and real, 334;
 external, 238; objective, 188; origin of,
 602
postmodernism, 27
potentialities, 226; and experience, 220ff.;
 and virtue, 645f.
pragmatism, 37, 225, 230f., 231, 233ff.,
 244ff., 261, 268ff.; and process
 philosophy, 237; five characteristics of,
 256f.
primary disequilibrium, 257
Prince, Gerald, 200n
privacy, 161ff., 282, 459, 548, 603;
 accessibility of, 359; and publicness,
 358ff.; and reality, 526; ontological, 359
probability, 118; historical, 188
problem-solving, 277
process, 140, 237, 249f., 259, 272, 618;
 and substance, 236; philosophy of, 545
propositions, and facts, 433; falsity of,
 435, 438ff.; intensive, 448
Pythagoras, 117, 120, 124

Quine, W.V.O., 8, 285, 288n, 451n

Ramsey, F.P., 428, 433, 451n, 470n
Rasmussen, Douglas, 268n
rational, 540f.
rationalism, 95, 279
Rawls, John, 510n, 534n
real, sense of, 281
reality (ies), 35, 40, 121, 123, 135, 141,
 147, 156, 239, 292, 350, 393, 417, 616;
 and appearance, 315; and finalities, 122;
 and interpretations, 69f.; and
 possibility, 334; and symbolization, 59;
 and ultimates, 634; conception of, 263;
 cosmic, 38; constituents of, 93;
 givenness of, 525ff., 540; hypostatizing
 of, 60; kinds of, 36ff.; nature of, 295;
 ultimate, 408
reason(s), and history, 208; philosophical,
 162; sufficiency of, 527, 540
reasonable persons, 495ff., 517ff.
reasonableness, 501; and impartiality,
 501; and rationality, 498; and
 complacency, 517; and tradition, 499;
 concept of, 498; sophisticated, 527, 532
Reck, Andrew, 243n, 507n
reductionism, 254, 316
reflexivity, grammatical, 98
regularity, and explanation, 102
Reichberg, Gregory, 514n
relations, 122; logic of, 122; reciprocal,
 124; self-referential, 449; systematic,
 122
relativism, 189
religion, and ethics, 385f.; and God,
 402ff.; and philosophy, 382, 387f.; as
 cultural expression, 387; relativism in,
 372f; truth-claims in, 374ff., 403
Rescher, Nicholas, 200n, 430, 510
resistance, sense of, 246
responsibility, 308
Reynolds, Frank E., 131n
Richards, David A., 510n
Ricoeur, Paul, 198nf.
rights, 529ff; inalienable, 30
Robinson, Richard, 469n
Roochnik, David, 654
"root metaphor," 134
Rorty, Richard, 130, 170, 174n, 176n,
 281, 288n, 460, 469n
Rosenthal, Sandra, 266n
Ross, W.D., 175n

Royce, Josiah, 356f., 363ff., 508n
Rousseau, J.J. 523
Russell, Bertrand, 10, 167, 171, 183, 191,
 198n, 205, 427ff., 435, 437, 440, 449,
 451n, 453, 525, 577
Ryder, John, 266n

Sagan, Carl, 132n
Salmon, Wesley, 100ff., 108nf.
salvation, 405
Sartre, J.-P., 193, 195, 197, 208
"saving the appearances," 406
Schall, James, 524f., 535n
Schlesinger, George N., 332, 347n
Schmitz, Kenneth, 629, 645, 653n
Schneewind, Jerome, 174n
Schopenhauer, Arthur, 133, 552, 555, 562,
 609, 634
Schulkin, J., 285, 288n
science, 104f., 244ff., 275, 277, 279, 294f.,
 307, 316, 325; and philosophy, 231;
 method of, 231, 248f.
scientists, 245ff.
Segal, Erich, 653n
self, 76, 226, 295ff., 307ff., 364; and body,
 74f.; and God, 305; and multiplicity,
 216; as autonomous, 301; as active, 299;
 as chance person, 300; as fiction, 302,
 305f., 310; changeless, 82; encrusted,
 300; forensic, 297; human, 74;
 hypostatized, 79f.; illusion of, 307;
 inside, 300; nature of, 89f.; postulating
 a, 86; six features of, 296f.
self-attributions, 298
self-cause, 156, 385
self-criticism, 304
self-discipline, 304
self-identity, 79ff., 296ff., 308
self-reference, 437
"self-referential paradoxes," 440
self-transcendence, 363f.
set theory, paradoxes of, 439
Sextus Empiricus, 471n
Shaw, Irwin, 673n
Sherburne, Donald W., 267n
Shils, Edward A., 510n
Shimony, Abner, 347n
Sibley, W.H., 510n
Singer, Marcus, 513n
Skinner, Quentin, 174n

Skyrms, B., 469n
Smith, John E., 267n
social contract, 523, 532f.
socialization, 86, 89, 363f.
society, and government, 529f;
 ontologization of, 88; union of, 528f.
Socrates, 66, 175n, 459, 474
Sokolowski, Robert, 525, 535n
space, 123
space-time, 339ff.; Einstein-Munkowski,
 343, 344ff.
species, 276
Spengler, O., 184
Spinoza, 120, 130, 172, 276f., 288n, 399,
 401
sport, 637ff., 655ff.; absurdity of, 650,
 657f.; aim of, 669; and character, 645ff.;
 and cheating, 647; and excellence, 638,
 640, 643; and meaning of life, 648ff.,
 659f., and philosophy, 651, 659; and
 process philosophy, 662f., 675ff.; and
 rules, 662, 678; and schools, 647; and
 women, 658; as action, 662; as applied
 philosophy, 661, 677f.; as play, 641ff.;
 as unifying, 639; as work, 656; essential
 nature of, 638; explanation of, 643;
 Greeks on, 638ff.; joy in, 645;
 metaphysics of, 662ff.; moral character
 of, 646; nature of, 637ff.; spectator, 641
sportsmanship, 643f.
state, function of, 529f.
Stein, Howard, 346, 347n
Stevens, Wallace, 93, 469n, 471n
storytelling, 633
Strauss, Leo, 13
subject, as construct, 60, 69
subjectivity, 337, 343f.
substance, 122, 149, 236, 237, 239, 249,
 276, 280, 282f., 293, 616; and process,
 236; category of, 335; nature of, 148
Sumida, Lynn, 175n
superstition, 475
symbolic forms, 68
symbolization, and reality, 59
symbols, 58
systematization, 40f.

Tao, 609
Taylor, Charles, 498, 509n
Taylor, Thomas, 654

team, nature of, 664
teleology, cosmic, 601f., 604, 612;
 determinist, 605; emergent, 612;
 operative, 612
temporal discourse, 332
temporality, 410
theology, 389ff.; philosophical 389, 404,
 402, 420
thing-in-itself, 526
things, created, 569; objective, 572
Thompson, J.A.K., 287n
time, 123, 239f., 331ff., 618; passage of,
 331; phenomenology of, 339; unreality
 of, 349
Tolstoy, Leo, 570
Toulmin, Stephen, 131n
Toynbee, Arnold, 184
tradition, 541; as interpretation, 502, 518;
 ethical, 500; living, 499; nature of, 499f.
transcendence, 125f.; creative, 544f.
transiency, 344, 352; paradox of, 333,
 339
Trianosky, Gregory, 508n
truth, 163, 258; definitive, 379; historical,
 190f.; philosophic, 325, 380; religious,
 404f.; types of, 242n
Turner, William, 451n
types, theory of, 271, 427ff.

Ullian, Joseph, 673n
ultimates, 22ff., 37, 40, 110ff., 116, 135,
 157, 290, 292, 315, 321, 408ff., 417,
 473, 567ff., 574, 587, 630; and being,
 23ff., 67; and categories, 21; and
 creative ventures, 545ff.; and Dunamis,
 112f.; and God, 24; and intermediaries,
 541, 574; and realities, 634; as
 constrictive projections, 68; as
 creativity, 553; as methodological
 constructs, 67; erotic, 553f.; evidence
 of, 465f.; four, 24; five kinds of, 149;
 nature of, 568; ultimate of, 556
ultimate conditions, 96
universals, 123
universe, 127ff.; as cosmos, 117; as moral
 entity, 496
unity, 126, 391, 402, 420; and actuality,
 125; and God, 404; and plurality, 356f.;
 ultimate, 405
utterances, religious, 374

Vanderwerken, David L., 673n
venture, creative, 544ff., 558
Verene, Donald Phillip, 175n
verificationism, 106n
Veyne, Paul, 190, 200n
Vico, G., 169
Vienna Circle, 183
virtue, as practice, 645ff.
Vlastos, Gregory, 131n
von der Luft, Eric, 557n

Wang Yang-Ming, 496, 518
Weiss, Jonathan, 480
Weiss, Victoria, 11, 18
Weissman, David, 245, 266n, 285, 288n
Wertz, Spencer K., 673n
Weyl, Hermann, 332, 428, 449
"Weyl's paradox," 440, 444
Whitehead, A.N., 8ff., 65, 129f., 140f.,
 154, 156, 165, 170ff., 176n, 178, 181,
189, 199n, 204f., 213, 237, 249, 259,
275, 277, 285, 288n, 293, 347n, 352,
360, 427f., 431, 434f., 437, 440, 451n,
453, 545, 553f., 577, 609, 615, 620,
663f., 673n, 677
Whitehead, Evelyn, 11
Wiener, P., 323n
will, creative, 497
Will, Frederick, 266n
Winch, Peter, 502, 512n
Wittgenstein, Ludwig, 171, 182, 430, 453
Wood, Robert E., 268n, 323n, 582
words, 459f.; medium of, 580
Wright, Chauncey, 247
Wright, Larry, 108n

Yates, Stephen, 268n

Zeilicovici, David, 332, 334f., 339, 343,
 347n